This book was created under the direction of

Enrico Isacco

with the editorial supervision of

Professor Anna L. Dallapiccola

and contributions by:

Professor Anna L. Dallapiccola
Head of the Department of History of Indian Art at the South Asia Institute of Heidelberg University

Professor Brijinder N. Goswamy
Professor and Head of the Department of Fine Arts at the Punjab University Chandigarh

Doctor Karuna Goswamy

Doctor Karl J. Khandalavala
Chairman of the Board of Trustees of the Prince of Wales Museum Bombay

Professor Walter Spink
Professor of History of Art at the University of Michigan, Ann Arbor

Doctor Kapila Vatsyayan
Joint Educational Adviser to the Government of India, New Delhi

KRISHNA
THE DIVINE LOVER

Myth and Legend through Indian Art

Serindia Publications
London

David R. Godine
Boston

Cataloguing in Publication Data

Krishna the divine lover: myth
 and legend through Indian art.
 1. Krishna 2. Mythology, Hindu
 294.5'13 BL1220

ISBN 0-906026-11-3 (Serindia)

ISBN 0-87923-457-1 (Godine)

LIBRARY OF CONGRESS CATALOG CARD NO. 82-083044

An Edita book copublished by

SERINDIA PUBLICATIONS, 10 Parkfields, Putney, London SW15 6NH.

C.H.P. EDITIONS, 110 East 59th Street, New York, New York 10022.

DAVID R. GODINE, PUBLISHER, INC., 306 Dartmouth Street, Boston,
Massachusetts 02116.

Distributed in North and South America by Harper & Row Publishers, Inc.
10 East 53rd Street, New York, New York 10022.

Printed in Italy and bound in Switzerland.

Contents

Photographic credits

All photographs were taken by Mr. Enrico Isacco with the following exceptions:

Illustration Nos. 127, 129, 150, 187, 193 provided by Professor Samuel Eilenberg; Nos. 51, 60, 66, 91, 157 provided by Galerie Marco Polo, Paris; Nos. 67, 94, 194 by The British Museum Photographic Service; No. 86 by The British Library reference division; Nos. 95, 96, 106 by The American Committee for South Asian Art - University of Michigan; No. 97 provided by Galerie Annapurna, Amsterdam; No. 125 provided by Dr. and Mrs. Hermann Kulke; No. 126 by Edita S.A., Lausanne; Nos. 137, 141, 144, 145, 147 by the Archeological Survey of India; No. 80 by Mr. J. Eskenazi; Nos. 138, 140 provided by the Government Museum, Mathura; Nos. 84, 116, 122 provided by private collectors.

Editor's note:

The transcription of Sanskrit and of various Indian languages is in the English commonly used in India. Diacritical marks are indicated only in the glossary and index, where Sanskrit words have been transcribed according to the M. Monier-Williams system, and regional terms according to the most common usage.

Acknowledgements

We wish to express our gratitude to the following institutions and their staffs who have graciously allowed us access to their collections: Bharat Kala Bhavan, Benares; British Library; British Museum; Chandigarh Government Museum; Gwalior Archeological Museum; Indian Museum, Calcutta; Museum Rietberg, Zurich; National Museum, New Delhi; Mathura State Museum; Orissa State Museum, Bubaneshwar; Prince of Wales Museum, Bombay; State Archeological Museum of West Bengal; Victoria and Albert Museum, London.

We also wish to express our gratitude to the following private collectors: Mr. M. Archer and Mrs. M. Lecombe, London; Mr. C.L. Bharany, New Delhi; Mr. G. Bornan, Marseilles; Colnaghi & Co. Ltd. London; Prof. S. Eilenberg, New York; Eskenazi, Milan; Galerie Marco Polo, Paris; Dr. K. and Mrs. M. Khandalavala, Bombay; Dr. and Mrs. H. Kulke, Heidelberg; Mr. and Mrs. J. Riboud, Paris; Rutland Gallery, London; Spink & Son, London; Colonel R.K. Tandan, Hyderabad; Dr. Vollmer, Freiburg.

We are particularly thankful, for their assistance in locating the visual material, to: Dr. H.C. Das in Bubaneshwar; Dr. P.C. Gupta in Calcutta; Mr. G.N. Venu in Kerala; Mr. S. Gahlin; Mr. B. Alderman, Mr. M. Zebrowski, Mr. T. Falk, in London; for her helpful advice, to Mrs. M. Pitoeff; for her work in correcting and proof reading to Ms. K. Macdonough; for her map-making skills to Ms. H. Nischk.

Visions of the Dark Lord

by Prof. B.N. Goswamy and Prof. A.L. Dallapiccola

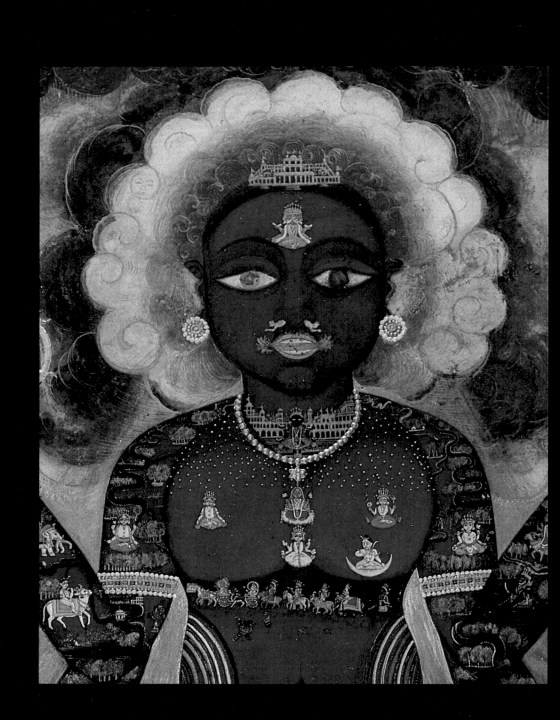

KRISHNA AND THE WEST

Adored, revered and doted upon by the great majority of the Hindus, Krishna is undoubtedly one of, if not *the* most popular deity of the Hindu pantheon, whose life and deeds had and still have an enormous impact on the cultural, religious and social background of Indian life. The ever present 'Blue God' could not fail to attract Western attention. Casual visitors, scholars, artists or missionaries all succumbed either positively or negatively to the fascination of this unpredictable and multifaceted 'Dark Lord.

The first information on Krishna to be found in Western sources comes from the Greek authors. In describing the victorious campaign of Alexander the Great to India, they dwell at length on the customs and manners of the Indian people, and they speak of the worship of a god whom they identify with the Greek god Dionysus. Dionysus was known to have conquered India. Alexander himself was eager to follow in the footsteps of the god, and, if possible, to go beyond the point reached by Dionysus himself, which, incidentally, he did. The shady hills of the North-West-Frontier Provinces, the ivy, the wine and many a familiar custom led the Greeks to think the inhabitants of those regions followers of Dionysus, and the enthusiasm of Alexander and his troops was such that they 'acted as Bacchanals' and sacrificed to the god. Arrian, the Greek historian and philosopher, who lived between c. A.D. 96 and 180 writes a detailed passage, compiled from previous material available to him, in his *Anabasis of Alexander*:

> ...So he went to Mount Merus with the companion Cavalry and the foot guard, and saw the mountain which was quite covered with ivy and laurel and groves thickly shaded with all sorts of timber...
> The Macedonians were delighted at seeing the ivy, as they had not seen any for a long time... They eagerly made garlands of it and crowned themselves with them, as they were singing hymns in honour of Dionysus, and invoking the deity by his various names. Alexander there offered sacrifice to Dionysus, and feasted in company with his companions. Some authors have also stated, but I do not know if any one will believe it, that many of the distinguished Macedonians in attendance upon him, having crowned themselves with ivy, while they were engaged in the invocation of the deity, were seized with the inspiration of Dionysus, uttered cries of Evoi in honour of the god, and acted as Bacchanals (1).

The expedition of Alexander to India took place in 327-326 B.C., and we may thus surmise that a form of Krishna worship existed already at that time. Better documented evidence of the existence of a Krishna cult in the first centuries before our era is to be found in the

Greek accounts of an Indian group, who apparently migrated to Armenia between 149 and 127 B.C., whose god was named Kishen or Damodara, both names of Krishna (2). The Greeks also noted a fairly widespread cult of Shiva, whom they identified with the Greek god Herakles.

Nothing can be said with certainty about the characteristics of Krishna and of Krishna worship at this early stage. However we know that the worship of Shiva had to compete as early as the third century B.C. with the increasingly growing popularity of the Krishna cult, and that by about the fourth or the fifth century A.D.

> ...Vishnu was completely synonymous with the hero-god of the north west regions, Krishna of Dwarka, who had formerly been an ecstatic god of Dionysian character... (3)

From about the 17th century onwards, when European visitors to India were comparatively frequent and very keen on recording their impressions, the source material on Krishna we are confronted with is larger, better documented and undoubtedly of utmost interest.

Individuals such as Jean-Baptiste Tavernier, Baron d'Aubonne, the Abbé Dubois, Colonel James Tod, or Mrs. Fanny Parks, to name but a few of the distinguished European visitors from the middle of the 17th century to the beginning of the 19th century, had ample opportunity to come across Krishna and his worship, the manners and the customs related to the Krishnaite view of life and so on, during their long stay in India. All of them, without exception, dwell at length in their narratives and in their memoirs on this 'cultural phenomenon', as we may call the world around the Krishna cult and faith.

Even if the above mentioned persons had not been interested in Indian culture and in Indian religions, but perhaps just curious to know more about their surroundings during their sojourn in such a totally different environment, as India was for them, they would have probably noted the recurring presence, perhaps one should say 'the imminence' of this beautiful divinity of a bluish hue. As a matter of fact his strikingly handsome appearance, his omnipresence not only in the visual arts, but also in literature, in music, in everyday life and worship could not pass unnoticed, or without mention.

Moreover, as soon as the shock caused by the novelty of the visual and verbal expression, the luscious imagery, and the very frank and open sensuality of some artistic works dealing with the Krishna theme subsided, the foreign visitors, who were Christians, could detect some elements in the myth of Krishna which sounded surprisingly familiar to them. Already the very name Krishna, sometimes pronounced in such a way as to sound something like 'Krishto', led some missionaries and some travellers to search for a link between Christ and Krishna.

1. Vishvarupa, Universal Form of Vishnu/Krishna. *(Miniature, detail, Jaipur c. 1810, Private collection.)*

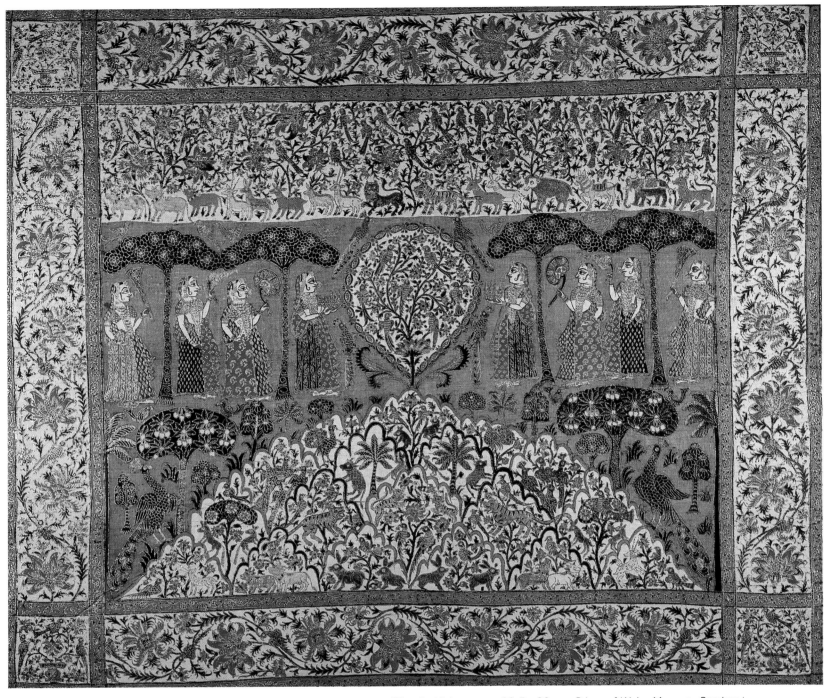

2. The gopis worshipping the tree of life. *(Painted cloth, Deccan [?] early 19th century, 69.5 × 80 cm, Prince of Wales Museum, Bombay.)*

This way of pronouncing the name of Krishna may also have been the cause of the well known episode of the Mass celebrated by Vasco da Gama and his followers in a Hindu temple at Calicut in 1498. The attempt to connect somehow the figure of Krishna with that of Christ was frustrated by later serious philological studies. There did however remain striking parallels between the narrative of the Krishna legend and the life story of Christ. Just to mention a few incidents which led European travellers and scholars to search for some link between Krishna and Christ, it will be useful to recall these episodes:

1) birth in poor surroundings

2) flight of the parents (or, as in the case of Krishna, foster-parents) with the child
3) massacre of the male children

Looking at the cult, we may also find some similarities:

1) worship of the child
2) stress upon 'complete devotion', on a complete surrender of oneself to that which may be termed as 'the faith in the grace of God'

All attempts at connecting the Krishna faith with the Christian faith proved, however, ineffective (4).
Having discussed the 'image' of Krishna as presented by outsiders, it is now the moment to turn to Indian sources.

KRISHNA IN THE INDIAN TRADITION

Who is Krishna really?

In the Indian tradition Krishna is perceived differently by different people. Responses to his multifaceted, flamboyant personality vary greatly now, as they did in the past. His fascination, however, persists.

He is often spoken of, in sober historical judgment, as being different persons coalesced into one: a hero, a teacher, a king, who became deified with the passage of time. But, whatever the aspects, whatever the process, Krishna has been a central figure and has, so to speak, held the centre of the stage for millions in India.

For the devotee, problems of historicity and the like are not in the least relevant; to him Krishna is all and everything. Perhaps it is through the eye of the artist and the words of the poet that one may share the emotional experience of the devotee, which, incidentally, may prove much more valuable than any intellectual approach to this complex divine personality. So for instance, the Poet knows Krishna. Krishna is, to him:

> as wing to bird
> water to fish
> life to the living. (*Vidyapati*) (5)

The Beloved also thinks she knows Krishna. Using the poet's words, she sees the Lord

> as the mirror to my hand
> the flowers to my hair
> kohl to my eyes
> *tambul* to my mouth
> musk to my breast
> necklace to my throat
> ecstasy to my flesh
> heart to my home... (*Vidyapati*) (6)

This said, doubts continue to linger. Something about him keeps eluding them, and plaintively, each asks in the end:

> But tell me
> Madhava, beloved,
> who *are* you?
> Who are you, *really*? (*Vidyapati*) (7)

The question is not a scholar's question; the question asked by the Poet and the Beloved is, in a sense, *the* Great Question.

'Who *is* he really?'

At a given point in the *Bhagavadgita*, Krishna reveals himself. On the field of battle the vision is granted to Arjuna, who, assailed by doubts, receives from Krishna the divine sight with which to perceive his Supreme Form. The charioteer who was speaking to him a mere moment ago, is now seen suddenly by Arjuna as a Being

> of many mouths, and eyes, of many visions
> of marvel, of many divine ornaments, of
> great uplifted weapons

> Wearing heavenly garlands and raiments, with
> fragrant perfumes and unguents, made up of all
> wonders, resplendent, boundless, with faces
> turned everywhere.

> If the light of a thousand suns were to blaze
> forth all at once in the sky, that might resemble
> the splendour of that exalted Being. (*XI. 10-12*) (8)

This god of gods is beheld by Arjuna, whose mouth is parched and whose hair stands on end, as a body 'without beginning, middle or end', the entire space beween heaven and earth filled by this wonderous, terrible form, whole worlds rushing into the mouth of this world-destroying-Time, 'as moths rush swiftly into a blazing fire to perish there'.

However, Krishna reveals himself quite differently elsewhere. We see him as a tender baby crawling about on all fours in the courtyard of the village home of his foster parents, Nanda and Yashoda. Here, for the moment, the all-important question seems to be whether he shall, or shall not be able to cross the door-step. The parents watch:

> He tries to come outside.
> It's so easy now
> to crawl within the courtyard,
> but the doorstep stops him every time.
> He trips and falls,
> can't get across;
> it's all such an enormous task.

Only the Poet takes us into confidence:

> Once he measured the Earth in a mere three steps;
> now he's stopped at the edge of his very own house...
> (*Sur Das*) (9)

3. Lahula Ragaputra. *(Miniature, Basohli c. 1700, 155 × 160 mm, Collection Colonel R.K. Tandan, Hyderabad.)*

4. A Messenger leads Radha to Krishna. Illustration to the Gita Govinda. *(Miniature, Bundi 18th century, 190×286 mm with borders, Galerie Marco Polo, Paris.)*

5. Love Games. Illustration to the Gita Govinda. *(Miniature, Basohli c. 1730, 210×305 mm with borders, Chandigarh Govt. Museum [ref. 153].)*

This 'knowing wonder' belongs to all those who see him as a child in this rural setting: the Primal Person stealing butter, being chastised by his mother, going around barefoot with a blanket draped over his shoulders to graze his herd of cows, being made to dance by the lowly Ahir cowherdesses in return for a sip of buttermilk from an earthen pot.

When he grows up, we see Krishna turning into the Great Lover. The cowherdesses of Vraja, the slender-waisted Radha, all fall distractedly in love with him. He romps with them in the fragrant forest, torments them with the sweetness of the melodies he plays on the flute, rouses longings and fulfills them. He is the lover of them all, 'hungrily embraced by those beauties of Vraja'; but he is also a suppliant in love, for he pays homage at his beloved's feet — 'massages them, paints them with lac, puts his head on them and worships them'. He who is adored by everyone is also reprimanded in no uncertain terms, described as deceitful and treacherous by the beloved.

> When you stay before my eyes
> You make me feel your love is firm,
> But out of sight how different you are!
> How long does false gold shine?
> Master of sweetness, I know your ways.
> Your heart is counterfeit.
> Your love is words.
> Speech, love and humor
> All are smooth
> And only meant to tease.
> When you shed a girl
> Do you laugh?
> Are your arrows always
> Poisoned with honey? *(Vidyapati)* (10)

There is a curious strangeness in the spectacle of 'the Supreme Lord who appears in the world to overthrow all evil', dallying with a young girl and being chastised by her thus. Confusion, *bhrama*, persists.

The inability to find an answer to the Great Question, 'who *is* he really' is common to everyone: to the parents of Krishna, to his many beloveds, even to the greatest of seers. In an early text, there is a passage concerning the wise Akrura who was taking Krishna with his brother Balarama from Vrindavana to Mathura. As they passed by the Yamuna, Akrura stopped the chariot to bathe in the purifying waters of the great river. Krishna and his brother sat under a tree on the bank. When Akrura entered the water of the Yamuna, he suddenly saw the two brothers, and thought in wonder:

> Both the brothers are seated under the shade of the fig-tree: yet I see those very two in the water: I don't apprehend the mystery of their being out and in the water; which shall I call their true forms?

He was reflecting on this, when

> in the midst of it appeared Shri Krishna, becoming first four armed and bearing the conch-shell, discus, club and lotus, surrounded in the water with all his worshippers, Suras, Munis, Kinnaras, Gandharvas, and others; then he appeared again sleeping on the Cosmic Serpent, Shesha (11).

At this Akrura was greatly perplexed.

Lila and Maya: Two Aspects of the Divine Activity

Closely connected with the phenomenon of 'multiplicity or multiplication of forms' there is yet another aspect to be taken into consideration; an aspect common to all

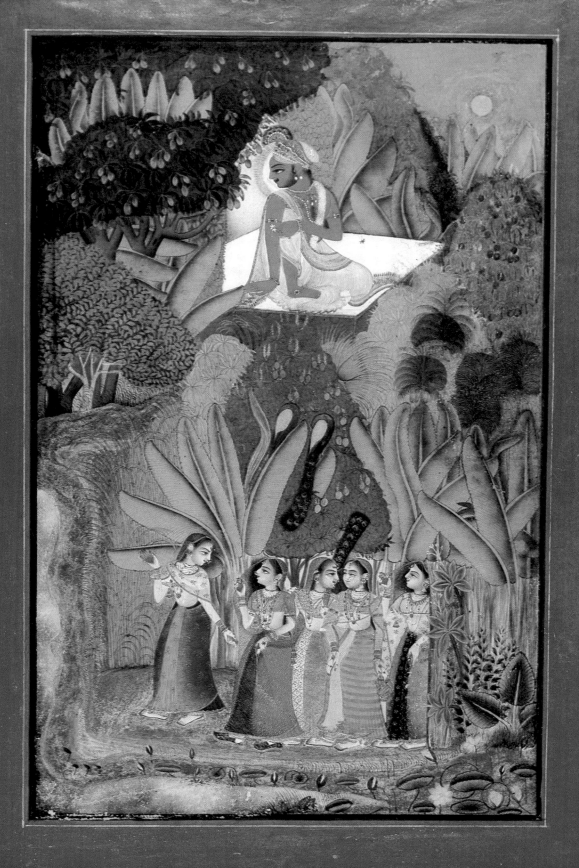

gods of the Hindu pantheon. This is the 'divine play, the sport or dalliance, the playful activity' termed *lila*, a Sanskrit word which means 'flickering of fire' and *in extenso* has the meaning of 'play', of unpredictability of action and which also came to mean divine activity. Because the gods have no needs and no desires, their activities are called 'play', *lila*. As mere players, they delight in playfulness and, enjoying this playful activity, they act aloof from the world:

> For Me, son of Pritha, there is nothing to be done
> in the Three Worlds whatsoever.
> Nothing unattained to be attained;
> and yet I still continue in action. *(III, 22)* (12)

Such are the words of Krishna to Arjuna in the *Bhagavadgita*.

Playing, the gods create the Universe, playing they involve themselves accidentally or voluntarily in human life or in the activities of the world. In creating, maintaining and destroying the above, this activity, not being subject to special laws, is highly unpredictable. Sometimes this unpredictability is coupled with an unrestrained freedom, with a joyful spontaneity, with a harmonious gracefulness, qualities which are shared by all the Hindu gods, but are somehow very typical of Krishna and his legend. Even when Krishna is involved in the most fearful contests against demons which assume the strangest, most blood-chilling forms, there is always this component of easiness, of gracefulness, of lightness, of play, which has the effect of elating the devotee; and not only this, it also has the effect of redeeming the Malignant. This gracefulness is aptly expressed by the following poem, describing the forest-fire, one of the many adventures which befell Krishna in the days of his youth among the cowherds:

> Amazed at the sight, the people exclaim:
> 'Earth and sky alike were aflame,
> fire spreading in great, bounding strides;
> There was no rain, no one brought water;
> what made it stop?
> It burst so fiercely upon the forest!
> Why did it go out?'
> 'Oh, you know these grass-fires',
> laughed Gopal;
> 'They are over almost before they've begun.'
> Listen, Sur, to the difference
> between what the Lord *does*, and what the Lord *says;*
> such are the games the Lord plays. *(Sur Das)* (13)

Divine actions thus seem to proceed from overabundance, from an overflowing of energy and fullness. The myth of creation according to Vaishnava mythology makes the point very neatly: Vishnu lies asleep on the coils of the Cosmic Serpent, Ananta or Shesha. While this is easily and effortlessly floating on the waters of the Primeval Ocean, from Vishnu's navel sprouts a lotus in which the Creator, Brahma, is seated. Brahma, in his turn, will create the world. Thus we see that creation is in

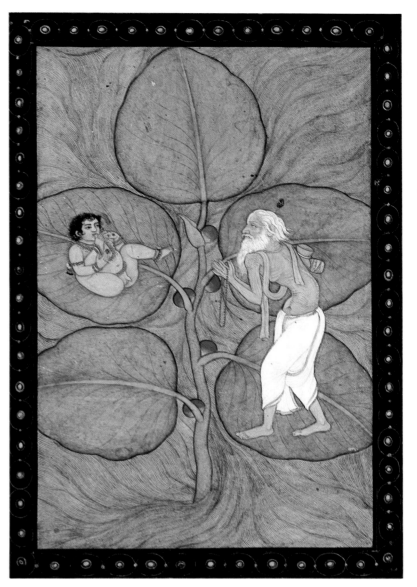

7. Baby Krishna reveals himself to the sage Markandeya. *(Miniature, Guler c. 1790, 108 × 160 mm without borders, Chandigarh Govt. Museum [ref. 170].)*

a way an effortless emanation of divine power. Vishnu created the Universe while asleep. Indeed he 'dreams the Universe into existence' (14).

This graceful, undramatic, easy and effortless creative process, a true mirror of the playful godly activity, is again expressed in the myth of the sage Markandeya, where the latter, in the vastness of the Primeval Ocean, sees the Creator as a small child resting on a branch of a fig-tree. The *Matsya Purana* describes the scene thus:

> He was seen playing all by himself without any anxiety in the Universe bereft of creation...

Then the creation process begins:

> In that great Ocean, the great place of pilgrimage, the infallible Hari, the creator of all worlds, plays for some time, and brings forth out of his navel a wonderful lotus of a thousand petals shining like the sun. (15)

The world is thus the toy of the child and like a toy it is something to play with, to be engrossed in, not to be

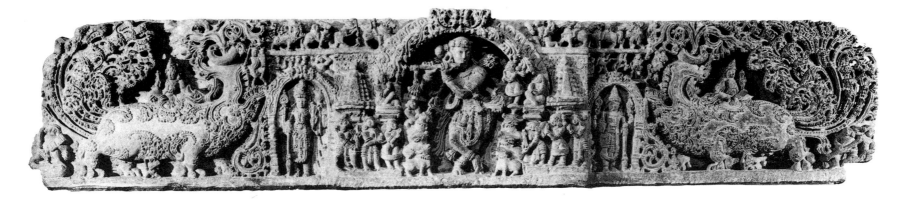

taken too seriously, nor to be held responsible for. This is clearly suggested by the following poem:

> Holding his foot in his hand, Gopal is sucking his toe.
> He lies alone in his cradle absorbed in his happy play:
> Shiva has started worrying and Brahma has become
> thoughtful.
> The Banyan tree has reached the level of the water of the
> sea.
>
> Sages are fearful in their hearts, the earth is shaking
> and the Serpent Shesha is spreading his hood in anxiety.
> The folks of Braj do not know what is happening.
>
> (*Sur Das*) (16)

The great gods may worry about the impending end of the world, about the cosmic dissolution, but the child goes on playing, absorbed in self delight and self display, not caring in the least about future events.

The myth of Markandeya goes on, introducing a further cardinal element of Hindu thought: the concept of *maya* or 'delusion'.

Again we see the sage in the waters of the Primeval Ocean beholding the 'radiant child' sporting on the fig-tree. The astonished sage then asks the child the following question:

> Let me know the secret of your *maya*, the secret of your apparition now as a child, lying and playing in the infinite sea. Lord of the Universe, by what name are you known?

Then Vishnu replies, using a name which is also the name of Krishna:

> I am the Primal Cosmic Man, Narayana... I am the Lord of Waters... I am the cycle of the year, which generates everything and again dissolves it. (17)
> I am the divine *yogi*, the Cosmic Juggler or Magician, who works wonderful tricks of delusion. This display of the mirage of the phenomenal process of the universe is the work of my creative aspect; but at the same time I am the whirlpool, the destructive vortex, that sucks back whatever has been displayed and puts an end to the procession of the *yugas*. I put an end to everything that exists. My name is Death of the Universe. (18)

Maya can be defined as 'that which prevents man from seeing the world as it really is'. The roots of *maya*, *maya* meaning illusion or delusion, are to be sought in ignorance, in the state of *a-vidya*, of not-knowing. It is due to this ignorance that man thinks this worldly existence to be the true one: permanent, worthy of attachment. According to some philosophical schools, all appearances of diversity and form are caused by *maya*, or are identified with *maya*. *Maya* is only and purely appearance; it has

no real cause or effect. It is merely a projection of pervasive ignorance.

But *maya* can also be seen from another perspective: it may be seen as the capacity of the gods to change forms, to create, to extend themselves, to destroy their creations. Because of this faculty, the gods are known as *mayins*, a *mayin* being 'the... juggler or magician who works wonderful tricks of delusion', as we have seen in the passage quoted above. As a result of this ability, of this *maya*, Vishnu, lying on Shesha, 'dreams the world into being'; in shaiva mythology, Mahadeva, the Great God, conjures up the world by dancing, only to destroy it in the same frenzied dance. As a child plays with its toy, so the gods play with the world:

> Thou are he who sports with the Universe as his marble ball.... (19)

Equal delight is experienced in the creation and destruction processes.

Being created by *mayins*, by magicians, the characteristics of this world of ours are instability, precariousness, caducity. All that we see here, though well concealed under a colourful and dazzling surface, is only ephemeral. It is the external beauty, this alluring aspect which ravishes the senses and the minds of men, and traps them in the snares of illusion. The seeker of *moksha*, liberation, must be able to see through the mere appearance of things and recognise them as they are in reality: unstable, unpredictable, a mere magical creation emanating from the playful activity of the gods. The seeker of deliverance, of *moksha* must tear down the veils of *maya* in order to be able to comprehend the Divine in its fullness.

Lila and *maya* are two means by which the gods reveal themselves. And *maya*, in this function as a means of revelation, can be also thought of as *lila* of the gods.

The Rasa Lila

Among the *lila* of all the gods, it is that of Krishna which is the most alluring, for 'it originates in bliss, is sustained in bliss, and is then dissolved in it'. We get a glimpse of Krishna's divine *lila*, when he becomes the 'Lord of the Autumn Moons', and dances his great, unending dance with the cowherdesses, the *rasa*. The love that binds him and the *gopis* is often seen as earthy and physical but there are also constant references to a higher meaning. The *gopis* are individual souls, *jivatmas*; he is the

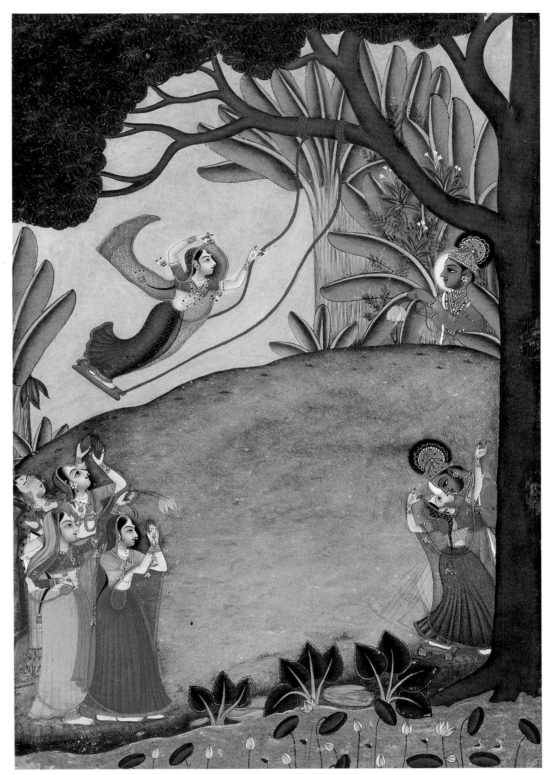

Supreme Soul, *paramatma*; their love is the longing of the individual for the Divine; all impediments must be removed before union takes place.

Krishna's amorous games can be classified under two broad headings: his love affair with Radha, and his relationship with the *gopis* as a group. From the theological standpoint, his affair with Radha is the more important, as it symbolises the relationship between the human Soul and the Divine, whereas his sports with the *gopis* express the intimate relationship between God and the devotees. The music flowing from Krishna's flute is much more than a simple melody: it is the call of the Divine which pervades the magic landscape of Vrindavana inviting all creatures to rejoin God in eternal bliss. Krishna's flute is endowed with the same spell, the same beauty, the same ineffable sweetness, grace and captivation as the god himself. Just as no one can resist his youthful splendour, so no one can listen impassively to the summons of his instrument. Even the gods fall under the magic spell of Krishna's flute; they join the *gopis* in the groves of Vrindavana and provide the musical accompaniment to their round dance, the 'round of passion', or *rasa mandala*.

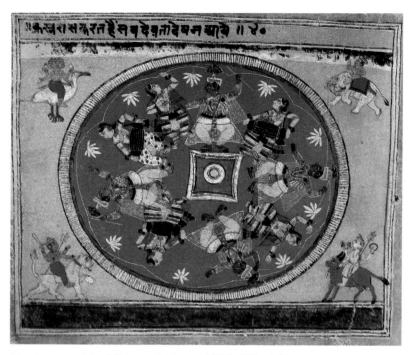

10. Rasa mandala. *(Miniature, Malwa c. 1650, 170 × 200 mm, Museum Rietberg, Zurich.)*

The imagery is concrete and vivid. In response to the call of Krishna's flute, 'at the hearing of which the very wood sticks in their kitchen fires turn wet and green again', the cowherdesses hasten to him in the forest, 'their garments slipping from their bodies'. There he plays with them, roaming all over the forest, bathing in the river Yamuna, and then he takes them through the 'many lanes of love'. He then leaves, suddenly, causing inconsolable anguish, forcing them to look for him everywhere, 'streams of tears flowing from their eyes'; and then he reappears. The cowherdesses emerge from the 'bottomless ocean of despair' and the Lord asks them to join him in a circular dance. But he is one, and they are many; so, 'as many cowherdesses as were there so many bodies did Krishna assume'. Then they begin to dance and play:

> Two and two the cowherdesses joined hands,
> between each two was Hari the Companion;
> Each thinks he is at her side,
> and does not recognize another of the illusions;
> Cowherdesses and Nanda's son, alternately,
> like a dense cloud and lightning all round;
> The dark Krishna, the fair Vraja women;
> like a gold and sapphire necklace. (20)

This is a dance that goes on 'for six months'. In fact, however, it never ends, for its place is the heart. But when Krishna and the cowherdesses return to the village, 'no one had noticed their absence'.

The meaning of the 'round dance of love', of the 'play of passion', the *rasa lila*, can be summarized as follows: Krishna moves in a realm of love and anyone who enters is fully released from the bondage of everyday life and from the burden of social and moral duties imposed by caste and kinship. The devotee can thus act as spon-taneously and as freely as he wishes, giving vent to all his senses and sentiments, ignoring all conventions and fully enjoying the bounty of life. This unrestrained emotional relationship between God and the devotee is aptly il-lustrated by Krishna's relationship with the *gopis*, which is a mere reflection of what happens continuously on the celestial plane, cowherds and cowherdesses representing heavenly beings whose presence enhances the heavenly abode of Krishna.

Krishna is the supreme among 'men', *purushottama*, and because of this infinite enactment, he is *lila purushot-tama*, the 'sublime player'. He behaves as if he were above all laws, as if nothing could restrain him. There is in him an abandon, a spontaneity, that brings his name to mind the moment the word *lila* is uttered. Krishna and Krishna-*lila* seem to be one.

It is in character with his *lila* that Krishna is so often call-ed *Mohana*, meaning 'bewildering, perplexing, in-fatuating, fascinating'. Similarly, there are intimations of the range of his aspects in the scores of names and epithets by which he is addressed. In fact, in much Indian writing on the subject of Krishna, one hears the other names of Krishna more frequently than the name 'Krishna' itself for the obvious reason that in each there is a dimension, a peculiar connotation which offers those opportunities for playing with words that the Indian poet delights in so much.

Krishna is the 'Dark One'. This name is thus the almost exact equivalent of *Shyama*, the *Kala* of Bengali poetry, the *Sanvara* of Hindi. It is also elaborated into *Ghanashyama*, 'Dark as the Cloud'. And with this purely physical description the poet juggles endlessly, creating images, inventing situations. The dark Krishna and the golden-fair Radha are ceaselessly brought into juxtaposi-tion: cloud and lightning, bee and lotus, night and day. Krishna gets taunted for his dark complexion; his legitimacy as the child of fair-complexioned parents is playfully called into question; he is roundly accused by the beloved of being dark both in his appearance and in his deeds; he who is smitten by the Dark One is like one that has been bitten by a snake. But he is *Shyama*, bluish, as the devotee knows of course, because Vishnu is Shyama, and that is the colour of infinity, of space.

Through many of these names, of which we shall speak in due course, even though his career on earth follows its own course, we are constantly being reminded of his identification with Vishnu, among whose incarnations he is counted. The tenet of incarnations is central to much Hindu thinking and it is in awareness of it that much of Krishna's *lila* can be understood. The rationale of incar-nation — two words are used in Sanskrit: *avatara*, 'des-cent', and *pradurbhava*, 'advent', 'manifestation' — is stated in classical terms in the *Bhagavadgita*: 'Whenever there is a decline of the Law, or Bharata, and an increase of iniquity, then I put myself forth (in a new birth). For the rescue of the pious and the destruction of the evil doers, for the establishment of the Law, I am born in every age'. This statement is made by Krishna *because* he is identical with Vishnu.

The Avataras

Many incarnations of Vishnu, the Great Preserver, are spoken of. He descends in various forms, in succeeding ages, although one form of his, 'the best one', forever abides in heaven, practising austerities, meditating on its own mysterious self. But as an *avatara*, another self, he descends to the earth. The list of Vishnu's incarnations varies greatly, but both the number and the sequence are established fairly firmly by the 11th century. The ten incarnations of Vishnu, the celebrated *dashavataras*, then become the object of impassioned song and devotion.

Vishnu assumes the forms, in succeeding ages, of Fish, *matsya*, plunging into the Ocean to recover the *Vedas*; of Tortoise, *kurma*, to support the great mountain which became the stick with which the Ocean was churned; of a Boar, *varaha*, to rescue the Earth from the hands of the demon Hiranyaksha; he then became the Man-Lion, *narasinha*, to protect his devotee from the tyranny of another demon; a Dwarf, *vamana*, to reclaim the Earth from a demon-king by measuring it in three steps; *Parashurama*, Rama-with-the-axe, to grant fearlessness to the Brahmins; and then Rama, Krishna, Buddha, and the incarnations of the future, Kalki.

Not all of Vishnu's *avataras*, forms, were 'complete'. Many, like the first six, were assumed for specific ends, and only isolated episodes and exploits are linked with them. These, then, are *amshavataras*, 'partial incarnations', but Krishna is a *purna avatara*, 'complete incarnation'. Among the incarnations Krishna, like Rama, is different from the others not only because he is human — the Dwarf and Rama-with-the-axe are also human — but because he leads a complete human life. Rama's guide, his ideal, his entire human career, is *maryada*, 'restraint, bounds, balance'. He is the perfect character: as son, as brother, as husband, as king. He is, therefore, *maryada purushottama*. The range of Krishna's activities also covers the whole span from birth to death. He emerges from his mother's womb; he grows up, marries, has a family, lives through events, episodes, crises, then dies. It is this marvellous aspect in the life of Krishna that makes it possible for the devotee to identify with him as with no one else.

In everyday life in India, even today, a mother will often wake her son up in the morning, singing much the same song that Yashoda sang to Krishna: 'Wake up, Kanhaiya, the day is dawned; the birds have been twittering all this while...'; the bridegroom will be compared in his beauty to Krishna; the newly married couple is none other than Radha and Krishna. Millions will fast on the Krishna *janmashtami*, the eighth day of the second half of the rainy month of *Bhadrapada*, the day of Krishna's birth in the dungeon, for they identify themselves with the hushed suspense of that day, with the suffering that his real parents were going through then.

When Krishna is adored in his human aspect, worship becomes fixed on his *saguna* form, 'form with attributes'. The Supreme Person, the One, is devoid of attributes, *nirguna*, and is indescribable. Fixing the mind on the One

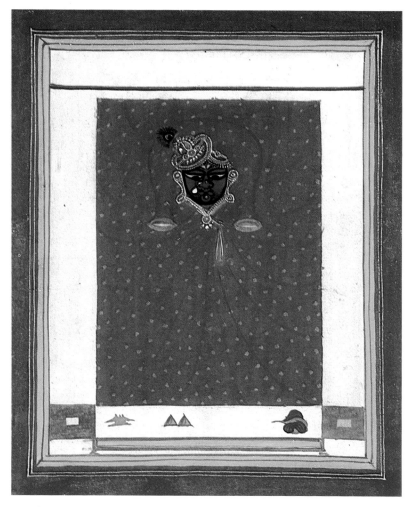

11. Shri Nathji. *(Miniature, Nathdwara c. 1830, 120 × 165 mm, Collection Colonel R.K. Tandan, Hyderabad.)*

without attributes is not easy. When Krishna does not return to Vraja but instead sends Uddhava with a message to his beloveds, the cowherdesses, Uddhava has a very difficult time. Krishna had charged Uddhava with the task of trying to convince the distraught *gopis*, the cowherdesses, that henceforth they should centre their minds on *nirguna* alone, not on Krishna. The *gopis* engage Uddhava in an argument:

> In what land does this *nirguna* live?
> Explain *that* to us, Uddhava!
> No,
> we're not laughing at you,
> tell us truly:
> Who's his father,
> who's his mother,
> who's his woman,
> who's his slave?
> What's he look like,
> what's he wear,
> what pleasures does he seek?
> Don't fool us, poor
> simple milkmaids,
> Or it'll be bad *karma* for you! (*Sur Das*) (21)

At this, Uddhava 'was struck speechless', for he had no answer for the cowherdesses, thus immersed in Krishna.

Bhakti

The questions asked here are again those of a devotee, being born of *bhakti*. *Bhakti* means adoration, intense devotion, as a personal approach to the Supreme, and it appears in Hindu thought very early. The various systems of Indian philosophical thought seek a practical way of reaching the supreme ideal. The beginning is made with thought, but the aim is to go beyond thought to the decisive experience. As Radhakrishnan says: 'Systems of philosophy give not only metaphysical theories, but also spiritual dynamics' (22). One of the pre-requisites is *yoga*, (derived from the root -*yuj*, 'to bind together'); *yoga*, thus means binding one's psychic powers, balancing and enhancing them, harnessing energies through intense concentration. And the goal is reached through at least three paths outlined with great clarity and precision in the *Bhagavadgita*: *jnana*, the way of knowledge; *bhakti*, the way of devotion; *karma*, the way of action. From among these the *bhakta*, or the devotee, chooses the path of devotion. Informed by Faith, he insists on the fact that, while others reach other ends, only he who is devoted to the One Supreme reaches infinite bliss. In its essence, *bhakti* becomes a relationship of trust, for trust purifies. It is deep attachment to God, and intense love for Him, supreme longing for its own sake. It also implies surrender, for the *bhakta*, emptied of himself, is taken charge of by God. In the *Bhagavadgita*, Krishna says quite clearly:

> O Son of Kunti..., know thou for certain that My devotee perishes never. *(IX 31)* (23)

From the early centuries of this era, *bhakti* becomes steeped in *rasa*, deep sentiment, feeling. It is not the 'flight of the alone to the Alone' (24), nor the soul's alienation from the world and attachment to God but an active, personal love for the Divine who enters the world to redeem it. The path of action, *karma*, is a thorny road paved with difficulties. But since there is no getting away from it, it is often combined with devotion. *Bhakti*, therefore, incorporates action to the extent that action is unavoidable, but it alone makes being in the midst of it bearable. And in it, in the final analysis, lies salvation.

If devotion is the way to deliverance, and if devotion entails centering attachment upon an intensely personal God, what could be better, in the *bhakta*'s view, than fixing it on a form of the Divine with which you can identify completely? Krishna, for instance. Thus, Krishna would *understand*, the *bhakta* seems to say, his predicament in life. The *bhakta* can speak to Krishna in his own language, and he is certain that Krishna will understand. He can talk to him of love and of pain, of attachment and of the joys of small things, of the fears of separation and of the longings of the heart. This is precisely what the Krishna-*bhakta*, surrendering himself completely to the care of the Lord, proceeds to do.

There is no prescribed form of devotion or service to the Lord. The *bhakta* is free to choose a role for himself, approach the Lord in a particular mode, *bhava*, state, sentiment. Thus, he could assume the state of *aasya*, taking Krishna to be the Master and himself a devoted servant; of *sakhya*, in which Krishna is a friend, a colleague; of *vatsalya*, in which the devotee sees Krishna as a child and himself as a parent. In this connection we may mention that the worship of Bala Krishna, of Krishna as a child, is a very popular form of worship. There is finally the state of *madhurya*, which is the same as *shringara*, a state full of sweetness, in which the worshipper sees Krishna as a lover, as did Radha and the *gopis*. No mode is superior to

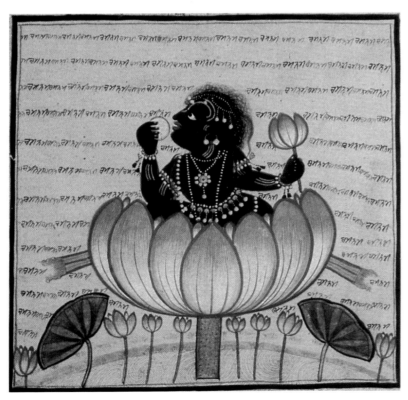

12. Dana Lila 'The taking of the toll.' *(Ivory, Orissa c. 17th century, 42 × 68 mm, Private collection.)*

13. Infant Krishna in a lotus. *(Miniature, Kulu c. 1700, Private collection.)*

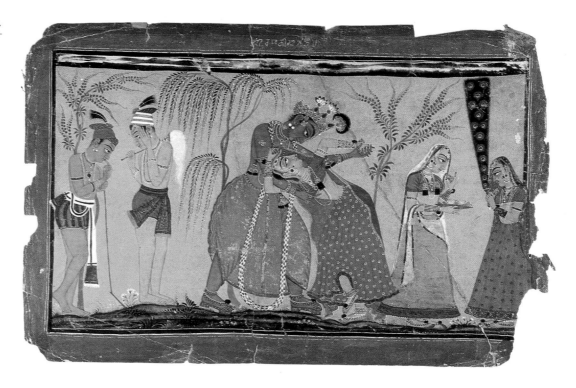

14. Love play. Illustration to the Gita Govinda. *(Miniature, Basohli c. 1700, 217×317 mm with borders, Chandigarh Govt. Museum [ref. 933].)*

the other, for love informs each mode, gives it colouring and, since without it deliverance cannot be achieved, love is everything.

The mere recitation of the names of Krishna, the singing of his *lila*, can ensure deliverance, but only when the undercurrent is that of love; love *must* enter it.

A verse widely popular in India says that:

> The wise one is not he who is learned in the four *Vedas*, the six *Shastras*; the wise one is he who 'knows' but two-and-a-half letters that make up the word *prema*, love.

A story is told of the great blind poet, Sur Das (16th century) who could always be seen near his little hut on the river bank in Mathura, singing movingly of Krishna. His fame had spread far and wide, and everyone came to hear him sing to the accompaniment of his simple one-stringed instrument, the *ektara*. To him came the great and the lowly, the Brahmin and the Shudra, the learned and the simple-minded. To him also once came the great Vallabhacharya, founder of the celebrated sect of Vaishnavas, author of profound commentaries on great texts, himself a devotee of Krishna. Sur Das sang for him in his usual strain, a passionate prayer to Krishna, seeking his Grace, pleading for deliverance. Vallabha was greatly moved and took the blind poet aside saying to him: 'What you say is beautiful, but why always this beseeching tone Sur Dasji? Sing of Krishna and describe his *lila* in your words. Let others partake, through your gifts, of the joy, *ananda*, that comes just from hearing of his deeds. That too, leads to deliverance.' Sur Das, who was born blind, pointed to his disability and asked how he could visualize Krishna for he had never seen a person. At this, tradition says, Vallabhacharya initiated him with a sacred formula, a *mantra*, and Sur Das, though continuing to be blind, was able to 'see' Krishna, to feel him. From then on, he began to celebrate in his songs the deeds of Krishna, his appearance, the whole aspect of the world around him, the many colours of Krishna and his environment. Those great passionate poems to the Child-God that Sur Das composed are said to date from this event. His 'vision' had become clearer than that of those who could see, for in it there was intense love. How else, the tradition seems to ask, could this vivid poem have been written?

> Krishna crawls, crowing with glee
> In the jewel-studded courtyard of Nanda,
> chasing his own reflection.
> He sees his form reflected,
> and reaches to grasp it with his hand;
> He laughs, and then stares in wonder
> at the mirrored gleam of his teeth
> His flower-like hands and feet
> are mimicked in the golden floor,
> as if a lotus blossomed from each and every gem
> to pedestal each tiny hand and foot... (25)

Or this, on the great love play of Radha and Krishna:

> Radha raises lovely splashes in the River.
> Saffroned breasts slip from her bodice,
> across them her hair hangs wet;
> Blue-stoned earrings dangle at her cheeks.
> Her hips sway slowly, like an elephant's;
> a girdle swings loosely at her tiger-thin waist.
> The Play goes on, in the waters of the Yamuna;
> immersed in love, swamped with passion... (26)

When Sur Das was on his death-bed, it is said, he was approached by Vallabha's son, who asked him: 'Where are your eyes now, Sur Dasji?' And Sur, characteristically, answered with a poem:

> Drunk with the colours of this joy
> my eyes dart like birds;
> They are so lovely now, so clear, so sharp;
> this cage will not hold them a second more.
> They flutter about my head;
> snared they thrash
> in the gold ring at my ear
> Sur's eyes are trapped in the vision of His darkness... (27)

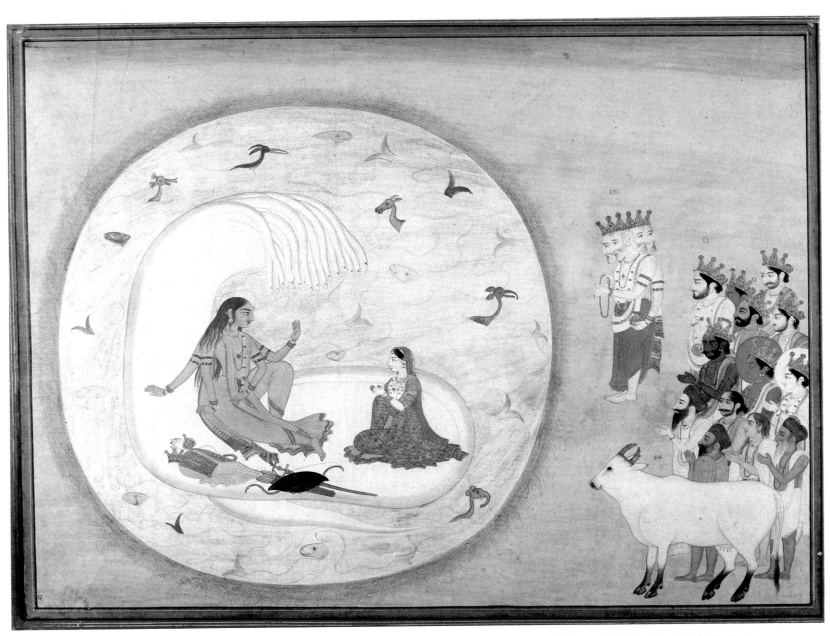

15. The Earth, Brahma and the gods beg the Lord for assistance. *(Miniature, Kangra c. 1800, 320 × 420 mm, Collection Colonel R.K. Tandan.)*

The Narrative

by Prof. B.N. Goswamy and Prof. A.L. Dallapiccola

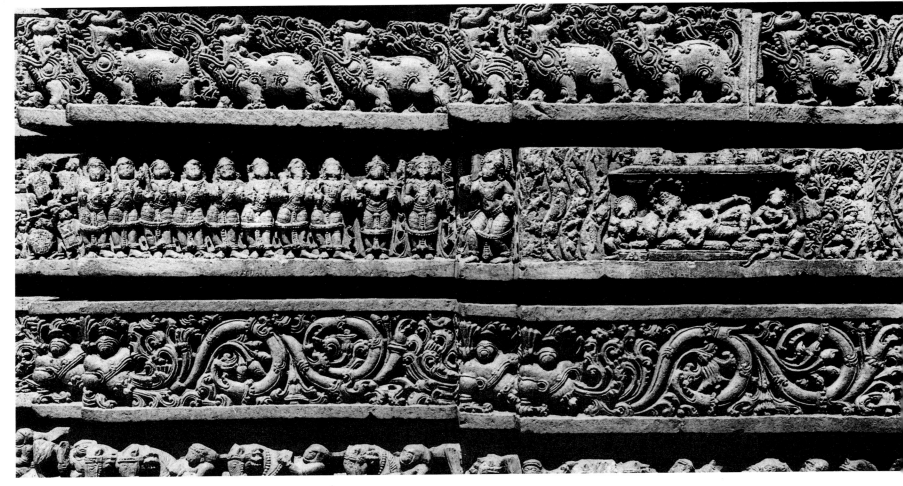

16. ...the Lord... lay on his serpent couch... *(Stone frieze, Somnathpur 13th century.)*

Seeking to explain the manner in which the devotee's heart is prepared for the message of God, a 14th century text from India takes an analogy from the world of painting. Like the linen cloth on which the painting is made, the heart, this text says, must first be washed, cleansed thoroughly of impurities. It must then be 'primed', made properly smooth, for only upon such a surface can a clear outline be drawn. With the drawing completed, the last stage follows: the colours are filled in.

For centuries, the story of Krishna, with all its colours, must have been received in India in hearts prepared more or less like this. The dust of doubt removed and the ground prepared, the outline of the story came from that which was heard or read; but the colours were filled in by each person himself, in keeping with his own *pratibha*, 'abilities'.

The narrative that follows here is drawn from different sources, but it is of the kind that rang 'true' to the devotee's ear. When the story of Krishna was heard or recited, nobody seemed to ask where an event, an episode, was taken from. All that mattered was the whole, the *lila* of Krishna as 'everyone' knew it. Each generation added in its own way something to the story, mostly elaborating, sometimes inventing; but the outline stayed firm and clear. There was no room for doubt. All questions had been asked by previous generations, and

the answers had all been woven skilfully into the texts themselves, in the dialogue between narrator and listener. Now what was relevant was the faith and love with which the account was recited, heard and passed by one generation on to the next.

The Earth seeks the gods' help

The story of Krishna is placed, in the unending cycles of time, in the *dvapar* age, when the last dissolution of the Universe lay far, far back in the past. Once, it is said, when Creation, emanating from the great Vishnu, had gone through countless ages, a point was reached in time, when there was again an excess of evil on earth. Untruth triumphed and hosts of *asuras* or demons were at large, some assuming the guise of arrogant kings, others roaming around in their own demonic forms. Burdened by their weight, the goddess Earth, assuming the form of a cow, journeyed to Mount Meru, where the assembly of gods, with Brahma at its head, was meeting. In piteous accents, she described her distress to them. Her face bathed in tears, she spoke of the grievous imbalance that now prevailed between good and evil. A demon like Kalanemi, destroyed by the all-powerful Vishnu in the past, had also been reborn with the name of Kansa, the ruler of Mathura. Unable to support this great load, the great Cow said she had come to the gods for succour. 'Il-

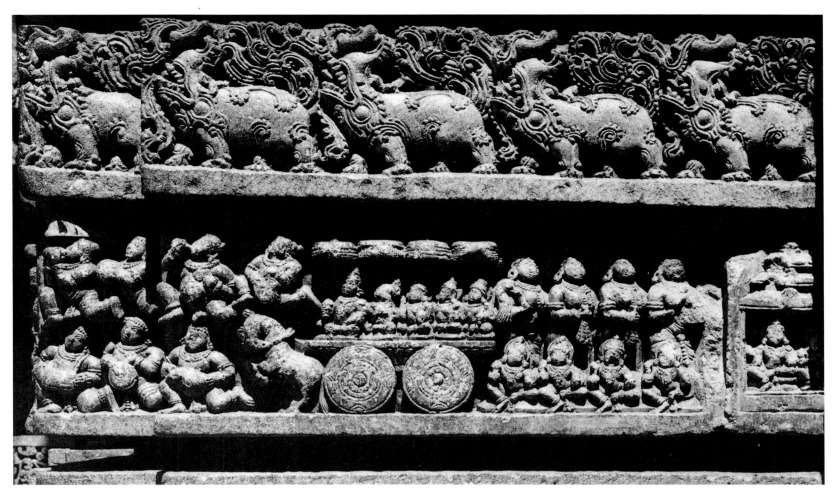

17. ...Devaki was newly married to the noble Vasudeva... and Kansa fitted out his chariot... taking the reins of the horse himself...
(Stone frieze, Somnathpur 13th century.)

lustrious deities, do you so act that I may be relieved from my burden, lest helpless I sink into the nethermost abyss.' Hearing this, Brahma, addressing the gods, said there was one way that the Earth's burden could be lightened; it was the great Vishnu alone who could accomplish this formidable task.

Brahma, the earth and the gods beg Vishnu for assistance

Accordingly, accompanied by the gods, sages and divine beings of all descriptions, Brahma went to the Milky Sea where the Lord, whose emblem is the great Garuda-bird, lay on his serpent-couch. 'Glory to thee', Brahma spoke, addressing Vishnu: 'the thousand-formed, the thousand-armed, the many-visaged, the many-footed; to thee, the illimitable author of creation, preservation and destruction; most subtle of the subtle, most vast of the great; to thee who art nature, intellect, and consciousness. Do thou show favour upon us. Behold, Lord, this earth, oppressed by mighty *asuras*, and shaken to her mountain basements, come to thee, who art her invincible defender, to be relieved from her burden.'

Vishnu plucks two of his hairs, one black, one white

When Brahma had spoken, the great Lord, forever committed to redressing the balance between good and evil in the world, smiled in his gentle way, and reassured the gods by agreeing to descend once more to the earth. Plucking two of his hairs, one white and one black, the great Vishnu said that they should be reborn in human form on the Earth to relieve her of her crushing burden. Speaking in a voice deep as the rumbling of clouds, he declared: 'This, my black hair, shall be impersonated in the eighth conception of the wife of Vasudeva, Devaki, who is like a goddess; and shall slay Kansa, who is the demon Kalanemi'. The white hair that he had plucked, the Lord said, would be born also to Vasudeva and Devaki, as Balarama, the elder of the two brothers who would slay every one of the haughty *asuras*. 'Doubt not of this; they (the *asuras*) shall perish before the withering glance of mine eyes.'

Saying this, the Lord disappeared, but not before he had urged the gods also to descend upon the earth to wage war with the demons, and asked the heavenly damsels to be reborn as cowherdesses and the sages as cattle in the blessed land of Vraja.

Vasudeva marries Devaki and Kansa attempts to take her life

The place that the Lord had chosen to be born again was Mathura, ruled at that time by the arrogant Kansa. Kansa's sister, Devaki, was newly married to the noble

27

Vasudeva of the Yadu clan, and Kansa fitted out his chariot to transport them, taking the reins of the horses himself 'surrounded by hundreds of gold-plated chariots'. But, on the way, an incorporeal voice from the skies suddenly addressed Kansa. 'Oh foolish fellow', the voice said, 'the eighth son, from the womb of her whom you are conducting, shall slay you'. Seized with panic and fury, Kansa stopped the chariot, descended sword in hand and, dragging his sister by her hair, was about to kill her when Vasudeva entreated him in conciliatory terms, 'simulating a blooming lotus-like countenance in spite of the pain in his heart'. 'Spare her life, this gentle girl who is just like a daughter unto you; and I shall hand over to you her sons from whom you apprehend danger.'

Devaki and Vasudeva are jailed

At this Kansa desisted from killing Devaki and placed Vasudeva and Devaki in a part of the palace guarded by stern watchmen. In due course, Devaki gave birth to six sons, one every year. The evil-minded Kansa now saw every child born of Devaki's womb as intent upon slaying him, and therefore killed each at birth. After he had thus killed all six of Devaki's sons one by one, a part of the great lustre of Vishnu, known as Ananta, the Serpent,

took the form of the seventh child and entered Devaki's womb, thus 'enhancing her joy and grief at the same time'. But the Lord took the necessary precautions and commanded the goddess Yogamaya to transfer the embryo to the womb of Rohini, another wife of Vasudeva, who lived away from Mathura in the settlement of cowherds headed by the gentle Nanda. Thus commanded, the Goddess, saying 'This will be done', circumambulated the Lord and descended to the earth.

The transfer of the embryo and Devaki's reported miscarriage

The embryo was transferred and Rohini bore the child, but in Mathura it was announced that Devaki had miscarried. Then the Lord himself entered the womb of Devaki as he had promised, in the form of the eighth child. When the portion of Vishnu thus became incorporate upon earth, 'the planetary bodies moved in brilliant order in the heavens, and the seasons were regular and genial'. No one could bear to gaze upon Devaki because of the light that invested her; and those who contemplated her radiance felt themselves greatly elated. Even the gods vied with each other to look at the radiant beauty of Devaki, who was carrying the Lord himself within her, and eulogized her.

28

18. ...Kansa stopped the chariot, descended sword in hand and, dragging his sister by the hair... *(Miniature, Pahari c. 1725, 185 × 273 mm with borders, National Museum, New Delhi [ref. 68125].)*

19. ...The river Yamuna was in deep flood at the time... but Vasudeva entered without fear... The Lord's own serpent Shesha followed Vasudeva and warded off the rain with his hoods... *(Miniature, Malwa c. 1680 165 × 345 mm with borders, Bharat Kala Bhavan, Benares [ref. 9422].)*

The birth of Krishna

Devaki gave birth to the divine child on the eighth day of the rainy month of Bhadrapada. As that day dawned, the lotus petals of the Universe began to expand, as it were. 'The quarters of the horizon became irradiant with joy as if moonlight were suddenly diffused over the whole earth. The virtuous experienced new delight, the strong winds were hushed, and the rivers glided tranquilly... The holy fires glowed with mild and gentle flame and the clouds emitted low, pleasing sounds', as midnight came and the child entered the world.

This was no common child. It was the divine form of Vishnu himself, 'that wonderful child of lotus-like eyes, endowed with four arms, bearing a conch and wielding aloft a mace and a discus and a lotus, having on its chest the *shrivatsa* mark of a curl of golden hair, with the *kaustubha* gem hanging from its neck; clad in yellow silken garments, possessing the charming complexion of a rain-bearing cloud'.

With incredulous eyes did Vasudeva behold the Lord now born as his son. His mind confused and enraptured, he bent low with humility and began to praise the Lord who smiled and spoke gently to Devaki and Vasudeva. He told them of *their* previous births, and of his present task upon the earth.

The exchange of the babes

Then addressing Vasudeva, he asked him to take him to Gokula, across the river Yamuna, and bring as his substitute the daughter of Yashoda, wife of Nanda, born at exactly the same time. Whereupon the Lord fell silent and turned once again into a human child before his parents' very eyes.

Through the divine *maya* of Vishnu, strange things began to happen. Vasudeva's iron fetters fell off and, suddenly in that dark night, the gate-keepers became unconscious while the citizens of Mathura were in deep sleep. All the doors of the palace-prison flung themselves open, 'like darkness dispersing at the appearance of the Sun', at the approach of Vasudeva, carrying the child on his head in a small rush basket. The river Yamuna was in deep flood at this time, 'full of hundreds of fearful whirlpools', but Vasudeva entered it without fear. The Lord's own serpent, Shesha, followed Vasudeva and warded off the rain with his hoods spread like an umbrella over the basket, and a tiger walked ahead. But as Vasudeva entered the waters, they began to rise higher and higher till Vasudeva began to fear for his life and that of the Lord whom he was carrying on his head. But the Yamuna was rising intentionally, to be blessed by the divine touch. And when the water came up to Vasudeva's shoulders, the Lord, ly-

20. ...Holding the child by its feet, Kansa dashed it against a stone slab...
(Miniature, Malwa c. 1680, 170×345 mm with borders, Bharat Kala Bhavan,
Benares [ref. 9423].)

ing in the basket, put his little foot out and touched it with his toe, whereupon the water quickly subsided. Vasudeva easily crossed the river now and entered Gokula where, finding all the cowherds peacefully asleep, he placed his son on Yashoda's bed, picked up her new-born daughter in exchange, and then returned.

Back in Mathura, he put the iron fetters back on his feet himself and was chained as before. The gates closed of their own accord and the watchmen woke up. Everything appeared as if nothing unusual had happened. Yashoda was unaware of her child having been exchanged; she even lost consciousness of the fact that her own child had been a girl and what lay by her side now was this boy, 'dark as the rain-laden cloud'. Nor did anyone in Mathura know of what had happened. In the morning, Kansa simply was told of the birth of the eighth child of his sister.

Kansa kills Yashoda's daughter

Tense and apprehensive, Kansa hastened towards Vasudeva's quarters. Devaki pleaded with her brother to spare the child's life, but her entreaties were of no avail. Holding the child by its feet, Kansa dashed it against a stone slab, but it rose into the sky and expanded into a giant eight-armed figure. For it was none other than the Goddess herself, born at Vishnu's bidding, as Yashoda's daughter. She now laughed aloud, filling the quarters with her voice: 'What avails it thee, Kansa', she thundered, 'to have hurled me to the ground? He is born, who shall kill thee, the Mighty-One amongst the gods, your destroyer in former births'. Having spoken thus, the Goddess vanished before everyone's eyes, 'hymned by the spirits of the air'.

Now warned, but helpless against Vasudeva and Devaki, Kansa released them. However, that night he called an assembly of his advisers, the great *asuras* and *daityas* whom he commanded, and they all decided to search for whatever young children might have been born on that day, especially for 'every boy who showed signs of unusual vigour'. All such children were to be slain.

Celebrations in honour of the birth of Krishna

Meanwhile, away from Mathura 'the city with its high gateways and entrances made of crystal, its huge gates of gold beautified with arches', great celebrations were taking place in the sylvan setting of Vraja. Delighted at the birth of a son in his old age, the noble Nanda had sent for Brahmins to perform the prescribed ceremonies and 'the cows and heifers were smeared with oil mixed with

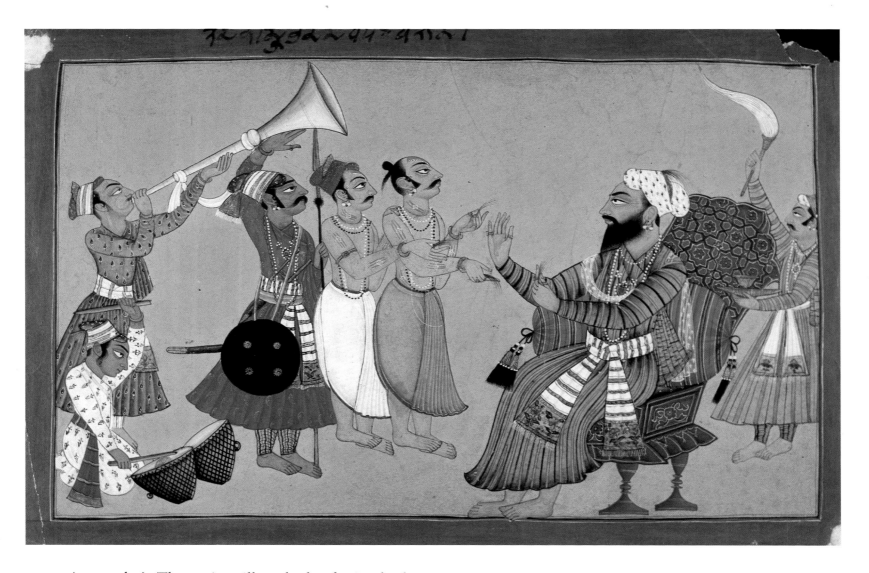

turmeric powder'. The entire village had a festive look, and people from the neighbourhood converged upon Nanda's house, singing as they moved, offering to their chief the traditional shoots of sacred grass in congratulation and receiving generous gifts in turn. Music was played and dancers danced. The Brahmins received cows and heaps of sesame seeds, and everyone was invited to a feast. The cowherds came adorned with valuable garments and the cowherdesses, 'the beauty of their lotus-like faces enhanced by the decoration of saffron paste', hastened to Yashoda. Merriment went on for days. Cool breezes blew, the grass grew verdant and lush. Nanda and Yashoda were the happiest of parents.

Shortly afterwards, when Nanda had to go to Mathura to pay his annual tribute to the King, Vasudeva hastened to Nanda's wagon-cart and, after making fond enquiries about Rohini's son, advised him to leave as quickly as possible for he feared for the safety of the children of Gokula. Nothing was revealed about the true identity of Krishna, the dark one, the child now lying by Yashoda's side in her bed. For Vasudeva out of caution wanted Nanda to believe him to be his own true son. He spoke only of the need for care and hinted darkly at 'omens indicating calamities'. Nanda hurried back to his village where the calamities that Vasudeva had feared did indeed begin to occur.

21. …people from the neighbourhood converged upon Nanda's house, singing as they moved, offering to their chief the traditional shoots of sacred grass… *(Miniature, Mankot c. 1725, 205 × 305 mm with borders, Chandigarh Govt. Museum [ref. 1267].)*

22. Krishna's horoscope is cast. *(Drawing, Kangra c. 1770, 210 × 315 mm without borders, Chandigarh Govt. Museum [ref. 459].)*

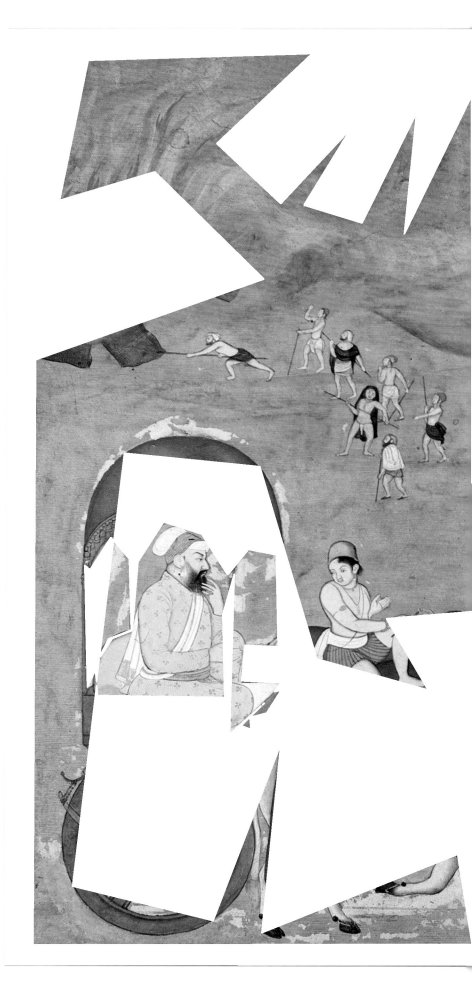

23. ...the cowherds and cowherdesses hacked the body of Putana to pieces and, taking it away bit by bit to the edge of the village, set it on fire... *(Miniature, Kangra c. 1790, 220 × 305 mm without borders, Bharat Kala Bhavan, Benares [ref. 6701].)*

The demoness Putana attempts to take Krishna's life

First there came to Gokula the demoness Putana, capable of racing through the skies and of assuming any form. On this occasion, she appeared as a beautiful young woman casting charming smiles and sidelong glances, 'the braids of her hair adorned with jasmine flowers, her slender waist crushed between her ample hips and heavy breasts, clad in rich garments, her face beautified with the radiance of the earrings that swayed brilliantly'. Holding a lotus flower delicately in her hand, she won all hearts and found all doors open to her. Entering the lovely Yashoda's house, she placed the child Krishna on her lap, her evil designs carefully concealed for the moment. But Krishna, 'lying quietly with his eyes closed', of course knew that Putana meant no good. Then she gave him her breast, covered with the most virulent poison, to suckle. And knowing this at once, Krishna 'squeezed her breast hard with his hand and sucked it along with her life'. The demoness 'being crushed in all her vital parts', cried out for him to let go of her, but Krishna would not. Her body now drenched in perspiration, and her hands and feet lashing about convulsively, she wailed and cried. Her noise made the 'earth and the mountains, the heavens and the planets, shake and the nether world reverberated with the sound of her wailing'. But Krishna persisted till the

demoness finally dropped dead, reverting to her original form with her mouth agape and her ears, hands and feet stretched out near the cowpen. As she fell, her giant body 'crushed to powder trees within an area of twelve miles'. Then, when their fear had abated a little, all the cowherds gathered together to see the body of the demoness, 'her mouth ranged with a terrible set of tusks, her nostrils resembling mountain caverns, her breasts huge like a pair of hillocks', but her belly looking now 'like a dried up, waterless pool'. But, to the amazement of everyone, the child Krishna was playing fearlessly on her bosom. Nervously, he was picked up by Yashoda and Rohini who took him inside, performed ceremonies intended to ward off evil spirits, waved the cows' tails around him and bathed him in various ways, praying all the while. Meanwhile the cowherds and cowherdesses hacked the body of Putana to pieces and, taking it away bit by bit to the edge of the village, set it on fire.

The emancipation of Putana

But, as the body burnt, it gave off a curious fragrance, like that of sandalwood and *agara*, and everyone asked: 'What is this fragrance due to? Whence does it come?' Few knew at that time that, demoness as she was, Putana had been purified by the Lord's touch. Despite her evil intent, her sins had been absolved.

The cart-demon episode

Other events soon followed. He was less than a month old when, laid to sleep under a cart by his parents, Krishna overturned it with his small feet, 'delicate like tender shoots', for he knew a demon had entered it.

The demon Trinavarta attempts to take Krishna's life

But the danger of this demon was nothing compared with that of another, Trinavarta, also a servant of Kansa, especially ordered to kill Krishna. Trinavarta came in the form of a whirlwind, enveloping the whole of Gokula in a cloud of dust and blinding the eyes of its inhabitants. The noise he made was unbearable and everyone trembled as dust and darkness covered the whole region and uprooted trees flew hither and thither. Yashoda was unable to see, nor was anyone else around her, being assailed by the fury of the dust let loose by Trinavarta in that blinding confusion. At that moment, when no one could so much as open his eyes, the demon carried the child Krishna away. When the storm had abated a little, Yashoda found Krishna missing, and began to wail in the most piteous fashion before dropping senseless to the ground, 'like a cow that has lost her calf'. Meanwhile, Krishna had been taken by Trinavarta far up into the sky. In the demon's arms, however, the little infant now started

26. ...Nanda begged the learned priest to perform in secret, for fear of Kansa, the purificatory rites... *(Drawing, detail, Kangra c. 1790, Chandigarh Govt. Museum [ref. 463].)*

gaining in weight. His ascent was halted, for the child began to feel 'heavy as a mountain' and, as Trinavarta began to wonder, Krishna gripped him tightly around his throat till he was unable to move at all. His eyes began to come out of their sockets, and then, with a fearsome groan, he fell dead to the ground, with Krishna still clinging to his neck. The earth heaved as Trinavarta fell, but, to the astonishment of everyone, once again the demon was dead, and Krishna unscathed. 'How miraculous', everyone cried.

Nanda performs the purificatory rites

In the meantime, Nanda had begun to worry about these strange happenings and he was relieved when, at the instigation of Vasudeva, who was always concerned about his two sons far away from Mathura in Gokula, the noble Garga, family priest of the Yadava clan, visited him. Nanda begged the learned priest to perform in secret, for fear of Kansa, the purificatory rites proper to the infants, and to name them. Garga agreed, and he named Rohini's son 'Rama', predicting at the same time that, because of his surpassing strength, *bala*, he would be known as 'Balarama'. As to the second son, the one 'with the dark complexion of the rain-laden cloud', Garga said he should be called 'Krishna', even though 'numerous are the names and the forms of this son of yours'. The priest did

of course know the real identity of the child, but he did not reveal it yet to Nanda, adding only: 'This son of yours, O Nanda, will be the peer of Vishnu himself in excellent qualities, splendour, glory and prowess'. Nanda was delighted.

Some time passed and Krishna and Balarama, now beginning to crawl around on their hands and knees, would playfully go round Gokula. The two children, one dark, the other fair of complexion, were a source of endless pleasure to all around them. The tiny bells on their girdles and anklets tinkled sweetly as they crawled. Yashoda and Rohini, their breasts spontaneously overflowing with the milk of motherly affection, would pick them up, besmeared as they were with mud from the sacred lanes of Gokula, and press them to their bosoms. They were suckled, loved, coaxed.

Krishna and Balarama's childish pranks

Reaching the age when they could run about, Krishna and Balarama, to the delight of the cowherd-damsels of Vraja, the *gopis*, roamed freely, holding the tails of calves and dragging them hither and thither, playing with the boys of their own age, untethering cattle, smashing jars of milk, curds and butter. Neighbours would occasionally bring good-natured complaints to Yashoda about their pranks, but no one paid serious attention.

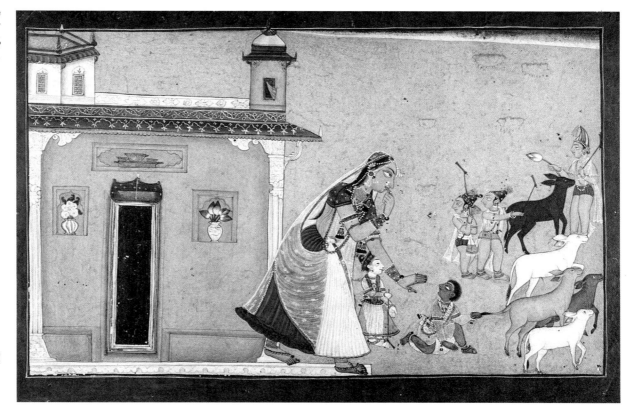

27. ...Krishna and Balarama, to the delight of... the gopis, roamed about freely, holding the tails of the calves... *(Miniature, Mankot c. 1725, 205×312 mm with borders, Chandigarh Govt. Museum [ref. 1306].)*

28. ...The two children, one dark, the other fair of complexion, were a source of endless pleasure... *(Miniature, Kangra c. 1800, 196×270 mm with borders, Galerie Marco Polo, Paris.)*

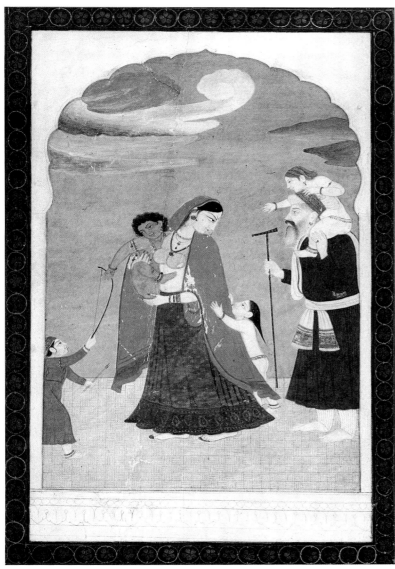

The mud-eater — As Krishna puts mud in his mouth Yashoda glimpses at the universe

The reports of Krishna's mischief, however, kept pouring in. It was on one such occasion that Yashoda heard from his playmates that Krishna had eaten some earth. Genuinely angry this time, Yashoda rebuked him and asked him if he had indeed done so. Krishna stoutly denied the charge. 'If that be the case', Yashoda said, 'open your mouth'. And when Krishna opened his mouth, for a moment Yashoda beheld 'the Universe consisting of objects that move and objects that do not move, the ethereal dome, the cardinal points, the sphere of the earth along with the mountains, the continents and the oceans, the winds, the fire, the moon, the stars, the whole planetary system, even the senses and the mind'. Amazed and terrified, Yashoda asked herself: 'Is this a dream or an illusion that I see? Is this a fantasy, a delusion of my own mind? Or is it the divine power of this very child of mine?' But the very next moment Krishna closed his mouth. He was once again his prankish self, proclaiming his innocence. Through the divine *maya* of Vishnu, Yashoda lost all memory of the vision she had had. She placed Krishna on her lap, her heart overflowing with affection. Once again, she was the fond mother, Krishna her ordinary child.

37

29., 30. ...Krishna... began surreptitiously to eat the butter inside... *(Drawing, detail, Kangra c. 1800, Chandigarh Govt. Museum [ref. 469].)*

The Butter-thief

Then one day, as Yashoda was churning the curds and singing to herself, Krishna caught hold of the churning rod and stopped her. Beaming with smiles, he demanded to be suckled, and Yashoda took him quickly onto her lap. Then suddenly, she got up and rushed inside, remembering that she had left a pot of milk on the fire and it might boil over any moment. Krishna now became cross and, shedding false tears, smashed the pot of curds and began surreptitiously to eat the butter inside it. Yashoda hastened back to find everything in disorder and Krishna sitting on a wooden mortar, surrounded by his companions, sharing the butter with them and laughing. Yashoda ran after him, rod in hand, feigning great anger.

Krishna tied to the mortar; the release to the two Gandharvas

Deciding to tie him to the same mortar to keep him out of further mischief, she began looking for a string. But Krishna 'so contrived that whatever string she fastened him with should be too short'. She gathered all the strings in the household, but Krishna was not fastened. Finally, seeing her greatly vexed, Krishna let her tie him to the mortar. Whereupon Yashoda went away, satisfied with the punishment she had meted out to the child. But

Krishna dragged himself along and, deliberately wedging the mortar between two *arjuna* trees that grew very close to each other, he pulled hard. And lo, the trees were uprooted. With a deafening noise they crashed to the earth, their trunks, and branches and leaves all scattering everything around. Yashoda came rushing out, along with everyone else, incredulous at this strange sight. But Krishna had, of course, done all this on purpose. He knew that the twin trees were no less than two divine *gandharvas*, reduced to this state by a curse in a former birth, a curse that was to be lifted only by a touch of the sacred feet of Krishna. The *gandharvas*, Nalakuvara and Manigriva, now 'released', emerged from the trees, 'irradiating all directions with their dazzling lustre', and, bowing to Krishna, they flew heavenwards. At this miraculous happening, even the gods appeared in the skies in their divine vehicles and showered the earth with the choicest flowers. Like everyone else, they had witnessed a part of the *lila* of the divine child.

The cowherds move from Gokula to Vrindavana

Meanwhile the succession of events in Gokula was making Nanda and the village elders uneasy. Seeing what they believed to be 'ominous portents', they conferred and decided to move to Vrindavana. All the inhabitants of Gokula then set off, keeping their bulls and cows and

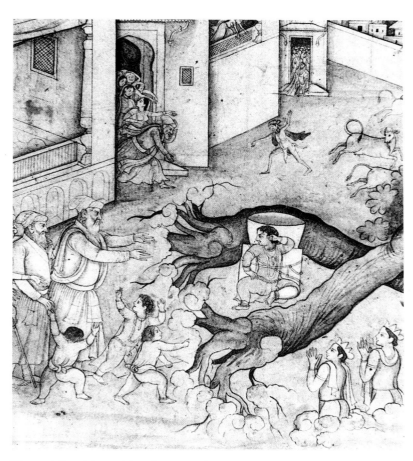

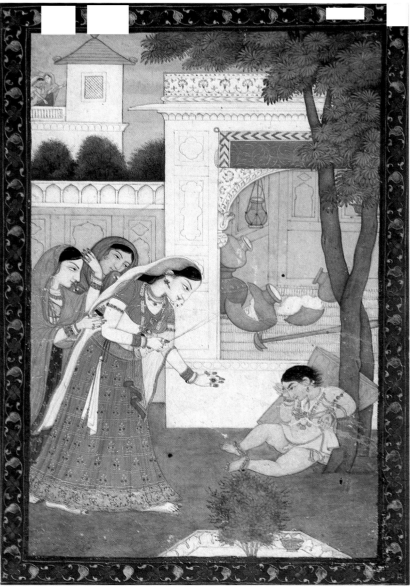

31. ...deliberately wedging the mortar between two arjuna trees that grew very close to each other, he pulled hard. And lo, the trees were uprooted... *(Drawing, detail, Kangra c. 1800, Chandigarh Govt. Museum [ref. 475].)*

33. ...Finally they reached Vrindavana... and the sand bank of the Yamuna... *(Drawing, Kangra c. 1800, 210×315 mm without borders, Chandigarh Govt. Museum [ref. 467].)*

32. ...Krishna let her tie him to the mortar... *(Miniature, Kangra c. 1790, 105×160 mm without borders, Bharat Kala Bhavan, Benares [ref. 372].)*

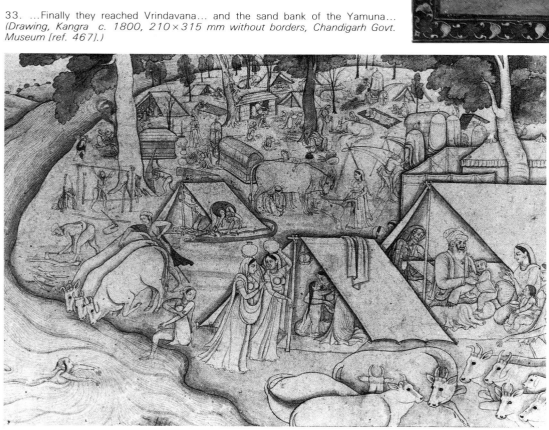

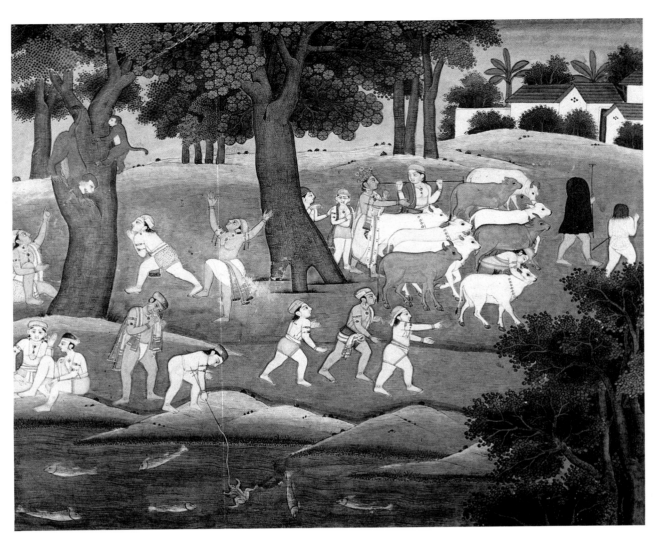

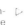

calves in front, and placing the aged and the young in chariots. It was a lovely sight. The family priests recited prayers, and horns blew and trumpets sounded on all sides as the group advanced. Mounted on their chariots the lovely-complexioned *gopis* 'with fresh application of saffron paint to their breasts, and wearing strings of gold coins around their necks', recounted the playful acts of Krishna in song as they moved. Finally they reached Vrindavana, and seeing the Govardhana hill nearby and the sand bank of the Yamuna close to it, everyone's heart swelled. Here the grass grew verdant in the hot season as in the rains, and this bode well for the nourishment of their cattle. Here then Nanda, with his entire extended family, decided to settle, setting up a semicircular habitation 'like unto the half disc of the moon'.

The two boys, Krishna and Balarama, were growing up fast. Soon they began to tend the cows, and took them out to graze. There, in the pastures, they engaged in boyish games the whole day long, 'making themselves crests of the peacocks' plumes, and garlands of forest flowers, and musical instruments of reeds and leaves'. Their hair was trimmed 'like the wings of the crow', and they resembled two young princes, 'portions of the deity of war', as they wandered about, always laughing and playing, sometimes with each other, sometimes with the other boys.

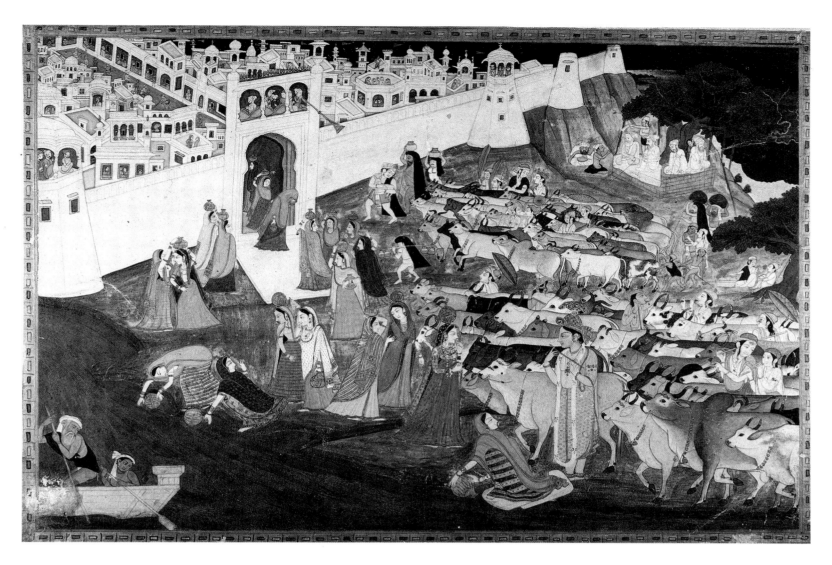

Life in the woods

Thus, 'the two guardians of the world went about as keepers of cattle'. The forest hummed with the bees and the cries of the peacocks as Krishna and Balarama either sang in chorus with their *gopa* friends or danced with them. 'They sought shelter from the cold sometimes under the trees; sometimes they stained themselves with various hues from the minerals of the mountain, sometimes they reposed on beds of leaves, sometimes they mimicked the cry of the peacocks with their pipes.' In the evening they would go back with the cows and the cowherds to the village where during the day all activity seemed to have become meaningless in the absence of everyone's beloved, Krishna. For the villagers, it was as if life came back only with the return of Krishna at the sacred hour of cowdust.

The calf-demon Vatsasura attempts to kill Krishna

But in Vrindavana, too, there were dangers. Once, while Krishna and Balarama were pasturing the cows, a demon, Vatsasura, came in the guise of a calf with the intention of killing the two of them. His attempts at mixing with the herd of cattle were futile, since Krishna, having seen him, caught hold of him by his hind legs and tail and whirled him around till he fell lifeless on the top of a woodapple tree, and the *gopa* friends of Krishna cried out, 'Bravo! Well done!'

The crane-demon Bakasura attempts to kill Krishna

Next came the powerful demon Baka, assuming the form of a giant stork. Flapping his great wings, he swooped down suddenly and, taking Krishna into his long, sharp beak, flew off. Everyone else stood petrified, but Krishna had devised a plan. Lodged within the monstrous beak of Bakasura, he now made himself so hot that the roof of the demon's palate began to burn as if on fire. He let go of Krishna, but then attacked him with his beak, whereupon Krishna, the protector of the righteous, caught hold of him by the two halves of his bill and tore the demon up 'like a blade of grass', as if it were a game. In the skies, conches blew and drums sounded to celebrate this deed of the Lord.

The python Aghasura swallows the cowherds and their cows

One day, to avenge himself for the death of his sister, Putana, and his brother Baka, the fearful demon Aghasura came to the region in the form of a gigantic python, 'eight miles in length and enormous as a big mountain'. As the cowherds were playing with Krishna in the forest, Aghasura lay in their path, apparently mo-

39. ...Krishna's friends all walked unsuspectingly into the mouth of the demon (Aghasura)... *(Miniature, Malwa c. 1650, 183×255 mm with borders, National Museum, New Delhi [ref. 56.61.17].)*

40. ...Brahma ...taking all the cowherds and their calves... imprisoned them in a cavern... *(Miniature, Gujarat 17th century, 185×220 with borders, Collection Colonel R.K. Tandan, Hyderabad.)*

tionless, with his cave-like mouth wide open. His lower jaw lay on the earth, while 'the upper touched the clouds'. His tongue was 'like a broad road', his breath 'like a tempestuous blast'. Impervious to the danger, Krishna's friends all walked unsuspectingly into the mouth of the demon. At this Krishna, knower of all things, evaluated the situation and entered the demon's cavernous mouth. There he increased himself suddenly to such enormous proportions that the passage of the demon's breath was choked, and his eyes, 'scorching like a forest conflagration', began to shoot out of their sockets. With all his vital breath passing out of him, Aghasura died. While Krishna revived all his friends and cows and calves, a mysterious and powerful light from the demon's body set 'all the ten directions ablaze' with its bright effulgence and then entered Krishna's person. Agha, like others before him, had been purified by the Lord's touch.

His friends and the calves all saved, Krishna led them to the bank of the river and spoke: 'Extremely beautiful is this bank of soft, clean, unstained sand, and so auspicious and suitable for our sports, O friends! It is encircled by beautiful trees, rendered fascinating by the echoing notes and humming of bees attracted here by the sweet smell of blooming lotuses. Let us have our meal here'. The boys all agreed and sat together in a circle around Krishna, shining like 'petals around the pericarp

of that lotus'. Krishna, with his flute tucked into his silken, yellow garment, and with his cane under his left arm, sat with the boys and shared their simple meal of boiled rice mixed with curds. In the meantime the calves seemed to stray and Krishna, asking his friends to continue eating, went in search of them himself.

Brahma steals the cowherd boys and their herds

This was the moment that the four-headed Brahma chose to play a trick, purely to experience the joy of seeing another of the Lord's feats. He descended to the earth, alighting from his swan vehicle and, taking all the cowherds and their calves to some far-off place, imprisoned them in a cavern. When Krishna returned, he found neither the cows nor his cowherd friends and 'he at once knew it to be the work of Brahma'. He now decided to multiply himself and created other cowherds and their calves exactly in the same number and appearance.

In the evening, carrying the same sticks and horns and flutes and slings, 'these numerous cowherds and calves now returned to Vraja, for the mothers were waiting, as were the cows. Nothing seemed different and life in the village went on without anyone noticing a change. If anything, the mothers felt an increase in their affection towards their children and the cows gave their milk more abundantly. No one suspected anything. In this way

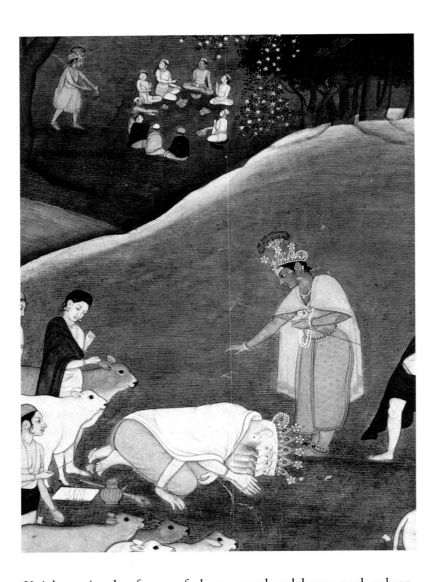

41. ...Thereupon Brahma... fell prostrate at the Lord's feet... *(Miniature, detail, Kangra c. 1790, National Museum, New Delhi [ref. 58.18.8].)*

42. ...Balarama grasped Dhenuka by both his legs with one hand, whirled him about violently, and then threw him onto the top of a tall palmyra-tree where the demon died... *(Miniature, Bundelkhand, mid 18th century, 127 × 148 mm on a manuscript page 142 × 395 mm, Prince of Wales Museum, Bombay.)*

Krishna, in the form of those cowherd boys and calves, passed a full year. Then Brahma returned, wanting to see for himself what had happened in this period, and he beheld all the boys and all the calves that he had taken away roaming about in the forests. He knew that these were not real, but try as he might, he could not tell any difference. Then, while he was looking at them, he suddenly saw them all 'dark as clouds in complexion and wearing silken yellow garments', each endowed with four arms, 'wielding a conch, a discus, a mace and a lotus, wearing crowns, earrings, pearl necklaces and wreaths of sylvan flowers'.

Brahma pays tribute to Krishna and returns the cowherd

Thereupon Brahma became dazed and motionless, and 'he stood still like a statue'. Knowing that he had just witnessed the *lila* of Krishna, he descended from his swan-mount and fell prostrate at the Lord's feet, 'touching them with the crests of his four crowns and bathing them with tears of joy'. Then, receiving Krishna's blessing, Brahma returned to his domain, and Krishna brought the real *gopas* and their calves back from their exile. Miraculously, though the children had been separated from Krishna for one whole year, they did not notice it. The *maya* of Krishna had made them forget all

that had happened and they continued with the meal they had been having when Krishna had wandered off. For them, only half a moment of time had passed. As the evening drew close, everyone returned to Vraja.

Balarama slays the ass-demon Dhenukasura

Krishna then reached the *pauganda* stage, boyhood between the ages of six and nine. He went into the forest more freely now, and the *gopas* gathered around him all the time as they played and tended their cows. One day they urged him to help them gather the fruit from the palmyra-trees which grew in a dark, dense forest guarded by the wicked Dhenukasura, a demon of great prowess, who, assuming the form of an ass, terrified everyone in the region. Krishna and Balarama went to the forest at the request of their playmates. Balarama entered it and began shaking the trees with his long arms, making the fruit drop liberally. Hearing this sound, Dhenukasura rushed to the spot and hurled himself with all his fury at Balarama, braying loudly and kicking him on the chest with his hind legs. Balarama grasped Dhenuka by both his legs with one hand, whirled him about violently, and then threw him onto the top of a tall palmyra-tree, where the demon died. The trees began to shake heavily 'as if swept down by a violent hurricane', and the fruit 'rained' on the earth to the delight of everyone. The forest thus rid

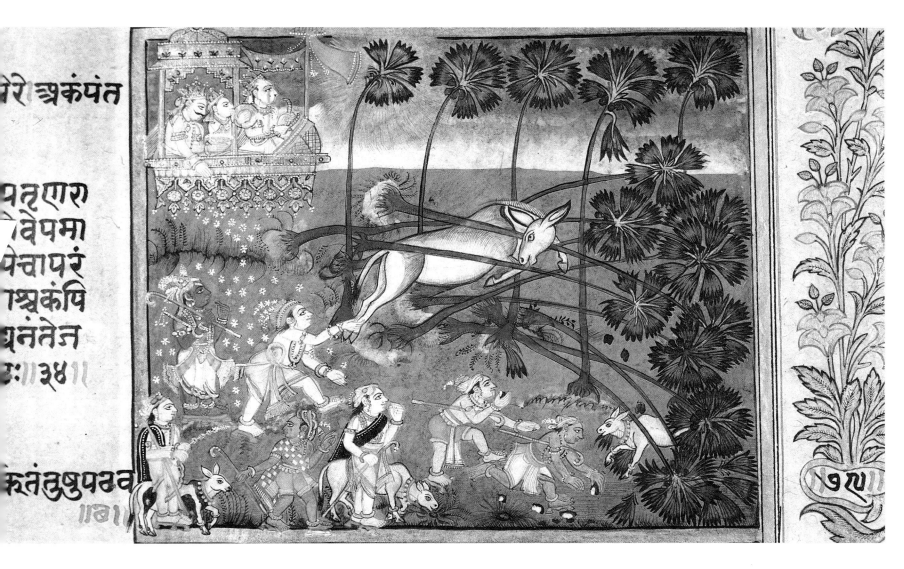

of Dhenukasura, the cowherds with their cattle moved in the pastures without fear.

The quelling of the snake Kaliya

One day on his way to the great river Yamuna which usually sparkled with foam, 'as if with smiles', Krishna saw some cows and cowherds lying senseless by its bank, having drunk the water. In the river bed the fearful serpent Kaliya was lying in a pool and the poison from his many mouths was setting the waters on fire. The fumes blighted the large trees growing on the bank, and when they rose into the air 'the very birds in the sky were scorched'. Krishna knew all this to be the work of Kaliya, who had fled here from the ocean out of fear of the great Garuda-bird. But his presence spelt great danger to the people of Vraja. Resolving to dislodge the *naga*, Krishna climbed up a *kadamba* tree close to the bank and, tightening his clothes around him, jumped boldly into the waters which, agitated by his plunge, splashed to a great distance from the bank and the spray, falling upon the trees, set them on fire with its poisonous vapours. The noise woke the Serpent-king, and the cowherds fainted with fear for Krishna. But Krishna, having dived into the *naga*'s pool, stroked his arms in defiance. At this, the Snake-king came towards him 'his eyes coppery red and his hood flaming with dreadful venom'. Around him were other snakes, equally powerful and poisonous, and hundreds of serpent nymphs, decked with the richest jewels to be found in the waters. Coiling themselves around Krishna, the snakes bit him with their deadly fangs, and when the cowherds saw Krishna in the grip of the snakes, they ran towards Vraja in great alarm.

There was fear and consternation, and everyone came running. Krishna seemed to be powerless and, seeing this, Nanda, suddenly limp, fell to the ground and Yashoda lost all consciousness. The *gopis*, overcome with sorrow, wept in convulsive sobs. 'Let us give our lives up,' they said, 'we cannot return to Vraja; for what is day without the sun? What is night without the moon? What is a herd of heifers, without its lord? What is Vraja, without Krishna?' But all was not lost. Balarama had also reached the river-bank and, seeing the exclamations of the *gopis* and the state of Nanda and Yashoda, cried out to Krishna, reminding him of his power: 'What is this, O God of Gods! Thou art the centre of creation, as the nave is of the spoke of wheels. Therefore, Krishna dost Thou disregard this?... Thou hast exhibited the tricks of childhood; now let this fierce snake, though armed with venomed fangs, be subdued by Thy celestial vigour.'

Reminded of his real character by Balarama, Krishna smiled gently and hastily extricated himself from the coils of the snakes. He lay hold of the middle hood of their

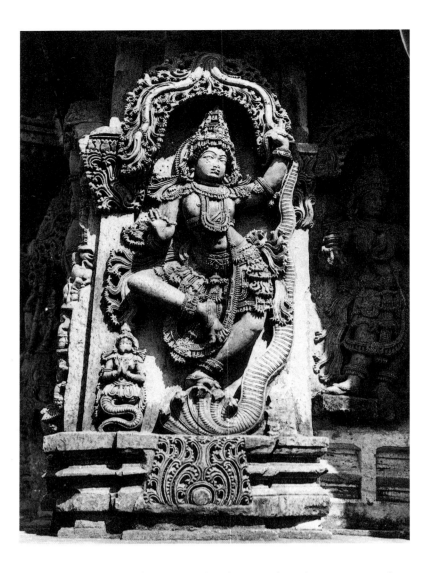

43. ...Krishna... placing his foot upon that hitherto unbended head, began to dance upon it (Kaliya) in triumph... *(Stone sculpture, Halebid 12th century)*

44. ...Pralamba... took Balarama and swiftly carried him away...*(Miniature, Mankot c. 1725, 202 × 303 mm with borders, Chandigarh Govt. Museum [ref. 1269].)*

45. ... Krishna took the fire in his cupped hands and swallowed it completely... *(Miniature, Chamba c. 1700, 215 × 282 mm with borders, Chandigarh Govt. Museum [ref. 1283].)*

chief, pressed it down and, placing his foot upon 'that hitherto unbended head', began to dance upon it in triumph. The snake was repeatedly trodden down, bruised and trampled until it fainted. Beholding his state, the serpent-nymphs all encircled Krishna, piteously begging his mercy for their lord, who, they said, was only bound by his nature. Kaliya, half-dead, added his pleas to theirs, seeking the Lord's forgiveness: 'I am quite unable, Lord, to worship or hymn Thee. Thy own clemency must alone influence Thy mind, therefore, to show me compassion.' Thus addressed by Kaliya, and full of mercy, Krishna ordered him to return to the sea, saying that Garuda would not harm him. Then he came out of the river, leaving his sacred foot-prints on the head of the great serpent, seen to this day. There was great rejoicing. Life was restored to the inhabitants of Vraja and, seeing their son's face, Nanda and Yashoda smiled 'like lotuses at the appearance of the sun'.

Balarama slays the demon Pralamba

Elsewhere, the demons lay in wait as before. The celebrations of Krishna's triumph over Kaliya were not yet over in the village, when a demon called Pralamba, assuming the guise of a cowherd, joined the group that had gone with Krishna and Balarama. Krishna knew at once the demon's identity but, not disclosing it, encouraged his

friends to play the game of pick-a-back, each boy taking turns at carrying another. Thus, riding and carrying, and grazing the cattle, they reached a banyan tree. As Krishna bore Shridaman on his back, Pralamba, the demon, took Balarama and swiftly carried him far away, beyond the limit set for the game. Balarama began to increase his weight, making it impossible for Pralamba to proceed any further. At this, the demon assumed his true form, his eyes aglow, his brows in a fearsome frown, his hair 'like the flames of blazing fire', and began to soar with hurtling speed towards the sky. But Balarama quickly recovered his wits and, like 'Indra striking vehemently a mountain with his thunderbolt', dealt the demon a heavy blow on his head. Such was the force of the blow that Pralamba's head was shattered and, emitting a terrifying roar, he fell dead to earth. Meanwhile Krishna just stood and watched.

Krishna swallows the Forest-fire

There were other dangers that lurked in the forest. Once, while the cowherds were engrossed in playing, they lost track of the cows. Krishna, climbing up a tall tree, loudly called out for those distressed cows, each by its individual name. Recognizing their beloved Krishna's voice, the cows were overwhelmed with joy and responded by bellowing loudly. But, at that very moment, a great forest

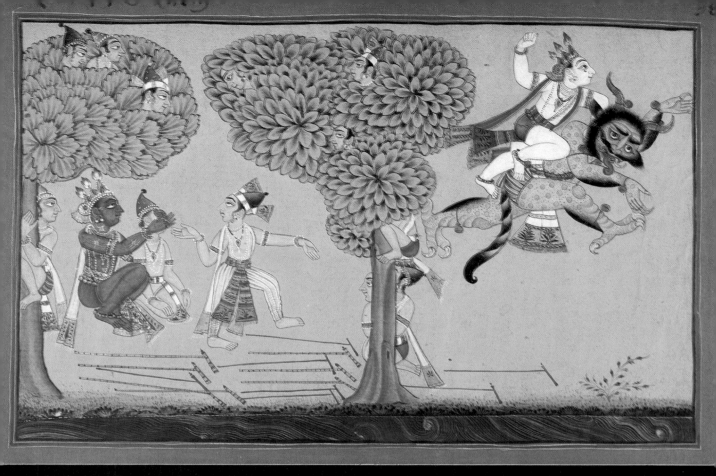

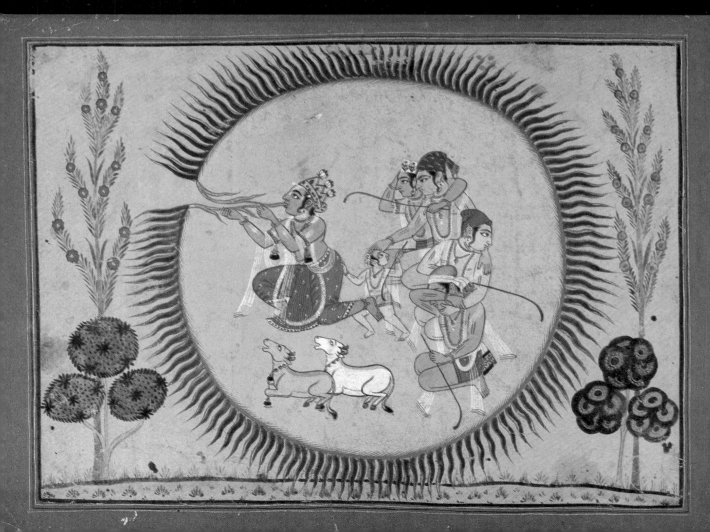

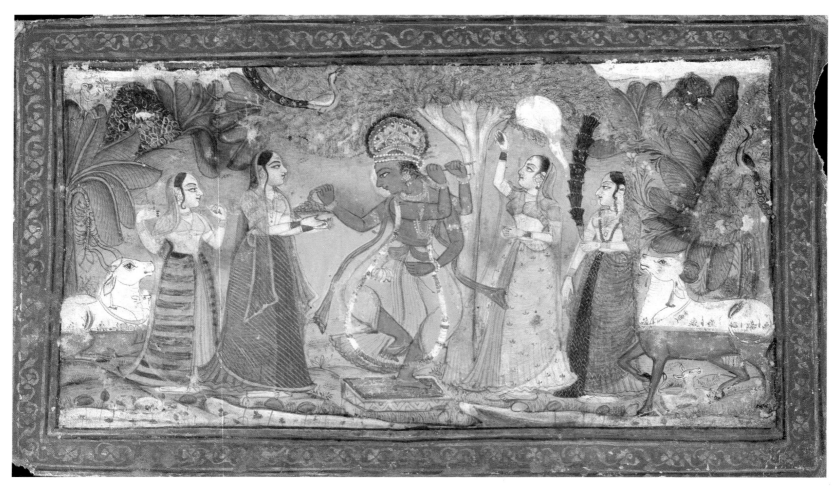

46. ...Krishna played upon his flute... *(Painted book cover, Bundi c. 1750, 138 × 232 mm, Galerie Marco Polo, Paris.)*

conflagration broke out and it began to spread rapidly in all directions. Fanned by a strong wind, it threatened to consume all things living and non-living, lashing 'its tongues of dreadful flames'. Observing this and afraid for their lives, the *gopas* and the cows with all their calves naturally turned towards Krishna begging him to save them. Hearing them, Krishna quietly said: 'Do not be afraid. Just close your eyes'. And as they did so, Krishna took the fire in his cupped hands and swallowed it completely. When the *gopas* opened their eyes, they could no longer see any trace of the fire. Then Krishna, playing on his flute, and Balarama led the herd and their friends back to Vraja.

Time passed, and the seasons went on changing. The rains came, 'with mighty clouds, charged with lightning, covering the skies'. The earth, parched with heat, received showers of life-giving water and the grass turned green again. The rivulets now overflowed their banks 'like the minds of men without restraint' and when Krishna entered the forest, the splendid beauty of the rainy season was enhanced by his enchanting presence.

Then came the autumn, when the lotus is full blown. The small *saphari* fish sparkled in their watery burrows, and the peacocks, no longer animated by passion, fell silent in the woods. The lakes started to dry up but they were embellished by white water-lilies. The skies became wholly free of clouds 'like the hearts of ascetics are of desires', and the nights brightened with stars. The earth shone lustrous and, day after day, in the forest caressed by the breeze charged with the fragrance of lotuses, Krishna would penetrate along with his cowherd friends and their cows. Charming, 'like an accomplished actor', and 'graced with a crown of peacock feathers, his ears decorated by *karnikara* flowers, clad in garments yellow like molten gold, wearing the floral garland made of five different colours and filling the holes of his flute with the nectar of his lips', Krishna blessed everyone with his presence. And listening to the music of his flute which bewitched and melted the hearts of all creatures, the women of Vraja 'continuously embraced him in their minds'. As Krishna played upon his flute, 'even celestial damsels moving in their aerial cars became infatuated with him, the chaplets of flowers dropping from their braids of hair, and the folds of their garments slipping'. Hearing the music that Krishna made, 'even the rivers exhibited their passion', and 'the birds perching on the branches of trees covered with fresh foliage looked at Krishna with unwinking eyes and remained speechless'. The cows 'quaffed the nectar-like music of the flute', and the calves stood entranced with 'the milk sucked from the flowing udders of their mothers still held in their half-opened mouths'.

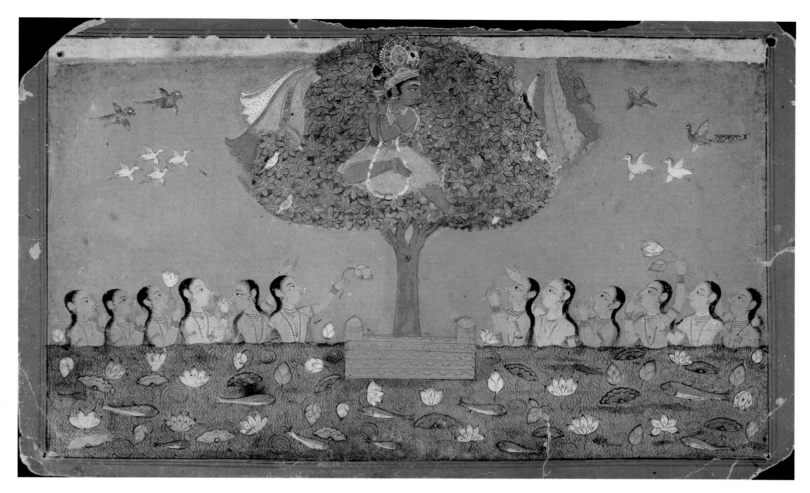

47. ...Krishna... collected all their garments and surreptitiously climbed a kadamba tree nearby, laughing to himself, and hanging the garments on the branches... *(Miniature, Basohli c. 1720, 149 × 238 mm with borders, Spink & Son, London.)*

Krishna steals the gopis' clothes

The maidens of Vraja thought of Krishna constantly. In the first month of winter, they observed 'the vow of the Goddess'. Taking a bath in the waters of the river Yamuna at daybreak, they would make an image of the Goddess in sand, worshipping it with sandal-paste and fragrant flowers and incense, and laying many gifts before it. As each maiden performed the worship, she repeated the same prayer: 'O Goddess! O Great Maya of the Universe! Be pleased to grant the son of Nanda to me as my husband!' Once, in the course of that vow, the maidens left their garments as usual on the bank and entered the waters of the Yamuna nude, playing merrily. All the time, however, in mind, word and deed, they were with Krishna. That day Krishna, seeing them from a distance, collected all their garments and surreptitiously climbed up a *kadamba* tree nearby, laughing to himself, and hanging the garments on the branches that now appeared 'like fluttering banners from a distance'. Perceiving the trick that Krishna was playing, the maidens were simultaneously overcome with love and embarrassment. Krishna then spoke to them, saying that he would give their garments back if they came to him of their own accord. Bashfully, the maidens looked at each other and smiled, but no one came out of the water. They consulted and finally said: 'Dear Krishna! Do not be unjust to us. We know that you, the son of Nanda, whom the whole of Vraja adores, are our beloved. But pray, do return our clothes, for we shiver so with cold'. But plead as they would, Krishna refused. His face beaming with smiles, he said they had to obey him first. At this all the girls, shivering and covering their breasts and their private parts with the palms of their hands, came out of the water and Krishna, 'perceiving the purity of their hearts', said to them that by entering the water nude, during the observance of a religious vow, they had offended the gods. 'For the expiation of this sin', Krishna said, 'you should bow, raising joined hands to your heads. Then shall you receive your clothes'. Hearing this command 'full of religious significance' the maidens obeyed him with one hand, keeping their private parts still covered. But Krishna would not relent, for 'respects to the Lord should be paid with both hands'. Then the maidens, driven to utter helplessness, realized that Krishna was asking complete surrender of them, 'the baring of themselves, as of their souls', to him. They did as he commanded, thus 'being washed of all sins, flaws and transgressions.' Pleased, Krishna gave them back their clothes and, bashfully, the maidens put them on. Having always known what was in their hearts Krishna said: 'O chaste ladies! Your object is already known to me. This cherished wish of yours is ap-

48. ...The ladies, having recognised the message of the Lord, brought them food in great quantities... (Miniature, Mankot c. 1725, 196 × 296 mm with borders, Chandigarh Govt. Museum [ref. 1305].)

49. ...He quickly uprooted the mountain Govardhana, and held it aloft on the tip of the little finger... (Miniature, detail, Kishangarh 18th century, Bharat Kala Bhavan, Benares.)

proved of by me, and it shall be realized. Your desire for my company is not censurable, for your longing to have enjoyment with me will not again lead to a birth in *sansara*. Return now to Vraja, for your object is accomplished. You will spend the autumnal nights in enjoyment with me'. Thus commanded, the maidens, 'contemplating his lotus-feet in their hearts', went back to Vraja.

The wives of the Brahmins feed the hungry gopas

One day the *gopas* felt hungry. Krishna sent them to beg for food at the sacrificial hall where some Brahmins were officiating. They were turned down. Krishna then told them to approach the wives of the priests. The ladies having recognised the message of the Lord brought them food in great quantities.

Krishna persuades the cowherds to worship Mount Govardhana, and the resulting conflict with Indra

In those very days, Krishna found festive preparations going on around the village for the worship of the rain god Indra. Feigning ignorance, he asked Nanda what the excitement was about. Nanda explained to him that Indra was the presiding deity of rainfall itself and 'the clouds his loving manifestations'. It was therefore appropriate that he be worshipped. But Krishna had other thoughts. Arguing with his father and the elders of the village he said: 'We, father, are neither cultivators of the soil, nor dealers in merchandise; we are sojourners in forests, and cows are our divinities... What do we have to do with Indra? Cattle and mountains are our gods. The Brahmins offer worship with prayers, cultivators of the earth adore their landmarks; but we, who tend our herds in the forests and mountains should worship them, the mountains and our kine'. He urged that prayers and offerings be made to the nearby hill, Govardhana, and suggested that the milk and food collected for Indra-worship be used for a new purpose. Everyone agreed to carry out Krishna's wishes and, 'singing benedictory hymns with purified hearts', the people of Vraja appeased Mount Govardhana, feeding the Brahmins and offering grass to the cattle. Then, to inspire greater confidence in the hearts of the villagers, Krishna assumed yet another form and saying, 'I am the mountain', he sat on the summit of the hill and started consuming the quantities of food himself. At the same time, in his own form as Krishna, he also kept ascending the hill along with the other cowherds to worship his other self. Sensing that his worship had been stopped, and greatly enraged, the god Indra directed the hosts of his clouds to bring about the destruction of that region. Asking them to flood the settlements of 'these arrogant cowherds', In-

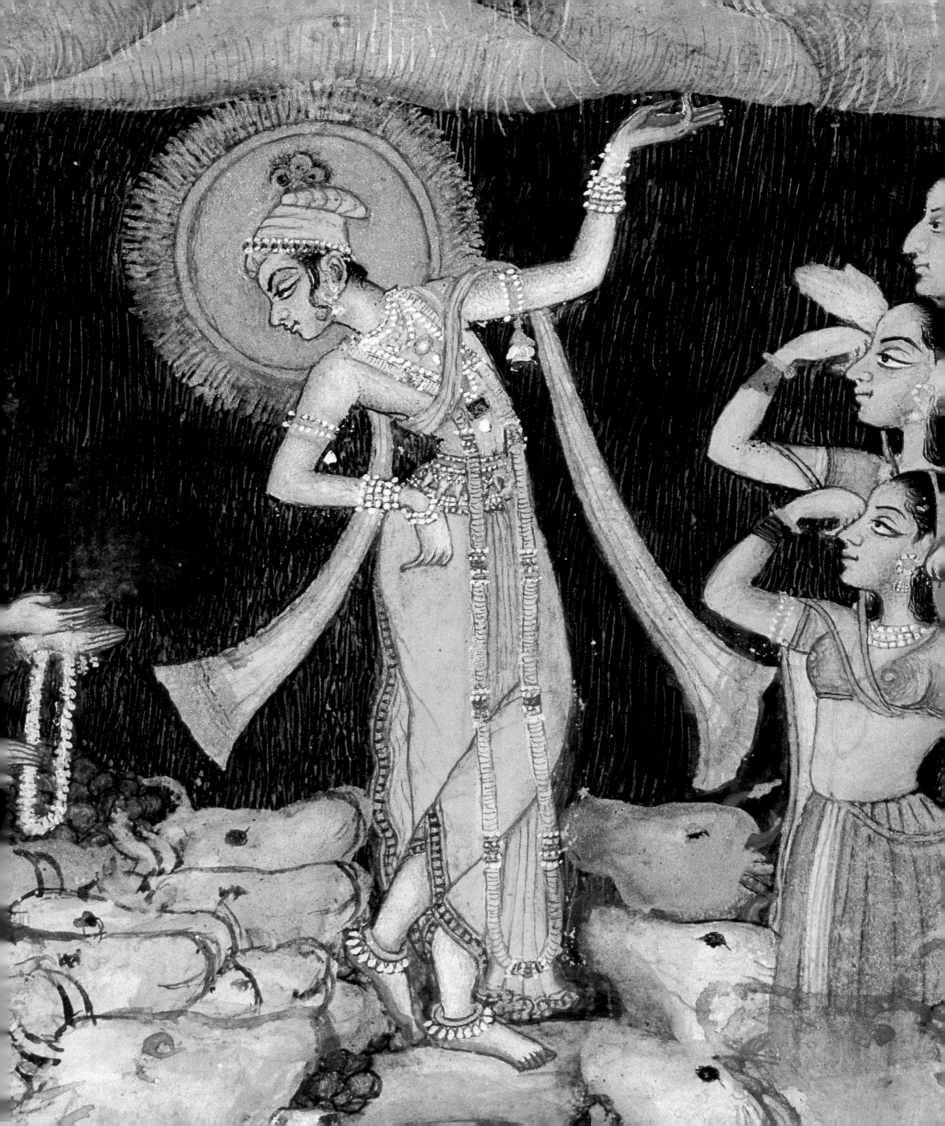

50. ...Krishna began to play upon his flute... *(Miniature, Bikaner c. 1750, 75 × 150 mm, Galerie Marco Polo, Paris.)*

dra told them: 'I will myself give you aid in strengthening the tempests that you bring down.' At this a fearful storm of rain and wind raged. In an instant, the earth, the points of the horizon and the sky, 'were all blended into one by the heavy incessant showers'. The clouds roared, 'as if in terror of the lightning scourge', and poured down uninterrupted torrents. The whole earth was enveloped in impenetrable darkness, and 'above, below, on every side, the world became water'. The cattle shivered and covered their calves with their flanks, and the inhabitants of Vraja were terrified for the safety of their houses and their families. Again they turned to Krishna for help.

Krishna lifts Mount Govardhana

Knowing the deluge to be the work of Indra in his anger, Krishna decided to act. He quickly uprooted the mountain Govardhana, and held it aloft on the tip of the little finger of his left hand as if it were a mere game. 'Lo, the mountain is on high; enter beneath it quickly, and it will shelter you from the storm!', he told the cowherds. Everyone gathered under the raised mountain, Nanda and Yashoda, the *gopas* and the *gopis*, the cows and their calves. For seven days and nights the clouds sent by Indra rained upon the Gokula of Nanda, but they were able to do no harm for everything was protected by the Lord himself. Seeing himself thus outwitted, Indra then stop-

ped the clouds from raining any further. And then, when the skies had cleared, Krishna restored the great mountain to its former site. Thoroughly humbled, Indra came down from the skies on his vast elephant-mount, Airavata, and offered Krishna prayer and worship. Taking holy water from an ewer, Indra performed the 'regal ceremony' of purifying Krishna in the presence of everyone. Krishna and Indra then embraced each other and the latter returned to his heavens. Krishna, with all the cattle and the cowherds, went back to Vraja where the wives of the *gopas* waited eagerly for his return.

Krishna saves Nanda from Varuna

Krishna was now no longer a child, but a *kishora*, having reached adolescence. However, his playmates and the inhabitants of Vraja found it increasingly hard to explain his many wonderful deeds. And once when Krishna saved Nanda from the power of the god Varuna, they all knew that 'Vishnu had indeed descended on the earth in the house of Nanda, our chief'. They insisted that Krishna reveal his true identity but, though he had shown them many a miraculous feat, and even a glimpse of Vishnu's great Vaikuntha heaven which they later forgot, Krishna simply said: 'Herdsmen, if you are not ashamed of my relationship; if I have merited your praise; what occasion is there for you to engage in any discussion concerning

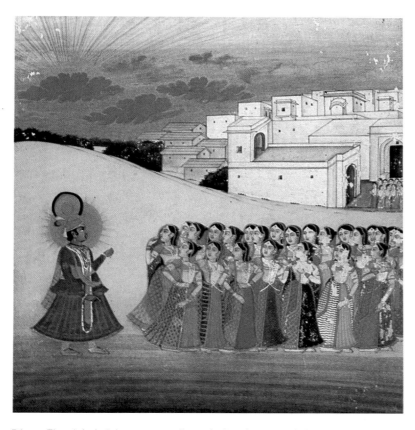

51. ...They left their houses regardless of what they were doing at the moment...
(Miniature, Jaipur c. 1800, 160 × 210 mm, Private collection.)

52. ...These lovely-eyed gopis were like souls that had surrendered themselves completely to God... *(Miniature, Kangra c. 1790, 132 × 222 mm on an album leaf 240 × 307 mm, Collection Mr Michael Archer and Mrs Margaret Lecombe.)*

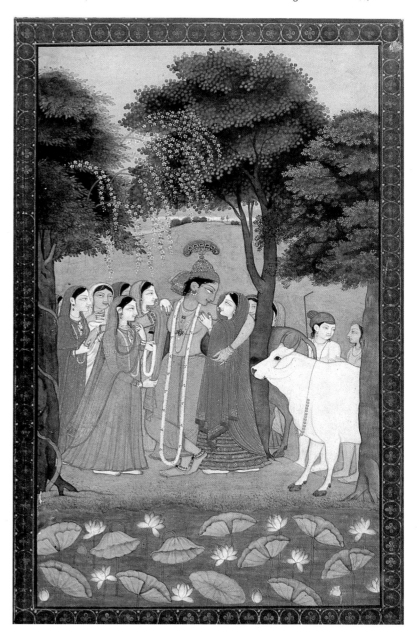

me? If you have any regard for me, if I have deserved your praise, then be satisfied to know that I am your kinsman. I have been born your relative, and you must think no differently of me'. At this the *gopas* kept silent, but when they were about to disperse, Nanda told them of what the sage Garga had hinted at when he had come to perform the purificatory ceremonies many years ago. Then once again came around that indescribably beautiful season, autumn, when the nights shone with full-blown jasmines. Krishna, in exercise of his supreme yogic *lila*, decided to play and dance the great *rasa*. His love-play with the *gopis* was partially to keep the promise he had made them when he returned their clothes to them, but also partially to reveal to them the many dimensions of love.

The summons of Krishna's flute;
the gopis leave their homes

Beholding the moon in full orb, now 'reddish like fresh saffron' and resplendent like the very face of the goddess Lakshmi, and seeing the groves of Vrindavana lit with its soft rays, Krishna began to play upon his flute. Hearing the music, the *gopis* of Vraja, with their minds already immersed in Krishna, found themselves utterly unable to resist this 'call' and they all hurried to him. They left their houses, regardless of what they were doing at that mo-

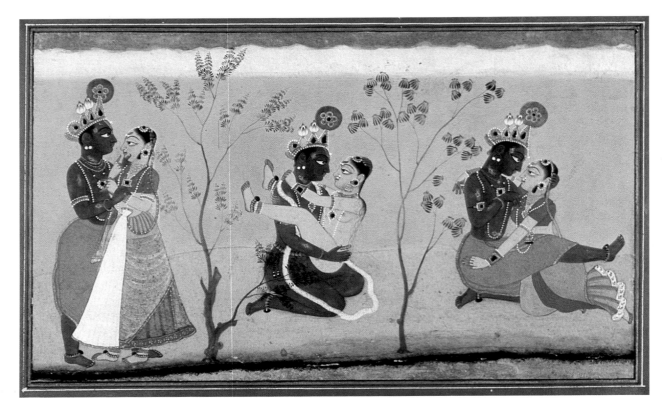

53. ...joined with him in unfettered love and free of all bonds... (Miniature, Basohli c. 1730, 205 × 305 mm with borders, Chandigarh Govt. Museum [ref. I.72].)

54. ...the gopis gathered around Krishna who looked like the full moon surrounded by stars... (Miniature, Bundi c. 1730, 208 × 320 mm without borders, 268 × 355 mm with borders, Colnaghi and Co. Ltd., London.)

ment, 'their ear ornaments trembling with excitement as they hastened to the forest'. Some, who were in the middle of milking cows, left their task, others left the pots they had left on the fire. Some left their infants half-fed at their breasts, and others forgot to serve food to their husbands and children. Some, busy smearing the body with sandal-paste, and others, applying collyrium to the eyes, left whatever they were doing and ran towards Krishna, their clothes and ornaments all in disorder. These lovely-eyed *gopis* were like souls that had surrendered themselves completely to God. Overcoming the obstacles that their husbands, parents, brothers and kinsmen placed in their way, they all rushed to where that divine music was playing. The few that were confined to their homes and were not able to get away, 'closed their eyes and began to meditate on Him, beginning already to see themselves in His company, joined with Him in unfettered love and free of all bonds'.

Krishna rebukes the gopis

When the gopis were all with Krishna, he began trying to persuade them to return to Vraja and their unfinished duties. But they had forsaken all other desires for his sake, and in faltering accents they beseeched Krishna not to abandon them: 'O Lord, O Free-One', the *gopis* said, 'it does not behove you to address such cruel words to

those who have sought refuge at your feet, renouncing everything else. Fulfil, on the other hand, the desires of your devotees, like the Primordial *purusha*, who never abandons those who seek salvation'.

Moved by these words, Krishna smiled benevolently. Seeing this, and their faces blooming under the gaze of their beloved Lord, the *gopis* gathered around Krishna, who looked like 'the full moon surrounded by stars'.

Water games

Krishna then entered the cool waters of the Yamuna with the *gopis* who resembled 'golden creepers growing on a dark-coloured hill'. There he played with them, with the fragrance of water-lilies wafting in all directions. 'Exciting amorous sentiment in the beautiful damsels of Vraja by stretching out his arms, embracing them, touching their hands, locks of hair, thighs, waists, bosoms, by indulging in jokes and by pricking them gently with his nails, by his playful glances and hidden smiles, Krishna gave endless delight to the *gopis*.'

Krishna disappears;
the gopis enact the Krishna lila

Receiving such attention and love from Krishna, the *gopis* were suddenly filled with pride and began to regard themselves as superior to all the other women of the

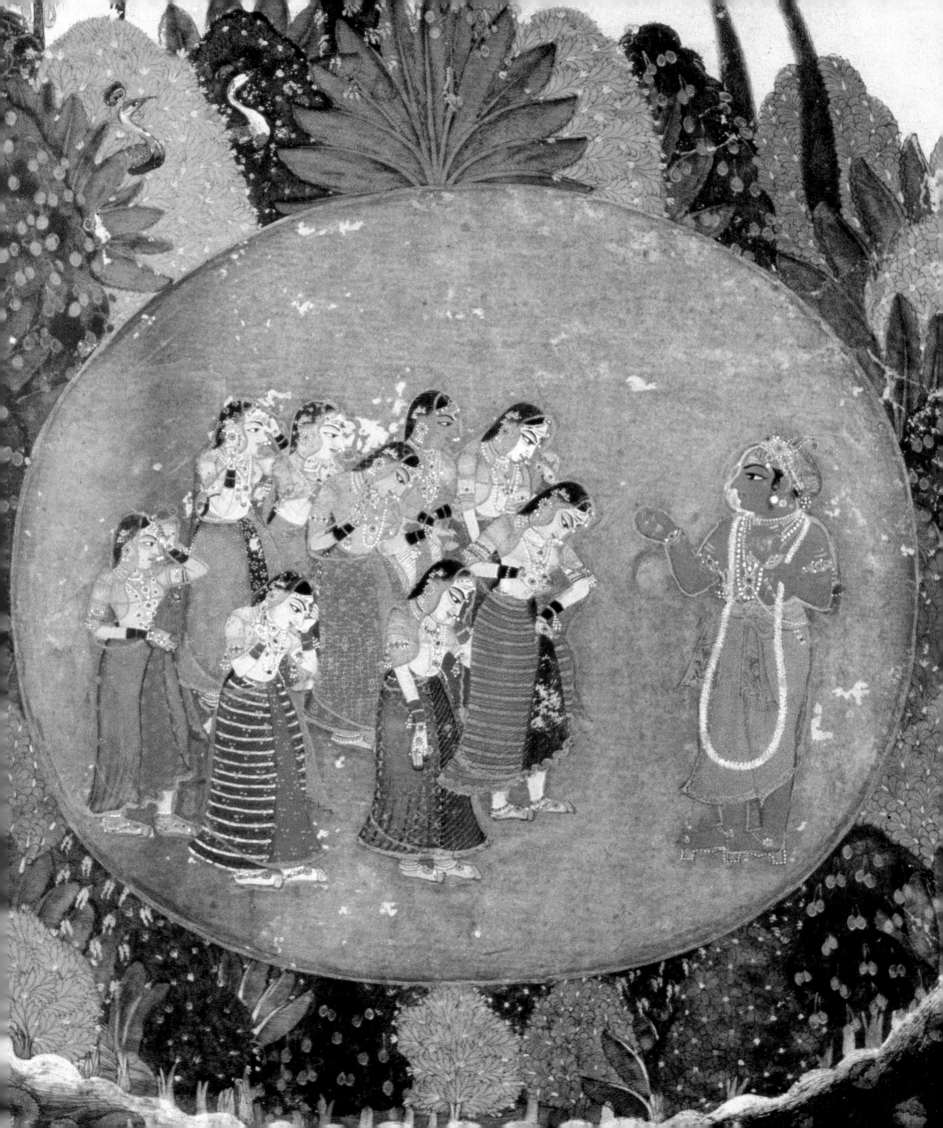

55. ...exciting amorous sentiments... by stretching out his arms, embracing them, touching their hands, locks of hair, thighs, waists, bosoms... *(Miniature, detail, Kangra c. 1810, Private collection.)*

56. ...they began to imitate Krishna and his various movements and exploits... *(Miniature, detail, Malwa c. 1720, Collection C.L. Bharany.)*

earth. But Krishna was quick to perceive their conceit and their pride and, quite suddenly, he disappeared from their midst. Whereupon the damsels of Vraja, 'like she-elephants without the leader of their herd with them', became deeply distressed. With their hearts totally absorbed in thoughts of him, at one with him, they wandered from grove to grove in their mad longing, searching for Krishna. They became objects of pity as they sang songs of him in low voices and thought of him ceaselessly. To the trees and creepers they addressed their enquiries, to the earth their entreaties. But they found no clue. Then, in their distracted state, they began to imitate Krishna and his various movements and exploits. A *gopi* impersonated Putana while another, thinking herself to be Krishna, fed at her breast; yet another upset an imaginary cart; some played like Krishna and Balarama with the cowherds while roaming in the forests. One of them, imitating the gait of Krishna, asked the others to note her graceful movements as 'she played upon her flute', and another reassured the rest saying that she would, like Krishna, 'protect them from rain and wind'.

The gopis see Krishna's footprints

While thus engaged in this acting, one of the *gopis* suddenly saw the footprints of Krishna 'bearing the sacred marks of the flag, the lotus, the thunderbolt, the noose,

57. ...The gopis suddenly saw the footprints of Krishna... *(Miniature, detail, Malwa c. 1720, Collection C.L. Bharany.)*

58. Krishna shelters Radha from the rain *(Miniature, Bikaner c. 1760, 123 × 163 mm, Galerie Marco Polo, Paris.)*

and a grain'. They began to follow the tracks and discovered those of a woman alongside. Seeing this, they were torn with jealousy, not knowing who this fortunate woman who had disappeared into the forest with Krishna could be. Excitedly, they pointed out to each other how her footprints 'have disappeared here', guessing that 'surely, his beloved's soft feet having been hurt by the new grass, Krishna must have lifted her'. At another spot where they found the footprints of Krishna sunk deeper than elsewhere, they imagined that 'he must have raised her here on his shoulder to pluck flowers from a tree;' they guessed also the spot where he must have sat in order to make a crown of flowers for her hair.

Radha and the gopis long for their lord

This *gopi* with whom Krishna had indeed disappeared, the Radha of classical Krishna-literature, was in turn filled with conceit. When she and Krishna had gone deep into the forest, she said to him: 'I cannot walk further. Take me wherever you will on your shoulders.' Krishna consented to do this, and then disappeared, leaving her with her arms outstretched. This beloved of God then began to lament: 'O Lord! O best of Lovers! O Long-Armed One! Where are you? I am your slave and am distracted. Take me to you, Friend! Be pleased to reveal yourself to me once again.' But Krishna was not to be

found. Meanwhile, the other *gopis*, looking for Krishna, caught up with the 'specially favoured one', and took her back to the bank of the Yamuna. Their minds saturated with the thought of Krishna and their conversation constantly centering on him, they all began to speak of him with deep, moving passion in their voices: 'O Friend, you are not only the son of Yashoda. You are the Indweller in the heart of all living creatures.' Again: 'Beloved, in what way and manner are we not yours? If you wished to destroy us, thus, why did you save us from the poisonous serpent, from fire and from inundation; why not have allowed us then to die?... What, beloved! do you wish to display your heroism towards us weak women? What pain do we not suffer, when we behold your gentle smile, your affectionate glance, the bend of your eyebrows, the coquetry of your eyes, the undulating motion of your neck, and the splendour of your discourses?' But Krishna still did not come. In utter despair, the *gopis* wept so bitterly that 'all things animate and inanimate, on hearing them, were afflicted'.

Krishna reappears

Then, as suddenly as he had vanished, Krishna, his lotus-face radiant with a smile, reappeared, wearing his silken yellow garment and a garland of wild flowers. At the sight of him, the senses of all the *gopis* revived, 'just as the

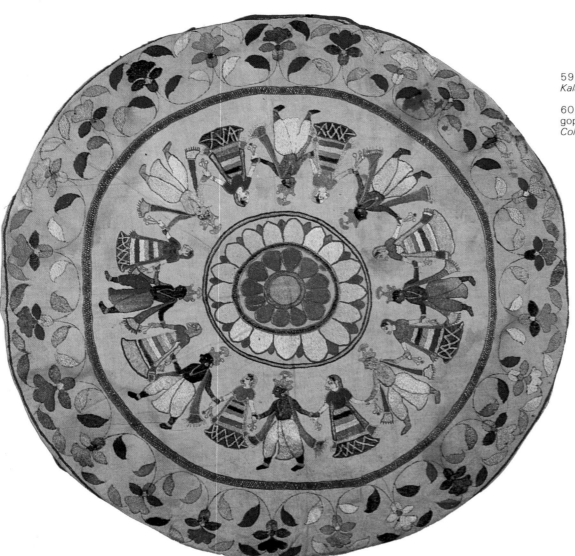

59. Rasa mandala. *(Chamba rumal 19th century, Bharat Kala Bhavan, Benares.)*

60. …Then Krishna began his great rasa-play with the gopis… *(Miniature, Nathdwara c. 1820, 232 × 318 mm, Collection Mr. and Mrs. J. Riboud.)*

organs of perception are restored to animation, when life is revived in a dead man'. Emerging at once 'from the sea of despondency', they surrounded him, their eyes shining with a newly-gained lustre. Krishna said to them, in response to their feigned reproaches, that he was really making 'a trial of their affection', and they spread out their scarves for him to sit on. They gazed at his lovely face and touched him fondly; one of the *gopis* clasped his hand in her palms and another placed his arm on her sandal-smeared arm. Yet another, burning with her love for him, placed his feet on her bosom. Then Krishna, conciliating them with soft speech and gentle looks, made his way towards the pleasant bank of the Yamuna. Here, clusters of bees swarmed, for the breeze was fragrant with the blossoming *kunda* and *mandara* flowers, and the rays of the autumn moon dispelled the darkness of the night. The waves of the river, 'like human hands, scattered soft sand on the bank'. Standing, Krishna asked the *gopis* to put aside their anger, and told them of his debt to them, who had abandoned for his sake their 'kinsmen, the social code, the sense of right and wrong', a debt he said, 'that knows no requital and will last unto eternity'.

The rasa dance

Hearing these words, all mirrors of the mind were cleansed, and the *gopis* overcame the grief of separation. Then,

on the sands of the Yamuna, Krishna began his great *rasa*-play with the *gopis*. As each attempted to keep as close to Krishna as possible, the circle of the dance could not be constructed. Krishna, therefore, took each by the hand, assuming as many bodies as there were *gopis*. Between two *gopis* there was a Krishna and as they began their dance, each of them thought that Krishna was hers alone. In this unending, circular *rasa* dance, 'the bracelets, and anklets, and waist bands of the *gopis*, united with Krishna, raised a loud sound of divine harmony'. Embraced by Krishna, who appeared now 'like a sapphire on a necklace of gold', and touched by him constantly, the *gopis* played and sang, 'their faces shining beautifully, and beads of perspiration forming on their foreheads.' Krishna danced in the middle of this vast circle. In his *lila*, the Lord was like a child playing with his own reflection. As the dance progressed, the wives of the gods themselves gathered in the skies in their aerial cars, longing to participate. The moon and the stars 'were filled with wonder' and 'the elements stood still… the night was prolonged so that six months passed away, whence that night was named Brahma's night'.

When everyone was physically exhausted but filled with indescribable joy, the dance came to an end and the *gopis* returned reluctantly to their respective homes at the break of dawn.

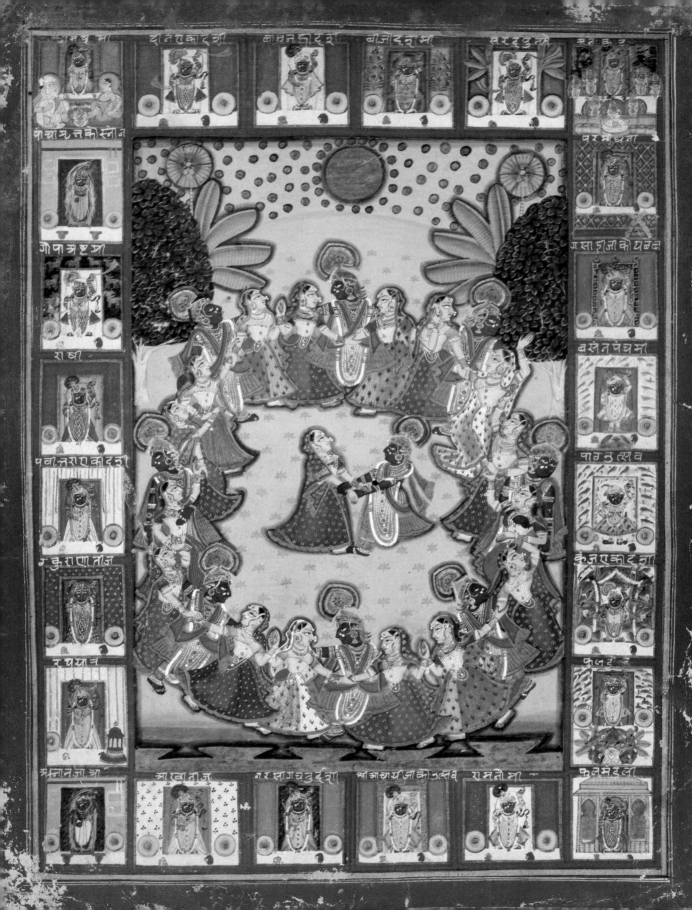

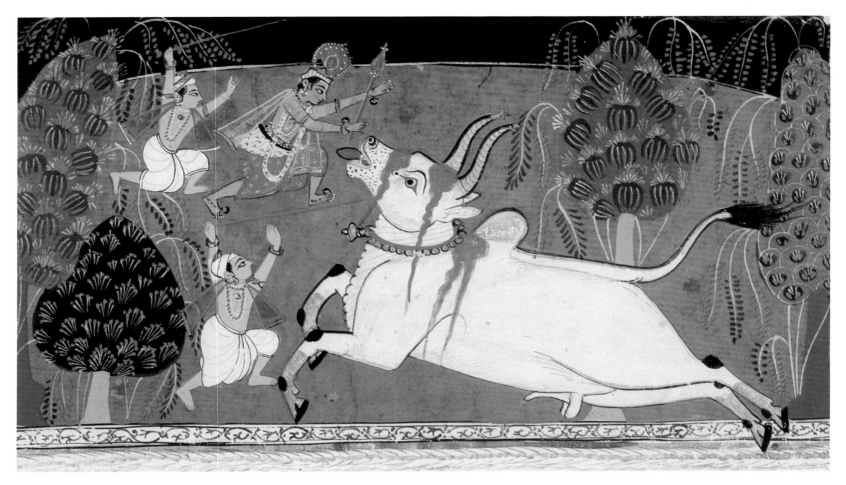

61. ...Arishta sprang back to his feet with the speed of lightning and dashed at Krishna once again... *(Miniature, Malwa c. 1650, 182 × 251 mm with borders, National Museum, New Delhi [ref. 51-61-1].)*

Nanda and the python

In Krishna's beloved village, life went on as before, full of love but also of danger. On one occasion, when the entire group of *gopas*, along with Nanda, Sunanda and others, had gone on a pilgrimage, and while Nanda was asleep by the side of a temple in a grove dedicated to the goddess Parvati, a huge python living in that forest approached and started swallowing Nanda. Terrified, Nanda shouted for Krishna. Hearing his shouts, everyone was awakened but all that the *gopas* could think of doing was striking at the snake with sticks of wood from the burning fire. The snake however, would not give up. Then Krishna advanced, without saying a word, towards the reptile, touching him with his foot. At once, the snake cast off his skin and turned into a most handsome man. He was none other than Sudarshana, a divine musician, who in youth had been endowed with great splendour and beauty, but then cursed to live the life of a snake for having made fun of a sage long ago. The curse was to be lifted only by the sacred touch of Krishna. This act finally accomplished, and his former self restored, the handsome Sudarshana 'praised the Lord with words overflowing with humility and gratitude' and walked around him admiringly. After a few moments he took his leave and flew heavenwards.

Shankhachura tries to divert the gopis

On yet another occasion, while Krishna and Balarama were roaming in the forest with the *gopas*, Krishna, 'with his left cheek inclined to the joint of his left arm and with dancing eyebrows, applied his flute to his lower lip and began to play on it with his tender fingers placed on its holes'. The *gopis* fell into a trance on hearing this music, unaware even of 'their garments slipping away from their persons and their braids loosening themselves'. At that moment there came into the forest a semi-divine being, a *yaksha* by the name of Shankhachura, who started rounding up the *gopis* to take them 'northwards'. Hearing their sudden cry for help, Krishna and Balarama pursued the *yaksha* and, reaching him, Krishna severed his head 'along with his heavenly diadem', with a blow of his divine fist.

The bull-demon Arishta attempts to take Krishna's life

Some time after this, the fearsome bull-demon, Arishtasura, with a huge body and a big hump 'tearing up and shaking the earth with his hoofs as he came running', arrived in Vraja. He bellowed in a frightening way and when he rushed with his tail upraised, 'mounds of earth were turned up with the end of his horns'. Finding Krishna with the *gopas* and the *gopis* in the forest, he

charged at them. The cattle ran away in terror and everyone called out piteously to Krishna. With a gentle smile playing on his lips, Krishna turned to face the demon. Stroking his arms and provoking the wrath of Arishtasura by clapping his hands, Krishna waited for the bull to charge. Enraged and beside himself with fury, Arishtasura came running at Krishna, 'creating furrows in the earth' and 'keeping his foe in perfect sight within his bloodshot eyes'. But Krishna, catching hold of Arishta by his horns, pushed him back to a distance of eighteen paces, 'as an elephant would do to drive back its rival'. Perspiring and short of breath, Arishta sprang back to his feet with the speed of lightning and dashed at Krishna once again. This time, Krishna seized the demon by the horns and hurled him to the ground. Pressing him down with one foot, he twisted his massive neck 'as one would wring a wet cloth' and, pulling out one of his horns, he struck the demon till he dropped dead. Not a trace of exertion could be seen on the Lord's face.

Narada explains to Kansa the incidents connected with Krishna's birth

Events were now beginning to move rapidly towards the great climactic moment, the entry of Krishna into Kansa's Mathura. One day, the divine sage Narada, *agent provocateur* in many a mythological tale, went to the court of Kansa and told him of the stratagem by which Krishna had been exchanged, soon after his birth, by his father Vasudeva for the daughter of Yashoda. It was he, and his brother Balarama, Narada said, who had killed all the demons dispatched by Kansa. Hearing this, and greatly agitated, Kansa picked up his sword to kill 'the treacherous' Vasudeva. He was restrained with difficulty, and agreed to place Vasudeva and Devaki back into irons inside a dungeon.

Krishna slays the horse-demon Keshi

Kansa began to make feverish attempts at having Krishna killed. Summoning Keshi, one of his most powerful demons to his presence, he gave him the simple order: 'Let Balarama and Krishna be killed by you'. At the same time, calling other ministers and advisers of his, he told them how Krishna and Balarama, the two sons of Vasudeva, had survived in the Vraja of Nanda. And he outlined his plans to lure them to Mathura, where he would have them killed. Meanwhile, he trusted that all this might not even be necessary, for he had implicit faith in the powers of Keshi. Keshi, for his part, assumed the form of a gigantic and powerful horse, 'swift as the mind'. 'Furrowing the earth with his hoofs, and overcrowding the sky with clouds, dispersing the heavenly cars by the waving of his mane, and terrifying all

creatures by his neighing sounds', Keshi headed for Nanda's Vraja. But, while everyone else stood trembling with fear, Krishna challenged Keshi. At this the horse-demon roared, almost with the sound of a lion. His mouth wide open and at hurtling speed, he came rushing at Krishna and kicked him hard with his hind legs. Krishna dodged the kick and angrily caught hold of the horse-demon's hind legs. Then he whirled him around with great contempt to 'a distance of a hundred bows', and stood defiantly as he had done before. Regaining consciousness, Keshi sprang again to his feet and came at Krishna. Smiling and without a hint of fear, Krishna now thrust his left arm in Keshi's open mouth, 'even as a serpent enters in its own hole'. When Keshi tried to bite Krishna's arm, his teeth dropped out because of the great heat that the arm now suddenly came to radiate. At the same time the arm also began to expand inside the mouth of Keshi. With his breath stopped by this ever-swelling arm , Keshi, his eyes rolling, kicked his legs and perspired profusely. But it was to no avail, for Krishna did not let go. Then, 'discharging balls of dung', Keshi fell dead to the ground. At the killing of the mighty Keshi, there were shouts of praise for Krishna from the people and from the gods. Among those who paid homage to Krishna was none other than Narada, the sage, who had come to prepare Krishna for the events that awaited him in Kansa's Mathura.

Kansa's plot to kill Krishna and Balarama; Akrura's mission

In Mathura, elaborate preparations were afoot for a great tournament, at which a vast multitude was to congregate, and which was to begin with a sacrifice connected with a great bow. Kansa took all possible precautions, and issued specific instructions. His two great wrestlers, Mushtika and Chanura, were called and instructed to kill Krishna and Balarama in a trial of strength, should they arrive in the arena. He also asked his keeper of elephants to post the elephant, Kuvalayapida, 'gigantic as a mountain', at the entrance of the arena with a heavy iron bar in his trunk to kill Vasudeva's two sons. Having arranged all this, Kansa summoned to him the noble Akrura, a prominent member of the Yadu clan and, in gentle words, asked him to go to the Vraja of Nanda to fetch the two sons of Vasudeva in his chariot. Kansa told Akrura of the prophecy that his own death was ordained at the hands of one of Vasudeva's sons, and confided in him his plans to protect himself. Then he ordered him to instruct Nanda and others to bring their regular tribute on that day, so that the occasion of the 'sacrifice to the bow' would appear authentic to everyone and not a ruse to lure Krishna and Balarama to Mathura. Akrura, 'a devotee of the lotus-feet of Krishna in his heart', hearing of the plans

62. ...When Keshi tried to bite Krishna's arm, his teeth dropped out... the arm also began to expand inside the mouth of Keshi... *(Miniature, Bikaner mid 18th century, 222×312 mm without borders, Bharat Kala Bhavan, Benares [ref. 10471].)*

63. ...he saw the footprints of the Lord... *(Miniature, Kangra c. 1810, 153×195 mm, Galerie Marco Polo, Paris.)*

that Kansa had made for the Lord's murder, realized what lay ahead and made little protest. Telling Kansa to maintain his equanimity and 'to trust in providence', he agreed to carry out his king's command. Kansa then entered his palace and Akrura went back to his home to prepare for the journey.

On his way to Gokula the next day, the noble Akrura, brimming with devotion for Krishna, wondered at the good fortune of having been trusted with this duty and said to himself: 'I must have performed some very virtuous act in a former birth, the excellence and glory of which have procured me this great advantage that I am going to see Lord Krishna today'. The longing to see Krishna mounting in his heart every moment, Akrura finally reached Gokula and brought his chariot to the door of Nanda. As he alighted, he saw the footprints of the Lord on that sacred earth, and at that sacred sight 'his body thrilled with the excitement of love, his hair stood on end, and his eyes filled with tears'. And then he saw Krishna and Balarama in the enclosure where the cows were milked, one wearing yellow and the other blue, and, unable to contain himself, Akrura fell at their feet. They in turn embraced Akrura as he bowed low before them, and Balarama, offering the homage due to a guest, washed his feet and took him home. Nanda was happy to see the noble Yadava.

That night Akrura slept in the house of Nanda and the next morning, he gave him the message with which he had been charged. On hearing the message, and seeing Kansa's design behind it, Krishna and Balarama laughed, but Nanda set about his business in earnest, asking the cowherds to collect all the cows and other gifts which were to be taken to Mathura in tribute.

Krishna leaves Gokula in spite of the gopis' supplications

There was excitement at what lay ahead, but the *gopis*, hearing that Krishna was about to set out, went into a state of great alarm and agitation. They came rushing from their houses, lamenting and trembling, and surrounded Krishna's chariot. 'Why are you leaving us, O lord of Vraja', they asked. 'What fault towards you have we committed?' They blamed Akrura for snatching their beloved away and said to each other: 'If Govinda departs for Mathura, how will he return to Gokula? His ears will there be regaled with the charming words of the city women. Accustomed to the talk of the graceful females of Mathura, will he ever return to us rustics?' But Krishna told them that he had no option but to go, and their supplications were of no avail. While they remained gazing at Hari's face, 'like doves that have been charmed', tears gushed from their eyes and 'their tresses spread in

disorder over their faces'. Then they saw the chariots beginning to move, and as dust rose from their wheels they quivered 'like fish deprived of water', and fell fainting to the ground.

Akrura's vision: the Lila of the Lord. Krishna reveals his divine nature

On the way, as he was driving Krishna and Balarama in his chariot, Akrura had a vision that both stupefied and delighted him. To take his bath Akrura stopped the chariot for a while, and entered the waters of the Yamuna. This was to turn into a revelation for him. For in the water, he saw the two sons of Vasudeva, whom he had left but a moment ago sitting in the chariot. Quickly, he emerged from the water and looked for them, and, sure enough, they were still in the chariot. To assure himself of this strange happening, Akrura plunged into the water again thinking:'Was my vision of them both in the water unreal?' Then, in that very water, he saw the great serpent Shesha being praised by thousands of divine and semi-divine beings, their heads bent in salutation. And he saw in the waters, on the coils of Shesha, the Supreme Person of Lord Vishnu, 'bluish-dark like a cloud in complexion, clad in yellow silken garments, with four arms, eyes reddish like lotus petals, and wearing a serene and gentle expression'. Deeply moved by this vision and folding his hands in prayer, Akrura began to sing in praise of the Lord. But then, having shown Akrura his great Vishnu form in the waters, Krishna withdrew again, 'even as an actor withdraws after playing his role'. The vision gone, Akrura came out of the water, still dazed by what he had seen. Almost as if to tease him, Krishna asked: 'Did you see something strange either on the earth or in the water, Akruraji? It would appear from your distracted state that you did'. To which Akrura replied: 'Whatever wonders are there on the earth, in the sky, or in the water, exist in you, O Lord, who constitute the whole of the Universe. Take me under your compassionate protection'. Akrura then sat in his chariot and gradually brought Krishna and Balarama to Mathura. Nanda and the cowherds had already arrived by a different route. Once in the town, Krishna alighted from the chariot and asked Akrura to go home, saying: 'From here onwards we shall be on our own'. But he also promised Akrura to visit him in his home after he had slain Kansa, when 'I shall come and bring joy to my friends'.

The day after their arrival, Krishna and Balarama and their friends set out to see the city of Mathura, its copper castle and outskirts embellished with parks and beautiful gardens, its decorated guildhalls for different classes of artisans, and even the houses of common people looking lovely with their auspicious pitchers full of water and

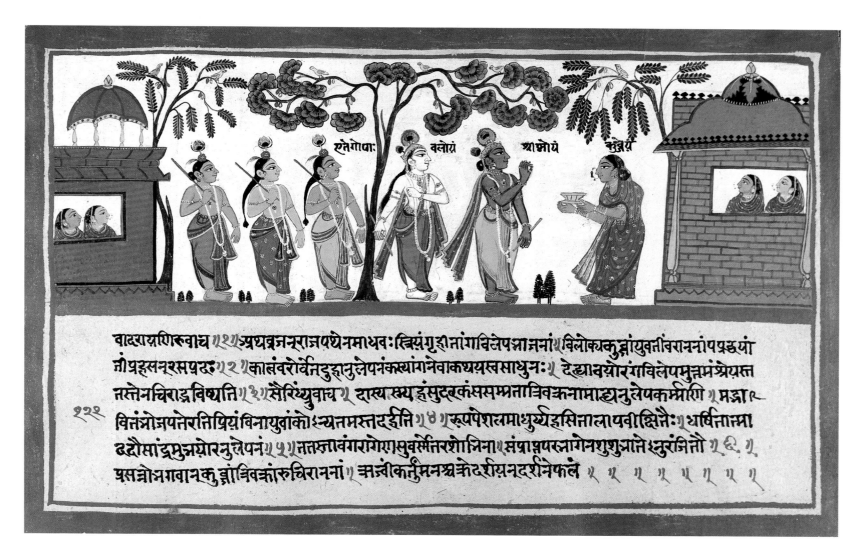

fragrant flowers outside. Wandering through the streets, the two brothers instantly captivated the hearts of the women of Mathura, who hastened from their homes to look at the two handsome youths. But Krishna and Balarama were intent upon other things.

Krishna kills the washerman

On their way to the palace where the great festivities that Kansa had arranged were to take place, they met a washerman. Not being themselves dressed in the fancy clothes that townsmen wore, Krishna and Balarama stopped the washerman and asked him to give them clothes becoming to their status. But this arrogant servant of Kansa scorned their request which enraged Krishna who, with one blow of his hand, severed the head of the washerman from his trunk. The bundles of clothes were now gathered and each member of the party wore what he liked.

Further on, they came to the house of a florist who received them respectfully and, recognizing Krishna and Balarama, loaded them with garlands and gave them flowers to carry in their hands.

Krishna heals the hunch-back Kubja

A little later, Krishna saw a young woman, deformed in body but lovely of countenance, carrying a small brass vessel with sandal paste and other unguents in it. Partly in jest, Krishna smiled and asked her: 'Who are you, O lady of shapely thighs? For whom is this vessel of unguents intended?' The young woman, known as 'Kubja' because of her appearance, used to prepare unguents better than anyone else in that city. Seeing Krishna, she was completely charmed by his beauty, his smiling face, the loving glances he threw in her direction, and liberally gave the unguents to him and his companions. Pleased with her, Krishna decided to render her bodily beautiful and, pressing the front part of her feet with his own feet, he held her chin with two fingers of his own hand, gave her a jerk and made her body perfectly straight. The mere touch of Krishna had turned her into a lovely beauty. Thus endowed with the loveliest of appearances, she felt the passion of love awaken in her and, drawing Krishna by the end of his upper garment, she looked at him invitingly and asked him to come to her home. Krishna merely promised her a visit after his prime object in coming to Mathura had been fulfilled. Then he left Kubja and went along with his companions.

Krishna breaks the bow

Reaching the place of the bow-sacrifice, Krishna entered the outer courtyard and saw that marvellous bow, 'beautiful and large like a rainbow'. Although guarded by

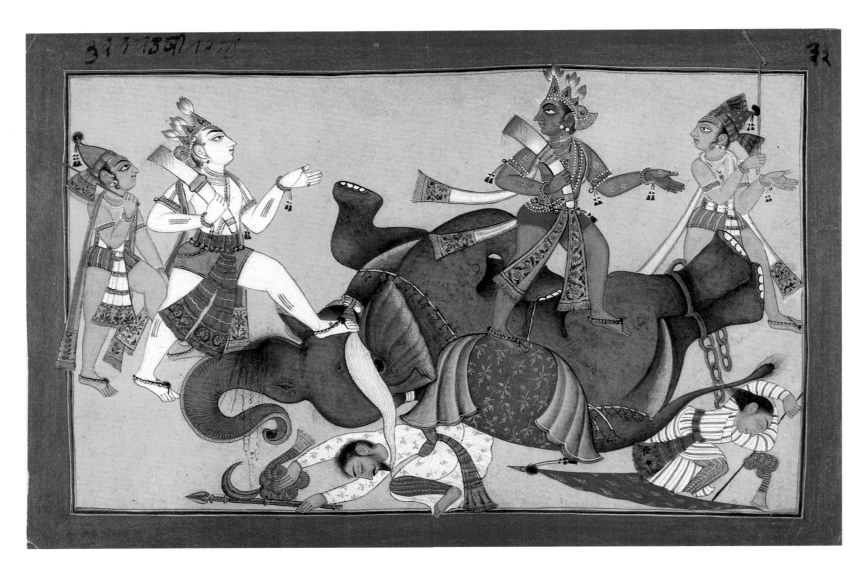

armed men, Krishna quickly reached it and, picking it up with his left hand and fixing its string, stretched it to the full with such power that it snapped into two, 'like a sugar-cane broken by an intoxicated elephant.' The sound of the breaking of the bow filled the sky, and even Kansa, sitting inside his own palace, was seized with terror upon hearing it. The guards, greatly alarmed and enraged, shouted at Krishna and made as if to seize him. But Krishna and Balarama beat them back before returning to their small encampment to rest for a while.

Meanwhile Kansa, struck with panic at the breaking of the bow, was having awesome presentiments. Not able to sleep, nor to stay awake, he saw a series of evil omens. In the water, he could not see the reflection of his head; planets appeared to him as if doubled; his shadow developed holes; he was unable to hear the sound of his own vital breathing when he closed his ears. These were bad portents and frantically Kansa instructed his guards and wrestlers to be vigilant on the fateful next day.

In the morning, the citizens of Mathura and the neighbourhood thronged to the great arena, filling it with their large numbers. They sat on high platforms raised especially for this occasion, while the princes, the ministers and the courtiers occupied high-backed seats. The judges of the games were stationed close to the centre of the circle by Kansa, while he seated himself on a lofty royal throne. Separate platforms had been erected for the ladies of the palace, the courtesans and the wives of the citizens. Nanda and the cowherds also had special places allocated them. At the end of the rows sat Akrura and Vasudeva. An air of anticipation hung over the arena.

The slaying of the mad elephant Kuvalayapida

Krishna and Balarama, walking casually in company with the *gopas*, then arrived at the outer gate. There they beheld the massive elephant, Kuvalayapida 'rut flowing copiously from his temples' under the stern control of his keeper. Tightening the cloth worn around his loins, Krishna ordered the keeper to move the elephant to one side and allow them to enter. But the elephant-keeper had other orders and, instead, he goaded the beast towards Krishna. The elephant came charging in unbridled fury and trumpeting, but Krishna seized his trunk, at the same time being careful not to be caught in its grip. He then concealed himself between his legs and when the enraged animal could not find him, he probed around with his trunk, looking for Krishna. Krishna then came out and, catching Kuvalayapida by his tail, dragged him to a distance of twenty-five bows 'as Garuda would do to a cobra'. Twisting his tail, and thus making the elephant turn from side to side, Krishna finally confronted the elephant and struck him a fierce blow with his bare

hands. Further enraged, the elephant now started pursuing Krishna, at which Krishna once again caught hold of his trunk and, 'like a lion', pressed the fallen elephant down with his foot, and then pried his tusks loose from his mouth. With one of these, dripping blood, he killed the elephant and his keeper and then, giving the other to Balarama, Krishna entered the arena.

The wrestling match

At their entrance, a wave of joy surged through the multitude. Each person present seemed 'to drink of the countenance of the two brothers', agleam with a pure light. At the same time thinking of the tender age of these 'boys' who were pitted against the might of Kansa's great wrestlers Chanura and Mushtika, there was much trepidation and many a heart stood still. Then, with the flourish of the trumpets, all other noise subsided. Chanura advanced towards Krishna and Balarama, taunting them and daring them now to show their prowess. But Krishna stood firm and quiet, waiting to take Chanura on, while Balarama agreed to wrestle with Mushtika. Soon hands and feet were interlocked, 'knee against knee, head against head, chest against chest', and with vehement pulls the wrestlers began to try and overpower each other. They tried all the tricks, 'whirling, squeezing, dashing, punching, advancing and receding'.

There was a hush in the arena and many prayed silently for the safety of the two youths out there. But quickly, 'with the swiftness of a hawk', Krishna rained blows on Chanura, who nearly fainted. Recovering, however, he came again at Krishna, who this time picked Chanura up effortlessly and, whirling him around many times till the life went out of him, he dashed him to the ground, where he lay prostrate, 'his ornaments and garlands scattered and his hair dishevelled', 'like the flagstaff of Indra struck down'. At the other end, Balarama dealt violent blows to Mushtika, who first swooned, and then, vomiting blood profusely, fell on the ground, 'like a tree uprooted by a stormy wind'. There were other, but minor, wrestlers to overpower, but these presented little challenge. And then Krishna and Balarama, inviting their cowherd friends to join them in the arena, began to move around it, their anklets jingling and their light, graceful steps delighting the hearts of the spectators. Kansa, however, was in utter terror and issued a hopeless command to his men to drive 'the two ill-behaved sons of Vasudeva' out of town.

Krishna slays Kansa

Krishna flew into a rage and, with a quick leap, sprang on to the high dais occupied by the evil king. Kansa had not the time even to grasp his sword and shield before Krishna, 'irresistible and the very personification of

कंसवेस

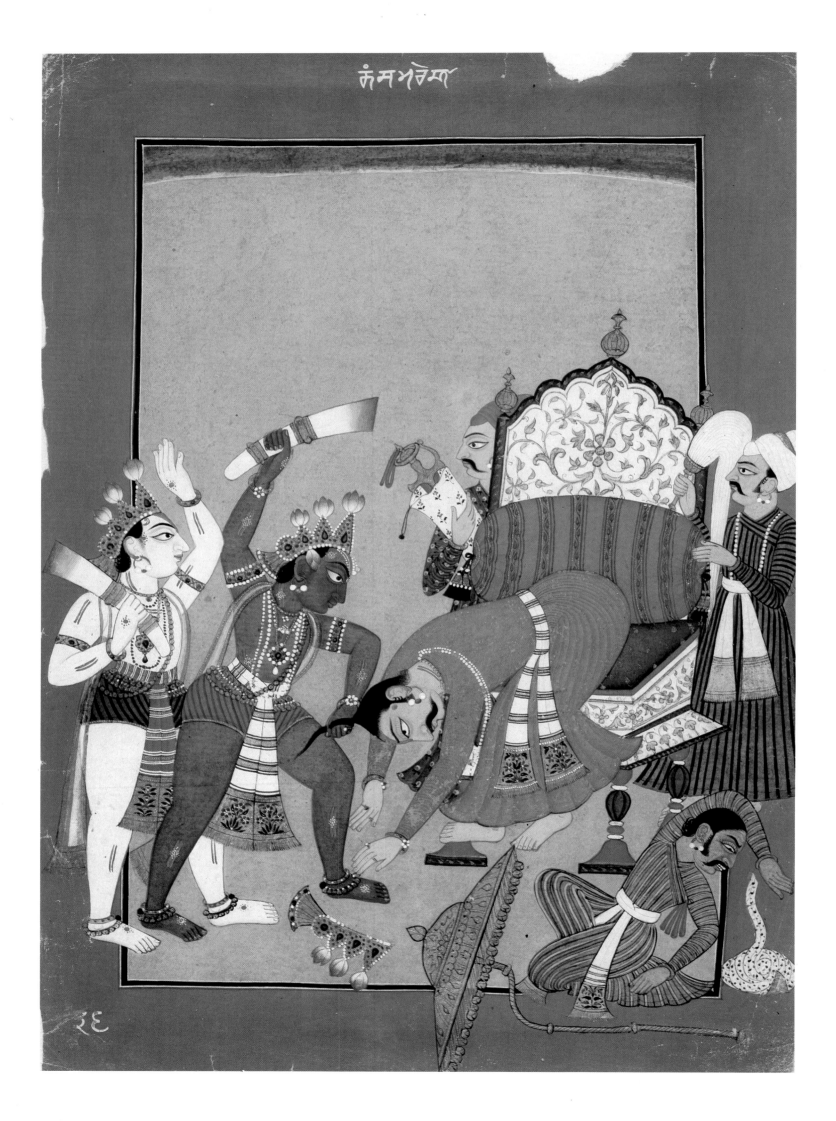

३६

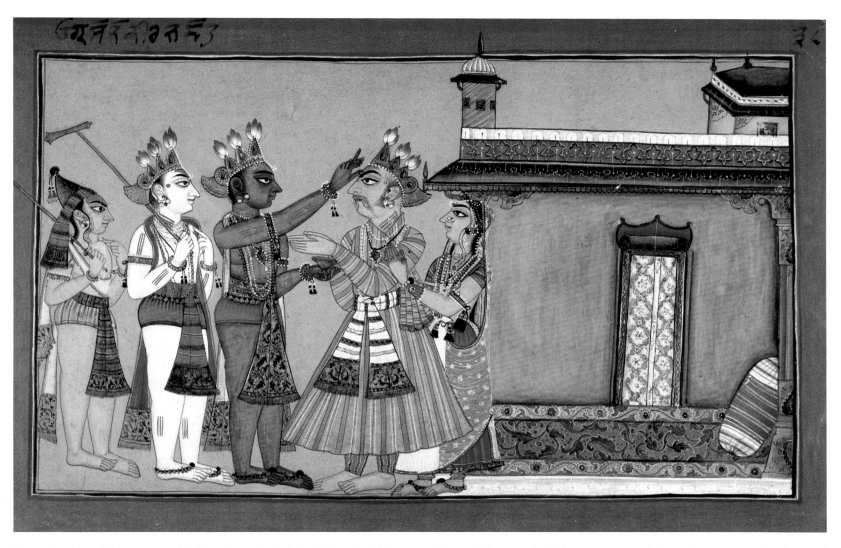

67. ...Knocking off his crown and holding Kansa by his hair, Krishna hurled him from the dais... *(Miniature, Basohli c. 1730, 205×280 mm, Reproduced by Courtesy of the Trustees of the British Museum, London [ref. 1966.7.25].)*

68. ...Krishna installed his maternal grandfather, Ugrasena, on the throne of Mathura... *(Miniature, Mankot c. 1725, 195×304 mm with borders, Chandigarh Govt. Museum [ref. 1300].)*

energy', caught hold of him 'like a falcon swooping down from the sky'. Knocking off Kansa's crown and holding him by his hair, Krishna hurled him from the dais to the floor of the arena and dragged him about, 'like a lion an elephant'. Kansa was now lifeless, and screams of grief and horror from his wives rent the sky. Meanwhile, Balarama dispatched others who rushed at him, and the *gopas*, seizing hold of the kettle-drums, beat on them. There was confusion all around, but also great joy, for tyranny was ended. With the death of Kansa, it seemed as if a burden had been lifted from the earth. 'All the gods and men and sages were delighted.'

Kansa dead, Krishna and Balarama approached their real parents, Vasudeva and Devaki, and, touching their feet with their heads, paid them respect. There was a moment of awkwardness for, suddenly awed by 'the Presence', the two, so long separated from their children, did not embrace them. Sensing their predicament, Krishna cast over them once again 'that curtain of *maya*, which infatuates the world' and he and Balarama appeared to them as nothing but their sons. At this, Vasudeva and Devaki, unable to contain their emotion, eagerly clasped and embraced them, 'their eyes dimming with tears'.

Ugrasena re-installed on the throne of Mathura

The parents freed, Krishna, in consultation with everyone, installed his maternal grandfather Ugrasena on the throne of Mathura. Then, turning to Nanda, and bowing, he asked him to return to Vraja with all his kin, promising to return there 'later' himself. This was a difficult moment. Nanda was paid homage with gifts and overwhelmed with love. But then, realizing the inevitability of the situation, he returned to Vraja.

Krishna and Balarama receive Sandipani's teaching

Thereafter, Vasudeva called the family priest to perform the ceremony of *upanayana*, 'investiture with sacred thread', for his two sons. Gifts were given, sacred *mantras* chanted, and the ritual fully observed. Krishna and Balarama were then placed in the custody of the great teacher Sandipani, who taught them all he knew: the *Vedas*, the *Upanishads*, phonetics, prosody, grammar, astronomy, ritual, etymology. He also instructed them in all the sciences and in the use of weapons of all kinds. Logic, with all its six branches, was placed within their reach, and in a matter of sixty-four days and nights the

69

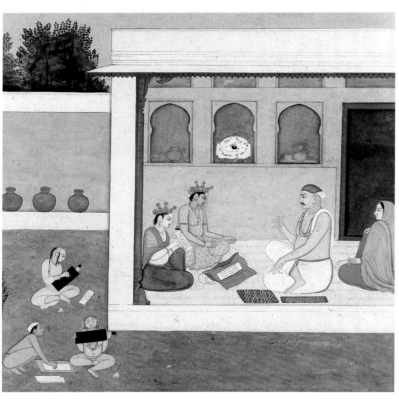

69. ...Krishna and Balarama were placed in the custody of the great teacher Sandipani, who taught them all he knew... *(Miniature, detail, Kangra late 18th century, National Museum, New Delhi [ref. 58.18.25].)*

two brothers, minds unwaveringly fixed on what they were learning, mastered 'all the sixty-four arts and crafts'. At the end of their education, Krishna and Balarama, as was proper, asked their teacher if they could do anything for him in 'payment' of his fee, *gurudakshina*. Sandipani, knowing his two disciples to be of unlimited prowess, spoke of his son who had died in the ocean at Prabhasa, in far away Saurashtra, and asked them to restore his dead son to him if they could. Saying, 'so be it', the two mounted their chariots, arrived at Prabhasa, and waited for the Ocean to pay them his homage.

Krishna slays the demon Panchajana and restores Sandipani's son to life

But, hearing from the Ocean that it was the demon Panchajana who had taken the child away, Krishna plunged into the waters, only to discover that the child had now passed into the possession of Yama, the god of Death. Not to be daunted, Krishna took a conch, 'which was the very body of the demon Panchajana', reached the gates of Yama's kingdom and blew on his conch loudly. Krishna claimed his *guru*'s son from Yama, and he and Balarama brought the child back to Sandipani. The *guru* was pleased and bestowed his benedictions upon them. Afterwards the two brothers returned to Mathura in their wondrous chariot 'which had the speed of the wind'.

70

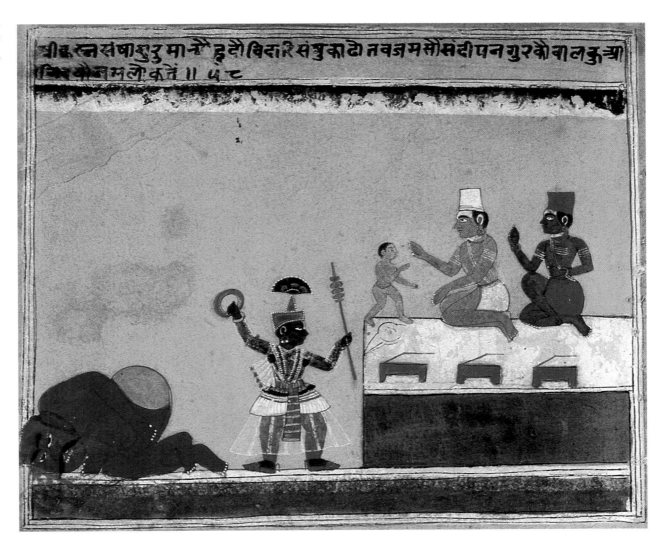

70. Krishna slays the demon Panchajana and restores Sandipani's son to life. (Miniature, Malwa c. 1650, 150 × 180 mm, Collection Colonel R.K. Tandan, Hyderabad.)

श्रीर्त्नसभाःगुरु मान्रै हृदौविदारिसंत्रुकादो तवज्रमसौसदीपनगुरकौबालकुत्रा
जिर्योजमलोकर्त्ते ॥ ५८

Uddhava's mission to Vraja

Although living in the city, Krishna had forgotten neither the scene of his childhood, nor his companions. So he called his trusted friend and devotee, Uddhava, asked him to go to Vraja and carry a message to his parents, Nanda and Yashoda, and to his beloved *gopis*, saying: 'they have entirely devoted their heart and soul to me and they regard me as their very life... Myself, being away at a distant place, the women of Gokula ceaselessly brood over me and, being overwhelmed with deep anxiety and grief caused by separation from me, they have become oblivious to everything else'. Thus, a message had to be taken to them. Accepting the responsibility, Uddhava left the next day for Nanda's Vraja in his chariot. There he saw 'the beautiful grove of Gokula and the habitations of the cowherds, the snow-white calves frisking and capering, and everyone going about attending to sacred duties, honouring the cows and Brahmins, the gods and ancestors'. To Nanda he brought news of Krishna, and as he spoke of him, Nanda and those gathered around him were overwhelmed with longing and admiration. Listening to the description of the most recent exploits of her illustrious and beloved son, Yashoda was filled with pride and her breasts once again overflowed with the milk of motherly love.

Uddhava delivers Krishna's message to the lonesome gopis

Uddhava had not yet confronted the *gopis* who were not even aware of his arrival. At dawn, the next day, the *gopis* 'got up before it was light, lit their lamps, worshipped the presiding deities of their homes and began to churn their curds, appearing resplendent with their jewels, shining, effulgent in the light of the lamps, the rows of their bangles jingling, and the pearl necklaces around their necks moving in a rhythmic motion as they pulled the cords of the curd-vessels'. At sunrise, the *gopis* saw the gold-plated chariot and began to wonder about the identity of the new arrival in the village. They learnt that it was not the 'cruel' Akrura who had taken their beloved Krishna away to Mathura, but Krishna's friend Uddhava. To Uddhava then they hastened to enquire about Krishna. But behind their seemingly simple questions lurked pain and longing, and deep despair. As Uddhava began to answer, their questions gradually began to take either the form of sarcasm, or of overwhelming desire for their absent Lord. Saying to Uddhava that they had been deserted by Krishna, 'like courtesans abandoning penniless lovers' or 'like birds leaving off the trees the fruits of which are exhausted', they insinuated, questioned, and refused to be placated by his words. The *gopis*

then began speaking of their own states, apparently ignoring Uddhava. One of the *gopis*, musing over Krishna, saw a black bee hovering around herself and, treating it as the messenger deputed to her by her beloved, addressed to it, in fact to Uddhava, a long song in skilfully chosen words: 'O Bee! O friend of our roguish lover! Why do you sing here, in front of us, homeless forest-dwellers, the glory of the Most Ancient Person, who is Krishna. That we know only too well. Go hence. Let Krishna, the chief of Madhus, whose messenger you are, curry the favours of the proud ladies of Mathura. Those lady-loves, the agony of whose breasts and hearts is soothed by his embrace and other amorous acts, will bestow on you your desired object, not us'. Or again: 'O gentle black bee! In the same way that you roam from flower to flower, tasting its sweets, and belong not to any particular one, Krishna does not love anyone, or belong to anyone'. She went on in this strain, and Uddhava fathomed the pain of the *gopis*. Finding it hard to console them, he did, however, convey the Lord's message. Krishna was aware, Uddhava told them, that they had 'renounced their sons, husbands, their very persons, and their home to seek refuge with him'. But Krishna asked them to meditate upon him for, he dwells in you 'as ether, air, fire and earth dwell in the body'. But the *gopis* were not easily consoled, and to their question: 'Why has

Krishna not come himself to tell us what meditations to perform', Uddhava had no answer. What he was now saying to them began to sound meaningless even to himself and secretly he envied the *gopis* and the strength of their attachment to their Lord.

In Uddhava's absence, Krishna had fulfilled the two promises he had made soon after his arrival in Mathura. He went to the house of Kubja, whose deformity he had cured. She waited there in her house, having prepared the finest unguents for him, 'equipped with choice articles and decked with garlands of pearls and flowers'. As she saw Krishna coming, she rose from her seat in a flurry and went forward to receive him, nervous and hesitant as she was. But Krishna took her by her hand and 'gave her the pleasure that she longed for'. However, he did not stay long. For he also had to go to the house of Akrura whom he ordered to go to Hastinapura to see the blind king Dhritarashtra and to find out news of the Kauravas and his beloved cousins, the Pandavas.

The mighty king Jarasandha wages war against the Yadavas

Before he could even receive any news from that quarter, much began to happen nearer home. Kansa's two wives were daughters of the mighty Jarasandha, king of Magadha in the east. Immediately upon hearing of

Krishna's killing his son-in-law, Jarasandha swore vengeance and resolved 'to wipe the Yadavas off the face of the earth'. Leading a formidable army, Jarasandha invaded Mathura and besieged it from all sides, mercilessly, his hordes 'surging like a sea overflowing its limits'. But Krishna was not perturbed. He and Balarama armed themselves with celestial weapons and sat in a chariot 'refulgent like the sun', ready to face the enemy and protect their people, the valiant Yadavas. Jarasandha's army fought with great vigour and the outcome of the battle hung in the balance for some time, but then Krishna, twanging his excellent bow, the *sharanga*, discharged volleys of piercing arrows at the enemy's ranks. 'Elephants fell with their temples split', and 'chariots came to a halt' with their warriors killed and their flagstaffs broken. 'Rivers of blood flowed bearing shields and broken swords.' Balarama, with his infinite prowess, mowed his enemies down in countless numbers, and then took Jarasandha captive, 'like a lion powerfully seizing another lion'. Later, however, Jarasandha was released. Penitent and ashamed, he at first announced his decision to retire from the world. But soon he forgot his repentent moments and changed his mind, returning to Magadha, and vowing to take bloody revenge. He attacked the city of Mathura seventeen times in the next years, and each of those seventeen times his attack was repelled.

Kalayavana attacks the Yadavas; The Yadavas move from Mathura to Dvarka

This ceaseless warfare was beginning to take its toll on Mathura and its people and Krishna, in the new role that he was playing, had little time for himself. Upon the heels of Jarasandha's battering invasions came the attack by 'an outsider', Kalayavana, unmatched in the art of war. With an army of 'three hundred million barbarians' he invaded Mathura and laid siege. Realizing the recurring danger to the capital city, Krishna and Balarama held consultations and decided to shift the entire population of Mathura to a far off place. There, 'twelve furlongs from the western ocean', in the city now named Dvarka, they built a fortress 'inaccessible to human beings and capable of being defended against all powers'. The city was laid out with love and care, 'its gold-towered buildings nudging the sky, and its balconies of crystal reflecting everything in sight', and to it all the gods brought sumptuous gifts. But Kalayavana was at the very gates of the fortress in no time, and his armies milled around outside.

Kalayavana's pursuit

Krishna, however, decided to resort to a stratagem to remove the mighty leader of the Yavanas. Without joining battle, Krishna emerged from the fortress, con-

spicuous but unarmed, whereupon Kalayavana recogniz-ed him and went after him in pursuit. Dodging Kala-yavana but leading him on at the same time, Krishna now entered a dark cave where he knew the glorious king Muchukunda to be asleep. Unsuspectingly, the Yavana also entered the cave. There he dimly perceived the form of a man lying asleep on the ground. Naturally assuming that this must be Krishna, he kicked him, at which Muchukunda woke with a start and cast on the intruder an angry glance which instantly reduced the Yavana to ashes. Muchukunda had, in a bygone age, aided the gods against the demons and, completely overcome with fatigue, had solicited just one favour from them: that he be allowed to enjoy a long repose. 'Sleep long and sound-ly' the gods replied, 'and whoever disturbs you shall be instantly burnt to ashes by the fire emanating from your body'. Krishna knew of this favour and had turned it skilfully to his own advantage. Seeing Krishna standing smiling before him, Muchukunda asked him who he was, for he had apparently slept through many ages of time. When Krishna revealed his identity, he 'fell upon his knees and praised the Lord', asking only for emancipa-tion from the cycle of existence which he had received. Krishna went back and, Kalayavana now out of the way, he restored many treasures taken from the enemy's army to the noble Ugrasena in Mathura.

Balarama visits Vrindavana and the gopis and diverts the Yamuna

In the course of his visit to Mathura, Balarama decided to go on his own to see his kinsmen in Vraja, revive old ties and spend some days once again 'surrounded by un-bounded affection'. In Vraja there was great joy at the coming of Balarama. With his *gopa* companions of earlier days he talked long into the night, and they laugh-ed together and spoke of the times they had had in the groves and forests of Gokula and Vrindavana. But the *gopis*, 'still burning in the fire of the pangs of separation' from Krishna, asked Balarama about the new life of Krishna 'with the women of Mathura'. And even as they spoke with anger and jealousy, their hearts brimmed with affection, for he, after all, was 'their Govinda, their Damodara'. Like Uddhava before him, Balarama now delivered to the *gopis* 'agreeable, modest, affectionate and gentle' messages from Krishna. With the *gopas*, however, he fell quickly into the mood of merriment, and rambled with them all over the lands of Vraja.

Once, while in the woods, Balarama saw juices oozing from the trees and smelled the pleasant fragrance of the intoxicating drink 'placed there by the goddess of wine'. Balarama was delighted and, gathering the vineous drops distilled from the *kadamba* tree, drank them with his

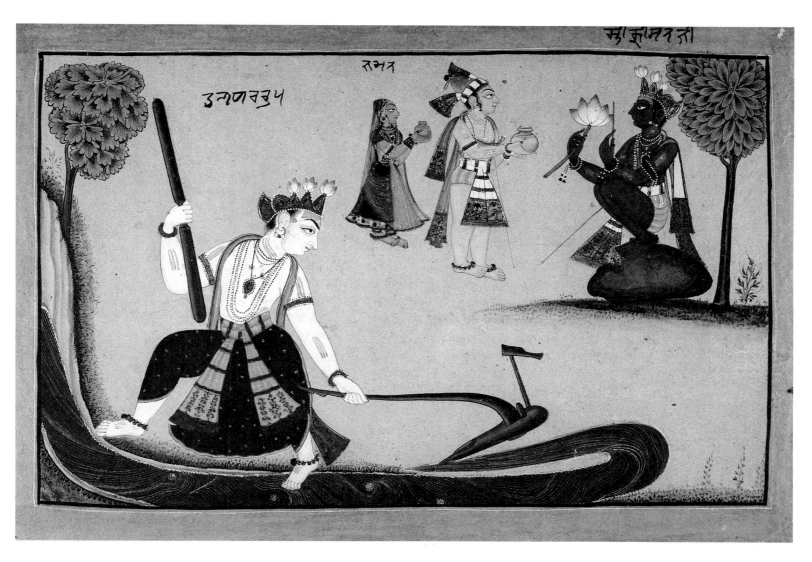

गोपा friends. Now inebriated, with 'drops of perspiration glistening like pearls upon his limbs', Balarama suddenly called out to the river Yamuna: 'Come hither, Yamuna river, I want to bathe'. The river disregarded what she thought were the words of a drunken man, at which Balarama, with the rage that came to him so easily, picked up his ploughshare, plunged it into the bank of the river and dragged her to him, calling out: 'Will you not come, you jade? Will you not come?' Saying this, he resolved to take the river wherever he pleased, 'compelling it to quit its ordinary course and to follow him wherever he wandered through the woods'. The Yamuna was tremulous with fear and, assuming human form, approached Balarama and begged him to pardon her. The great Balarama was appeased with difficulty but he let go of her, though not before he had 'watered the entire country in that region', and bathed in it with his *gopa* friends and the *gopis*.

Preparations for Rukmini's wedding to Shishupala

Meanwhile, in Dvarka, Krishna heard of the coming marriage of the lovely Rukmini, daughter of King Bhishmaka of Kundinapura. Rukmini's brother, Rukmin, had set his mind upon marrying his sister off to Shishupala, the powerful King of the Chedis, who

was 'befriended by valorous allies'. The princess had, however, lost her heart to Krishna, of whose powers and virtues she had heard for long. With her marriage now announced and devoid of all hope, she decided as a last resort to send a trusted Brahmin to Krishna with the urgent message that he come and rescue her if he could. At Dvarka, the Brahmin was ushered into Krishna's presence and received with great affection and respect. He delivered to Krishna Rukmini's letter which said, 'shedding all bashfulness', that her heart 'had entered into the Immortal Lord'. The letter also informed Krishna that Shishupala and the armies of all his allies, including Jarasandha, were hurrying to Kundinapura to attend the royal wedding. Rukmini's message was heard by Krishna with perfect equanimity and, having ascertained from the Brahmin the constellation under which the marriage was to take place, he asked him to go and ask Rukmini to 'banish her sorrows'. In the meantime in Kundinapura, the marriage preparations were in full swing. The city, 'with its streets sprinkled with perfumed water and its gates decorated with banners visible from long distances', was crowded with kings from far away. Krishna and Balarama soon arrived there, ostensibly to participate in the auspicious ceremonies. Hearing of the arrival of Krishna, his enemies among the kings seethed with anger, but the citizens of Kundinapura flocked to see him, 'the

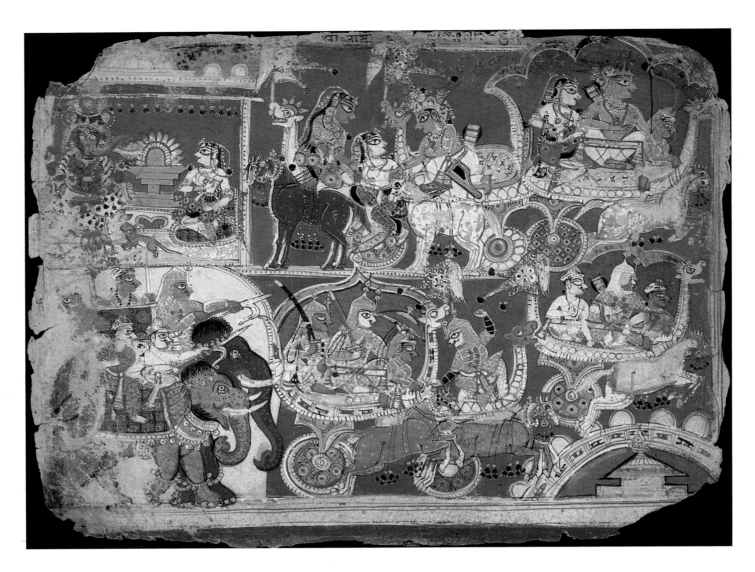

light of the world'. As they saw him, they said among themselves: 'Only Rukmini and no other girl deserves to be his consort'.

Rukmini's abduction

In fulfilment of the initial observances before her marriage, Rukmini set out to offer prayers at the shrine of the goddess Ambika, just outside the town. But as she made her way towards it, guarded by soldiers and accompanied by her friends and maids, her heart was absorbed in thoughts of Krishna. At the temple, while drums sounded and conches blew and songsters sang nuptial songs, Krishna quite suddenly arrived. With the guards looking on, Krishna caught hold of Rukmini's arm and mounted his chariot 'with the ensign of Garuda fluttering above it'. Then, fearlessly, 'like a lion having seized his own share of prey from the midst of a pack of jackals', he set course for Dvarka, leaving to Balarama and his army the task of meeting the armed challenge that was bound to come from Shishupala, denied his bride, and his allies. Hearing the news of the abduction of Rukmini, the many kings, affronted and outraged, mounted their vehicles and gave Krishna a chase but to no avail, for Krishna had got away. The pursuing armies were kept successfully at bay by Balarama. There was a pitched battle, and in a matter of minutes 'the ground became red with the enemies'

blood'. Even the mighty Jarasandha turned back. Only Rukmini's brother, the impetuous Rukmin, caught up with Krishna while he was crossing the river Narmada. A fierce engagement followed, but soon Krishna struck Rukmin's bow down and wounded him with six arrows, cutting all the weapons that Rukmin picked up to use into splinters. Then, jumping down from his chariot, sword in hand, Rukmin rushed at Krishna on foot, but this was like 'a moth dashing at fire'. Krishna cut Rukmin's sword down and was about to kill him when Rukmini pleaded for her brother's life. Krishna let him go, but not before he had disfigured him by shaving his head and moustache.

Krishna's marriage to Rukmini

Krishna reached Dvarka in safety and his nuptials with Rukmini were celebrated with great and joyous ceremonies in the presence of the people of that lovely city, 'the beauty of the scene baffling all'.

The story of Pradyumna, thrown into the sea by the demon Shambara and swallowed by a fish

In the course of time, Rukmini gave birth to the handsome Pradyumna, the very incarnation of Kama, the god of Love. Pradyumna was, however, spirited away by the demon Shambara, who threw the baby into the sea,

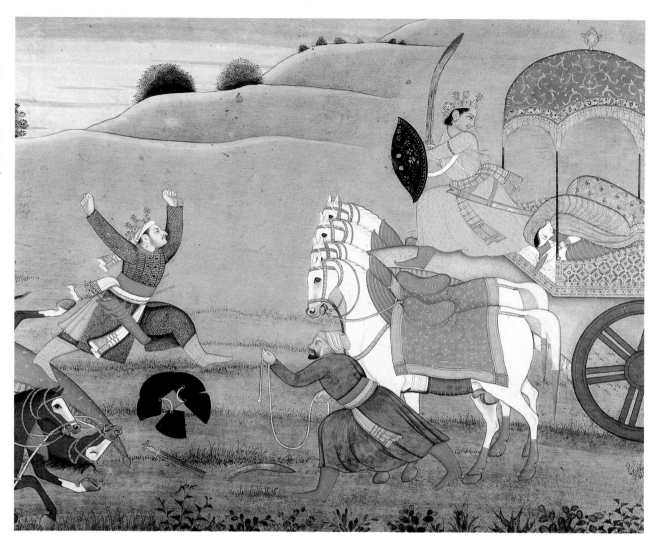

where an enormous fish swallowed him alive. But the fish was caught some days later by some fishermen who took it to the kitchens of the very same Shambara, where, when the fish was cut open, the lovely Pradyumna emerged from it. One of Shambara's wives, Mayavati, who was none other than Kama's spouse Rati in another form, fell in love with him. As Pradyumna grew, Mayavati took fond care of him. Later, Shambara was killed by Pradyumna who, with the assistance of Mayavati, who knew all the arts of magic and *yoga*, flew through the air and landed in Dvarka where he was at once recognized by everyone to be 'another Krishna in form and appearance'. The joy of Krishna and Rukmini knew no bounds.

The Narakasura episode and the demon's death

In Krishna's own career, too, other events lay ahead. One day Indra, 'the lord of the three worlds', came to him complaining of the demon Narakasura at whose hands he had suffered grievously and who inflicted ceaseless injury upon all creatures, carrying off the maidens of the gods and saints and demons and kings, and shutting them up in his own palace. He had also seized the divine umbrella of the god Varuna, 'the jewel mountain crest' of Mandara, even the celestial 'nectar-dripping earrings of Indra's mother', Aditi. Naraka's arrogance was such, Indra said, that he had even demanded his elephant mount,

the Airavata, from him. Hearing this, Krishna rose from his throne and took Indra by the hand in a gesture of reassurance: he had made his mind up to do away with this demon too. Summoning the Garuda-bird, Krishna mounted it and made for Naraka's city of Pragjyotisha. Pragjyotishpur was well defended. On all its sides were 'inaccessible hilly fortifications with missiles and weaponry mounted on them', and deep moats of water making any approach impossible. Fire raged and winds blew on all its sides; 'strong snares had been devised by the architects of Narakasura'. But Krishna, arriving with the speed of a whirlwind, shattered the hills around Pragjyotishpur with his mighty mace and devastated the fortifications with his discus. With a loud blast on his conchshell, he blew down the defensive mechanisms fixed on the ramparts of the fortress and challenged Narakasura. A great battle ensued in which the demon general of Naraka was the first to die, followed by many of his sons. On seeing Krishna seated on the Garuda-bird, 'like a cloud emblazoned with a streak of lightning appearing just above the disc of the sun', Naraka was petrified. When he summoned the power to rush at Krishna, he was slain by the discus and his head, 'still adorned with the earrings of Indra's mother, Aditi', lay rolling on the ground. Gathering these and other objects that belonged to the gods, Krishna then returned. There was great re-

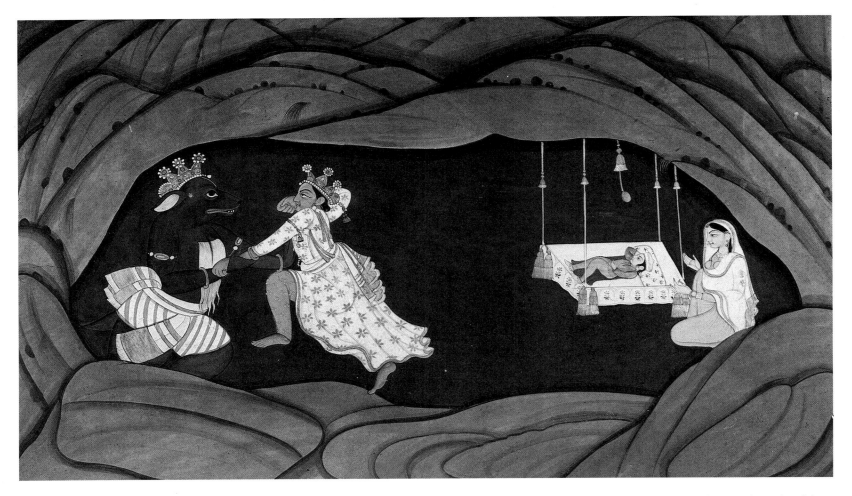

75. ...Krishna found a child playing with the jewel and as he advanced to take it from him, Jambavan rushed at him in rage... *(Miniature, Jammu c. 1785, 308 × 397 mm with borders, Coll. Mr. Michael Archer and Mrs. Margaret Lecombe.)*

76. ...Krishna... uprooting the Parijata tree from Indra's garden, placed it on Garuda's back... *(Miniature, Chamba c. 1720, 210 × 269 mm with borders, Chandigarh Govt. Museum [ref. 1292].)*

joicing on the earth as there was in the heavens, and adoration was offered to Krishna. In the fort of Pragjyotishpur, Krishna found no less than sixteen thousand and one hundred maidens, daughters of kings and gods, held captive for so long by Narakasura. All of them were now released but each sought refuge with Krishna, begging to be taken as his wife. Krishna granted them their desire, and they all returned with him to the city of Dvarka.

Krishna rescues the Syamantaka gem from Jambavan, King of the Bears

Once Krishna became involved in a complicated episode centering round the priceless *syamantaka* jewel, which was in the possession of Satrajit, an intimate friend of the Sun-God. Satrajit used to wear this jewel around his neck, and such was its lustre that hardly anyone could look at it. Krishna knew of this jewel and had once asked Satrajit to present it to Ugrasena, the Yadava king, but Satrajit had refused. As it happened, Satrajit's brother borrowed this jewel one day and went out on a hunt, in the course of which he was killed by a lion. The lion, however, did not have the jewel for long as he was killed by the bear-king Jambavan in a ferocious encounter outside a mountain cave. This Jambavan was none other than the Jambavan who had served Rama, the seventh in-

carnation of Vishnu, with such devotion when he had invaded Lanka. Gaining possession of the jewel, Jambavan took it into his mountain-den and gave it to his son to play with. In the meanwhile, rumors were afloat that it was Krishna who had taken the jewel away. Hearing these, Krishna decided to clear his name of this calumny. He took a host of people with him to look for the jewel, but when they traced their way to the dark mouth of the bear-king's cavern, where the lion had been killed, his companions remained outside, and only Krishna entered. There, in that frighteningly complex cave, Krishna found a child playing with the jewel and as he advanced to take it from him, Jambavan rushed at him in rage. They came at each other ferociously, 'like two hawks fighting for a piece of meat', but even the mighty Jambavan was no match for Krishna. His limbs crushed and his entire body soaked in perspiration, he knew that his opponent could be none other than Vishnu himself. Then, as a devotee and remembering Rama in his heart, Jambavan bowed to Krishna, and sought his grace, offering him at the same time not only the *syamantaka* jewel but also his daughter, Jambavati, in marriage. Taking his two prizes, Krishna came out of the cave only to find that the citizens had returned to Dvarka. They had given him up for lost, for the battle between him and Jambavan had raged for several days. And now, when Krishna arrived at Dvarka

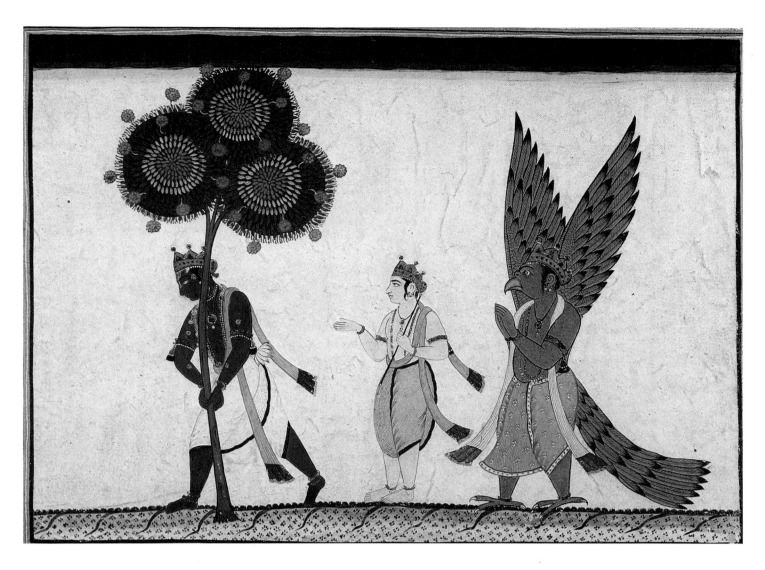

where everyone had been in a state of utter despair, there was great jubilation. Krishna took the jewel to Satrajit and told everyone the whole story of its recovery. Struck by remorse, Satrajit brooded over his sinful act of having imputed vile motives to Krishna. In expiation of his sin, he offered the *syamantaka* gem, as well as his daughter, 'a jewel among women' to Krishna. This was Satyabhama, 'blessed with good disposition, incomparable beauty and many excellent virtues'. Krishna accepted Satyabhama in marriage, but not the jewel, which later went into the hands of Akrura and others.

Krishna visits Indra's heaven and steals the parijata tree

Satyabhama, greatly loved by Krishna, was once the cause of a contest between him and Indra. Among the objects that Krishna had secured from the demon Narakasura were the earrings of Aditi, mother of the gods, and, in order to return them, Krishna went with Satyabhama on the back of the swift Garuda to Indra's heaven. There the divine couple received the blessings of Aditi and the homage of Indra, who received Krishna with great respect, but little attention from Indra's wife, Shachi. Indra conducted Krishna and Satyabhama through the fragrant Nandana grove where the wish fulfilling *parijata* tree, a great favourite of Indra's wife,

grew. It had been in Indra's possession since it had emerged from the Churning of the Ocean, many ages ago. Its 'bark was of gold', and it was 'embellished with young, sprouting leaves of a copper colour and fruit stalks bearing numerous clusters of fragrant fruit'. When Satyabhama saw the tree, she urged Krishna to transport it to Dvarka, pleading that this would be proof of his much-declared love for her. Saying: 'You have often said to me, neither Jambavati nor Rukmini is so dear to me, Satya, as you are', Satyabhama begged Krishna to let this *parijata* tree adorn her mansion in Dvarka, for 'she longed to shine amidst her fellow-queens, wearing the flowers of this tree in the braids of her hair'.

Thus pressed by Satyabhama, Krishna inwardly smiled and, uprooting the *parijata* from Indra's garden, placed it on Garuda's back. At this the keepers of the garden remonstrated, for the tree belonged to Indra's wife and she was deeply attached to it. Indra, hearing of the incident, was greatly agitated and marched at the head of an army of celestials to stop Krishna from taking the tree away. A raging battle ensued which witnessed the strange spectacle of Krishna, the God of gods, killing and maiming other gods. The armies of Indra were soon dispersed 'like cotton-fleece from the pods of the *simul* tree'. Garuda also joined in the battle, using his fearful beak and wings and claws. Indra hurled his great thunderbolt

77. ...A raging battle ensued... *(Miniature, detail, Mughal c. 1590, Victoria and Albert Museum, London [ref. IS.5 1970].)*

78. ...Nikumbha started hostilities again, and after a furious battle Krishna severed his head with his chakra... *(Miniature, Mughal c. 1590, 193 × 350 mm without borders, Victoria and Albert Museum, London [ref. IS 61970].)*

at Krishna, but nothing was able to make an impression on the discus-bearing Lord. The outcome of the battle was soon clear; Indra was humbled. Satyabhama revealed her true purpose, saying that she had felt slighted at not having been received with the respect due to her by Indra's wife, and maintained that she did not really want the *parijata* tree for herself. But Indra insisted that the tree be transferred at least for some time to Dvarka; for it to 'remain upon earth as long as Thou abidest in a world of mortals', he told Krishna. Then Krishna returned in triumph to Dvarka where, at the sound of his conch-shell, the inhabitants of that city were filled with delight. The *parijata* was planted in Satyabhama's garden and 'its smell perfumed the earth for three furlongs and an approach to it enabled everyone to recollect the events of a prior existence'.

Krishna slays Nikumbha

Again Krishna was confronted with powerful demons. One of them, Nikumbha, came to the Brahmin Brahmadatta, a friend of Vasudeva, with the request to partake of the holy oblations of the sacrifice as well as wanting to marry the daughters (500 in number) of Brahmadatta. When the Brahmin refused, Nikumbha destroyed the sacrifice and took away his young daughters. With the help of Pradyumna, Krishna's son,

who created by his magic power five hundred 'false' girls which he left with the *asura* Nikumbha, and took the real ones to Brahmadatta, the situation was saved. The sacrifice started anew; in the meantime Krishna and Aniruddha with their armies had arrived in order to protect it. Nikumbha started the hostilities again, and after a furious battle Krishna severed his head with his *chakra*.

The story of Aniruddha, Krishna's grandson, and Usha, daughter of the demon-king Banasura

Once Krishna's might was pitched against a deity no less than Shiva himself, and this was because of Aniruddha, son of Pradyumna and thus his own grandson. In Shonitpur lived the demon-king Banasura, eldest of the sons of Bali with whom Vishnu had had an encounter in his fifth incarnation as the dwarf. Bana was a great devotee of Shiva and had received so many favours from him that his pride had grown inordinately. Bana had a daughter, Usha, so lovely that 'the full moon hid its diminished rays on beholding the lustre of her countenance'. Usha once dreamt of a prince, divinely handsome, and imagined enjoying herself with him as her consort. However, not knowing the identity of the prince, and naturally abashed at 'the excess' she had committed in her dream, she confided her pain to Chitralekha, her companion, who was

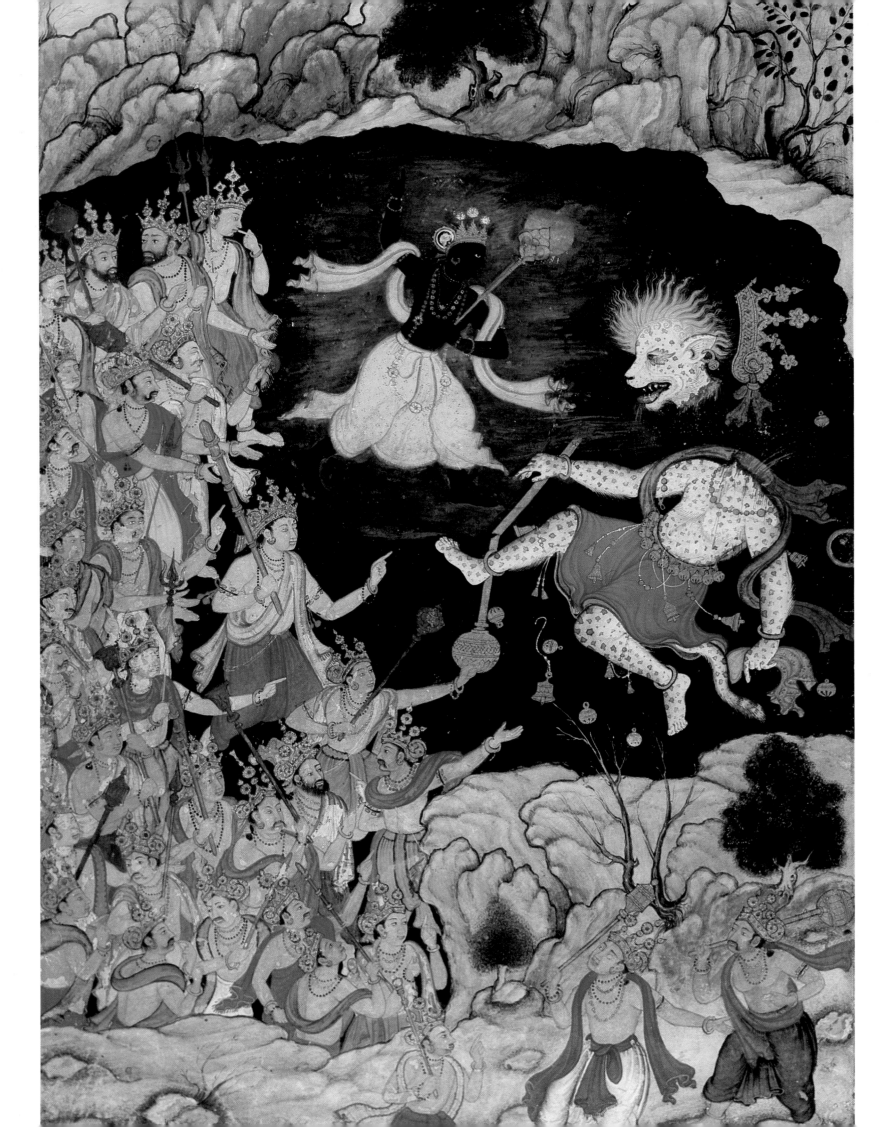

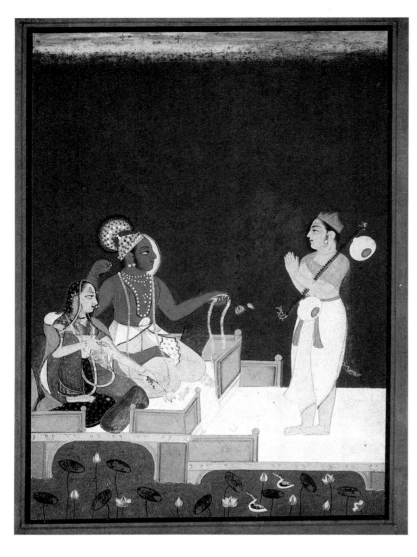

79. ...Narada entered the mansion of Rukmini. There he saw the Lord seated by the side of his divine consort... (Miniature, Bundi c. 1760, 243 × 332 mm, Galerie Marco Polo, Paris.)

possessed of magical powers. Hearing of Usha's dream of an 'unknown man of dark complexion and lotus eyes and long arms', Chitralekha drew portraits of all the gods and *gandharvas*, and kings and princes, to enable Usha to identify the prince that she had seen. As soon as Usha saw Aniruddha's portrait, she cried out: 'It is he, it is he!'. Aware that he was none other than the grandson of Krishna, Chitralekha flew through the air to Dvarka and bore Aniruddha sleeping on his gem-studded bed, to Shonitpur, where he was presented to Usha. Beside herself with joy, but also bashful, Usha woke up this very incarnation of the god of Love, who was greatly astonished at his new surroundings. But his love for Usha was also fervent, and the two engaged in 'long, loving dalliance'. Aniruddha, however, had to stay secretly in Usha's apartments, for fear of Banasura. Many days passed and, Usha's whole 'deportment having changed', her guards became suspicious. They informed Banasura of the many arms who was promptly seized with suspicion and rage, and hurried to discover the truth. Entering Usha's apartments unannounced, he saw her playing at dice with Aniruddha. When Bana saw the signs of love on the bodies of both of them, he ordered that Aniruddha be seized. This was not easy until Banasura himself bound Aniruddha down with his famed *nagapasha*, serpent-cords. Usha was overwhelmed with grief.

Banasura's defeat

Chitralekha carried the news to Krishna. The discomfiture of Aniruddha brought him and Balarama, and the heroic army of the Yadavas, in frenzied haste to Banasura's fortress-kingdom. Seeing his devotee thus threatened, Shiva himself and his numerous followers took the side of Banasura. A great battle ensued. Weapon was hurled against weapon and untold slaughter followed. Finally Krishna 'stupefied' Shiva by hurling a weapon at him that made him 'instantaneously lethargic' and 'forced him to go out of battle'. But Bana's brave resistance continued and only when his thousand arms had been cut off by Krishna's discus, and Krishna had mastered all 'the spirits' unleashed upon the Yadava army, did Bana beg his forgiveness. Krishna's anger was only assuaged when Shiva interceded on behalf of Bana and reminded him of the promise that he had made in the earlier Vishnu-incarnation as Narasinha, to protect forever all the progeny of the best of his devotees, Bana's ancestor, Prahlada. At this, Krishna spared Bana's life and returned to Dvarka with Aniruddha and Usha, whom Bana now gave away as a bride 'according to the injunctions of the Vedas'. There were great celebrations at Dvarka, where Rukmini clasped Usha to her bosom and heard 'songs of congratulations sung for many days'.

Narada visits Krishna in Dvarka and is astonished by his delusive powers

In Dvarka Krishna was leading a happy domestic life. With his numerous wives, he spent his days in great felicity, surrounded by love. Once it occurred to the divine sage Narada to go and see for himself 'the way the Lord carried on his domestic affairs'. Approaching Dvarka, Narada was dazzled by the beauty of the city and of the palaces of Krishna, where 'joy seemed to be diffused throughout. Narada entered the mansion of Rukmini to meet Krishna. There he saw the Lord seated by the side of his divine consort, fanned with a yak-tail fly-whisk with a golden handle, and surrounded by the most beautiful objects imaginable. Seeing Narada enter, Krishna rose from his couch and paid him the respects due to a sage. They conversed for some time, before Narada, bowing to Krishna, took his leave. Then he entered the mansion of Satyabhama where he saw Krishna playing at dice with her. Seeing Narada enter, Krishna rose, offered the sage a comfortable seat and enquired after his welfare, saying: 'When did you come, O worshipful sage?', as if he were not already aware of Narada's arrival. Greatly perplexed, Narada rose without a word and went to the house of yet another wife of Krishna. There he saw Krishna playing with his infant sons. Wherever he went, Narada saw the Lord engaged in different activities. In one house he saw him preparing for his bath, in another offering oblations to the sacrificial fire. He had visions of Krishna who seemed to be everywhere at the same time, worshipping the gods, feeding the Brahmins, attending to horses and elephants, planning a war, holding consultations with his counsellors, listening to auspicious stories from the *Puranas*, sitting alone in meditation. There was 'not a house without Krishna in it'. Seeing the Lord's yogic powers at work, Narada spoke aloud: 'O Lord of *yoga*! Your *maya* is incomprehensible — nay, not even easily recognisable'. At this, Krishna, 'the bestower of happiness' appeared again to Narada and said to him: 'Narada! be not perplexed; my delusive power is mighty and has been spread over the whole world; it fascinates even me.' Then, assured of the Lord's grace, Narada departed.

Krishna's life was filled with joy. He cavorted with his countless wives in their resplendent palaces night after night. Music played and dancers 'equal in beauty to the *apsaras* of heaven' danced. Laughing and playing, Krishna's chest remained constantly smeared with the saffron paste from the breasts of his queens as they embraced him. When the proper season came, Krishna dived into the swimming pools of his mansions, full of crystal-clear water and 'scented with the pollen of full-blown

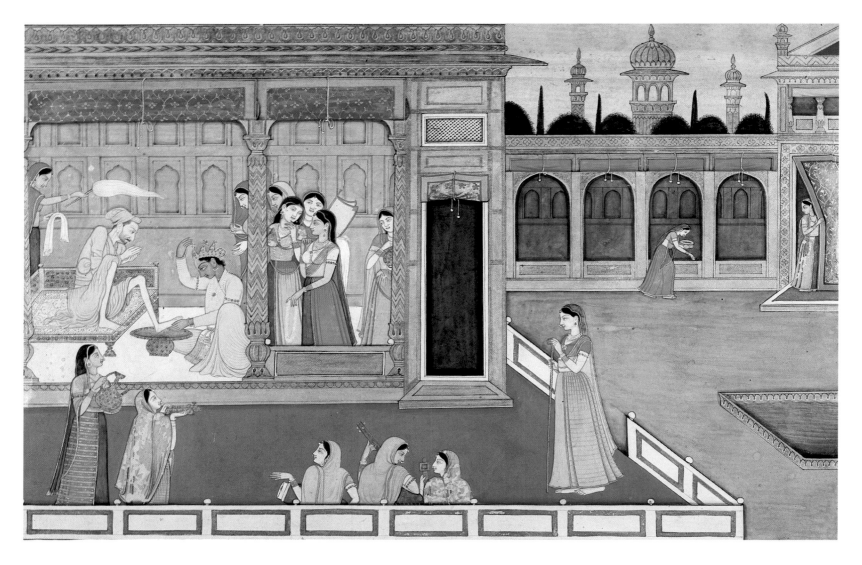

lotuses', and played games in the water. Here he was drenched with jets of water discharged from syringes by his consorts who laughed and teased him but, undeterred, he sprinkled water profusely over them. 'The thighs and the breasts of the queens became prominent to view through the clinging of their wet *saris*', and as they sprinkled water on Krishna, 'they advanced towards him under the pretext of snatching away from him his syringe of coloured water and embraced him'. Passionate desire seemed to permeate the air.

Sudama visits Krishna in Dvarka

But Krishna also had time for his friends, even the poor and the lowliest that approached him. Once his childhood playmate, Sudama, came to him. This Brahmin, 'serene in mind, and possessed of complete control over his senses', led a life of purity but also of great privation. He had married, but had little means to support himself or his wife, with whom he lived in a miserable thatched hut. They did not have enough clothes, nor enough to eat. One day, Sudama's wife asked her husband if he should not visit his childhood friend, Krishna, who, she heard, had become a great king, and possessed unlimited means. Krishna, she said, 'will surely understand our circumstances and bestow upon us a small part of his abundant wealth'. Thus entreated, though naturally reluctant,

Sudama agreed to go and visit Krishna in Dvarka, even if only to have 'the sacred sight of the Lord'. Before he left, however, Sudama's wife gathered 'four handfuls of parched rice', tied them up in a rag, and gave them to him 'as a gift for Krishna'.

With these tucked under his arm, the gentle Sudama set out on his journey to Dvarka, wondering all the while how he would ever be able to get past the doorkeepers and gain entrance to those palaces. But, once there, Sudama had no difficulty at all in reaching the portals of the palace in which Krishna was at that time with Rukmini. Seeing a Brahmin approach from a distance, Krishna instantly rose from his seat and went forth to receive him. Seeing that it was none other than his childhood friend, Sudama, Krishna joyfully embraced him and clasped him to his breast, 'tears of joy pouring forth from his eyes'. He seated Sudama on his own couch, washed his feet, and 'sprinkled his own head with the drops of water in which he had washed them'. Then he made Sudama sit for his meal, fanning him himself with a fly-whisk. Seeing him thus, the queens of Krishna and the attendants 'wondered at what meritorious acts this naked, beggarly Brahmin of emaciated body' must have performed for him to be treated 'as a king'. But Krishna was unaware of all this and held Sudama's hand between his own as they spoke at length of their days together at the

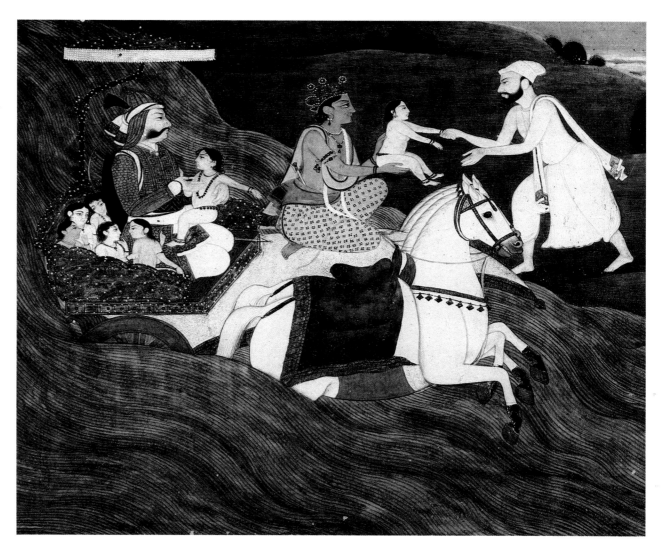

81. ...He seated Sudama on his own couch, washed his feet... (Miniature, Kangra c. 1800, 203 × 295 mm with borders, Chandigarh Govt. Museum [ref. 888].)

82. ...It was at this point that Krishna restored the six sons of Devaki to life... (Miniature, Garhwal c. 1790, Private collection, photographed at Christies, London.)

guru's hermitage. In this manner a great part of the day passed. Then, noticing that Sudama had on his person something tied in a little rag, Krishna asked him playfully 'what delicacies he was carrying'. Finding Sudama shy and embarrassed, he reached out himself, untied the rag with the parched rice, and 'ate handfuls of it with great delight'. Everyone was greatly amazed. Night fell and Sudama was shown to the bedchamber in the palace that was to be his.

The next morning, Sudama took his leave of Krishna, being seen off to some distance by the Lord himself. All this time, however, the poor Brahmin had not had the courage to ask anything of Krishna, and comforted himself with the thought that 'having had the mere sight of Krishna was more than enough'.

So thinking, Sudama reached the place where his homestead was and was exceedingly perplexed. For he did not see his own hut. In its place stood a magnificent palace 'surrounded on all sides by moats, several stories high and resplendent like the sun'. Close to it he saw 'beautiful pleasure gardens and groves swarming with warbling birds'. Countless attendants, men and women, moved about in haste. Not believing his eyes, Sudama stood there wondering. But then his wife saw him from a distance and hastened towards him. Full of love and eagerness, she took Sudama by the hand and led him in-

side that great palace 'whose walls were of pure crystal studded with emeralds and reflected light from which made everything around it shine'. All this had happened as if by miracle, but both Sudama and his wife knew it was Krishna's doing. Without a word being said, Krishna had guessed at Sudama's need, and had attended to it.

The meeting of Krishna and the gopis at Kurukshetra

In the days when Krishna and Balarama were at Dvarka there was a total eclipse of the sun. It was time for everyone to go on a pilgrimage to the sacred site of Kurukshetra to take a bath in the holy waters there at the time of the eclipse. Krishna came to Kurukshetra with multitudes of citizens, all his queens, his wives, his sons and his grandsons. A great Yadava gathering took place there, and everyone took the purificatory bath at the time of the eclipse and gave generous gifts to Brahmins and performed all the other rituals. Hearing of Krishna's presence, 'Rajas from the four quarters with their families and armies' went to Kurukshetra, as did Nanda with all the cowherds and the *gopis*. There they gazed with ecstatic joy at the face of Krishna, and their own acquired a bloom. Everyone embraced everyone else, 'voices choked with emotion, transports of joy coursing through their bodies'. Vasudeva and Devaki met Nanda and Yashoda, with tears in their eyes, and Krishna paid homage to all of

83. Arjuna wins Draupadi's hand by shooting through a revolving fish. *(Stone sculpture, Belur 12th century)*

84. ...Krishna came to the camp of the Pandavas and met the noble Yudhishthira... *(Miniature, Paithan c. 1840, 312 × 470 mm, Collection Dr. F.J. Vollmer.)*

them and received their blessings. The *gopis*, seeing their beloved Krishna, were speechless with joy. And Krishna spoke to them, reminding them of the pleasure they had all together, and of the joys of union. However, he now wished them to know a part of the Eternal Truth. He told them of the deep affection he had for them but also that what he had now to say to them 'was incomprehensible and unfathomable'. Then he said: 'O lovely damsels, just as the elements such as space, air, fire, water and earth constitute the inside and the outside, the beginning and the end of all material objects, I am really the Beginning and the End of all beings, permeating them all from within and without'. With words like these, Krishna initiated the *gopis* into the mysteries of being, and through contemplation of him the *gopis* destroyed the sheath of their subtle bodies and, in time, merged in him.

Krishna restores Devaki and Vasudeva's children to life

It was at this point that Krishna restored the six sons of Devaki to life. All of them were thus released by the curse of Brahma, and after having honoured their parents, Devaki and Vasudeva, they ascended to heaven.

Rivalry between the Kauravas and the Pandavas

Throughout the period of his rule at Dvarka, among Krishna's cares was that of the welfare of the Pandavas,

the five great heroes of the *Mahabharata*, epic story of their war with the Kauravas, their cousins. The connection was through the mother of the three older Pandava brothers, Yudhishthira, Bhima and Arjuna, who was none other than Kunti, sister of Vasudeva, and thus Krishna's aunt. From Mathura and then, later, from Dvarka, Krishna had been sending messengers to enquire after Kunti's welfare, but it was only after some considerable time that he actually met the Pandava brothers. Their father having died, the vast kingdom was in the trust of their uncle, Dhritarashtra, the blind king, but power really lay in the hands of Duryodhana, Dhritarashtra's arrogant and powerful son, and his brothers and confidantes. Duryodhana was feared far and wide. The Pandavas had a legitimate claim to a part of the kingdom, but Duryodhana had viewed them with consuming jealousy since his childhood because they, and particularly the great Arjuna, wielder of the glorious Gandiva bow, had always outstripped him. Duryodhana, therefore, ceaselessly conspired to get rid of them. His attempts were ruthless. Once, a plot to get the Pandavas killed in a fire was frustrated by the timely intervention of a senior relation, Vidura. Several similar adventures befell them, when, finding themselves unwelcome at Dhritarashtra's Hastinapura court, the Pandavas moved from place to place.

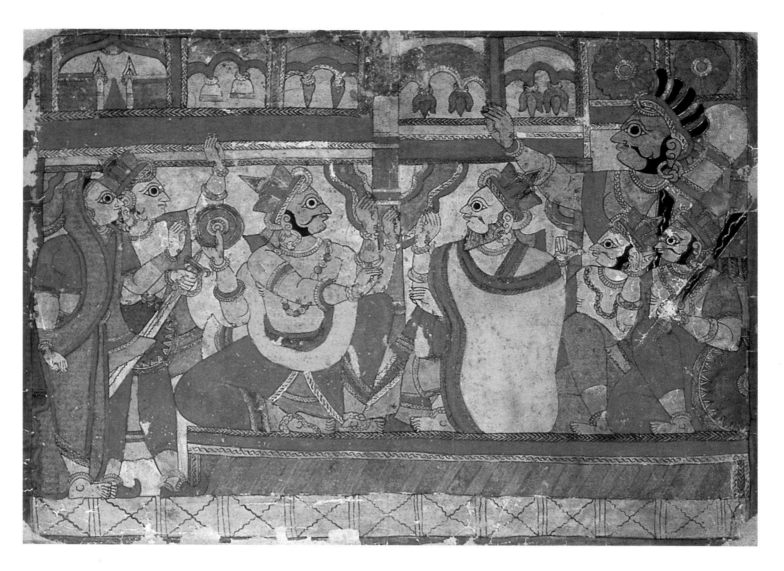

Arjuna wins Draupadi's hand
by shooting down the revolving fish

In the course of their journeys they landed in disguise at the court of King Drupada where, in a most difficult contest, Arjuna performed the feat prescribed as a condition for winning the hand of King Drupada's daughter, the doe-eyed Draupadi. He was the only contender to shoot an arrow through the eye of a fish revolving above him while watching its reflection in a basin filled with water. It was at the court of Drupada where the powerful princes who had gathered to claim Draupadi's hand saw their prize snatched away by someone who looked to them to be a mere Brahmin, that Krishna first saw Bhima and Arjuna. They helped the king to beat back the many princes 'who advanced against him like mad elephants' and, seeing their valour, Krishna guessed that these must indeed be the sons of Kunti. Here in the role of a wise counsellor, a role that he was to play to perfection later, Krishna spoke to everyone, asking the princes to desist, for, as he said, 'the princess had been won fairly'. After this, Krishna came to the camp of the Pandavas and met the noble Yudhisthira, who was overjoyed and made solicitous enquiries after Krishna's welfare, wondering all the time how he had been able to trace them, living as they were in hiding. Krishna smiled and replied: 'O King,

even if a fire is hid, it can be traced. Which other men except the Pandavas can perform such feats?' Then, blessing the Pandava brothers, he took his leave, and went away accompanied by Balarama.

Krishna becomes a close ally of the Pandavas
and marries his sister to Arjuna

In time, he became a close ally of the Pandavas, and their most consistent adviser. Krishna was especially close to Arjuna, with whom his relationship was 'like that of Nara to Narayana', divine sages who were deemed to be jointly an incarnation of Vishnu himself. It was to Arjuna that Krishna gave his sister, Subhadra, in marriage, for Arjuna, in the course of a long pilgrimage, had seen her and fallen ardently in love with her.

The Pandavas shift their capital to Indraprastha

Meanwhile, temporarily at least, things took a slight turn for the better for the Pandavas, for the old Dhritarashtra, under Vidura's advice, agreed to seek a reconciliation with them and to confer upon them a portion of his kingdom. Yudhishthira chose Indraprastha as the seat of his new power, where the building of a magnificent palace was undertaken and preparations were set afoot in connection with the coronation of the eldest of the Pandavas. Naturally Krishna was to be present but, before

that, he had his final encounter with his old foe, Jarasandha, who was still implacable, and still very strong. The miserable plaints of many kings held in captivity by Jarasandha reached Krishna's ears and he was only too inclined to renew the old and outstanding quarrel with Jarasandha. However, the Yadavas were reluctant, for a battle with Jarasandha would have been 'expensive'. Finally a stratagem was thought of: that Jarasandha be lured into single combat. The plan established, Krishna set out for Indraprastha.

Preparations for the rajasuya, the royal consecration

At Indraprastha, Krishna was received with great affection and honour by Yudhishthira and the other Pandava brothers who embraced him and paid him homage. There was 'jubilation in all quarters', and people flocked 'to see the Lord in their midst'. Then, in the presence of all people gathered, Yudhishthira announced that he intended to perform the noblest of sacrifices, the *rajasuya*, and that the highest honour, that of presiding over this sacrifice, was to be Krishna's. Addressing him, Yudhishthira said: 'O Lord Govinda! I intend to adore you and your hallowed part-manifestations at this *rajasuya* sacrifice. May you be pleased to help us in accomplishing this.'

Krishna accepted the honour, telling Yudhishthira that 'his resolution was excellent', for the performance of the *rajasuya* sacrifice would spread the Pandavas' fame 'throughout the three worlds'. It was decided then to send the younger Pandava brothers in all directions 'for the conquest of the cardinal points of the world', as befitted the sacrifice. Krishna himself, Bhima and Arjuna disguised themselves as Brahmins and went to the capital of Magadha, Jarasandha's land.

Bhima's fight with Jarasandha

Jarasandha, always generous, said to 'these Brahmins' that 'they could have from him what they wished'. At this, Krishna said that they were really Kshatriyas who had come to this place to seek a fight. He revealed his identity to Jarasandha and asked him to engage in single combat with Bhima. Jarasandha, proud and confident of his might, took the challenge up lightly and, handing over a huge mace to Bhima and taking another for himself, was ready to begin. Then, going out of town, 'with a level ground as the arena', the two powerful adversaries engaged in a mighty contest. With wheeling manœuvres to the right and the left, and 'lightning-swift attack and defence', the combat became a spectacular event. Maces were hurled and 'their harsh and clanging sound the like of which comes from the clashing of the tusks of two

fighting elephants', filled the sky. Twenty-seven days passed in this combat and there was no clear outcome. Krishna, knowing that Jarasandha could be killed 'only by being torn asunder from the legs', conveyed this little-known secret to Bhima who, the next day, seized Jarasandha by his feet and knocked him to the ground. Then, pressing one foot of the enemy down with his own feet, he tore Jarasandha apart, 'like an elephant splitting a branch of a tree'.

When his people beheld the mighty Jarasandha slain, a great lament arose, but there was also relief, and the captive kings were released in hundreds from the dungeons of Magadha by Krishna, together with the two Pandava brothers.

The royal consecration, rajasuya, is performed

It was time now to return to Indraprastha where preparations for the *rajasuya* sacrifice were now complete. Great gifts had been amassed to be given away in charity and the most learned of Brahmins had been summoned. On the day fixed for the extraction of the *soma* juice, worship was begun by the noble Yudhishthira with a serene mind. Then he reiterated his resolve to offer the highest honour to Krishna, 'the Lord and Protector of the Yadavas'. 'For', Yudhishthira said, 'he is not only all Deities, but also Time and Space.' There was wide

approbation, and Yudhishthira proceeded to wash Krishna's feet as was appropriate. Then, quite suddenly angered by this glorification of Krishna's virtues, Shishupala, who had been robbed earlier of Rukmini's hand when Krishna had eloped with her, stood up, raised his arm and began to speak harshly within the hearing of everyone. 'How is a cowherd', he said, 'considered to be eligible to receive such honour? How can a crow deserve to receive any sacrificial oblation?' Shishupala proceeded with an impassioned indictment of Krishna and poured insult and abuse upon him. 'He does not belong to any class of society', Shishupala said, 'or nobility of birth. He behaved wantonly and is devoid of virtues. How does he deserve worship?'

The slaying of Shishupala

Shishupala's words rang in the assembly. Most of those present closed their ears rather than hear Krishna thus belittled and maligned. But, unable to bear this grossness, the Pandavas sprang to their feet and Shishupala took out his sword. When matters reached this point, Krishna himself stood up and, restraining everyone else, let 'his glorious, sharp-edged discus go forth' and cut the head of Shishupala off. Then, 'as if from a meteor fallen upon the earth' an effulgent light emerged from Shishupala's body and 'entered Krishna's person'. Even for one who had

been steeped in hatred and anger, 'the Lord's touch had meant deliverance from the cycles of birth and rebirth'. After this, the *rajasuya* ceremony proceeded unhampered and when it was over, 'Yudhishthira shone like Indra, the king of gods, in the assembly of all the Brahmins and Kshatriyas gathered there'.

The first game of dice

While everyone else praised Yudhishthira for the glorious *rajasuya* sacrifice, Duryodhana was gnawed by jealousy. He returned to Hastinapura unable to forget either the magnificence he had seen in Indraprastha, or the derisive laughter of some of the Pandavas at his discomfort, during his visit to their palace. The palace had many a skilful deception devised by its architect, and Duryodhana had first mistaken a transparent surface for water, and then fallen into a water cistern which looked 'as if it was only a surface covered with painted lotus-blooms'. Seeing the great Duryodhana caught in these 'traps', the Pandavas, Draupadi in particular, had made fun of him, and Duryodhana swore vengeance. With the aid of his uncle, Shakuni, an expert in the game of dice, he conceived an elaborate plan to humble the Pandavas. He knew Yudhishthira to be fond of gambling, but no match in the game for the wiles of Shakuni who could load the dice and perform other tricks with it. He invited Yudhishthira

to what seemed to be a friendly game, in which, unable to restrain himself, Yudhishthira staked almost everything he had and lost it in game after game played in the thousand-pillared hall Duryodhana had had especially built. Not only did Yudhishthira lose his kingdom and all his wealth; he even staked and lost his brothers and himself and, finally the slender-waisted Draupadi.

Draupadi's offence

This was the moment of sweet revenge that Duryodhana had waited for. For heaping the ultimate insult on the Pandava brothers, who now sat downcast, he asked Duhshasana to seize Draupadi and bring her 'within everyone's sight', at the same time baring his thigh. Then, having dragged Draupadi by her hair to the hall, he proceeded to undress her as the elders sat in stunned silence. Soon, there were loud cries of protest, but not a word from the Pandavas who, having lost, had forfeited all right to object. As they saw Duhshasana pull at Draupadi's clothes, they clenched their teeth and bit their lips. Crying, Draupadi, who had never before been seen in public except once in the *svayamvara* arena, called out aloud, asking 'the dark-bodied Lord', who was nowhere near, to come to her aid in this hour of trial. Her words echoed in the hall and, suddenly, a miracle took place.

90

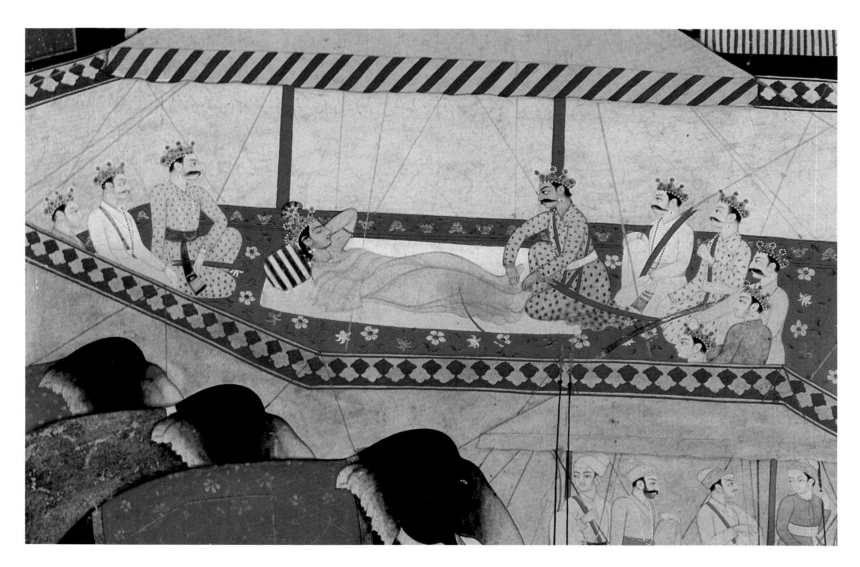

The *sari* that she was wearing became longer and longer. Everyone was amazed, for the end of the *sari* seemed not to be in sight, and masses of cloth were heaped in the midst of the assembly. Divinely, Krishna had intervened. Finally Duhshasana, tired and abashed, gave up his sinister effort and sat down. But before the drama ended, Bhima, the mighty mace-bearer, made a vow that he would one day break the very thigh that Duryodhana had indecently bared as Draupadi was dragged into the hall.

The second game of dice, resulting in the Pandavas' exile

Things had taken the worst possible turn for the Pandavas. They were let go but, playing upon his weakness, Duryodhana invited Yudhishthira for yet another game of dice and won. The wager was that the losers spend twelve years in exile and an additional year 'in hiding'. The Pandavas thus took off their royal clothes and, 'wearing garments of deer skin' made for the forests. Their sole friend in the days that lay ahead seemed to be Krishna. In the years that followed, many adventures befell the Pandavas but they survived the period of exile. At the end of it, there was a mood of jubilation, for it was now time for the Pandavas to return to Hastinapura and demand their kingdom back from Duryodhana.

Preparations for the Great War; Krishna's mediation

In Krishna's presence, plans were formed. The newly-won friends of the Pandavas, convinced that Duryodhana would not restore their rights, pleaded that preparations for the war be made and allies sought. Others favoured sending a peaceful embassy to Duryodhana. Krishna, with his usual sagacity, advised that both courses be adopted. 'If the Kaurava leader agrees to a just peace', Krishna said, 'there will be no harm done to the fraternal feeling between the Kauravas and the Pandavas. If, however, impelled by pride and folly, Duryodhana should refuse, then summon your other allies and us too'.

Duryodhana and Arjuna seek Krishna's help for the Great War

These were times of great excitement and war on an unprecedented scale seemed to hang in the air. Both sides began consolidating old alliances and forming new ones. Duryodhana went to Dvarka to win Krishna over as an ally. On the very same day Arjuna arrived, on behalf of the Pandavas, to ask formally for his help. The two entered Krishna's palace at the same time and found him asleep. Deciding to wait, Duryodhana sat 'on a fine seat near Krishna's head'; Arjuna, with his hands respectfully

folded, stood near Krishna's feet waiting 'for the Lord to wake up'. When Krishna woke, he naturally saw Arjuna first and Duryodhana afterwards. When he learnt from them the reason for their visit, 'after he had done them due honours as a king', Krishna said that since he had set eyes on Arjuna first, he should first hear him. But since both of them had come seeking aid, Krishna also said that he would give them a choice: either take his army of ten million *gopas* or Krishna himself 'alone, unarmed and non-combatant'. The first choice was to go to Arjuna who, without the slightest hesitation, begged that Krishna be with them. Duryodhana took the whole of Krishna's army, 'being well pleased with getting thousands upon thousands of warriors'. When Duryodhana had departed, Krishna asked Arjuna: 'Why have you chosen me, O son of Kunti, knowing that I shall not take any part in the battle?' Arjuna smiled, and said: 'I have always yearned to have you as my charioteer, and it behoves you to fulfill this long-felt desire of mine, Lord'. He was referring to more than Krishna literally driving the chariot in which Arjuna was to ride; it was guidance in action and thought that he wanted.

Krishna's embassy to the Kaurava Court

Soon it was time for a mission to go to the court of the Kauravas and Krishna himself went as the Pandava's emissary. He was hopeful. There was a tumultuous welcome for him in the city of Hastinapura where people gathered to see 'the lotus-eyed hero enter the ash-coloured palace of Dhritarashtra'. But the atmosphere inside the court was different. There, having been received and seated in the vast assemblage, and when all was still, Krishna said, in a voice with the depth of a drum-beat: 'I have come so that there may obtain peace between the Kauravas and the Pandavas, without slaughter of heroes on either side'. Then, addressing Dhritarashtra, Krishna spoke wise and conciliatory words. Reminding him that his sons had acted impiously and deceitfully, 'putting behind them all considerations of morality and earthly good', he said: 'Restore to the Pandavas their due share of the ancestral kingdom, and enjoy the blessings of life along with your sons. As for me, O Bharata, I desire your welfare as much as that of the others'. But Dhritarashtra was unable to restrain his impetuous son, Duryodhana, from speaking rudely to Krishna, and saying that the Pandavas would not get back from the Kauravas 'even that much land as is covered by the point of a needle'. Losing his temper, Krishna, his eyes red with anger, said to Duryodhana: 'It is your desire to get the death of a hero, and it shall be fulfilled'. A tense silence fell upon the court. Then Duryodhana, who had conspired to seize Krishna if matters took an unfavourable turn, made a

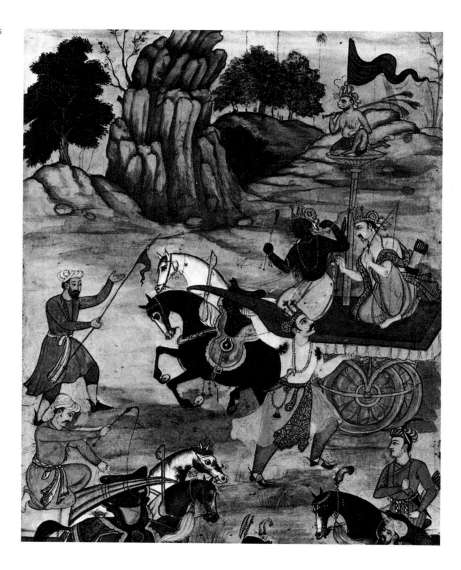

sudden move towards him. At this Krishna laughed aloud, 'and at this laughter the body of the Great Souled One became like lightning'. A celestial form stood in that assembly at which each man looked with awe. Not a soul could move. Then, taking his companions from the Pandava camp by the hand, Krishna went out as he had come into that assembly hall, unharmed.

The issues were now clear, and only one course lay open. With the failure of Krishna's mission began a speedy raising of soldiers and chariots and horses and elephants. 'The sky was filled with the noise caused by the blaring of the conches, and the sound of the drums of the armies as they approached', the mobilisation causing 'a roar like that of the sea at high tide'. The Pandavas had forty thousand chariots, five times that number of horses, ten times that number of foot soldiers, and sixty thousand elephants'. Among them were 'great and valiant fighters, kings of tremendous renown and warriors of unparalleled strength'. The Kauravas commanded a vast army of eleven *akshauhinis* and Duryodhana surveyed his forces with justifiable pride, for, ranged on his side were the noblest of warriors, the great Bhishma, 'grandfather' of the Kauravas as well as the Pandavas, and the invincible Drona and Karna and others. The smell of fierce massacre hung in the air. The great fratricidal *Mahabharata* war was about to begin.

The Great War; The Bhagavadgita; Krishna as Arjuna's charioteer

On the first day, the massive armies stationed on either side and the air filled with the tumultuous sound of conches and kettle-drums and horns. On the side of the Pandavas the mighty Arjuna stood in his great chariot yoked to white horses, with Krishna as his charioteer. All was ready for the action to begin when, suddenly, looking at the sons of Dhritarashtra drawn up in battle order on the other side, and seeing among the Kauravas the noble Bhishma, Dronacharya, the *guru* of them all, and others, 'fathers and grandfathers, teachers, uncles, brothers, sons, grandsons and companions', Arjuna was overcome with great compassion. He spoke in tones of deep sadness: 'When I see my own people arrayed and eager for a fight, O Krishna, my limbs quail, my mouth goes dry, my body shakes and my hair stands on end'. His bow began to slip out of his trembling hand and he felt his skin burning all over. 'I am not able to stand steady, Lord! My mind is reeling'.

Krishna's sermon to Arjuna

It was at this moment that Krishna delivered to Arjuna that great sermon on the field of battle known as the *Bhagavadgita*. Seeing the 'delusion' into which Arjuna

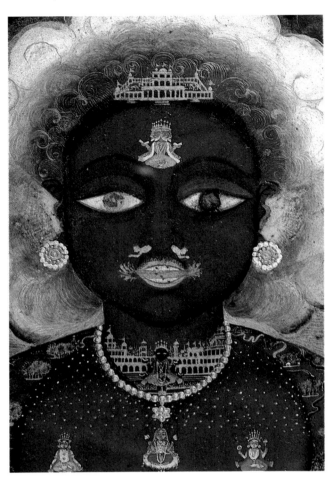

had fallen, Krishna began his speech and, with supreme eloquence, in words that are beautiful and vital, he expounded the nature of action and inaction, the purpose and meaning of life, the eternal and the transitory aspects of the Self. He spoke to him of the human being's relation to God, and of the road to salvation. The dialogue was long and complex, with Krishna as the principal speaker. Penetrating questions were asked and clear, penetrating answers provided.

In words that contained 'both metaphysics and ethics', 'the science of reality and the art of union with reality', Krishna spoke to Arjuna of more than one path to the attainment of God: that of meditation and contemplation, that of knowledge, and that of selfless action. But he also spoke to Arjuna of the path of devotion towards a God that was not remote and uncaring, but personal, attentive and accessible.

Krishna reveals his universal form as Vishvarupa

Since Krishna spoke of himself as the Supreme Spirit, Arjuna humbly asked him to reveal himself. Whereupon, with the divine sight granted to him especially for this purpose, Arjuna saw Krishna in his divine form. 'Behold now the entire Universe with everything moving and not moving', said Krishna, 'here standing together in my body'. Arjuna saw that majestic vision, the great manifestation of Krishna as the Supreme Spirit. Arjuna spoke ecstatically now:

> If there should be in the sky
> a thousand suns risen all at once
> such splendour would be of the splendour of Thy
> great Being
> ... I see Thee everywhere, infinite in form;
> not the end, nor the middle, nor yet the beginning of Thee
> I see, O Lord of all, whose form is the Universe.
> Crowned, armed with a club and bearing a discus
> a mass of splendour, shining on all sides,
> with the immeasurable radiance of the sun and blazing
> fire...

Arjuna fell upon his knees, saying:

> Thou art the unchanging, the Supreme Object of
> knowledge;
> Thou art the ultimate resting place of all;
> Thou art the imperishable Defender of the eternal law;
> Thou art the Primeval Spirit.

Then, before Arjuna's eyes, the vision turned even more terrifying, for Krishna revealed himself to Arjuna as Time, the mighty cause of world destruction, 'here come forth to annihilate the worlds'. 'Even without any action of thine', Krishna said to Arjuna, 'all these warriors who are arrayed in the opposing ranks, shall cease to exist'. Led through truths like this and greatly fortified in spirit, 'with the scales fallen from his eyes', Arjuna picked up his mighty bow, the Gandiva, once again, and was ready for

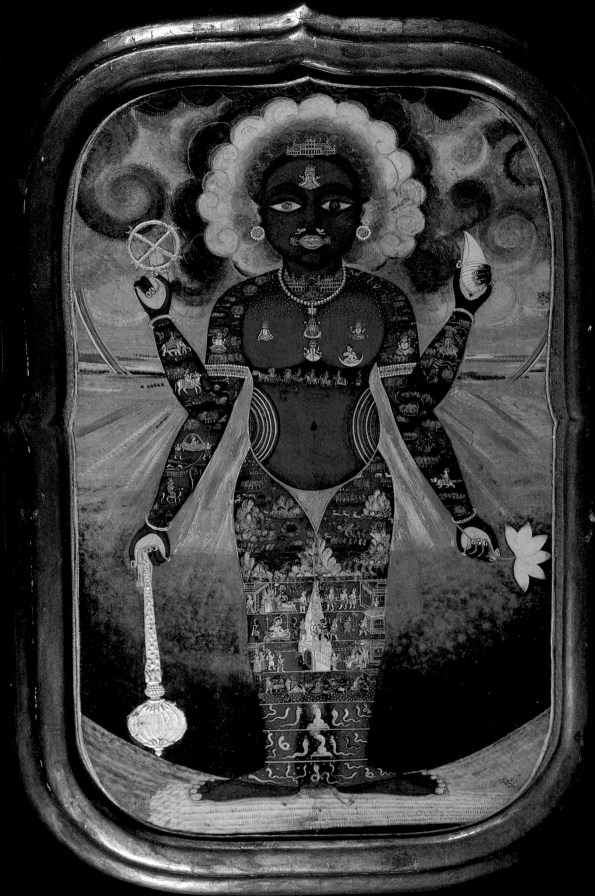

91. …So began the great battle that raged for eighteen relentless days… (*Miniature, Kangra c. 1820, 280 × 398 mm, Collection Mr. Bornan, Marseille.*)

92. ...The carnage that ensued was unprecedented... *(Stone sculpture, Halebid 12th century)*

action. So began the great battle that raged for eighteen relentless days.

The carnage that ensued was unprecedented. From day to day fortunes changed, and the outcome of the battle hung in the balance. At every step the Pandavas sought Krishna's advice; it was he who extricated them from crises. Krishna took no part in the battle himself, for he was to be on the side of the Pandavas 'unarmed, non-combatant', as he had declared earlier.

Bhishma faces Krishna in battle

Only once was he driven to such wrath that he removed the wheel of a chariot and picked it up in his hands 'like a discus' to hurl at Bhishma. But then his anger subsided, seeing that Arjuna had taken up the battle in earnest. When Arjuna's son was killed treacherously by a combination of Kauravas, and Arjuna set out to settle the score with his killer, Brihadratha, it was Krishna who warned him against acting rashly. For he knew that 'he who makes Brihadratha's head fall upon the earth', was liable to have his own head miraculously 'split into a hundred pieces'. Arjuna cut Brihadratha's head off, but escaped the fearful fate himself. Again, when the great *guru*, Dronacharya, wrought havoc among the Pandavas' forces, it was Krishna who encouraged Yudhishthira, the 'very son of Righteousness', to tell a half-lie by announc-ing aloud that Ashvatthama, a name that Drona's son shared with an elephant, 'had been killed'. It was this that made Drona lose heart and lay down his arms, only to be killed by a Pandava hero.

Were it not for Krishna's timely intervention, things might have gone wrong for the Pandavas, the eventual victors. But then he was with them 'heart and soul', as he had declared. His role was questioned; he was even reproached by Duryodhana as he lay dying after a duel with the mighty Bhima who had struck him an unfair blow, but Krishna explained things in terms of a different morality. To a sage, who later accused him, he simply said: 'In every cycle of ages, I have to repair the causeway of virtue, and I am born in diverse forms, out of my desire to do good to my creatures. When I am born among the celestials, I act like a celestial. When I am born among the *Gandharvas*, I act in every respect like a *Gandharva*. Since I am now born in the order of men, I appealed to the Kauravas as a human being'. But they were unrighteous men, he said, who had acted in bad faith from the moment that the Pandavas laid claim to their share of kingdom.

Bhishma's death

But now the great war was over. Even the noble Bhishma who, from his 'bed of arrows', instructed Yudhishthira in

93. …he removed the wheel of a chariot and picked it up in his hands like a discus to hurl it at Bhishma… *(Miniature, Kangra c. 1830, 200 × 300 mm without borders, Bharat Kala Bhavan, Benares.)*

the arts of peace and bowed to Krishna, the Supreme Person, gave up his life. Hundreds of thousands of warriors lay dead on the field. The sky was rent with the lamentations of widows, and crows and vultures wheeled about in the heavens above. Then Krishna led the Pandavas back to Hastinapura to pay respects to the old, blind king Dhritarashtra and his faithful wife, Gandhari, whose hundred sons lay dead on the field of battle. Facing the old couple was no easy task, but eventually Dhritarashtra reconciled himself to the outcome.

Gandhari's curse on Krishna and the Yadavas

Gandhari, however, was not easily consoled and, turning squarely towards Krishna, she pronounced a curse upon him: 'Since you remained indifferent while the Kauravas and the Pandavas slew each other', Gandhari said in ringing tones, 'you, O Krishna, shall be the slayer of your own kinsmen. Thirty-six years hence you shall, after causing the death of your kinsmen, friends and sons, perish by ignoble means in the wilderness'. Everyone was struck speechless with fear and amazement.

A certain weariness may have already begun to overtake Krishna. And at the time pronounced by Gandhari, many years later, he 'engineered the destruction' of his own people, the Yadavas. At that juncture, events became complicated but the die was cast.

94. …the noble Bhishma… from his bed of arrows instructed Yudhishthira in the arts of peace and bowed to Krishna… *(Miniature, Mughal 1598, 142 × 243 mm, Reproduced by Courtesy of the Trustees of the British Museum, London [ref. 1930.7.1601].)*

99

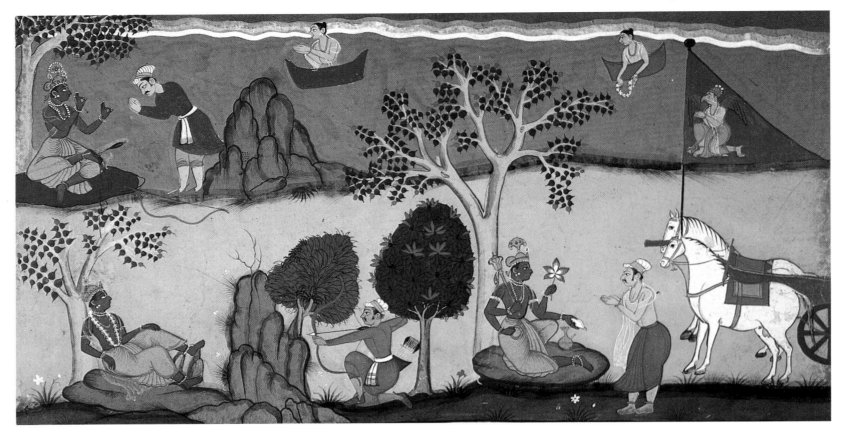

95. ...the hunter named Jara... seeing the foot of Krishna from a distance... mistook it for a deer and shot an arrow which lodged in the sole of the foot...
(Miniature, detail, Mewar 1648, American Committee for South Asian Art.)

The episode of the youth Shamba, Narada's curse and the birth of the iron club

Some boys of the Yadu tribe, full of arrogance and youthful enthusiasm, once insulted three great sages, including Narada. One of them dressed and adorned Shamba as a damsel and, conducting 'her' to the sages, asked them to predict what child, male or female, this woman was going to bear. The sages, possessed of divine wisdom, became angry at thus being slighted by the boys' joke. Cursing them, they said: 'She will bring forth a club that shall crush the whole of the Yadava race'. The boys, greatly alarmed at the sages' curse, went and related all that had occurred to Ugrasena, but, as foretold, an iron club emerged from the belly of Shamba. Fearful for his people, Ugrasena had the club ground to dust and scattered. But the particles of its iron-dust turned into rushes and grew everywhere. One part of the club, 'like the blade of a lance', could not be broken, and was thrown into the sea where, having been swallowed by a fish which was later caught, it was taken from the fish's abdomen by a hunter named Jara and thus survived.

The gods ask Krishna to return to heaven

During this time, a messenger from the gods came to Krishna as he sat alone. He bowed to him with great reverence and said: ' I am sent to you, O Lord, by the deities, and do Thou hear what Indra, together with the *Vishvas, Maruts, Adityas, Sadhyas* and *Rudras* respectfully represents: more than a hundred years have elapsed since Thou, as a favour to the gods, hast descended upon earth, for the purpose of relieving it of its load. The demons have been slain and the burden of earth has been removed: now let the Immortals once again behold their monarch in heaven'. To this Krishna replied that 'he had heard all, and was aware of it'. Then he told the messenger of the gods that 'the destruction of the Yadavas was already commenced; and when they were destroyed, he would 'wind this descent of his unto earth up'. This would come to pass 'in seven nights'.

The pilgrimage to Prabhasa; the Yadavas' drunkenness and their extermination

Soon, 'the lotus-eyed Lord beheld evil signs and portents', both on earth and heaven, foretelling the coming ruin of Dvarka. Pointing these out to the Yadavas, he urged them to hasten to Prabhasa on a pilgrimage, asking Uddhava to go alone to a holy place in the mountains. The Yadavas then mounted their swift chariots and drove to Prabhasa with Krishna, Balarama and the rest of their chiefs. There they bathed and drank liquor. As they did

96. Krishna's wives commit sati. *(Miniature, detail, Mewar 1648, American Committee for South Asian Art.)*

so, among them were kindled 'the destructive flames of dissension', flames that were 'fed with the fuel of abuse'. Infuriated, they fell upon each other with weapons, and when their weapons were expended, they used the lethal rushes that grew there. These rushes, having sprung from the dust of the club cursed by the sages, became 'like thunderbolts in their hands'. They struck one another fatal blows and even Krishna could not succeed in stopping them. Enraged, even he rushed to destroy them and slew many of the Yadavas who had now turned murderous. In a short time there was 'not a single Yadava left'.

The only survivors were Krishna, Balarama and the charioteer of Krishna with his swift steeds. Even Krishna's mighty emblems, the discus, the mace, the conch-shell, 'now circumambulated their Lord and flew heavenwards'.

The death of Balarama and of Krishna, and the submersion of Dvarka

Krishna then moved towards the forest, where he noticed Balarama, reclining at the foot of a tree. He saw a large serpent come out of Balarama's mouth and proceed towards the Ocean, 'hymned by saints and by other great serpents', for Balarama was none other than Vishnu's Shesha himself now entering the waters of the deep.

Turning to his charioteer, Krishna asked him to go and narrate all this to Vasudeva and Ugrasena. 'I shall now engage in meditation', Krishna added, 'and quit this body'. Bowing to Krishna, his charioteer left. Then Krishna sat, lost in thought under a tree, resting his foot upon his knee. At that moment the hunter named Jara came, his arrow tipped with a blade made of the same piece of the iron-club that he had recovered from the belly of the fish. Seeing the foot of Krishna from a distance glistening in the light, he mistook it for a deer and shot an arrow which lodged in the sole of his foot. When he approached his mark, however, he saw 'the four-armed Lord'. Falling repeatedly at his feet, he now begged his forgiveness, saying that he had not known what he was doing. But Krishna, perfectly calm, said to the hunter: 'Fear not thou in the least. Go, hunter, through my favour to heaven, the abode of the gods'. And then Krishna himself, uniting with his own spirit, 'inexhaustible, inconceivable, unborn, undecaying, imperishable, universal' abandoned his mortal body, and the 'condition of living in threefold qualities'.

On the day that Krishna departed from the earth, the ocean rose and submerged the whole of Dvarka. Also on that day began 'the dark-bodied Kali age' on this earth. In the cycles of time, endless and ever-moving, a point had been reached and crossed.

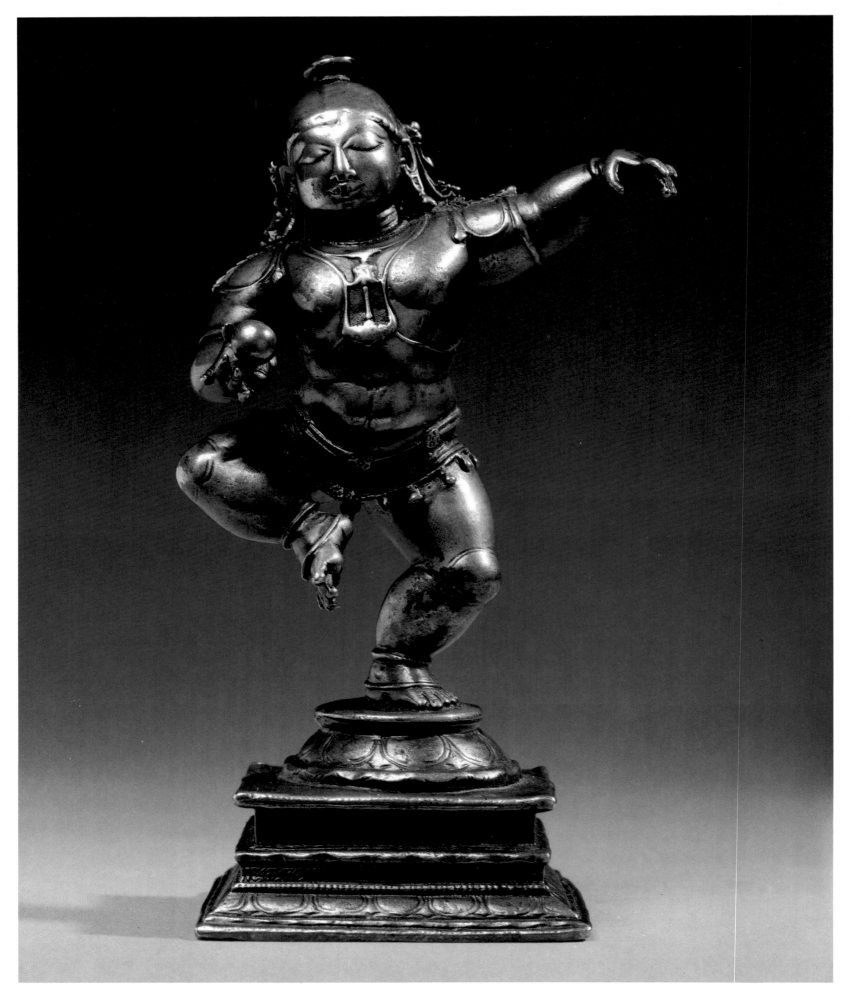

The Elaboration of the Myth
by Prof. W.M. Spink

97. Navanitapriya. *(Bronze, c. 17th century, Private collection.)*

The devotee can surely know who Krishna is; for this is knowledge, lodged in the heart, that is learned in the home, along the streets, and in the shrine. However, the historian, searching through the shades of the past, can be much less sure. Krishna's biography, like that of many other divine figures, appears to have been drawn from a variety of ancient sources, and is rooted in both history and myth. Overlaid with a rich covering of developing belief, which increasingly stressed his superhuman character, it changed from century to century — just as, one could point out, it is still changing today.

Scholars generally accept the view that beneath the multiple layers of tradition that have grown up around Krishna, defining his divine nature with an ever-increasing complexity over the course of time, there is a substratum of historical fact. In the great battle described in India's early epic, the *Mahabharata*, Krishna appears, probably for the first time, as an ally and advisor of the house of the Pandavas to which he, as a prince of another important tribe, the Yadavas, is related. But there are no reliable dates given in the course of this long tale, which appears to be a complex mixture of legend and of fact. Furthermore, the text itself grew by accretion, assuming its present form sometime between the fourth century B.C. and the fourth century A.D. in the view of most scholars, and drawing in the course of this development upon a long oral tradition. Even when we turn to external sources we find that references to the great war are full of conflicts and confusions, so that no one is at all certain about its proper dating. Very orthodox scholars would claim that the battle described in the *Mahabharata* occurred in the late fourth millenium B.C.

This view, which is hardly based on empirical evidence, takes account of the fact that the beginning of the present age — the *kali yuga* — is fixed at 3102 B.C. according to the Hindu cosmic calendar, and credits the traditional assumption that this event coincided with Krishna's death.

When the portion of Vishnu (that had been born from Vasudeva) returned to heaven, then the Kali age commenced. As long as the earth was touched by his (i.e. Krishna's) sacred feet, the Kali age could not affect it (1).

Thus, since Krishna was involved in the epic struggle, traditionalists have proposed that it took place at this very early date. However, this idea that the battle described in the *Mahabharata* and the subsequent death of Krishna both stood close to the watershed between the better age of the past and the declining age of today is certainly mythologically based. It seems much more likely that the *Mahabharata*, to the degree that it reflects an actual event, refers to a period no earlier than c. 1400 B.C., and possibly some three or four centuries later (2). This in turn would provide us with a reasonable, even if hypothetical, date for the original historical nucleus which underlies the complex personality of the hero-god Krishna, for the major role he plays in the epic suggests that he

was a noble leader whose renown was established at that time.

This is not to say, however, that every chieftain or sage named 'Krishna' in early sources can be identified with the great culture hero who gradually came to be recognized as a divinity. When we read, in the *Rig Veda* (3), that Indra orders the Maruts to 'go and fight the battle' against 'Krishna, swiftly moving on the uneven bank of Anshumati, like a cloud touching the water' the reference is probably only to a homonymous early chieftain, despite the fact that in *puranic* literature, developed many centuries later, Indra and Krishna do occasionally come into conflict. A better case might be made for identifying Krishna, the 'destroyer of Keshi' in the *Atharva Veda* (4), with Krishna 'the destroyer of Keshi' of the *Puranas*, since the action is more out of the ordinary than a mere battle would be; furthermore, the later date of the *Atharva Veda* puts it into a temporal context where Krishna was already being characterized as having divine and demon-quelling potentialities. Significantly, Krishna is referred to as Keshi's killer in the *Mahabharata* too, in contexts which some scholars believe to be quite early (5).

In the *Mahabharata*, Krishna is identified as a member of the great Yadava clan, a people settled along the course of the Yamuna river near Mathura; at the same time the fact that he was the ruler of the western sea-coast city of Dvarka suggests the extent of his territories and his power. Related by marriage to the great house of the Pandavas, as the advisor and charioteer of Arjuna, his princely brother-in-law, he wisely, and sometimes even deceitfully, led the Pandavas to victory over the rival house of the Kauravas, finally establishing peace under their rule. His actions were crucial in determining the outcome of the great conflict which, according to tradition and perhaps to a significant degree in fact, gathered together contending factions from the whole Indian subcontinent. At the most literal, and earliest, level of the *Mahabharata*, Krishna need hardly be thought of as divine; that comes later. At first, he must have been sung as a great ally — brave, high-born, more devoted to action than to speculation, and involved in minor palace contests and intrigues as well as in the epic battle itself.

The very 'human' stratum in Krishna's ultimately composite character is reflected in the surprising account of his own end, and of that of his people. They, having moved from Mathura to Dvarka because — according to later *puranic* accounts — Krishna felt there was no way to establish peace in the former area, ultimately became caught up in a desperate drunken brawl and massacred one another. Krishna himself, mistaken for a deer, was killed by the hunter Jara (meaning *geras*, or old age [6]), whose arrow pierced his heel. Finally, his capital city of Dvarka was inundated and swept away by the nearby sea.

Such an ending to his earthly career, unique among the biographies of the Indian gods,

reinforces the sense that at its earliest level the Krishna story involves a human hero, caught up in specific historical events, for there is an air of earthly imperfection and of fallibility about the tale. There is a curious western aura, too, in the description of the dying hero-god, wounded in the heel; as with Achilles, this was his one vulnerable spot. The description of a people gone murderously wild, and the account of the great city being swept away, also suggest western parallels. It is quite possible that at a very early stage in the evolution of the story, there was some influence from western sources. These could have been transmitted, albeit in a somewhat confused form, by the Aryan invaders who had come into India, bringing an ancient body of their own beliefs, before the period when the *Mahabharata* epic was developed (7).

Such possible western intrusions may also explain still later additions to the Krishna legend, such as the 'massacre of the innocents' by the demonic King Kansa during Krishna's infancy. But a much more significant transformation involves the increasing emphasis on Krishna's divinity, already clearly manifest at various points in the *Mahabharata* — as when he rescues the beautiful Draupadi from the shame of being stripped bare by the taunting Kauravas, by his making her garment infinite in length (see page 90).

This urge to reveal that the mortal hero was in truth an immortal god reflects the growing devotional trends which were developing in the last half of the first millenium B.C., not only in the Brahmanical tradition but in Buddhism and Jainism as well. Thus it is hardly surprising that, after his death, Krishna ascended into the illumined skies and returned to the abode of the gods, regaining his original character, as Vishnu, once again; for by the later levels of the *Mahabharata's* development, he was clearly recognized as an avatar of that divinity, who can be defined as the universal source, the essence of all things.

In an even more dramatic way, the identification of Krishna, the hero, with Vishnu, the cosmic presence, is revealed in the very midst of the preparations for the battle which was to consume the Pandavas and the Kauravas in the epic account. Arjuna, with Krishna as his charioteer, looks across the great plain of Kurukshetra, and sees on the opposing side his beloved kinsmen against whom he must do battle; and his limbs tremble, his mouth is parched with horror at the thought of slaughtering them in the oncoming fray (see page 93). At this point Krishna, taking the role of divine sage, addresses him with the long and illuminating message of the *Bhagavadgita*, stressing the virtue of selfless action. This great sermon, which has nourished the minds and spirits of countless thinkers over the centuries, is clearly an interpolation into the basic account of the Pandava-Kaurava war, and adds to Krishna's role as a heroic strategist another role as sage and spiritual guide. And as the lesson continues, it becomes evident that the

98. Battle formation Kurukshetra. *(Stone frieze, Halebid 12th century)*

speaker — the charioteer — is a transcendent presence. Arjuna, moved and sustained by the teachings of Krishna, and now aware that Krishna is no ordinary mortal, but is indeed an incarnation of the divine, finally asks his preceptor to reveal himself in his ultimate, cosmic, form. The awesome vision which he then receives is the vision of God as Universe (see page 94).

Stunned by this revelation, Arjuna finally begs to see Krishna in his familiar human form again. But the point is made: Krishna has revealed himself as an apparition of the ultimate. This vision of Krishna-as-Vishnu and of Vishnu-as-Cosmos perfectly illustrates the manner in which, in the course of the development of the epic, the hero has become a god, a transformation which was probably completed sometime during the first few centuries B.C.

The transformation of Krishna which takes place in the *Mahabharata*, as it changes over the centuries, prepares one for the Krishna which we encounter in the much more clearly and consistently developed 'biographies' of later centuries, starting with the *Harivansha* and the *Vishnu Purana*. In these, Krishna's conception, birth, and childhood are carefully detailed; the purposes of his descent to earth, as an avatar of Vishnu, are more specifically rationalized (8).

In the *Puranas*, Krishna becomes incarnate as the son of the noble Devaki and Vasudeva; and it is significant that much earlier we find a reference, in the *Chhandogya Upanishad*, to a Krishna Devaki-putra (i.e. Krishna, son of Devaki), who received instruction from the sage Ghora Angirasa, the message conveyed being not dissimilar to the teachings set forth by Krishna in the *Bhagavadgita*.

Ghora Angirasa, having told all this to Krishna the son of Devaki, added: 'When man is free from desire, in his last hour, he should take refuge in the three following (maxims):

You are imperishable
You are immovable
You are firm in the breath of life' (9).

Scholars generally agree that this reference, perhaps datable as early as the sixth or seventh century B.C., refers to the same Krishna, son of Devaki, who figures so importantly, centuries later, as a divinity in the *Puranas*. Although not generally seen as bearing any reference to Krishna's divinity, it may represent an intermediate stage in the development of Krishna from hero to teacher to god — that same course of development which is revealed in the growth of the *Mahabharata* epic, where Krishna moves from action to speculation to revelation. Interestingly, B.B. Majumdar interprets this passage rather differently, suggesting that it is really a reference to Krishna as divine already — as *embodying* the qualities (imperishable, immovable, firm in the breath of life) described, rather than merely being instructed about them (10). Whether or not Majumdar is right in this unconventional interpretation of the famous passage from the *Chhandogya Upanishad*, it does seem quite conceivable that Krishna was already recognized as a divinity at about this time, when the *Mahabharata* was developing and when the early *Upanishads*, already with a deeply speculative cast, were starting to appear. There are also references to Krishna, suggesting his importance, although hardly his divinity (nor would we expect this) in the Buddhist *Ghata Jataka* (11) and the Jaina *Uttaradhyayana Sutra*; and these sources may have been formulated (even if not written down) before the Christian Era, though their date is admittedly uncertain (12).

Supporting the hypothesis that the concept of Krishna's divinity was recognized quite early, we can refer to the development of the worship of Vasudeva, an early divinity generally identified with Krishna, at least by the second century B.C. As early as about 600 B.C. Panini, in his *Ashtadhyayi* refers to Vasudeva as to a divinity (13), and as time goes on this recognition of Vasudeva as a god (specifically as an emanation of Vishnu) is made increasingly clear, as is his fusion with Krishna.

This may explain why, very early, Krishna's father was recognized as Vasudeva (with a short a) — Vasudeva, as Basham points out, having been falsely interpreted as a patronymic (14). It should also be noted that in the above-mentioned *Ghata Jataka* the names Krishna and Vasudeva are both used in reference to the brother of Ghata the *bodhisattva*, and may reflect a contemporary awareness of a *Bhagavata* cult divinity of that name (15).

It must be Vasudeva/Krishna whom Megasthenes (fourth century B.C.) identifies as Herakles in his famous account of ancient India; he states that 'Herakles was worshipped by the inhabitants of the plains — especially by the Sourasenai, an Indian tribe possessed of two large cities, Methora and Kleisobora, and who had a navigable river, the Jobares, flowing through the territories'

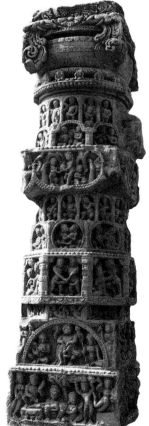

99. Krishna lila. *(Stone pillar, Gwalior c. 8th century, Gwalior Archeological Museum.)*

(16). Methora is clearly Krishna's birthplace, Mathura (also called Surasena) while Kleisobora, as Krishnapura, would refer to Vrindavana, or some other location associated with Krishna, through which the Jobares (Yamuna) flowed (17).

The reference by Quintus Curtius (18), in his *History of Alexander the Great*, to 'an image of Herakles' (which) was borne in front of the line of infantry as Porus advanced against Alexander may also be a reference to Krishna, whose role in the *Mahabharata* battle — to say nothing of his developing demon-quelling propensities — may have enhanced his talismanic significance as a warrior god; however, this identification is much less certain than that based on Megasthenes' account.

Such references, which are more precisely datable than the equally significant transformations in the *Mahabharata*, make it very clear that by the centuries just preceding the Christian era, Krishna (or Vasudeva/Krishna) was already recognized as an important and powerful divinity, significant enough to attract the attention of foreign commentators. Indeed, more than this, he was one of the developing deities who attracted the 'worship' of some of the many foreigners who were entering India from the West at this time. The most famous of these was the Greek Heliodoros, the ambassador of Antialkidas, who, in the time of the Shunga king Kashiputra Bhagabhadra (of the second century B.C.) erected the handsome freestanding pillar at Besnagar, near Vidisha and Sanchi in central India (19). The inscription on this pillar, originally surmounted by an image of Vishnu's vehicle Garuda, refers to Vasudeva as Devadeva (the god of gods). The *Bhagavatas*, worshippers of Vasudeva (Vasudeva/Krishna) exemplify the trend toward theistic devotion, rather than an involvement in the complex and intellectualized sacrifices and rituals of an earlier day. This new stress on personal devotion (*bhakti*) was affecting worshippers all over India at this time; something very similar underlies the 'popularization' of contemporary Buddhism and the growth, in the early centuries A.D. of Pashupati worship among Shaivites. The awed apprehension of Krishna by Arjuna revealed in the *Bhagavadgita* is deeply linked with this same new and reverential approach to God, and is a product of the same general period. The human hero, in Krishna's makeup, is receding more and more, as the *devadeva* concept demands greater and greater realization.

The developing devotionalism of the *Bhagavatas*, which was clearly a major force in India by the second century B.C., involved not only the worship of Vasudeva/Krishna but equally of Balarama (Baladeva) or Sankarshana. Although Balarama becomes clearly secondary in importance to his dark brother Krishna in the later texts, in early inscriptional records such as those at Nanaghat, and at Ghosundi (and also on a second century B.C. coin found at Ai Khanoum) it appears that they were referred to, and worshipped, as equals (20). Balarama, it would appear, was always particularly connected with agriculture. In a remarkably early relief of the second century B.C. — some two or three centuries earlier than the first known representations of Krishna — he is already shown with his major attribute, the plowshare (21). Krishna, on the other hand, from a relatively early time, was associated with the cows and the cowherds; and this division (if not overly subtle) may reflect an early cultic separation in the developing Vaishnavite devotionalism. Although Balarama was early recognized as the 'elder' brother of Krishna, apparently had priority in terms of imagery (see above), was probably more clearly and specifically defined in the first few centuries B.C., and was more often than not mentioned before Vasudeva (Vasudeva/Krishna) in early inscriptions, Krishna soon became the more important divinity, Balarama being by and large reduced to the role of his companion and supporter. This is, needless to say, largely because Krishna early found identification as a major (the eighth) avatar of Vishnu, thereby gathering unto himself all of the attributes of that supreme deity who, like Krishna himself, is among the most approachable of divinities. Krishna's background as an epic hero may have helped to recommend this identification, but it is more likely that his fusion with Vasudeva was of paramount importance, since Vasudeva, relatively early, was given a transcendent position in the developing Hindu pantheon. Vasudeva's rise to importance was evident by the second century B.C., if not even earlier. This is clear from an analysis of the complex *vyuha* doctrine which was developing at that time. In this Vasudeva is identified with Vishnu (who had *Vedic* sun-god connections) as well as the later cosmic god, Narayana (really a variant of Vishnu by this time) who figures importantly in the *Brahmanas*. This powerful triune divinity came to be deified as a complex single deity by the energetically developing *Bhagavata* cult, which later came to be identified as the *Vaishnavas*, as the connection with Vishnu became more and more clearly established and as the concept of avatars displaced that of *vyuhas*. In the *Bhagavata*'s *vyuha* doctrine, some of Krishna's relations were given major positions; notably his brother Sankarshana (Balarama), his son Pradyumna and his grandson Aniruddha. Vasudeva, according to this doctrine, represented the highest self, while the other three figures, conceived as progressive emanations from Vasudeva, were identified with *jiva* (living soul), *manas* (intelligence) and *ahankara* (egotism or consciousness) (22). This elaborate system of belief, in which the highest self (Vasudeva-Vishnu-Narayana) could be conceived in multiple forms — from *para*, the highest, down finally to *archa*, or imagery, had increasing appeal, and by the beginning of the Christian era, at least in central India, must have been in large part responsible for the firm establishment of Vasudeva/Krishna as the appropriate incarnation of Vishnu in his role as the highest self (23). As the *avatara* doctrine became more and more established, due to its attractiveness to the populace in general, to whom it had a more direct appeal than the *vyuha* doctrine, Krishna (i.e. Vasudeva/Krishna) became more and more important while interest in Balarama and the other *vyuhas* — and of the *vyuha* doctrine in general — declined.

At this time, however, it would seem that the 'biography' of this newly assertive avatar was still very inchoate, composed as it was of aspects of Vasudeva, who had developed by this time as central in the speculative *vyuha* doctrine; Krishna, the *Kshatriya* family-hero; Narayana, the mystic embodiment of cosmic power; and Vishnu, with his ancient solar connections. Among the worshippers of this developing divinity — and they were increasing in both numbers and ardour — there must have been a demand for more 'biographical' detail, as well as a desire to incorporate a great variety of long-held concepts and beliefs into the tenets of the developing cult. And so, in the first few centuries A.D. the conception and the history of Krishna-as-Vishnu's avatar clearly grew throughout India both in the oral tradition and in the changing modes of worship.

Krishna's evolving biography, with its developing emphasis on his childhood and his childhood exploits — a matter which is neglected in the *Mahabharata* — is first treated in some detail in Bhasa's *Balacharitam*, a drama which appears to date from the third or early fourth century A.D. This play deals exclusively with Krishna's early career in Gokula and Mathura. It is worth noting that throughout, the young cowherd is called Damodara — referring to the incident of the mortar (see page 38) and not Krishna as such, while his brother Balarama is only referred to as Sankarshana, his more ancient name. Such varied namings, which are common in later texts too, suggest the different aspects and activities of such divinities, thus adding 'meaning' to the ac-

100. Damodara episode. *(Drawing, detail, Kangra c. 1770, Chandigarh Govt. Museum.)*

101. Vasudeva carrying the baby Krishna across the Yamuna. *(Miniature, detail, Mankot c. 1725, Chandigarh Govt. Museum [ref. 1271].)*

counts; but they suggest their complex ancient origins as well.

In the opening scene of the *Balacharitam*, the fact that Damodara (Krishna) is an incarnation of Vishnu is revealed by the sage Narada, who in introducing the play states that he has come 'to see the Lord Narayana, the primeval, imperishable and immutable one, begotten in the clan of Vrishni for the destruction of Kansa in the interests of the worlds' (24). As we might expect, considering its dramatic form, a number of details, found in later *Puranas*, are not included — for instance, Krishna's miraculous revelation to his parents as a four-armed divinity, and his birth within Kansa's prison, while his foster-mother Yashoda, so important in later texts, is not mentioned here by name. At the same time, Bhasa does refer to many events of Krishna's youth, such as the carrying of Krishna across the Yamuna (25), and it is of particular interest to note that some of these are found in relatively early sculptural examples, for this attests to the widespread popularity of the Krishna story. As we might expect, sculptural representations of such scenes increase in number and are scattered over a wider geographical area in the fourth and fifth centuries; however, a number of second and third century A.D. examples have also been found, all originating from regions within the area of Kushana domination, it would appear. Such an origin for the earliest sculptures dealing with the Krishna legend is hardly surprising, since *Bhagavatism* first flourished in the regions which later came under control of the great Kushana dynasty. It is interesting too that a number of Kushana kings were named Vasudeva, again suggesting the importance of the *Bhagavata* cult in that area (26).

Significantly, the subjects of the early narrative Krishnaite sculptures — both those ascribable to Kushana times and those found shortly thereafter, from the Gupta period — all involve the events which occurred during his career in and around Mathura, the Kushana capital. They reflect the increasing popular interest in his youthful life in that general area; and this region, where the stories may well have first been told, had every right to priority because it seems that it was here, centuries before, that Krishna — and probably Balarama (Sankarshana) and Vasudeva too — had once been important princely and/or cult figures, whose legends gradually became intertwined and fused.

By the time that accounts such as Bhasa's *Balacharitam* were written, Vasudeva and Krishna, as divinities, had long been regarded as one and the same, while Sankarshana (Balarama) was by then identified as Vasudeva/Krishna's brother, and was also regarded as divine. Later texts explain that Sankarshana/Balarama was formed from a white hair of the lord Vishnu while Krishna took incarnation from a black hair; but in ancient times they must have been quite separate, and of course much more localized in their influence.

Compared with the *Puranas*, Bhasa's drama reveals Krishna's sacred biography in a very incomplete outline, but of course the very fact that the divine child's life was used as the subject for a play and treated in a way which suggests that the story was already very familiar to the audience proves that it must have already been well established, at least in the oral tradition. Indeed, in this regard we should mention that at least one part of the tale, namely the killing of Kansa by Krishna, can be attributed to a date as early as the second century B.C., and probably even earlier, since Patanjali refers to it in the *Mahabhashya*. In fact he says *chirahate Kamse*, meaning that the conflict took place at some much earlier date. Furthermore, in another place in the *Mahabhashya* we read, *Jaghana Kamsam kila Vasudevah*: 'in the days of yore Vasudeva killed Kansa' (27). Thus, besides proving that this part of the Krishna story, at least, existed very early, we have further proof of the early identification of Vasudeva and Krishna.

Despite the evidence which shows that at least some portions of Krishna/Vasudeva's biography were well established by the second century B.C., the first consistent codification of Krishna's enlarging story is to be found in texts which can be ascribed to about the fifth or sixth centuries A.D. These give a clear and consistent exposition of his early life among the cowherds in Vraja. At the same time, they put his story into the wider contexts of his cosmic origins on the one hand, and of his later career as prince, sage, and ruler, on the other.

The first of these was probably the *Harivansha*, or 'Genealogy of Hari (i.e. Vishnu and/or Krishna)', which forms an appendix or addition to the *Mahabharata*. It must have been added to that epic to make up for the lack of biographical consistency in the *Mahabharata* itself. This is first apparent in its opening section, where a great *rishi* registers a complaint: 'O Souti', he says to his friend, 'you have recounted the great history of the descendants of Bharata,... of the gods, demons, *Gandharvas*... You have described in sweet words... their wondrous deeds... (But), O son of Lomaharshana, while describing the birth and history of the Kurus (i.e. while recounting the *Mahabharata*) you forgot to narrate the history of the Vrishnis and Andhakas (i.e. tribes associated with Krishna). It becomes you to relate their history' (28). Thus the sacred biography of Krishna is requested, and is consequently given careful treatment in the text, just as it is in the very similar *Vishnu Purana*, a composition of approximately the same date.

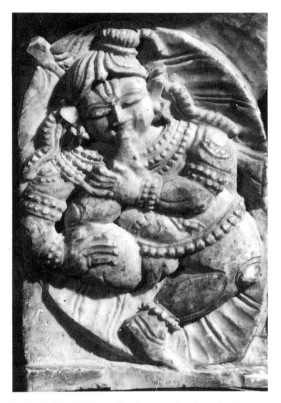

102. Infant Krishna floating on the Cosmic Ocean. *(Ivory, Orissa c. 17th century, c. 45 × 72 mm, Private collection.)*

In both of these two early accounts, Krishna's biography is integrated with (one might say inserted into) a general history of the cosmos, which begins with the origin of the universe, and describes the creation of time, space, and history — both the history of the gods and the history of men. Finally, at or near their ends, both refer to the dissolution of the universe.

It is interesting to note, in both the *Harivansha* and the *Vishnu Purana*, that Krishna is referred to, almost in passing, long before the consistent accounting of his career begins; for instance, he figures as the central character in the story of the recovery of the *syamantaka* jewel (see page 78), a long episode which may well recall ancient clan rivalries, revealing how feuds were fought and settled. Krishna, in the end, refuses to keep the jewel for himself, presenting it to the sage Akrura. In the *Vishnu Purana* (29)

he explains that he cannot himself keep it because he can by no means be pure enough, the reason being that he has sixteen thousand wives. '... This jewel,' he explains, 'to be of advantage to the whole kingdom, should be taken charge of by a person who leads a life of perpetual continence: if worn by an impure individual, it will be the cause of his death'. His brother Balabhadra (Balarama), too, he explains, '... is too much addicted to wine and the pleasures of sense to lead a life of self-denial'. With a touch of masculine vanity he further asserts that he cannot give it to his new bride Satyabhama, since she too would hardly be able to 'agree to the conditions that would entitle her to the possession of the jewel'. Such reasonings, which stress Krishna's human rather than divine nature, are still those of the hero of the early levels of the *Mahabharata* rather than of the transcendent divinity who reveals himself in the *Bhagavadgita*, and later *bhakti* texts.

In the *Vishnu Purana*, (although not in the *Harivansha*), there is another section which presents problems. This is the brief reference to Krishna's connection with the family of Vasudeva; it states that Vishnu 'descended into the womb of Devaki and was born as her son Vasudeva (i.e. Krishna)' thus creating 'universal happiness'; and it also briefly refers to the importance and the impressive size of the Yadava house, and to the fact that the gods descended to earth to be born as mortals into it (30). But then it elaborates no farther, giving no hint that later on in the text this house, as well as its divine scion, will be singled out for special attention. It is as if, when this part of the account was composed, the long and consistent exposition of the life of Krishna which occurs some chapters later, had not yet been composed.

The long accounts of Krishna's life in the *Harivansha* and the *Vishnu Purana* cover his total career, with much less concentration on his boyhood activities among the cowherds and cowherdesses than we find to be the case in the *Bhagavata Purana*. Nor do references to his divine nature occupy very much space, even though we are of course apprised — much more than in the body of the *Mahabharata* — that he is an incarnation of the divine Vishnu.

As narrated in both the *Harivansha* and the *Vishnu Purana*, the story of the god's life opens with an account of the birth of Krishna and of his brother Balarama (see page 29). We are at once informed that this is no ordinary birth. '... the oceans were agitated, the pillars of the earth were shaken, the fires, that had been extinguished, began to burn, auspicious winds began to blow... When the invisible, eternal and powerful Lord Hari (Vishnu) of subtle soul, who encompasses the well-being of the world, was born,... the whole universe was in an ecstasy of joy' (31). Then Vishnu, having become incarnate as Krishna, his eighth manifestation in this present world cycle, appeared before Vasudeva in his transcendent four-armed form. This vision is barely mentioned in the

Harivansha, but the *Vishnu Purana*, which often elaborates upon events more fully (possibly suggesting that it was composed at a slightly later date) has Vasudeva describe Vishnu's celestial form, with its attributes. Then, seeing it, Vasudeva's wife, Devaki, exclaims: 'God of gods, who art all things, who comprisest all the regions of the world in thy person, and who by thine illusion has assumed the condition of an infant, have compassion upon us, and forego this thy four-armed shape, nor let Kansa, the impious son of Diti, know of thy descent' (32). The episode at first recalls Arjuna's request that Krishna revert to his anthropomorphic form; but the reason here is different. The impulse behind Devaki's request is not so much to avoid the terrifying vision of the cosmic form, as to emphasize the importance of Krishna's 'human' form as a disguise, as well as a delight. And so Vishnu/Krishna assumed the appearance of a mere baby once again, and requested his father Vasudeva to transport him, for safety, to the house of Nanda the cowherd.

Thus begins Krishna's 'hidden' career as a god among the cowherds (see page 29). He has come to establish order in the world, and the cowherds' village, as the place where the divine is manifest, becomes the focus of a confrontation with the demonic. On one level the wicked King Kansa, fearful that Krishna will fulfill an early prediction and slay him, is engaged in a personal assault upon the cowherd-god, but on a larger level, the balance between the stability and the instability of the order of things is being played out in this spot and in this story. The villagers, representing as they do the imperceptiveness of the world in general, which does not know that god is everpresently among us, do not perceive that Krishna is divine; they do not know that the divine is always within our reach. In fact they do not know — or as yet they cannot see — that they themselves are integral parts of the revelation of the divine. And Krishna himself, in these relatively early texts, must constantly be reminded of his dual nature.

Thus in the great confrontation with the serpent Kaliya, it is Krishna's brother Balarama — himself an incarnation not merely of Vishnu but specifically of the cosmic serpent upon which Vishnu lies — who must urge Krishna on to victory. 'What is this, O god of gods! ...dost thou not know thyself eternal? Thou art the centre of creation... Now let this fierce snake, though armed with venomed fangs, be subdued (by thy celestial vigour)' (33). Essentially both the *Harivansha* and the *Vishnu Purana* agree in having Balarama remind Krishna of his divine identity, but the *Vishnu Purana* goes even further. Balarama, here, makes it clear that Krishna's career in the region of Vraja is only part of an even larger and more miraculous descent — that the whole village, and all of its inhabitants, is merely a projection, upon the earth, of the ordering presences of heaven. 'The gods' he says, 'have all descended under a like disguise; and the god-

desses have come down to Gokula to join in thy sports... Wherefore, Krishna, dost thou disregard these divinities who, as cowherds, are thy friends and kin; these sorrowing females, who also are thy relations?' (34) Such a statement casts a remarkable light on this simple tale of village life and necessary miracles. The village of Gokula, wherein god has been hidden away, is the very centre where truth and order — the gods, and what they represent — must be found; it is the very place where the conflict between light and darkness must be resolved. All of divinity — ultimately all of Vishnu, or Krishna, or *brahman* — is concentrated here; and all of the demonic, the chaotic, the anti-divine, must concentrate here too. One can look elsewhere to find truth, but one need not. And perhaps, ultimately, one can not; but this is the lesson of much later texts.

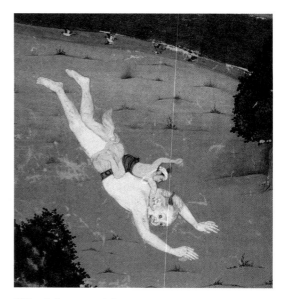

103. Balarama killing the demon Pralamba. *(Miniature, detail, Bikaner c. 1670, Chandigarh Govt. Museum [ref. 60].)*

The story goes on. In another episode, it was Balarama himself who was threatened, and Krishna finds it necessary to remind *him* of his divinity. The demon Pralamba, having taken the form of a simple cowherd sporting with the other boys of the village, carried off Balarama, and as he did so became mountainous in form.

'Krishna, Krishna,' Balarama cried, 'I am carried off by some demon disguised as a cowherd, and huge as a mountain! What shall I do?' (35) Now Krishna is able to remind his brother, also born from Vishnu, of his true nature, of which he too partakes. 'Doest thou not know that you and I are alike the origin of the world, who have come down to lighten its load? The heavens are thy head; the waters are thy body; earth is thy feet; thy mouth is eternal fire; the moon is thy mind; the wind thy breath; thy arms and hands are the four regions of space. Thou hast, O mighty lord, a thousand heads, a thousand hands and feet and bodies; a thousand Brahmas spring from

thee, who art before all, and whom the sages praise in myriads of forms... Knowest thou not, that at the end of all, the universe disappears in thee?' (36)

Again, the presence of a terrifyingly potent divine being — indeed Arjuna's vision once again — is profoundly felt; but the narrative flows on.

In still another episode, again confirming Krishna's divine authority, Indra, the king of the gods, bows down to Krishna, after their famous confrontation, in which Krishna triumphed. 'As the Himalaya is amongst the mountains', Indra says, 'as the great ocean is amongst the watery expanses, as Garuda is amongst the birds, so thou art the foremost of the celestials... O hero, while thou art at the head of all the works of the gods and their guide, forsooth, every thing will be accomplished and nothing will remain undone. Thou art alone eternal amongst the gods and in all other worlds' (37). And then Indra makes a request which helps to link the career of Krishna in Vraja with the career of Krishna in the great battle of the *Mahabharata* — two disparate aspects of his 'biography' which must have been developed at different times and from quite different sources. Indra tells Krishna that, upon Krishna's father's sister, he (Indra) has begotten a son called Arjuna, who will be the greatest of the house of the Kurus, and who will be instrumental in winning the great Bharata battle which is to come. He asks Krishna to defend and befriend him, and Krishna agrees. He says to Indra: 'I know thy son, who has been born in the race of Bharata, and I will befriend him as long as I continue upon earth. As long as I am present, invincible Shakra (Indra), no one shall be able to subdue Arjuna in fight' (38). He then predicts the coming of the great war — the battle which forms the setting for the *Mahabharata*, in which Krishna acts as the charioteer, strategist, and spiritual adviser of Arjuna.

Although, at least intermittently, Krishna and his brother Balarama know and speak of their divine nature, and although the gods, such as Indra, know this too, the cowherds and cowherdesses are by and large oblivious of it. They, although they may too be divine descents, are treated as simple peasant folk, constantly mystified by the saving powers and compelling attractiveness of their dark friend.

However, sometimes the miraculous effectiveness of Krishna becomes too remarkable for them to bear! After Krishna had lifted Mount Govardhana over them, to protect them from the storm god, for instance, they came to him in awe: 'We have been preserved,' they say, 'together with our cattle, from a great peril, by your supporting the mountain over us; but this is very astonishing child's play... all thy actions are those of a god... Assuredly we repose at the feet of Hari, O thou of unbounded might! For, having witnessed thy power, we cannot believe thee to be a man... Yet reverence be to thee, whether thou be a god, or a demon, or a

104. Krishna lifting Mount Govardhana. *(Stone sculpture, Halebid 12th century)*

Gandharva, or whatever we may deem thee; for thou art our friend' (39).

However, Krishna once again asserts his 'divine right' to avoid the conventions of 'truth' whenever he so wishes. Without hesitation, he replies: 'If you have any regard for me;... then be satisfied to know that I am your kinsman. I am neither god, nor Yaksha, nor Gandharva nor Danava; I have been born your relative, and you must not think differently of me' (40).

Thus, in episode after episode, the devotee — for which these texts were composed — knows what is going on; he knows that Krishna is in reality Vishnu and that he can take delight in the stories of Krishna's exploits, safe in the knowledge that all must

turn out all right in the end. But the villagers are not party to this secret knowledge; they can only wonder, and occasionally suspect. Krishna insists that he is a mere cowherd, and one of their kinsmen — which, even in mortal terms (having been born in a noble house) he is not. Such playful devices, of course, keep the intensity of the story at a high level, and help to explain the great popularity of such accounts. Even moments when the truth is openly revealed to certain witnesses, such as to his mother and father at the time of his birth and again after his defeat of King Kansa, are only temporary. 'Having permitted to Devaki and Vasudeva an interval of true knowledge,... Hari again spread the delusions of his power over them and the tribe of Yadu' (41).

In general, the *Harivansha* and the *Vishnu Purana* are rather similar to the *Bhagavadgita* in the way in which they interrupt the narrative to remind the reader of Krishna's 'real' identity. But at this stage of the development of the *bhakti*-cult, and even as late as the more exuberant *Bhagavata Purana* — perhaps dating from the tenth century A.D. — the texts provide only an intermittent revelation of divinity to the devotee. This is quite different from the need for an all-consuming participation, as the single approach to salvation, which characterizes the attitude of the poets and other writers of the late medieval period.

It is particularly in the account of the *rasa* dance, where Krishna meets the cowherdesses under the full autumn moon, and sports with them, that one finds, in these relatively early texts, a foretaste of the depths of ardour which later on are held up as the ideal, and in fact the inevitable end, of true devotion. Omitted from the more epic *Mahabharata*, this event is still described in relatively brief and restrained terms in the *Harivansha*, much more extensively and dramatically in the *Vishnu Purana*, in full-blown terms in the *Bhagavata Purana*, and — one might say — in over-blown terms in

105. Rasa mandala. *(Stone sculpture, Orissa 12-13th century, 86 × 88 cm, Somnath temple, Vishnupur [Puri district].)*

the highly erotic *Brahmavaivarta Purana* account. We shall consider all, in some detail, later on.

After the *rasa* dance, which can be seen as the culmination of Krishna's life among the cowherds and cowherdesses of Vraja — and this point is emphasized increasingly as the cult of intense devotion to him develops in India's medieval period — Krishna moves back into the 'real' world. He returns to the nearby city of Mathura, where, while he has been blissfully 'playing in the fields of the lord' with a divine unconcern, his high-born mother and father have remained under Kansa's power. He kills the demon king, frees Vasudeva and Devaki, proclaims his 'proper' high birth as a noble, and then involves himself in the struggle to establish, for his Yadava kinsmen, a stable political milieu in a world where his contemporary political rivals (who may be demons) and demons (who all too readily take birth as his contemporary political rivals) abound. One constantly feels, in this latter part of the Krishna narrative, that the texts reflect — obviously with many modifications — certain events which probably did actually take place in history and in historical time. Krishna here, abiding by *kshatriya* conventions in war, rule, and love, has definite links with that great culture hero who figures as the practical military planner and adviser of Arjuna in the *Mahabharata*, and who when that text was in its formative stages was certainly more an object of ordinary praise than of religious devotion.

The events and confrontations described in the later chapters of the *Harivansha* and the *Vishnu Purana*, which involve not only Krishna himself but his noble relatives and sons, now sometimes are touched by what seem to be the chilling fingers of historical reality. Victories, a foregone conclusion in the childhood world of Vraja, are no longer absolutely predictable. Most suggestive, perhaps, is the account of Krishna's decision to move his people westward to Dvarka, in order that they avoid further harassment by other military and political powers, notably Kalayavana (apparently the ruler of a people of foreign origin) and Jarasandha of Magadha, in the heart of the Gangetic valley. Such encounters, remembered in these texts, almost certainly reflect events in early history when the Yadavas had probably been forced west by some stronger rival power; and quite possibly this was during the time of some great leader, who later became fused or confused with Krishna, the *Mahabharata* hero and/or Krishna, the prince of Mathura in the *Puranas*. This episode functions too as a way to get Krishna out of his childhood haunts of Vraja (and Mathura) to the region of Dvarka in the west — the base for his later operations.

Were these parts of the texts not based to some degree on actual past situations, the shift to Dvarka could have been explained in a more positive way, rather than in this manner, which curiously reflects upon Krishna's omnipotence. The compilers themselves clearly realized this, and rationalized the matter as follows:

That the Yadavas were not overpowered by their foes, was owing to the present might of the portion of the discus-armed Vishnu. It was the pastime of the lord of the universe, in his capacity of man, to launch various weapons against his enemies; for what effort of power to annihilate his foes could be necessary to him, whose fiat creates and destroys the world? But as subjecting himself to human customes, he formed alliances with the brave, and engaged in hostilities with the base. He had recourse to the four devices of policy, or negotiation, presents, sowing dissension, and chastisement; and sometimes even betook himself to flight. Thus imitating the conduct of human beings, the lord of the world pursued at will his sports (42).

A somewhat similar justification for Krishna's surprisingly 'faulted' power — a characteristic which makes him so much more human and approachable than most other gods — is given in the *Mahabharata*; and would seem to be a response to questions which must have arisen in the minds of his devotees when they faced these ambivalences. In the *Ashvamedha Parva* — referring to the Kaurava-Pandava holocaust — Krishna, speaking to the sage Utanka, admits: 'I tried my best to bring about peace with the Kauravas. But in spite of all my efforts, I could not succeed in averting war.' 'In every cycle,' he explains, 'I am born in diverse forms, out of my desire to do good to my creatures. When I am born among the celestials, I act like a celestial... Since I am now born in the order of men, I appealed to the Kauravas as a human being. But stupefied as they were and deprived of their senses, they refused to accept my counsel and ignored my piteous entreaties' (43).

Such an explanation would have been neither satisfying nor believable to devotees of later centuries, when an insistent recognition of Krishna as the ultimate divinity would obliterate all such possibility of fault in his nature; they would not take the idea that he was born a man with such a literalness.

The death of Krishna, as we have mentioned above, equally suggests the presence of some 'historical genes' in Krishna's divine nature. Perhaps this is why — along with the ultimate destruction of the Yadavas and the inundation of his capital Dvarka, by the sea — it is not referred to in the *Harivansha*, where the last reference to Krishna only mentions how, having triumphed over Bana, 'encircled by the Yadavas and enjoying the highest prosperity, Krishna lived in Dvarka and governed the whole world' (44). The *Vishnu Purana*, like the *Mahabharata*, is more explicit. It tells how he was killed by a hunter, but explains at the same time that such a seemingly mortal ending was in truth only part of his own divine plan, and the celestials were eagerly awaiting the return of his heavenly rule (45).

The circumstances of Krishna's death again remind us of the complexity of the makeup of Krishna's character as a deity; and when we study the various early texts with a view to explaining the development of his power and popularity we can gradually come to understand or surmise how many factors contributed to his ultimate definition as a god with remarkably wide-ranging qualities and connections.

Krishna, as his tale unfolds, is revealed as the divine child, as the queller of demons, as one who humbles other deities, as the divine lover, as a noble leader, as a sage; and he became these things, one could say, as he grew — as his worship, intensifying, made room for a wider and wider variety of beliefs and approaches. The very vagueness of his origins, which confuses the scholar today, must have encouraged the gradual enrichment of his divine personality. He appears to have roots not only in the well-established and speculative brahmanical theology, but also in the simple country cults of the fields and forests and streams. His origins go back as well, without doubt, to epic history, out of which, as a great culture hero, he finally emerged in divinized form. Such a process was undoubtedly stimulated by western influence, which was a major factor in Indian

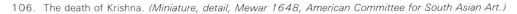

106. The death of Krishna. *(Miniature, detail, Mewar 1648, American Committee for South Asian Art.)*

developments during the centuries when texts such as the *Mahabharata* were being formulated; for in the western traditions heroes and kings were easily assimilated to the divine.

First and foremost, of course, Krishna comes to be recognized as an incarnation of the great god Vishnu. This provides his most crucial legitimization, no matter how many aspects of his character or of his worship are brought in from outside of the central brahmanical tradition. It is also, on a practical level, in large part responsible for the fact that his story, like the stories of other gods who found major roles within the great tradition, has been well recorded; for the priests of the brahmanical establishment — like monks in the west — were the chief recorders of legend and history, both in the written and the oral media. Their power in defining and preserving (or in some cases in reducing or absorbing) divinities cannot be gainsaid.

Although we must believe that Krishna originally existed quite independent of any specific identification with Vishnu — first as a culture hero, and then as a cult divinity who gradually became identified with Vasudeva and perhaps also with Narayana — by the time that the *Bhagavadgita*, the *Harivansha*, and the *Vishnu Purana* were composed the connection was clearly established. Thus, in the *Bhagavadgita*, Krishna allows Arjuna an awesome vision of his 'true' universal form (see page 94); but the everyday mechanics of the incarnation are not revealed. As if to correct this oversight, both the *Harivansha* and the *Vishnu Purana*, and later accounts generally, explain how Vishnu, moved by the earth's entreaties, took incarnation, in this present world cycle, as the eighth child of the noble Vasudeva and Devaki of Mathura. Significantly, he chose birth in the *kshatriya* caste, just as did the Buddha and the Jain saviour Mahavira; for the Krishna cult, like Buddhism and Jainism, (which became widely popular in the same general period) represented a reaction against the complex ritualism of the priest-dominated orthodoxy of the middle of the first millenium B.C. It is worth noting, too, that Krishna chose birth in Mathura — Vishnu, needless to say, always chooses *some* place in India as the locale of his descents — since this appears to have been a center of the developing *Bhagavata* cult, which early assimilated Krishna to itself; and of course his assimilation into the generally lower-caste cowherds' village emphasizes this 'ecumenical' strain in the developing cult. And it is significant too that the cow-earth, in her appeal to the gods, stressed the problems being caused by strife in the land, since this probably reflects the actual historical situation and helps to explain why Vishnu, in this incarnation, would derive an aspect of his character from the great culture hero and leader whose exploits are reflected in the *Mahabharata* and in the later chapters of the *Puranas*, as we have mentioned earlier.

107. Krishna Venugopala. *(Stone sculpture, Orissa 12-13th century, 58 × 86 cm, Somnath temple, Vishnupur [Puri district].)*

It is interesting that Vishnu chose to be born of a woman (Devaki) who was the sister of the chief demon whom he had to battle — King Kansa of Mathura — for this makes the demon-king Krishna's uncle! Furthermore, the first six sons of Devaki, all of whom King Kansa smashed to death, were actually reincarnated demons, so here again Krishna, as god, is in close association with the demonic: the murdered baby-cum-demons (so cleverly disposed of by the gods) were his brothers! In fact, since they were the sons of the ancient demon Kalanemi, who had become reincarnated in King Kansa, Kansa 'is in himself in a sense the father of Krishna' (46). Such a connection between the demonic and the divine seems startling from a western religious point of view, but in India, where the demonic and the divine, the dark and the light, chaos and order, are in a more symbiotic equilibrium, it adds a sense of the precarious and subtle balance which invests all relationships and gives energy to life. The play of the divine begins where demons dwell; had the earth not been in pain, Krishna would never have come to bring back its delight and cause its blossoming. In Krishna's world — which mirrors the realities of our own life — the demonic, like the divine, is always present, ever very close at hand; the one is often very hard to distinguish from the other.

At least according to later sacred texts, the incarnation — the descent of truth in time — went much farther than the mere embodiment of Vishnu in Krishna. Each of the inhabitants of Krishna's pastoral world — every cowherd and cowherdess — was a god or a goddess come down to earth to play out the drama of light and darkness. Further-more, they were balanced against an equal concentration of demons, who equally took birth in that particular area, to carry on this play. As time goes on, of course, it becomes clearer and clearer to the devotee that Vraja's boundaries enclose the whole word; it is an image which expands, while on another and perhaps even more essential level the concentrations of the divine and the demonic ultimately are concentrated in the human heart.

Although Krishna's connection with Vishnu is of primary importance in establishing the legitimacy and the authority of the new cult, it is worth noting that the matriarchal aspects of godhead are given considerable attention early in the story. When Devaki bore Krishna in her womb, she was praised by the celestials as the mother of the universe, as the 'eternal being, comprising in (her) substance the essence of all created things,... identical with creation ...descended upon earth for the preservation of the world...' (47) Later on, the cowherdess Radha will be praised in similar terms, as representing *Prakriti*, the 'eternal feminine', which sponsors and supports existence and is essential for the god's total revelation.

The destructive potential of the great mother, which developing Hinduism recognized and propitiated in the forms of Durga and other powerful goddesses, also is revealed early in Krishna's story. Just as Vishnu took incarnation as Krishna in Devaki's womb, the great goddess was incarnate in the tiny girl to whom Yashoda gave birth (see page 30); and she manifests herself in a revengeful and awesome aspect as the goddess of death when the wicked Kansa kills the child.

Thus, at the very beginning of the *puranic* accounts, the founding of Krishna and Krishna worship in the 'great tradition' is made clear; and devotees of the high Hindu gods and goddesses would have no trouble accepting and worshipping Krishna as an orthodox divinity, no matter how far afield, as a cowherd, he might stray. High-born, identical with Vishnu, and energized by the goddess, his pedigree was both appropriate and impressive.

The *reason* that this Krishna, although a comparative latecomer to the Hindu pantheon, was raised so high, was probably a direct result of the popularity which he enjoyed as a local cult-divinity before the process of assimilation to the great tradition took place. One can hypothesize that a tradition of tales had grown up about such a local pastoral divinity or divinized hero in the same region and at the same time that Bhagavatism was developing, and that the local cult became so important that it soon merged with the orthodox tradition — the local god finally being raised to the eminence of an avatar. Like that other great incarnation, Rama, Krishna seems to have been drawn in very large part from local history and legend. Priestly speculation must also have played a part, but probably less than in the growth of traditions surrounding many other gods.

Almost from the start, in the *puranic* accounts of Krishna's life, we move into contexts which suggest compelling local connections. As soon as Krishna is born, he is immediately transported by his father into a different world — across the Yamuna River — at a spot which local people will still show the traveller today — to the cowherds' village of Gokula. The darkness of the night, the raging storm, the swollen waters of the river, and the fact that Krishna is sheltered from the elements by a protective cobra: all these things take us out of the world of the city and of the established conventions and into the timeless pastoral setting where the story of his childhood is played out, as if in a dream. The cultural context on this other side of the river is significantly different from that into which he was really born; he has become, or so it appears, a child of the cowherds, a divinity who is seemingly connected with a relatively low-status group. This may help to explain his representation as dark-skinned. The shift in venue and in status also emphasizes his ready availability, as a divinity, to all. Furthermore, one should note that the diminution of the importance of caste distinctions is a characteristic of the developing *bhakti* cult where, particularly in its later phases, the standard conventions are often completely disregarded or disrupted.

The *Purana's* insistent inclusion of Balarama, Krishna's brother, who was mysteriously saved from Kansa's murderous hands by being transferred from Devaki's womb to that of Rohini (see page 28) further stresses Krishna's connections with the world of the fields and forests. Although the orthodox accounts explain that Balarama was created from a white hair of Vishnu (just as Krishna was created from a black hair) the greater question is, why was Balarama inserted into the Krishna story at all? The reason must be that in earlier times he had been too closely associated with Krishna to warrant being summarily dropped; and in fact we know that the two (Balarama as Sankarshana and Krishna as Vasudeva) were closely associated in developing *Bhagavata* worship before their connection with Vishnu was finally fully made. Balarama, like Krishna, keeps his 'country' habits; he carries the plow, and remains throughout a great lover of wine, women, and song. Evidently he was a cult-divinity of some significance in early days, although by the time the *vyuha* doctrine had developed, he was probably already yielding his authority to Vasudeva/Krishna. Finally, by being brought into the orthodox context as an aspect of Vishnu and as some texts say, 'identical' with Krishna, he largely lost his independence, his worship becoming subsumed in the worship of Krishna/Vishnu.

As the cult of Krishna grew — probably before the close identification of Krishna and Vishnu had been established, and quite possibly at a time when he was still known by another name or names — it must have come into conflict with many other developing cults. This was a period of great religious ferment in India, when rival divinities vigorously confronted and in some cases destroyed or absorbed one another's powers and prerogatives. The famous account of Krishna's confrontation with the demoness Putana (see page 32) may well recall an early rivalry between the developing Krishna cult on the one hand and the continuing but probably declining worship of some female divinity associated with the productiveness of the earth on the other. Ancient India (like tribal India still today) clearly abounded with powerful autochthonous deities which stand quite apart from the orthodoxy of the great tradition; and being 'outsiders' they must generally have been viewed in a negative light and classed as demons — although certainly not in the uncompromising way in which rival western divinities might view each other or be viewed by their respective devotees.

The story of Krishna's sucking the very life out of Putana may well suggest how he literally took unto himself her devotees, while her transmutation from the 'stinking one' (Putana) into a pervasive fragrance that filled the whole region around Gokula when her pyre was lit, and the miracle of her rebirth as a result of her having come into contact with Krishna's feet, provides an example of how such cults could be assimilated to a stronger rival cult in a manner which must have made such a process of absorption attractive and even compelling to the lesser divinity's original devotees. Beyond this, there was a lesson here for every worshipper: if a creature like Putana could be translated from earth to Paradise simply by the touch of Krishna's foot, how much greater a reward

108. The death of Putana. *(Miniature, detail, Kangra c. 1790, Bharat Kala Bhavan, Benares [ref. 6701].)*

must await those who approach him, innocent from the beginning, with pure and ardent devotion?

The *Vishnu Purana* and the *Harivansha* include a number of incidents which merely display Krishna's miraculous strength, derived from his divine energy. Once he overturned a heavy wagon (presumably a bullock cart) while lying beneath it and kicking it with his feet. (Much later texts suggest it was actually a demon who had taken such an inorganic form). Even more amazing, after his foster-mother Yashoda had tied him to a heavy mortar (actually a sacred instrument in *Vedic* ritual, and so appropriately connected with such a god) he dragged it between two huge trees and uprooted them; his name Damodara comes from this tying of the rope (*dama*) around his stomach (*udara*).

A good example of how a sacred tradition develops can be seen by referring to the somewhat later *Bhagavata Purana*, where further elaborations of the miracle, stressing the divine nature of the child, are presented. Firstly, Yashoda, finding the binding rope a few inches too short, tried to add to it, but no matter how much rope she added, it always remained shorter than was required, until the baby Krishna, out of compassion, stopped this prankishly didactic display of his potentialities and allowed himself to be bound. Then, when he had finally uprooted the trees, we are told that two sons of the *yaksha* Kubera, who had been cursed in a previous life to imprisonment therein, were released from them. The incident could be read as a way of showing the dominance of Krishna's cult over that of Kubera; in a similar way Kubera and other *yakshas* are brought into contemporary Buddhism and Jainism as important but clearly subsidiary figures.

In the *Bhagavata Purana's* telling of this tale, the divinity of Krishna is stressed in a way which goes far beyond what one finds in the less evolved accounts of this episode in the *Harivansha* and the *Vishnu Purana*. The two released youths, 'illumining all the quarters

with their wonderful beauty... began to pray... "O Krishna, O thou of great *Yoga*, Thou are the great Prime *Purusha*. Persons cognisant with *brahman* consider this Universe, manifest and unmanifest, as thy form". These salutations, which continue *in extenso*, stress the lord's great powers and the increasing devotional emphasis which characterise this text.

The next great event narrated in the earlier texts, the *Harivansha* and the *Vishnu Purana*, is the quelling of the serpent Kaliya, who had taken up his abode in the river Yamuna, and had seriously polluted it by his toxic presence (see page 45). Here too, as in the Putana episode, we can read below the narrative level to see that Krishna's triumph in the contest probably refers to and reflects the triumph of the developing Krishna cult over the kind of animistic serpent worship that was pervasive in ancient India. Snake divinities were given significant roles in all of the growing major religions at this time; in Buddhism, for instance, the *naga* Muchalinda protects the Buddha at the time of the great Enlightenment, while in Jainism, Parshvanatha is similarly protected by a multi-hooded cobra. The great Hindu divinity Shiva wears snakes as ornaments, while Vishnu lies upon and is protected by the many-hooded serpent Ananta. In another context Ananta is identified with Krishna's brother Balarama, from whose mouth he emerged at the time of the latter's death. So it is hardly surprising to see the snake cult affecting and enriching that cult of Krishna. Indeed the end of the Kaliya episode has Krishna allowing the serpent to depart in honor, decorated by the lord's imprinted footprints upon his head. The tale is elaborated in the somewhat later *Bhagavata Purana* by having Kaliya and his serpent wives worship Krishna with great pomp and with many presents; but this is a typical transformation. The earlier *Harivansha* and the *Vishnu Purana* only describe the victory. The episodes with Putana and Kaliya and the sons of Kubera reveal the manner in which various tutelary divinities of the forest, field, and stream were conquered but at the same time honored by the increasingly potent cult of Krishna. And while this process was going on with divinities external to the orthodox brahmanical tradition, another process was in progress too, which involved deities *within* the great tradition. At the very start of the Krishna story, the gods in heaven, led by Brahma, admitted that Vishnu should be the one to save the earth in her distress. In this sense, they were putting themselves in the inferior position; or perhaps one should say that the compilers of such accounts, being devoted to Vishnu, were doing this. The tendency continues throughout the later parts of the story too, although this process of one-ups-man-ship is less developed in the *Harivansha* and the *Vishnu Purana* than in the later *Puranas*, where the additive compulsion characteristic of the development of nearly all Indian sacred texts manifests itself. In the *Harivansha* and the *Vishnu Purana* the most developed account of a conflict between Vishnu/Krishna and another high brahmanical divinity is revealed in the story of the lifting of Mount Govardhana (see page 52). This story ends by Indra offering his praise and his devotion to the triumphant Krishna, whom he names as 'Indra of the cows'. In the somewhat later *Bhagavata Purana* Indra's adulation is even more intense, as we might expect in this even more assertively devotional text; Indra, after a long eulogy, ends by saying 'O Lord, I have been favored by thee. I seek protection in thee, who art Ishvara, the Preceptor of the universe and the Supreme Soul' (48).

Indra was of course the ancient king of the gods; but his worship had declined in significance from *Vedic* times on. Many of Krishna's victories over demons bear clear connections with Indra's earlier exploits, so it seems apparent that a process of assimilation was well underway by the time that the Krishna cult stories had developed (49).

Such developments, where one high brahmanical divinity recognizes the supremacy of another, are characteristic of a tradition where — even if 'all of the gods are ultimately one' — devotees still have their own particular attachments and are likely to be somewhat chauvinistic in their views. Similarly, in Buddhism, it seems to have been of great importance to Buddhist devotees to enhance the significance of their lord by showing, both in literature and in the visual arts, that the older Brahmanical divinities were subservient to him. Thus Indra and Brahma attend upon Prince Siddartha at the time of this birth, and praise him when he proclaims his own supremacy.

Krishna also outwits the high god Brahma in an episode recounted in the *Bhagavata Purana*, but the incident is not recorded in the somewhat earlier accounts. The same is true of the incident of the forest fire, which

109. The quelling of the snake Kaliya. *(Miniature, detail, Kangra c. 1810, Bharat Kala Bhavan, Benares [ref. 378].)*

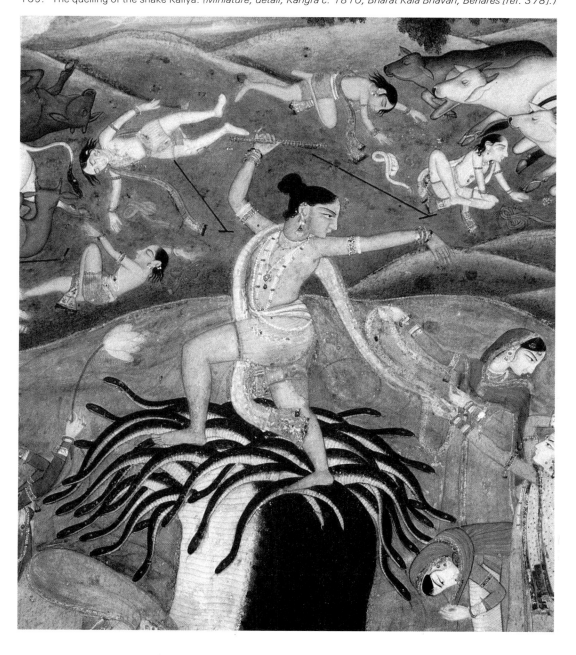

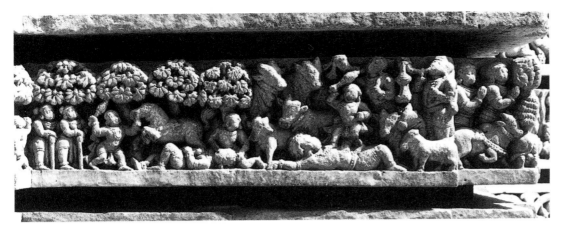

110. Scene from the Krishna lila. *(Stone frieze, Somnathpur 13th century)*

can be seen as merely one further display of Krishna's ability to triumph over any problem caused by nature or by man; but it is also possible to interpret it as suggesting the transcendence of the Krishna cult over that of the fire-god Agni. Like Indra, Agni was of tremendous importance in the period of the *Vedas* and the *Brahmanas*, but his worship declined — waned as that of other divinities waxed — as time went on.

Later in his career, after leaving the cowherd village and asserting his position as a noble leader in Mathura and finally in Dvarka, Krishna continues to triumph over other divinities, or to graciously assist them when they are incapable of restoring order without him. In the story of the humbling of Narakasura, for instance, he provides needed assistance not only to Indra, but also to Indra's mother, Aditi and to the sky-god Varuna.

The conflict with Shiva and with Shiva's great devotee, the demon Banasura, is of even more significance, because Shaivism was growing so vigorously in the early centuries A.D., when these accounts were formulated. Devotional Shaivite cults, such as the *Pashupatas*, must have formed the most important rivals to the growing cult of Krishna; and, indeed, something of the interplay between the rival gods and the rival groups is revealed in the oppositions nar-

rated here. We should also note that the rather fragile distinctions between the demonic and the divine come to the fore again in this tale, for in it Shiva intercedes on behalf of the demon-king, while Krishna finally gives his grandson in marriage to the demon's beautiful daughter.

As time went on, the stories of Krishna's powers and prowess continued to accumulate, often being drawn in from folk traditions and involving the assimilation of both divinities. However, even if we are correct in finding a suggestion of early cult rivalries in stories such as those of Putana and Kaliya, this does not mean that every later addition to the tradition can or need be similarly interpreted. By the time the *Bhagavata Purana* was compiled, only a few centuries later than the *Harivansha* and the *Vishnu Purana*, Krishna has to do battle with an increasing number of demons, who come in the shapes of horses, bulls, whirlwinds, and different reptilian forms — a quite gratuitous assortment of adversaries, who probably, at least in many cases, had their source in the imagination of the faithful, always ready to credit Krishna with new victories and new virtues. Through battling such creatures, the many sides of Krishna's cosmic character are continually revealed. Sometimes he becomes immense in size, so that demons such as Aghasura, or

Bakasura, or Keshi cannot contain him, or must break apart if they hold him; sometimes, as in the dance on the hoods of Kaliya, he becomes enormously heavy, for all of the weight of the universe becomes concentrated in his form; or he becomes immensely powerful, or immensely intrepid in battle, or quite literally everywhere at once.

All of these conflicts, whether they be major or minor, and whether they involve demons or divinities, naturally end in victories for Krishna. They are part of the process by which his significance as a divinity is magnified. The point is not so much that he always wins — that is the foregone conclusion — but that each episode, and the accompanying commentaries upon it, is yet one further link in a marvelous chain which in the end inexorably binds the devotee. Each story is one more offering of praise — told, or sung, or seen — in the ultimately hypnotizing recitations of devotion.

The quasi-historical sections in the Krishna story happily complement and of course are often fused with the less 'believable' displays of Krishna's triumphs over demonic forces. The sense of his continual involvement in earthly as well as in cosmic history — his connections with the Herod-like King Kansa, the conflicts with characters such as Jarasandha, and his convincing relationship to known tribes or families — is rather peculiar to his story, and in part must account for the force it has long exerted on Indian culture. Even the flooding of Dvarka and the startling account of his own death and of the destruction of the Yadavas may well recall a natural calamity which could not be forgotten, but instead was gradually transformed in a manner which converted what in another tradition would appear to be the account of the tragic death of a hero and the tragic destruction of a people into one more revelation of the divine will. Krishna ordains it all, reflecting on the insubstantiality of deed and of time in the aloof flow of divine history.

The very dichotomies within Krishna's story — reflecting the patchwork manner in which it must have been pieced together from various different sources over the course of time and space — are instructive. If one would worship him as a cowherd, it must be remembered that he is really a prince; if he is death to demons, he is their salvation too; if he seems unquenchably playful early in his career, he opts for duty when duty calls; if he disrupts the conventions with his youthful ardours, he establishes them by his example when he leaves his early dancing grounds. Yet this sense of balance in his tale starts to give way by about the twelfth century — during the period of the composition of Jayadeva's *Gita Govinda* — as a more and more fervent, often clearly erotic, emotionalism developed.

The importance of the later aspects of Krishna's career, when he plays the role of the wise and responsible ruler of the Yadavas, is never explicitly denied in the literature and in the modes of worship which

111. Krishna kills the demon Keshi. *(Stone frieze, Somnathpur 13th century)*

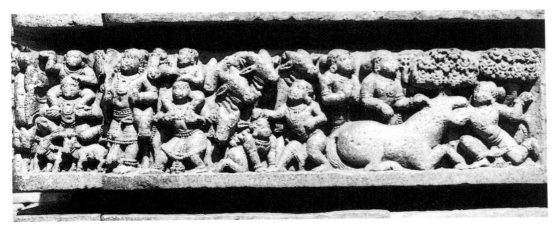

developed over the course of the medieval period, culminating in the ecstatic devotionalism of poets such as Sur Das, Vidyapati, and Mira Bai and others in the 15th and 16th centuries. However, the increasing development of *bhakti* concepts — the stressing of the importance of a blissful connection between the lover and the beloved, the divinity and the devotee — made a concentration upon his childhood in Vraja and upon his irrepressibly endless play with the *gopis* more and more the focus of both writers and worshippers; his later career becomes an incidental, even irrelevant, concern which can only deflect attention from the rapturous delights of Vrindavana. It is significant to see how this trend gradually develops and where it leads; and we can perhaps best do this by concentrating our attention upon the famous episode of the *rasa lila*, the climactic event in his life among the cowherds.

Going back to the early texts bearing on the Krishna story, we do not — nor would we expect to — find a description of the *rasa lila* in the *Mahabharata*, which only concerns itself with the later aspects of Krishna's career. On the other hand, Bhasa's *Balacharitam*, dealing with Krishna's life as a child, quite understandably includes it. This is, apparently, the first significant mention of the dance in the literature, and one finds it rather differently described than in later accounts. In the *Balacharitam* the dance — called a *hallishaka* rather than a *rasa lila* — is clearly an open and communal celebration, with the tone of a conventional village festival, in which Sankarshana (Balarama) and all of the other young cowherds and even some of the older villagers too, joined Krishna and the women (50).

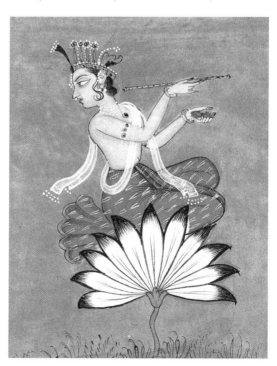

112. Krishna playing his flute. *(Miniature, Bikaner c. 1760, 70 × 125 mm, Galerie Marco Polo, Paris.)*

In all later texts which we have been considering the *rasa* dance is enacted by Krishna and the *gopis* alone; and it gradually takes on the character of a more and more devotional ritual. The *Harivansha* and the *Vishnu Purana* accounts are quite straightforward descriptions of a delightful autumnal pastime, but it is clear by the time of the tenth century *Bhagavata Purana* (upon which the narrative in chapter 2 is mostly based) that the dance has a clear spiritual significance, as a display of the lord's power and grace; for therein we read that Krishna 'assumed a human form (and) joined in these kinds of sports' (51) in order to enhance the realization of divinity within the souls of his devotees.

At the same time, the dance described in the *Bhagavata Purana* still has the distinct character of an earthly celebration, which took place at a particular time and place in the past — even though there is already a clear suggestion in this relatively developed text that the participants are all celestials, like Krishna himself (52). This direction of development, as we shall see, by the time of the *Brahmavaivarta Purana*, has prospered remarkably. The *rasa* dance has become a highly mystical and eternal event — a clear projection of the delights and activities of the gods and goddesses of heaven upon the earth below. It is, one can finally say, a miraculous and total display of Krishna's own ultimate form, of a full revelation of godhead into the experience of the devotee — and of the experience of the devotee into a full revelation of godhead. And an explanation of the meaning and the means of participation in this all-encompassing dance is clearly the main goal of this late account, which expresses in a very dramatic way a late stage in the development of the cult of *bhakti*. Therefore it behoves us to review the process by which this point in the development of the texts, and of the faith, was reached.

In the *Mahabharata* Krishna, revealing himself to Arjuna as an avatar of Vishnu, dispenses both divine wisdom and divine aid to his friend and devotee, and to mankind in general. This same purpose, to bring order into the distraught world — to set the present world aright and to secure man's place within it — provides the justification for Krishna's incarnation as the son of Vasudeva and Devaki in Mathura at the opening of the story of his earthly career as recorded in the *Harivansha* and the *Vishnu Purana*. Ostensibly he has taken birth to suppress the ravages of King Kansa and his demonic hosts; and indeed he does do battle, and does defeat, each and every evil envoy which is sent against him while he resides with the cowherds; and ultimately he does accept an invitation to go back to Mathura, where he dethrones and destroys Kansa himself. But his role in these first accounts of his childhood career is clearly reactive, rather than active. He does not look for trouble; instead, trouble comes to him, interrupting the childhood sports which appear to be his main concern. He is far from being a Per-

113. Krishna slays Kansa. Illustration to the Harivansha. *(Miniature, detail, Mughal c. 1590, Victoria and Albert Museum, London [ref. IS 1970].)*

cival, far from being caught up in the temporal and political concerns which were, if we believe what we are told by the texts, the *raison d'être* for his incarnation.

How do we explain this situation? Does it not seem that the committed and moralizing heroic avatar of the *Mahabharata* has been somewhat inappropriately transplanted into a lucid pastoral setting, where such 'work' only interrupts his play — and then only temporarily?

The most telling point of the revelation of Krishna as a cowherd in texts such as the *Harivansha* and the *Vishnu Purana* seems to be the expression of the irrepressibly playful exuberance of the divine child — an expression of the overflowing delight and auspiciousness of god; this is not to say that power is not expressed, but it is expressed with the unconcerned potency of play.

Then, as time goes on, and the cult of ardent devotion to Krishna develops, more and more emphasis is given to Krishna's intense association with the *gopis*. What was once child's-play now becomes love-play. As we compare the accounts of the *rasa lila* starting with the *Harivansha* and the *Vishnu Purana* and progressing to the *Bhagavata Purana* and finally to the *Brahmavaivarta Purana*, we can see the transformation taking place, until heedless and selfless participation in the eternal dance becomes the final goal of all. Ultimately, by the time of the *Brahmavaivarta Purana*, as we shall see, Krishna's descent into the world appears to be only incidentally in order to do battle with Kansa and his hosts, but chiefly to involve himself in a *rasa lila* which is at once temporal and eternal, and which is both the climax and the end of his career on earth; for after the *rasa lila*

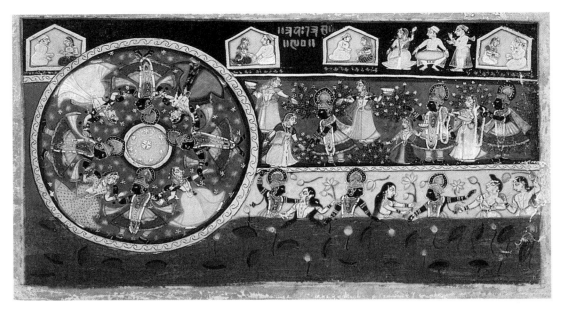

114. Rasa mandala. *(Miniature, Nathdwara c. 1780, 190 × 330 mm, Museum Rietberg, Zurich.)*

ends, he, and all of the other dancers, returned to the radiant heavenly sphere from which they came.

Looking back some thousand years before these late developments to the account of the *rasa lila* in the *Harivansha*, we find it very brief indeed. 'Beholding the charming autumnal night and the beautiful moon the powerful Krishna felt a desire (for) sporting' (53). So he first teased the cows and cowherds, and then he turned his attention, already quite ardent, to the *gopis* who, glancing and gesturing at him, 'began to assail him with their rising breasts' (54).

The pattern of the *rasa lila* is by no means fixed into the compellingly diagrammatic, cosmicized forms of later times. 'Sometimes arranging themselves in rows and sometimes in circles they, singing hymns relating to Krishna's glories, used to satisfy him... As she-elephants, covered with dust, enjoy (themselves) with an infuriated (male) elephant so those milk-women, their limbs covered all over with dust and cow-dung used to sport with Krishna encircling him on all sides' (55).

The description of these delights goes little beyond this, and whereas there is a clear implication of erotic play, it is not at all stressed, at least as compared to later texts. The account is quite straightforward, reminiscent of the kind of innocent sexual encounters that have been described in studies of tribal people in India today. The whole account might be considered little more than a description of the sensual play of pastoral youths; no philosophical or obvious theological 'meanings' appear to be attached to it. When we turn to the account in the *Vishnu Purana*, we find it strikingly elaborated, which might again suggest that the *Vishnu Purana* is indeed a slightly later composition than the *Harivansha*, although it is also possible that they merely represent somewhat different contemporary interests and attitudes. The *Vishnu Purana* devotes

much more space to the event, plots it much more thoroughly, and emphasizes the importance of an ardent devotionalism, anticipating the *Bhagavata Purana*; the *Harivansha*, by contrast, does not rationalize its simple sensuality.

As in the *Harivansha*, Krishna, moved by the autumnal moon, 'felt inclined to join with the *gopis* in sport' (56). But then the burden of action shifts to these devotees themselves, as if the whole encounter were a test of their ability to give themselves completely, in their attention and their affections, to him. Drawn to Krishna by his song — the flute, with its phallic overtones, does not appear in these earlier accounts — they approach him in a variety of ways, ranging from tremblingly shy to assertively bold. One, we read, contented herself with 'meditating on Krishna with closed eyes and entire devotion, by which immediately all acts of merit were effaced by rapture, and all sin was expiated by regret at not beholding him: and others, again, reflecting upon the cause of the world, in the form of the supreme Brahma, obtained by their sighing final emancipation' (57). Such passages already show, when compared with the descriptions in the *Harivansha*, the kind of total commitment, including but transcending sensual satisfaction, which is the goal of *bhakti*, or ardent devotion to the god.

Suggesting the rapture of their desire at identification — at becoming one with him — 'many of the *gopis* imitated the different actions of Krishna... "I am Krishna", cries one; "behold the elegance of my movements!" "I am Krishna", exclaims another; "listen to my song!" "Vile Kaliya, stay for I am Krishna," is repeated by a third, slapping her arms in defiance.' Thus, 'in various actions the *gopis* imitated him... and beguiled their sorrow by mimicking his sports' (58).

But then their passion and their pain was magnified, because he strangely disappeared from their midst, having gone off with one

single fortunate *gopi*, who (the *gopis* explain) must have enjoyed this favour because of having propitiated Vishnu in a prior existence. Even when tracks are found, they find it impossible to follow the couple into the deep forest. But finally, drawn back into their midst by the very intensity of the *gopis'* need, he reappears among them, and they are consumed with delight.

All is now ready for the great dance. However, since each of the *gopis* wants Krishna by her own side, 'the circle of the dance could not be constructed, and he therefore took each by the hand, and when their eyelids were shut by the effects of such touch, the circle was formed' (59). In other words, he created the illusion, when their eyes were closed, that each was dancing at his side; they were, in effect, blinded by their total involvement. The *Bhagavata Purana* goes even farther, for there Krishna, out of his infinite power, through the force of his *yoga*, 'multiplied himself into as many Krishnas as there were *gopis*' (60) in order to satisfy all of his partners in the dance. 'Then proceeded the dance to the music of their clashing bracelets, and songs that celebrated in suitable strain the charms of the autumnal season... The drops of perspiration from the arms of Hari (Krishna) were like fertilizing rain;... and whether he went forwards or backwards, they ever attended on his steps' (61).

Both the *Harivansha* and the *Vishnu Purana* would have us believe that this ecstatic playing and dancing continued night after night during the autumn season, despite the objections of the men, who remained at home. 'Prohibited in vain by husbands, fathers, brothers, they went forth at night to sport with Krishna, the object of their devotion' (62). In the *Harivansha* it is not clear how breaking such rules was possible, but the *Vishnu Purana* already suggests that Krishna, through his power of illusion, was able to make the men believe that the women were not actually away. 'Thus the illimitable being, the benevolent remover of all imperfections, assumed the character of a youth amongst the females of the herdsmen of Vraja; pervading their natures, and that of their lords, by his own essence, all diffusive like the wind: for even as in all creatures the elements of ether, fire, earth, water, and air, are comprehended, so also is he everywhere present, and in all' (63).

The later *Bhagavata Purana* is even more explicit about this divine device: 'The male dwellers of Vraja were not jealous of Krishna, for they, being infatuated by the energy of His illusion, considered that their wives were always present by their sides' (64). The suggestion is that Krishna not only created duplicates of himself for each of the women in the dance, but that he also, through his infinite powers of illusion, created duplicates of the absent women, so that they would not be missed at home. Thus the cowherds too were in intimate contact with the lord, during the whole rapturous period of the dance. The feat recalls the way

in which, in another episode first reported in the *Bhagavata Purana* he created, as it were from himself, duplicates of all of the cowherds and the cows which Brahma had stolen away (65).

The account of the passionate preludes to the *rasa* dance, and of the climactic ecstasy of the dance itself in the *Bhagavata Purana* far outdoes the description in the earlier accounts. Called now by the flute, 'that fortunate instrument which is drinking the nectar from Shri Krishna's lips', the women hasten toward him with no thought of self, of family responsibilities, or of societal conventions whatsoever. Perfectly absorbed in their impassioned devotion — expressing perfectly the ideal of *bhakti*, 'some went away leaving the milk they had been boiling over fire; others flew to him without even taking down the preparation of wheat they had been baking;... some had been suckling their babies, some had been serving their husbands;... All these gopis... flew to Krishna, their garments and ornaments having fallen off from their persons in consequence of their great hurry' (66). Some, confined in their houses, and without any hope of meeting him meditated upon him unceasingly nonetheless; and as a result 'the sins of these women melted away;... attaining the supreme soul, ever by meditating on him as their beloved, they instantly renounced this corporeal frame... for their bonds of actions had been broken' (67).

More than in the earlier accounts, the precipitousness of the *gopis'* flight into the forest is now stressed; and when they finally find the fluting lord, the dramatic tension is increased by Krishna's teasingly non-receptive attitude, to which they respond with such deep distress, that he finally allows them the delight of his embraces. But no sooner are the *gopis* lost in these pleasures

115. Illustration to the Gita Govinda. *(Miniature, Orissa c. 1800, 150 × 225 mm with borders, National Museum, New Delhi [ref. 49.19.83].)*

than, to humble their pride at feeling so desired, he disappears completely, and their painful search for him begins. Now once again, the intensity of their passionate longing — their mind-obliterating devotion — brings him back to them, and the story again instructs the listener about the way that one must give oneself completely, if one is to become one with the lord.

Finally, 'to show grace to His devotees' (68) Krishna joined them all together — himself between every pair of women — and began the seemingly endless involvements of the dance. The moon and the stars, and the gods with their wives in their sky-borne chariots, were all amazed. Again, much more than in the earlier texts, the whole universe participates in the celebration, and considerations of time and space are obliterated. Furthermore, the dancing, which in the *Harivansha* and the *Vishnu Purana* took place on a series of different nights, now is one unified, indeed cosmicized, event — one great vortex of delight into which all must ultimately be whirled, and by which all shall ultimately be transformed.

The intensification of devotional commitment which is revealed in the *Bhagavata Purana* account of the *rasa lila* is characteristic of the whole text, which was probably composed in southern India, and influenced by the ideal of ardent surrender to the lord which characterized the rituals and the writings of the *Alvars* in the period around A.D. 800 (69). The goal which Krishna proclaims to the *gopis*, of having their hearts so absorbed in him that 'they will not perceive anything else' (70) is the goal of the *bhagavata*, the true worshipper, and the *rasa* dance perfectly exemplifies this loss of self in god, this giving up of everything outside of god, in order to find true union. Couched in the erotic metaphor, which perhaps alone can express the urgency and the ecstasy of pure *bhakti*, or devotion, the descriptions of the deepening association between Krishna and the devotee become increasingly passionate as the popularity of the cult grows in later centuries, culminating in the poetry of Jayadeva and his successor (see Krishna in Poetry). This unrelenting devotionalism is very different from the more sober and contemplative *bhakti* of an earlier day. Arjuna, in reverencing Krishna in the *Bhagavadgita*, when the cosmic form of the lord is manifested to him, feels awe and terror and necessary separation; he cannot fling himself into this maelstrom of the divine, into such a totality of revelation. 'Show me your other Form, O Lord, be gracious' he finally begs (71). In contrast, the later *Bhagavata* proclaims: 'Without the bristling of the hair of the body, without the mind dissolving, without being inarticulate because of tears of joy, without *bhakti*, how can the heart be purified?' (72)

Without completely letting go, one cannot be bound. The goal of the true devotee is complete destruction of the need, the desire, for things peripheral to god. This is what the *gopis* leave behind, when they compulsively

116. Dancing Krishna. *(Bronze, southern India, c. 13th century, Private collection.)*

go forth at the sound of Krishna's flute — that 'voice of eternity, heard by the dwellers in time'. Their husbands; their babies; the milk boiling over on the fire; the wheatcakes in the oven; time; space; convention: these are symbols of that which, ultimately, is insignificant. The sound in the forest, the centre where self is lost, that is what overcomes *sansara*, the round of rebirth, the bondage of *karma*. This is why, for the *Bhagavata*, the *rasa lila* goes on forever, with no beginning and no end, deep in the forest of the heart.

It is interesting to compare the impassioned sensuality of the descriptions of the association of the *gopis* with lord Krishna in the *Bhagavata Purana*, and to some degree in earlier *Bhagavata* texts as well, with the similarly exuberant descriptions of the meeting of Prince Siddartha (the Buddha-to-be) with the maidens of his court, when they meet in the garden.

In the *Bhagavata Purana* we read: 'One of the damsels placed her cheek on Krishna's, which was beautified by the lustre of his earrings that were oscillating in consequence of the movements of his body in dancing. Then Krishna gave unto her mouth the betel which he had been chewing. Some of the milk-women sang and danced, producing a jingling sound with the (ornaments) on their legs. Being tired they drew the auspicious hands of Krishna onto their breasts and their fatigue was removed' (73).

In the *Buddhacharita* of Ashvaghosa, a much earlier text which already manifests ex-

uberant modes of description which may well have influenced, or at least interacted with, the developing *bhakti* cult in Hinduism, we read: '... some of the young women there, pretending to be under the influence of intoxication, touched him with their firm, rounded, close-set breasts. One made a false stumble and clasped him by force with her tender arm-creepers, which hung down loosely from her drooping shoulders. Some walked up and down so as to make their golden zones tinkle and displayed to him their hips veiled by diaphanous robes. Others grasped mango-boughs in full flower and leaned so as to display bosoms like golden jars' (74).

However, Siddhartha's response to such blandishments is hardly one of joy. 'Despite such allurements the prince firmly guarded his senses, and in his perturbation over the inevitability of death, was neither rejoiced nor distressed. 'My mind', he said, 'does not delight in (the objects of sense) because I hold them to be transitory... A man who, himself subject to death, disease, and old age, sports unperturbed with those who are subject to death, disease, and old age, is on a level with the birds and beasts' (75).

To Krishna, on the other hand, the ascetic compulsions of Siddhartha are completely foreign; indeed asceticism is almost the only approach to truth that Krishna does not at one time or another recommend, over the course of his long historical career. Of course occasionally Krishna may reject such erotic overtures, but if he does do so, he does so only temporarily, and always playfully — or perhaps didactically, in order to instruct. He is not averse to teasing, or acting fickle, or pretending to be disinclined, if this will, in the end, intensify the connection sought by the devotee. 'O damsels!', Krishna says in the *Bhagavata Purana*, 'Thus in order to intensify your affection for me I disappeared, forsaking you who have for my sake renounced your sense of worldly right and wrong, your relatives and your duty. Though I did hide myself from your sight, yet my heart was attached to you all' (76).

The *Bhagavata Purana* even recognizes that the goals of *bhakti* can be achieved by an intensity of communication quite removed from a knowledge that the focus of one's devotion is the divine. How, King Parikshit asks a sage, could the *gopis* achieve the goal of a total attachment to and identification with god, when they did not even know that the object of their passion, the lord Krishna, was anything more than a beautiful man? In response, the sage explains that the meditation upon god, the loss of the constraints of self, is in itself enough — that even those who focus on Krishna only through hatred, or through fear, or through other such qualities, can attain emancipation, if their attention is totally fixed upon him; for 'through his agency even the immobile creation may be emancipated' (77).

'So', the sage continues, 'it behooveth thee not to wonder at the deeds of the almighty and unborn Krishna, who is well-versed in the *Yogas* and is Ishvara (i.e. the supreme lord) himself' (78). It is enough to involve oneself in the mystery for how can one comprehend it?' 'The desires of persons having their hearts engrossed in me', Krishna says elsewhere, 'do never again incline towards the enjoyment of gross worldly objects' (79). If one is in contact with god, even unknowingly, what then can be beyond the self?

If the erotic metaphor is very developed in the above description of the *rasa lila*, and in a few other sections of the *Bhagavata Purana*, such as the story of Krishna's theft of the *gopis'* clothes — an episode which is not found in the earlier texts — such modes of description go far beyond the bounds of expectation in the *Brahmavaivarta Purana*, a very late compilation of uncertain date, perhaps as late as the 16th century A.D. This text, strongly influenced by the passionate *bhakti* literature of the same general period, and also reflecting late tantric developments, heightened the description of the *rasa lila* to peaks of sensual frenzy which can hardly be sustained, and are virtually unparalleled in any other religious texts, in India or elsewhere.

Here a new figure enters the equation too, at least with regard to the accounts with which we have been concerned. This is the cowherdess Radha. Possibly prefigured in the unmarried *gopi* whom Krishna accompanied into the forest in the *Bhagavata Purana* (see page 57), and mentioned in a few other texts of about that period, she finally came into great prominence in Jayadeva's *Gita Govinda* in the late 12th century A.D. (80). There, as Krishna's beloved, Radha is revealed as the paradigm of devotion, the perfect *bhagavat*, whose ecstasy in union with her lord can finally symbolize the bliss of the individual soul in the realization of union with divinity. So attached is she to Krishna, and he to her, that she is represented in the late *bhakti* texts as his divine equivalent. 'You become Radha', Radha says, in a later poem by Sur Das which expresses this same idea, 'and I will become Madhava (Krishna)' (81). Through her passionate devotion she has transcended the trammels of the world, the attachments of the self, and points a pathway to all to let an all-consuming devotion be their guide.

The *Brahmavaivarta Purana*, however, goes far beyond such texts where Radha's identification with the god and her ascendancy as the goddess incarnate is only tentatively revealed; where it is implied rather than asserted. In the *Brahmavaivarta Purana*, she is identical with Krishna from the start. The lord Brahma proclaims to her: 'You are the outcome of the body of Krishna and equal to him in every respect. No one can say which of you is Radha or Krishna... (He) represents the soul of the world and you are its body and receptacle... For a wonder, it is impossible to make out which architect is at the bottom of this creation. You are eternal like Krishna' (82). 'When one of us is wanting', Krishna says, 'there can be no creation' (83). According to the *Brahmavaivarta Purana*,

Krishna's status is very different from that of a conventional avatar of Vishnu, even though he does descend — or perhaps one should say 'display himself' — to the temporal world. He is the highest, the ultimate divinity. 'Maha-Vishnu who holds a universe on each of the pores of his skin is but a sixteenth part of (Krishna)' (84). Krishna presides, inseparable from Radha, 'as the whiteness of milk is inseparable from milk' (85), over the highest of all the supreme worlds — Goloka, the Cow-world. Goloka is higher than Vaikuntha, Vishnu's heaven, itself. 'An embodiment of light... capable of being seen or attained only by Vaishnavas, that Cow-world, devoid of mental or bodily pain, disease or decrepitude or death, sorrow and fear, is fixed in the sky solely by the meditative power of the Supreme Being (Krishna)' (86). And if Krishna is the informing spirit, Radha, as the eternal, productive goddess, is praised by Krishna as equally essential. 'As the potter cannot make a jar without clay, so I cannot create without you... Oh Goddess, you are always my container...' (87).

The appearance of Radha, as separate from Krishna, in the Goloka, is an immediate consequence of the desire of the god. 'The willful Lord Krishna desired to commit sexual intercourse. At once Radha came into existence; as everything is done by the will of God. At that time, Krishna, who is all volition or desire... divided himself into two parts. The right side of his body became Krishna; the left side became Radha. The lovely Radha in the sphere of the Rasa wanted intercourse with Krishna... The jovial Krishna was excited with lust at the sight of his young licentious spouse who was bending under the pressure of her huge but-

117. Radha joins Krishna in bed. *(Miniature, detail, Kangra c. 1800, Rutland Gallery, London.)*

tocks. She ran to her husband when she saw that he was excited with passion' (88).

And then, 'for a wonder... from the pores of the skin of Radha a number of cowherdesses equal to Radha in beauty and toilet came into existence. The sages who can calculate figures estimated that the above cowherdesses were lac-crores in number.' '... Simultaneously from the pores of the skin of Shri Krishna sprang cowherds equivalent to Him in apparel and matchless beauty. The above sages calculated the number of these cowherds whose beauty the Shastras cannot describe in words to be thirty-three crores. At that time, again, from the pores of the skin of Shri Krishna cows of various hue and of permanent youth, countless bulls... and other innumerable cows that fulfil desires sprang into being' (89). Thus was Goloka filled, becoming an embodiment in the celestial realm of the 'earthly paradise' of Gokula on the earth. Krishna, as we can see, above all other gods, and with him that other part of himself, the divine Radha, is both the source of all creation, and the final goal of all devotion.

The Cow-world, where Radha and Krishna reside, 'of all the worlds... is the most expansive like the sky. By the will of Lord Krishna, it manifests itself like an egg. In the beginning of creation, it was moistened with the perspiration of the Supreme Being (i.e. Krishna) while he was flirting with the goddess Nature (i.e. Radha)... Situated at a distance of fifty crores of yojanas above the excellent Vaikuntha (i.e. Vishnu's heaven)... it contains many temples of precious gems... excellent diamond-pillars and gates lighted up by looking-glasses of pearl... It is encircled by the river Viraja and decorated by the mountain of a hundred summits' (90).

'In the midst of this best of all best worlds the Lord Krishna constructed the radiantly beautiful forest Vrindavana for the satisfaction of Radha' (91). It had 'five hundred millions of bowers which were lighted up with diamond lamps, redolent of frankincense, replete with tasteful objects and filled with bedsteads that were covered with wreathes and anointed with sandal. It resounded with the hum of bees attracted by honey and was encircled by damsels, gorgeously clad. The Vrindavana contained thirty-two lovely forests guarded by five hundred millions of cowherdesses at the instance of Radha' (92).

This lovely Vrindavana, where Krishna and the *gopis* are eternally sporting, occupies fully half of the celestial Goloka; and fully half of Vrindavana is occupied by the sphere of the Rasa. 'Circular and excellent, (the sphere of the Rasa contains) a thousand groves of flowers with clusters of bees and mansions of pleasure... constructed with gems... Besmeared with white paddy leaves, fried rice, fruits, bentgrass, sandal, aloe, saffron and musk, (it is) surrounded by ten millions of cow-herdesses decked with ornaments and wreaths of gems (possessing) arch glances and gentle smiles, (and)... inflamed with passion' (93). It is on that circular dancing

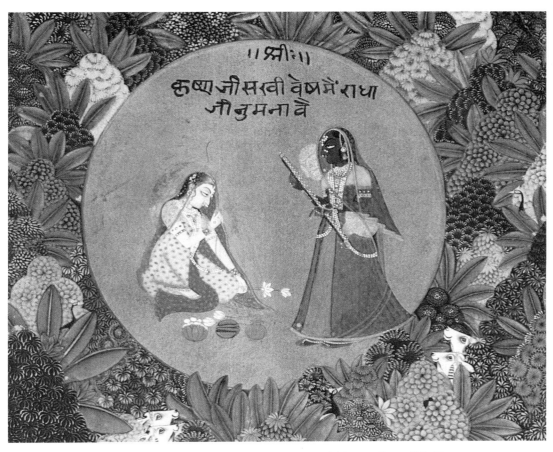

118. Krishna dressed as sakhi. *(Miniature, Bundi c. 1790, 225 × 307 mm, Bharat Kala Bhavan, Benares [ref. 10692].)*

ground that Shri Krishna, 'decked with a yellow dress pure like fire and ornaments of gem, besmeared with sandalpaste and adorned with wreaths of pearls' (94) sports with the *gopis* in their endlessly ecstatic dance. And there the eternal Radha, 'the mistress of the Rasa, always serves Lord Krishna' (95). But if this is a picture of bliss, of wholeness, of union, fate decreed that for Radha the enjoyment of these delights, and of this delightful land, had to be interrupted. For she was cursed, after a quarrel, to descend to earth. 'You will be born a woman' her antagonist, Shridama, said, 'and wander over the earth as a milkmaid' (96). Then Radha, afraid, said to Lord Krishna... 'O destroyer of fear, what means shall I adopt? How can I live without you? You are my life, soul, vision, and I am merely the body... My master, I cannot live without serving you for a single minute' (97). 'Lord Krishna thereupon consoled her, and said: 'Fair one in the Varaha age, I shall descend to the world... It has been pre-destined that you will go with me and have your birth there. Goddess, there I shall go and make merry with you in the forest of Vraja... Why should you fear, when I am by your side?' (98)

'This is why the Lord of the universe went to Gokul,' the *Purana* explains, 'in the guise of a cowherd, to fulfil his vow he sported with Radha and the cowherdesses' (99). The old reason for Krishna's descent — to kill the demon King Kansa and to set the temporal world aright — is hardly more than a minor

justification now. His real goal is delight — to bring down to earth and earthly beings the purifying play of heaven.

In due course, Radha took her earthly birth in Gokula as the daughter of one 'Vrishabhanu, the best of Vaishyas' (100). Then, at age twelve, she was married to a youth named Ayana or Rayan, the brother of Krishna's foster-mother Yashoda. We are assured, incidentally, that this Rayan was actually an incarnation of Lord Krishna himself; and we are further assured that Radha herself was born only as a 'shadow' (i.e. in illusory form) in Gokula. The text declares: 'to this shadow Rayan was married. The people of Gokula can not observe the real (celestial) Radha even in dream. Radha personally used to frequent the lap of Krishna. The shadow or phantom resided in the house of Rayan' (101).

Thus it is clear that Radha's marriage to Rayan was ephemeral and incidental; in fact, an illusion. She was, in truth, the spouse of the supreme Lord Krishna. Indeed, in their first encounter, as described in the *Brahmavaivarta Purana*, this is made clear. Krishna, who had also taken incarnation in the temporal world, a few years later than Radha, was living as a child in the house of Nanda and Yashoda. One day when Nanda had taken the child Krishna to Vrindavana to graze the cows, 'through the illusion and the supernatural powers of the boy, the sky (became) overcast. The forest assumed a dark-blue aspect. There was an outburst of

119

storm and tempest and the trees, agitated by the wind with very great force, quivered' (102). Nanda, occupied with the frightened herd, did not know what to do with his son, but by good fortune — or by divine desire! — Radha suddenly appeared and offered to take him home. '... The charms of her features', we read, 'marked with musk and vermilion were extraordinary... The nipples of her breasts were hard and graceful... Her belly was round and her graceful navel was inclined downwards. The zone round her waist was constructed with gems' (103).

Then Radha, with the child she had taken from Nanda, 'went to a desireable place at a distance, (and) excited with passion, clasped and kissed him, again and again, with a thrill of raptures'. She was reminded of the sphere of the *rasa*. And then, on a floral bed inside a gem-built house in that *rasa*-sphere of which she was reminded, 'she found a youthful being, dark-blue in appearance, lovely and in the prime of his youth... His features seemed to have stolen the beauties of the full moon; his eyes looked blooming like the autumnal lotuses' (104).

Then Lord Krishna looked at the smiling Radha... and said, 'My beloved Radha, recollect the days of the Goloka. I must fulfil the promise which I held out to you. You are dearer to me than my life... You are the container of the world and I am the cause. Therefore, O chaste one, come and occupy my heart. As an ornament decks the body, come and deck me likewise' (105).

Suddenly the lord Brahma, the priest of the gods, appeared, wishing to perform a marriage ceremony for them — a curious new in-

119. Krishna makes love to Radha. *(Ivory, Orissa c. 17th century, Private collection.)*

cident which does not appear in the earlier *Puranas*, where the unmarried (*parakiya*) relationship is stressed. While he did so, 'the gods played upon drums and trumpets' (106). Then, when Brahma had departed, Radha 'was excited with lust; and a thrill of rapture animated her frame... She... went to the sleeping room and applied the paste of aloe and sandal mixed with musk and saffron to the chest of Lord Krishna... Then Lord Krishna held Radha by the hand, embraced and kissed her and loosened the cloth which covered her body. O saint, in this war of love, the small bell worn by Radha as an ornament was torn from her body; the hue of her lips was removed by kisses; the paintings with cosmetics were wiped out by Krishna's embrace; the chignon was dislocated, the mark of vermilion was obliterated by the sexual intercourse and the lac-dye paintings on her feet removed by the sexual intercourse performed in an inverse order. There was a thrill of raptures in her body owing to the excitement... she nearly lost her reason and could not distinguish day from night...' (107)

But then, later on, while the distracted Radha 'busied herself in securing ingredients for the toilet of Krishna, he ceased to be a youth and took the form of an infant again. He was weeping out of hunger and resumed exactly the same condition in which Nanda had left him' (108).

'With the speed of wind, Radha went... to Nanda's house and... she handed over the child who was bathed in her own tears to Yashoda saying... 'God lady, take and suckle him. I have been away from home for a long time. I am going to my place now... So saying, she went away. Yashoda took him in her lap, kissed and suckled him. Radha busied herself with domestic affairs, but every day she came to the sphere of Rasa and sported with Hari (Krishna)' (109).

This mysterious juxtaposition of higher and lower realities continues throughout the extended descriptions of Radha's and Krishna's life in the cowherds' village. For in truth, just as the celestial realm of Goloka is a crystallization and an amplification of the charming environs of the earthly Gokula — a projection, beyond the boundaries of time and space of the ecstasy-filled fields of Vrindavana, where the cowherd Krishna danced — so also those earthly fields and forests are, to those who dance in them, a projection into the world of time and space, of the ecstasy-filled realms of Radhakrishna's highest heaven. For the true devotee, there is no discontinuity between them.

'Lord Krishna', we read, 'constructed Vrindavana in the Goloka for the satisfaction of Radha, and when a grove was set up on earth also for her gratification, it was famed by the name of Vrindavana' (110). ('As above, so below', as Heraclitus said.) It was here, in the delightful autumn season, that Krishna had promised the cowherdesses: 'In the sphere of the Rasa, you will sport with me... As I am, so you are... I constitute your life and you constitute my life... You have

descended to the earth along with me from the Goloka (and, after the duration of this descent) you will go back with me to the Goloka' (111).

Thus it is clear, in the *Brahmavaivarta Purana* account, that the whole descent into the earthly Vrindavana is a revelation of godhead, which is delighting in and continually discovering, continually displaying, itself. The duration of the descent is mysteriously equivalent to the duration of the dance; for the descent is indeed nothing other than the dance, when the whole of the earth, out to the farthest horizons of the heart, has become a dancing-ground.

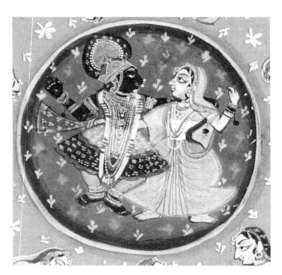

120. Rasa mandala. *(Miniature, detail, Nathdwara c. 1780, Private collection.)*

Krishna, in the celestial Goloka, in his perpetual self-revelation, produces (or one might better say *comprises*) the whole hierarchy of heaven, the whole celestial schemata of cowherdesses and cowherds and cows, together with the superb environment in which their (or his) eternal play proceeds. And so that the earthly devotee can join the dance, or one might better say *because* the earthly devotee has joined the dance, the celestial *lila* proceeds without distinction in the terrestial sphere as well. The godhead's constant dalliance in self-delight produces an overflow of bliss available to every one of the fluting cowherd's devotees — to all of the people of the earth who hear his call. Losing themselves as *gopis* in the rapture of their dance, they finally find themselves, as part of an all-embracing, exuberant divinity which they themselves sustain by their devotion. In these late manifestations of the *bhakti* movement, which push to a blissful extreme the already blossoming devotionalism of the *Bhagavata Purana*, the Krishna who is sought seems oblivious of King Kansa and unconcerned about the oncoming destruction of his city by the sea. 'He has no mission, seeks no prestige or power; he simply overflows himself... He simply lifts the curtain, as it were, on his innermost being, which is revealed to be self-delight... (The

godhead) is shown to revel in its own incomparably joyful being by playing with itself, making love to itself, inciting itself to abandon itself in itself' (112).

Thus the frenzied fusing of the dancers in the *rasa lila* of the *Brahmavaivarta Purana* is not a metaphor for the bliss which the devotee can realize in conjunction with divinity; it is a revelation of that bliss, of which Radha is the eternal embodiment, and Krishna the eternal source. Vrindavana, the dancing ground, is the world in which the world is forgotten, the magic world of Krishna's youth, continually blossoming back into itself, out of its own delight.

121. The call of the flute. *(Miniature, Deccan c. 1760, 168×260 mm without borders, Bharat Kala Bhavan, Benares [ref. 190].)*

Then, Shri Krishna 'played upon his lovely flute to excite the lust of the milk-maids. Radha with a heart full of passion, swooned at the melody. Her mind and soul dissolved with the tune... She was thereupon very much excited... she then laid aside her necessary duties, rushed from her house, and looking on all sides, (hurried) onward in the direction from which the sound of the flute was proceeding' (113). Along with her came her thirty-three chief attendants, and with each of them many thousands of other *gopis*, carrying garlands, and sandal paste, and musk, and saffron, all singing and shouting in praise of Krishna. And Radha, with her enchanting walk, her face like the full moon of autumn, and her great loins and buttocks, was wonderfully beautiful. Then Krishna

himself, 'dark-blue in appearance and extremely handsome', suddenly struck by the arrows of love, 'stood up before her senseless like a stone. The flute and the bright lotus used as a toy dropped from his hands. The yellow dress and the plumage of the peacock likewise slipped from his body' (114).

'Then the destroyer of Madhu ate with pleasure the fragrant betel leaves offered to him by Radha. Radha, the mistress of the Rasa, also merrily chewed the betel given to her by Krishna. When Hari gave Radha the betel-leaf chewed by him, the passionate Radha smiled and cheerfully and reverentially ate it up... Then the most witty Hari committed with her the eight kinds of sexual intercourse (adverse, etc) systematically assailed her with teeth, nails and hands and kissed her in eight mysterious ways consistent with the doctrines of sexual science and delightful to the ladies... At the time of sexual intercourse the passionate Hari with the different members of his body embraced delightfully the different members of the bodies of the lustful damsels... so the war of love knew no intermission. Thus the lord of Radha assumed identical forms at one and the same time and entering into every chamber committed sexual intercourse with each and every woman in the lovely sphere of the Rasa... In his intercourse with nine lakhs (nine hundred thousand) of milkmaids, he assume nine lakhs of forms of cowherds... The hair of every one were dishevelled, the ornaments of every one were shattered. That place solely resounded with the noise caused by armlets, bracelets and anklets. Every one was infatuated with passion and fainted' (115).

The play, and the passion, only increased. Time stood still, as Krishna and the *gopis* further explored their permutations of delight, taunting and frolicking with each other. Finally, 'as a mountain is decorated with red chalk, so the body of Lord Krishna also was decorated with the scratches caused by the armlets and with the lac-dye (from)... the feet of the milkmaids' (116). Then, 'when this game of Rasa... was in full swing, the gods with their wives and attendants mounted the golden car and assembled in the heavens. The sight of the sports sent a thrill of emotion across their bodies and afflicted them with (love)... The gods... showered on the scenes sandal-liquid and flowers. Some of them were spell-bound; others almost fainted. The saints showered on the assembly wreaths perfumed with musk. The goddesses were animated with passion at the sight' (117).

Krishna and Radha, always pivotal to the *lila*, (which they indeed produced), then entered into the waters of the Yamuna, along with all of the *gopis*, each accompanied by one of the endless forms of Lord Krishna. 'The passionate Krishna, in the first place, sprinkled Radha's body with water. Radha also poured three handfuls of water on the body of the passionate Krishna' (118). Then Krishna snatched away the clothes of Radha, tore off her flower garlands, and treated her with such urgency in the water that 'the

wonderful hue of her lips and the linings of her eye with collyrium were all obliterated by (its) churning... Then Krishna, having displayed the abashed, naked Radha to the cowherdesses threw her again... into the water. Radha got up in haste..., seized Krishna by force, took away his flute in anger, cast it at a distance, snatched his yellow garment, tore the wreath of wild flowers and (threw) water on him again and again. Then Radha dragged Hari and gave him a push whereupon the Lord of the universe was immersed in deep water at a distance. But shortly afterwards he emerged from the liquid with a smile (and) kissed and embraced the naked Radha, again and again. In this way the imaginary forms of the Lord (also) merrily played with the cowherdesses on the coasts of the Yamuna and within the water' (119).

The milk-maids having wantonly played with Hari in the sphere of the Rasa played with him again on different occasions and in different places, in some lovely solitary place, in a grove of flowers, on the coast of a river, in the cave of a mountain, in a crematorium, in the forest of the holy fig tree, in the Vrindavana, in the pleasing forest of the Kadam, in the forest of Nim, in the wood of the holy basil, in the grove of Kunda, in the Madhuvana, in the forest of lime, cocoanut, areca nut, plantains, plum, bamboo, pomegranate, peepul, bael orange, mandar, palm, mango, screwpine tree, Ashoka, date, emblic myro-bolan, rose-apple, sal, thorn, lotus, jaminum grandiflorum, Indian-fig tree, sandal and kesara. In these 33 forests very much liked by girls they passionately sported for 33 days and yet their desire was not satisfied. Their passions instead of being satiated increased like fire fed with clarified butter. The gods and goddesses were very much astonished at the sight and eulogising the scene went home. Subsequently actuated by the desire of sexual intercourse with Hari, the passionate goddesses assumed their birth in the houses of kings in India... (120)

When one's 'greed' for Krishna reaches a certain point (when it approximates that of the *gopis*) the injunctions of the *Shastras* and *Vedas* become irrelevant (121). This is the significance of this startling late description of the *rasa* dance, and of the *gopis'* participation in the dance. Lost in their world-obliterating devotion, they have transcended all convention, become careless of all 'appearance'.

The dance is endless, because the revelation of Krishna is. It goes on forever, both in the universe and in the heart. And it does not satisfy: '... their passions instead of being satiated increased like fire fed with clarified butter' (122). Pure butter, the essence of godhead itself, inflames the soul. When one is finally assaulted by that reality, participates within that overflow with such intensity, one cannot get enough of God.

The dance can also be here. The world upon which the love-struck goddesses look down from their seats in the skies above, and into which they wish to be reborn, is not the world of Goloka; it is the world of Gokula, the world of time, when time suddenly stops. It is in *this* endlessly blossoming world that Krishna so radiantly reveals and revels in himself, continual and complete. And it is here, where Krishna is, that the radiant devotee can find that passionate stillness — that final union with divinity where everything beyond the union stops.

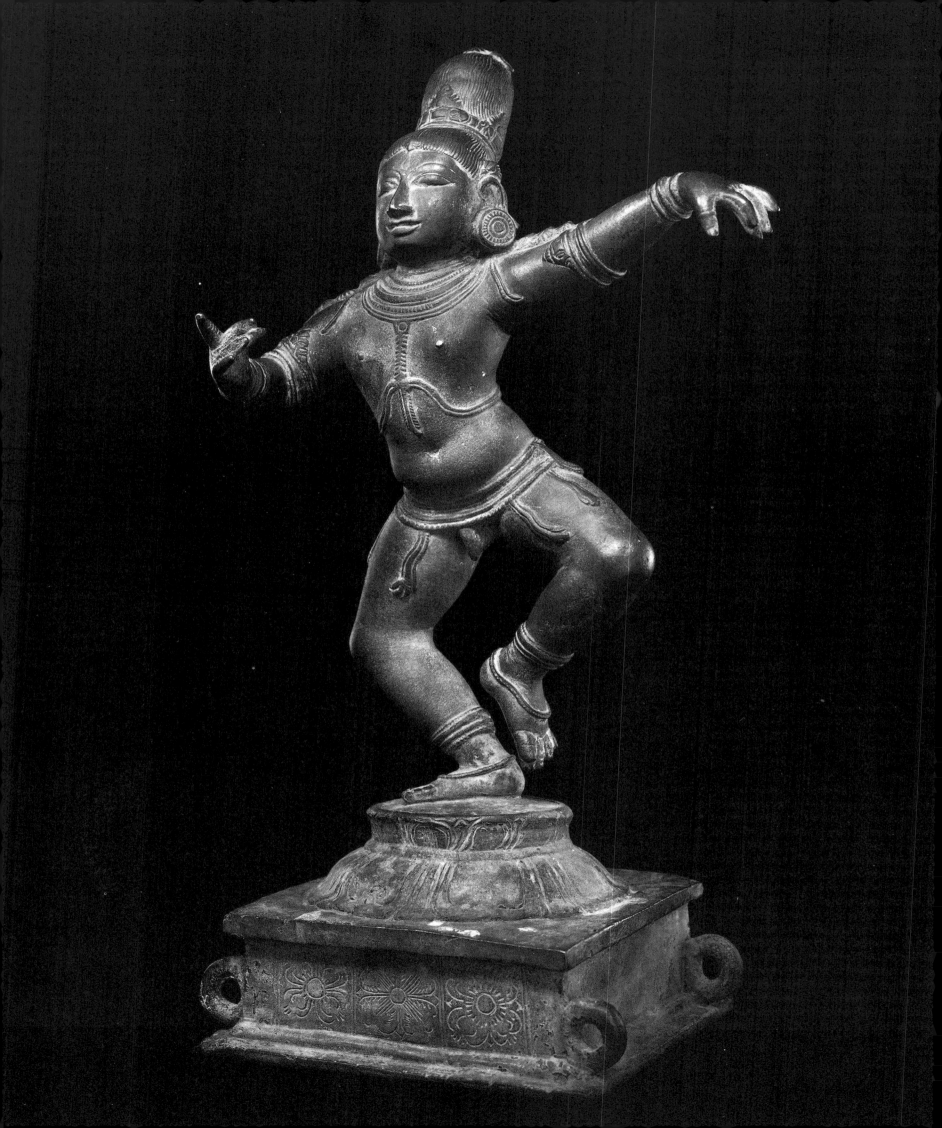

The Cult
by Dr. K. Goswamy

122. Dancing Krishna. *(Bronze, southern India 12-13th century, Private collection.)*

RITUAL

There are countless forms of worship in Hinduism of which the following three are the most widely known: the foremost and highest form of devotion is the worship of Brahma in his purest, most abstract form, Brahma without attributes (*nirguna*). This is based on the 'realization of the identity of the self with Brahma'. The second is the worship of Brahma as the creator, the ruler, the Lord of life and death, i.e. Brahma with attributes (*saguna*). The most popular form of devotion is the third, the worship of a *pratika*, or symbol of the deity especially meant for those incapable of higher meditative effort. Ritual is essential in all forms of Hindu worship. There are two main types of ritual: one is the *Vedic*, based on the *Vedas* and their commentaries; the second is *agamic*, i.e. based on the traditional religious teachings contained in non-*Vedic* texts called the *Agamas* (lit. 'that which has come down', traditional teaching). The *agamic* ritual is generally based on the adoration of the idols, which of course varies according to the sect. There is a distinction to be made in all rites and ceremonies between those which are obligatory and those which are optional.

Various acts of homage are paid to a deity which is installed in a temple or in a private home. They are referred to as *upachara*. There is no fixed rule for the method of service, nor is there a prescribed number of items constituting the service. The Vaishnava *upacharas* are generally numbered up to sixteen, other sects or *sampradaya* have more; in any case the number varies considerably. Out of this variety there are, however, some ten *upacharas* which are the most important and should be briefly explained here:

Prabodha-'awakening'
This takes place at dawn, when the doors of the chamber in which the deity is enshrined are opened. The chamber is then cleaned by priests and attendants.
There may be a midday sleep, as well as some longer periods of sleep observed by some of the major deities during certain months. In such cases there are special 'awakening' ceremonies.

Snana-'bathing'
After being awakened the deity gets a ceremonial bath, is anointed with sandalwood paste, dressed in fresh robes and decorated with fresh flowers.
This part of the ceremonial takes place behind a curtain placed between the idol and the devotee. The sound of a little bell held by the priest punctuates the various phases of worship.

Avahana-'inviting'
This is the act of invocation, the calling upon the god by his name or his appellation.
Sacrificial offerings are then placed before a holy fire, the conch-shell is blown, the bell is rung in order to summon him.

Archaka-'adoration'
On his arrival, the god is welcomed with a formal salutation (*namaskara*) and with a reverent salutation (*pranama*). Then the deity will be presented with garlands of flowers, will be offered a seat, will be given water with which to wash the feet, and for ablutionary sipping (*achamana*). It is interesting to note here, that exactly the same services are offered to the *guru*, or preceptor, and to distinguished guests.

Pradakshina-'circumambulation'
The rite in which the devotee walks around the image clockwise. The same applies to the *guru* or to the distinguished guest.

Balidana-'offering of gifts'
This act consists of various offerings known by the general term of *bali*, generally consisting of rice, grain, clarified butter. There are also other kinds of offerings such as: flowers, water mixed with perfume, saffron, mustard seeds and other spices, incense, betel, sandalwood paste which is then applied to the forehead.

Arati-'waving'
The ceremony of waving a lighted lamp before the image. The waving takes place in a clockwise direction and is accompanied by the recitation of sacred formulas (*mantras*).
The purpose of this rite is to please the deity, as well as to protect it from the evil eye.

Prasada-'favouring'
The devotee, with this act, seeks the favour of the deity through the offering of food. The term *prasada* refers also to the food so offered. Offering of food takes place in the morning, afternoon and evening. In larger temples food is offered more frequently. At Puri, for instance, refreshments are offered to Lord Jagannath 52 times a day.

Prarthana-'supplication'
The devotee makes his own request to the deity.

Visarjana-'dismissal'
The last part of the ceremonies, when the deity is bidden farewell and takes his leave (1).

In the course of this brief description of the main *upacharas*, we have noted that the *guru*, or preceptor, and the god are treated very much alike. This may seem strange in a Western context but, in the Indian social and religious system, the *guru* is a pivotal figure. The word *guru*, according to the *Advaya taraka Upanishad* (*14-18*) can be interpreted as follows: the syllable *gu* means 'darkness', the syllable *ru* means 'dispeller' so the *guru* is the one who 'dispels darkness' (2). There are, however, other interpretations of the word as, for instance, the one by which *guru* means the 'the Weighty One', the spiritual quality of the *guru* being thus expressed in measure of quantity.

The *guru*, in olden times, used to receive his pupils in his own hermitage. The pupils worked for him in the household and paid him great reverence as well as giving him complete and implicit obeisance. This was the case in the educational as well as in the religious system. There was a very close relationship between the *guru*, who was a sort of spiritual father, and his pupil. This fact is further stressed by the disciple's being prohibited from marrying his *guru*'s daughter, as she stands in the relation of a sister to him. Nowadays a *guru* acts as adviser to all who seek spiritual guidance and in this function he is distinguished from the family priest, whose task is almost limited to the performance of specific rites.

In the religious system a deity is regarded as the founder of a particular order; as such he is the 'first *guru*' of that order. Each successive *guru* is thus taken to be the embodiment of the founder deity and the last of the line of succession starting from the god. The *guru*, being the deity incarnate, is the only one capable of giving salvation. After his death, a disciple designated earlier by him becomes the *guru*. As a result the *gurus*, or leaders of the various religious orders, are said to have been initiated either by the previous *guru*, or by the founder god himself during a vision.

The compelling need for a spiritual guide capable of giving initiation to a pupil is dictated by various factors. For one, important truths very seldom come through the study of texts, or through independent meditation. They are generally the result of 'inherited wisdom' handed down from preceptor to pupil. The esoteric truths can therefore only be transmitted by one who has been divinely appointed to receive them in the first instance. The most secret tenets of the cult are 'stored' in the *guru* and the mere formality of teaching these truths or uttering the sacred syllables of a *mantra* will not convey enlightenment unless done so by the *guru*. Practical initiation is therefore impossible without the help of the *guru*. In cult-practice, the selection of a suitable *guru* is not to be dispensed with; whether, however, the selected *guru* will accept a particular disciple or not, is another matter.

To understand Krishna, or at least the devotee's approach to him, we shall deal here with the rites and ceremonies connected with him. In these, there is much that Krishna shares with Vishnu, or any of his other incarnations, for the rituals and the religious practices of the Vaishnavas have a character of their own; to the worship of Krishna, however, there is another aspect: an element of joy and celebration.

There are two very important words which shall be explained here, in order to understand what is to follow. These are: *puja* and *seva*. Puja means 'adoration'. The origin of this widely used term is still unexplained, but it is thought by some authorities to derive from the Dravidian *pu-chey*, 'flower action', or worship with flower offerings as opposed to animal sacrifice. There is yet another theory that it derives from the Dravidian term *pushu*, which means 'to anoint, to smear', i.e. with sandalwood paste or with vermilion, instead of blood.

Today the term *puja* generally incorporates most forms of ceremonial worship, from the most simple ones, like the daily offerings of flowers and fruits, to the more elaborate ones. This will make sense if we recall that, as previously described, the image of the god, duly consecrated, is treated as a distinguished, royal guest. Objects are brought before it, as they would be brought before a living person: food, scent, flowers, etc. are offered to it and in fact it is thought of as the Lord in person.

Seva, as distinct from *puja*, is the offering of service. The word *seva* means literally 'service, attendance on', and the privileged devotee is viewed as a *sevaka*, a servant or menial, attending on the deity, performing *seva*. The *sevaka* must be one who prepares himself for the act of service through rigorous discipline.

To cite an example: in many of the sects associated with the worship of Krishna, the

devotee must rise early, utter the name of Krishna first thing in the morning, rinse his mouth, drink a little of the water in which the sacred feet of the Lord have been washed, and then, with his face turned towards the North or the East, voice the name of his *guru*. Then he must remember Krishna by his many names, conjuring in his mind the sacred river Yamuna, and recite from texts that sing Krishna's praise. Afterwards, having cleaned and bathed himself, and taken a little water and residue of the betel-leaf that had been offered to Krishna the night before, he must mark his forehead with white earth, and imprint other marks on his body, like that of a lotus on his bosom and of a bamboo leaf on his arms. He must also 'put on' the signs of the sacred weapons of Vishnu, for Vishnu *is* Krishna. It is then that the devotee is ready to open the doors of the temple and to remove the garlands of the previous day, sweep and clean the temple and the throne, and to prepare himself to receive Krishna when he wakes up. There are many other ritual acts connected with the worship of Krishna. Suffice it here to remember that the ritual varies from sect to sect and from region to region. In spite of this conspicuous range of variations the approach to the deity and the feeling imparted to the ritual remain in essence the same.

In order to demonstrate the nature of the relationship that exists between the devotee and Krishna, we shall briefly describe here the daily ritual as performed at Nathdwara (Udaipur), at a major temple devoted to Krishna in his aspect of Shri Nathji. This temple is the principal seat of the Vallabhacharyas, an important religious order founded by the Telugu Brahmin Vallabha in the 16th century.

We must first define the concept of *darshan* which is characteristic of the Vallabachari cult. The literal meaning of *darshan* is 'seeing', thus implying the entry into the presence of a revered or important person or of a deity. It emphasises the manifestation of God's grace through the mere sight of his image. The word *darshan* is used by the Vallabachari in preference to *puja*.

Here Krishna is seen as a mere child effortlessly lifting up Mount Govardhana on the palm of his raised left hand. Krishna is virtually the 'Lord' of the place. The shrine he occupies is referred to as his *haveli*, his palace or lordly mansion, and not as his *mandir*, or temple. Great care is devoted to the daily ritual and eight times a day the courtyards of the temple are packed with devotees and pilgrims eagerly waiting to catch a glimpse of the Lord. This particular aspect whereby large gatherings of people wait for the opportunity of seeing the Lord gives the Vallabhachari rites a congregational aspect, generally lacking in normal temple worship, in which the devotees discreetly pay their individual devotions. The service varies according to a strict routine, but nothing changes the spirit in which the service is performed in every season, throughout the year.

Mangala darshana

At about five o'clock in the morning, Krishna as Shri Nathji is awakened from his sleep by the blowing of a conch-shell.
Upon hearing the sound of the conch-shell, the devotees rush in, and those that are able to see Krishna consider themselves lucky because, for them, the day has begun well. Upon waking, Krishna is offered a light breakfast of fruit, butter and sweet and salted snacks. At this time of the day he wears a light wrap during the summer and in the winter he is dressed in an *angarakha*, a robe-like garment, which leaves just his face exposed.
The musicians play on the *vina* and the singers sing verses of the saint-poet Paramanand Das in praise of Krishna. Paramanand Das is one of the famous poet-devotees belonging to the *ashtachhap* group (lit: 'Eight Seals'), the corporate name given to eight Hindi poets who wrote in the Braja bhasha dialect. Out of them, four, including the most inspired of them, Sur Das, were associates of Vallabhacharya, and the remaining four of his son Vittalnath.
There is the belief that Paramanand Das himself sings in honour of Krishna each day.

Shringara darshana

This *darshana* takes place at about six in the morning in the summer and at about seven-thirty in the winter. It is the time when Krishna is dressed in rich attire, wearing precious ornaments and garlands. Behind a drawn curtain, that ensures privacy and protects Krishna from the public view, the head of the establishment has the privilege of dressing and adorning Krishna for the day. The colour of the clothes worn by the image, of the flowers, of the drapery in general is altered according to the season. Thus, in the rainy season, he is protected against the rain, in the winter season, against the cold. Great care is taken to make the god feel comfortable, because it is not an image that is dressed here, but Krishna himself.
While Krishna is getting dressed compositions by Nandadasa are sung to the accompaniment of the *tanpura* the *sarangi* and the *mridanga*.
As soon as Krishna is ready, he is offered some fruit; before the curtain is removed, Krishna, who is now holding a flute in his hand, is shown a mirror, so that he can check his appearance.

Gwala darshana

This *darshana* takes place one hour after the previous one, i.e. when Krishna is ready to take the cows out to graze. On this occasion he looks like a cow-herd. The *arati* ceremony is now performed, incense is offered. The food offered at this time is entirely made of milk. Govindaswami's compositions are sung during this *darshana* to the accompaniment of the *shenhai* and of the *nakkaras*.

Rajbhoga darshana

At about midday comes the moment of *Rajbhoga*, of the main meal of the day. This is the most elaborate of the *darshanas*. Krishna is clothed in the most resplendent fashion, and he is offered a magnificent repast of choice foods, all made of 'pure' ingredients such as: milk, sugar, chosen vegetables etc. The chief of the establishment himself has the privilege of serving Krishna his meal. And again, as in the case of the *Shringara darshana*, this *darshana* takes place behind a curtain, in order to avoid evil eyes and defilement. As soon as Krishna has finished his meal the doors are thrown open and they remain open longer than usual. Songs of Kumbhan Das are performed and music is played on different instruments.
Then it is time for Krishna to rest, and the doors are closed again.

Utthapana darshana

At two o'clock in the afternoon Krishna is again awakened. The conch-shell is blown, offerings of fruit and milk are placed in front of the deity. It is on this occasion that the songs of the famous poet Sur Das are performed.

Bhoga darshana

An hour later, at about three, it is time for the afternoon meal. A variety of sweets and fruit are offered to the deity. A staff-bearer, dressed in Mughal attire, stands in attendance and carries a long golden stick. In the hot season cooling fountains shoot up jets of water, in the winter a stove warms the air.

It is at this time of the day that the compositions of Chaturbhuja Das are sung.

Sandhya arati

This ceremony takes place at about five o'clock in the evening. Krishna comes home after having led back the herds at twilight. This blessed hour, the much spoken of 'hour of cowdust', is celebrated by waving the ceremonial lamps in front of the image. Krishna's elaborate clothes are now removed and he is offered another light meal.
On special festive days and during the rainy month of *shravana* this *darshana* is combined with the previous one, the *bhoga darshana*.
On this occasion the compositions of Chhitaswami are sung.

Shayana darshana

This is the moment when Krishna is put to bed. This ceremony takes place behind closed doors, especially between the months of March/April and September/October. Before the celebrants withdraw from Krishna's presence they leave some food by the side of his bed, lest he feel hungry at night.
Along with the food there is a brass vessel containing the water of the river Yamuna.
At this time of the day Krishnadasa's verses are sung and the temple is shut till the next day, when the whole daily routine starts again.

Each phase of the daily program involves, as mentioned above, the offering of food to the deity. This is a very important feature of worship. The offering of food is not merely born of the desire to please the god, but these offerings play a sacramental role. The taking of food in Hindu civilisation is subject to a very strict and complicated system of rules connected with ritual purity. Food touched by a low-caste person, or left over from the meal of another person, or even looked on by some lower caste may cause defilement. This is not so in the case of the wife and the children partaking of the left-overs from the meal of the husband, as he is the lord of the house; in this case the power emanating from these leavings is considered to be highly

123. Puja of Shri Nathji. *(Miniature, detail, Nathdwara c. 1830, Private collection.)*

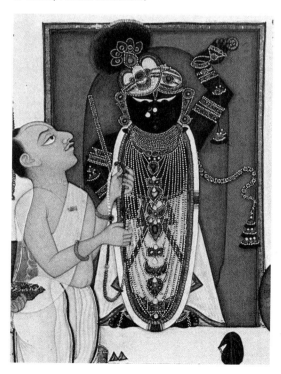

beneficial. The same happens in the case of the *guru* and of course the leavings of food from the table of the god are particularly holy and auspicious and become *prasada* ('favouring').

The distribution of food offered previously to the deity is a normal procedure in a Hindu temple. Guests and votaries all partake of this *prasada*, and it should be noted here that, especially at Vallabhachari shrines such as the one at Nathdwara, great care and attention are devoted to the preparation of the divine meals. This has its *raison d'être*:

At Vallabhachari shrines, however, enormous care, skill and expense are devoted towards creating an *haute cuisine* worthy of a deity, who not only embodies *rasa*, the pleasure principle, but is the supreme *rasika*, i.e. possessed of perfect discrimination in savoring aesthetic experience. To take *prasada* at an important shrine of this sect is to experience a gastronomic delight as well as to take part in a solemn sacrament… On this aspect of the worhip several thousand *rupees* may be expended in a single day… (3)

What has been described above is the daily routine. There are also special festivals, called *utsavas* when the service offered to the deity is more elaborate. There are 24 principal festivals throughout the year and two additional ones associated with Krishna's life among the cowherds.

According to the northern Indian custom, each month begins on the day after the full moon and is divided into two fortnights of fifteen days. The first of these is called the 'dark half', when the moon wanes, the second the 'bright half' when it waxes.

The year generally starts for the inhabitants of northern India in the middle of the month of *Chaitra* (March/April); it may also start with three other months in areas where the Vallabhachari cult is followed. At Nathdwara for instance the year starts at the beginning of the month of *Shravana* (July/August), in other parts of Rajasthan and Gujarat it starts one month earlier, during the month of *Asharh*, and finally elsewhere in Gujarat and in southern India it begins in the middle of the month of *Kartik* (October/November).

Among the most popular festivals celebrated at Nathdwara there is the *Phul Dol*, the 'swinging ceremony' connected with the festival of *Holi* at the end of the Hindu year at the time of the full moon in the month of *Phalgun* (February/March). During this festival the image of Krishna as *Navanitapriyaji* ('Lover of fresh butter') is placed on a flower-decked swing (hence the name of the festival — 'flower-swing') and rocked.

Another very popular festival is the one called *Krishna Janmashtami* immediately preceded by the one called *Panchamritsnan*. Both of these are connected to the birth of Krishna and take place in the month of *Bhadon* (August/September). The date of the *Panchamritsnan* is the seventh day of the dark half of the month, and it is preceded by a fast. The birth of Krishna took place at midnight, and it is at this time that the image is bathed with the five nectars (*panchamrit*): milk, curds, clarified butter, honey and sugar. This is immediately followed by the most important event of the Vallabhachari calendar, the celebrations of the birthday of Krishna, the *Krishna Janmashtami*. We shall mention here some other festivals connected with the Krishna legend, for instance the *Sharat Purnima*, the full moon in the month of *Ashvin* (September/October) when Krishna met the *gopis* in the forest and danced the *rasa* with them. There is the *Annakut*, the 'mountain of food', also known as the Govardhan. It commemorates the feeding of Krishna in his aspect as lord of the Govardhan. It is celebrated on the first day of the bright half of *Kartik* (October/November) and coincides with the reaping of the first fruit of the autumn harvest.

There are many more celebrations, including those associated with the leaders of the sect; each one of these differs. On each of these festive occasions there is a special mode of dressing the image of Shri Nathji and of decorating the temple. The wardrobe and the jewellery of the god are not only of a very

SEASONAL FESTIVALS AT NATHDWARA TEMPLE (4)		
Festival	Time of year	Event celebrated
Phul Dol	Chaitra, dark half	A ceremony associated with the *Holi* celebrations. The image of Krishna as Navanitapriyaji is rocked in the flower-decked swing from which the festival takes its name.
Rama Navami	Chaitra, bright half 9th day	Birthday of Rama, the seventh incarnation of Vishnu
Mahabraphuji ka Utsava	Vaishakh, dark half 11th day	Birthday of Vallabhacharya
Akhya Tij	Vaishakh, bright half 3rd day	Celebrates the settling of the accounts after the spring harvest
Narasinha Chaturdashi	Vaishakh, dark half 14th day	Commemorates the appearance of Vishnu as Narasinha in order to protect his devotee Prahlada
Asnan Jatra	Jyeshtha, full moon	In the heat of the summer, the image of Shri Nathji is ceremonially bathed.
Rath Jatra	Asharh, bright half 3rd day	A silver chariot is brought before Shri Nathji and twenty-five thousand mangoes are offered to the god.
Thakurani Tij	Shravan, bright half 3rd day	Day sacred to the goddess Parvati on which swinging ceremonies take place
Pavitra Ekadashi	Shravan, bright half 11th day	On this day the new sacred threads are presented.
Rakhi Bandhan	Shravan, full moon	Festival celebrating the descent of the goddess Lakshmi to the lower regions and making king Bali her brother by tying a silk thread around his wrist.
Panchamritsnan	Bhadon, dark half 7th day	Part of the celebrations connected to Krishna's birthday. The birth took place at midnight, after which the image is bathed in the five nectars (*Panchamrit*), i.e.: milk, curds, clarified butter, honey and sugar.
Janmashtami	Bhadon, dark half 8th day	Krishna's birthday
Radhashtami	Bhadon, bright half 8th day	Radha's birthday
Dana Ekadashi	Bhadon, bright half 11th day	Celebrates the *dana lila* (see p. 155)
Vamana Dvadashi	Bhadon, bright half 12th day	Birthday of Vamana, the fifth incarnation of Vishnu
Dashara	Ashvin, bright half 10th day	Celebrates the victory of Rama over the demon Ravana, king of Lanka
Sharat Purnima	Ashvin, full moon	Celebrates the meeting of Krishna and the *gopis* in the forest under the autumn moon
Annakut (Govardhana)	Kartik, bright half 1st day	Commemorates the feeding of Krishna manifesting himself as god of the mountain (see Narrative p. 52)
Gopashtami	Kartik, bright half 8th day	On this day Krishna was promoted to a cowherd. The cows are worshipped.
Prabodhini	Kartik, bright half 11th day	On this day the gods awake from their slumber, which lasted four months.
Gosainji ka Utsava	Paush	Birthday of Shri Vittalnathji
Vasant Panchami	Magh, bright half 5th day	Spring festival. Vishnu is worshipped by setting up pots with plants or blossoms. Red powder is thrown on friends and relatives as in the *Holi* festival.
Pat Utsava	Phalgun, full moon	The festival lasts several days, and reaches its climax on the full moon day. It corresponds with the *Holi*.
Kunj Ekadashi	Phalgun, bright half 11th day	Celebrates the discovery of the image of Shri Nathji

124. Krishna and Radha playing Holi. *(Miniature, Kangra c. 1780, 172×270 mm without borders, Indian Museum, Calcutta.)*

high standard of workmanship, but also extremely varied. All these items vary in design and colour according to the prescriptions laid down in the manuals on ritual, and take into account the season, the hour of the day and the occasion.

Not only is the image dressed differently, but its whole surroundings are exquisitely decorated with painted hangings, the famous *pichhvais*, showing motifs and scenes pertaining to the festival being celebrated. Not only are painted hangings displayed in the temple, but also costly brocades, silks, painted and printed fabrics. Great care is taken to make the halls worthy of Krishna and to create an aesthetically pleasing and refined atmosphere in order to suit even the most fastidious taste. This stress on aesthetic appeal, on refined taste and on enjoyment is typical of the followers of the Vallabhacharya sect.

The forms of worship vary according to the temple, to the aspect of Krishna venerated in it, to the place and to the legends connecting it to Krishna. These play a very important role in the development of the religious establishments, and 'explain' the origin of the temple, or relate the miraculous 'finding' of the icon set up at that very spot. We have just described one of the most important and famous forms of ritual, the one followed by the Vallabhacharyas, a sect we shall have occasion to refer to in a more detailed manner at a later stage. One may wonder how it is that the most important temple of this creed is to be found in a rather sleepy hamlet not far from Udaipur. There is a legend connected to it, which is related by Col. J. Tod in his *Annals and Antiquities of Rajasthan*:

When Aurangzeb proscribed Kanhaiya (i.e. Krishna), and rendered his shrines impure throughout Vraj, Rana Raj Singh 'offered the heads of one hundred thousand Rajputs for his service', and the god was conducted by route of Kotah and Rampura to Mewar. An omen decided the spot of his future residence. As he journeyed to gain the capital of the Sesodias the chariot-wheel sunk deep into the earth and defied extrication; upon which the Saguni (augur) interpreted the pleasure of the god, that he desired to dwell there. This circumstance occurred at an inconsiderable village called Sirah... Nathji (*the* god) was removed from his car, and in due time a temple was erected for his reception, when the hamlet of Sirah became the town of Nathdwara...(5)

At Nathdwara Krishna is known as Shri Nathji, just one of the many names of Krishna, which means 'Lord of Shri'.

This playing with the names and the epithets of the gods and the heroes is very common throughout Indian literature, religious and secular alike. The god Vishnu has a thousand names, as does the Devi, the Great Goddess. Shiva as Rudra has litanies devoted to him. Krishna can lay claim to all of Vishnu's names, being one of his incarnations. Each of these names hints at an aspect of his divine personality; for instance his beauty is referred to in names such as: *Keshava*, 'with long, handsome hair'; *Vanamali*, 'wearer of the garland of forest flowers'; *Madana Mohana*, 'alluring as the god of Love'; *Kanhaiya* (or *Kanu*), 'handsome youth'.

Some names describe his deeds, his vocation. He is, for this reason, *Govinda*, 'cowherd'; *Gopala*, 'protector of cows'; *Balagopala*, 'the child cowherd'; as a child he is *Navanitapriya*, 'lover of butter', and *Makhanchor*, 'butter thief'.

Yet other names link him with the scenes of his childhood and of his royal glory as a king in later years. Thus, he is *Vrajakishor*, 'the handsome boy from Vraja', the 'Lord of Vraja'. He is *Gokulachandrama*, 'the moon of Gokula'; he is *Dvarkadish*, 'the Lord of Dvarka'.

He is *Vallabha*, 'beloved, desired, longed for'; therefore he is also *Gopivallabha*, 'the beloved of the *gopis*'. At the same time he is *Shri Nath*, the 'Lord of Shri' and *Jagannath*, 'Lord of the World'.

In this particular aspect, as Jagannath, Krishna is worshipped in Bengal and other parts of India, but it is Puri, 'the Town', which is the great seat of his worship, and multitudes of pilgrims hailing from all parts of India flock to Puri on occasion of the two main festivals, the *Snana Yatra* (Bathing Festival) and the *Ratha Yatra* (Car Festival) celebrated in the months of *Jyeshtha* (May/June) and of *Ashadh* (June/July).

The legend relating the origin of Jagannath is worth mentioning here, as it also 'explains' the peculiar appearance of the icon of Jagannath, of his brother Balabhadra, and of his sister Subhadra, the three of them forming the 'Jagannath Triad' worshipped at Puri.

Krishna was killed by the hunter Jara and his body was left under a tree. Eventually some pious persons found the dried bones and put them in a box. It was the devout King Indradyumna who, directed by Vishnu, undertook to form an image of Jagannath and to house the bones of Krishna inside. He consequently summoned the architect of the gods, Vishvakarama, who accepted to fashion the image on one condition: nobody was to look at him while he was working. The King (other versions say that it was the Queen) could not resist the temptation of peeping in before the image was completed, and Vishvakarama left the work unfinished, departing in great anger. The King then was granted a favour by Brahma, who promised to make the image famous, and he did so by giving it eyes and a soul, and by acting as high priest at its consecration.

There are many versions of this legend; all of them try to justify the unusual features of the group. As a matter of fact these three wooden images differ greatly from the images generally worshipped in other Hindu temples. They are usually referred to as being 'crude', or as having a 'tribal look'. The three figures differ, despite being similar in the iconographical pattern. Subhadra, Jagannath's sister, the smallest of the triad, consists of a trunk and a head, whereas the icons of Jagannath and Balabhadra, while

125. The Jagannath triad. *(Painting on paper of a wood sculpture in the sanctum of the Jagannath temple 20th century, Collection Dr. and Mrs. Hermann Kulke.)*

basically consisting of a trunk and an over-dimensional head, have arm stumps and are considerably larger in size. The heads of Balabhadra and Subhadra are very similar: oval in shape and with almond-shaped eyes. The head of Jagannath, on the contrary, is flat on the top, and the face is dominated by huge round eyes. The image of Balabhadra is white, the one of Jagannath is black, and the one of Subhadra is yellow.

This is not the place to discuss the origin of such a peculiar iconography of the deities. Suffice it to say that the tribal origin of the figures is emphasized by the role played by the *Daityas*, a special group of priests, who are thought to be descendants of the original tribal worshippers. These *Daityas* are called the 'relatives' of Lord Jagannath and they are specially entrusted with those services necessitating close contact with the figures, such as dressing them or moving them. There is also another group of tribal origin, playing a major role in the ritual connected with Jagannath: the cooks, the *Savaras*, entrusted with the preparations of the elaborate meals offered to the gods. We are here possibly confronted with a phenomenon of a tribal cult being adopted and transformed by Hinduization. And as regards the three images, the original aniconical symbol has been anthropomorphized in order to comply with the tenets of Hindu image worship.

The ritual of Jagannath is very elaborate. It consists of sixteen *upacharas* (services) most of which are similar to those described in the section devoted to Shri Nathji. The *puja* takes place five times a day, and the common expression by which the *puja* is designated is *dhupa*, a word meaning 'incense', so called because the *puja* takes place behind the closed doors of the shrine, and when the doors are opened and the ritual has almost come to the end, the visitor sees the sanctum full of incense vapour, hence the term *dhupa*.

It would be too lengthy to give a detailed description of all the actions which take place during the *puja*; however, it may be of interest to note some of its main features. After a rigorous ritual purification of the mind and the body, the devotee proceeds to meditate upon the deity, i.e. Jagannath, and since Jagannath is going to appear in his heart, the devotee considers his whole body as a 'seat' (*pitha*) for the deity, and starts contemplating the different parts of his body as being parts of a sacred diagram, a *yantra*, in the centre of which the deity shall emerge. After sanctifying his own body by means of sacred formulas, *mantras*, the worshipper proceeds to sanctify the image of Jagannath, once it has been purified, as both his own body and the image will serve as abode for the coming deity. The image as such is a mere object, devoid of any meaning, as long as it is not 'inhabited' by the deity. When Jagannath appears in the heart of his worshipper, and has been duly worshipped there, his presence is transferred to the prepared image as well. After various other acts of 'mental' worship, the preparation for the 'external' worship can begin.

As soon as the preliminaries are completed, the acts of external worship can begin. The devotee offers the sixteen acts of homage to Jagannath, who graciously accepts to be his guest. The sixteen *upacharas* are presented in this order: seat, words of welcome, water for washing the feet, water for washing the face, ablutionary water, sweet refreshments, ablutionary water, bath, clothes, ornaments, perfume (sandal paste), flowers, incense, waving of lights, food, and finally obeisance and pleasing words. All the sixteen services are accompanied by their particular sacred formulas, *mantras*, the appropriate hand gestures, *mudras*, and sacred utterances generally stressing the abstract nature of the deity and the futility or conventionality of all acts of worship, which are performed by the worshipper for his own satisfaction and to observe a worldly convention.

During the offering of the *upacharas*, as soon as the presentation of flowers, *pushpa*, is completed there is a pause. The worshipper starts honouring the retinue and the associates of Jagannath (for instance: the four close friends of Krishna), the retinue being divided into six groups, each of whom receives a special worship. This act over, the sequence of the *upacharas* is resumed.

The most important part of the ceremony is the offering of food: *naivedya* or *bhoga*. The food presented to Jagannath consists of: rice, pulse, curries and other dishes cooked in the temple kitchen. There is, however, an exception: the early morning *bhoga* consists only of uncooked food such as: puffed rice, fruit, curds, butter etc. All these eatables undergo a long process of ritual purification before they can be offered to the deity. The time devoted to the meals is generally one hour, during which the gates of the inner enclosure of the temple are closed. When Jagannath has completed his meal, the doors of the sanctum are opened and the lights are waved around the image to the accompaniment of music.

The offering of a heap of flowers and the bowing of the worshipper in front of Jagannath marks the end of the *puja*. It is then that the worshipper takes the 'radiance' of the deity he has been worshipping all along as an image, back to his heart, and after reciting some hymns in praise of Jagannath the 'mental' part of the *puja* comes to an end.

At the four principal meals a very large quantity of food is prepared and laid out in the refectory. The doors are then opened and the divinities enjoy the sight of the meals from their throne. The special offerings of the devotees are placed in the refectory. There is an exception to this rule: only the offerings made by the Raja of Khurda are to be taken into the immediate presence of the divinity. One special offering of the Raja, the *gopala vallabha*, a sweetmeat prepared in the royal palace, is sent in daily. Like the rest of the offerings it is, after having been duly consecrated, sold to pilgrims and the sum is credited to the Raja's private account.

The quantity of food prepared daily is large; on festive occasions it is enormous. At the time of the Car Festival, *Ratha Yatra*, enough food is cooked to suffice for the consumption of a hundred thousand pilgrims and considerable profit is made by its sale. As stated before, except in the case of the *gopala vallabha*, all articles of food brought within the sanctuary are afterwards appropriated by the officiating priests, but those which are served in the refectory are sold to the benefit of the temple fund.

The cooks employed in dressing the food are called *Savars*, a term designating some aboriginal group, which means 'wild hunter'. The sanctity attached to the food prepared by these people, the lowest of the low-caste

126. Jagannath temple, Puri. *(Engraving, 19th century, Private collection.)*

128

people, and offered to the deities is immense. It is called *mahaprasad*, 'great favour' or 'great present', and esteemed to be the holiest of the holy. A single particle of it is sufficient to wash away the moral taint of the greatest crimes one can commit; on the other hand, there is no crime so heinous as that of treating it disrespectfully. It should be eaten the moment it is received, regardless of time, place or circumstances. Notwithstanding the strong prejudice of the Hindus against eating rice dressed by other than their own caste fellows, not only is the rice *mahaprasad* eaten from the hands of members of the lowest classes, but it is dried and carried to all parts of India for consumption by devotees of all social classes.

The town of Puri is synonymous with the *Ratha Yatra*, or the Car Festival, perhaps the most famous event of its kind in India, and definitely one of the features of Indian religious life which have been described by numerous foreign travellers. The first European account of the festival is to be dated about 1321.

In the words of Friar Odoric of Pordenone:

…many pilgrims who have come to this feast cast themselves under the chariot, so that its wheels may go over them, saying that they desire to die for their god. And the car passes over them, and cuts them in sunder, and so they perish on the spot… (6)

The self-immolation of the devotees under the wheels of the huge car became one of the clichés of every travel account; etchings and drawings of such scenes were to be found in every description of India, and later the name 'Jagannath' became a by-word in the English language for everything which is odious and detestable.

A very detailed description of the festival is given by the Abbé Dubois in his *Hindu Manners, Customs and Ceremonies*. The Abbé is more concerned with the 'immorality' of the goings on among the crowd, with the indecency of the carvings decorating the car, than with anything else. It will be of interest to compare the description of the Abbé Dubois with the actual practice of today. He reports:

There is not a single temple of any note which has not one or two processions every year. On such occasions the idols are placed on huge massive cars supported on four large solid wheels, not made, like our wheels with spokes and felloes. A big beam serves as the axle, and supports the car proper, which is sometimes fifty feet in height. The thick blocks which form the base are carved with images of men and women in the most indecent attitudes. Several stages of carved planking are raised upon this basement gradually diminishing in width until the whole fabric has the form of a pyramid.
On the days of the procession the car is adorned with coloured calicoes, costly clothes, green foliage, garlands of flowers & c. The idol clothed in the richest apparel and adorned with its most precious jewels, is placed in the middle of the car, beneath an elegant canopy. Thick cables are attached to the car, and sometimes more than a thousand persons are harnessed to it. A party of dancing girls are seated on the car and surround the idol with fans made of peacock's feathers; others wave yak tails gracefully from side to side. Many other persons are also mounted on the car for the purpose of directing its movements and inciting the multitude that drags it to continue efforts. All this is done in the midst of tremendous tumult and confusion…
The procession advances slowly. From time to time a halt is made, during which a most frightful uproar of shouts and cries and whistlings is kept up… as long as the procession continues, the drums, trumpets, and all sorts of musical instruments give forth their discordant sounds. On one side sham combatants armed with naked sabres are to be seen fencing with one another; on another side, one sees men dancing in groups and beating time with small sticks; and somewhere else people are seen wrestling. Finally, a great number of devotees crawl slowly before the car on hands and knees. Those who have nothing else to do shriek and shout… (7)

As previously stated, the Car Festival takes place in the month of *Ashadh* (June/July) and the occasion of this festival is the moving of Jagannath from the great temple of Puri to his summer residence. Before the *Ratha Yatra* there is another celebration, which is, so to speak, a preparation for the greatest event of the year. This other event, the *Snana Yatra* or Bathing Festival, is celebrated on the 15th day of the waxing moon in the month of *Jyeshtha* (May/June). The occurrence celebrated here is the descent of Jagannath to earth. On this occasion the images are brought to the bathing platform where they are bathed at midday with a profusion of water taken from a holy well. Then they are sumptuously dressed, decorated and worshipped. After their bath they are taken to a special room of the temple where they are kept for fifteen days. This room is called the 'sick chamber', as the divinities are said to have contracted a fever as a consequence of taking a bath at such an unusual time of the day.

During this time they cannot grant audience to the public and they cannot have their usual meals so the outer doors of the temple are shut, and there is no cooking to be done. Possibly the real purpose of the ceremony is to wash off the soot and the dust accumulated over the year, in spite of the daily washing and wiping of the images, and also to repaint them. These operations are accomplished during the fifteen days of the 'illness' and it would not be proper for the public to see the images unpainted. For this reason the temple is closed. This is also the time in which, when the occasion demands it, the images are renewed. This takes place around every twelve years.

After the 'illness', when the images are repainted and revarnished, they are exhibited to the public on the second day of the waxing moon in the month of *Ashadh*, corresponding to the months of June/July. This is the time of the Car Festival: the images are then set on open cars and taken out for an airing in a grand procession along the main streets of the town. It is not only one car, as would be supposed from the accounts of the early travellers, but three, carrying Jagannath, Balabhadra and Subhadra respectively. The three cars are dragged from the Great Temple of Puri town to the summer residence of the gods, the Gundicha Temple, at a distance of some three kilometres.

The three cars, *rathas*, are of different sizes, the biggest one being obviously that of Jagannath. They are all of different colours, and each of them has a different number of wheels. The car of Jagannath measures some 13,5 m and rests on 16 wheels. It is covered by a yellow and red cloth; the one of Balabhadra measures 13,2 m, rests on 14 wheels and is covered by a red and green cloth; finally the *ratha* of Subhadra is adorned with a red and black cloth, measures 12,9 m and rests on 12 wheels (8). The wheels of all three cars have 16 spokes, and are not, as we may read in the account of the Abbé Dubois 'solid wheels', a feature, incidentally, seen to this day in many of the southern Indian temple cars.

The shape of the chariot recalls the shape of a temple: indeed the car becomes a sort of mobile temple for the journey of the gods

127. Krishna dancing with the butterball. *(Bronze, southern India, 18-19th century, Collection Prof. Samuel Eilenberg.)*

from the main temple to their summer residence. The chariots are duly sanctified on the eve of the festival, and thus the identification with the main temple is ritually sanctioned. Through the divine presence placed in the cars, the whole area through which the conveyances pass becomes automatically a consecrated area, and thus the city of Puri is transformed into a veritable 'temple city' for the duration of the festival (9).

The images are brought to the car in the afternoon by special priests, the *Daityas*, the supposed descendants of the aboriginal

tribes connected with the cult of Jagannath, to which this office belongs from time immemorial. The small image, the one of Subhadra, is brought on the shoulders of the carriers whereas the other two are each dragged by a silken rope fastened to the waist. The priests hold the images in order to prevent their falling on the ground. An inclined plane is used to lift the images onto their respective cars, and this duty is also accomplished by the *Daityas*. When the images have been installed on their thrones, they are richly dressed and ornamented for the occasion, and they are provided with golden hands and feet.

After this the Raja of Kurda comes in with a large procession of horses, elephants, palankins and other paraphernalia, and at about some seventy to a hundred metres in front of the foremost car, he descends from his vehicle and walks barefoot and, as the hereditary sweeper of the temple, sweeps the ground before the car with a jewelled broom and worships the images in due form with flowers and incense. He then figuratively leads the operations of dragging the cars: he holds the cables attached to the three cars and at that moment a body of 4200 coolies, called *Kalabetiyas*, who enjoy rent-free lands in the neighbouring villages for this service start the actual dragging. They are largely assisted by the immense concourse of pilgrims, every one of whom longs to have the supreme felicity of dragging the cars and thereby dissolving sin forever, and many of them do gratify their desire.

In spite of this, however, the cars move slowly and three to four afternoons are required to pull them to the Gundicha Temple. On the arrival of the cars at the gate, on the fourth night, the goddess Lakshmi is carried in a grand procession from the temple to the car, where she pays a visit to her lord. This day is called *Harapanchami* and is marked by a special feast.

The gods remain in their summer residence for four or five days and on the 10th of the moon, they begin their journey back. This is not completed until the 14th or the 15th day. The slowness of the return journey is caused by the paucity of pilgrims, most of whom leave Puri immediately after the first procession, and the road is generally rendered difficult by the setting in of the rains (10).

On the day the cars arrive before the great Temple, the image of the goddess Lakshmi is brought out from her mansion and placed in a pavillion on the road-side to welcome her lord and escort him home. When the cars arrive at the Lion Gate, a rite is performed on the cars to celebrate their return. When this is over, the *Daityas* carry the images to their sanctuary in the same way they bring them out. After placing them on their throne, the priests perform lustrations in order to remove the defilement to which the images have been exposed while in the cars by the touch of people of all classes and castes who drag the vehicles.

A feature which is peculiar to the Car Festival is that the cars are built each year and dismantled as soon as the festival is over. Some parts of the car, however, are kept in order to be used again on the next occasion: so for instance the upper portion, the nine small painted wooden carvings placed in the immediate proximity of the wheels, and the wooden horses attached to each car.

Some of the names of Krishna hint at his lineage: thus he is *Vasudeva*, 'descendant of Vasudeva'; he is *Devakinandana*, 'Devaki's son'; he is *Nandanandana*, 'Nanda's boy'. Through his names we get to know his clan affiliations. As a Yadava, a descendant of Yadu, he is also *Yadavendra* or *Yadupati*, 'the foremost of Yadu's clan'. For this reason he is also *Madhava*, 'among the descendants of Madhu', i.e., the Yadavas. But *Madhava* also means 'honey-sweet, vernal', and who is better related to spring than the Divine Lover?

Because he wanders at pleasure, he is *Vihari*; he chooses fragrant groves to wander in, therefore he is *Kunjavihari*; as the most handsome of those that wander in this fashion he is *Banke Bihari*. Since no one dances like him, he is the 'foremost among dancers', *Natavara*. Playing upon his flute he becomes *Muralimanohar*, the 'handsome one with the flute'; in this aspect he is also *Venu Gopala*, 'the cowherd with the flute'.

Lifting Mount Govardhana, he becomes *Govardhanadhari*.

Krishna being Vishnu is also *Hari* which, among its many meanings, is 'the sun, a ray of light'; he is also *Murari*, 'the enemy of Mura'; he is *Madhusudhana*, 'the Slayer of the demon Madhu'; he is *Janardana*, 'exciting, agitating man'; he is *Narayana*, 'the original man'; he is also *Jaganmohana*, 'the enchanter of all the world', the one looked upon by all *bhaktas* as *the* Lover.

Blessed indeed are the citizens of Guruvayur! For there shines before their very eyes that Supreme Brahman, which is the ultimate goal of all human endeavour; which shines through a hundred thousand scriptures and yet remains indistinct; which is ever free; which is devoid of the limits of time and space; which is incomparable; and which is the crystallised essence of Bliss and Knowledge (11).

Guruvayur, the 'Dvarka of the South', is the third of the important centres of Krishnaite devotion, which will be discussed here in some detail. Situated near the town of Trichur, Kerala, nothing definitive can be said about its origin or its antiquity. From the 16th century onward, however, Guruvayur becomes the centre of Vaishnava religious and cultural activities, and plays a great role in the economic and political life of Kerala.

The image worshipped at Guruvayur is described in great detail in the *Narayaniyam*, a work of the saint poet Narayana Bhattatiri, one of the great *bhaktas* of the 16th century connected to this temple.

I worship Thy form — that form with Thy crown rivalling the Sun, the middle of Thy forehead refulgent with that sandal mark drawn up. The eyes melting with compassion. Thy face beaming with that sweet smile, Thy nostrils beautiful, Thy cheeks shining with the pair of ear ornaments of the shape of *makara* fish. Thy neck radiant with the *kaustubha* ornament, and Thy body charming with the wood garland, clusters of pearl necklaces and the mark of *srivatsa*.

I cling to that indescribable form of Thine — that form that destroys all distress, with those lustrous four arms bedecked with shoulder ornaments, arm bracelets, bangles and rings studded with the best of precious gems, and holding therein the mace, the conch, the disc and the lotus, that form wearing the yellow silken garment, and shining with the gold waist-girdle, and with feet of the lustre of charming lotus (12).

It is the form in which Krishna appeared to his parents at his birth in the dungeon (see Narrative p. 29), the form of Mahavishnu, which he immediately changed for that of a newly born infant.

The story of this image is worth recounting. After Krishna had witnessed the massacre of his kinsmen and retired in the woods to prepare to rejoin the world of the gods, he requested his disciple and friend Uddhava to transfer the image of Narayana, which he himself worshipped as he was living in Dvarka, to some safe place, knowing that immediately after his death, Dvarka would have been swallowed by the sea. The image had to be installed at some holy place for the benefit of the devotees of the coming age, the *kali yuga*, which was to begin soon after Krishna's death.

128. Krishna Kaliyamardana. *(Wall painting, Pariyal, Kerala 18th century)*

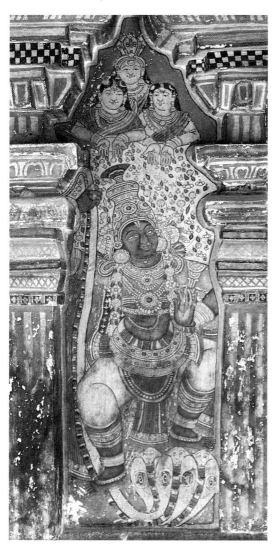

The suitable spot had to be selected accordingly, after consulting the *guru* of the gods, Brihashpati. Escorted by his disciple, the wind-god Vayu, Brihashpati, also called Guru, arrived at Dvarka. The sea-god Varuna had already occupied the town and the holy image of Narayana was tossed into the sea by the surging waves. Guru and Vayu, however, managed to rescue it, and, Vayu carrying it on his head, they both went in search of a suitable place to install it respectfully.

After a long time they finally entered Kerala through the Palghat gap, and there they met Parashurama who had just created Kerala and who was on his way to Dvarka in search of that very image that Guru and Vayu were bringing.

Parashurama now led the way for the two gods, and they eventually arrived at a beautiful lotus lake, called Rudratirtha where they were welcomed by Shiva and his wife Parvati. It was here that the god Shiva had recited the hymns in honour of Vishnu, the *Rudragita*. He gladly consented to consecrate the image with the holy water of a nearby well, and after duly worshipping it, turned to Guru and Vayu, asking them to perform the installation ceremonies.

As they were the founders of the temple, the temple is known as Guruvayur, from their names Guru and Vayu. The deity enshrined there is called the 'Lord (*appan*) or Guruvayur' i.e. Guruvayurappan.

Local tradition has it that after the installation of the holy image, Guru and Vayu requested the divine architect Vishvakarma to build the temple. This is perhaps to 'explain' some striking features of the construction, which baffle modern architects. One of the peculiarities of the building is that the deity can be seen from quite a distance from the eastern gateway, though it is 'seemingly hidden by the huge *Dipastambha* (pillar of lights), *Dhvajastambha* (flag-staff) and *Balikallu* (altar)' (13). There is another peculiarity: on the day of the vernal equinox the first rays of the rising sun are to be seen falling at the feet of the icon, as though the sun god itself were rendering homage to Krishna. Another belief is that Vishvakarma, after completing the building, left his measuring rod, somewhat longer than the usual one, engraved on the porch, as it could come in handy for any future repair.

A wealth of legends such as these has been woven around this very hallowed place. There is no building in the temple complex which is not connected to some myth or to some holy person.

The temple as such is comparatively small in size, but, as already mentioned, a centre of great activity not only in spiritual matters. The influence of the temple on the daily life of an average Hindu, especially a South Indian, plays a far from negligible role. As a matter of fact, to him the temple is not only the residence of the deity, symbolising the Supreme Principle controlling the affairs of the world and focussing the spiritual needs of the people.

It is much more than this.

Taking Guruvayur as an example it is possible to draw many conclusions. Kerala is a region in which temples, perhaps more than anywhere else in India, are the focus of a social and cultural life. This is particularly true when the big annual feasts are celebrated with great pageantry and sumptuousness. These feasts provide the occasion not only for worship, but also for special gatherings, general rejoicing, and social and cultural activities as well. Music and dance recitals, staging of sacred representations, public lectures take place in the temple premises. Fairs and markets are organised promoting a brisk trading activity. Rest houses and facilities for pilgrims are organised in and around the temple precincts so that the sacred establishment becomes an important economic factor in the life of the town around it. If this is true of times of great annual gatherings, the importance of the temple as a source of employment and income for the town should not be underestimated. Even at normal times the temple provides employment for a large number of people: for instance, artisans of all descriptions are needed to protect the premises against damage by weather, for routine repairs etc. Florists, musicians, attendants, sweepers, cooks and others have permanent jobs in the temple, in order to ensure the orderly and smooth routine of the daily ritual. The temple is also a landowner: kings, devotees and nobles gave the establishment land grants, which are administered by the temple authorities in the name of the presiding deity. A whole system of social and economic interests revolves around the temple.

The *Malabar Gazetteer*, 1951, describes the Guruvayur temple in such terms:

The most popular of all Kerala temples at present is the Krishna shrine at Guruvayur which has sprung into importance from about the sixteenth century. This temple is square in shape and is enclosed on the east and the south by a lofty laterite wall; on the west by tiled buildings, where pilgrims are lodged and fed; and on the north by a bathing tank built of laterite steps.
The *Srikoil* or central shrine square in shape and having two *Prasadas* or storeys, the *Nambalam* (cloister) around it and *Kuttambalams* (auditorium, dancing hall) in the outer courtyard where *Puranas* are recited, are all roofed with copper. A conspicuous feature of this temple is the lofty bell-metal *Dhvajastambha* (flag-staff), 110 ft. in height, plated with gold.
A wide street leaps up through rows of shops to the eastern and main gateway of the temple which is surmounted by a two-storeyed *Gopura* (tower). The porch and its pillars are elaborately carved with heads of elephants and bulls and other sculptures in bold relief: its walls are covered with gaudy frescoes depicting the adventures of Arjuna, the Pandava. A Sanskrit inscription on one of the walls of the temple recites that the temple within is heaven and the gateway the ladder thereto, they were built by the Lord of the Seas and Hills and had been trodden by the feet of many kings. The writing is comparatively modern Malayalam characters; and by the Lord of the Seas and Hills, the Zamorin probably is meant. The *Deepastambha* (pillar of lights) in front of the gateway has two inscriptions recording the fact that it was erected by a native of Travancore in 1011 Malayalam Era (A.D. 1836); and fragments of another inscription are seen on a broken slab of granite now used as a doorstep in the house of Mallisseri Namboothiri. Adjoining the temple in the north is the *Arattukulam*, (tank), where the idol is bathed in the month of *Kumbham* (February). A writing on the granite door

post of the western entrance which is also covered with a *Gopura* relates that the gate was erected by Panikkaveetil Ittiraricha Menon, Karyasthan in 922 (A.D. 1747). Pilgrims, especially those subjected to rheumatism resort to Guruvayur temple in large numbers and make offerings.
Grouped around the temple are the houses of Ooralers or trustees viz., Zamorin and Mallisseri Namboothiri and those of the Eralappad Raja, Punnathoor Nambidi and many of the higher castes.
The great Ekadasi festivals held annually about the second week of December; and it is very largely attended to by pilgrims from all parts of Malabar (14).

Before coming to a description of the ritual it is necessary to stress the fact that Kerala can boast a very old Vaishnava tradition. Leaving aside the problems connected with the authenticity of the legends surrounding the founding of the temple, as reported in the *Guruvayur mahatmya*, Vaishnavism seems to have spread to Kerala quite early. The fact that Parashurama is reputed to have created Kerala, and that Shiva and Parvati reveal themselves as Vishnu *bhaktas*, and leave the Rudratirtha for Guru and Vayu to build the temple, seems to point to a strong Vaishnava 'bias' permeating the Keralese tradition. From the ninth century onward, there is ample material to show how strong the Vaishnava faith was then, and how the *bhakti* movement was already popular and well established in the South. About the year A.D. 800 the Chera King Kulashekhara, a most capable ruler and administrator wrote a work in praise of Vishnu, the *Mukundamala*. He is reported to have renounced the world and to have turned completely to a life of religion. He is generally known as Kulashekhara *Alvar*, an ardent Krishna *bhakta*, the sixth of the twelve saint-poets, of the *Alvars*, responsible for a great change in the religious outlook of southern India, for social, political, literary renewal and for the stressing of the concept of *bhakti*, surrender to a personal god, as the only means to attain salvation.

The literature of Kerala is full of instances of poets, both Sanskrit and Malayalam, singing the praises of Krishna. There is the famous Bilvamangala, also known under the name of Lilashuka, author of the *Krishnakarnamritam*, a Sanskrit poem of about 300 stanzas celebrating the childhood of Krishna and his loves with the *gopis*. Bilvamangala lived in the 11th century and his work was written in a very simple style, of such captivating charm and so full of unrestrained emotion that it immediately became very popular. He is reputed to have been reborn as Jayadeva, as the author of the famous *Gita Govinda*, and also as Narayana Bhattatiri, the author of the already quoted Sanskrit poem in praise of the Lord of Guruvayur, *Narayaniyam*.
Narayana Bhattatiri (c. 1560-1646) and his contemporary, the Malayalam poet Puntanam Nambudiri (c. 1547-1640) were both connected with the Guruvayur Temple, and were perhaps the most famous of all the saints, poets and learned scholars attached to the temple.
The *Narayaniyam*, known popularly as the 'Gospel of Guruvayur'; is the most important of the works in praise of Guruvayur. It con-

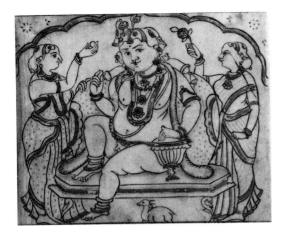

129. Navanita Krishna. *(Ivory comb, southern India 19th century, 9.8 × 13 cm, Collection Prof. Samuel Eilenberg.)*

The temple opens at c. 3 a.m.

Nirmalya darshana	The *darshana* of the image enshrined in the *srikoil* wearing the garlands and the ornaments of the previous day. This 'viewing' is considered particularly auspicious.
Abhishekam (bathing rights)	The image is bathed in gingelly oil, then rubbed with *vaka*, the bark of a tree reduced to powder with highly antiseptic properties and then bathed again in water.
Ushah puja and Etirittu puja	(c. 6 a.m.) Early morning *puja*
Ushah naivedyam	Food offering
Siveli (procession)	Begins at about 6,30 a.m. A miniature image of the deity is mounted on an elephant and is carried thrice around the temple. The main priest offers food, (*naivedyam*), to the retinue and companions of the deity, symbolized by small altars or *balikallus* set up in the temple precincts. At about 7,30 the *siveli* is over and the deity is bathed again.
Kshirabhishekam	The deity is bathed in milk (*Kshirabhishekam*) and then it is again bathed in water. This ceremony, called
Navakabhishekam	consists of pouring on the image the water from nine sanctified pots.
Pantirati puja	(9 a.m. to 10 a.m.) Mid-morning *puja*
Pantirati naivedyam	Food offering
Uchcha puja	(c. 11, 45 a.m. to 12,45 p.m.) Midday *puja*
Uchcha naivedyam	Food offering. Ceremonial feeding of the Brahmins in the refectory attached to the temple

From c. 1 p.m. to 4 p.m. the temple is closed.

Siveli (procession)	See above. This second procession takes place from c. 5 p.m. to 6 p.m.
Diparaāhana (arati)	An impressive ceremony during which the superbly clad image is lit by the flame of a myriad of small lamps.
Attara puja	(c. 7,30 p.m.) Evening *puja*
Attara naivedyam	Food offering. Ceremonial feeding of the Brahmins in the refectory attached to the temple.
Siveli	See above. This third procession takes place from 8 p.m. to 9 p.m.
Tirupakka	Reading of the accounts of the day and burning of incense

At about 10 p.m. the temple is closed.

sists of more than a thousand *shlokas* (double verses) and its message is very much the same one as contained in the *Bhagavadgita*, the attainment of liberation, *moksha*, from the cycle of birth and death through the path of devotion, i.e. *bhakti marg*.

Puntanam Nambudiri (c. 1547-1640), unlike Narayana Bhattatiri, was a person of no formal education. He wrote his lyrics in praise of Krishna in Malayalam. His Song of Wisdom, *Jnanappana*, is most impressive for its simplicity of style, force of diction and devotional fervour. There are many legends and anecdotes relating the rivalry which existed between the learned Bhattatiri and the humble Puntanam: one of these relates how Krishna himself had to intervene in a strife, and appeared in a dream to Narayana Bhattatiri saying that to him the *bhakti* of Puntanam was more welcome and dearer than his (i.e. Bhattatiri's) grammatical excellence, *vibhakti*. This may also be interpreted as the wish of Krishna to have his praises recited in a language easily understandable and common to all people as was Malayalam, instead of the highly refined and exclusive Sanskrit. It is said that the elaborate routine of daily worship and offerings followed at Guruvayur has been established by the famous saint-philosopher Shankaracharya (A.D. 788-820), a younger contemporary of Kulashekhara *Alvar*, mentioned above.

In general in all great temples there are four main *pujas* which take place at the following times of the day:

Early morning	(*Ushah*)
Mid-morning	(*Pantirati*)
Midday	(*Uchcha*)
Night	(*Attara*)

At Guruvayur, however, there are five main *pujas* (they are known under the collective name of *panchamahapujas* meaning literally 'five great *pujas*') and the additional one takes place after the early morning *puja*, the *ushah*, and it is called *etirittu*.

Only after the daily ceremonies are over is it possible to witness a performance of the typical 'dance-drama' connected to the Guruvayur Temple, the *Krishnattam*, on the day it is offered by the devotees.

Behind such an involved daily routine there is a very well-organised and efficient set of persons, whose task it is to see that everything goes on without incident.

The principal person responsible for the orderly conduct of the rites is the head priest, the *melshanti*, who is assisted by a *tantri*, who has a profound knowledge of temple rituals, and a number of assistant officiants, the *pujaris*, called *kizhushantis* in Malayalam. These deal with the preparation of the *naivedyam*, the food offerings, of the sandal paste and of other services as required by the head priest. In addition to them there are a number of temple servants, *ambalavasis*, drawn from certain privileged families, whose duties consist of collecting flowers, making garlands, holding lamps in the processions. There is yet another class of attendants, the *pattukarans*, 'the men for ten days'. It is their duty to supply every material required for the various *pujas* and *naivedyams* for a period of ten days. This privilege is also hereditary.

The office of the head priest usually lasts six months. During this time he has to observe strict celibacy and has to live in the temple precincts. Out of the five daily *pujas*, he is entrusted with the performance of four. The mid-morning *puja*, and the offering of food connected with it are performed by the *tantri* or by the *odhikkans* (i.e. 'chanter of the Vedas', a category of officiants similar to the *tantri*). The office of the *tantri* is hereditary. In case of doubt with regard to any ceremonial or ritual, the word of the *tantri* is decisive. The head priest, the *tantri* and the *odhikkans* are the only persons allowed to touch the image and perform the rites. The assistant officiants can enter the sanctum but cannot touch the idol.

Kerala is the land of temples and processions. The annual temple feasts, called *utsavams*, provide ample opportunities to display gorgeously attired elephants going in procession, much in the same way, as the chariot of the presiding deity is dragged along the streets in other parts of India. Colourful parasols and fans held up at the sides of the huge animals, fly whisks hanging at their sides: all this provides an impressive spectacle. The number of elephants employed is a matter of prestige for the temple and for the festival. The processional deity is carried on the tallest elephant, and the procession is accompanied by various drums, pipes and horns. Generally the festival culminates in the ceremony called *arattu* when the deity is immersed in the temple tank, amidst the chanting of *mantras* and the general rejoicing. To have a holy dip along with the deity is considered very auspicious by the devotees.

However, ceremonies do exist which are connected to special temples. The most important festival held at Guruvayur is the

Ekadashi, held in the bright half of the month of *Vrishchika* 'Scorpion' (November/December). The eleventh day of every lunar fortnight is considered highly auspicious. Of the twenty-four *ekadashis* of the year, some are endowed with a special significance and are celebrated with great solemnity. So for instance the *ashada ekadashi* (June/July) at Pandharpur in Maharashtra, the *Vaikuntha ekadashi* of Shrirangam in Tamil Nadu, and of course the Guruvayur *ekadashi*. On this day, even before the famous 'temple entry proclamation act' of the year 1935, all Hindus irrespective of caste and creed were allowed to enter the temple.

The celebrations begin eighteen days before. By way of a prelude to the main events there is a festival of lights, called the *Vilakku*, on each of these days. Gaily attired elephants are taken in procession around the temple night after night when the ritual is over. The eleven rows of lights on the wooden framework surrounding the cloisters, the *vilakkumatam*, and the lofty *dipastambhas*, the pillars for the lights inside and outside the temple, are lighted during the procession. The expenses of the *Vilakku* on different days are met from contributions from certain families who have been the recipients of the blessings of the deity.

On the concluding day of the festival, the *ekadashi*, the sanctum remains open from the morning till the following dawn, to enable the thousands of worshippers to pay homage to Guruvayurappan. On the day following the *ekadashi*, the *dvadashi*, the image is taken out in procession in order to give an opportunity for *darshan* to the crowd outside the temple. This festival celebrates many important events: it was on this day that Krishna as Parthasarti, Arjuna's charioteer, revealed to him the message of the holy *Gita*. It was on this day that the people of Vraja worshipped Mount Govardhana instead of worshipping Indra. It is believed that on every *Vrishchika ekadashi* day of Guruvayur, Indra comes along with the wish fulfilling cow, the cow Surabhi, gives material wealth to everybody and offers worship to receive the blessings of Krishna. It is also said that, on this very day, all the sacredness of all holy *tirthas* (pilgrimage places) of India, such as for instance Varanasi, Allahabad etc. and all holy rivers, such as the Ganges and the Yamuna, assemble in the sacred precincts of Guruvayur to honour Krishna. No wonder then, that this Guruvayur *ekadashi* is considered the most holy of all the *ekadashis*.

The third event celebrated on this day is the arrival of Shankaracharya, his stay at Guruvayur and the establishment of the cult as observed till our days.

There is yet another festival to be mentioned, which stands next to the *Vrishchika ekadashi* in order of importance. This is the ten day *Utsavam* (feast) held in the month of *Kumbha*, 'Acquarium', (February/March). This festival is celebrated with great pomp and pageantry. The emphasis lies on the various tantric rituals which are of utmost importance to ensure the prosperity of the temple. One of the many features of the festival is the elephant race which takes place on the inaugural day. At the auspicious moment, the temple flag is hoisted after the performance of all kinds of rituals. Before this the temple elephants are ranged in a line some half a mile away from the eastern gateway. At a given moment the animals have to run through the gateway and the one which arrives first at the flag-pillar has to remain within the temple walls for the next ten days.

On the following six days of the festival there are elephant processions three times a day. The elephants appear in the morning, in the afternoon and in the evening; there are offerings of oblations at the various altars in the morning and at night before the evening procession and much more of the like.

It is the eighth day of the *Utsavam* which is the most important. On this day a great oblation is offered to all gods and goddesses. This ceremony is performed on the southern side of the temple and is attended by thousands of pilgrims. From 12 noon till 4 p.m. the ritual goes on without interruption. And not only are the gods and goddesses fed but also pilgrims, birds and animals alike.

On the ninth day there is again an important ceremony. This is the 'Hunting expedition of the Lord', the *Pallivetta*. The procession is

130. Krishna holding Mount Govardhana. *(Wall painting, Pariyal, Kerala 18th century)*

led outside the temple walls and after having made its way around the temple and the tank it goes back to the temple. Here the deity is mounted on another elephant for the hunting expedition and leaves the premises through the eastern gateway. Men dressed as animals join the procession. This symbolises the destruction of such evils as anger, greed etc. through the grace of the deity.

On the tenth day there is the final ceremony, the bathing of the image in the temple tank. At dusk the procession starts from the temple, and after winding its usual way it reaches the tank. The people gathered on its way greet the deity with some paddy and a lit bell-metal lamp. At the tank the deity is bathed in the holy waters after special rituals. The devotees accompany their Lord in the waters chanting hymns and praying. After the immersion the *uchcha puja* (on this day it takes place at night) is held at the Bhagavati temple, near the tank. After eleven rapid circumambulations of the temple, the deity returns to the sanctum. A special feature of the Guruvayur *arattu puja*, i.e. immersion ceremony, is that the image is bathed in coconut milk.

No account, however brief, of the rituals, festivals, and activities of the Guruvayur Temple would be complete without mention of the dance-drama called *Krishnattam*. The word *Krishnattam* means 'dance of Krishna' and its subject is based on the *Gita Govinda* by Jayadeva. The origin of the *Krishnattam* can be traced back to the person of Prince Manavedan (1595-1658), who later became Zamorin, and who was a great devotee of Krishna and very much attached to the holy establishment of Guruvayur. He was so fascinated by the poem that he used to arrange for recitals of the *Gita Govinda* to be held daily in the temple. He eventually wrote a series of eight dramas, collectively known under the name of *Krishnagiti* or *Krishnattam* representing the most important events in the life of Krishna. The last of these dramas, the 'Ascent to Heaven' was completed in 1653. Manavedan drew inspiration not only from the *Gita Govinda*, but, being also a friend and a devout admirer of Bhattatiri, the author of the *Narayaniyam*, he based some elements on it, as well as on the much earlier *Bhagavata Purana*, especially books ten and eleven, those dealing with Krishna's life.

The *Krishnattam* can be considered as a forerunner of the world renowned *Kathakali* dance-drama. As a matter of fact, in the *Krishnattam* the actor was exempted from the necessity of narrating the story, and he could concentrate entirely on the elaborate language of gestures of the body and the hands alike. The singing was entrusted to another person who then became the voice of the actor. This change was a challenge to the imaginative faculties of the audience, who had to unify the 'sound' and the 'sight' into one emotional and mental entity.

The costumes and the general character of the make-up are very similar to those normally seen in the *Kathakali* dance-drama.

Festivals celebrated all over India

Dol Purnima	Phalgun	Swinging ceremony. The image of the child Krishna is put in a cradle or on a swing and gently rocked. It also commemorates the birthday of Shri Krishna Chaitanya.
Holi	Phalgun	The festival of spring (see Pat Utsava in the Nathdwara festival list) Several myths are connected to it: 1. The burning of the demoness Holika, aunt of the Vishnu-devotee Prahlada. She was entrusted with the task of destroying the boy by fire, but by Vishnu's aid the demoness was herself destroyed. 2. The burning of the god of love by the fire issued from Shiva's third eye. 3. The killing of Putana. The festival lasts two days. On the first one a bonfire is lit and the image of the demoness Holika is burnt. On the second people, irrespective of caste, 'play holi', throwing handfuls of coloured powder on friends and relatives.
Krishna Janmashtami	Bhadon	Krishna's birthday. When the moon appears the festivities start. Plays and tableaux are enacted which represent the most important episodes of his life.
Ananta Chaturdashi	Bhadon	Celebrations in honour of Vishnu laying on Ananta on the Milky Ocean, and of Lakshmi.
Divali	Kartika	The 'festival of lights'. Several myths are connected with it: 1. The victory of Krishna over Narakasura of Pragjyotishpur. 2. The victory of Rama over Ravana. 3. Vishnu as Vamana sends Bali in the underworld to free Lakshmi. Rows of lamps are lit and set on terraces and balconies or small floats with lamps are sent on lakes and pools, and fireworks are lit. In Bengal instead of Lakshmi the goddess Kali is worshipped.

Festivals observed in the various States

Vrindavan (Mathura) U.P.	Car Festival of Shri Ranganathji (ten-day festival)	Phalgun	Vishnu and Lakshmi are mounted on a car and taken out in procession.
	Shravana Festival of Shri Ranganathji Temple	Shravana	This festival commemorates the Gajendramoksha episode, the rescue of the King of the elephant from the crocodile. Plays treating this subject are enacted.
	Vana Yatra	Bhadon	'The going to the forest' Commemorates the Govardhana episode (see Narrative p. 52)
	Kans ka Mela	Kartika	Commemorates the slaying of Kansa. Two young boys dressed as Krishna and Balarama, destroy an image representing Kansa with flower-decked arrows.
Assam and Manipur	Rasa Lila Festival	Kartika	Performance of dances and plays related to the Krishna legend
Gujarat	Jal-Jhilani Festival (celebrated also in Saurashtra and Maharashtra)	Bhadon	The episode connected to this festival is the cowherds' bathing in the rain. An image of Krishna is set up in the open and bathed in the rain.
Orissa	Ratha Yatra at Puri	Asharh	see p. 129
Andhra Pradesh	Tirupati Festival	Bhadon	Ten days festival in honour of Shri Venkateshvara
Andhra Pradesh and Tamil Nadu	Ananta Vrata	Bhadon	In honour of Vishnu in all his incarnations
Tamil Nadu	Vaikuntha Ekadashi	Aghana	Festival observed for 20 days at Shri Rangam Temple. (Trichinopoly)
	Parthasarathi Festival	Summer	Celebrated especially at Triplicane, Madras, at the Parthasarathi Temple. It commemorates the episode of Krishna as Arjuna's charioteer in the Kurukshetra battle.
Kerala	Onam Festival	Chingam (Bhadon)	The most important of the Keralese festivals, falling at the close of the SW-Monsoon. It celebrates the victory of Vishnu as Vamana/Trivikrama over Bali.
	Guruvayur Ekadashi	Kartika	see p. 132
Maharashtra	Vithoba Festival	Asharh	The most important festival at Pandharpur
Solar/lunar eclipses			Particularly celebrated at Allahabad at the confluence of the two sacred streams, Ganges and Jumna. Equally celebrated at Hardvar, Varanasi etc., people take a dip in the holy rivers. But the biggest concourse of pilgrims takes place at Kurukshetra, where Krishna expounded the *Bhagavadgita* to Arjuna on the eve of the great battle. On such occasions a big fair is held there.
Kumbh Mela (Allahabad) Magha			This great festival commemorates the churning of the Milky Sea, occurs once every twelve years. Many pilgrims resort to Allahabad, Hardvar, Nasik, Ujjain to bathe in the holy rivers.

The repertoire consists of the following dramas: *Avatara, Kaliyamardana, Rasakrida, Kamsavadha, Svayamvara, Banayuddha, Vivida Vadha, Svargarohana.* These cover the whole span of Krishna's life, from his descent, *Avatara*, to his ascent to heaven, *Svargarohana*, and as the last drama of the series is reputed to be inauspicious, on the ninth day, after the series of the eight dramas has been completed, the *Avatara* is again enacted (15).

These three major centres apart, there are in the whole of India thousands of holy places which are regularly visited by numerous pilgrims. The visit of holy places is one of the main religious duties of a devotee. The pilgrimage, the *yatra*, 'going', is one of the many ways in which a devout person can please the deity, can accumulate merit and gain spiritual benefit.

Generally the pilgrimage sites are called *tirtha*, a word which means 'bathing place' or 'ford across a stream'; in a wider sense, it means a crossing point, a sacred spot which is worthy of reverence.

Some of these pilgrimage sites are of special sanctity for the followers of Shiva, some for those of the Shakti and some for those of Vishnu, Krishna or Rama, but it should be noticed here that a Hindu need not confine himself to a shrine of a particular deity to absolve his duties as a pilgrim, he may also offer his devout homage even to the shrine of a Muslim saint, if such a shrine should be on his way, and this without any sense of doing something objectionable.

Obviously the followers of the Vaishnava school of thought will go to places associated with Vishnu and his main incarnations, Rama and Krishna. The *tirthas* will be listed with the map on the following page.

Many ancient legends are connected with each of these places, telling the deeds of the gods and the saints who either worked miracles there or just happened to alight on the hallowed spot and who still manifest their powers in that place. These legends are known as *mahatmyas*, the best of them being drawn from the *Puranas* and still published in the popular guidebooks available at the sites.

THE FOUR MAJOR SAMPRADAYAS

The Vaishnavas, followers of Vishnu, are one of the main three divisions constituting modern Hinduism, the other two main ones being the Shaivas and the Shaktas. These three main streams of thought are divided and subdivided into hundreds of what we in the West call 'sects'. The Sanskrit term commonly used to denote these subdivisions is *sampradaya* meaning 'transmission' of a tradition. It is really the 'passing on of all that belongs' in a spiritual sense, from the teacher, the *guru* to the *shishya*, the disciple. This concept of transmission and the implicit sense of continuity of tradition, like an unbroken chain, from teacher to pupil is very

The seven holy cities:
Ayodhya, Mathura, Gaya, Varanasi, Ujjain, Hardvar and Dvarka.

The seven sacred rivers:
Ganges, Jumna, Sarasvati, Godavari, Narmada, Indus and Kaveri.

Sacred hills and mountains:
Kailasa, Parasnath, Girnar, Abu, Palni and others.

Holy lakes (*sarovara*):
Bindu lake in Siddhapur, the Pampa in Karnataka, the Narayana in Kutch, the Manasarovara at the foot of Mt. Kailasa, the Pushkar near Ajmer.

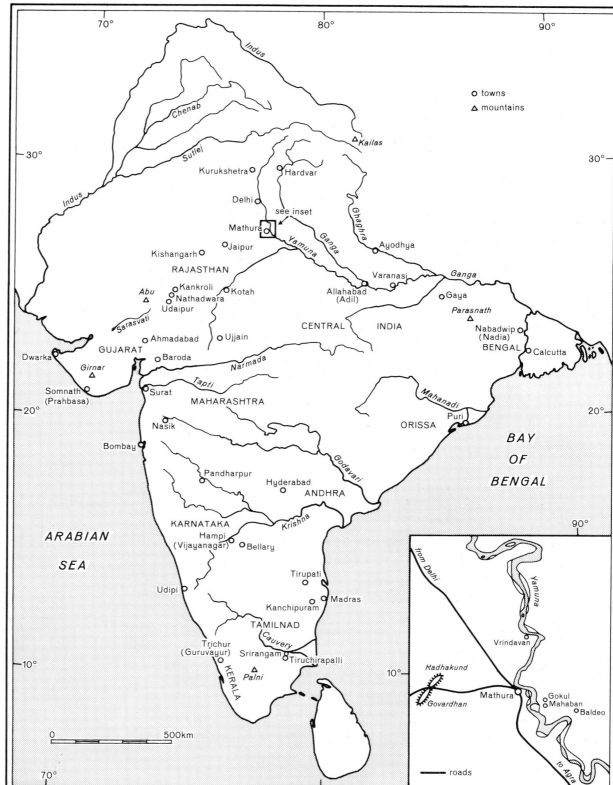

131. Raja Dalip Singh of Guler performs his morning puja. *(Miniature, Guler c. 1740, 165×247 mm without borders, Chandigarh Govt. Museum [ref. 185].)*

important in all aspects of Indian life, especially in the context of philosophical and religious speculation.

In Vaishnava thought there are four major *sampradayas* which we shall now describe, and some 139 subdivisions.

There is a saying in old Hindi, enumerating the four principal Vaishnava *sampradayas* thus:

The magnanimous Ramanuja, a treasure of ambrosia and terrestrial tree of plenty; the ocean of kindness and

transporter across the sea of Universe, Vishnusvamin; Madhvacharya, a rich cloud in the autumnal season of piety; and Nimbaditya, a sun that illuminates the cave of ignorance.

Not all the four *sampradayas* are specially concerned with the cult of Krishna, a brief account of these main four divisions of Vaishnavism, however, will clarify its evolution and explain the emphasis on the worship of Krishna and of Radha and Krishna, which were to develop in time.

The Shri sampradaya of Ramanuja

Ramkanuja was born at Shri Parambuttur, near Madras in 1017, or according to another tradition, in 1027. He belonged to a brahmin family and studied at Kanchipuram under the guidance of the philosopher Yadavaprakasha. He lost his father at an early age, had an unfortunate marital experience and while still young took to the life of a wandering mendicant, a *sannyasin*.

135

Such was the profundity of his learning, that he was reputed to be an incarnation either of Lakshmana, Rama's brother, or of the cosmic serpent Shesha. He wrote extensively on philosophy, and his most famous works include commentaries on the *Bhagavadgita*, on the *Vedanta-Sutra*, also known under the name of *Brahma-Sutra*, and it is this commentary, called the *Shribhashya*, which is considered *the* classic text for today's Vaishnavas. Ramanuja, though Tamil, wrote in Sanskrit. His followers, however, wrote in Tamil.

He travelled extensively through the whole of India visiting all the holy places of pilgrimage including Dvarka and Mathura; he finally settled at Shrirangam, near Trichinopoly, where he did his life's work. Tradition says that for his views on matters of religion and social life he was persecuted by the Chola ruler of those times. He consequently fled to Karnataka, and it was there that, among many other converts, he converted the King who, after his conversion from Jainism to Vaishnavism, took the name of Vishnuvardhana. At the death of the Chola king, Ramanuja returned to Shrirangam. There he is said to have lived till the age of 115, and he was buried in the great temple of Shriranganath.

Ramanuja accepted the caste-divisions in limited form; he accepted *shudras* and outcastes as members of his school. He strove for social equality between men and women, and he encouraged female education.

The only way to achieve emancipation from re-birth is, so states Ramanuja, not through knowledge, but self surrender, or *bhakti*. Such a view influenced many other doctrines, such as those of Madhva, Vallabha, Chaitanya and in modern times, the influence of Ramanuja's teaching is to be seen in the reform Brahmo movements.

In the *sampradaya* founded by Ramanuja there is an insistence on purity of practice both in matters of worship and in practical, everyday life. This emphasis is to be explained by the fact that at Ramanuja's time there was a shocking licentiousness which prevailed in the religious establishments. As a rebellion against this state of things, there is this preoccupation with purity and simplicity.

The worship of icons is permitted, these being 'auspicious bodies'. The followers of the Shri *sampradaya* are required to observe the strictest privacy while having their meals. The sacred basil plant (*ocymum sanctum*), the *tulsi*, must be grown in their homes. In every household, another of the symbols of

Nimanandi *Vallabhacharya* *Madhvacharya*

Main orders of Vaishnavas

Vishnu, the black ammonite stone, the *shalagrama*, must be kept and regularly worshipped. They should wear the 'caste-mark', the *tilaka* or the *namam* as it is called in the South, consisting of two perpendicular white lines drawn on the forehead, from the root of the hair to the beginning of the eyebrows, connected by a transversal stroke at the root of the nose. Between these two white lines, there should be a third one, a perpendicular red line. The white colour is obtained from special white earth, called *gopichandana*. There is a legend whereby the *gopis*, on learning of Krishna's death, committed suicide by drowning themselves in a pool. The earth of this pool, situated near Dvarka, should be used to draw the *namam*. The red colour is made from a preparation of turmeric and lime, called *roli*.

It is not only on the forehead that the devotees should draw the marks, proclaiming their 'belonging' to a deity. On their bodies also, they should bear these hallowed signs, and some permanently mark the sacred attributes of Vishnu on their bodies with the help of small metallic stamps heated in the flame. In this case the sign is called *chhap*, seal, and is especially prized if made after a pilgrimage.

Generally the *tilaka*, 'mole', somewhat inadequately rendered as 'caste-marks', can be of two kinds: the perpendicular ones of the Vaishnavas and the horizontal ones of the Shaivas and the Shaktas.

The Brahma sampradaya of Madhvacharya

The next great Vaishnava thinker was the philosopher Madhva, also called Anandatirtha. He was born in a Brahmin family in a small village near Udipi, Karnataka, in 1197. He is said to have been prodigiously learned. There are many legends hinting at this fact and one of them relates how, while still a young boy, Madhava disappeared from his parental home, and was eventually found in a temple teaching gods and men alike how to worship Vishnu properly.

He soon left his home and led the life of a wandering preacher. He toured southern India extensively, wrote commentaries on the *Bhagavadgita* and the *Vedanta-Sutra* and then proceeded towards the North of India preaching and performing many miracles. Being highly controversial, he is credited with having learnt Persian in order to defend his theological theses against the criticism of the *mullahs*. Finally he settled down at Udipi and established his school. He died in 1280.

The followers of the Brahma *sampradaya* are particularly numerous in Karnataka, in the South of Maharashtra, and generally on the west coast of India. The teachings of Madhava were written in Sanskrit but inspired many religious works in Kannada.

Madhva is one of the few thinkers who believes in eternal damnation: like those eternally liberated, those forever damned are also exempted from birth and re-birth.

Some authors suggested a Christian influence in the teachings of Madhva; they were led to such conclusions not only by some elements

in his doctrine, but also by the strong and sustained missionary activity of his school.

The followers of Madhvacharya, like those of Ramanuja, follow the practice of branding the shoulder with a 'seal' bearing the attributes of Vishnu. Their *tilaka* consists of two perpendicular lines, made with the *gopichandana*, but instead of wearing in the centre the red line, like in the case of the adherents of the Shri *sampradaya*, they wear a straight black line, made with the black of the incense burnt before Narayana. The *tilaka* terminates in a round mark made with turmeric.

The Sanaka sampradaya of Nimbarkacharya

The third of the great exponents of Vaishnava philosophy is Nimbarka, often identified with the famous astronomer Bhaskara. He was born in c. 1130 in a Telugu Brahmin family, settled in the Bellary District of Andhra Pradesh and is reputed to have spent most of his life in the North of India, especially in the region of Mathura. He died possibly in 1200.

There is a legend connected with his name. When the philosopher was in Vrindavana he met an ascetic and started with him a profound discussion which was protracted till late in the day. As it was evening Nimbarka offered the ascetic some food, but the latter had to decline his offer, because it was a rule of his order that no food be taken after sunset. The philosopher, so the legend tells us, immediately caught hold of the last rays (*arka*) of the setting sun and hung them on the branches of a nearby *nimba* tree. Thus able to stop the course of the sun, the meal could be prepared and eaten. For this feat he was called Nimbarka, and his followers are called Nimandis.

In Nimbarka's philosophy the concept of *bhakti* plays a dominant role. The only way to salvation lies in the complete surrender of the human soul to God. In this case the devotee is to give himself up to the constant and concentrated worship of Krishna and his consort Radha. As long as one lives, there is no hope of release. If there is to be release, it will take place only after death.

The most striking element of Nimbarka's doctrine is the stress on the combined worship of Krishna and Radha seen as his consort. This is met here for the first time. In this connection it may be of interest to mention that the poet Jayadeva, the famed author of the *Gita Govinda*, is said to have been a friend of Nimbarka.

The followers of the Sanaka *sampradaya*, the Nimandis, were especially numerous in the North of India, especially in the Mathura region and in the places so intimately connected with the life and deeds of Krishna. They had an extensive literature, which, unfortunately was for the greatest part destroyed during the reign of the Mughal Emperor Aurangzeb Alamgir (1659-1707). The Nimandis' *tilaka* consists of a circular black mark between the two usual lines made on the forehead with the *gopichandana* earth. They wear a necklace and a rosary

made out of the wood of the sacred *tulasi* plant. Most of them are settled in northern India, especially around Mathura and in Bengal.

The Rudra sampradaya of Vishnusvamin

The fourth of the great Vaishnava thinkers, Vishnusvamin lived at the end of the 14th century. The information about him is scanty, but the import of his doctrine is to be seen in a later exponent of his teachings, Vallabha, the founder of the Vallabhacharya *sampradaya*. In the *Bhakta Mala* of Nabhaji, Vishnusvamin is said to have had some illustrious disciples, such as Jnanadeva and Namadeva and finally, much later, Vallabha.

In Vishnusvamin's doctrine the central role is played by Krishna in his aspect as *Balagopala*, as child-cowherd. The Primeval Soul, such is the teaching of Vishnusvamin, was unhappy, feeling alone. Desiring to be many, it multiplied: it became the inanimate world, the individual soul and so on. All that exists sprang from it as sparks originate from a flame, and the whole creation is part of it. This concept is developed fully in the doctrine of Vallabha.

OTHER SAMPRADAYAS

The Bhagavatas (17)

The four main schools of Vaishnava thought mentioned above date only from the 11th century to the early 16th century. All of them, however, have their roots in a much older doctrine, predating Christ by many centuries. It is the teaching of the Bhagavata doctrine, which constitutes the base of all the philosophical speculation developing in later times as far as the worship of Vishnu, and hence of Krishna, is concerned.

Nothing definite and clear about the origin of the Bhagavatas has come to us. Still, since its very beginnings, as far as we know, the three strands which were to constitute the classical Vaishnavism had already merged. These three elements were: the worship of the *Vedic* Vishnu, the epic Narayana and the largely historical hero of the Vrishni clan, Vasudeva Krishna.

The name Bhagavata, which was assumed by this school, hints at the fact that the followers of this doctrine were exclusively devoted to the 'Adorable One', to the Bhagavata. Interestingly enough, there was another name for this doctrine, a name which corroborates the impression of devotion to one deity exclusively: Ekantika.

It is possible that this deity might have been Krishna. In this respect, the words uttered by Krishna in the *Bhagavadgita*, the most representative text of the Bhagavata doctrine, are explicit:

Leaving all other faiths, take my refuge alone.

To this devotion to a single deity were added the precept of non-injury, non-violence, of remaining pure in thought, word and deed. Moreover, there was an intensity of belief unknown to other doctrines.

The followers of Bhagavatism are referred to by yet another name: the Satvatas. This name is derived from a relatively small but influential non-Aryan group, and as regards religion, out of the pale of *Vedic* beliefs and precepts. It is to this group that Krishna and his brother, Balarama, or Sankarshana, belonged. It is possible that the followers of the special mode of worship, of the Satvata *vidhi*, had at least initially to overcome the resistence and the antagonism of the orthodox Brahmins.

References to this special mode of worship are to be found in a somewhat obscure passage, the *Narayaniya* section of the *Mahabharata*. In this we are told that the sage Narada visits the Shvetadvipa, the 'White Island', and there he utters the praises of the Great Being. The words spoken by Narada hint at the purity, at the greatness, at the splendour of the Great Being, who is devoutedly worshipped and who shows himself only to those who are completely absorbed in him.

And yet in another text, it is Narada again that is described as the secret bearer of the mode of worship of the Satvatas. This later text describes how Narada visits some sages who are in search of the home of Krishna. To them he imparts the secret traditional modes of worship, i.e. Vasudeva is the Highest, and it is from him that the redemption of the world emanates.

Along with the kind of monotheism as reflected in the passages quoted above, the Bhagavatas developed the doctrine of grace, *anugraha*. It is through grace alone, that man can be emancipated from the cycle of rebirth. This infinite grace is within reach of the devotee who surrenders himself completely in thought, action etc. to the Adorable One, to the Bhagavata. There is yet another important characteristic in this doctrine of the Bhagavatas, the doctrine of selfless action, *karma*, without hope of reward and without fear of retribution.

It is believed that the Bhagavatas first gathered around Mathura, and later rapidly spread far and wide. Ample evidence for their existence all over India is afforded by the epigraphical evidence: the Heliodoros pillar from Besnagar (near Sanchi); the inscription from Ghosundi, in Rajasthan; the Mora Well inscription at Mathura; and the records from Nanaghat in Maharashtra are all cases in point. Further evidence is afforded by the accounts of the travellers like Megasthenes, Q. Curtius and Ptolemy. The numismatic finds are quite explicit: evidence of the devotion and worship Vasudeva was receiving at that time is to be seen in the coins of the Kushana Kings.

There is therefore no doubt that Bhagavatism was a power in the centuries immediately preceding the Christian era, and that this doctrine continued to be popular till, as far as historical evidence is concerned, the sixth century A.D. The Guptas, as a matter of fact, styled themselves as *paramabhagavatas*, that is 'eminently devoted to the Adorable One'.

Sect-marks of the Ramanujis of Southern India

The classic mystical formula of the Bhagavatas, the *mantra*, was *Om namo Bhagavate Vasudevayah*, which means: 'Om. Obeisance to the Bhagavata Vasudeva'. This *mantra* has stayed with the devotees of Vishnu and of Krishna to the present day, regardless of the developments and of the variations that Vaishnavism underwent.

The Pancharatras (18)

It is not easy to distinguish the Bhagavatas from the Pancharatras, for there are points at which the two schools are inextricably linked. Moreover, the Bhagavatas are often referred to as the Pancharatra and *vice versa*. The significance of the name Pancharatra (lit. five nights), as well as its early history is obscure. Out of the many hypotheses and speculations as to the meaning of the name, there is the statement of an early text, saying that the name refers to the fivefold nature of Vasudeva. There may well be, in this name, an allusion to the *panchaviras*, to the 'Five Heroes' of the Vrishni clan: Vasudeva, that is Krishna; Sankarshana, or Balarama, his brother; the two sons of Krishna, Pradyumna and Shamba; and finally his grandson Aniruddha. These five heroes figure in the Mora Well inscription mentioned above.

The doctrines of the Pancharatras were systematized in the first century of our era by Shandilya, who emphasized the duty of devotion, of *bhakti* to Vishnu, as the supreme deity. At a later stage, however, while still singling out the unique position of Krishna Vasudeva, the Pancharatras asserted that Sankarshana, Pradyumna and Aniruddha were not merely aspects of the divine character, but divinities in their own right. Interestingly enough, Shamba, Krishna's son was then 'dropped'.

Each of these heroes has its distinctive emblem: Krishna Vasudeva has Garuda; Sankarshana has a fan-palm tree, evidently a 'reminder' of his exploit of killing Dhenukasura; Pradyumna has a *makara*, a fish; and Aniruddha has a deer. For this last one there is only literary evidence, whereas for the first three there is archaeological evidence.

The Pancharatra doctrine is very complex. In it, the Supreme Being is thought of as manifesting himself in five different ways. The first of these is *para*, the highest, beyond cognition and beyond description. The second is *vyuha*, a concept which can be rendered by the term 'emanation'. These *vyuhas*, 'emanations' are four: Vasudeva,

Sankarshana, Pradyumna and Aniruddha. Their relationship is thought of as the one emanating from the other, in the same way as a flame proceeds from a flame. So from Vasudeva emanates Sankarshana, from Sankarshana emanates Pradyumna, and from Pradyumna emanates Aniruddha. These emanations partake of the six qualities which, according to Hindu tradition, are: knowledge, lordship, ability, strength, virility and splendour. Vasudeva is endowed with all the six qualities, called the *gunas*, whereas the other three emanations have only two particular qualities each. This group of four *vyuhas, chaturvyuhas*, became in time an important feature of the Pancharatra doctrine.

The third way in which the Supreme Being is thought of as manifesting himself is in the 'incarnatory', *vibhava*, a concept which forms the root of the theory of Vishnu's *avataras*. The number of the *avataras* is not limited, though generally one hears of ten principal incarnations, starting with the Fish incarnation and ending with Kalki. The fourth way is called *antaryamin*; in this, the Supreme Being dwells in the hearts of all and controls them. Only the *yogis* can see this divine presence. Finally, there is the fifth way, which is called 'images', *archa*. These

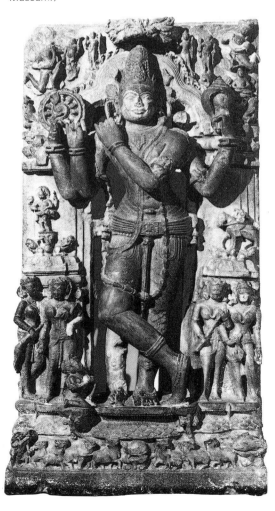

132. Vishnu as Krishna. *(Stone sculpture, Orissa 12-13th century, 71 × 163 cm, Orissa State Museum.)*

are the images of the Supreme Being set up in homes, in temples, in towns etc. and in these the Supreme Being is thought to dwell.

The Pancharatra theology is elaborated in several late texts called *Samhitas*, i.e. collections of compositions of a similar character or topic, methodically arranged. A significant part of these texts consists of elaborate descriptions of images and of their importance. Images are consecrated symbols of the deity in his *archa* manifestation, and they are almost like an incarnation of the deity himself.

In view of this stress on the importance of the images, it will not come as a surprise that the Pancharatra texts gave a most important and relevant contribution to the development of iconography and to the making of images. No one should stay for a single day or night, or take food or drink in a house or in a village in which there are no images of Vishnu; such was the practice among the Pancharatras. In the same way, it was made clear to them that no food ought to be taken in a house where there are images of other divinities, but none of Vishnu or Krishna, even if the householder is well-versed in the knowledge of the *Vedas*.

Perhaps the Pancharatras were not very numerous as a group, but highly influential as they were, their close relationship with the Bhagavatas made them a strong cultural presence.

The Vallabhacharya Sampradaya

Speaking of the Rudra *sampradaya* of Vishnusvamin, we anticipated the fact that the doctrine of Vallabhacharya owed a great deal to the teachings of Vishnusvamin, and that Vallabha (1478-1530) is often taken to be virtually the founder of this school.

There are detailed accounts of the life of Vallabha. He was born in a Brahmin family originally from Andhra. Tradition has it, that during one of the many journeys which the parents of Vallabha, Lakshmana Bhatta and his wife Yallamagaru were undertaking to visit some holy place (another tradition says that they were flying from a Muslim invasion), the child was prematurely born. Thinking it to be stillborn, the parents abandoned it. That very night, Vishnu appeared in a dream to Lakshmana Bhatta, enjoining him to go back to where the child lay, as his spirit had entered the infant's body. To the great astonishment of the parents, the child lay unscathed at the very spot where it had been left, and was surrounded by a wreath of protective flames. The child eventually developed a prodigious learning. At the death of Lakshmana Bhatta, Vallabha started off on a series of pilgrimages to various holy places. From the South, Vallabha journeyed to the North of India visiting the sites connected with Krishna. He visited Gujarat and Mathura, and it was here, near the hallowed spot of Gokula that he dreamt of Krishna. Krishna told him that he was lying buried in the Govardhana. Vallabha went to the spot the god himself had shown him and discovered the half

buried image, the very image of Shri Nathji: it showed Krishna in the act of lifting up Mount Govardhana. It was this image, now preserved at Nathdwara, that became the principal *svarupa* (icon) of the *sampradaya*. After having wandered for some twenty years, learning and preaching, Vallabha went to live at Benares and married. Then he settled down at Adil, a small town near Allahabad, and it was there that his two sons, Gopinath and Vitthalnath were born.

In time, his doctrines attracted a great number of followers. Being a profound scholar he wrote a number of commentaries on sacred treatises. It was only in his last years, after severing the family ties and turning to the life of an ascetic, that he returned to Benares. There, in 1530, after meditating and fasting, he entered the holy waters of the Ganges, where he is said to have been enveloped in a brilliant flash of light and taken slowly heavenwards.

At Vallabha's death, the leadership of the school passed to his younger son, Vitthalnath, for the elder, Gopinath, a remarkably learned and profound scholar, had died soon after his father. Vitthalnath was the one who established the organisation of the *sampradaya*, who took care of giving it an institutional basis, who thought of all the matters related to the cult, to the ceremonial aspect of the ritual, who gathered around himself scholars, artists, and poets, such as Sur Das and Kumbhan Das. It was Vitthalnath, who is credited with establishing contacts with several important courts, including that of the Mughals, whose ruler at that time was Akbar.

During his lifetime, Vallabha had gathered several images of Krishna, apart from the principal one of Shri Nathji. These images were given from Vitthalnath to his seven sons, and the principal icon was placed in the joint care of all of them. However Girdhar, the eldest son, was made chiefly responsible for it.

To begin with, they were all kept in Mathura, and then they were installed, each with a shrine to itself, in an area ranging from Uttar Pradesh to Gujarat. Nathdwara, however, continues to be the principal seat of the *sampradaya*.

Vallabhacharya's teachings are styled 'pure monism', *shuddhadvaita*. According to his doctrine (this element is already familiar to us from the teaching of Vishnusvamin) the Highest was alone and therefore unhappy. He then created out of Himself the whole universe. The phenomenal world is not an illusion, since the Highest Being created it out of Himself and at His own wish.

The Highest Being is identified with Krishna. Krishna is the origin of everything, the creator of the world, at the same time Krishna is the supreme joy *(paramananda)* and the supreme enjoyer of the world. Since the creation sprang out of Krishna, the whole of the material world and the universe are of a divine nature. It would be an offence to Krishna to renounce well being and pleasure. Penance and mortification of the

flesh are not virtues. The grace of god *(pushti)* enables us to attain the objects of life, and through the 'way of grace and bounty' *pushti marg*, another name for the doctrine of Vallabha, he is led to supreme self surrender and this again leads him to the attainment of God. The devotee must thus enter in a mood of 'playful enjoyment'; he must be able to participate mystically in the 'pleasures of Krishna', to enjoy the particular mood of all the ceremonies connected with him, and to surrender himself completely to God's grace, meditating constantly upon Vallabha's mystic formula 'Shri Krishna is my refuge'. Only through this selfless devotion is there salvation.

The form of Krishna that receives pre-eminent worship among the Vallabhacharis is that of the adolescent youth, handsome and playful. The loves of Krishna with the *gopis* of Vraja, the episode of the *rasa* dance are the incidents of Krishna's life which are most passionately celebrated. The whole cult is suffused with an atmosphere of sweetness, *(madhurya)* of love and enjoyment, of beauty and self-surrender. The devotee is required to surrender everything to the Lord: mind, body, possessions. It is this last aspect that was at a certain point pushed beyond the limits of decency. The *gurus* of the Vallabhacharya *sampradaya*, who styled themselves as *maharajas* were accused of licentious deeds under the pretext of demanding from their followers this kind of self surrender. In the second half of the last century this cult became notorious and the *maharajas* were involved in a scandal, and consequently in a celebrated case which was discussed in the Bombay High Court in 1861/62. This unfortunate circumstance did not however affect the future of the Vallabhacharis, who have a vast number of followers, especially in western India and Rajasthan.

Their *tilaka* consists of two vertical white lines that join at the bottom, and between them they place a red dot.

The Chaitanyas

The Vaishnava movement, especially the Krishna cult has assumed in eastern India and in Bengal a very special character; responsible for this are the Chaitanyas, the followers of Shri Krishna Chaitanya (1486-1534) one of the most interesting personalities among the exponents of the Krishnaite philosophy and mystic. His personality was unique and his charisma absolutely beyond description.

Chaitanya was the tenth child of a couple of Brahmin extraction, and was born in 1486 at Nadiya, in Bengal. The accounts of his life are inextricably mingled with legends, extraordinary prodigies and feats. His real name was Vishvambhara and only after his initiation in January 1510 did he change his name to Shri Krishna Chaitanya, then abbreviated to Chaitanya.

In his early years he studied Sanskrit and acquired a very profound knowledge of the sacred texts. At the death of his father, he set

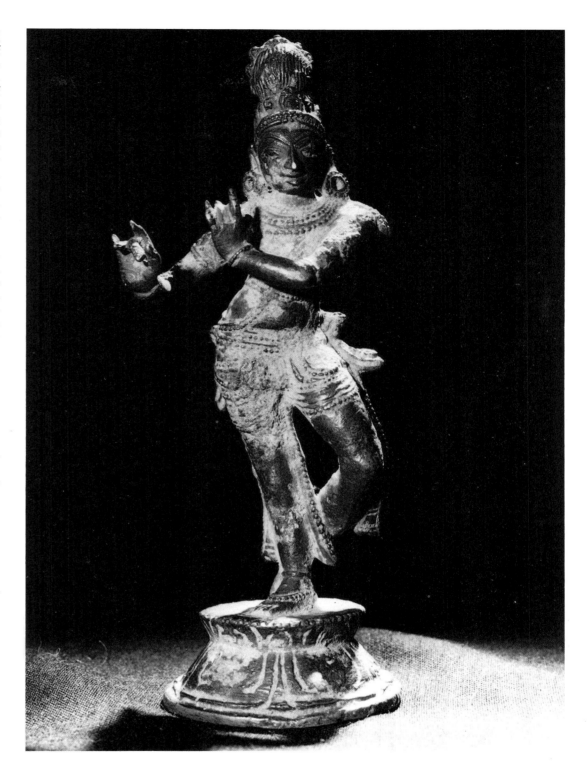

133. Krishna Venugopala. *(Bronze, Tanjore 13th century, 5.5 × 13.8 cm, Collection Colonel R.K. Tandan.)*

up a school. He married for the first time at the age of fourteen, and when his wife died from a snake bite, he married a second time. It was at the age of twenty-two, that his life was completely changed. As he was visiting Gaya, he met an ascetic of the Madhva school, and it was this recluse who gave him the Krishna-*mantra*. From this moment Chaitanya became another person: he started devoting himself to the service of Krishna. At the age of twenty-four he took to the life of a wandering preacher, journeyed to the temple of Jagannath in Orissa, and there he preached and made a number of

converts. From there he proceeded further to southern India, and finally he returned to the North, and journeyed to Dvarka and Vraja. It was largely due to the influence and personality of Chaitanya, that the sites so intimately connected with the life of Krishna, such as Mathura, Vrindavana and the Vraja country were rescued from ruin and decay. Chaitanya himself elevated Vrindavana to the status of paradise on earth.

The devotion of Chaitanya, who came to be called in his own lifetime *mahaprabhu*, that is 'great Master', was of a deeply emotional kind. Tradition says that the very mention of

the names of Krishna and Radha, the sight of their images, the sound of a flute, were sufficient to send him into mystical raptures. His biography is filled with accounts of ecstatic moments, when he would break into song and dance with fervent abandon, calling out the divine names of Radha and Krishna. He is said to have run to and fro like a mad man, often climbing trees, and suddenly collapsing in a stupor. Chaitanya himself, however, attributed his fits to epilepsy.

A new type of emotional song was the feature of his communal gatherings. His disciples, including his two most famous devotees and followers Advaita and Nytyananda, came together chanting devotional songs, called *kirtans*, often consisting only of repeating the names of Krishna and Radha, and dancing to the accompaniment of simple musical instruments, like cymbals. These meetings were held very frequently in the house of some of the followers of Chaitanya, and the emotional impact was such that men were known to fall into a state of trance, or start dancing and jumping as if in a frenzy, or have wild fits of hysteria, all carried away in a torrent of religious and mystical ecstasy.

This type of mystical frenzy, of emotional worship of God made the Chaitanyas highly popular among the masses. The gatherings, originally of a private character, became *nagar kirtans*, that is processional worship, which was carried through the streets of the town, much to the annoyance of the orthodox religious establishment and of the civic authorities. The public tumults which these gatherings caused disgusted a large section of the public, so that the Governor of Nadiya had to prohibit the *kirtans*. It was then, that Chaitanya adopted the method which in our days is called 'civil disobedience', and defied the order till it was rescinded.

Kirtans (also called *sankirtans*) apart, Chaitanya is said to have organised and also to have taken active part in performances of a dramatic character, called *kathas* (i.e. story), centred on the life of Krishna. These performances lasted nights on end.

There is no doubt that Chaitanya was profoundly influenced by the poetic works of Jayadeva and of Chandidasa, both stressing the passionate love of Krishna and Radha. This appears in his doctrine: Krishna is everything, he is the source, support and goal of the world. The highest manifestation of Krishna is the power of *hladini*, that is delight. Being the source of delight himself, he savours delight through conferring delight. He is thus the cause of all delight in the Universe. The expression of this delight is, according to Chaitanya's view, in *prema*, in pure and legitimate love. Hence the total devotion to Radha and Krishna is a central tenet of his system. Radha and Krishna are engaged in an eternal *lila*, they are one soul in two bodies whose delight lies in experiencing mutual love.

As was the case with the Vallabhacharis, the followers of Chaitanya were also often ac-cused of immoral practices, because of the importance attached to the erotic aspect of their worship of Krishna. Apparently this charge also arose because of another aspect of the movement: people of all classes were allowed to join the Chaitanyas. This was another of the revolutionary features of this doctrine. Chaitanya himself stated that, as followers of one faith, all individuals were equally entitled to a share of the *prasada*, or food, which had been previously offered to the deity. An often quoted saying of Chaitanya is:

The teacher of the four *Vedas* is not my disciple; and the faithful Chandal enjoys my friendship; to him be given, and from him be received; let him be reverenced, even as I am reverenced.

There was much opposition, especially from the orthodox point of view to a doctrine like this. In spite of this, the followers of Chaitanya grew steadily in number. To their eyes Chaitanya combined in himself the attributes of Krishna, the lord of all sentiments and flavours, and those of Radha, the embodiment of love. Chaitanya is in fact venerated to this day as the incarnation of Krishna and Radha in a unique person. Probably no other saint carried to such an extent the emotional approach to God as a lover to his beloved.

The work of Chaitanya is limited to eight couplets known as the *Ashtaka*. In spite of this, his influence played a major, if not a decisive role in the development of Bengali literature and helped to place Bengali on the same footing as Sanskrit as a medium of works of scholarship.

In the course of one of his ecstatic moments, Chaitanya is said to have dived into the sea near Puri and to have died. His body was then recovered and buried near Puri.

From among his many followers and disciples the two already mentioned, Advaita and Nityananda are designated as *prabhus*, masters. Their descendants living respectively at Santipur and Nadiya, are the spiritual leaders of the school. Out of the numerous followers there were also the ones called the *gosvamis*, who became the founders of several establishments all over northern India. Out of the *gosvamis*, Rupa, Santana, Jiva and Raghunath Bhatt, the so-called Gaudiya Vaishnavas (i.e. the Vaishnavas of Bengal) became an important force in Bengal and have remained there ever since.

The Chaitanyas wear a *tilaka* consisting of two white perpendicular lines on the forehead joined together at the bridge of the nose, and a line continuing up to the tip of the nose. They wear a three-stringed necklace and a rosary of *tulsi* beads.

The Sahajiyas

The term *sahaja* means literally 'original, natural'. The idea behind it is that of living a spontaneous life, free of inhibitions, without convention, without bondage of a social or moral nature. What is natural, in the opinion of the followers of the natural way of life, cannot be transgressed.

The *sahaja* current is to be found both in Vaishnavism and in Shaivism, and it originated as a protest movement against all the social formalities and restraints imposed by the orthodox way of life and religious observance.

Those who opted for the 'natural' way of life were convinced that the truth was not to be found through the usually recommended ways of reading, studying, doing penance, through fasting or adoring images, through sacrifice or through *mantras*. Natural occupations, a simple way of life were praised and practised. As a consequence of this attitude, there was a tendency to a complete surrender to the carnal appetites, and in view of this aspect the *sahaja* doctrine was considered by some as an aberration, whereas by others, as the only way of attaining release. The early history of this movement is shrouded in mystery. This is obvious, for the sahajiya cult, because of its peculiarities had to remain secret, or at least not openly spoken of. There are, however, some views on the origin of the doctrine: some trace the origin of the Sahajiyas to Lakshminkara, a royal lady who belonged to an Orissan royal family, and who is reputed to have lived in the eighth century. According to some others, the seed of the doctrine is to be sought in some early Buddhist text, styled the *Charyapadas*, 'verses on practices', revealing a strong Sahajiya bias.

Clearly there was a strong tantric influence in eighth century Buddhism, and definitely from this period onwards, one must reckon with a Buddhist-Sahajiya cult from which the Vaishnava-Sahajiya was developed. The core of this doctrine is the love, the eternal passion of Radha and Krishna.

This school flourished in Bengal, and the general opinion is that this movement must be dated back to the eighth or ninth century. Many a great poet has been a member of this school of thought. Though there might be some doubt, it seems that the poet Jayadeva, the author of the *Gita Govinda* was a follower of this doctrine. The focus on the physical love of Radha and Krishna, its passionate setting, the ecstatic tone of the poetry, could all very well fit in a Sahajiya context. With much greater legitimacy, the Sahajiyas point at the poet Chandidas, one of the greatest Bengali poets (?1350-1430), as having been one of them. The description of his love for the outcaste washerwoman Rami, and his terse, moving and deeply felt poetry, touching upon human and divine love, is clearly to be placed in a Sahajiya setting. Another of the great poets, Vidyapati, (1352-1448) writing with great delicacy and psychological insight on the loves of Krishna and Radha, could also have been a Sahajiya. Whether the mystic Chaitanya himself had ever been a Sahajiya is controversial.

The central figure of the Sahajiya doctrine is Radha. Radha is *the* pivotal figure of the Bengali Krishna cult. There are many theories about her origin, even though it is normally accepted that her personality and her character were fully developed in the

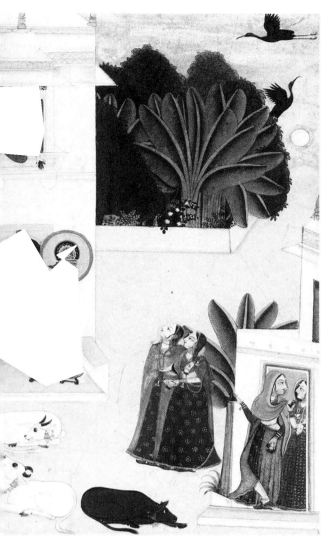

134. Radha dressed as Krishna. *(Miniature, Bundi c. 1760, 165 × 270 mm without borders, Bharat Kala Bhavan, Benares.)*

Gita Govinda. It should be remarked here, that at the folk level, there are clear indications that Radha was already associated with Krishna long before Jayadeva. She is also to be traced back to the eighth century, though definitive evidence remains to be seen. She was treated by the poets with great warmth and was described as a 'touchingly trusting woman in love'. She thus became the epitome of *prema* or pure love, for the devotees of Krishna.

For the Sahajiyas, Radha has yet another deep symbolic meaning. Radha is much more than the beloved of Krishna; her presence on earth permeated all women, all human beings, and afforded men a way to the experience of the Divine. In the person of Radha, the Sahajiya doctrine and Bengali Vaishnavis came together and blended.

Radha is seen as the prototype of the heroine, of the *nayika*. She is the *parakiya nayika*, the one 'who belongs to another'. 'Illicit' love is present in many currents of Indian thought, as the one leading to the greatest of bliss. The intensity of emotion in *parakiya* love, the idea of total surrender, of the breaking of all moral and social conven-

tions, of all bonds, in order to attain union with the beloved, was very popular in India. When Radha is mentioned, she is always thought of, not as the legally wedded wife of Krishna, but as the supreme *parakiya nayika*. She is either the one wedded to a cowherd, or just the innocent maiden in the prime of youth.

This concept lay at the root of some of the secret practices of the Sahajiyas, centring around some elaborate ritual in which the *parakiya* was first worshipped, and then the adepts made love to her. In these rituals there are references to the awakening of the latent powers of the body. There is a stress on the concept of seeing the body as the microcosm, as well as the belief that desire fully indulged in cures desire, and other beliefs related to the *vama marg*, left-hand path, a way of attaining liberation through disregard for conventions, by the belief that one is beyond good and evil, by sexual mysticism etc.

On the purely philosophical plane, the Sahajiyas state that the nature of pure love presupposes two factors: the enjoyer and the enjoyed. On earth these two factors are identified in the male and the female. To put it in the words of Chandidas:

There are two currents in the lake of love, which can be realized only by the *rasikas* (i.e. by the people versed in *rasa*). When the two currents remain united together in one, the *rasika* realises the truth of the union.

Rasa, enjoyment, is the ultimate emotion in the heart of the enjoyer and *rati*, is the object of *rasa*. Krishna is *rasa* and Radha is *rati*. In order to realise this state, a particular couple should first of all realise their true selves as Krishna and Radha, as *rasa* and *rati*. Only when this condition is fulfilled, do they attain through human love the dimensions of divine love. It is only then that human love can transcend gross sensuality.

In Sahajiya doctrine and rituals there is a great stress on the importance of the *guru*; the devotee was to surrender himself completely to his will. The *guru* was not necessarily a learned man and among the Sahajiyas, women were often chosen for this task. Without his guidance there could not be understanding, nor a proper sense of direction and no realisation of the higher meaning of ritual and faith. Though the Sahajiyas are remarkably against traditional scholarship, the *guru* is the only one who knows, who is in a position to guide the adept, the *sadhaka*, and to help him in his progress towards his goal of bliss. There are three distinct stages: first the adept is prepared, then comes the stage at which the sexual ritual is undertaken, and finally, after the sexual ritual the adept has reached the stage in which he is beyond all mortal and external things, and pervades all time and space.

In spite of denunciation, suspicion and criticism, the Sahajiyas have remained an influential group, at least in Bengal. Their remarkable influence on literature can be seen even nowadays, albeit in a somewhat altered form, in the songs of the Bauls, the 'God-mad' singers, who are constantly on

the move playing upon their *ektara* and singing their compositions. These poet singers, who belong to what could be called the counter-culture of Bengal, are not all Sahajiyas, but *sahaja* comes naturally to their way of thought.

The Radha Vallabhis

One of the minor religious groups of Krishnaite inspiration is that of the Radha Vallabhis, i.e. that of the followers of 'Radha's Lover', Krishna. From the name of this group it is already clear that the central figure is not, as it might have been expected, Krishna, but Radha: the founder of this movement, Hita Harivansh (c. 1503-1553) is very explicit in stating the position of Radha in one of his works, the *Radha-sudha-nidhi*, the 'Treasury of Radha's Delights'. In it he says that those who are content with the love of Krishna and do not know Radha are satisfied with a mere drop of nectar while neglecting the ocean of nectar, which is Radha.

Hita Harivansh was born in a small village near Mathura, Bad. His father was a Brâhmin from Bengal who had long been childless and in grateful recognition for the fulfilment of his prayers he gave the name of Harivansh ('Hari's issue') to the child. When Harivansh grew up, he married, and had two sons and a daughter. After having given the daughter away in marriage, he decided to abandon the world and lead the life of an ascetic. With great determination he made his way to Vrindavana and suddenly, reaching Charthaval, he came across a Brahmin who presented him with his two daughters and insisted upon his marrying them, as this had been revealed to him in a vision. This Brahmin gave Harivansh an image of Krishna with the name of Radha-Vallabha, and this very image was then set up in the temple he himself founded at Vrindavana, the Radha-Vallabha Temple.

Originally Harivansh belonged to the Madhvacharya *sampradaya* and it is from the Madhvas and from the Nimandis that his doctrine and some elements of the ritual are derived.

The *Bhakta Mala* of Nabhaji, explains the devotion of Harivansh as follows:

The Gosain Shri Hari Vansh: who can understand all at once his method of devotion? with whom the feet of blessed Radha were the highest object of worship; a most staunch-souled devotee; who made himself the page in waiting of the divine pair in their bower of love; who gloried in the enjoyment of the remnants of all that was offered in their shrine; a servant who never pleaded obligation or dispensation; a votary of incomparable zeal. Account him blessed who follows in the path of Vyasa's great son, the Gosain Shri Hari Vansh; who understands all at once his method of devotion? (19)

It is obvious from the amazed tone of the account of Nabhaji that this system was viewed, at least at first, with no small degree of wonder. The whole episode of the appearance of the Brahmin, the marriage with the two young girls, and the foregoing of the intention to lead a celibate life, has been very differently interpreted. Mohsin Fani wrote, in the middle of the 17th century, that the

Radha-Vallabhis 'deliver their wives to the disposition of their preceptors and masters and hold this praiseworthy'. Though this has been attributed to the Vallabhacharis, the fact of emphasizing the person of Radha, the erotic aspect of the Radha-Krishna relationship and the personal conduct of the founder of the sect, seemed at least puzzling to a person outside the doctrinary influence of Harivansh.

Harivansh was the author of two poems, one in Hindi, the *Chaurasi Pada*, or '84 Stanzas' and the already mentioned Sanskrit poem in 170 couplets, the *Radha-sudha-nidhi*. These works are recited daily by the adherents to the Radha-Vallabha doctrine.

The Sakhi-Bhavas

Related to the Radha-Vallabhis, but carrying the adoration of Radha a step further, the followers of this group assume the role of women in their worship of Krishna. A description of the Sakhi Bhavas written at the back of an 18th century painting portraying one member of this group, reads as follows:

This sect is in favour with those with an effeminate turn of mind. The faith of the members of this order focuses on Radha, consort of Shri Krishna. They declare themselves to be (her) female (companions), with the idea of paying her homage and establishing identity (with her). They even take on the manner of speech, the gait, the gestures and the dress of women. At monthly intervals, in the manner of menstruating women, they put on red-coloured clothes as if affected by menstruation and pass three days in this state. After the period of 'menstruation' is over, they take a ceremonial, purificatory bath. In the manner of married women, anxious to be physically united with their husbands as enjoined upon by the Veda, they take to themselves on the fourth night, a painting of Shri Krishna, and stretch themselves, raising both their legs, utter 'ahs' and 'ohs', adopt woman-like coy manners, and cry aloud: 'Ah Lalji (i.e. Krishna), I die!', 'Oh Lalji, I die!'. Through practices like this they believe that they earn great merit and please Shri Krishna by engaging themselves thus the whole night. Every month, on the fourth night after 'menstruation', this practice is observed. Members of this... order are to be found in large numbers in Mathura, Bindraban (Vrindavana) and their environs (20).

Before one passes judgment on the Sakhi Bhavas, one should recall that some of the foremost of the Vaishnava poets, including Jayadeva, Chandidas and Vidyapati, placed themselves very often in the position of the *sakhi*, the female companion of Radha and Krishna, who never longed for her own union with Krishna, as has been said, 'but ever longed for the opportunity of witnessing from a distance the eternal love making of Radha and Krishna in the supra natural land of Vrindavana'.

The Charan Dasis

Founded by Charan Das, a merchant, who lived in the 18th century in Delhi. Krishna, according to the tenets of this doctrine, is the source of all things in the Universe. There is no bar of caste or of sex upon joining this group. The singular feature of the Charan Dasis is that, at least in the early years of their activity, they worshipped no images and no 'sensible representations of the deity'. They excluded from their devotion the sacred *tulsi* and the *shalgrama* stone.

The adherents to the Charan Das doctrine mainly belong to the mercantile classes and wear yellow garments, with a single streak of sandal paste or of *gopichandana*, vertically down the forehead. In general they wear a small pointed cap, around the lower part of which is tied a yellow scarf.

The authorities of the Charan Dasis, as in most of the religious groups spoken of above, are the *Bhagavata Purana* and the *Bhagavadgita*, and their own vernacular literature including compositions by their founder Charan Das.

The Mira Bais

The admiration in which Mira Bai is held, and the prestige attached to her name are such that there are many that owe her allegiance. Mira Bai herself sang of Krishna as Giridhar Gopala, emphasizing the aspect of Krishna which raised Mount Govardhana. The image, however, to which she paid adoration is designated as Ranchhorji.

135. Krishna lifting Mount Govardhana. *(Ivory, Orissa c. 17th century, 4.7 × 7.0 cm, Private collection.)*

The Mira Bais worship this form of Krishna and there are numerous temples bearing this name in Rajasthan and Gujarat.

The Bal Krishnivas

The adoration of Krishna as the Divine Child takes diverse forms. As Balaji, or the infant Krishna, he received devout homage especially in the South of India. Within the cult of Balaji, there are many different variations, so that one hears of a Banjara cult, a

Tirupati cult, a Berar cult, a Nasik and a Marwari cult.

In other parts of India, there are devotees of Krishna who pay homage to no other form of Krishna except as Balaji, believing that he lived only as a child on the earth; all that is worth adoring, in the view of these devotees is what Krishna made others experience as a child in Gokula and Vrindavana.

The Hare Krishnas

The message of Krishna has been carried to the West in the last fifteen years. This is mainly due to the activity of a group popularly called Hare Krishnas. The correct name of their organisation is the 'International Society for Krishna Consciousness'.

The members of this society owe total allegiance to their supreme Master, A.C. Bhakti Vedanta Svami Prabhupada, who founded the Society in 1966. Svami Bhakti Vedanta belongs to a line of teachers of Bengal Vaishnavism, who trace their descent from one of the most prominent of Chaitanya's disciples, Jiva Gosvami.

Svami Bhakti Vedanta studied at the University of Calcutta and had once worked in a chemical firm. In 1959 he renounced the world and started devoting himself totally to God. There were some difficulties at the time he was due to take over the succession to the position of his master, Svami Bhakta Siddhanta, and for this reason Svami Bhakti Vedanta decided to take up the mission of his master and worked exclusively towards carrying this doctrine to the West.

The movement founded by Svami Bhakti Vedanta can be seen as a continuation of the doctrine of Chaitanya, with the necessary modifications demanded by the epoch. The teachings of this creed are very simple: Krishna and Radha are at the centre of this doctrine.

The only possibility of approaching them is through self surrender, *bhakti yoga*. Because man has forgotten his true relationship to Krishna, from whom the world emanates and into whom it returns, his only escape lies in accepting Krishna's grace.

The Hare Krishna maintain a life style that in the Western context stands out as very distinctive. Communal living, obedience to a common preceptor, collective chanting, a uniform way of clothing etc. mark them. Self surrender is what is expected of the members of the Society. All devotees are expected to avoid gambling, frivolous sports and games. They should avoid alcohol, drugs, tobacco, coffee and tea. They should refrain from having meat, eggs and fish, they should abstain from illicit sexual pleasures. There is an emphasis on private chanting (*japa*) of the mystic formulas. Very important is the partaking of the *prasada* food, that has been first offered to Krishna. There is fasting on the *ekadashi*, the eleventh day after the full moon, and after the new moon. All this, in the opinion of the devotees, increases the love (*prema*) for Krishna. This is not a new love, but the recovery of the original love that the soul had for Krishna.

Krishna in the Performing Arts

by Dr. K. Vatsyayan

136. Infant Krishna sucking his toe. *(Bronze, southern India 12th century, c. 15 cm, Private collection.)*

As early as the eighth century A.D., the popularity of Krishnaite sculpture was reflected in shrines, such as those of Osian in the Marwar area of Rajasthan, and in the sculptured panels on the walls of Vaishnava temples. These panels were surprisingly widespread considering that few temples were specifically dedicated to Krishna. The explanation for this lies partly in the devotional motivation behind such sculptural representations, although other factors are also relevant.

137. Krishna slaying Kuvalayapida. *(Stone sculpture, Osian 8th century)*

Sectarian schisms were rife and harmony by no means prevailed between the adherents of the Shaiva and the Vaishnava faiths, the two principal religious denominations in India. Despite Shiva's words:

> I, Vishnu and Brahma are one

each sect strived to propagate its faith through the construction of temples dedicated to a particular deity. Lithic art was the instrument whereby the great storehouse of myths pertaining to a god might be recreated, thus composing a drama in stone, a passion play which aroused emotions, confirmed devotees in their religious beliefs while binding them to their god, and attracted those who sought salvation but were hesitant as to which faith to follow.

Sculpture and painting proved the most effective means of conversion to the Vishnu cult. They told stories of the Blue God, through the love of whom the devotee might be liberated from all the troubles, hardships and sorrows to which the flesh is heir. The Krishna legend, which incorporated various themes, exuded the elements of heroism and power, romance that did not slight illicit love and human passions and an all-embracing aura of divinity.

The theme of Krishna and the *gopis* was alluded to in the famous Tamil epic poem *Shilappadikaram* (The Lost Anklet) and in other works as early as the second century A.D. but it reached a far wider public with the composition of the *Bhagavata Purana* in about the ninth century. The latter has

KRISHNA IN SCULPTURE

Sculpture relating to the Krishna theme was originally inspired by the series of legends which had grown up around the supreme deity of the *bhakti* cult. These legends were passed by word of mouth from generation to generation until they came to be embodied in that great epic the *Mahabharata*, and later in the *Harivansha*. Although the oral tradition probably continued, particularly among the illiterate, these epics provided a fund of incidents and inspiration for sculptors who could use them as a set reference.

The use of sculpture as a means of disseminating the *bhakti* cult was undoubtedly influenced by the early example of the Buddhists who had manipulated this art form for the same ends. The reliefs on the *stupas* at Bharhut and Sanchi narrate incidents from the life of Buddha and *jataka* tales on the subject of his former births for the benefit of the pilgrims and worshippers who visited

them. These Buddhist reliefs were therefore essentially visual sermons, as were the early Krishnaite sculptures, albeit on a far more limited scale. There is every reason to believe that the Krishna theme also featured in the early paintings to be found in the *chitrashalas* (picture galleries) of temples, palaces and mansions, but no example remains to compare with those of Ajanta and Bagh which belong to the Buddhist faith.

The *Bhagavata Purana* was written in about the ninth century A.D. and, along with the *Mahabharata* and the *Harivansha*, became a major source and inspiration for the constantly increasing number of Krishnaite sculptures to be found in medieval shrines. Meanwhile, in the South, the *bhakti* cult had already received a further impetus from the profoundly devotional hymns of the Vaishnava saints known as the *Alvars*. The composition of the *Bhagavata Purana* was thus an additional element which contributed to the strengthening of the *bhakti* cult, already established throughout India.

always been the most popular of the *Puranas* among sculptors and painters, even though others also describe Krishna's life.

No early Krishnaite paintings are extant but sculpture attracted attention from as early as the classical or Gupta age, between the fourth and fifth centuries A.D., partly as a result of the spread of the Bhagavata cult, as Krishna worship came to be known. But, despite its enormous impact on painters and sculptors, an equally important source of inspiration was the sheer beauty, tenderness and intrinsically human quality underlying Krishna's loves and exploits.

One fact has probably always been underrated: while the Krishna legend dominated the vast output of miniature painting from the second half of the 16th century onwards, sculpture, whether in stone, wood or metal, gave pride of place to the cult images of Shiva, Vishnu and Devi and their many forms and mythological situations. This can be explained by the very nature of the cult of the god Vishnu, a member of the all-pervading Trinity. Although Krishna was one of the ten incarnations of Vishnu and the most extensively worshipped as a personal deity (*ishta devata*), more so even than Rama, far fewer temples were dedicated to him than to Shiva and Vishnu, the two supreme deities of the Brahmanical pantheon. This is puzzling because the Bhagavata creed owed its wide popularity to the Krishna cult which, particularly in northern India from the 13th century onwards, became the refuge of millions and dominated their lives in song, dance, literature and painting.

The earliest sculptural representations of the Krishna theme can be traced back to the second and third centuries in Mathura, known as the Kushana period. However, these images are few and mediocre alongside the Buddhist and the Jaina sculpture. Such episodes as Vasudeva carrying the baby across the river Yamuna, the subjugation of the snake Kaliya and the killing of the bull-demon Arishta are depicted. The paucity of these rather elementary images suggests that, at this time, there were no marked leanings towards representing the Krishna theme. On the contrary, Kushana period art concentrated on the person of the Buddha, narrative reliefs pertaining to the Buddhist faith and to the Jinas and Jainism. It would seem that, despite a certain popularity in northern India, the Krishna legend did not greatly inspire Mathura sculptors at this time. Similarly, in the Krishna Valley complex in the South, during the same period, sculptors were chiefly concerned with Buddhist narrative reliefs.

However, in the Gupta period (A.D. 320-550), sculptures on the Krishna theme increase in size and number, reflecting the desire of the devotees of the Krishna cult to emulate the vast output of Buddhist, Jaina and other Brahmanical sculpture. There is, for instance, a magnificent large work, from the fifth century, showing Krishna lifting Mount Govardhana, now in the Bharat Kala Bhavan, Varanasi. The same episode is depicted in the late Gupta temple at Deogarh, dating from the sixth century, and there is yet another on the same subject in the Government Museum, Mathura, also from this period.

These three Giri Govardhana sculptures share the characteristic simplicity of Gupta period plastic art. The feat of effortlessly raising Mount Govardhana is conveyed by a single upraised hand and by a graceful figure displaying not the slightest sign of stress or strain while he rests his free hand on his girdle or knee to emphasise his imperviousness to the weight of even such a mighty hill. The latter is also depicted very simply as a thick slab of stone with clefts, raised above Krishna's head. Mathura sculptors introduced the grateful cowherds with their cattle, albeit in a formal manner, to indicate how

138. Vasudeva carrying Krishna across the river Yamuna. *(Stone sculpture, Mathura 2nd-3rd century, Government Museum, Mathura.)*

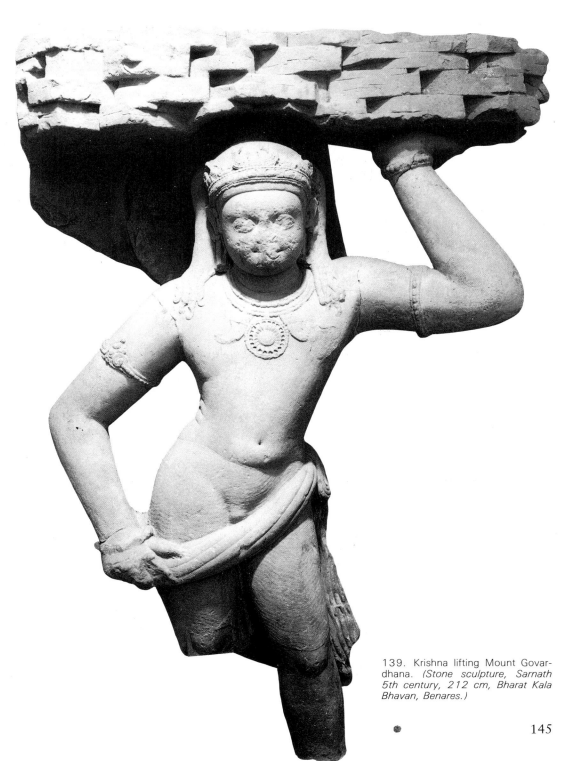

139. Krishna lifting Mount Govardhana. *(Stone sculpture, Sarnath 5th century, 212 cm, Bharat Kala Bhavan, Benares.)*

142. Krishna stealing butter. *(Stone sculpture, Mathura 4th century, c. 40 cm, Bharat Kala Bhavan, Benares.)*

deity Vishnu than with Krishna. Now, at Mandor and Osian, there was evidently a desire on the part of sculptors to represent the Bhagavata faith through Krishna as a specific incarnation of Vishnu, and to depict several of his feats.

As far as painting and sculpture are concerned, a distinction should be made between the various modes of expression adopted for the visual propagation of the Bhagavata creed, of which principal ones are:

a) representations of Vishnu himself in various forms.
b) representations of his incarnations.
c) representations of various mythological stories relating to Vishnu.

141. Krishna lifting Mount Govardhana. *(Stone pillar, Mandor 5th century now at the Jodhpur Museum).*

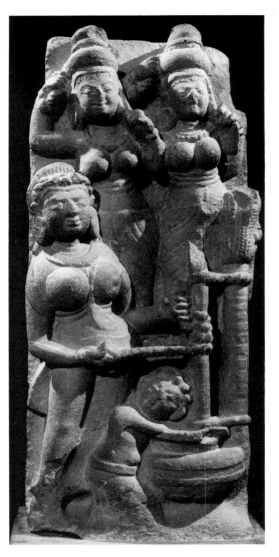

140. Krishna lifting Mount Govardhana. *(Stone sculpture, Mathura 6th century, Government Museum, Mathura.)*

the people of Vraja and their herds were spared the wrath of Indra. These Mathura sculptors were alone in their attempt to elaborate such images by featuring two very static cows, one above the other, on either side of Krishna, and two *gopas* at the base. Elsewhere, the episode is depicted with Krishna standing alone, beneath a formal rock formation, with one hand raised to show that he is lifting Mount Govardhana. On two pillars from Mandor, near Jodhpur in Rajasthan, also dating from the Gupta period and now in the Sardar Museum, Jodhpur, there are several panels showing incidents from Krishna's life and executed in more detail. In the Giri Govardhana episode, for instance, the mountain has peaks and is inhabited by various creatures, while, under it, the *gopas* and the *gopis* seek shelter with their herds. The killing of the horse-demon Keshi is also depicted, with a certain austerity offset by an extraordinary vigour. The animal is shown rearing wildly with its neck arched, its back hollow and its jaws open, ready to attack. Krishna, in an athletic pose, thrusts his hand into the creature's mouth to choke it to death. The immense power of the combatants is admirably conveyed with an economy rarely achieved.

This early attempt at Mandor to relate episodes from Krishna's life in stone in more detail than at other Gupta sites may reflect the beginning of a movement in the Rajasthan areas to popularise such episodes. Sculptural friezes at Osian, dating from the eighth century, would seem to confirm this trend. The Bhagavata creed had already established a foothold in northern and western India but its sculptural manifestations were more concerned with the pristine

Some incarnations, such as the Varaha avatar and the Narasinha avatar, were more popular than others with painters and sculptors, but the narrative possibilities of these avatars were limited in comparison with those afforded by the Krishna and Rama avatars. The latter were a great source of inspiration and consequently came to dominate the Bhagavata cult from the representational point of view, particularly in painting. However, sculptures drawing from the Krishna legend also became more widespread and elaborate than they had been at Mandor and other Gupta sites such as Deogarh. Here the plinth sculptures herald the common medieval practice of introducing panels on temple walls to show incidents from Krishna's life but, even at Deogarh, each episode is depicted with marked economy.

In the incident where the baby Krishna kicks and overturns the cart, the latter is shown in the air with its pots inside, both still intact. The extraordinary nature of the feat is conveyed by the baby's upraised leg touching the cart. The amazement of Yashoda is reflected

143. Narasinha avatara. *(Detail from a pillar, c. 8th century, Gwalior Archeological Museum.)*

144. The cart demon episode. *(Stone pillar, Mandor 5th century, now at the Jodhpur Museum.)*

in her lowered head, her chin resting on her hand. The narrative consists of the simple formula of the baby, the cart and Yashoda and differs enormously from the elaborate portrayal of the same episode in the paintings of later centuries. This concision of detail recalls the technique used on the reliefs of the *stupa* of Bharhut, narrating incidents from the life of the Buddha which were so familiar to worshippers that the minimum number of people and objects were considered necessary.

In the earlier Mandor relief of the same story only the baby and the upturned cart are depicted. The limitations of stone as a material partially explain this concision but, at this early period, the representational style was based more on suggestion than on detailed explanation.

However, in Karnataka in the seventh and eighth centuries, the approach to the increasingly popular legends as a source for temple sculpture, undergoes modification. At Badami, where there are a number of reliefs relating to the Krishna theme, both the concise and more detailed forms of portrayal are to be found. The Putana episode is represented by the single seated figure of the demoness who raises her hands in desperation as the baby sucks the very life-blood from her poisoned breast. In contrast, in the Giri Govardhana story, Krishna is seen lifting the mountain while a cow stands on either side of him and grateful villagers of Vraja strike various poses of adoration and astonishment.

At the same site there is a relief of the Kaliyamardana episode, when Krishna subjugated the snake Kaliya. He tramples on the body of the great serpent who raises his multi-hooded head and clasps his hands in supplication. The demon's wives are also shown with their hands clasped as they beg Krishna to spare their husband's life. The river Yamuna, where the incident occurs, and the onlookers on its banks, are suggested in a terse manner but the main elements of the story are conveyed, unlike in some other reliefs which merely show Krishna dancing on Kaliya's hoods.

Despite a growing tendency towards more elaborate sculptural representation, the earlier concise practice nevertheless continued in vogue. Nearby, at Pattadakal in the Mallikarjuna temple, the killing of the ass-demon Dhenuka is shown in two phases: firstly, Balarama is depicted as a strong, man-sized figure triumphantly holding the body of the ass by its hind legs prior to flinging the beast into the palm-trees; the *gopas* look on in astonishment. On the right, a single stylised palm-tree represents the entire grove with the ass lying limp against its trunk and fronds, similar to the Gupta pillar at the Gwalior Museum.

On the other hand, the reliefs showing Krishna slaying the elephant-demon Kuvalayapida and the horse-demon Keshi are handled in the concise manner. He is seen alone on the brink of killing the still upright elephant with his hands. The demon appears tiny alongside Krishna in order to indicate the immense strength of the latter. Similarly, Krishna is seen alone about to strike the rearing horse-demon Keshi with one hand, while he pushes back its head with the other. This represents the first assault of the *asura* Keshi told in the story and the second part, where Krishna thrusts his hand down the demon's throat and chokes it to death, is left to the visual imagination of the viewer.

145. Krishna suckling Putana. *(Stone frieze, Badami 8th century.)*

146. The quelling of Kaliya. *(Stone panel, Bubaneshwar 6-7th century, 41 × 92 × 30 cm, Orissa State Museum, Bubaneshwar.)*

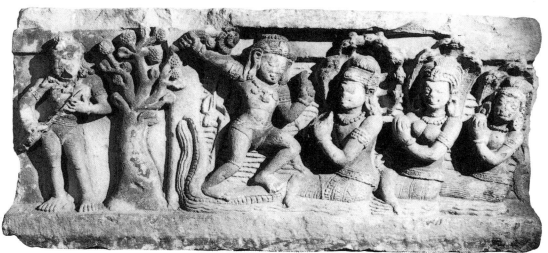

147

147. Denukasura thrown into a palm grove. *(Stone pillar, Pawaya [Gwalior] 5th century, Archeological Museum, Gwalior.)*

148. Krishna lila. *(Stone frieze, Somnathpur 13th century)*

Both methods continue in later sculptural representations of the Krishna legend but the carving becomes more intricate and realistic in the Hoyshala period temples such as those of Belur, Halebid and Somnathpur and at several shrines of the same date.

Although sculptors of the Krishna legend described the main incidents in each episode, their treatment of these subjects varied considerably. In the Putana story, for instance, some would show the baby in the demoness's lap as he suckled her to death, while others had Krishna standing to accomplish his deadly deed and some showed him lying on the body of the fallen Putana and killing her in this position. Such variations on the theme are common because, although all sculptors referred to the *Bhagavata Purana*, any given episode was open to diverse visual interpretations.

The popularity of the Krishna legend as an inspiration to sculptors continued to grow in the mediaeval period when they worked not only in stone but also in metal, terracotta and wood.

Quite a number of metal images were cast in various parts of India, very frequently showing Krishna dancing, sometimes with a knob

148

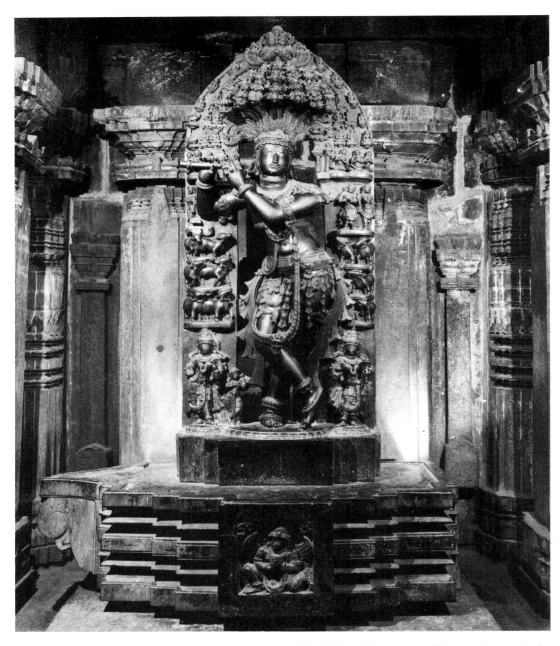

Wood was yet another sculptural medium, above all in southern India. In several temples dedicated to Vishnu or one of his many forms, the interior wooden architecture frequently showed scenes from Krishna's life. Such scenes were also carved on the *rathas* or great ceremonial carriages belonging to a number of southern Indian temples. Many a cherished anecdote was to be found on these massive vehicles: the lifting of Mount Govardhana, the subjugation of Kaliya, Krishna and the *gopis* and so on. Although the remaining temple carriages date from a later period and have been either

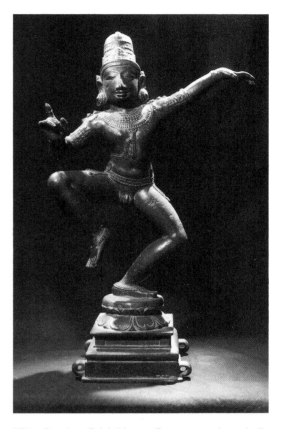

149. Krishna Venugopala. *(Stone sculpture in the sanctum of the Somnathpur temple 13th century)*

150. Krishna dancing with the butter ball. *(Bronze, southern India 18th century, 8.3 cm, Collection Prof. Samuel Eilenberg.)*

151. Dancing Balakrishna. *(Bronze, southern India 12th century, 61 cm, Prince of Wales Museum, Bombay.)*

152. Baby Krishna crawling. *(Bronze, southern India c. 17th century, 7 cm, Galerie Marco Polo, Paris.)*

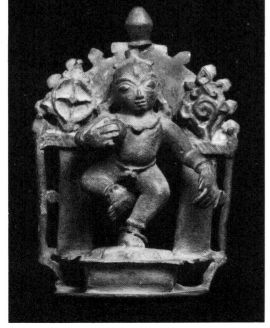

of butter in one hand, or Krishna as Venugopala, the divine flute player. The splendid dancing Krishna of the Chola period (11th century) comes from southern India. As with the sculptured panels on temple walls each area cast these metal images in a different style. An image of the baby crawling and a unique example of exceptional quality and rarity from Nepal, which shows Krishna dancing, are of particular interest. As far as terracotta is concerned the temples of Bengal house moulded bricks and panels of great charm, lovely colours and outstanding artistic merit which relate the story of Krishna. The 18th century temples of Vishnupur and Birbhum are particularly richly endowed.

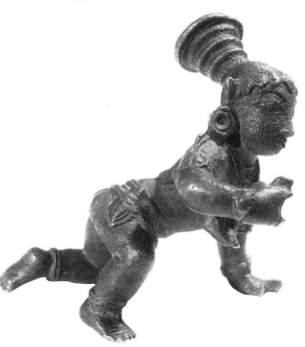

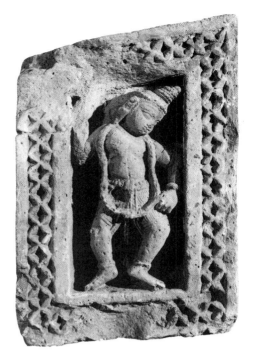

153. Dancing Krishna. *(Terracotta, Bengal 18th century, 12 × 15 cm, State Archeological Museum - West Bengal.)*

restored or rebuilt, the carvings from the late 18th and early 19th centuries are nevertheless delightful. As these impressive carriages slowly filed through the teeming throngs of worshippers on certain religious occasions, they provided a moving panorama of the life of Krishna to enchant his devotees.

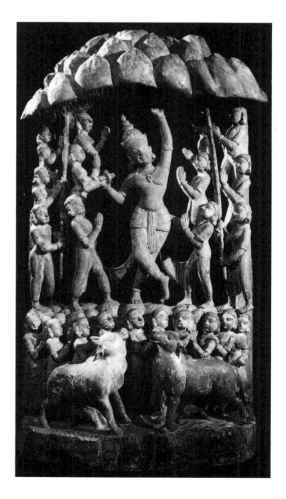

154. Krishna holding Mount Govardhana. *(Wood sculpture, Orissa 18th century, 52 × 80 cm, National Museum, New Delhi.)*

155. Dancing Krishna. *(Gilt bronze, Nepal 18th century, 43.5 cm, Prince of Wales Museum, Bombay.)*

KRISHNA IN PAINTING

Having attempted to discover what motivated sculptors to represent the Krishna theme, the question remains as to whether painters were spurred by the same reasons, particularly when examining their vast output between the 16th and 19th centuries. Was painting occasioned by a love of miniature art or was it the manifestation of religious sentiments which found their expression in the illustration of texts relating to Krishna and other deities?

No categorical conclusion can be drawn. religious sentiments were undoubtedly of considerable importance in the pictorialisation of the Krishna theme but these paintings were also objects of beauty which fostered a love for the finely illustrated manuscripts of the *Bhagavata Purana*, the *Gita Govinda*, the *Harivansha* and the romantic and devotional poetry which worshipped Krishna as the

source of emancipation through his doctrine of joy and love. It is of paramount interest to trace the course of this development because it resulted in an ever-increasing production of miniatures throughout India.

Struggles with Demons and Gods

From the earlier works it was the section of the *Bhagavata Purana*, known as the *Dashamaskanda* (tenth section or tenth book), which most inspired the artist. Krishna's birth, his youthful pranks, his subjugation of demons, his entanglement with the *gopis* and his slaying of Kansa were particular favourites.

The stories about all the demons who came to destroy Krishna provided unlimited scope and the artistic treatment of each attack and defeat reveals the extent to which these episodes touched the imaginations of painters who had, of course, a certain advantage over the sculptors working in wood or stone.

The variety of forms assumed by the blue Krishna, his brother, the white Balarama, and all the *gopas* and *gopis*, not to mention the bird, animal and reptile shapes of some demons and the monstrous appearance of

others, all set against the landscape of Vraja, afforded limitless opportunities to painters. They used every imaginable form of grotesque demon and an enormous range of colours to portray these scenes. (see Narrative ill. 23)

At times, as in some of the great *Bhagavata* sets of the Kangra artists, the colours were generally mellow with only an occasional marked accent but they could also be rich and vivid, as in the schools of Basohli and Malwa. Interpretation also varied: some schools, such as that of Kangra, struck a softer note. Others stressed the climax of the episode. This can be seen in the different ways artists treat the miracle where Krishna swallows the forest fire threatening the herdsmen and their cattle (see Narrative ill. 45). The fire, with its circle of leaping flames, often painted in red and gold, lent itself ideally to the painter's sense of the dramatic. Another favourite episode was the death of Putana which received powerful treatment from painters. The massive ungainly body of the demoness writhes in agony, her eyes dilate, her hair stands on end and she wears a dreadful expression on her dying face which contrasts strongly with those of the benumb-

156. The Trinavarta episode. *(Miniature, Kangra c. 1790, 225 × 305 mm without borders, Bharat Kala Bhavan, Benares [ref. 6854].)*

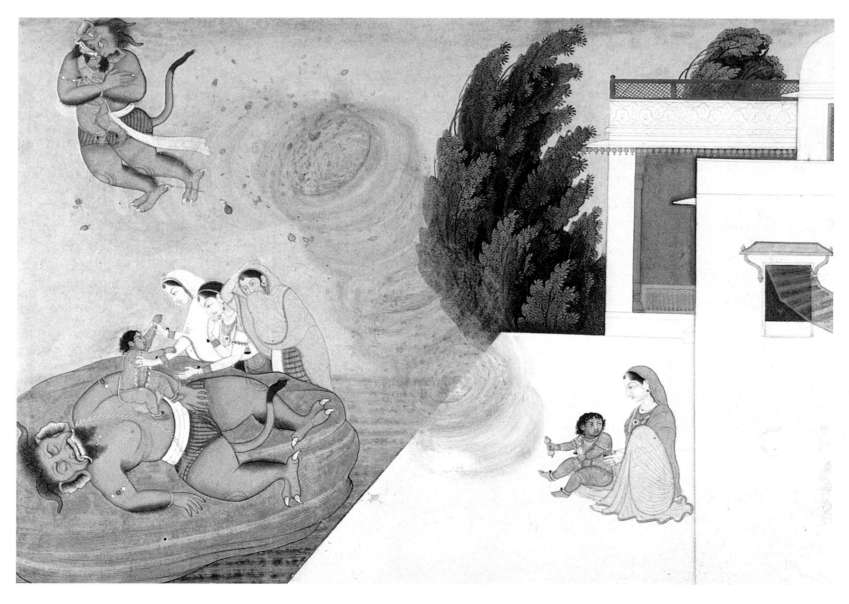

ed spectators and of the baby Krishna who plays fearlessly on her body. Although there are impressive compositions on this theme they never seem to capture the feelings of suspense aroused by the attacks of some other demons, such as Trinavarta (see Narrative ill. 25). The paintings of this episode often take the form of a continuous narration, starting with the demon high in the air and the infant Krishna enveloped in the dust of the whirlwind and finishing with Trinavarta lying dead on the ground, crushed under the intolerable weight with which Krishna's body is miraculously endowed. The whirlwind always dominates paintings of the incident.

Paintings of the Aghasura episode (see Narrative ill. 39) are dominated by the figure of the terrifying python to a degree unparalleled in pictures of the other *asuras* destroyed by Krishna. It was known that pythons of great length and breadth roamed the forests crushing both large animals and human beings to death.

There is also the demon Bakasura who assumed the form of a mighty white crane and was determined to kill Krishna. Its size and colour had a particular appeal for the painter, providing as they did a strong contrast with the green woodland and grey water of the Yamuna by which the massive bird sits in sham innocence waiting to destroy its prey. Some paintings take the form of a continuous narrative showing Krishna swallowed by the crane and then destroying it, while others merely depict Krishna slaying the demon.

The Dhenukasura episode (see Narrative ill. 42), set in the beautiful palm forest and describing the powerful ass-demon with his kinsmen and the crashing palms, was another favourite although the painted versions vary considerably.

Another very popular episode, the destruction of the serpent Kaliya, also underwent several variations at the hands of painters. The demon almost always dominates the composition as do the *asuras* sent by Kansa to kill Krishna. In most of these paintings the artists subtly convey the fear of the *gopas* and *gopis* and the other inhabitants of Vraja that the young Krishna will prove no match for the colossal strength of the *asuras*.

In the Giri Govardhana episode there is clearly a conflict between the cults of Indra and Vishnu. It shows how a rural population was converted from the former to the latter by Vishnu's incarnation as a cowherd, establishing a direct and intimate rapport with his fellow herdsmen. Krishna's emphasis on the environment in which he and his companions lived, introduced a pantheistic element into Vaishnavism which secured the adherence of rural communities to this faith.

This incident has been approached in a variety of ways by painters: the lifting of the mountain is sometimes accomplished by a single hand and at others by a mere finger (see Narrative ill. 49). The mountain also varies from a bare geometrical rock forma-

157. Abhisarika Nayika. *(Miniature, Guler c. 1780, 170 × 225 mm without borders, Collection Mr. and Mrs. J. Riboud.)*

tion to a vast surface with forests, hermits and other living creatures. Artists also liked to alter the shape and colour of the mountain and in a painting from Orissa it is even in the shape of Rama's bow.

Radha and the Gopis

Another popular Krishna theme is the stealing of the *gopis* clothes (see Narrative ill. 47). From the pictorial point of view, it gave unlimited scope for subtle humour and studies in the nude as well as introducing a sensuous element which, in theory, has no place in divine love.

In fact, all the paintings and sculptures of the Krishna theme dealing with the relationship between the cowherd god and the *gopis* exude sensuality. Even though the *Bhagavata Purana* describes the *gopis* as pure-minded worshippers of the divinity, the painters saw them frankly as lovers, caught up in the whirlwind of spontaneous earthly passions which the Blue God reciprocated with all the ardour of a human.

The *Bhagavata Purana* makes a reference to a particular *gopi* who is Krishna's beloved and consequently arouses the envy of the other milkmaids. This *gopi*, later identified with Radha, is never actually mentioned by name. When Jayadeva, the court poet of

153

Lakshmanasena, the last king of Bengal, wrote his famous *Gita Govinda*, (The Song of the Cowherd) in the 12th century, this particular *gopi* is recognised as Radhika. The *Gita Govinda* is the last great lyric poem written in Sanskrit and the content of the verses and the way in which each story unfolds through Krishna, Radha and her *sakhi* (confidante), suggest that Jayadeva may have been inspired by a folk tradition in Bengal which expressed the essence of the *bhakti* cult in terms of human love.

The *Gita Govinda* constantly alludes to the marvels of nature, the allure and beauty of young womanhood and the joyous presence of Krishna who captures the heart of every maiden (see Visions ills. 4, 5, 14). Its literary form rendered it not only eminently suitable and attractive as a basis for dance drama in many parts of the country but also an inspiration to painters. The vivid descriptions of the landscape and woodland, of romantic situations, of lovers' estrangements and reconciliations, of the bliss of sexual union as opposed to the crudities of lust and of the joys of festal dancing and music proved irresistible to the painter.

Artists were not slow to recognise the immense possibilities of the *Gita Govinda* and, from the 15th century its popularity gradually spread from Gujarat throughout the country until it became one of the most important artistic sources. Although Krishna is omnipresent in the *Gita Govinda* as the supreme deity, its most delightful aspects are those relating to the love of a man and a maid:

> My love came not to our trysting place,
> A bower where *vanjula* creepers abound,
> Oh could it be that his memory strayed,
> Or he lost himself in a darkening glade
> And wandered around and around,
> Or was he in festive dancing delayed,
> Or may be he went with another maid.
>
> *(Gita Govinda)*

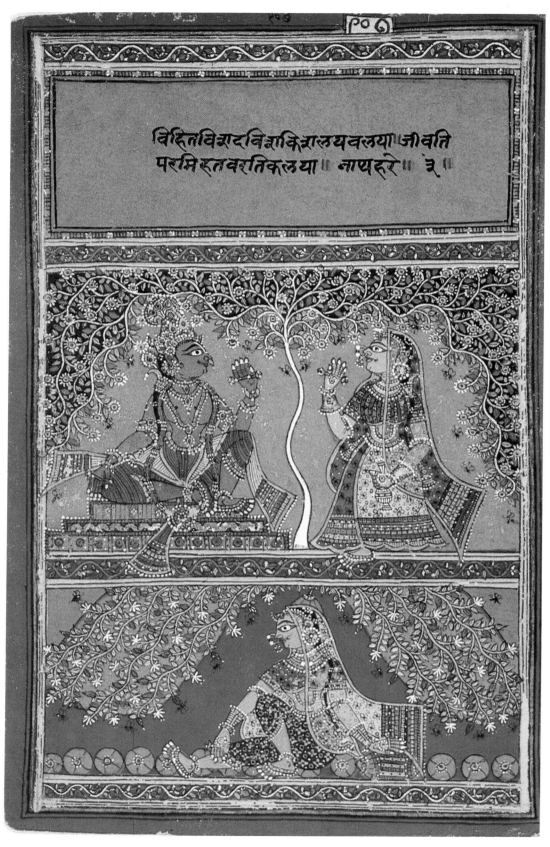

159. Radha's messenger meets Krishna. *Illustration to the Gita Govinda. (Miniature, Orissa c. 1800, 150 × 225 mm, National Museum, New Delhi [ref. 49.19.72].)*

158. Krishna and Radha in a lotus. *(Miniature, Basohli early 18th century, 150 × 255 mm, Bharat Kala Bhavan, Benares.)*

Literature, and particularly the Braja bhasha and Hindi poetry, became such an influential repository of the Krishna legend that it enraptured millions of devotees of the Blue God. However, before proceeding to examine the vast output of paintings it is necessary to understand the religious and cultural background which was the source of so much of the artists' inspiration.

The Poets and their Influence on painting

Shyama I met in the woodland
Both body to body and face to face,
Only she whose lover is absent
Writes letters to gain his grace,
But Shyama he dwelleth within my heart
So neither he cometh nor doth he depart;
The sun and the moon and the earth and the sky
Will finally pass away,
And the roving winds and the depthless seas
All will vanish one day;
But Shyama he dwelleth within my heart
For ever and ever to stay,
Mira doth say. *(Mira Bai)*

The Krishnaite cult in northern India found a great religious apostle in the Telugu Brahmin, Shri Vallabhacharya, who lived from 1479 to 1531. He preached that *bhakti* was both a means and an end, the worship of Krishna being the way to attain the divine grace of god. His philosophy was clothed in poetic imagery: Krishna and Radha were one and all the *gopis* and *gopas*, herds and occupants of the woodlands of Vraja emanated from them. Krishna and Radha, he said, revel eternally with their devotees whose dearest wish is to dally with the Blue God in a celestial Vrindavana. The concept of joy was central to Vallabhacharya's philosophy and his teachings stressed that the way to reach the Krishnaite heaven was through love and not reverence. The union of love and joy leads to a state of rapturous oblivion sometimes culminating in erotic passions which are nevertheless the consummation of true love, devoid of lust. This allegory inspired devotional verse of great intensity and lyrical creations of exquisite melody. In poetry, enchanting situations between the god and his lovers were described, and they were often so powerful that the fact that the inner meaning behind the love of god was lost in the joy of a lover's earthly passions seemed unimportant.

A poet said of the *gopis*:

Not for them the rites of atonement
Sin's very name is forgot,
And if to heaven they go not,
Of earth they make heaven
Chanting Thy name.

The land of Vraja became the centre of the Krishnaite cult when Vallabhacharya made his home there. Many a *bhakta* sang the praises of the Lord and recounted his loves and exploits in the rhythmic cadences of the Braja bhasha language which became associated with the extensive body of poetry relating to the Krishna legend. This poetry is extremely rich in descriptive qualities and invented several novel situations between Krishna and the *gopis* not to be found in the *Bhagavata Purana* or the *Gita Govinda*. The popular *dana lila* theme deals with Krishna and the *gopas* demanding the toll of a kiss from the bashful *gopis* and waylaying them as they walk along the village paths with their pots of milk. (See ill. 12) The story was created by the Braja bhasha poets and became a favourite subject with painters who would often transform their own surroundings into the land of Vraja and the river Yamuna. This was particularly true of the Pahari artists who turned hill woodlands into Vrindavana and hill rivulets into the Yamuna while the *gopas* became hill cowherds and the *gopis* hill maidens.

Although these poems lack the high moral tone of the *Ramacharitamanas* of Tulsi Das, they were an extremely important source of inspiration from the late 16th century onwards, largely because of their poignant descriptions of human love.

If you feel not love's longing for the Beloved,
Then it is vain to adorn your body
And make beautiful your face.

This poetic movement is essential to the understanding of Krishnaite painting for it gripped the imaginations of both princes and peasants, thus receiving the patronage of royalty and aristocracy, merchants, litterateurs, bibliophiles and even of the less literate who favoured folk art.

160. Meeting by the riverside. *(Miniature, Mandi 19th century, 148 × 223 without borders; 234 × 310 mm with borders, Galerie Marco Polo, Paris.)*

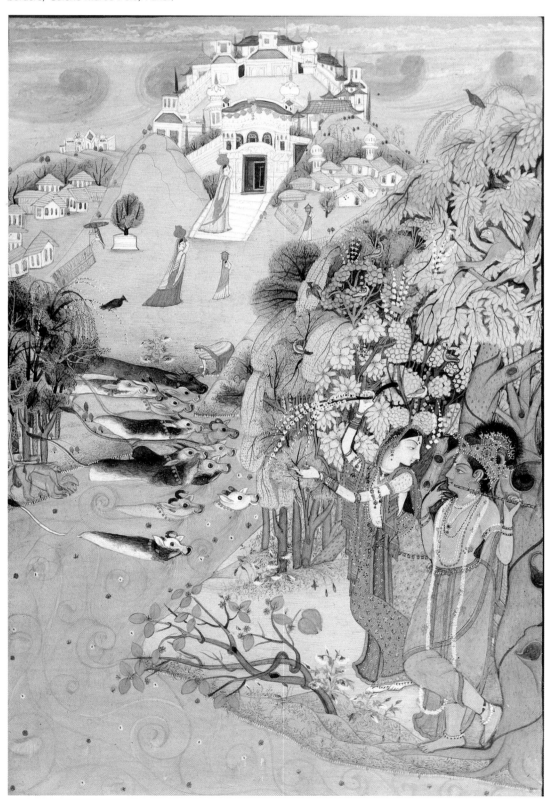

charming detail. Another composition of Sur Das, also illustrated by Mewari artists, was the *Bhramaragita* in which he describes how the heart-broken *gopis* questioned Uddhava, sent by Krishna to console them when he left the land of Vraja for Mathura. An outstanding series from 16th century Mewar illustrating this work is now in the National Museum, New Delhi.

Another of the most popular episodes was that in which Krishna and Radha exchange clothes. Painters approached the subject in different ways but what inspired them can best be expressed in the words Sur Das puts in the mouth of Radha:

Is it I who dwell in Hari
or is it Hari who dwells in me?

Sur Das was followed by Keshava Das whose works have been illustrated more extensively than those of any other writer on the Krishna theme despite their being more appropriate for a court than a peasant's milieu. Two of his poems were illustrated: first and foremost his *Rasikpriya*, a favourite with all schools, and his *Kavipriya*, both of which are elaborate compositions on poetics and rhetoric. A verse would be illustrated accord-

161. Radha contemplates the portrait of Krishna. Illustration to the Rasikpriya. *(Miniature, Malwa c. 1630, 175 × 203 mm, Galerie Marco Polo, Paris.)*

The writings which most directly influenced painting were those of the Braja bhasha poets. They describe Krishna not as an ascetic but as the embodiment of beauty, love and joy and the *gopis*, not as adulteresses, but as beautiful women whose love, being for the Lord, cannot be a sin.

The Krishna faith, as expressed in poetry, prose and the painting which drew from them, was a refuge from the ills, sorrows and hardships which beset so many in these times, troubled by several factors, not least of which was the religious persecution carried out by fanatical followers of Islam.

Amongst the poets whose works were illustrated by painters, Sur Das (1503-1563) was particularly celebrated and his name was a byword throughout northern India. His *Sur Sagar*, which chiefly inspired Rajasthani artists, dealt with Krishna's infancy and he described incidents and episodes so originally that artists were able to transpose many a

163. Krishna and Radha exchange clothes. *(Miniature, Bundi c. 1750, 152 × 245 mm, Bharat Kala Bhavan, Benares [ref. 8009].)*

162. The tossing of the rose. *(Miniature, Garhwal 1810, 130 × 180 mm without borders, Colnaghi & Co. Ltd., London.)*

156

165. Radha stupefied. Illustration to the Rasamanjari. *(Miniature, Basohli c. 1670, 235 × 330 mm with borders, Victoria and Albert Museum London.)*

166. Krishna fanning Radha while she sleeps. *(Miniature, Basohli c. 1730, 162 × 233 mm without borders, National Museum, New Delhi.)*

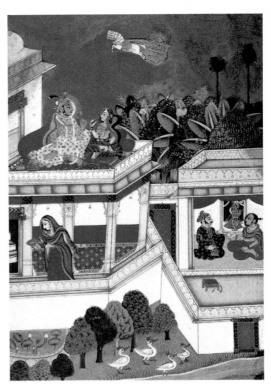

167. The month of Pausha (December-January). Illustration to a Barahmasa. *(Miniature, Bundi c. 1750, 180 × 264 mm without borders, Bharat Kala Bhavan, Benares.)*

ing to set formulae which appear to have been established shortly after these works were penned.

The most important of the later poets to inspire painters was Bihari Lal (1595-1663) whose *Sat Sai* (lit. The 'Seven Hundred' Couplets) found favour with several schools. Sections of the extensively illustrated *Sat Sai* of Bihari Lal, dated 1719, are now to be found in Museums and private collections. It belongs to the Mewar school.

There was also Matiram whose work appears to have inspired many Pahari artists. In the illustrations of all these poems, Krishna appears as the central character.

The Nayaka-Nayika-Bheda and Related Themes

The poetry of what is called the *nayaka-nayika-bheda* was also popular material with artists. It describes different types of 'heroes' and 'heroines' involved in love situations. 'Heroines', or *nayikas*, may be faithful or faithless, or somewhere between the two, and 'heroes', *nayakas*, also vary, some being heartless and others merely lax, for example. One of the best known of the *nayaka-nayika-bheda*, or 'Hero-Heroine-Classification', is Bhanudatta's *Rasamanjari* (composed in the 14th century) which was illustrated by both Pahari and Rajasthani artists. It was a special favourite of Raja Kirpal Pal of Basohli (1678-1695 reg.), the first Pahari ruler to have a court atelier and to whose reign the beginnings of Pahari miniature painting should be ascribed. His artists illustrated at least two sets of the *Rasamanjari*, the earliest of which is unique in the sense that Krishna

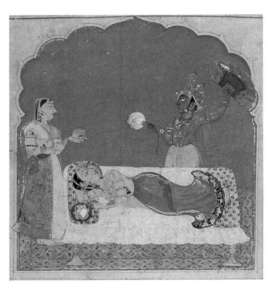

is the 'hero'. This was probably the idea of the patron Kirpal Pal himself rather than of the artists of the series. He was of a scholarly bent and, as a devotee of Vishnu, must have felt that the essence of the *bhakti* cult could best be conveyed by a secular theme that dealt with love, be it profound or profane. These *Rasamanjari* illustrations in the Basohli style are characterised by a boundless vitality and exceedingly lovely warm colours which encapsulate the many nuances in the romance between Krishna and Radha.

The Ragamala Theme

The growth of a new and unique form of painting known as *ragamala* (garland of *ragas*) was the result of the merging of many

sources of inspiration: the codification of musical modes, the poems attached to each of them describing its mood and its appropriate setting in time (season, day or night) and the pictorial rendering of the poetic description.

This form of painting became very popular throughout India, especially northern India, particularly between the 17th and 19th centuries, and consisted of a set number of illustrations which varied in accordance with the system of musical classification chosen by the artist. The number ranged from 36 to 84. Melodies were also divided into male and female. In course of time *ragamala* painting incorporated elements from the *nayaka-nayika* and *barahmasa* themes.

Ragamala sets originally owed nothing to Krishna worship, but in time, no doubt as a result of the conception of divinity as the embodiment of joy, music, dancing and all that was beautiful, the male figure in the paintings came to be identified with Krishna. Such was the case in *Vasanta ragini*, where he dances merrily with maidens at the beginning of the spring, just as Krishna danced with the *gopis* in the *Bhagavata Purana* and the *Gita Govinda*. Similarly in the *Megha Malhara raga*, the male figure is sometimes the Blue God dancing with girls who play musical instruments and sing to herald the delightful refreshing rainy season.

168. Vasanta Ragini. *(Miniature, Bundi-Kotah c. 1760, 203 × 117 mm, Galerie Marco Polo, Paris.)*

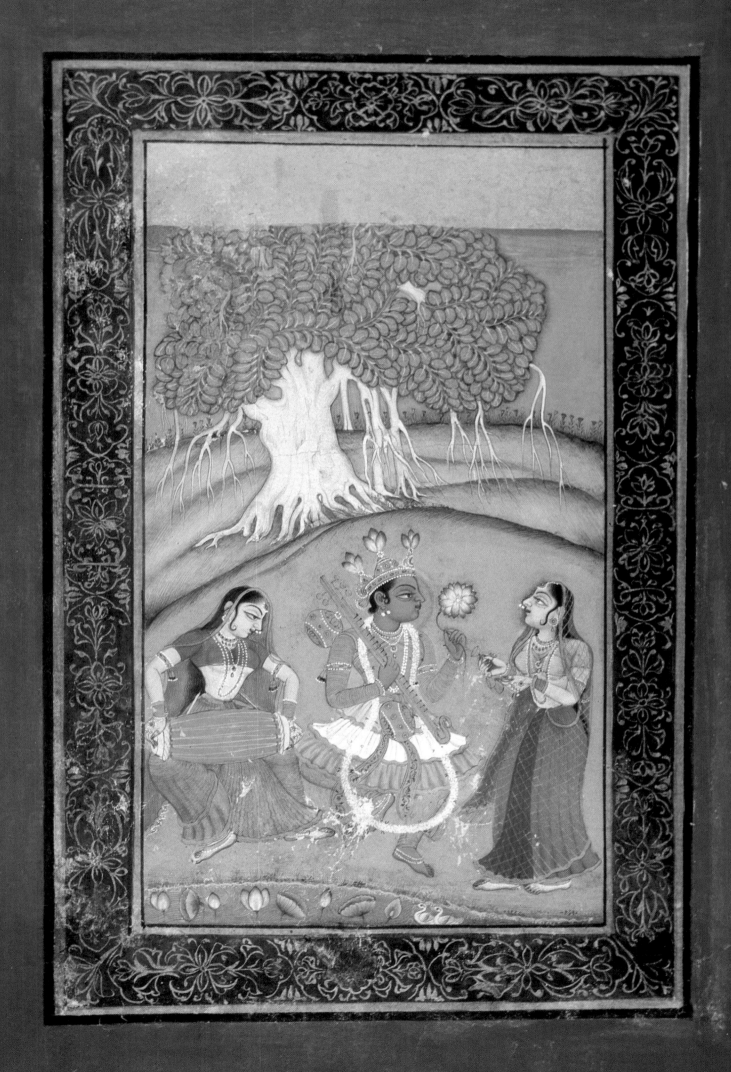

Such examples suffice to show that the devotional approach of artists and their patrons to Krishna led to their conjuring up his presence even in the world-pictures of the verses of the *ragamalas*, composed independently of the Krishna cult.

The *Barahmasa* Theme

A similar phenomenon is to be seen in the *barahmasa* (lit. twelve months) paintings. These depict the months of the year varying with each seasonal change as the freshness of spring cedes to the heat of summer which, in turn, makes way for the refreshing rains before autumn sets in with its colourful falling leaves, only to be followed by the barrenness of winter.

However, the *barahmasa* is not solely concerned with seasonal changes, as is clear from the dominant role which love plays in these paintings, altering as do nature and landscapes throughout the year. In these paintings as in the poems which inspired them, the main character is the young woman, whose lover or husband is absent. She is in a state of *viraha*, separation. Her distressed state, her thoughts of love and her yearning for reunion are really the main topic of the painting and poetry. It should be noted here that the state of the young woman is the state which the individual soul experiences, separated as it is from the Absolute and yearning for reunion. These themes of love and nature always brought the image of Krishna to the minds of his devotees and the lover in these paintings is frequently the Blue God himself.

169. Love-making. *(Miniature, Gujarat c. 1450, 103 × 225 mm, Museum Rietberg, Zurich [ref. 6867].*

The Krishna Theme and the Evolution of Styles of Painting

In 15th century Gujarat, versions of the *Gita Govinda* and the *Balagopalastuti* were already being illustrated. These pictures had the same format and style as the illustrated Jaina manuscripts, known as Jaina painting, Gujarati painting or Western Indian painting. Archaic, hieratic and limited from the point of view of colour, these highly stylised compositions nevertheless reflected the desire to see the incidents described in the verses in a pictorial form.

These illustrated Vaishnava manuscripts owed less to royal patronage than to that of the merchants and religious preceptors who devoutly adhered to the Vaishnava creed. The desire to own such manuscripts was doubtless influenced by their popularity among the Jaina clergy, kings and ministers who had collected thousands of illustrated Jaina canonic texts, be it on palm leaves or paper, from the 12th century onwards. These quaintly stylised Gujarati manuscript illustrations of the Krishna theme were essentially pictorial explanations of the text and had few aesthetic pretensions.

Once this desire to visualise stories about Krishna had been born, it increased in momentum and, during the early years of Akbar's reign, probably between 1560 and 1580, a number of Krishnaite texts were illustrated. Today, these manuscripts interest art historians, collectors and museums.

In northern India, in a region stretching from Delhi to Jaunpur, a particular style developed in the late 15th century under the Lodi sultans known as the Lodi school of painting. Despite the marked influence of the Jaina Gujarati style, there are certain highly

original features, notably the elimination of the cliché of the farther eye and the adoption of contemporary costumes. Right up to the end of the Lodi rule in 1526, a variety of manuscripts including Jaina canonical texts and secular Persian and Indian ones were illustrated. The most important was the famous *Aranyaka Parvan* of the *Mahabharata*, painted in 1516 in the Agra region during the reign of Shikandar Shah Lodi, and now in the Asiatic Society, Bombay. The publication of this exceptional 16th century manuscript by the present writer and the late Dr. Moti Chandra has ended the muddled debate over several important manuscripts of this date which deal with the Krishna legend (1). Notable among these are the *Bhagavata Purana* painted at Palam (Delhi) (see Narrative ill. 73), now widely dispersed; the Vijayendra Suri *Gita Govinda*, now in the Goenka Collection; the Isarda *Bhagavata Purana*, also dispersed; the Piraji Sagar *Bhagavata*, and the *Gita Govinda* in the Prince of Wales Museum, Bombay. A variety of dates and origins were ascribed to these manuscripts, which are similar in style and reflect the increasing desire of Krishna devotees to possess illustrated Krishnaite texts, infinitely more attractive from the pictorial point of view than the archaic compositions in the Western Indian style.

It can now be said with reasonable certainty that this development occurred during the early Akbar period, between 1560 and 1580. For instance, Krishna and the other male figures in these illustrations are seen wearing the *chadkar jama* which was not worn at the

170. Krishna stealing the Parijata tree. Illustration to the Harivansha. *(Miniature, Mughal c. 1590, 184 × 296 mm on an album leaf 325 × 436 mm, Victoria and Albert Museum, London [ref. ISS 1970].)*

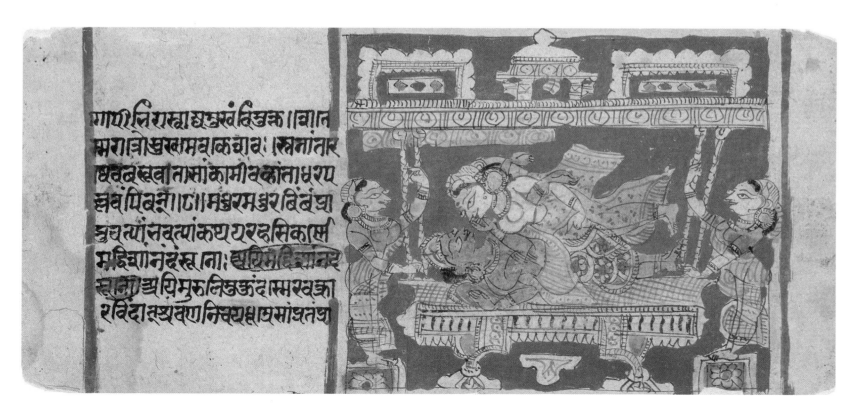

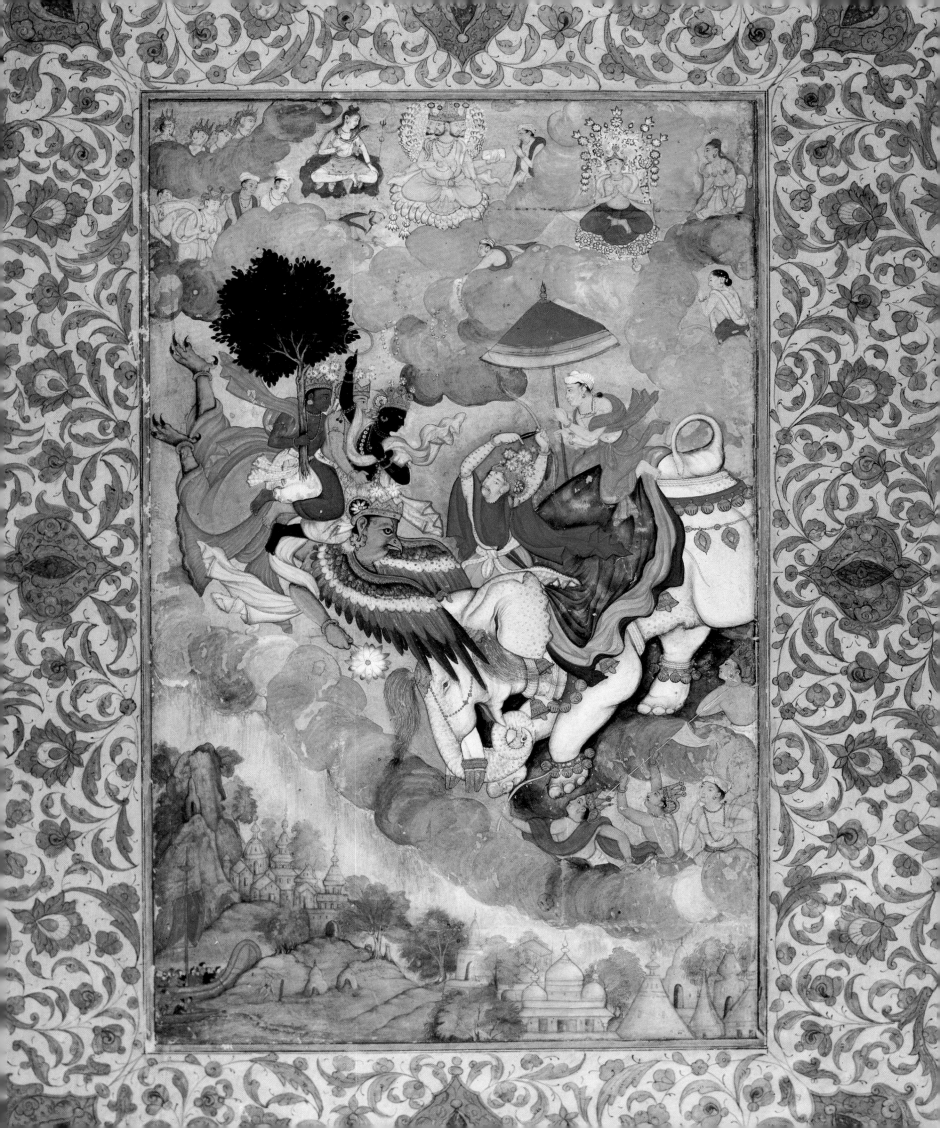

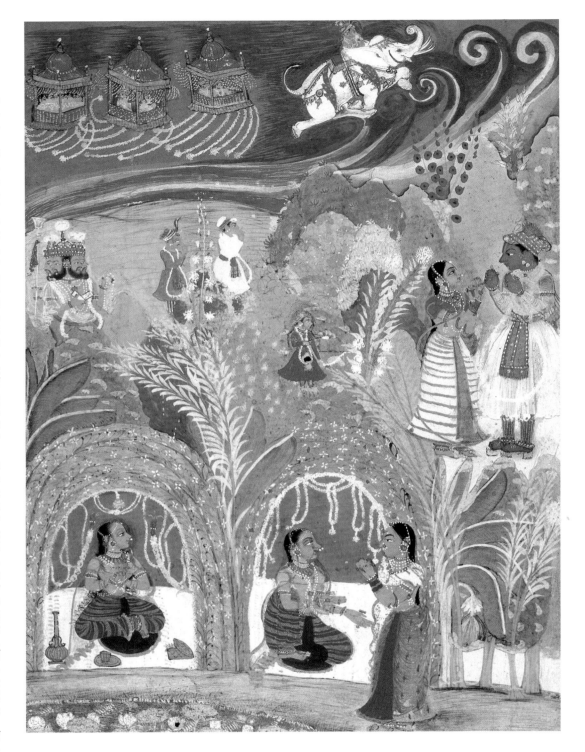

Mughal court before 1560. This *jama* was a coat with cuts showing four or six points and there is no evidence to testify to the Indian origin of this distinctive garment.

These pictures continue in the Lodi style, as seen in the *Aranyaka Parvan* of 1516, which is not surprising given that the Mughals, whose reign began with Babur (1526-1530), brought no new school of painting in their wake. Babur was succeeded by Humayun (1530-1556) and Akbar (1556-1605) and it was under the latter that the famous atelier, dominated by the two renowned Persian masters, Mir Sayyid Ali and Abd al Samad, was established. This atelier can be traced back no further than 1567 when the great *Hamza Nama* project was launched. In fact, the last two manuscripts, the Isarda *Bhagavata* and the Piraji Sagar *Bhagavata* respectively, show influences from this early Mughal school. Another reason why it is not surprising that this increased production of illustrated Krishnaite texts should begin in the old Lodi region is because the school known by this name thrived here as had the *bhakti* cult of Krishna stimulated by Vallabhacharya.

The most important Krishnaite manuscripts illustrated in the Lodi style are known collectively as the *Chaurapanchashika* group after the Sanskrit poem of the same name written by Bilhana (fl. 1100 c.) and meaning 'Fifty Stanzas of the (love) Thief'. It formed the principal manuscript of the group and had eighteen illustrations. It is now in the N.C. Mehta collection in Ahmedabad. These manuscripts are also known as the *kulahdar* group because in them the male figures are seen wearing a turban with a projecting *kulah*, a sort of crest, which was the characteristic headgear of the Lodi period. However, in the Piraji Sagar *Bhagavata* of about 1580, the turban had become the *at-pati* type worn at Akbar's court. This is but one indication that the above-mentioned Krishnaite paintings, and similar manuscript illustrations, date from the Akbar period.

Recent theories suggesting that this group of manuscripts was illustrated in Mewar under Rana Kumbha in the 15th century are too unsubstantiated to be acceptable but even an early 16th century date is no longer tenable in the light of contrary evidence. Only a precisely dated manuscript could undermine the present conclusions which are corroborated by a cogent body of facts.

Whereas the Vijayendra Suri *Gita Govinda* is the earliest of this Krishnaite group, the Isarda *Bhagavata* is the finest from the point of view of quality. Nevertheless, it is the extensive Palam *Bhagavata* which is the most interesting. It was definitely commissioned by a merchant family from Palam near Delhi and written and illustrated at Palam itself where there is evidence to confirm the existence of competent scribes and illustrators practising their skills in 1540. The names of Sa Mitharam and Sa Nana, which appear on these paintings, are not those of the artists but rather of the members of the family who commissioned the manuscripts. The Palam *Bhagavata* infers that these two merchants were devotees of Krishna and they doubtless wanted the paintings to be seen at the same time as the text was read out on religious occasions. This provides an insight into the motives behind the ownership and function of Krishnaite paintings.

Many merchant families following the *bhakti* cult must similarly have owned illustrated copies of the *Bhagavata* and the *Gita Govinda* from as early as the 16th century and the practice of commissioning such manuscripts continued until the 19th century. These paintings served a religious rather than an aesthetic purpose, that of accompanying the reading of the text. Middle-class patrons never commissioned ateliers but only guild painters or scribes, unlike the royalty or nobility who kept a permanent coterie of artists. As the latter could afford the best artists, the work produced in their ateliers, including illustrated Krishnaite texts, was naturally of a superior quality.

Religious sentiments thus contributed considerably to the production of this form of court art but the high quality and refinement of the works led in turn to an appreciation of their aesthetic values. This can be seen in the Mughal school of painting. It was court art

par excellence, dealing with all the pomp of the *darbars*, with court occasions, battles, hunting scenes and also producing some very fine protraits. Yet, the emperor Akbar, who was particularly broad-minded, commissioned the illustration of a great album of the *Mahabharata* as well as of the *Harivansha*. Magnificent as such pictures are, they nevertheless fail to attain the depth of feeling which characterises the work of the Rajasthani and Pahari artists although, from about 1590, with the development of the sub-Imperial or 'popular' Mughal school, there is undoubtedly greater warmth. The excellence of the works produced by the Imperial ateliers was not, however, equalled.

The Krishna theme had broad aesthetic appeal for Mughal rulers and it is consequently of no surprise that their palace collections, housing works belonging to the Rajasthani and Pahari schools, should be of such a high standard. These paintings included illustrations of the *Bhagavata Purana*, the *Ruhmini Harana*, the abduction of Rukmini and the works of the Braja bhasha poets.

The 17th and 18th centuries witnessed a proliferation of works of art based on Krishnaite texts. Illustrations of the works of the Braja bhasha poets and the introduction of Krishna into the iconography of the *ragamala* and *baramasa* themes, together with the *Bhagavata Purana* and the *Gita Govinda* produced in turn many thousands of miniatures, both as book illustrations and as individual paintings.

Court ateliers apart, the desire for such paintings led to a considerable extension of the guild system. The usual pattern was for members of the same family to form a guild in order to meet the growing demand which came from various strata of society, although mostly from followers of the *bhakti* faith. However, it is interesting to note the number of Muslims who painted Krishnaite themes. In the Rajasthani state of Mewar, between about 1628 and 1655, the master painter of the court atelier was a Muslim by the name of Sahibdin who undertook the famous *Bhagavata Purana* in Udaipur in 1648. This work is now in the Bhandarkar Research Institute, Pune. Krishna themes were also painted by several Muslim artists, in the court atelier of the state of Bikaner in Rajasthan. (See ills. 95, 96)

Most of the paintings of the Krishna legend were produced in the various states of Rajasthan and the Hill States of the Panjab, now the newly formed province of Himachal Pradesh. In Mewar, the Krishna theme appears to have been particularly favoured and the *Bhagavata Purana* and the *Gita Govinda* were not the only texts to be illustrated. There were also the *Rasikpriya* of Keshava Das, the *Sur Sagar* of Sur Das, the *Mahabharata*, the *Harivansha* and the

ragamalas in which Krishna played a major and pervasive role.

In Bundi and Kota the Krishna theme was also particularly popular for miniature and wall painting. These two states were so close to each other that members of the same families worked in both using similar styles. Artists would occasionally accept commissions in states other than their own. For instance, a Ranthambor artist painted several *ragamala* and other series at Antarda, a *thikana* or barony of Bundi, for a local patron. Painters sometimes accompanied their rulers on state visits.

For the most part, the courts of Rajasthan and their subjects were ardent devotees of Krishna. The teachings of Vallabhacharya had resulted in widespread worship of the

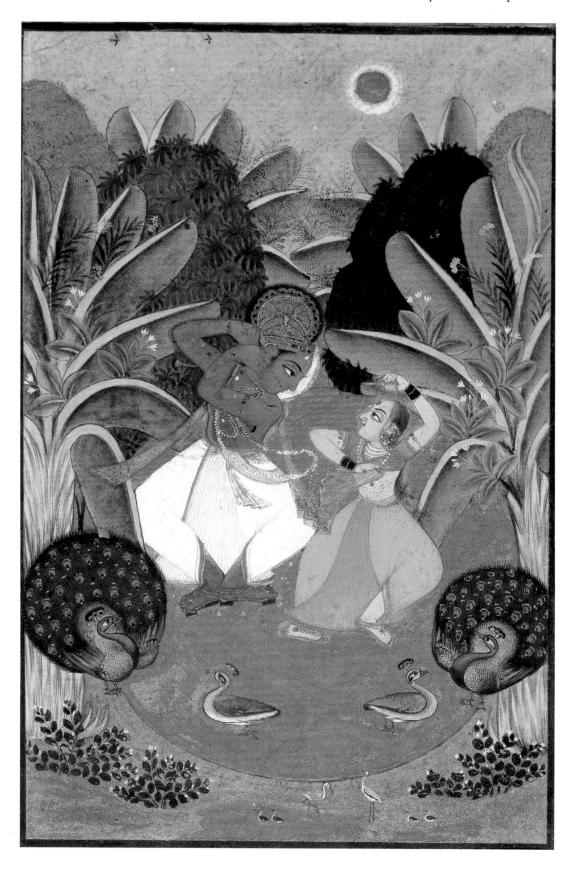

172. Krishna and Radha dancing. *(Miniature, Bundi c. 1740, 115 × 184 mm without borders, Bharat Kala Bhavan, Benares.)*

173. A messenger from Radha. Illustration to the Gita Govinda. *(Miniature, Kangra c. 1780, 150 × 255 mm, Bharat Kala Bhavan, Benares [ref. 423].)*

cult of Shri Nathji, the form of Krishna revered at Nathdwara, the principal shrine of the Vallabha creed, situated not far from Udaipur in the state of Mewar. At Kota, where the Vallabha creed predominated, the deity was known as Shri Brajnathji whereas at Kishangarh, where the same cult was preeminent, the deity was known as Kalyan Rai. At all these Rajasthani centres, as well as at others where the Krishna cult was particularly popular, the attachment of both rulers and subjects to the deity, regardless of the form in which this attachment manifested itself, and the deeply religious feelings it evoked, accounted for the atmosphere of single-minded devotion. This atmosphere explains the creation of paintings of singular beauty by exceptionally gifted artists.

The worship of Krishna also predominated in the Central Indian Rajput states and the Malwa and Bundelkhand idioms of Rajasthani painting, as the art of Central India is known, are to be seen in the numerous miniatures depicting Krishna's life and romances. In Malwa painting, the landscapes of trees and rocks are stylised, there is a constant use of architecture and strong colouring with frequent black skies. Its pictorial compositions are original, whether dealing

with the *Bhagavata Purana*, the *Gita Govinda*, the *ragamala* or the works of the Braja bhasha poets.

No account, or even summary, of Krishnaite painting in Rajasthan can omit reference to the most exquisite period of its evolution between 1735 and 1748 when the poet prince Savant Singh of Kishangarh inspired his master artist, Nihalchand, to represent the love scenes between Krishna and Radha in pictures of outstanding beauty in which Savant Singh himself and his devoted mistress, the lovely Bani Thani, both well known to the world of Braja bhasha literature, appeared in an idealised form as the Blue God and his beloved *gopi*.

In the Rajput Hill States, Pahari miniature painting was also intimately connected with the Krishna theme. The reign of Raja Kirpal Pal of Basohli (1678-1695 reg.), a scholar prince and devotee of Vishnu, saw the composition of some splendid paintings based on episodes from the *Bhagavata Purana* and on stories about Krishna and Radha. His son and successor, Dhiraj Pal, (1695-1725 reg.), was again a very erudite ruler who took a keen interest in all the *Puranas*; there is a remarkable series of the *Bhagavata Purana*, now in the Chandigarh Museum, which some scholars have attributed to the hill state of Mankot. It was painted in Dhiraj Pal's atelier and given to his uncle, the ruler of Mankot, which explains how it made its way into a Mankot royal collection. Artists in this

state were inspired by this series to paint another attractive and well-known *Bhagavata* which served as a dowry for the Lambagraon *darbar* (court) on the occasion of a marriage between the two princely families. These examples expose the pitfalls that an art historian may fall into in seeking to ascribe a particular picture to the area in which it is found.

In 1730, during the reign of Dhiraj Pal's son, Medini Pal (1725-1736 reg.), a famous *Gita Govinda* series (see Visions ill. 4) was commissioned by a lady of the royal Basohli house. She was a poetess who wrote Sanskrit verse under the pen-name of Manaku, which is why the series is widely known as the Manaku *Gita Govinda*. She is described as a devotee of Vishnu and was apparently so enthralled by the beauty of Jayadeva's lyric poem that she had it finely illustrated in the Basohli style for her personal pleasure. The colophon of this series reveals that even royal ladies, who were greatly touched by accounts of Krishna's exploits and romances, would patronise painters to illustrate the timeless poems describing the Blue God.

Once the fashion of a court atelier had been set in Basohli, it spread rapidly to every part of the hill states and thousands of paintings were produced at the royal courts as well as at those of the aristocratic *miyans*, highborn Rajput related to the royal family.

Another outstanding *Gita Govinda* was painted at the Guler court in the reign of

Govardhan Chand (1744-1773 reg.), a great patron of the arts. It was the work of his master painter, Manak, the eldest son of the artist *pandit* Seu whose name is famous as being that of the head of the family that produced many of the most important Pahari pictures. Unfortunately, Manak's name has been confused with that of Manaku, who commissioned the Basohli *Gita Govinda*, and consequently, the latter has often been erroneously attributed to him. However, he is definitely the artist of the Guler *Gita Govinda*, most probably painted between 1765 and 1775.

Innumerable paintings on the Krishna theme were produced in other hill states such as Chamba, Kulu, Mandi, Garhwal and Kangra. In the latter, Raja Sansar Chand (1775-1809 reg.), the most powerful ruler of the hills, kept the largest and most prolific atelier of all these states. The English traveller, Moorcroft, left a description of Sansar Chand's court where, even in the days of its decline, the ruler would listen to Krishna stories in song. He also kept artists and there are pictures which show the Raja sitting with his retinue as they study and admire the compositions of his court artists. He had three outstanding painters from the family of *pandit* Seu: Fattu, Kushala, otherwise known as Kushan Lal, and Godhu who created some of the most famous sets depicting scenes from the legend and the life of Krishna. The most celebrated is a *Bhagavata Purana*, most of which is now in the National Museum, New Delhi, and known as the Modi *Bhagavata* after Jagmohandas Modi of Bombay, an art collector who originally had it in his possession. It must have been painted between 1780 and 1790 and has great merit and charm. Its tones are more subdued than those of the Rajasthani sets or other Pahari paintings of the *Bhagavata Purana*, and the women are exquisitely portrayed, with faces as delicate as porcelain. These female figures were so

distinctive that all Pahari pictures of the same character were referred to by dealers as being in the *Bhagavata* style of the Kangra School.

In about 1790 at Sansar Chand's court, the artist Fattu illustrated an extensive series of the *Sat Sai* of Bihari Lal.

These three artists were closely related and worked together as a family guild in the service of Sansar Chand. There is documentary evidence to suggest that they trained other painters in the court atelier. Godhu was irrefutably a master painter and there is every reason to suppose that Fattu and Kushala were in a similar position.

Between 1800 and 1809 an attractive *Gita Govinda* series was illustrated at Sansar Chand's court. It is now widely dispersed. It is named after the Lambagraon branch of the family which inherited it from Sansar Chand and kept it at their *darbar* (court). The landscapes are particularly charming but the female characters, although graceful and attractive, do not equal their counterparts in the earlier Modi *Bhagavata*.

At some point, probably between 1815 and 1820, another much larger *Bhagavata Purana* was undertaken in Sansar Chand's atelier. While lacking the superb quality of the Modi *Bhagavata*, it is of no small interest in its detailing of the last phases of Sansar Chand's famous atelier. It is known as the Nadaun *Bhagavata* after the branch of the ruler's descendants which inherited it. It is also widely dispersed but the finest folios are to be found in Chadigarh Museum.

Sansar Chand of Kangra, the great patron of Pahari artists, died in 1823. In 1809, he had become a tributary to the Sikhs under Ranjit Singh and it is from this time that a decline in the quality of his court painting dates. This decline was in inverse proportion to the increase in the military strength of the Sikhs and it affected all the hill states. Furthermore, the older generation of Pahri artists, whose talent had established the reputation

of the ateliers of Basohli, Guler, Kangra, Chamba, Kulu, Nurpur, Mankot and other hill states, had either died or retired. Their descendants, while competent, lacked the genius of their predecessors and royal patronage was no longer as discriminating as it had once been, largely because the rulers had ceased to be as affluent. Prof. Dr. B.N. Goswamy's researches have shown how several hill artists migrated to the Sikh courts where their work was of a very different nature. Sikh patrons favoured portraits which emphasised their martial bearing, along with hunting scenes, erotic themes and pictures of the Sikh *gurus*. Other subjects were undoubtedly painted but Sikh patrons were less sensitive to art than the hill rulers had been.

The growth in the 19th century of what is termed the 'Company School' also contributed to the decline of Pahari and Rajasthani art. This School succumbed to the dominance of the British Raj with the inevitable result that western ideas on draughtmanship and colour were introduced. The decline of Rajasthani painting was less marked than in the Hill States, but the level of patronage had degenerated and was no longer what it had been in the heyday of the schools of Mewar, Bundi, Kota, Malwa, Bikaner, Marwar, Kishangarh, Deogarh, and many other principalities and states. Moreover, although it is true, as Prof. Dr. B.N. Goswamy asserts, that Indian painting of this period has for too long been underestimated, it cannot be denied that it suffered considerably as far as quality is concerned. As regards the volume of art produced, numerous manuscripts of the *Bhagavata Purana*, albeit in a very reduced format, were still being illustrated in northern India and

174. Krishna and gopis. Illustration to the Bhagavata Purana. *(Miniature, Orissa c. 1800, 247 × 372 mm, Galerie Marco Polo, Paris.)*

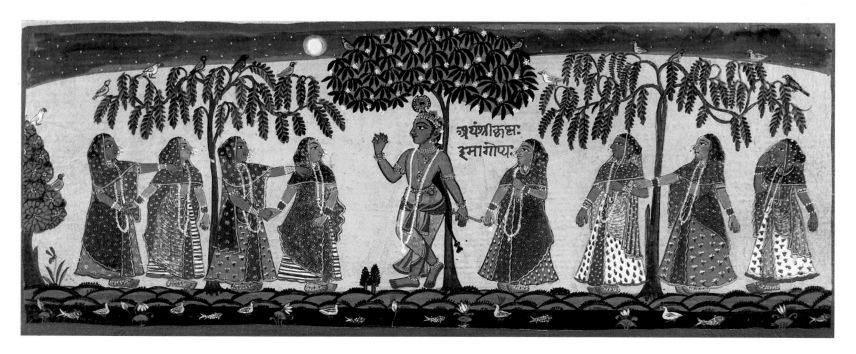

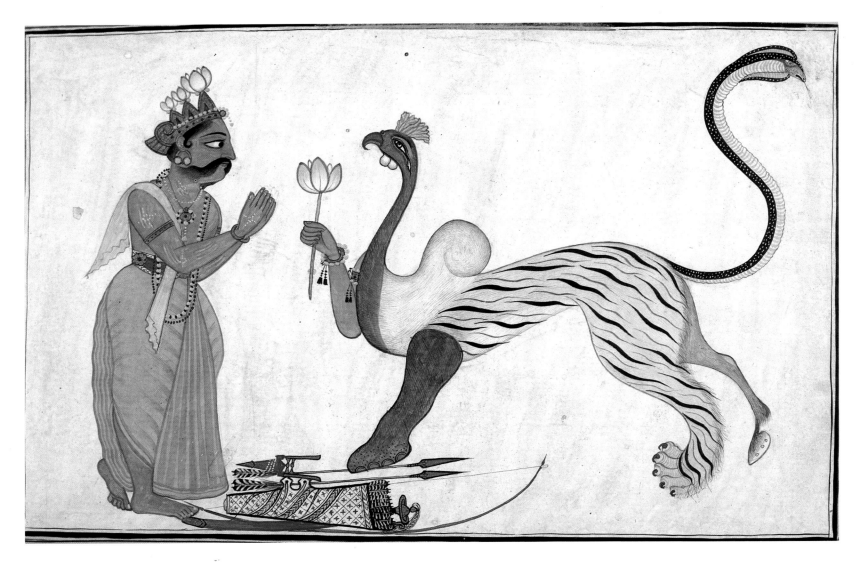

Rajasthan. Nor did the popularity of the Krishna theme diminish in the 19th century but its interpretation and presentation had lost all subtlety while the draughtsmanship and use of colour were of a lower order and the indefinable beauty that had characterised such works in the past was missing.

Probably the most interesting 19th century work on the Krishna theme is that produced in Orissa and Bengal, where both the *Bhagavata Purana* and the *Gita Govinda* were illustrated in a fairly large format and not without charm. In these two eastern Indian states there was a long tradition of Krishnaite painting on both paper and palm leaves. This tradition owed much to the teachings of Chaitanya, the poet-saint of Bengal, which had as strong an impact in eastern India as did the incomparable songs of Mira Bai in praise of Krishna in Rajasthan.

As far as folk art is concerned, the so-called Kalighat paintings from Calcutta are perhaps the most notable example of 'art for pilgrims' and they often represented Krishnaite themes: Krishna and Bakasura, Krishna and Kaliya, Krishna killing Kansa, Krishna and Balarama, Krishna and Radha as one single figure, a 'composite' form, and other such themes dealing with Chaitanya and his followers. All reveal a deep commitment and

175. Krishna as Navagunjara. *(Miniature, Kulu c. 1700, 150 × 220 mm, Private Collection.)*

an astonishingly strong feeling for Krishnaite philosophy. These paintings were long neglected and have only fairly recently begun to be appreciated. They provide an interesting insight into the religious life of the common people and into an aspect of artistic activity which is generally overlooked as a result of having no connection with courtly patronage.

Whereas the 'art for pilgrims', which had spread in popularity from the great Kalighat temple of Calcutta, came to an end at the beginning of the 20th century, in Orissa a brisk tradition of folk art, connected with the cult of Puri, continues to this day. This tradition is rooted in the tenets of classical Orissan iconography as seen in palm leaf painting of the 17th and 18th centuries. Modern works are on a variety of materials including paper, wood, cloth, palm leaf.

177. Gopashtami, the cow festival. *(Pichhvai, painting on cloth, Nathdwara 19th century, 153 × 200 cm, Bharat Kala Bhavan, Benares.)*

Following double page:
178. Love play. *(Wall painting, Mattanchery, Kerala 18th century, 150 × 200 cm, Duch palace, Mattanchery, Cochin, Kerala.)*

176. Krishna and Radha in the syllable ''Aum''. *(Miniature, Kalighat, Bengal 19th century, 410 × 640 mm without frame, Collection C.L. Bharany.)*

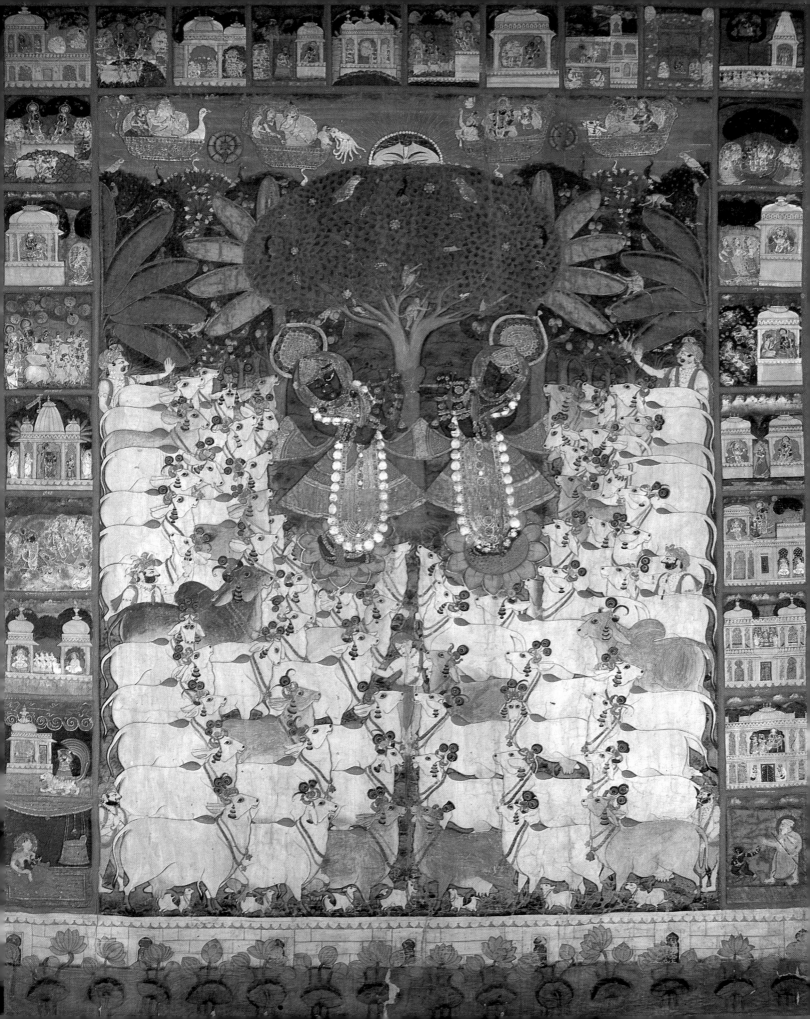

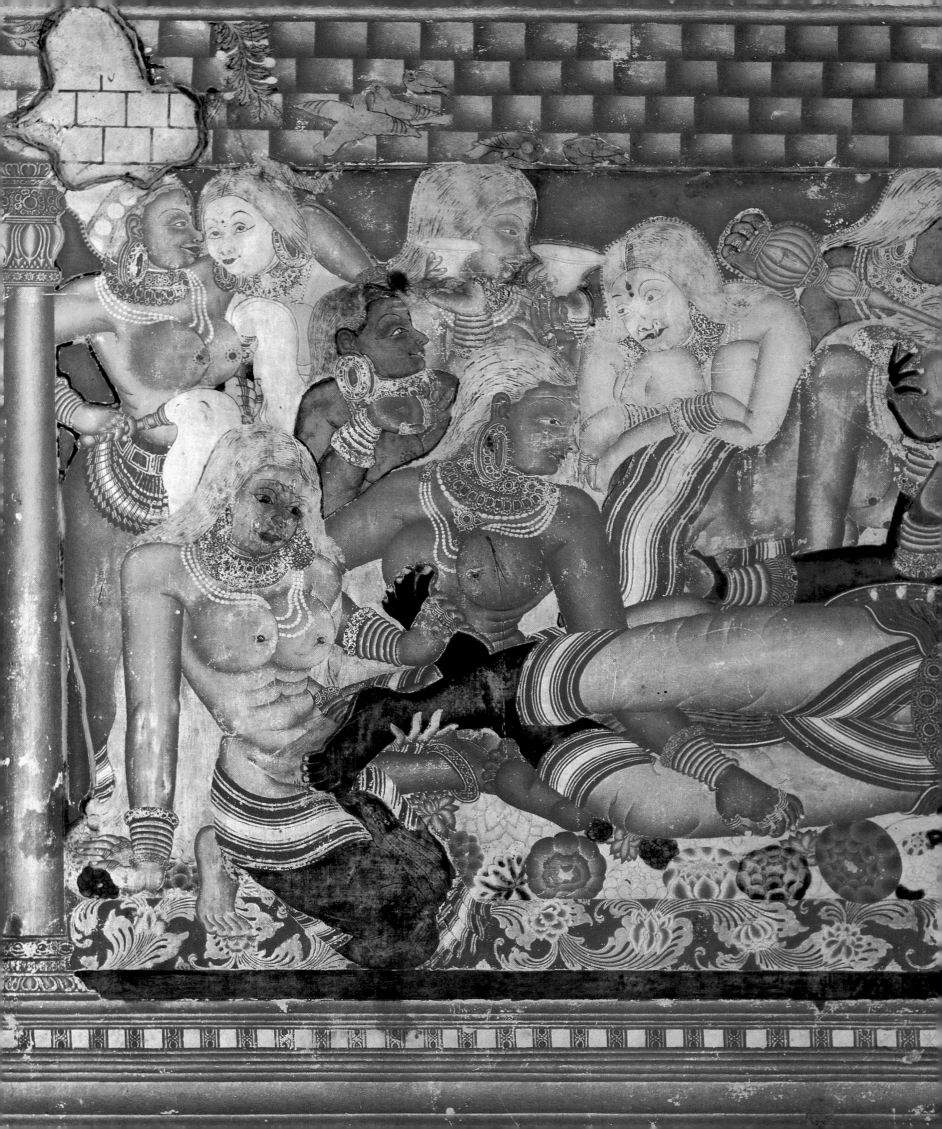

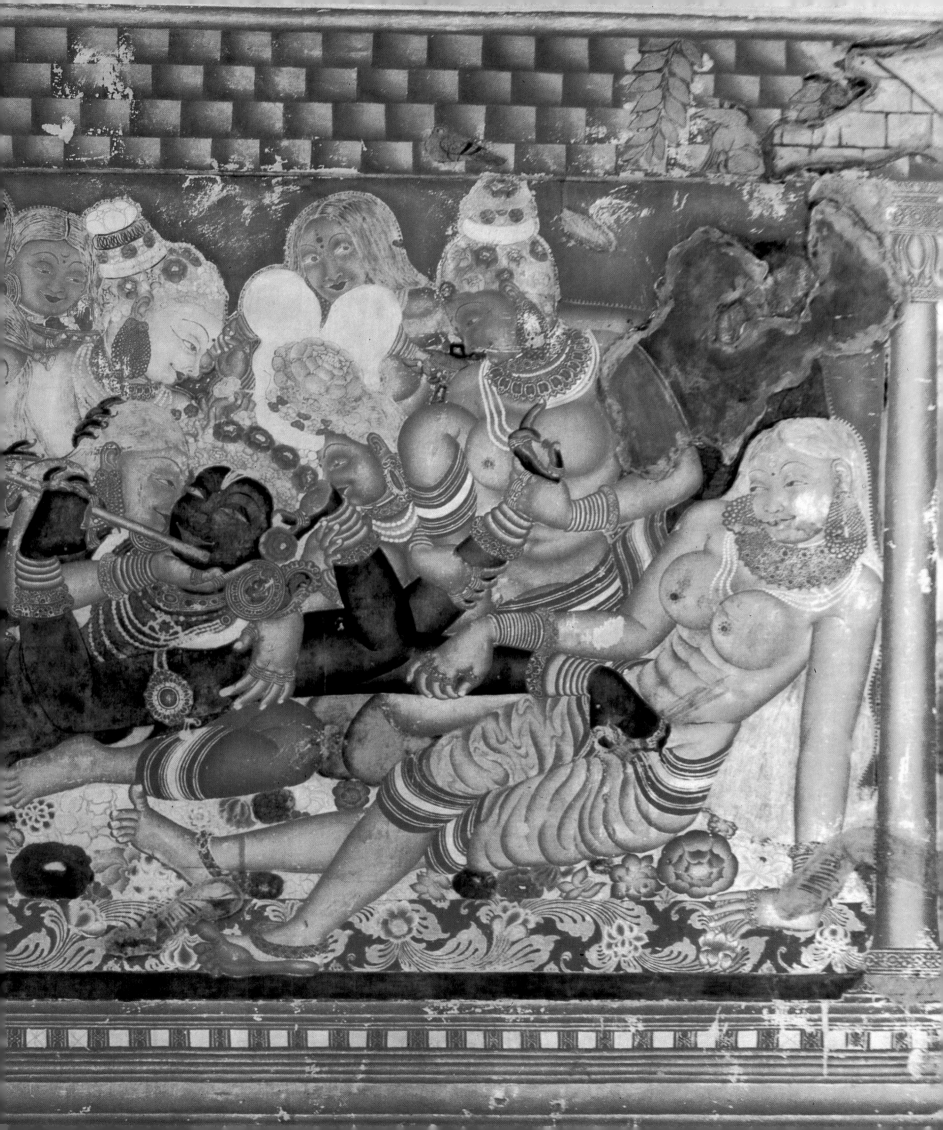

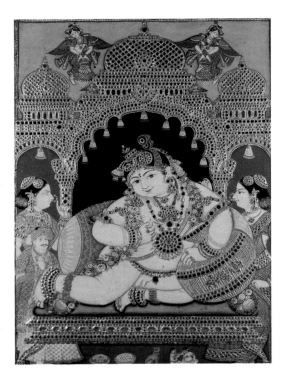

179. Navanita Krishna. *(Painting on wood, Tanjore 19th century, 495 × 685 mm, National Museum, New Delhi [ref. 62/490].)*

Among the most popular themes are the shrine of Jagannath at Puri, the series of the ten *avataras* of Vishnu, incidents from the Krishna legend and particularly those concerning his relationship with Radha, and the *rasa* dance. There is another highly original form in which Krishna is depicted. This is the *navagunjara*, a creature of nine 'beautiful forms', the elements of which are drawn together to constitute a supernatural being, symbolic of Krishna in his universal form (*vishvarupa*). The elements consist of the beak of a parrot, the comb of a cock, the hump of a bull, the hand of a woman, the waist of a lion, the tail of a snake, the neck of a peacock and the legs of a tiger and of an elephant. The *navagunjara* generally holds a discus (*chakra*) in his hand before which the hero Arjuna is shown kneeling.

In the 19th century the Krishna theme became very popular in the paintings of the Tanjore and Mysore Schools of southern India. Such works were elaborately inlaid with gold and coloured glass and have a certain decorative value while lacking the excellence and sensitivity of the miniature paintings of Rajasthan and the Hill States.

Wall paintings depicting episodes from the Krishna theme are to be found in both the North and the South of India. Although no early examples are extant, there are some superb murals in Kerala where the theme has been extensively illustrated on the walls of the Dutch Palace at Mattanchery (Cochin), the Padmanabhapuram Palace at Padmanabhapuram (Nagercoil Dst.) and, on a smaller scale, at Krishnapuram, near Quilon. Incidents from Krishna's life and legend are also lavishly represented on many temple walls. These forceful and very striking murals cover a period of some three hundred years from the late 16th century well into the 19th century.

Yet another form of painting closely connected with Krishna in the shrines of the Vallabhacharya creed was done on large painted cloths, called *pichhavai* (lit. 'that which hangs at the back' of the icon). They were used in various daily ceremonies appertaining to the ritualistic worship of Shri Nathji and at the festivals devoted to Krishna's life. These were so many and so varied that twenty-four iconographic types were developed, a fact that explains the diversity of the painted *pichhavais*. Some of them are particularly striking because of the gold which offsets a red or black background. They usually depict Krishna as Shri Nathji with the *gopis*, or the adoring cowherds in the pastoral paradise of Vrindavana.

As with the traditional Orissan paintings, arts connected with the shrine of Shri Nathji continue to flourish to this day. Artisans' families still produce small images of the deity and *pichhavais* of all sizes on diverse subjects for both the local pilgrim and the export markets.

No survey of Krishna painting should fail to mention the everyday art of India. This was much inspired by the life and legend of the Blue God and folk artists were particularly attached to such themes as the deity in the role of cowherd, killer of demons and above all of the snake Kaliya, to stories of his pranks, his games with the cowherds and the milkmaids and especially the *dana lila*, the taking of the toll episode. Illustrations of the *nayaka-nayika-bheda*, the *ragamala* or the *barahmasa* are rarely, if ever, found because they presupposed a courtly milieu and were too far removed from the basic life of peasants and artisans to have an appeal.

Folk artists, and those who came to admire their work, could readily relate to the account of Krishna's life among the cowherds, to the world of Vrindavana, to the daily incidents of pastoral life and even the natural catastrophes of floods, forest-fires and the damage wrought by wild animals.

However, there are exceptions: notable among these are the so-called 'Paithan' paintings, probably produced in the border area between Maharashtra and Karnataka, and ascribed to the last century. They were used by local bards to illustrate their stories and show Krishna as the epic hero, acting as counsellor and companion to the Pandavas, or as the helper of his grandson, Aniruddha, when the latter becomes involved with the beautiful princess Usha, daughter of the fearful demon Bana. No picture depicting episodes of the Krishna *lila* has yet come to light. The motif of Vrindavana and its idyllic pastoral situation, of Krishna's beloved milkmaids, of his games and jokes with the cowherds may have been considered unsuitable for the virile heroic style of the paintings in which fights, gory scenes, and blood-chilling episodes from the epics and the *Puranas* have pride of place. (See ill. 84)

Nowadays, folk painting still thrives and receives encouragement in centres other than Orissan and Rajasthan. In Bihar, so-called 'Mithila or Madhubani' art has been in a state of revival since the sixties and has become very popular in Europe in the last two decades. The style is both bold and naive while the colours range from bright to monochrome. They mostly draw from the Krishna legend but lack the creativity and spontaneity which generally characterises the works of rural artists. Originally painted onto the mud walls of houses and periodically restored, the same themes are now reproduced on paper. The pressure of mass production is but thinly disguised in the majority of these pictures which rarely, despite an undeniable visual charm, convey any idea of the artist's personality or commitment to the theme. This shortcoming is not exclusive to Bihar and unfortunately blights the work of other centres as well.

Repetitiveness is not an accusation that can be filed against either classical or folk painting of the Krishna legend, despite the fact that both deal with stories from the *Bhagavata Purana* and the *Gita Govinda*. Each artist approaches the same subject in an original and individual manner and this variety is a testament to the inventiveness of the Indian miniaturist. The composition, colouring and portrayal of the demons, humans, animals and birds which populate the world of Krishna, not to mention the interpretation of Krishna's relationship with the *gopis* of Vraja and his separation and reunion with the most adored of them all, Radha, are all treated differently.

> How heavy the garlands lie on her breasts
> For her body hath wasted in pining for you,
> On her limbs the fragrance of sandal now rests
> Like poison, Oh Keshava parted from you,
> And her breath with the fire of passion doth blow,
> And her flowers couch is like fires aglow,
> Oh Keshava parted from you
> And 'Hari, O Hari' she constantly cries
> for her pain is the pain of a love who dies,
> Oh Keshava parted from you.

These artists were humble men with few material possessions and yet they shared a conception of beauty which is granted to few. The landscape settings of their pictures were frequently influenced by their own simple surroundings and Krishna and Radha would at times be represented as peasants. At others, Krishna was depicted as a resplendent prince with a golden crown and the *gopis* as exquisitely elegant, bejewelled and sumptuously dressed maidens. Visual beauty aside, the central theme of *bhakti* was eternally present, not in a didactic, sacerdotal or obvious sense but expressed in a fleeting glance, a fleeting action, a fleeting thought, or a haunting landscape, a fairy woodland, the adoration of both man and beast, footprints in the silvery sands of the Yamuna when the Lord of the Autumn Moons danced with the maidens of Vraja and then left, never to return...

All, all is a reminder of one and only one refrain:

> Oh Krishna, without you all is dark!

Krishna in the Visual Arts

by Dr. K.J. Khandalavala

Although dance as an artistic motif is known to all civilizations, no other 'culture' in the world has visualised its supreme gods and goddesses as dancers. In India one cannot conceive of the cosmos, in an eternal rhythm of creation, evolution and destruction without Shiva the *Nataraja*, and Krishna — the *Natavara*. If these dancing aspects were eliminated from the myth and the legend, the religion and the theology, the stone and the bronze, the line and the colour, the sound and the movement, the Indian arts would be but a pale shadow of what they are. Over a period of 2,000 years, the image of the dancing Shiva and the dancing Krishna has fascinated the poet, the sculptor, the painter and the musician. In turn, the myriad manifestations of these gods, their loves and battles, have become the substance of the arts. While Indian drama and poetry, sculpture and painting have immortalised these eternal myths through word, stone, bronze, line and colour, it is the Indian performing arts which have provided a living link into contemporary times through a staggering richness of genres.

The Krishna of myth and legend, the human being and the divine, the loveable child, the naughty adolescent, the supreme lover, the warrior and the charioteer, the God incarnate, and the formless in human form, appears and disappears. Month after month, at specified times in every village or town from Kashmir to Kanyakumari, Manipur to Gujarat, these music and dance recitals are presented in village squares, humble courtyards, palaces, sanctums of temples and urban theatres. The life of the God is enacted, danced and sung through solo, duet and group performances. The genres and the styles are diverse. They range from shadow, string and rod puppets to spectacular human drama. Sometimes, it is the lonely singing of a sole musician beggar, at others, congregational singing and the collective dancing of thousands. The plays are performed in the village streets or in vast open spaces. A few theatre spectacles are restricted to the closed precincts of a temple while others emerge as sophisticated classical forms on urban

181. Krishna playing the flute to the gopis. *(Bronze, Orissa 17-18th century, 93 mm, Collection Prof. Samuel Eilenberg.)*

stages. The image of the God emerges from the vortex of the collective psyche, is created and recreated each day, month and year giving it a local regional contemporary identity but alway as an omniscient presence. On these occasions Krishna is alive here and now, human and divine, sacred and profane, and yet it is the Krishna of bygone ages, of the epics and the *Puranas*, of the stone sculptural reliefs, of the innumerable mural and miniature paintings, of medieval poetry in Sanskrit and of 20 different languages across the Indian subcontinent.

In considering Krishna in the performing arts of India, it is necessary to cover the entire country and beyond into Nepal, Laos, Cambodia and Indonesia. There is no region, no town or village where Krishna is absent. In some, he is the child, the *Bala Gopala*; in others he is the dancer, the *Natavara*; in yet others, he is the naughty adolescent indulging in his innumerable sports (*lilas*). Sometimes, he is the lover, either of the countless *gopis*, or of Radha alone. In some regions and forms, the youthful Krishna of the *Harivansha* and the *Bhagavata Purana* is predominant, while in others it is the King Krishna of Dvarka. Now it is not the child Krishna or the adolescent Krishna playing his naughty pranks, but Krishna, ruler of Dvarka, who is supreme. The heroine is no longer Radha, his beloved of Vrindavana but Rukmini, the Queen, and Satyabhama, another beloved. Here he is also the King who receives his humble friend Sudama at court. In yet other dance forms, it is the warrior Krishna who dominates as the killer of Shishupala — the evil king. Finally there is Krishna, the charioteer of Arjuna (who battles with his adversaries), who gives the sermon of the *Gita*. In some rare theatrical presentations the latter half of Krishna's life

180. Dancing figures. *(Stone sculpture, Orissa c. 13th century, 28 × 66 × 33 cm, Orissa State Museum.)*

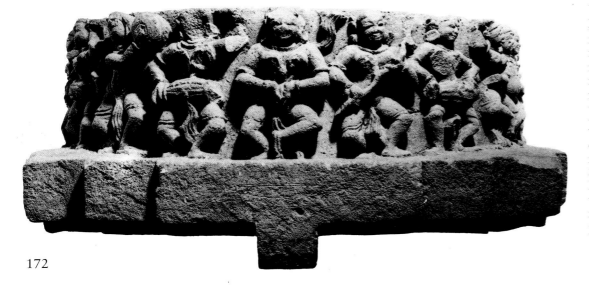

172

is re-enacted, especially the events surrounding his death. In short, the life of this enigmatic child and man hero and god is recreated from birth to death.

The theme having such limitless popularity in contemporary India, it is impossible to present a total picture of the multi-faceted expressions of the myth in the Indian performing arts. Its spatial spread and time dimension have a staggering complexity which forbids neat categorisation either in terms of rural or classical arts or with regard to music, dance, theatre and puppets. More often than not these are multi-media presentations with a strong religio-cult nuance and a character which is *prima-facie* secular and profane, full of fun and frolic, humour and laughter, love and anguish, and yet always symbolizing the spiritual dimension of the yearning of man for God.

Despite these complexities, it is perhaps possible to distinguish between the concept of Krishna dancing and the theatrical and musical presentations based on the life of Krishna. Also it would be pertinent to remember that the image of the dance of Krishna can be clearly distinguished from the image of the dance of Shiva as *Nataraja*. The latter is without doubt the dance on the cosmological plane, whereas Krishna's is the dance of the God incarnate on the human plane. Hence the history of the myth of the dance of Krishna with either the *gopis* or with the *gopis* and Radha is very different from all ten types of the *tandava* (dance) of Shiva.

The dance of Krishna is first mentioned in the *Harivansha*, although without any mention of the crucial word *rasa*. Instead there is a description of the sport of Krishna with the *gopis* in Vrindavana. It is only in the colophon to the second chapter of Book 20 that the word *hallishaka* appears. Here a feast is described. During the celebrations, an opera is led by Krishna. The heavenly celestials (Rambha, Urvashi and Menaka) sing

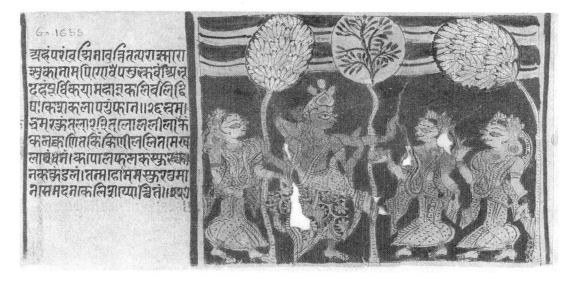

183. Dancing in the groves. Illustration to the Balagopalastuti. *(Miniature, Gujarat c. 1500, 103×240 mm, National Museum, New Delhi [ref. 60 1655].)*

and act. The commentator, Nilakantha, describes at length the nature of the dance. The dance is held on an autumn night under a full moon. The *gopis*, as if spellbound, come out to dance with the Lord. They form a circle and move with hands interlocked. The nymphs and the cowherds form pairs in a circular chain formation with Krishna always in the centre. Later the *gopis* recite verses in praise of Krishna who introduces a novel feature by placing himself between each two women. They also dance around a spike which is driven into the ground. The *Vishnu Purana* elaborates on this description of the *rasa*.

Krishna, observing the clear sky bright with autumnal moon and the air perfumed with fragrance of the wild water lily, felt inclined to join the *gopis* in sport. Accordingly, he and Balarama, his brother, started singing sweet and low strains in various measures. Thus surrounded by the *gopis*, Krishna thought the lovely moonlight of autumn propitious for the *rasa* dance. Many *gopis* imitated different actions of Krishna and, in his absence, wandered through Vrindavana.

I am Krishna, see the elegance of my movements. I am Krishna, listen to my song.

Thus the various actions of Krishna were imitated by the *gopis*.

Madhava, coming amongst them, conciliated some with soft speeches, some with gentle looks and some he took by the hand; the illustrious deity sported with them in the joy of the dance. Since each of the *gopis* attempted to keep in one place so as to be close to Krishna, the circle of the dance could not be constructed, and he therefore took each by the hand and when their eyelids were shut by the effect of his touch the circle was formed.

Although this is a rather inexplicit statement, a later commentary makes it clear. 'Krishna,' it is said, 'in order to form the circle, takes each damsel by the hand and leads her to her place. There he quits her but the effect of the contact is such that it deprives her of the power of perception and contentedly [she] takes the hands of her female neighbor thinking her to be Krishna'.

These accounts reveal that the *rasa* was a formation of women around one man where the interlocking of hands and circular chain formations were essential. It is, however, not clear whether the dance was really of women alone, or of men and women in couples, as suggested by the commentator Nilakantha. In the *Vishnu Purana* there is similar description. The dance was performed to the accompaniment of jingling bracelets and songs that suitably celebrated the charms of autumn. Krishna sang the praises of the moon and the *gopis* the praises of Krishna. At times, one of them, wearied by the revolving dance, threw her arms around Krishna.

Krishna sang in strains appropriate to the dance. The *gopis* repeatedly exclaimed '*dhanya* Krishna' (Krishna be adored), to his song. He led and they followed; and whether he went forwards or backwards they ever attended to his footsteps.

Although these descriptions do not provide us with any technical data about the dance, they do offer valuable insight into the dance called *rasa* and its mythical origins. In the course of time the *rasa* assumed varying forms in the different regions of India. In contemporary India the *rasa* can be danced only by men or only women or women dancing

182. Rasa mandala. *(Miniature, detail, Nathdwara c. 1780, 190×330 mm, Private collection.)*

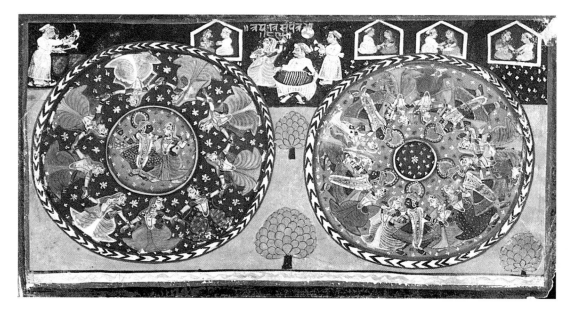

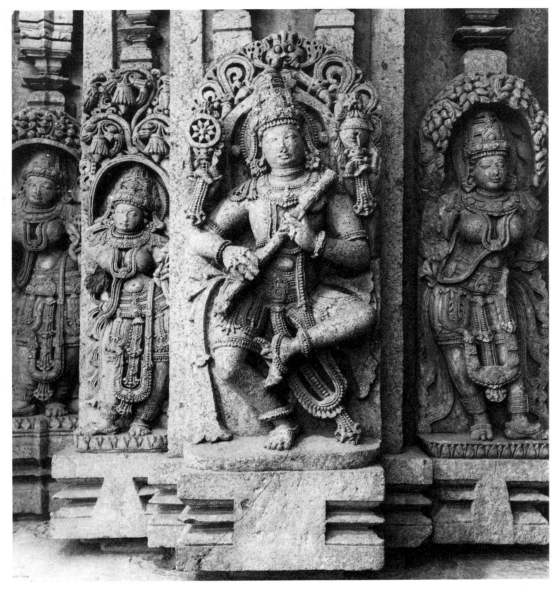

184 Dancing Krishna. *(Stone sculpture, Somnathpur 13th century)*

Puranas mentioned above, there was one other poetic work, the *Gita Govinda*, which transformed the myth of Krishna and the *gopis* into the myth of Krishna and Radha. The creation of the character of Radha as a special *gopi* led to a shift in the nature of the *rasa*. The presence of Radha naturally introduces a dramatic quality which was of great significance both artistically and mystically. Now both Krishna and Radha are in the centre and others dance around the divine pair.

Besides the *rasa* dance there are the vivid descriptions of the life of Krishna through his varied *lilas*, described in the *Harivansha, Vishnu, Bhagavata, Agni, Vayu, Kurma* and *Padma Purana.*

It is thus evident that between the period of *Harivansha* (latest date suggested, third century A.D.) and *Shrimad Bhagavata* (about 10th century A.D.) on the one hand, and the Sanskrit *kavyas* and *natakas* from the seventh to the 12th century on the other, the Krishna theme, and the *rasa* in particular, was known to many parts of India and constituted a key motif of mythological, poetic and dramatic writing.

In addition, the academic discussion on this form in the treatises relating to dance, drama and music should be noted. Although some scholars have tried to establish a connection between the different types of lyrical styles described in the *Natyashastra* as *rasa* (the earliest text on dramaturgy, dated second century A.D.), neither Bharata nor Nandikeshavara (two theoreticians belonging to the second and 13th centuries A.D.) considered *rasa* as a distinct category. Only the *Agni Purana*, (a text of the ninth century) mentions a form called *rasaka*. However, from the 10th century onwards, and particularly since the 12th century, it is included in most texts. Hemachandra's *Kavyanushasana* and Sharadatanaya's *Bhavaprakasha* (two important texts on aesthetics) of the 12th and 13th centuries devote considerable attention to it. The *Sangitaratnakara* (a text on music of the 13th century) alludes to it. From all these works, it is amply clear that the *rasa* or *rasaka*, as a distinct category of performance, assumed importance only in the medieval period. Descriptive interpretations of the *rasa* in the *Shrimad Bhagavata* and the later *Puranas* were repeatedly re-enacted. A special genre called *rasa* or *rasaka* was distinguished from the many other types of dramatic performance (called *uparupakas*) and the pure music or dance form (called *sangita* or *nritta*). These groups of compositions comprised the forms called *rasaka, rasa, hallishaka* and *charchari.* Although there was some overlapping amongst sub-forms, the distinguishing feature was certainly a group dance, phased or unphased to the accompaniment of instrumental or vocal music. It can be gathered from other sources that the *hallishaka* mentioned in the *Harivansha*, denoting a circular dance of many women around one man, may have been the earliest. *Rasaka* or *rasa* became a circular dance of couples. Much

around one man or couples dancing around one man or couples dancing in a circle. The circle as the basic choreographical motif is common to them all. Perhaps the most direct descendants of the *rasa* dances described in the *Puranas* are the *rasa* dances of Vrindavana and far off Manipur in eastern India. After the *Harivansha* and *Vishnu Purana*, the *Shrimad Bhagavata Purana* contains the most graphic description of the *rasa* dance. The word *rasa krida* (the play of the *rasa*) is mentioned here. In this dance Krishna multiplied himself and actually stood between two women: the circle (*mandala*) was thus formed with one man and one woman (i.e., one *gopi* and one Krishna).

In this *rasa mandala* (circular formation) each *gopi* was dancing with her lover (Krishna). The type of *rasa* suggested here is most definitely of couples, and is not a circle of women around one man.

The *Purana* vividly describes couples dancing in a circle. It is a vigorous dance demanding practice and stamina of the *gopis*. We are told that the *gopis* sometimes move fast, sometimes slowly, their eyebrows raised to attract. To an appropriate song the *gopis* gesticulate to express various sentiments (*Shrimad Bhagavata* X, 8). The various forms of Krishna are likened to the circle of clouds and *gopis* to lightning. The *Bhagavata* uses the words *krida* (play), *nritya* (dance) and *nritta* ('pure dance') frequently in this context. There is another masterly description of the *maharasa* (the grand dance). The contemporary dance called *Maharasa* in Manipur is performed to these verses of the *Bhagavata Purana.*

A much later *Purana*, the *Brahma Vaivarta*, also devotes a section to the *rasa* dance, (*Krishna Janma Khanda*, XXVII). In the *rasa mandala*, (circular dance), of the *Brahma Vaivarta Purana*, Radha is accompanied by 36 of her special friends amongst the *gopis*, each one of whom is attended by thousands of inferior personages and escorted by a male multiple of Krishna. In the *Brahma Vaivarta*, the mediator is enjoined to contemplate Krishna with the specially beloved Radha. Besides the descriptions of the *rasa* in the

174

later, *rasaka* and *rasa* also began to denote a dramatic piece with a definite script comprising dialogues, music and dance.

Besides the Sanskrit tradition, there was the literature of *Prakrit*, and *Apabhransha* (the earliest forms of vernaculars). Interestingly enough, the first important examples of the *raso* or *rasa* as a theatrical composition came from Jaina sources of the 12-13th centuries. The *Jambusvami Charita*, a Jaina work of the 11th century, mentions an *Ambadevi rasa* (a composition based on the goddess Amba). In the 12th century the *rasa* forms appear to become very popular in Jaina literature and nearly a thousand or more *rasa* texts have now been located. Two of them deal with the theme of Krishna: one is the *Shri Neminatha rasa* where Neminatha, a Jaina saint, and Krishna are seen in a combat in which the former is the eventual victor (obviously, the *rasa* presents the conflict of the Jaina and the Vaishnava faiths in dramatic form); the other is the *Gayasukumara rasa* which describes a *rasa* dance only at the very end. The tradition of writing *rasakas* and *rasas* continued until the 15th century before giving rise to another class of composition called the *phagu*.

The Jaina tradition continued until the 18th century as a parallel stream; it was coeval with the popularity of *rasa* primarily as a music and dance composition, in the Vaishnava tradition.

The period from the 10th to the 14th century also witnessed the evolution of different languages in northern, eastern and western India. The early phases of Bengali, Rajasthani, Gujarati Maithili and Punjabi have much in common. This in turn produced the common background of the theatre, dance and musical forms which flourished in these parts of the country from the 10th to the 15th century.

It is against this linguistic background involving developments in Sanskrit and

185. Dancing musicians. *(Stone sculpture, Halebid 12th century)*

various *Prakrit* and *Apabhransha* languages, such as Sauraseni and Braja boli in particular, that the 15th century flourishing of poetry, painting and theatre forms, especially in Mathura and Vrindavana, must be understood.

Though the Krishna theme was pervasive in literature, the form of *rasa* or *rasaka* was not restricted to it, just as the form was not restricted to a merely lyrical mode of dance, called *lasya*. While a variety of the circular dance form continued in Gujarat, as can be surmised from an early Gujarati work, the *Saptakshetrirasa* (1271 A.D.) which mentions the *tala rasa* and the *lakuta rasa* (the first including clapping of hands and the other using sticks), the term *rasa* was also used for a class of composition which had a long narrative in rhymed verse with heroic or didactic themes. Jaina works like *Bharateshvara Bahubali* by Shailabhadra, written in early Gujarati, were typical of these new developments.

From the 15th century yet another phase begins. The Vaishnava movement spread, and with it came a renewed interest in the Krishna theme which gave new vigour to the theatrical and dramatic forms which revolved around it. This was also the period which witnessed a renewed popularity in eastern India of the *Gita Govinda*, by Jayadeva. For a century or so after its composition in the 12th century this work does not seem to have attracted much attention, but from the 14th century onwards commentaries and imitations were based on it in all parts of the country, particularly Bengal, Orissa and Rajasthan. The earliest Bengali narrative poem, *Krishnavijaya*, based on the Krishna legend, belongs to the 15th century and was written by Maladhara Vasu, who borrowed freely from both the *Bhagavata* and *Vishnu Purana* as well as the *Gita Govinda*. Chaitanya, the saint devotee of the 16th century, was acquainted with this work and used it at large devotional gatherings. Badu Chandidasa, another saint poet, modelled his work, the *Shrikrishna Kirtana*, closely on the *Gita Govinda*. In Orissa, Jayadeva's influence was pervasive. Many translations were made in Oriya and imitations were popular. From the temple records of Jagannath Puri, the frequent presentation of dramas in the courtyard of the temple can be established. The singing of the *Gita Govinda* was integral to the ceremonies of worship. Special women called *maharis* were retained by temples. Poets from other regions, especially Vidyapati and Umapati, were influenced by the work. It travelled to the West in Gujarat and to the South, particularly Kerala and Andhra. Chaitanya and his followers were largely responsible for this. Their socioreligious cultural movement spread to Assam, Orissa and finally to Vrindavana. Chaitanya's stay in Puri and his travels throughout India in the company of his many disciples were chiefly responsible for popularising the Vaishnava Bhagavata faith, to which the worship of Radha-Krishna became central.

186. Ceremonial dancing. *(Miniature, Nathdwara c. 1820, 190 × 285 mm with borders, Galerie Marco Polo, Paris.)*

Vrindavana became the most important centre of the Bhagavata faith. Vaishnavas from all parts of India gathered there and then returned to their regions. Central to their movement were music, dance and drama. The congregational singing called *kirtana* was the most important, but dance and dramatic forms called *rasa* and *rasaka* and the enactment of the life of Krishna were equally popular.

It was these medieval developments, whereby the Krishna of the *Bhagavata* and that of the *Gita Govinda* coalesced, which were responsible for a distinct theatrical form called *rasa lila*.

The purpose of this brief outline of the main landmarks of Vaishnavism and the related artistic forms has been to demonstrate that the contemporary *Braja rasa*, attributed to the *gosvamis* (priests) of Vrindavana has vital links with the rest of India both on the level of religious institutions and literary and artistic forms. In this context, the developments in southern India and their interaction with the movements in the North are also pertinent. The renowned saint Vallabhacharya was a migrant from the South. He settled in Vrindavana and brought with him the devotional poetry of the *Alvars*, the Vaishnavas of southern India. In this poetry too there was the counterpart of the character Radha known as Nappinai. What emerged in Mathura and Vrindavana was an amalgam of all these diverse trends.

The *ashtachhapa* poets of Mathura, known as the eight jewels (Sur Das, Nandadas etc.), were the disciples of Vallabhacharya and his

son. Their language was Braja Bhasha which was related to early forms of other Indian languages, particularly Maithili, Asamiya, Rajasthani and Gujarati. All these poems reverberate with the music of Krishna's flute. The dancing Krishna is the hero of this poetry as he is of the work of Mira Bai, the saint poetess of Rajasthan and Gujarat. While the *Bala Gopala* (child Krishna) is extolled in this poetry, there is valuable evidence relating to the *rasa*. The *rasa* of Krishna, which had formed only a small part of the poetry of the period immediately preceding the 16th century, is given prominence and a central place here. Radha is always included: she is without doubt a multi-dimensional character now, with more than one significance. More often than not, she is deified as *shakti*, the female principle. In artistic terms, the theme of Radha-Krishna and the *gopis* provides scope for the creation of solo, duet and small group dance. The seemingly unsophisticated form called *rasa lila* thus has a complex history of interconnections with other regions of India, a feature characteristic of all aspects of Indian culture.

While there is some controversy about the beginnings of the *rasa lila* form of Mathura and Vrindavana, the present tradition can perhaps be traced back to the 16th century. Some scholars have attributed its origins to Narayana Bhatta, others to a *svami* called Ghamandi. The *Granth Sahib* (the sacred book of the Sikhs) alludes to the form *rasa*: Abu'l-Fazl, the chronicler of Akbar mentions it, and the form is described in another work called *Krishna Sangita*. In addition, evidence is provided by inscriptions and other records. From all these references it would be possible to say that the *rasa lila* performance in the precincts of the temple was well established by the time of Akbar.

It is also quite possible that the *rasa lila*, as described in the *Shrimad Bhagavata* of the 10th century, was a contemporary living theatrical tradition. However, the popularity of the new socio-cultural movement of the Vaishnavas gave it a new impetus only in the 15th and 16th centuries. The most important centres of the movement were Mathura and Vrindavana in the North, Jagannath Puri and Nabadvip in the East.

Valuable evidence of the continuity and prevalence of the tradition is also extant in the innumerable miniature paintings of the medieval period on the Krishna theme, particularly the *rasa* as described in the *Bhagavata*. It is significant that, in spite of the prolific depiction of dance in Indian sculpture generally, it is not until the 13th and 14th centuries that we come across scenes of collective dance with pairs either holding sticks or clapping. The most outstanding example of the *lakuta* or *dandiya rasa* (dance with clapping and with sticks) comes from the Hazara Rama temple of the Vijayanagar period. One male dancer surrounded by many women is also unknown in Indian sculpture. In painting, two well-known examples come from the Bagh and Ajanta caves

and date from the fifth and seventh centuries. The scene in Bagh has been identified as the *hallishaka*, while the Ajanta mural shows a woman surrounded by other women. Thereafter few traces are apparent until the theme re-emerges in miniature paintings. The paintings clearly portray Krishna's life at Vrindavana in two different ways; his *lilas* and his *rasa*. This development in the literary and pictorial arts may well reflect a theatrical reality which the poets and painters attempted to portray. The theatrical experience and possibilities it furnished for innovation may also explain the occasional enlargement of a *puranic* content by adding new episodes or interpretations which were no doubt the contribution of the local variations. Furthermore, it must be remembered that these developments were contemporaneous with the Jaina traditions of *rasaka* and *raso* where the themes were didactic and heroic and the form narrative and dramatic, rather than operatic and kinetic.

These diverse elements helped to determine the performance of the *rasa lila*. Jayadeva, without doubt, was responsible for giving a different mould to the theme both through the introduction of Radha and the association of *ragas* (modes) and *talas* (metrical patterns) to the poetic verse. Other socio-

187. Krishna Venugopala. *(Bronze, Orissa 17th century, 11.5 cm, Collection Prof. Samuel Eilenberg.)*

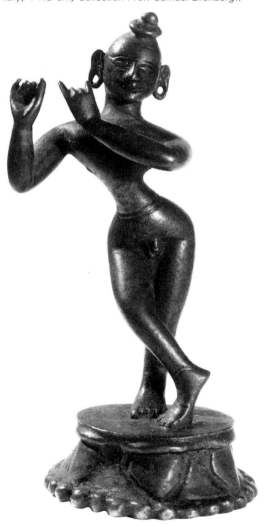

cultural and religious movements accounted for its emergence as a distinctive artistic form. It was the *rasa lila* of Mathura and Vrindavana which travelled to Manipur in the 18th century and gave rise to a form which soon became particular to that region, having, at the same time, affinities with the Vaishnava traditions of neighbouring regions like Bengal. Here the aspect of the *lila* was minimised and the different forms of *rasa* were developed in such a stylized manner that today it represents one of the most elaborate and refined forms of classical dance.

But all this is still spatially outside Vrindavana and, temporally, exists in the past. What about the actors, the social organisation of the performance and finally the artistic form of the *rasa lila* as seen today?

The contemporary *rasa lila* of Vrindavana is the special domain of the *svamis* and the *gosvamis* (priests) who trace their family history back many generations, in most cases to the 16th century. The *Mathura Gazetteers*, memoirs and papers of British and other foreign visitors of the 19th century, speak both of the families of patrons and performers and of the spectacle.

The special organisation of the contemporary performers of the *rasa lila* is popularly called the *rasadhari mandalis*. The groups are maintained by the head of the organisation who supports and educates his pupils. Young boys from the age of eight are enrolled. Some may be the sons and relatives of the head of the institutions, called the *svami*. The boys are chosen from all castes and classes, but the roles of Radha and Krishna and the *gopis* are performed by boys under the age of 14. At puberty, their career either comes to an end or they assume other roles such as that of Sudama or Uddhava which can be played by adults. In the *Rama Lila* of Varanasi, (an analogous form revolving around the story of Rama), Rama, Sita and Lakshmana are played exclusively by young boys before the age of puberty; in the Manipur *rasa* a similar convention is followed whereby only young girls not yet having reached puberty perform all the roles, including that of Krishna. In Nepal a similar convention is followed in rituals and plays connected with *shakti*.

The training is broad, comprising the study of *Puranas* and other literature, singing and dancing; discipline is strict, as in an *ashrama* or a residential school where pupils are allowed to visit parents only for limited periods and at specified times. Although the *svamis* are attached to particular temples, the upkeep of the trainees and the raising of financial resources seem largely to be their responsibility. The site of the *rasa lila* is not restricted to the temple although in many cases it continues to be the temple courtyard. Sometimes it is now a patron's residence, or a public stage or an auditorium.

In all cases the *rasa lila* demands a special stage. It is normally a circular platform of stone or concrete, three feet high. The symbolic significance of the circular stage is

clear, for it recalls the descriptions of the *rasa mandala* (the round arena of the *rasa*) in the *Shrimad Bhagavata*. On one end of the stage is a dais or platform called *rangamancha* (the stage of the dance) or a raised throne called the *sinhasana*. All the scenes where Radha and Krishna appear in their deified form, and to which they return at the end, are performed on the raised back stage; other scenes suggesting the passage of time or change of location are performed on the lower stage.

The ritual is held either behind a curtain on the platform or on the *sinhasana*, as in the case of some other dramatic forms. It should also be recalled that, in Indian theatre, the preceding ritual, whether long or short, is essential and integral to the performance.

In the case of *Braja rasa*, the time during which make-up and costumes are worn is considered to be the period of the transformation of the child-actor into the incarnation (the *svarupa*). Thus garbed, he is no longer himself but a symbol of God-hood and all honours and deference due to an icon are consequently given to the human *svarupa*. He is carried on the shoulders of others, is worshipped by the *svami* and devotees alike and, to all intents and purposes, has acquired divine status and attributes.

The performance itself is divided, as has been mentioned, into two clear-cut portions: the *rasa* and the presentation of the *lilas*. Some scholars have considered it necessary to divide it into three parts: the *nritya rasa*, (a circular dance), the *sangitaka* (operatic sections) and the *lila* (playlets on the life of Krishna).

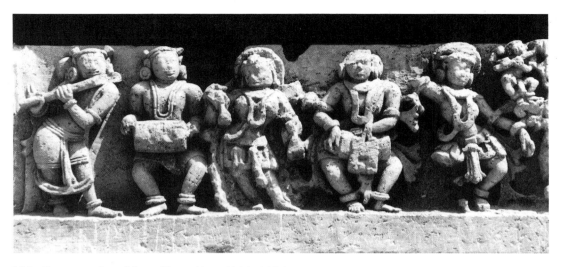

189. Dancers and musicians. *(Stone frieze, Halebid 12th century)*

188. On the banks of the river Yamuna. *(Miniature, Kangra c. 1800, 130×190 mm without borders, Chandigarh Govt. Museum [ref. 908].)*

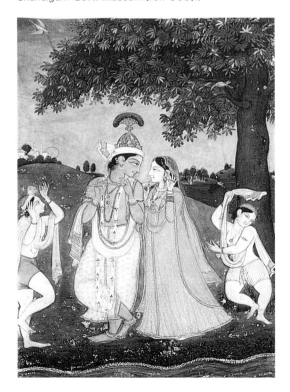

The spectacle begins with the *jhanki* or tableaux-like presentation behind a curtain held by two assistants. When the curtain is raised, Radha and Krishna are seen sitting on the raised platform (called the *sinhasana*). An invocatory verse is sung, and this section is called the *mangalacharana*. The *svami*, who is the director of the performance, touches the feet of Radha, Krishna and the *gopis* as the invocatory *mangalacharana* is sung. The verses are drawn from many literary sources, both Sanskrit and Braja Bhasha. They range from an invocation to the Supreme teacher as Guru Brahma, Guru Vishnu and Guru Maheshvara to the *padas* (verses) of Sur Das or the compositions of the *svamis* themselves. There are two sections of the *mangalacharana*, one a *shloka* (invocatory verse) in Sanskrit and the other a *doha* (a verse) in Braja bhasha. The recitation is followed by the musicians and their accompaniment, the instrumentalists, singing verses. Additional songs or rhymed couplets are added to suit particular occasions. The singing of this portion largely follows an older form of Indian music called the *dhruvapada* style. The entry of the *gopis* with plates bearing different articles for the *arati* (worship) coincides with the end of the first phase. The *arati* (with lamps, incense, flower petals on a plate) is performed by the *gopis* with great solemnity. The musicians sing the *arati* song and are joined by the child actors performing the role of the *gopis*. The first two sections comprise the *stuti* (the invocation) part of the *rasa*: this creates an atmosphere of devotion and solemnity. The *arati* verses are also drawn from several literary sources and are often the creations of *svamis* themselves. The *arati* is performed before the divine pair, Radha and Krishna. Then follows the *gopiprarthana* or the entreaty of the *gopis* to Krishna to begin the *nritya rasa* (dance called *rasa*). In simple prose, Krishna is asked to enter the *rasa mandala* (the acting area on the lower stage) whereupon he turns to Radha and requests her to join the *rasa*. This is done both through prose dialogue and sung verses.

Radha agrees, responding affectionately through another verse which extols Krishna as *Rasashiromani* or *Rasakashiromani*, and describes him as the musician-dancer supreme. Most verses are drawn from the *ashtachhapa* school and from the compositions of the *gosvamis*, including Hita Harivansha, Haridasa, and others. Radha's response completed, the couple gradually descend to the *rasa mandala* to prepare for the *rasa*. The most exciting section, the *rasa* dance, then commences. This is rigorously structured into different phases comprising many complex choreographical patterns. While the first phases of the *rasa* have an element of mime (*abhinaya*) they consist of speech and singing — the *rasa* section proper is pure dance (*nritta*). The vocal accompaniment is also all mnemonics (*bols*), which are often common to contemporary *kathak* (a northern Indian form of dance) and *Braja rasa*. In the initial stage, Radha and Krishna face each other with the *gopis* between them. In the phases which follow circles are formed. The formations are of many varieties, as are the methods of interlocking hands and arms. Often the accompaniment is only the mnemonics of the drum (*pakhavaja*); sometimes many technical terms are strung together in rhymed verse. There is frequent mention of the nature of foot-work used (*padapatakani*), or of the nature of waist movements (*kati*) or of the nature of facial gestures (*havabhava*) or of the use of the hands (*hastaka*); also mentioned are the nature of circles (*mandalas*) and choreographical patterns made by interlocking hands.

The technique of the dance is built on an elaborate and developed system of *tala* (metrical cycles) and the utilization of all the tempos: slow, medium and fast. The circle formations are reminiscent of the descriptions in the *Puranas* of the *rasa*, specially the interlocking patterns of hands and arms. The choreographic designs of the open and the closed circle recall the description of a class of movement patterns described by Bharata in the *Natyashastra* as the *pindis* (chain for-

mation). The *pindibnadhas* are mentioned in the *Natyashastra* in the context of the preliminaries of the play and are said to be of four or five types. Chief amongst these are the *shrinkhala* (chain formation) or open circle, the *gulma* (cluster formation) or the closed circle, and the radii-like formation of the petals of a lotus.

At one point, in keeping with the descriptions of the *rasa* in the *Vishnu Purana*, the *gopis* imitate Krishna and this is followed by an exacting and exciting solo dance sequence by Krishna. A characteristic feature of this solo is the dance on the knees wherein the child actor whirls swiftly around. This is a phase of great excitment and is the test of the dancer. Pirouettes are frequent. They recall the ancient descriptions of movements called *bhramaras* (pirouettes) in the *Natyashastra* and other dance texts.

The *rasa* of Vraja also incorporates the *dandiya rasa* (the circular dance with sticks) or the *lakuta rasa* (with clapping) described in the Gujarati texts and known to other parts of India, particularly Saurashtra. Sometimes the *rasa* is performed with each of the child actors (*gopis*) holding lights or torches. Occasionally this provides an opportunity to exhibit acrobatic skills. As the tempo increases, the excitement of the audience is heightened and, in a mood of intense ecstasy, the *nritya rasa* (the dance called *rasa*) ends after many duets and group dances. Then, almost in a flash, the vigorous movement, the complexity of the rhythms, the vivacity of the songs give place to a calm stillness of iconic form, with the return of Radha-Krishna to the raised dais to take their seats on the *sinhasana* (throne), as if framed in a picture. The illusion òf gods come to earth for sport and play and their ultimate deification is complete. The *svami* returns to offer his obeisance to the group. All spectators join in, offer flowers, money or objects of their choice to Radha and Krishna as if they were entering temples and worshipping icons.

Finally, there is a discourse (*pravachana*) by Krishna or Shri Thakurji as he is called in the *rasa*. In this he can speak as Krishna and the special attributes of this *avatara* or any other subject and often the *Gita* or other texts are brought to aid. The curtain is lifted and held open and the God-incarnate (*svarupa*) disappears.

Throughout the performance the objective is to emphasize the symbolism or the dual level on which the theatrical spectacle moves. The *rasa* is performed exclusively by child actors, as suggestive of happenings elsewhere, and at no point is there a realistic presentation of the theme. The nature of stylization and the techniques used are very different from those in epic dramatic forms which revolve around the *Mahabharata* theme. In the *lilas*, it is truly sport-play, a vision or glimpse with a mystical significance. A dream-like lyrical form, swiftness of movement and lightness of touch are characteristic.

The end of the *rasa* is the beginning of the *lilas*. More than the *rasa*, the *lilas* draw upon the poetry of the *ashtachhapa* school. An anthology compiled by Indra Brahmachari, called the *Shri Krishnalila rahasya*, includes the works not only of the poets of the 16th to 18th centuries but also contemporary *rasadharis*. The poetry of Nandadas, Sur Das and Kumbhana Das, Svami Haridasa and Shri Hita Harivansha provides the verbal content. Over 150 *lilas* constitute the repertoire of the *rasadharis* or the different *rasa mandalis* from which the *svami* chooses according to the occasion. The themes of some of these are culled from the *Puranas* while others are the innovations of the *svamis* themselves.

Night after night the life of Krishna as child, adolescent and youth is re-created sequentially. Each night a new theme is presented. In one performance Krishna is transported by Vasudeva across the rising Yamuna into the lap of Yashoda. Another time it is Krishna stealing butter from the homes and hearths of the villagers. A third day it is the enactment of Krishna killing the demon Kaliya; a fifth day it is Yashoda tying him to the pillar and yet a sixth day we see Yashoda chiding him for having eaten mud, making him open his mouth and then suddenly discovering that the child is not an ordinary child but God in whose mouth lies the whole universe. Although the content of most of these *lilas* is drawn from the *Puranas*, much of the literary content is also based on regional literature, especially on the compositions of a writer called Vrindavandas. Popular amongst these is the famous *Govardhana lila*, in which Krishna lifts Mount Govardhana on his little finger, and the *chiraharan*, where Krishna steals the clothes of the *gopis*. Unlike the *rasa*, the *lilas* are presented more realistically, with actual earthen pots being broken and milk and butter strewn over the stage.

As has been pointed out earlier, Krishna, Radha and Yashoda are acted by child actors. The leader, a *svami*, often takes the role of Uddhava (the messenger of Krishna) or Sudama (the childhood friend of Krishna). The *svami* is a narrator-director-actor all in one with the fullest freedom to improvise, create or innovate. He can be the editor of older texts, who selects his material to suit the occasion, or a creative poet, preacher and director. The audience listens to his interpretations of these timeless myths in spellbound silence. The ecstatic devotion of the *rasa* is replaced by a charged fervour of another order. Day after day, night after night, thousands of spectators throng to participate in an event which is more than mere theatre. The life of Krishna is recreated and through it the collective psyche rejuvenated. The music of the *rasa* and the *lila* is set to *ragas* and *talas* (modes and metrical cycles). In most cases the poets of the *ashtachhapa* school indicate the *raga* and *tala* of their verses, following a convention begun by Jayadeva. Some *ragas* (musical modes) are common to *Braja rasa* and Hindustani classical music. Other melodies are drawn from local tunes and folk forms. The instruments comprise the drum (*mridanga* or the *pakhavaja*), cymbals (*manjira*), the flute (*bansuri*), and today, the *sarangi*, the *sitar* and, alas, the harmonium. In medieval poetry there are frequent references to the *rhubab* (a stringed instrument) the *vina* (also a stringed instrument), the percussion instruments such as tambourine (*dapha*), cymbals (*manjira*) and the drum (*pakhavaja* and *mridanga*).

Costume is very special, as is the make-up of the *rasa lila*, which aims at presenting characters as icons. Krishna wears a *dhoti* or a *pyjama* (trousers), a long skirt with abundant frills, possibly called the *katakachani*. The multiple frills are in different colours dominated by yellow, blue and purple. The skirt is held at the waist by a *pataka* or sash. The upper garment is a full-sleeved blouse. In the latter phases of the *rasa lila* he exchanges the skirt for a *dhoti* or a *pitambara* (a yellow *dhoti*). Garlands, beads and strings of pearls are worn on top of the blouse and skirt. Medieval miniature painting, especially of the Rajasthani schools, depicts Krishna in this costume. His headgear is quite unique. Over a small turban (*pag*) are worn several ornaments: a tuft of peacock feathers thrust into the turban almost at the centre to which, on one side, is tied a little tilted, conical, gilded ornament. In the centre, in front of the peacock feathers, is a gilded crest which is often spade-shaped. On either side, over the ears, are worn locks of false hair or plumes which hang like tassels at shoulder or chest level. All this is secured by a gilded tiara (*moramukuta*) which covers part of the forehead, as well as the crest and the cone which are immediately behind the tiara. The crest is worn slanted a little to the left by the followers of the Vallabha-*sampradaya* and to the right by the followers of the Gaudiya and Nimbarka-*sampradaya*. From the back of the turban, a piece of black cloth hangs to the hips or the knees. Although people believe that this adornment, called the *choti*, has something to do with the story of Krishna's vanquishing the serpent Kaliya, it is perhaps an ornamental device to conceal all the strings and ribbons needed to secure the different parts of the intricate headgear. Radha and the *gopis* are more simply dressed in *saris* or skirts with *mukutas* (tiaras) and the usual garlands and strings of beads.

The costume of Krishna represents a fairly long tradition, documented by Rajasthani paintings from the 16th century onwards which often show him wearing multiple skirts over a *dhoti*, or a skirt with layers of bands and frills. The paintings of Shrinathji and the Nathadwara *pichhavai* also depict Krishna wearing this type of skirt, the crest, the hanging tassels and the *moramukuta*. The costume appears to have been popular in Rajasthan and Gujarat for nearly three to four hundred years.

Whatever may be the origin of the present *rasa* costuming, it appears that the *rasadharis* were following a tradition which was well established and popular both in the context of the Krishna theme and outside it.

190. Dancer and musician. *(Stone sculpture, Halebid 12th century)*

It was this *rasa lila* of Vrindavana which travelled to far-off Manipur and Assam in the eastern-most regions of India. It reached Assam without the character of Radha but in Manipur she was included.

Manipur is known as the Valley of the Gods. This jewel of natural beauty is said to be the envy of gods and men alike. Legend has it that Shiva himself was drawn to this valley and, with his trident, drained the water of a beautiful lake to create a valley fit to be the site of his dance with Parvati. Scholars have tried to identify the area with the episodes in the epic *Mahabharata*. It is believed that Arjuna fell in love with the Princess Chitrangada here. The earliest inhabitants of the valley are called Meitheis; they trace their origins to pre-*Vedic* times. A perusal of the chronical called *Meithei Purana* reveals the long and unbroken cultural heritage of the people of the valley. Originally the Meitheis comprised seven clans known as the Salais. Ethnically and linguistically, the people belong to the Tibeto-Burman group. According to most scholars, although many *Vedic* traits can be discerned here, Hinduism first came to the Valley in the eighth century. Vaishnavism entered the Valley only in the 16th century and Rangba (1568 A.D.) was the first king to be initiated. He was followed by Garib Nivas who was the principal ruler, instrumental in converting the Valley inhabitants into Vaishnava *bhaktas*. The origin of the famous *rasa* dances is attributed to Rajarshi Bhagya Chandra Maharaj (1763-1798) who, along with Chandra Kirti (1850-1886), laid the foundations of all that is known by the name of classical Manipuri dance.

In spite of this complete transformation of the people into Vaishnava *bhaktas*, many pre-Hindu ritual practices and forms of music and dance continue to linger amongst the people. The history of these forms can certainly be traced back to many centuries prior to the advent of Vaishnavism in Manipur.

Amongst the most beautiful lyrical manifestations of this transformation of an earlier layer of Manipuri culture to Vaishnava culture is the *rasa lila*. Today it is easily the most highly intricate and refined form of dance-drama. The message of Chaitanya was taken to Manipur by his disciples. They introduced the tradition of community singing and dancing. In the fields and open spaces of Manipur one can still regularly participate in dances which extol the name of Lord Krishna. Old men, young women and children all take part in these circular dances. They constitute the prelude to what makes up the *rasa lila* proper. The theme of the immortal *rasa lila* of Shri Krishna and the divine *gopis* is said to have been seen in a vision by the King Bhagyachandra. It is as if the exquisitely beautiful Manipuri *rasa lila* dance were born overnight.

There are several types of *rasa lila* in Manipur. The *Basantrasa* (spring *rasa*) is performed at full moon in March and the keynote of the story is the union of Radha and Krishna which comes after a painful separation. Hurt and infuriated by Krishna's faithlessness, Radha initially refuses to accept him. He implores her forgiveness and says, 'I fall prostrate at your feet; without you and your love I cannot live', and after much pleading, the repentant Krishna succeeds in appeasing Radha.

The *kunjrasa* is lighter in spirit and is per-

formed during the early autumn festival of Dussehra. It represents the daily life of Radha and Krishna who are seen as ideal lovers, amusing themselves and revelling in a relationship unmarred by separation.

The *Maharasa* is performed on a full moon in November-December and depicts the separation of the divine lovers. Krishna abandons Radha, who threatens to kill herself, and finally Krishna returns to her. In addition to these, there are other *rasa lilas*. The *Nityaras*, for instance, may be performed on any evening of the year. Only the *Divaras* may be performed during the daytime. In the *Natnaras*, there are eight *gopis* who sport with Krishna. The *ashtagopiashtashyamrasa* is performed at the end of spring, as the name indicates, and has a cast of eight *gopis* and eight Krishnas.

The traditional *rasa lila* costume is highly decorative, and rich in colour and brilliance. The accompanying music is skillfully varied to avoid monotony.

Instrumental music accompanies all the passages of pure dancing, and two women singers periodically relieve the performers from singing so that they can gesticulate more freely.

The women singers generally sing the *arias* of Radha while a chorus of male singers recite those of Krishna. The performers are all young girls. The sequence of the Manipuri *rasa lila* can be broken up into six main phases or parts as follows:
1) Krishna appears and dances;
2) Radha appears and dances;
3) Krishna and Radha dance together. This constitutes the *rasa lila* proper;
4) *Bhangi*, the argument, when either Radha or Krishna refuses to join in the dancing, and the subsequent persuasion;

191. Gopas dancing in the woods. *(Drawing, detail, Kangra c. 1770, Chandigarh Govt. Museum [ref. 467].)*

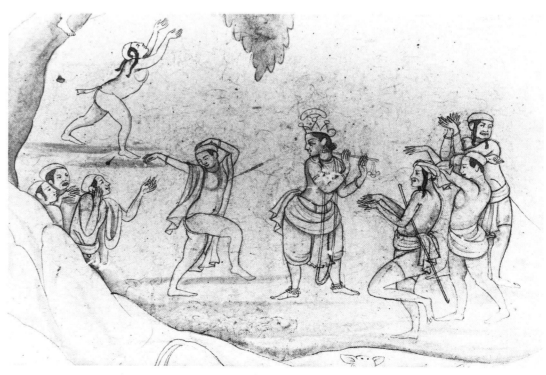

192. Bhramaranda Ragaputra. *(Miniature, Basohli c. 1700, 150 × 160 mm, Collection Colonel R.K. Tandan, Hyderabad.)*

tional prayer hall called the *nama ghara*, a sanctum called the *manikuta* and an inner throne called the *sinhasana* as in the *rasa lila* of Vrindavana. In these congregational prayer halls, *nama gharas*, episodes from the *Bhagavata Purana* are performed every night, couched in a language as full of lyrical beauty as it is of dramatic power. Once again, as in Vrindavana and Manipur, we have the enactment of the *lilas* of Krishna. The texts used are the work of Shankaradeva based on the *Bhagavata Purana* but with a very distinctive Assamese character. Popular amongst them are the *Kaliyadamana* and

Amritmanthan, Gajendraupakhyan and two later episodes from the Krishna of Dvarka — namely the elopement of Rukmini, called *Rukminiharana* and the bringing of the *parijata* flower, called *Parijataharana*. The performance is spectacular, characterised by glittering costumes, masks, models of mountains, animals, chariots. It begins with an orchestrated drumming by ten to twenty musicians, after which the director, the *sutradhara* — counterpart of the *svami* of Vrindavana — appears. The drama itself is one long sustained performance wherein particular episodes from the *Bhagavata Purana*

193. Dancing Krishna. *(Bronze, southern India 18th century, 10.7 cm, Collection Prof. Samuel Eilenberg.)*

5) *Milan* or the union of Radha and Krishna when they joyously dance with the *gopis*; and

6) Prayer, when Radha and the *gopis* pledge their eternal devotion to Krishna.

Although the Manipuri *rasa* is essentially a play of emotions and a devotional offering, the artistic form is rigorously structured with the rich vocabulary of movement distinctive to Manipur. Here also the amalgam of indigenous local forms of dance were superimposed onto the Krishna theme.

The dance of Krishna and the cowherds forms yet another subgroup wherein, instead of the Krishna and Radha theme, only that of the playful Krishna with the cowherds is presented. The numbers of the Manipuri dance called *gostha bhangis*, *gostha nartana* and the *goparasa* constitue the *gostha* (cowherd) group of dances. Many episodes of the playful Krishna are represented from stories of the *Bhagavata Purana*; sometimes it is the famous story of the stealing of the butter, at others, of the killing of the demon Bakasura. The mood of maternal love pervades these numbers, which are full of childlike innocence and vitality. They are often presented by a group of young girls, playing the part of Krishna.

The *Vishnu* and the *Bhagavata Purana* also travelled to Assam. In the course of time, through the genius of one man, Shankaradeva, a whole genre of theatre was created around the Krishna theme. A poetic language called Braja boli was the vehicle of communication; the tool of their missionary zeal and movement was a theatrical form today called the *bhaona* or *ankia nata*. It continues to be used in the monasteries of Assam, called *sattras*. For nearly four centuries the *sattras* have been the chief vehicles for the propagation of the Vaishnava faith. They provide the setting for religious, social and artistic activities. The *sattra* invariably consists of living cubicles for the monks, a temporary structure which is the congrega-

are presented as a multi-media theatre. There is an amalgam of prose passages, recited verses, sung poetry, dance and drama. The composition of Shankaradeva, called *Patni Prasad*, revolves round the themes of *rasa* and once again we are back to the circular dances around Krishna. Here the musical content rather than the dramatic episode is predominant. The dance style is complex. The costume and the masks, the music and the dance are illuminated only by oil torches. At dramatic moments mobile torches light up faces and disappear into darkness. The austerity of the white costume of the director is in deep contrast to the richly coloured costumes of the other characters. The masks are life-like, the drumming clear and tympanic, the lighting full of mystery and wonder. Altogether the performance is quite unique. In Manipur performances are held in the open on moonlit nights. In Assam they are under a canopy. This itself produces a meaningful difference at the level of dramatic performance. However, the symbolism of the dance and the enactment of the life of the lord is identical. Here, too, Krishna is deified. The roles of Krishna and Balarama must be played by young boys who have not yet reached the age of puberty. This is an all-male cast as in Vrindavana. Once again it is the icon-come-to-life. The play over, the child must return to mundane living, but for the duration of the performance, he is God incarnate, consecrated and divine. The collective singing, the group drumming and the presentation of the plays is characteristic of Assam, but there are affinities with both Vrindavana and Manipur in the story.

The theatre and dance forms revolving around the Krishna theme are equally popular in other regions of India, especially in Gujarat (in the West) and southern India. Amongst the many important forms of dance and drama in southern India, there are two widely known forms called *Kathakali* and *Krishnattam*. While it is impossible to elaborate on the history of these important forms, it should be pointed out that *Krishnattam* also emerged in Kerala as a result of the influence of the *Bhagavata* and the *Gita Govinda*. The two works transformed the earlier Shaivite traditions into Vaishnava theatre. King Manavedan, who reigned in Kerala from 1655 to 1658, was a renowned poet and the author of a work entitled *Krishnagiti*. He was also a great patron of the famous Guruvayur temple, which is today the most important centre of the Krishna faith in the South. His work, the *Krishnagiti*, was deeply influenced by the *Gita Govinda*. Today it is performed in an eight-day serialised enactment in the precincts of the Guruvayur temple, by an all-male cast. The cycle begins with the descent of Vishnu as Krishna and concludes with his return to heaven (*svargarohnam*). On the first day, as in the Vrindavana *rasa lila*, the birth of the Lord is represented. Krishna is taken to Gokula by Vasudeva. On the second day, the earlier life of Krishna is

presented and on the third, and most important, the *rasa krida* (dance-play) is performed. In between, the episodes of the killing of the various demons, especially Putana and Banasura, are presented. The most impressive of these are the episodes in which Krishna overwhelms the demon Kaliya, the fight with the demon Banasura and the killing of Kansa. The themes provide an opportunity for soft lyrical movement in the *rasa krida* episode and powerful mime presentations in the *Putanavadha* (the killing of the demoness Putana when she tries to poison the child Krishna). The scenes where Krishna kills Shishupala and cuts open the entrails of the evil uncle Kansa are compelling drama. The eighth day's episode, when Krishna is killed by a hunter's arrow, is poignantly presented. The characters of *Krishnattam* emerge from lush tropical vegetation as in the wall paintings of Kerala. They appear against dark foliage with dazzling red, black and green make-up, high crowns and headgear twinkling with studded mirrors, larger-than-life masks, gilded ornaments. Then, in a flash, they merge back into the mystery of the night. Except in the performance of the *rasa krida* on the third night of the cycle of plays, little else is lyrical or romantic. The episodes are played throughout the night, and by morning the spectators are moved to an elated state of wonder and devotion. The temple bells begin to chime; there is the music of pipes and horns and, as if cleansed and purified, the congregation approaches the sanctum of the temple to pray.

This dance drama is confined to the precincts of the temple. *Kathakali*, the related dance drama of Kerala, moves into the open spaces. It is the same world of gods and demons, heroes and villains, but now the life of Krishna is based on episodes from the epics, especially the *Mahabharata* and the *Ramayana*. The libretto is in Sanskrit or in Malayalam. It is sung and narrated; the dance is highly stylised with a fully developed language of hand and facial gestures. The Rama theme is dominant but Krishna appears time and again in many *Kathakali* plays. The plays themselves are sometimes preceded by the episode of the *Putanavadha* common both to *Krishnattam* and *Kathakali*. Alice Boner, the great art historian, saw one such performance in 1935 by a veteran male artist. Here is her description:

... In his female attire he incorporated, whether consciously or unconsciously, one of those experienced, cunning kind of women, always out for intrigue and mischief, dreaded and propitiated by all. A female who might be twisting a man's will for evil or good on to destruction, enchanting, bewitching and extremely clever. She enters the stage with innocently wondering eyes, as if searching the way to the village where Krishna lives. Approaching the village she complacently describes people who play and gossip, and miming their dances and games of ball with an entrancing grace. On finding out Krishna's abode, she depicts ecstatically the beauties of the seven-storied mansions, the shining courtyards, the cool water running through flower groves, the enraptured peacocks dancing on mount Govardhana, the lovely cowherds and Nanda's house, from which arises the fragrance of curd drops and sweet

194. Krishna Venugopala. *(Bronze, 18th century, 18.5 cm, Reproduced by Courtesy of the Trustees of the British Museum, London.)*

butter. After having admired her fill, she swiftly slips into the house. To suggest this, a small bench is introduced, on which lies a primitive wooden doll representing the child Krishna. Putana carefully looks round to see whether anybody has noticed her intrusion and, being reassured, slowly approaches the child. On horizontally spread knees she stealthily advances, gliding like a snake, without lifting her feet from the ground. All her evil intentions are expressed in this gait. But she contrives the sweetest and most loving smile on her face and starts playing with the child. To amuse him she delicately snaps her fingers in his face and surreptitiously caresses him. Then, turning back to Krishna with tender glances, she describes his dark blue colour, the envy of the clouds and how he is sitting on the leaf swimming on the water, raising his toe to his mouth. Enrapturing herself by his sight, strange scruples assail her heart (which is a woman's after all) and with compassion, almost weeping, she contemplates the infant she is sent to kill. Suddenly she shakes herself to proceed with her task. Seeing the baby weep, she affectionately asks him whether he is hungry and offers to feed him, describing voluptuously the roundness and plenty of her breasts. Cheering the child she takes him in her arms, quickly smears poison on her breast, and sets him to drink. Rocking the child on one arm and resting her head on the other hand, she looks absorbed and forlorn as women often do when they nurse. She takes the child from one breast to another, shakes him when milk runs into his nose and smiles at him till all of a sudden a flash of pain runs over her face. She looks alarmed, as if apprehending a menacing danger, but swallowing down her fear goes on feeding, rocking and smiling. The pain increases. She rubs her bosom with a contracted face. No use, the pain becomes ever more violent, till she writhes scratching her neck, her breasts, her legs and tries to remove the child. As she does not succeed in this by force, she tries

181

to persuade him by an engaging, and — how artificial — smile to take the other breast. Nor is this of any avail. She becomes mad with suffering, she pulls and pinches the child while pain distorts her face, she hammers wildly on his head, she tears her own feet, but the godly child is not to be shaken off the breast and slowly sucks the life out of her. She jumps to her feet in wild despair, running up and down, alternately beating her head and chest with the child hanging from her breast. Her features in agony are disfigured to a horrible grimace, the grimace in which her real devilish nature is revealed. When she finally drops dying on the floor, no trace remains of the lovely woman she was before. She is a ghastly Rakshasi (demoness) killed by her own wicked deed (1).

This presentation is invariably a solo performance. The others are full-length plays lasting from four to ten hours. In one Krishna appears in the court of Duryodhana as the protector of Draupadi when she is being disrobed. In another he appears again as the abductor of Rukmini and the killer of Shishupala. In a third, he appears as the charioteer of Arjuna and delivers the sermon of the *Gita*. There are innumerable versions of these stories and others.

In the scenes relating to the game of dice and the disrobing of Draupadi, Krishna is conceived as the soft and lyrical God, full of benignity, who gives benediction. As the abductor of Rukmini and the killer of Shishupala, he is cast in a heroic mould, simultaneously brave and angry. The headgear establishes the different moods. Krishna, as the youthful god, wears a small conical headdress with peacock feathers. As the heroic king, he wears a large crown with a circular disc. Furious, he wages war against Shishupala and other demons. In contrast to this stirring drama of heroic loves and wars, killings and conquests, is the deeply human episode concerning the childhood friend of Krishna, Sudama, who appears at Krishna's court in Dvarka (see Narrative p. 84). The poor Brahmin devotee finds no solution to his problems of poverty. Miserable and helpless, his ears resounding with the piteous cries of his hungry children, his eyes full of tears, hesitant and nervous, he arrives at the court of Krishna, Prince of Dvarka. The court guards naturally stop him, and many are the obstacles on his path before he is finally led before the radiant God prince. Upon seeing him, Krishna descends from the throne, despite the dictates of protocol, embraces his childhood friend, and seats him in his place. Though not a word is exchanged, the Lord knows all. After repeated hugs and embraces and precious memories of childhood pranks have been shared, Sudama takes his leave, empty-handed. He has made no entreaties, asked no favours, begged not so much as a morsel. The return to his family is miraculous; instead of destitution, he is greeted by a palace and joyous well-being.

This episode is performed without stage sets or scenery. The two dominant actors — those who play the roles of Sudama and Krishna — recreate the pathos and compassion of the human drama through gestures and mime. Only veteran artists, sometimes over 70 years of age, assume the role of Sudama in these plays. The performances are memorable; the audience watches, enraptured, and like Sudama and his wife, tears of joy flow involuntarily. Mythology and legend are alive in the beings of the actors and spectators alike, uplifting them to a state of spiritual release and ecstasy. Little wonder that this episode of Krishna's life has transformed the existences of many, teaching them lessons of loyalty and love.

In Karnataka there is another dance-drama called *Yakshagana* related to *Kathakali*. The theatrical spectacle is totally different. Krishna appears in two roles, as the young brother of Balarama and as the warrior hero. The *lilas* of the child Krishna are almost absent from the repertoire of *Yakshagana*. Although the origins of this form of dance and drama are attributed to the 16th-17th centuries, its roots can be traced back to the fifth and sixth centuries. Both the literary drama known as the *Yakshagana* and the theatre known by this name common to Karnataka, Andhra and Tamil Nadu in southern India. While there is a great difference in the nature of movement, patterns, hand gestures, musical content, costume, headgear, crowns and make-up, there is a family kinship with the *Kathakali* and *Krishnattam* forms from Kerala. The repertoire revolves round the killing of Kansa (*Kansavadha*), the elopement of Rukmini (*Rukminiharana*) and the great war of *Mahabharata*, where Krishna is Arjuna's charioteer.

The performances are held in open air against the background of rich vegetation of the western coasts of India in Karnataka. The stage is either rectangular — 16 by 20 feet — or square, each side measuring 16 or 20 feet. Poles are erected at each of the four corners with banana trunks and leaves tied to them. Two oil lamps are placed on the side, mid-stage. At the back centre stage sits the *bhagavatar*, the chief director, reciter, and conductor of the play, holding cymbals and accompanied by a drum player (*maddale*). At a distance to their right sits the *chande* (a vertical drum played with sticks) player. The audience sits on all three sides. There are vast open spaces at the back shrouded in darkness to provide for quick exits and entrances.

The drums beat loudly and the chief director begins to sing. The audience gathers in reponse and within an hour a crowd of five to ten thousand people can assemble. The performance begins with an invocation to Ganesha and is quickly followed by the entry of two comic characters called Kodangi and Hanumanayaka. In the third phase of the prologue, two young dancers, Bala-Gopala and Krishna-Balarama, enter. Their appearance is significant, underlining, once again, the Vaishnava character of the entire drama.

The preliminaries over, each character enters the arena after being introduced by the *bhagavatar*. The character first hides behind a curtain, revealing himself only partially from behind through the elaborate headdress and then disappears. The continuous in-

195. Dancing drummer. *(Stone sculpture, Orissa 11th century)*

terplay between the character and the curtain creates a tension and prepares the audience for the actual dramatic situation. Like the other forms — *Krishnattam* and *Kathakali* — the *Yakshagana* repertoire also revolves round the stories of the *Ramayana*, *Mahabharata* and the *Bhagavata Purana*. Krishna appears as an important character in the episodes relating to the abduction of Subhadra and in those relating to the war of the *Mahabharata*. The child Krishna and the adolescent Krishna in his *lilas* and *rasa* is not as popular as the Krishna of the *Mahabharata*. It is only in the preliminaries that Krishna appears as a Bala-Gopala.

Like the *Kathakali*, the *Yakshagana* is spectacular for its costuming, jewellery, make-up and an endless variety of large head-dresses. Each type of character has its distinctive garb. The characters thus become larger than life, as in *Kathakali*, and the entire presentation is full of swift dramatic action. All the region of Karnataka looks forward to the *Yakshagana* months which last from November till May. Practically every night drums beat and the sound of the singer calls young and old to participate. Like the *Krishnattam*, *Kathakali* and the *sattra* dances of Assam, *Yakshagana* is also performed by an all-male cast.

Closely related to the *Yakshagana* of Karnataka is yet another form recognised today

as the *Bhagavata Mela* and *Kuchipudi* of Andhra. Only in the case of the solitary character of the man-lion incarnation of Vishnu called Narasinha are faces painted and masks used. However, the drama is as potent. What attracts the Andhra actor is the episode of Krishna, Rukmini and Satyabhama. This story is the theme of two famous plays performed not only in Andhra but also in Tamil Nadu, Orissa, Assam and Bengal. They are known popularly as either *Satyabhama* or *Krishna Parijata* (bringing of the flower called *parijata*).

Here Krishna gives the flower of the heavenly wish tree, *parijata*, to his queen Rukmini. (See Narrative p. 79). By doing so, he naturally arouses the jealousy of his other consort Satyabhama. To please her, Krishna undertakes a journey not merely to obtain a flower or branch, but the entire tree. He travels to the celestial region (*Vaikuntha*) the paradise of the Gods, where he asks his old adversary Indra, who is now the tree's custodian, for a branch. Indra will have none of this and turns Krishna away, refusing to part with a branch of the tree. Does he not remember that it was the same Krishna who had lifted Mount Govardhana against the rage of Indra? Krishna, undaunted, goes to the tree, attacks its guardians and tears it away. He then returns to Dvarka and plants the tree in Satyabhama's palace. An all-male cast enacts the roles of Krishna, Rukmini and Satyabhama. It is the test of mature male actors and the ultimate challenge of histrionics to depict the role of Satyabhama. The scene opens with Satyabhama displaying

196. Dancing Apsara. *(Stone sculpture, Belur 12th century)*

197. Musician and Dancer. *(Stone sculpture, Orissa 11th century)*

her colourful plait and asking Krishna for the flower. The story moves swiftly with the appearance of Rukmini, Narada and other characters. The present form of the Andhra *Kuchipudi* dance drama revolving round this theme was the creation of great Telugu poets and especially one Kanarese Vaishnava Saint poet called Nara Hari Tirtha. He, like Shankaradeva from Assam, was deeply influenced by the *Bhagavata Purana* and the *Gita Govinda*. To him Satyabhama is the counterpart of Radha and therefore the love of Radha and Krishna is replaced by the love of Satyabhama and Krishna. On the mystical plane it is once again the depiction of the embodiment of love of the human for the divine and the divine for the human. Krishna is incomplete without Radha or Satyabhama as are Raddha and Satyabhama without Krishna. On one level it is the call of the individual soul for the supreme. Thus Satyabhama and Radha personify the *jivatma* (the individual soul) and Lord Krishna *paramatma* (Universal soul). The individual soul (*jivatma*) faces disillusion (*maya*) unless it overcomes the hurdles of ego, pride and conceit. In turn the Lord himself gets entangled with the very forms he creates, the *lilas* of his own being. The dialectic of the two is the communication between the individual ego and the involvement of the God with the illusions of his own creations. The two unite only when Satyabahama and Radha transcend their egos and Lord Krishna can see beyond the *lila* of his own creation. It is not without significance that in both the *Gita Govinda* and the Satyabhama theme, the poet and the actor, the musician and the dancer have to establish that all external trappings of the limited ego symbolised by dress, costume, and ornaments have to

be shed before the soul can merge with the divine. Once united, the two return to their respective worlds.

Although this symbolism is not as explicit in the Satyabhama theme as it is in the *Gita Govinda*, the dialogue between Krishna and Satyabhama on the stage, like that between Radha and Krishna, can become one of the most humanly moving and spiritually uplifting theatrical experiences. In Andhra, the Satyabhama theme can be performed by a single actor or as a full length dance-drama. One could recount the innumerable interpretations of this theme in other dance and dance drama and musical forms in India in the classical solo forms called *bharata natyam* from Tamil Nadu, *orissi* from Orissa and *kathak* from northern India. In these the performers are more often women although they can also be men. Now it is invariably the solo-artist who portrays the theme of the beloved, symbolising the individual soul (*jivatma*) and Krishna the lover, symbolising the Eternal (*paramatma*). The dance moves on many levels concurrently from the varied moods of the different types of heroines and the moments of expectant desire, jealousy, anger, despair, anguish and union, to the depiction of different seasons. Together they are the symbol of the eternal yearning of the individual soul and its journey to God. The poetry of the medieval saint poets whether of the South or the North or the East or West written in Tamil, Telugu, Kannada, Hindi, Oriya or Bengali is the base. The poetic line is set to a melody (*raga*) and metrical cycle (*tala*). The verbal imagery is then interpreted through movements and gestures and mime in endless permutations and combinations depending upon the creative genius of the performer. Great dancers have kept large audiences spellbound, by the presentation of a single verse or line. The dancer's ability to improvise and present variations is the test of both artistic skill and emotional and spiritual involvement. Other lyrics revolving around the child Krishna have inspired dancers to present memorable performances. The episode of the child Krishna eating mud and being reprimanded by Yashoda has been danced by one of India's greatest dancers, Smt. T. Balasaraswati, for over four decades and each time it is the cosmos which is recreated through her mime, and the audience transported to a mystical state wherein they become oblivious of time. Other great dancers have chosen verses from the *Gita Govinda* or Sur Das, Vidyapati or the Alvars and have transformed the stage into the universal Vrindavana of Krishna. The sacred and the profane, the romantic and the mystical, the poetic and the pictorial, the aural and the visual, the movement and the stillness of love in separation and in union all come together in these performances of Krishna, the blue God, and Radha, the yellow heroine. The earth and the sky unite, the clouds pour rain through the sound of music, ankle bells and speaking hands recreate the vision of the blue God eternal and ever new.

183

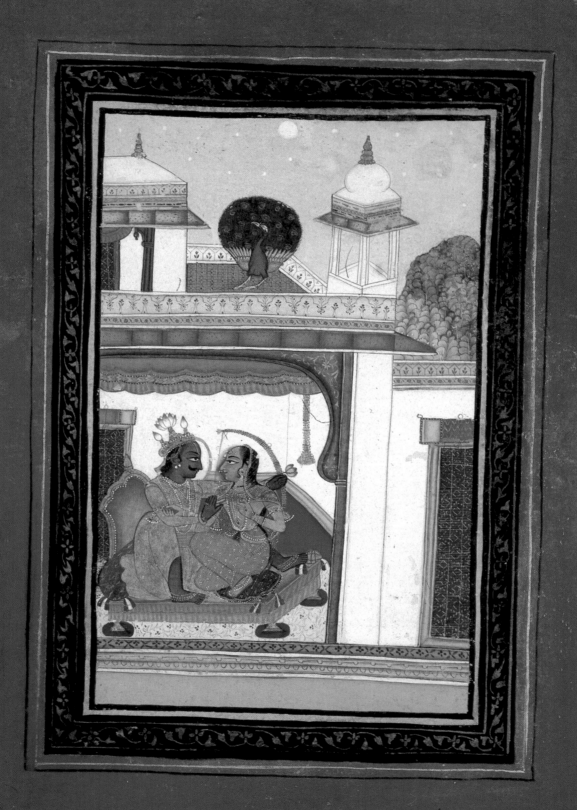

Krishna in Poetry

by Prof. B.N. Goswamy and Prof. A.L. Dallapiccola

198. Vibhasa Ragini. *(Miniature, Bundi Kota 1766-70, by Dalu, 255×360 mm with borders, Galerie Marco Polo, Paris.)*

A Sanskrit poet, disciple of Chaitanya (1485-1534), describes his approach to Krishna, 'If you are looking for him, you may first hear from a distance the notes of a flute wafting gently in the air. If you go towards them, you will find yourself in a thick grove, fragrant with the smell of jasmine and *kunda* and *maulashri* and other flowers. Then, in the heart of that grove, somewhat hidden, you might discern a glow, like that of the crescent moon; come closer, and you may see a cloud of blue. Then, you will recognize him and, if your heart is pure, perhaps even touch him.'

There is, in this passage, something of the essence of Krishna as he appears in Indian poetry. There is the process of *anavarna*, of gradual unveiling, and slow recognition; and there is a gathering of all the senses, of hearing, of smell, of sight, of touch, towards one point.

Speaking of Krishna, the Indian poet draws upon a wealth of myths, situations, incidents etc. which form a part of the common background of the cultural heritage and tradition of the subcontinent. Regardless of place in time and space, and regardless of the language he employs, be it Bengali or Tamil, the poet is perfectly aware that he can freely play with puns and allusions, hint at situations which will be immediately grasped by his audience and duly understood and appreciated; he is also aware that some of the words or poetic elements he is working with are charged with emotions and associations which will set his audience in the right mood for participating and enjoying the unique *rasa* experience, i.e. 'aesthetic enjoyment' which derives from the pleasure of 'tasting' aesthetic delight.

If one were to look at the above passage in some detail, one could detect many an element which will contain more meaning to an Indian audience than to the casual reader from the western world. So, for instance, when the poet speaks of the notes of the flute wafting gently in the air, the Indian listener will immediately think of Krishna perhaps as Muralimanohar, the 'handsome one with the flute', or as Venugopala, the 'handsome cowherd with the flute'. And to him the air in which these melodious tones resound will be the magic air of the fragrant groves of Vrindavana, the summons on the flute will recall to his mind the episode of the Divine Lover, calling the *gopis* to him to enjoy the raptures of the *rasa*-dance under the autumn moon. The flowers will again conjure in the mind of the listener the vision of the blessed country around Vraja, and will slowly and almost imperceptibly set the atmosphere of a love-tryst. It is the *gopis* who meet their Lover, and it is the individual soul who meets the Lover. It is a hide-and-seek in this superb grove, perhaps again an allusion to the difficult path to God, when the poets speak of the gradual unveiling, of the gradual emerging of the form of Krishna glowing like a moon crescent and enveloped in a cloud of blue. And at the end, the listener will himself become one of the *gopis*, swept away by the

sentiments of love and self-surrender which the words of the poet have created in him.

The epic poems, the immensely rich *puranic* literature provide endless subject matter for every branch of the arts: visual, dramatic or literary. From this material some episodes will be rendered again and again throughout India, with certain regional differences whereby particular episodes may be given special attention. In spite of the variety of languages, one cannot help feeling a unity in the diversity, and the poets are ever capable of amazing the reader with their freshness of inspiration and depth of feeling.

The richness of this poetry is not easy to describe, nor is its great variety. A great deal of it is in Sanskrit and partakes of that language's best-known characteristics: delight in simile and metaphor, sensitivity to mood, multiplicity of levels in meaning, resonance of sound. But most of it, that which is sung and recited throughout the land with great joy, is in regional languages, the vernaculars as they are called, ranging from Hindi to Bengali, from Gujarati to Marathi and Rajasthani. This poetry draws upon Sanskrit and is aware of its conventions, but is generally more direct, more spontaneous and less formal, possessed of a greater intimacy of tone. Very little of it is narrative in form, for the story of Krishna, by the time of the rise of the vernaculars, was taken for granted: the emphasis in these is on taking episodes and bringing out the flavour inherent in them, or on developing a 'relationship' with Krishna by speaking to him, by addressing him with words of love, of devotion, confidence or remonstrance, even frivolity. A lightness of touch belongs to this poetry, but also a great closeness of feeling. For without this closeness of feeling, the poet seems to say, how does one caress or complain, joke or extract promises?

The Indian mind inclines easily towards poetry: it is in poetry that the best thought of India, like its feeling, is contained. In the context of Krishna, in addition, poetry attains an ardour, a warmth, that would take the unprepared reader completely by surprise. The terseness of some of the poems, the expansive, syllable-rich nature of some others, are all designed to heighten specific feeling, the emotion of *bhakti*, self-surrender, ardent devotion. But *bhakti* is not of one kind alone, not only that of the devotee who sees himself as a servant of the Lord. Bhakti, as the *Bhagavata Purana* defines it, is of nine kinds, involving different attitudes. A more popular, simpler approach sees *bhakti* as being essentially of four kinds of *bhavas*, feelings or attitudes (1). Thus, the devotee can approach the Lord as a parent would a child and delight in him (*vatsalya*); see him as a lover (*madhurya*); hold him dear as a friend (*sakhya*); or regard him as a master and himself his slave (*dasya*). No formal choices are necessary; the same devotee-poet could at one time sing of Krishna while seeing him through the eyes of Nanda or Yashoda, his parents, and at another address him as a friend. In the final analysis, the con-

sciousness of Krishna being the Lord never left the devotee, but he was able so vividly to see himself in the role of a parent or friend or beloved that the identification seemed complete.

There are preferences that one notices in the work of the poet-devotees: one of them inclines far more towards *madhurya* than *vatsalya*; another might not even have the courage to regard Krishna as anything but his liege Lord. This range of approaches fills the poetry of Krishna with a peculiar flavour, as if all the *rasas* (flavours, moods) belonged to his world. In addition to the fact that the poet-devotees had varying approaches towards Krishna, they developed their own poetic strategies. One naturally has to master the story of Krishna before any of this poetry makes sense.

THE POETS

Andal - 9th century

Tradition reports that Andal, also called Goda, was found under a *tulsi* tree by the great poet-saint Periyalvar. She was adopted by him and raised as his daughter. Originally she was not included in the group of the *Alvars*, the poet-saints of Vaishnava inspiration, but in the course of time her name found a place among those of the *Alvars*. The range of her poetic inspiration, though somewhat limited, impresses the reader by the intensity of devotion, depth of feeling and ardour of the poetess's love for Krishna. Her tone has a penetrating sweetness and charm as well as an unusual sensuousness. Her passion for Krishna, described very frankly, is the very earthy and voluptuous passion of a woman for a man. Despite this, there is a lightness of touch, a feminine delicacy in the treatment of the theme, that earned Andal a place apart among the Tamil poets.

Andal, who is the only woman among the *Alvars*, refused to marry any mortal, having chosen as her husband the God of Shrirangam, Lord Ranganatha. The legend says that she imagined herself to be Krishna's bride and that finally Lord Ranganatha accepted her as his spouse. She is said to have suddenly vanished in front of the holy image at Shrirangam.

She left only two works: the *Tiruppavai* consisting of 30 stanzas, and the longer *Naycciyartirumoli* of 143 stanzas. In both these poems Krishna and Andal are the main characters. The *Tiruppavai* describes a religious rite practiced by the unmarried girls of the cowherd-caste: after having fasted throughout the night, they go early in the morning in the month of *Markali* (corresponding to December/January) to bathe in the river and to practise certain rites in order to earn a suitable husband, and to ensure plenty of rain for their country.

Andal sees herself as one of the *gopis*, who, accompanied by other girls, goes around the village, knocking at the doors of the sleeping *gopis* to wake them up, and summon them

for the ritual bath. Finally all of them reach the house of Krishna's foster father. There the door is opened by the wife of Krishna, Nappinnai. Andal then demands that Krishna help her friends in the rites, for he is not only the husband that they require and the god they are honouring with their prayers and rites, but their companion and playmate as well. She asks Krishna to accept their services, as they wish to be his slaves, while Nappinnai remains his wife. She bids him: 'Send us not away without accepting our services, and deliver us from other desires!'

In the *Naycciyartirumoli* the poetess narrates a dream she had of her marriage with Krishna. The most famous section of this remarkable poem is the 'Dream-Hymn' in the sixth *tirumoli* known as 'One thousand elephants' from the first words of the hymn. This has achieved such great popularity that it is sung at every Vaishnava wedding in Tamilnadu. There are other beautiful poems such as the section in which the poetess sees herself as a little girl, whose doll's house has been destroyed by the mischievous Krishna, or the exquisite poem addressed to the white conch. And indeed 'everything left by Andal shows a rare sense of word-values, a trembling sensitiveness to beauty and a deep single-hearted passion' (2).

Bilvamangala - 11th century

There exists little information on the life of this poet, known also as Lilashuka. The scanty references to his career which can be gleaned from the vague and scattered hints in his poems are not sufficient to draw any kind of sound conclusion. In spite of the vagueness enshrouding the poet's life, his works were very popular. The *Bilvamangalastava* and the *Karnamrita* are two collections of Sanskrit hymns in praise of Krishna, which were known to the famous disciple of Chaitanya, Rupa Gosvamin. He quotes extensively from them in his works on *bhakti*, works composed in the 16th century. Today the *Karnamrita* is widely known. There are two widely different recensions, the one popular in Bengal, and the other in southern India. 'Thus, there are two long, well established traditions of the *Karnamrita*. It is known throughout as the *Karnamrita* or the *Krishnakarnamrita*' (3).

There is, however, a great confusion with regard to the *Bilvamangalastava* quoted, as stated before by Rupa Gosvamin. There are various manuscripts and two printed editions, known under many names such as: *Balagopalastuti, Krishnabalacharitra, Krishnabalakrida* etc. containing various hymns in praise of Krishna, and all attributed to a single poet known as Bilvamangala or Lilashuka, or Lilashuka Bilvamangala. At any rate it seems that Bilvamangala was probably a southern Indian, and it is from southern India that Chaitanya brought the *Krishnakarnamrita* to Bengal.

The poems selected here come from the *Krishnakarnamrita*, an anthology of 110 stanzas, terse in form and rich in suggestion.

Jayadeva - 12th century

'The last great name in Sanskrit poetry' attained great fame with his *Gita Govinda* which 'surpasses in its completeness of effect any other Indian poem'. The *Gita Govinda* skilfully weaves song and recitation together, becoming a small pastoral drama in which the intensity of the love of Radha and Krishna comes alive, with all its nuances of longing and passion, union and separation. The name of the poet hints at his very deep spiritual involvement with his most revered and adored God. It is in the second song of the *Gita Govinda* that Jayadeva invokes Krishna in these words: '*Jaya, jayadeva hare*' which can be translated thus: 'Triumph, God of Triumph, O Hari.' The name of the poet, thus becoming an epithet of Krishna, gains a new dimension, a dimension of sacredness and sanctity. In such a way the listener or the reader is always aware of the special bond connecting the poet with his chosen God as the name is repeated in the final verse, the so-called 'signature' verse of each song.

A great deal of legend has crept into the life account of Jayadeva. It is said that he was born to a Brahmin family, that in the course of time he became a very accomplished Sanskrit scholar, that at a relatively young age he left the life of a scholar for that of a wandering mendicant devoted to God alone. But this ascetic life came soon to an end. A Brahmin of Puri insisted on giving his daughter Padmavati to Jayadeva as a wife. The Brahmin was compelled to do so by order of Lord Jagannath himself. Padmavati was dedicated as a temple dancer to the Jagannath temple of Puri and Jayadeva thus shared her devotion to Jagannath.

There are various local variants of the story which evolved in the course of time. The place of birth of the poet is also a matter of controversy. Bengal, Orissa and Mithila contend for the honour of having been the birth place of Jayadeva: Bengal seems the most probable place of his origin. Though this is still a matter of controversy and speculation, there is ample documentary evidence that Jayadeva worked in eastern India during the second half of the 12th century. He was at that time the court poet of King Lakshmanasena of Bengal, who styled himself as 'highest Vaishnava', *paramavaishnava*. There is no doubt, that the *Gita Govinda* would have found an adequate reception there, even if it was not actually composed in the cultivated and poetry-loving courtly milieu.

The legends based on the character of Jayadeva have no historical value, though they tell us some very relevant things: in the course of his wanderings the poet visited Puri, came in the sphere of influence of the Jagannath cult and had a relationship with Padmavati. It is possible that the whole account of his marriage with the dancing girl is a veiled allusion to his being initiated into the Shrivaishnava cult established in Puri under the influence of Ramanuja.

By the 15th century the *Gita Govinda* had attained such a wide popularity in Puri, that it became part of the ritual of the Jagannath temple. In this context, it may be of interest to note that an inscription on the left side of the Jayavijaya doorway, in Oriya language and dated A.D. 1499, prescribes the performance of the poem in the temple.

In the early 16th century Chaitanya made a pilgrimage to Puri. It is recorded in his spiritual biography, the *Chaitanya-charitamrita* by Krishnadasa Kaviraja, that Chaitanya loved to listen to the recitation of the *Gita Govinda*, as well as to the poems of Chandidasa and of Vidyapati. It is his predilection for the *Gita Govinda* that led to its canonization among the followers of the Vaishnava-Sahajiya tradition. As noted before, the Vaishnava Sahajiya school claims Jayadeva not only as a member, but as 'original preceptor' — *adiguru* — of its cult. Whether Jayadeva was actually a member of the Sahajiyas is not known, but his songs are sung nightly during the worship of Jagannath. This tradition has been upheld for more than 700 years.

In the 13th century the *Gita Govinda* was known in western India; it is possible that it was brought to Gujarat by pilgrims coming from some Vaishnava centre in eastern India. In the 15th century it came to Nepal, and by the 16th century it was universally praised and recognized all over northern India for the intensity of its religious expression and poetic feeling.

Namadeva - 1270?-1350?

One of the most important of the poet-saints of Maharashtra, author of many simple and passionate lyrics in honour of the god of Pandharpur, Shri Vithoba, the name under which Vishnu-Krishna is worshipped in Maharashtra, was born at Pandharpur. He was the son of a low-caste tailor, and was brought up in his father's trade. In his youth he appears to have been a somewhat unsavoury character, but suddenly his mind turned to religion. Some say that this dramatic turnabout was due to his contact with the saint Jnanadeva, the author of the famous *Jnaneshvari* (1290) a landmark in the cultural history of Maharashtra. The *Jnaneshvari* is a free rendering, in Marathi, of the *Bhagavadgita* and this was the first time that a sacred text was translated and interpreted in the 'language of the people', as opposed to the 'language of the learned', the Sanskrit. It is thus that Marathi-speaking people, regardless of their status, could have access to religious texts and profit from listening to the words of the saints and philosophers. In the wake of this renewal, and of this social upheaval, Namadeva started to compose his passionate poems in Marathi, immediately capturing the minds of the devotees.

A *corpus* of some thousands *abhangas* (lit: 'the unbreakable one', the name of the metre), devotional lyrics, composed by him has come down to us. A critical study of these lyrics shows the developing personality

of Namadeva. At first his approach to the deity is purely emotional. Vithoba is the only object of his devotion; he cannot stay away from the sacred precincts of the Pandharpur temple. Then, a more reflected and calm view of things creeps into his poetical strain. Vithoba gradually becomes for Namadeva the symbol of the all-pervading, the supreme universal soul.

The main source of inspiration for his poetry was *bhakti*, self-surrender to the chosen divinity. At the same time he used his poetic talents as a means of expressing his social thoughts, his critical approach to the established authorities and his awareness of the social plagues affecting the times he was living in.

His very direct and simple style of writing had a great impact on the minds of the people, so much so that some of his followers composed poems of their own on devotional and other themes. All of them, with Jnanadeva as spiritual leader, and Namadeva as their doyen have produced a literature which is the backbone of the cultural and spiritual development of Maharashtra.

Vidyapati - 1352?-1448?

There is some uncertainty regarding the year of his birth, but generally he is thought of as having been born in 1352 to a Brahmin family of Mithila. His father was attached to the court, but we do not know exactly in what capacity. Nothing is known of the early years of Vidyapati, but it is very probable that his life followed the usual pattern of young Brahmins: he must have learned Sanskrit, and mastered verse-making. His first commission came from the Maithili King Kirti Simha, who ruled from about 1370 to 1380. The result of this commission was an eulogy in praise of the King, the *Kirtilata*, or 'Creeper of Glory'. The patronage was, however, not extended, and it is only under Kirti Simha's son that Vidyapati started his life as a courtier, an accepted and established scholar. At this time he wrote a work of fiction, the *Bhuparikrama*, or 'Around the World'. But what interested him more than anything else was poetry. It was through his friendship with the heir apparent, Shiva Simha, that Vidyapati had the opportunity of composing more than five hundred love songs in Maithili. This was something new in Indian literature. Not only were these songs different from the usual formal poems, but they were in sharp contrast with the standard poetic convention, being written not in Sanskrit but in the language of the common people, Maithili. These highly inspired poems were composed between c. 1380 and 1406. They were understood and appreciated by the learned and the villager alike. At once highly erotic and devotional, these songs swept the whole of eastern India, and are said to have been adopted as Vaishnava hymns by Chaitanya himself.

There is a freshness, a deep psychological insight and a warmth of feeling in them that makes them timeless.

Chandidasa - 14th/15th centuries

Since the 15th century, this poet's love poems have been a source of inspiration in the development of Bengali literature. He is thought to have lived between the end of the 14th century and the first half of the 15th. However, his dates are a topic of constant speculation. No official sources exist from which to reconstruct the events of his life; all the available information is contained in songs, ballads and legends. Despite this lack of reliable sources, three elements appear repeatedly in accounts of his life: his connection with the Sahajiya movement, his career as a village priest, and his relationship to Rami, a low caste washerwoman.

Apparently Chandidasa inherited from his father the priesthood of the temple of the Devi; his predisposition to wild, ecstatic states and bursts of spontaneous poetry earned him the nickname of 'mad'. In his love relationship with Rami (or Tara) he centred all his devotion upon her, raising her to the status of the Mother Goddess herself, like the Vaishnava Sahajiya poets who raised love to the level of absolute reality in the worship of God, and relied on the natural propensities of man — including all his sexual instincts — to lead him on the true path. He sang passionately of love of all kinds, including that of Radha for Krishna, with a strange, deeply moving intensity. His poetry was a great source of inspiration for Chaitanya: the songs, composed for an audience rather than for a reading public, had an enormous and immediate impact on the listeners, and were very popular in the *kirtan* gatherings of the past as they are widely acclaimed nowadays. The mood reflected in the songs reveals the spirit of *bhakti*.

It should be noted here that in addition to the paucity of information, the research work on Chandidasa has been made more difficult by the tendency of some of his followers during the subsequent centuries to assume his name and imitate his style and themes; some, however, added a prefix to the name Chandidasa, so that we have an Adi Chandidasa (the 'first' Chandidasa); or a Badu (the 'great') Chandidasa or a Dvija ('twice born') Chandidasa, both of them surely Brahmins if one can judge from the names. There was, for instance also a Din Chandidasa (a 'poor' Chandidasa). There were also some poets who just signed Chandidasa with no other name or prefix. Literary criticism and stylistic evidence attribute some two hundred poems to the original Chandidasa.

Govindadasa - 16th century

Also known as Govindadasa Kaviraj, this 16th century poet composed in Braja boli, an artificial language akin to both Bengali and Maithili, but whose real origin is obscure.

Like Vidyapati, whom he emulated in many ways, Govindadasa is believed to have been born in the Mithila region. The conventions of his poetry are familiar, as are the themes he treats. There is, however, in his work a sensuous beauty, a sweetness that sets him

apart from many of the other followers of Vidyapati and Chandidasa. At his best he is able to conjure up, in very few words and through suggestion, a remarkably complete picture.

Sur Das (Suradasa) - 1478?-1563?

One of the most celebrated of all Hindi poets. He composed his poems in Braja bhasha, the much loved form of western Hindi spoken in the district around Mathura. Sur Das is rated even higher than the famous Tulsi Das (1532-1623) in a popular estimation. No authentic details regarding his life are available. Blind from birth, he was reputedly the son of a Brahmin singer and a disciple of Vallabha. He is said to have been initiated into the Vallabha *sampradaya* at the age of thirty-two by Vallabha himself. Even in his own lifetime he was regarded as among the greatest of the singer-poets of India, and had a following at the Imperial Court of the Mughals. He wrote several works — only a few of which have survived — among them the justly famous *Sur sagar* (or 'Ocean of Sur'), a series of lyrics dealing with the Krishna theme and the *Suravali* which is a collection of devotional lyrics. He composed a Hindi version of the story of Nala and Damayanti, as well as a translation of the *Bhagavata Purana*. It has been often said that the 'devotional literature of Rama worship is to a large extent epic in character and reached perfection in the work of Tulsi Das, and the literature of Krishna is lyric and saw its perfection in Sur Das' (4).

Mira Bai - 1498-1546?

Poetess and mystic, regarded as the foremost woman devotee of Krishna. As in the case of other poets and saints, there is no certainty about the details of her life, and a number of legends have been woven around her person. She was apparently a Rajput princess who was given in marriage to the Rana of Udaipur, thus becoming the queen of the proudest state of Rajasthan. However, she had already surrendered herself in her young years to Krishna, and refused to accomplish her wifely duties, thus incurring the wrath of her husband and his family. The displeasure of her relatives increased when she became the disciple of the low-caste saint, Raidas. There are various accounts of attempts made upon her life, but through divine intervention she was saved each time. She composed and sung songs in praise of Krishna incessantly, and is said to have spent her days and nights in front of the image of her beloved deity in his form as Giridhari (supporter of the mount Govardhana). She spent her last days in Vrindavana steeped in the worship of Krishna, and tradition has it that the icon she was worshipping came to life and ordered her to follow; then, a fissure opened in the earth and the deity, accompanied by the poetess, disappeared into it.

Her songs and lyrics were composed in Braja bhasha, and are expressed in a very simple, straightforward style, full of feeling and of touching beauty. These are still recited all

over the country as her *bhajans* (devotional songs). In them she speaks of herself as Krishna's wife. Her impact is still very strongly felt in Rajasthan and Gujarat.

Nandadas - 1533-1583

One of the celebrated *ashtachhapa* poets, or eight great devotional poets, held in specially high esteem in the Vallabhachari *sampradaya*. Little can be said about his life. Even the information we can gather from the *Bhakta Mala*, or Garland of Devotees, a work by Nabhadas in verse form which describes the lives of Vaishnava devotees up to the 17th century, is somewhat difficult to interpret. From his work, however, one can collect some references regarding his religious life: he was a fervent follower of the Vallabha *sampradaya*, was bound by deep devotion to Vitthalnath and to his son Giridhar, and apparently delighted in dwelling in Vrindavana and in the sacred Krishnaite sites. There is a tradition according to which Nandadas began his religious career as a devotee of Rama, and only later in life turned his attention to Krishna. This, however, is matter of speculation.

Some 30 works have been attributed to him. By far the most important of them are: the *Rasapanchadhyayi* 'The Round Dance of Krishna' (5) and the *Bhramaragita*, 'The Song of the Bee'. Both of these are drawn from the *Bhagavata Purana*. The *Rasapanchadhyayi* describes the individual soul's love and longing for God and God's love and grace. This is symbolised in Nandadas's poem by the nightly meetings of Krishna and the *gopis* on the banks of the Jumna. The poet strives to depict the ineffable delight he experiences in being a Krishna-devotee. The *Bhramaragita* is the dialogue between Uddhava, Krishna's friend and emissary, and the *gopis* after Krishna's decision not to visit Vraja again. In it the importance of *bhakti* is stressed, and it 'helps us to grasp the cultural importance of *bhakti*, a credo at once simple and sufficient, which offers an essential spiritual independence, should the *bhakta* wish to accept it, from the dogmas and conventions of orthodox society' (6).

Keshava Dasa - 1555-1617

Native of Bundelkhand in today's Madhya Pradesh, he became a poet at the court of the Bundela rulers of Orchha one of which was Birsingh Deo, in whose honour he also composed a eulogy. It is said that the royal courtesan of Orchha, Rai Parvina, was among his pupils, and she figures prominently in his poetry. The theme of his most famous work, the *Rasikpriya*, is erotic art. In this he describes, using traditional rhetoric, the types of 'heroes' and 'heroines', the *nayakas* and the *nayikas*, in different love situations. It is almost always Krishna who is the 'hero', the *nayaka* of his poetry, and Radha who is the *nayika*. There is great relish and a genuine sensitivity of feeling in his work. He is the author of another notable work, the *Kavipriya*, a treatise on poetics.

Ekanatha (Eknath) - 1533-1599

One of the most reputed of the poet-saints of Maharashtra, Eknath was born at Paithan on the Godavari. He was the grandson of the Saint Bhanudas, who is reputed to have brought back the idol of Shri Vitthal from Vijayanagar to Pandharpur, the centre of the Bhagavata cult in Maharashtra.

Eknath lost both his parents at a very young age, and was brought up in the household of his paternal grandfather. He lived a simple and saintly life, devoting himself to learning and commenting on philosophical works. One of his great achievements is the commentary and a sort of 'critical' edition of the famous *Jnaneshvari* of Jnanadeva, which had become thoroughly corrupted since the days of its composition. Another great work is his commentary on the eleventh book of the *Bhagavata Purana*, and besides this he composed several minor works as well as *abhangas* (hymns), which gave expression to his mystical feelings and experiences.

The aim of his writing is to bring salvation within the reach of the uneducated, outcastes, *shudras* and women. He used to say that the message of religion was sacred whether enshrined in Sanskrit or Marathi. As a consequence of this attitude, and of his extreme tolerance compared with the caste and sectarian prejudices of his day, he suffered great persecution by the Brahmins.

Tukaram - 1607-1649

Born at Dehu, a village near Pune, Tukaram was the son of a grocer. He became a devotee of Shri Vitthoba of Pandharpur and neglected his domestic duties. He was married twice: his first wife died of starvation during a ravaging famine, and his second wife made his life very miserable. Being unsuccessful both in domestic and business life, he took to the life of a wandering mendicant. Throughout his life he suffered persecution at the hands of the Brahmins. He is reported to have received his mystic initiation from a saint in a dream. Most of his hymns, his *abhangas*, are in praise of Krishna. There are many miraculous deeds which are said to have happened in Tukaram's life, but it is essentially as a result of his inspired, clear and simple devotion to Krishna that he became famous and attracted masses of devotees. He is said to have been a great favourite of Shivaji, though he never accepted invitations to visit his court. Tradition says that when he felt that the end of his life was approaching, he walked into the river and drowned himself.

Even today pilgrims going to Pandharpur sing Tukaram's compositions.

Bihari Lal - 1595-1663

Bihari Lal Chaube was born at Govindpur near Gwalior. He spent his early years at Orchha, where his father was living. Later his family moved to Mathura. It was there, on the occasion of a visit by the Mughal Emperor Shah Johan, that Bihari Lal had the opportunity to display his talents. He was in-

vited to the Mughal Court at Agra and lived there for some time. There he met the ruler of Amber, Jai Singh I (1625-1667 reg.) who was most impressed by his poetic talents, and who invited him to his court at Amber (Jaipur).

Tradition tells us that Jai Singh, who was a very powerful monarch, had a newly-wed young wife. Completely taken by her charms, the ruler had disappeared from public view and was neglecting state affairs. This situation was a source of concern and displeasure for his chief-queen and for the courtiers, and it was decided that Bihari Lal should compose a verse in order to recall the ruler to his official duties. The verse was concealed in a garland of flowers which was to be delivered with the other flowers to the harem. This stratagem worked wonders. The verse had such a powerful effect on Jai Singh that he immediately returned to his stately duties and rewarded the poet for his wit and talent, promising him adequate remuneration for each series of verses he composed. Thus, in the course of time, the *Sat Sai* 'Seven Hundred' (couplets) came into being. The themes of the poems are the love of Radha and Krishna, their estrangements, their reconciliations, the beauty of Radha, and handsomeness of Krishna and the comments of the friend or of the maid servants carrying the messages between the lovers.

THE POEMS

Making any kind of selection of poetry is difficult; it is even more so when it comes to the poetry of Krishna, for the material to choose from is truly vast. All that one can hope to do then, is to represent all of its flavours, however inadequately.

The selection of poems is arranged in four different sections dealing respectively with the four *bhavas* or states of being: *vatsalya*, *madhurya*, *sakhya* and *dasya*.

VATSALYA

A state of being in which the worshipper considers Krishna as a child and himself a parent, as did Nanda and Yashoda.

With a cow's halter Yashoda firmly ties the butter
 thief to her wooden mortar
where he rubs his eyes with his hands and
 quietly cries. *(Bilvamangala)*

We honour the child glory, the younger brother
 of Balarama,
who eats mud at play as if thinking
"Earth, it's said, has more properties than any
 other element.
I'll eat it and become greater." *(Bilvamangala)*

Under the pretext of borrowing and returning pots
 and pans, women with tarrying gait
go again and again to Yashoda's house, not getting
 their fill of seeing the face of Krishna.
 (Bilvamangala) (7)

Yashoda puts Madana Gopala to sleep
And the Three Worlds tremble at the sight,
 even Shiva and Brahma are deceived.
His sleepy eyes,
 black beneath their drooping lids,
Are like a pair of bees, each trapped at dusk
 in the night-closing petals of a flower.

Breath ripples through his torso
 as waves through the churning Sea;
Brahma mourns his lotus-throne
 as the child's navel sinks with every breath.
Shyam runs a hand through his lovely locks,
 scattering them in disarray,
O Sur, as if the Serpent
 spread its thousand hoods above the Lord.

 (Sur Das)

He tries to come outside.
It's so easy now
 to crawl within the courtyard,
 but the doorstep stops him every time.
He trips and falls,
 can't get across;
 it's all such an enormous task.
Once he measured the Earth in a mere three steps;
 now he's stopped at the borders of
 his very own house.
And Balarama says to himself,
 "What an act he's putting on!"
(The infinite glories
 of the Lord of Surdas
 are a delight to his devotees.) *(Sur Das)*

Again and again, Yasoda coaxes:
"Come, Moon!
 Moon, my little one's calling you!
He's going to eat
 honey and fruit and nuts and sweets,
 and he might give you some too!
He'll play with you in his hand,
 and he won't even drop you once;
Just come down and live in this bowl of water
 I've got here in my hand..."
She set the bowl upon the ground,
 and took him and showed him the moon;
And Sur's Lord laughed
 and dipped his two hands
 again and again and again. *(Sur Das)*

In the jewel studded courtyard of Nanda
 the two Brothers are at play.
The White and the Black, such a pair they make! —
 Balarama and Kanhaiya.
Lovely locks dangling,
 yellow *bindu* on their brows,
The lion-claw necklace agleam on their breasts,
 lifting the sorrow of the saints;
And Yashoda and Rohini together,
 devoted mothers both,
Snapping their fingers to make them dance,
 thinking the children their sons.
The blue and yellow silks
 are pleasing to the eye;
Suraja sings the praises
 of the joy of children at play. *(Sur Das)*

Wake up, wake up, Gopal!
Child, you mustn't sleep so much;
 morning's the best part of the day!
All the little boys in the village
 come by to see you, and then leave,
Like a string of black bees, all waiting
 for a lotus-bud to bloom.
If you don't believe me, Sur's Lord,
 my little black Tamala tree,
Then just wake up
 and open your eyes
 and come and see for yourself! *(Sur Das)*

Then the child jumped out of bed:
"Mother, where are you?
 Why did you leave me alone?"
Nanda awoke, and Yashoda awoke,
 and they called him to their side.
"You were asleep, what woke you up?"
 they asked as they lit the lamp.
"In my dream, somebody pushed me
 and I plunged into the Yamuna-dah!"
Yashoda said to Sur's shyam:
 "Don't be afraid, my love." *(Sur Das)* (8)

MADHURYA

A state of being in which the worshipper considers Krishna as a lover, as it was with Radha and the *gopis*.

At midnight they hear a magic spell — the sweet
 melodious flute of the honourable Hari.
The cows break their bonds and the milkmaids banish
 their fear to follow the sound.

 (Bilvamangala)

"Come, Govinda, I shall give you some milk."
What woman would not thus lure the artless boy
 alone in the lane
and take him, skittish in the way of love's war,
 to her own home?

 (Bilvamangala)

Frail woman by force of eyes like fetters binds
 the great wayward elephant, Krishna,
who even in the mind is hard to hold
 as he wanders alone in a forest of Tamala trees
 on the banks of Kalindi river.

 (Bilvamangala)

He, who lifted Govardhana mountain in the
 divine play which protected Gokula,
becomes weak and trembling at the sight of
 the peaks which are the breasts of Radha.

 (Bilvamangala)

When my two eyes, O Lord, saw, all alarmed,
your celestial, fresh lotus face of natural beauty,
I joined my hands in prayer and whispered with a
 feeling of love.
"Heart, be so alarmed in my next birth too."

 (Bilvamangala)

Krishna's eyes are bright,
long, full, fluttering,
soft, and traced with red,
cool — all like a lotus petal. *(Bilvamangala)*

With his lotus hands Krishna places the conch shell
 at his lotus mouth
where, white like cow's milk and lotus roots, it
 seems to be a swan in the middle of three
 red lotus flowers. *(Bilvamangala)* (9)

GITA GOVINDA

Joyful Krishna

Yellow silk and wildflower garlands lie on dark
 sandaloiled skin.
Jewel earrings dangling in play ornament his
 smiling cheeks.
 Hari revels here as the crowd of charming girls
 Revels in seducing him to play.

One cowherdess with heavy breasts embraces
 Hari lovingly
And celebrates him in a melody of love.
 Hari revels here as the crowd of charming girls
 Revels in seducing him to play.

Another simple girl, lured by his wanton quivering look,
Meditates intently on the lotus face of Madhu's killer.
 Hari revels here as the crowd of charming girls
 Revels in seducing him to play.

A girl with curving hips, bending to whisper in his ear,
Cherishes her kiss on her lover's tingling cheek.
 Hari revels here as the crowd of charming girls
 Revels in seducing him to play.

Eager for the art of his love on the Jumna riverbank,
 a girl
Pulls his silk cloth toward a thicket of reeds with
 her hand.
 Hari revels here as the crowd of charming girls
 Revels in seducing him to play.

Hari praises a girl drunk from dancing in the rite
 of love,
With beating palms and ringing bangles echoing his
 flute's low tone.
 Hari revels here as the crowd of charming girls
 Revels in seducing him to play.

He hugs one, he kisses another, he caresses another
 dark beauty.
He stares at one's suggestive smiles, he mimics a
 willful girl.
 Hari revels here as the crowd of charming girls
 Revels in seducing him to play.

The wondrous mystery of Krishna's sexual play in
 Brindaban forest
Is Jayadeva's song. Let its celebration spread
 Krishna's favors!
 Hari revels here as the crowd of charming girls
 Revels in seducing him to play.

When he quickens all things
To create bliss in the world
His soft black sinuous lotus limbs
Begin the festival of love
And beautiful cowherd girls wildly
Wind him in their bodies.
Friend, in spring young Hari plays
Like erotic mood incarnate.

Winds from sandalwood mountains
Blow now toward Himalayan peaks,
Longing to plunge in the snows
After weeks of writhing
In the hot bellies of ground snakes.
Melodious voices of cuckoos
Raise their joyful sound
When they spy the buds
On tips of smooth mango branches.

Lotus-eyed Krishna Longing for Love

I'll stay here, you go to Radha!
Appease her with my words and bring her to me!"
Commanded by Madhu's foe, her friend
Went to repeat his words to Radha.

Sandalwood mountain winds blow,
Spreading passion.
Flowers bloom in profusion,
Tearing deserted lovers' hearts.
 Wildflower-garlanded Krishna
 Suffers in your desertion, friend.

Cool moon rays scorch him,
Threatening death.
Love's arrow falls
And he laments his weakness.
 Wildflower-garlanded Krishna
 Suffers in your desertion, friend.

Bees swarm, buzzing sounds of love,
Making him cover his ears.
Your neglect affects his heart,
Inflicting pain night after night.
 Wildflower-garlanded Krishna
 Suffers in your desertion, friend.

He dwells in dense forest wilds,
Rejecting his luxurious house.
He tosses on his bed of earth,
Frantically calling your name.
 Wildflower-garlanded Krishna
 Suffers in your desertion, friend.

Poet Jayadeva sings
To describe Krishna's desolation.
When your heart feels his strong desire,
Hari will rise to favor you.
 Wildflower-garlanded Krishna
 Suffers in your desertion, friend.

Abashed Krishna

After struggling through the night,
She seemed wasted by the arrows of love.
She denounced her lover bitterly
As he bowed before her, pleading forgiveness.

Bloodshot from a sleepless night of passion,
 listless now,
Your eyes express the mood of awakened love.
 Damn you, Madhava! Go! Keshava, leave me!
 Don't plead your lies with me!
 Go after her, Krishna!
 She will ease your despair.

Dark from kissing her kohl-blackened eyes,
At dawn your lips match your body's color, Krishna.
 Damn you, Madhava! Go! Keshava, leave me!
 Don't plead your lies with me!
 Go after her, Krishna!
 She will ease your despair.

Etched with scratches of sharp nails in the battle of love,
Your body tells the triumph of passion in gold writing
 on sapphire.

Damn you, Madhava! Go! Keshava, leave me!
Don't plead your lies with me!
Go after her, Krishna!
She will ease your despair.

Drops of red lac from her lotus feet wet your sublime
breast.
They force buds from the tree of love to bloom on
your skin.
 Damn you, Madhava! Go! Keshava, leave me!
 Don't plead your lies with me!
 Go after her, Krishna!
 She will ease your despair.

The teethmark she left on your lip creates anguish
in my heart.
Why does it evoke the union of your body with mine
now?
 Damn you, Madhava! Go! Keshava, leave me!
 Don't plead your lies with me!
 Go after her, Krishna!
 She will ease your despair.

Dark Krishna, your heart must be baser black than
your skin.
How can you deceive a faithful creature tortured by
fevers of Love?
 Damn you, Madhava! Go! Keshava, leave me!
 Don't plead your lies with me!
 Go after her, Krishna!
 She will ease your despair.

Why am I shocked that you roam in the woods
to consume weak girls?
The fate of Putana shows your cruel childhood bent
for killing women.
 Damn you, Madhava! Go! Keshava, leave me!
 Don't plead your lies with me!
 Go after her, Krishna!
 She will ease your despair.

Jayadeva sings the lament of a jealous girl deceived
by passion.
Listen, sages! Heaven rarely yields such sweet elixir.
 Damn you, Madhava! Go! Keshava, leave me!
 Don't plead your lies with me!
 Go after her, Krishna!
 She will ease your despair.

The red stains her lac-painted feet
Lovingly left on your heart
Look to me like fiery passion
Exposing itself on your skin.
Cheat, the image I have of you now
Flaunting our love's break
Causes me more shame
Than sorrow.

Canto IX
Languishing Krishna

Then, when she felt wasted by love,
Broken by her passion's intensity,
Despondent, haunted by Hari's
Response to her quarreling,
Her friend spoke to her.

Hari comes when spring winds, bearing honey, blow.
What greater pleasure exists in the world, friend?
 Don't turn wounded pride on Madhava!
 He is proud too, sullen Radha.

Your swollen breasts are riper than palm fruits.
Why do you waste their rich flavor?
 Don't turn wounded pride on Madhava!
 He is proud too, sullen Radha.

How often must I repeat the refrain?
Don't recoil when Hari longs to charm you!
 Don't turn wounded pride on Madhava!
 He is proud too, sullen Radha.

Why do you cry in hollow despair?
Your girlfriends are laughing at you.
 Don't turn wounded pride on Madhava!
 He is proud too, sullen Radha.

See Hari on his cool couch of moist lotuses!
Reward your eyes with this fruit!
 Don't turn wounded pride on Madhava!
 He is proud too, sullen Radha.

Why conjure heavy despair in your heart?
Listen to me tell how he regrets betraying you.
 Don't turn wounded pride on Madhava!
 He is proud too, sullen Radha.

Let Hari come! Let him speak sweet words!
Why condemn your heart to loneliness?
 Don't turn wounded pride on Madhava!
 He is proud too, sullen Radha.

May Jayadeva's lilting song
Please sensitive men who hear Hari's story!
 Don't turn wounded pride on Madhava!
 He is proud too, sullen Radha.

When he is tender you are harsh,
When he is pliant you are rigid,
When he is passionate you are hateful,
When he looks expectant you turn away,
You leave when he is loving.
Your perverseness justly
Turns your sandalbalm to poison,
Cool moon rays to heat, ice to fire,
Joys of loveplay to torments of hell.
 (Jayadeva) (10)

Who can gauge Krishna's love for me? says Radha
He bathes in the ghat below
the place where I bathe
that the waters, after touching my body
should touch him.

He gives his clothes to the same washerman
that I do,
so that his clothes will touch mine.

He walks behind me swiftly
to cover my shadow
with his

Who can measure Krishna's love for me?
He runs as one possessed
to embrace the wind as it comes
from where I roam. (Anonymous) (11)

When they had made love
she lay in his arms in the *kunja* grove.
Suddenly she called his name
and wept — as if she burned in the fire of
separation.

 The gold was in her *anchal*
 but she looked afar for it!
— Where has he gone? Where has my love gone?
O why has he left me alone?
And she writhed on the ground in despair,
only her pain kept her from fainting.
Krishna was astonished
and could not speak.

Taking her beloved friend by the hand,
Govinda-dasa led her softly away.
 (Govindadasa) (12)

With the last of my garments
shame dropped from me, fluttered
to earth and lay discarded at my feet.
My lover's body became
the only covering I needed.
With bent head he gazed at the lamp
like a bee who desires the honey of a closed lotus.
The Mind-stealing One, like the *chataka* bird,
is wanton, he misses no chance
to gratify his thirst: I was to him
a pool of raindrops.
 Now shame returns
as I remember. My heart trembles,
recalling his treachery.

So Vidyapati says. (Vidyapati) (13)

Let the earth of my body be mixed with the earth
my beloved walks on.
Let the fire of my body be the brightness
in the mirror that reflects his face.
Let the water of my body join the waters
of the lotus pool he bathes in.
Let the breath of my body be air
lapping his tired limbs.
Let me be sky, and moving through me
that cloud-dark Shyama, my beloved.

Govinda-dasa says, O golden one,
Could he of the emerald body let you go?
 (Govindadasa) (14)

FEVER OF LOVE

Tell me what to do.
Even the bed of water-drenched lotuses
Dries up as he reclines.
The coolness of sandal paste
Is no remedy,
Nor the hostile moon.

Be sure, O beautiful one,
Krishna pines away
From wanting you.
Day by day his body grows thin.
His heart ignores all others.
The doctors have left him
Without hope,
His only medicine
The nectar of your lips. (Vidyapati)

DARKNESS AND RAIN

Clouds break.
Arrows of water fall
Like the last blows
That end the world.
The night is thick
With lamp-black for the eyes.
Who but you, O friend,
Would keep so late a tryst?
The earth is a pool of mud
With dreaded snakes at large.
Darkness is everywhere,
Save where your feet
Flash with lightning. (Vidyapati)

A BED OF FLOWERS

A bed of flowers,
A glowing lamp
And scented sandal wood
Await you.
Whenever you were with her
To no avail time passed.
She stayed
Tortured by love.
O Madhava,
Radha has made
Her love-bed for you...
O go to your tryst
At the waving flames
Of the forest-fire... (Vidyapati) (15)

As water to sea creatures,
 Moon nectar to *chakora* birds,
 companionable dark to the stars —
my love is to Krishna.

My body hungers for his
 as mirror image hungers
 for twin of flesh.

His life cuts into my life,
 as the stain of the moon's rabbit
 engraves the moon.

As if a day when no sun came up
 and no color came to the earth —
 that's how it is in my heart when he goes away.

 Vidyapati says Cherish such love
 and keep it young, fortunate girl. (Vidyapati)

What avails the raincloud
that only passes over, and leaves the seedlings
 to scorch?
Or a painted likeness of your lover
if you are far from him all the days of your youth?
The sea on every side, but no water
to quench your thirst.
Such is my fate.
The sandal tree has lost its fragrance,
the touchstone has lost its magic,
the moon rains fire.
Such is my fate.
The clouds of Shravan give no rain,
the *sur* tree bears no fruit,
the servant of Him-who-holds-the-mountain
finds no refuge.
Strange this fate seems to Vidyapati.
 (Vidyapati) (16)

FIRST RAPTURE

There was a shudder in her whispering voice.
She was shy to frame her words.
What has happened tonight to lovely Radha?
Now she consents, now she is afraid.
When asked for love, she closes up her eyes,
Eager to reach the ocean of desire.
He begs her for a kiss.
She turns her mouth away
And then, like a night lily, the moon seized her.
She felt his touch startling her girdle.
She knew her love treasure was being robbed.
With her dress she covered up her breasts.
The treasure was left uncovered.

Vidyapati wonders at the neglected bed.
Lovers are busy in each other's arms.

(Vidyapati)

DAWN

Awake, Radha, awake,
Calls the parrot and its love.
For how long must you sleep,
Clasped to the heart of your Dark-stone?
Listen. The dawn has come
And the red shafts of the sun
Are making us shudder...

(Vidyapati) (17)

What sudden sound from the kadamba wood,
Startled my ears!
What essence of life,
Sweetness and poetry
Raised sadness and wonder in my heart!
How can I describe
The stir?...
The sound persists from the enticing flute
As poison and life...

(Chandidasa)

I never touch a black flower
In my diffidence.
Sadness grows.
I hear everywhere
Whispers about my dark love.

I never look at the sombre cloud
Fearing Krishna.
I do not wear kohl.
I screen my eyes
while going to the stream.
As I pass by
The kadamba shade,
I seal my ears
Hearing the flute.

(Chandidasa)

The cries of the black kokila
Blackens Brindavan
Like the forest of death.
The other hazard
Is the son of Nanda.
My life hungers
For the sound of his reed-flute...

(Chandidasa)

My growing youth is my one great danger
And then,
The dreaded forest of Brinda,
The kadamba grove,
The flowing Jamuna,
My beautiful jewels,
Mount Gobardhan,
And with all these dangers I live alone
With no one to share my tales.

(Chandidasa)

Darkness and clouds
Shroud the frightening night,
Alone, I suffer
Under the kadamba tree.
I scan distances in vain,
Krishna is nowhere.
Split the earth open
And I will conceal myself.
My youth runs away,
Yet still my heart suffocates
Waiting for Krishna...

(Chandidasa)

She lingers out of doors.
She rushes in
And she rushes out,
Her heart is restless.
Breathing fast,
She gazes at the kadamba wood.
What has happened
That she is not afraid?
The elders chatter
And the wicked gossip.

Is she possessed
By some enchanting god?
Forever restless
Careless of clothes,
Startled, she jumps in her dreams...

Her desire inflamed
By passion and longing,
She reaches for the moon.

Chandidas says that she is caught
In the snare of Kaliya, the dark.

(Chandidasa) (18)

Fingering the border of her friend's sari, nervous and
 afraid,
sitting tensely on the edge of Krishna's couch,

as her friend left she too looked to go
but in desire Krishna blocked her way.

He was infatuated, she bewildered;
he was clever, and she naive.

He put out his hand to touch her; she quickly pushed
 it away.
He looked into her face, her eyes filled with tears.

He held her forcefully, she trembled violently
and hid her face from his kisses behind the edge of
 her sari.

Then she lay down, frightened, beautiful as a doll;
he hovered like a bee round a lotus in a painting.

Govinda-dasa says, Because of this,
drowned in the well of her beauty,
Krishna's lust was changed.

(Govindadasa) (19)

How can I describe his relentless flute,
which pulls virtuous women from their homes
and drags them by their hair to Shyam
as thirst and hunger pull the doe to the snare?
Chaste ladies forget their lords,
wise men forget their wisdom,
and clinging vines shake loose from their trees,
hearing that music.
Then how shall a simple dairy maid withstand its call?

Chandidasa says, Kala the puppetmaster
 leads the dance.

(Chandidasa) (20)

When you listened to the sound
of Krishna's flute,
I stopped your ears.
When you gazed at the beauty
of his body,
I covered your eyes.
You were angry.
O lovely one, I told you then
that if you let love grow in you
your life would pass in tears.
You offered him your body,
you wanted his touch —
you did not ask if he would be kind.
And now each day your beauty
fades a little more;
How much longer can you live?
You planted in your heart
the tree of love,
in hope of nourishment
from that dark cloud.
Now water it
with your tears,

says Govinda-dasa.

(Govindadasa) (21)

When Hari puts the flute to his lips

The still are moved and the moving stilled;
Winds die, the river Yamuna stops,
 crows fall silent and the deer fall senseless;
 bird and beast are stunned by his splendor.
A cow, unmoving,
 dangles a grassblade from her teeth;
Even the wise can no longer
 hold firm their own minds.

Surdas says: Lucky the man
 who knows such joy.

(Sur Das)

Honeybee, Krishna's flute is honey-sweet.
We hear, and our very breath is immersed in love
 like a wick immersed in oil,
 shining hot and bright,
And the moths see the flame,
 and destroy their greedy bodies;
Like a fish who yearns for a sliver of meat,
 and seizes a bamboo hook;
 a crooked thorn,
It twists in the heart
 and then will not come out.
As a hunter sounds a horn
 and draws a herd of deer;
Aims an arrow,
 looses it,
 and threads their hearts upon the shaft.
As a thag lures a pilgrim
 with laddus sweet with wine,
Makes him drunk and trusting,
 takes his money and his life;
Just so, Honeybee,
 Hari takes our love by deceit.

Sur's Lord tore up the sweet sugarcane
 and planted a garden of longing.

(Sur Das)

Black tresses tangle in earring
Yellow cape catches on nosering
 within a single garland, two bodies entwine.

Breath clings to breath
Eye clings to eye
 black cloud enshrouds a brighter beauty.

They dance, each surpassing the other;
They embrace, each delighting in the other;
 "Ta! Ta! Thei! Thei!" they cry out the tal.

Sur's beloved Lord
In the great Circle of his lovers
 takes the border of a woman's skirt
 to wipe the sweat from his limbs.

(Sur Das)

O Mother!
It was like lightning flashing
 cloud to black cloud,
Lightning 'midst cloud and cloud amidst lightning:
 Shyam gleaming black amidst the fair girls of Braj!
And the jasmine scent on the Yamuna bank,
 heavy in the Autumn eve;
The forms of our bodies lit by the moon,
 its liquor in every limb;
Passion's dance, led by passion's prince,
 and the village-girls roused to joy!
And he,
 Form of all forms,
 a black cloud,
 clouding our minds with his bliss...
We danced like birds,
 like parrot and peacock and sparrow and finch;
 darting, like the fish;
 stately, like the elephant;
O Sur, which of us can say
 what it was like with Mohan?
 Enchantresses
 enchanted
 by the Enchanter. (Sur Das) (22)

UDDHAVA AND THE GOPIS

These words from Mohan brought his image dear
Back to their minds —
And through their lips, their hair
An ecstatic shiver ran, betrayed
Their bodies' frenzy!

Racked and faint,
They fell to the ground, these women: Uddhav
Splashed them with water, rousing them with the words
 'Women of Braj!—

....

'What light of Brahma? Who are we to hear
Of knowledge, Uddhav?
Shyam the fair is ours!
Our path of love is straight — Mohan reveals
In eye, ear, nostril, voice
His form so dear,
Snatching our minds and memories with his flute—
Casting love's spell,
 O friend of Shyam!'

....

'You call him Kanha — he who's fatherless,
Nor born of mother! — and from whom arose
The universe entire,
The egg of Brahma!
He took man's shape, and came to earth
To work his will, as Shyam;
But yoga's discipline alone wins him,
And highest Brahma's city is his home,
 O women of Braj!'

'Tell *him* of yoga, Uddhav, whom you find
Fit for it,
But to us sing lovingly,
Of Nanda-nandana's reality!
In Mohan's eye the proof of his being shines!
It fills his voice, heart, soul—
And where's the man
Who scorns love's nectar, turning to scoop up dust,
 O friend of Shyam?'

....

'Shyam has no qualities! The *Vedas* state
Their negative, and Upanishads propound
The Self as absolute,
Though seeming qualified
Vedas, Puranas too have never found
One quality; if all is qualified,
Say, what supports the sky,
 O women of Braj?'

'Has Shyam no qualities? Then how
Are qualities formed, we'd like to know!
How can a tree unseeded grow?
His quality, though single,
In illusion's mirror gleams
Reflected, and many seems:
So pure and muddy streams
— Both water — mingle,
 O friend of Shyam!'

....

'All qualities apparent to the eye
Must vanish, but eternal Vasudev
Suffers no taint from these!
His radiance
Is that of perfect knowledge — undisclosed
To the gross senses, seen by those
Who know this truth of him, the babe reborn,
 O women of Braj.'

'Can disbelievers recognise
That form beneficent? They spurn
The sun itself, in yonder skies,
And to clutch at its scattered rays they turn!
But we're intent upon that form
And countless Brahmas no more prize
Than a tiny plum, that lies
Unseen within the palm—
 O friend of Shyam!'—

....

Just then a bee, that chanced to fly that way,
Came humming, bright in beauty, through the throng
Of the Braj women,
And on their feet
(Thinking the nails red lotuses) went to alight:
The girls were startled by its sudden flight!
And saw in it a metamorphosis
Into bee's form
 Of Uddhav!

And to that bee
Each one now made her own reply—
Of words a subtle snare

Instinct with love's delight, but linked to sense:
'Don't touch my feet! Away!
You filch the joy
And bliss we feel, and Mohan, that dear boy,
Deceived us, just as you—
 Be off! Fly hence!'

'Why, everything born black,' said one,
Is devious, guileful, cruel — and if a man
The darkest villain!
We know this — our limbs
Touched his dark body, and to this day burn!
And now this bee comes here, and brings
The serpent yoga, with its sting!
 He'll have no mercy!'

....

One cried 'You're called a lover, bee,
But why, for what ability?
This baffles us! We only see
Black body, yellow face,
Proclaiming sin, and your disgrace
In the world's eyes!
Then recognise
Your sum of virtue, bee, and vice —
 Look in a glass!'

....

And one said 'Look, if Shyam's a yogi,
You're his disciple then!
Turn to the hunchback — make her your pilgrimage,
Make sensuality your fair!
You've peddled talk of final liberation
All over Mathura,
But love's the rule in Gokul,
Who'll want your ware?
 Be off, sir!'

Another said 'Look, bee, if Mathura's holy men
Are like yourself, what of its sages then?
You twist vice into virtue, but deform
Virtue itself:
And surely Mohan would flee this body's form
On sight of saints like you—
 Squander his wealth!'

'Are all your friends like this?' said one;
'If so, we understand
Why he of the dark body should dissemble
On every hand!
In Gokul here
Murari, though a lover, found no mate,
But matched to his own bent limbs
A hunchbacked mistress,
 Twisted in form and ways!'

And in this way
Each herdgirl addressed Uddhav as the bee,
Filled with the longing of Govinda's Lay,
Unmindful of becoming modesty!
Then all at once
All these Braj women wept,
Crying 'Lord, show pity!
Keshav — Krishna — Murari!
 Our hearts are rent!'

And from their eyes there streamed
A flood of tears, that swelled and drowned
Its lotus sources — drenching
Bodices, garlands, necklaces;
—While in that sea of love
Uddhav, who'd come to Braj to dike it round
With knowledge, was swept off,
 And his race redeemed! (23)

'Meera has gone mad, (they say):
Alone she stands on palace-tops, desolate and cries:
My Lord, My Beloved One!'

The days pass
I do not eat by day nor sleep by night.
My body I regard not;
My clothes slip, and I stand without them
It is not easy.
With the hem of my garment, I dry
My tears, and with them do I entreat:

'Lord! Mohan! Why did you not
 leave a word for Meera
When you left?'

 (*Mira Bai*)

Kanh (i.e. Krishna) I have bought
The price he asked, I gave.
Some cry, 'Tis great',
 and others fear 'Tis small'—
I gave in full, weighed to the utmost grain.
My love, my life, my self, my soul, my all.'

 (*Mira Bai*)

Mother, give me my mountain—
 bearer, my Girdhari!
No jewellery do I long for, no
 costly raiment
No palace do I seek, no
 mansions.
I swear by the lotus-feet of
 Girdhar
Dearer to me than life:
It is my Lord, Girdhar, that I
 yearn for
Again, and yet again. (*Mira Bai*) (24)

AN EXAMPLE OF HIDDEN LOVE

Once in the woods when Krishna did sport
With Radha, seeking pleasures sweet,
And shouts of joy did issue forth
As oft when lustful lovers meet
When she did take the active role
Her necklace studded with dark gems
Did wildly shake thus to and fro
Says Keshava, as if it were the sun
Had taken Saturn on his lap
And joyfully him he had swayed
In swing of black silk — so did flash
Those dark gems with each move she made.

 (*Keshava Dasa*)

EXAMPLE OF AN ANUDHA NAYIKA

Amidst the belles of Braja one day
Sat Radha, daughter of Vrishabhanu
The lovely game of dice she played
With bosom friends; and when far gone
She was in it, perchance there stole
Softly behind her, her lover, Krishna;
Whom hearing, restlessness awoke
Within her mind, and none took in
This secret; and they wondered why
So suddenly were roused her eyes.

 (*Keshava Dasa*)

MEETING BY REMOVAL OF FEAR

Hearing that fire had broken out
In Vrishabhanu's house, all Braja poured in;
From all sides men did throng and shout,
And fear threw all shame to the winds.
When parrot and starling he had moved,
And woken the other maids — then Krishna
At last near slumbering Radha stood,
And kissed her lovely eyes and chin,
And quivering breasts; and clasped her close
As *champa* flowers in garland stringed—
Thus that fair maiden he awoke!

 (*Keshava Dasa*)

MEETING AT AN INVITATION

Yashodaji once did invite
Vrishabhanu's child, and herself brought her
Fully adorned, with great delight,
Into her house, when meals were over,
Chewing *betels* she upstairs did go
Alone, perchance some joy to seek,
When seeing her lover, Krishna approach
She fled; whereas he fearlessly
Caught her and grasped her snake-like braid,
Embraced her and did as he chose;
Then rubbing saffron on her face,
Took her nose-ring, and left her so.

 (*Keshava Dasa*)

193

THE EMOTION OF SLIGHT OF THE *NAYIKA*

When she knew Shri Krishna to approach
She feigned sleep, softly he essayed
To wake her — she would not be woke:
Then venturing forth, his hand he placed
Upon her rising bosom, so
That she did titillated feel;
Emboldened thus his hand did go
Her waist-band to unite, when she
Did start and rise, and knowing him close
Said, 'All day long, oh! boor ill-bred,
Your cows you tend and at night force
Yourself in another woman's bed!'

(Keshava Dasa) (25)

CLOUD AND LIGHTNING

The day has dawned, and Krishna and Radha come out
of the garden pavilion in which the night was spent.
Radha is wearing a blue sari; Krishna is in his
yellow *pitambara*.
Their garlands are broken;
Beads of sweat shine on Krishna's limbs like stars
peeping through the clouds;
The collyrium in Radha's eyes has trickled to the lips,
And the vermilion on her lips has spread to the eyes;
The ornaments on her person are displaced in their
joyous abandon,
It looks as though a mighty cloud
And impetuous lightning have come to rest after
their night-long play.

(Keshava Dasa) (26)

Release me from earthly bondage, O Radha, celestial
damsel, the mere lustre of whose body tints dark-
complexioned Krishna in ever-green haloes of delight.

(Bihari Lal)

What spell have you cast on Krishna? Since he saw
you he has quite lost himself. He does not know
where his flute is, or his saffron robe, where his crown
and where his garland.

(Bihari Lal)

The inhabitants of Braj got greatly alarmed as they saw
the Govardhan hill shake on Krishna's finger;
and Krishna
looked shame-faced, for his heart had leapt at the sight
of Radha.

(Bihari Lal)

Colour, fragrance, and delicacy are all merged in her;
a rose-petal, touching her cheeks, loses its identity.

(Bihari Lal)

Nothing can separate you from me: your soul
from mine?
Mere distance should make no difference. The kite may
float and fly where it lists, but it is attached by means
of the string to someone's hand all the time.

(Bihari Lal) (27)

SAKHYA

A state of being in which the worshipper
considers Krishna as his friend, as did the
cowherds of Vrindavana.

Don't ask for things we'll never give you!
Every time you catch a girl alone in the woods,
you run to block her path;
On road, and riverbank, and narrow trail,
you plague us with your silly patter!

Who ever taught you you could ask for a thing like this!
Well, we can tell
you won't be content
'til we've told you a thing or two:
You just can't have the thing you want,
but you can have all the milk you can drink!
First go get it, Mohan,
from somebody else,
and then *we* might give you a call!
Now stop being such a naughty little boy
with us, Sur's Shyam!

(Sur Das)

This same Hari drapes a blanket 'round his shoulders
and goes barefoot to drive the herds to graze.
Lord of the Three Worlds

Lord of the Four Quarters
Lord of man and woman
Lord of bird and beast
feared
by Sun and Moon;
He fills the meditations of Shiva and Brahma;
He soothes the triple sorrows of his devotees;
and for their sake
he takes on a human form.
Surdas says,
He of whom the *Vedas* sing "Neti!"
wanders now from grove to grove.

(Sur Das)

Today I will surpass them all,
surpass those sinners one by one!
It's you or me, Krishna;
and I'll fight, trusting in my strength,
For I am a sinner of seven generations;
fallen, I will be freed!
Now I want to dance naked!
I shall strip you
of your honor—
Why do you flinch? O I've got you now,
Hari-hard-as-Diamond!
Sur the Fallen will rise only, Lord,
when laughingly you give him
the flowers of your grace.

(Sur Das) (28)

The mother bird goes early in the morning for food.
The chicks, hungry wait for her coming.
Just so my heart longs for Thee.
Day and night I think of thy feet.
The infant calf is tied at home, O God!
In its heart it is calling to its mother.
Says Nama, "Thou art my close friend, O Keshava,
Do not turn me away, O Protector-of-the-helpless."

(Namadeva) (29)

When salt is dissolved in water,
What is it that remains distinct—

I have thus become one
In joy with thee
and have lost myself in thee

When fire and camphor
are brought together,
Is there any black remnant?

Tuka says:
Thou and I were one light.

(Tukaram) (30)

DASYA

A state of being in which the worshipper
considers Krishna as the Master and himself
as the servant.

NANDA'S SON

....

O Nandagopan, lord who graciously
Dost raiment, water, rice, bestow on us,
Arise! And thou, our lady, Yashoda,
Queen among all the slender-waisted ones,
And glory of our tribe, arise! Sleep not!
Awake, awake, King of the gods, who pierced
The sky, and, swelling, measured out the world;
Arise! And dear lad, Baladeva, thou
With golden anklets on thy feet, asleep.
And thy young brother! Ah, Elorembavay!

....

Thou who art strong to make them brave in fight,
Going before the three and thirty gods,
Awake from out thy sleep! Thou who art just,
Thou who art mighty, thou, O faultless one,
Who burnest up thy foes, awake from sleep!
O Lady Napinnai, with tender breasts
Like unto little cups, with lips of red
And slender waist, Lakshmi, awake from sleep!
Proffer thy bridegroom fans and mirrors new,
And let us bathe! Ah, Elorembavay.

....

Govinda, whose nobility is such
As conquers e'vn thy foes, by singing thee

With the drum, what is the glory that we gain
By the prize that all the country deems a boon?
Many a jewel we put on — bracelets
Wristlets and armlets, flowerlike ornaments
For ears, and anklets; beauteous robes we wear.
Thereafter, plenteous meals of rice with milk,
And elbow-deep in *ghi*! In company
With thee, what bliss! Ah, Elorembavay!

....

After the cows we to the jungle go
And eat there — cowherds knowing nought are we,
And yet how great the boon we have, that thou
Wast born among us! Though who lackest nought,
Govinda, kinship that we have with thee
Here in this place can never cease! — if through
Our love we call thee baby names, in grace
Do not be wroth, for we, — like children, — we
Know nought — O Lord, wilt thou not grant to us
The drum we ask? Ah, Elorembavay!

(Andal) (31)

I think upon that which is beyond the province of
the Agamas. It is the Absolute
who, firmly tied to the wooden mortar, has tears
flickering on the lashes of his tear-filled eyes,
whose chest and stomach are smeared with bits of
butter like stars.

(Bilvamangala)

I take shelter with him who removes the sins of the
Kali age, who is the home of Lakshmi
who is an affectionate child, whose body is
tempting because of his lovely eyes,
who is the color of blue water lilies, bees, dense
rain clouds, and Tamala trees,
who is death, it's said, to the demon race, who
plays happily.

(Bilvamangala)

Although Brahma knows the *Vedas* and lives in the
lotus which grows from Vishnu's navel, he
does not know Vishnu
whom, as the woodland wreathed Krishna powdered
with cowdust, young milkmaids delight.

(Bilvamangala)

O glorious Krishna, Krishna, avatar born among
the Vrishnis;
O Vishnu, lion killing the elephant of
worldly existence;
O cowherd, garlanded by the lotus eyes
of milkmaids;
O home of compassion, protect me from evil.

(Bilvamangala) (32)

Children, wife, friend—
drops of water on heated sand.
I spent myself on them, forgetting you.
What are they to me now,
O Madhava, now that I am old and without hope,
apart from you. But you are the savior of the world
and full of mercy.

Half my life I passed in sleep—
my youth, now my old age,
how much time.
I spent my youth in lust and dissipation.
I had no time to worship you.

Ageless gods
have come and passed away.
Born from you, they enter you again
like waves into the sea.
For you have no beginning and no end.

Now
at the end, I fear
the messengers of Death.
Apart from you, there is no way.
I call you Lord,
the infinite and finite,
my salvation.

(Vidyapati) (33)

Now I have danced too much, Gopal!
Robed in anger and desire,
a garland of passions at my throat;
The bells of illusion encircle my ankles
and chime sweet sounds of slander.
My mind, become a drum dusted by delusion,
beats an inchoate cadence,
Echoes through my body its tones of longing.
played to a dozen different beats.

With the sash of *maya* bound at my waist,
 and the *tilak* of greed on my brow,
I summon up a thousand artful steps,
 across sea and solid land,
 beyond Time.
Vanquish all this,
Sur's sinful ignorance,
O Nandalal. *(Sur Das)* (34)

He is one, but fills and encompasses many,
Wherever you look you find him there.

There is scarcely one who understands him,
all being deluded by the variegated picture
drawn by *Maya* (delusive power).

Everything is Govinda,
Everything is Govinda;
There is nothing without Govinda.

Just as there is one thread
and on it are woven
breadth-wise and length-wise
hundreds of thousands of beads,
so is everything woven in the Lord.

The waves,
the form and the bubbles of water
are not different from
Reflecting in you must
see all this to be the creation of Hari,
says Namadeva
In the inside of every individual
there is one Murari alone
Without any interstice. *(Namadeva)* (35)

Whom have I beside Thee, O God?
Hasten to my help, O Lord of the Yadavas
 (Krishna), My Mother and Father.

I have fallen into the deep whirling pool of
 worldly things.
Who aside from Thee can give me peace of heart?
I am caught in the succession of births and deaths.
Deliver me, O The-All, The Giver, My Mother
 and Father.
Hasten quickly to Eka Janardan's help,
And when Thou hast come, dwell in my heart.
 (Eknath) (36)

Thou art the giver of help to the helpless.
Thou art the destroyer of the sorrow and
the sinful temptations of the heart, I have
now come to Thee as a suppliant. Save me,
O Merciful One, My Mother and Father.

In the company of Thy saints give me the
privilege of serving their feet, so that I may
not forget Thee. This is the longing of my
life. Fulfil this desire of my heart, O God!

Give me trust and love of Thee. Give me the
love of singing the praise of Thy goodness
and Thy name. Free me from the clutches of
hindrances, and listen to this my plea.

I have nothing more to ask of Thee, such as
happiness, property, royalty and wealth.
This will not place a burden on Thee,
except that of the worship (I give Thee).
O My Mother and Father.

Joining palm to palm (in prayer) I place my
head at Thy feet. Tukaram is pleading, O
Pandharinath. Inspire me with mirth and
delight in Thy glorious exploits. Fulfil the
longing of my heart, O my Mother and Father.
(Tukaram) (37)

O God, Supreme God, Life of the three-worlds,
listen to my prayer, O Keshava.

Give me some art and love, whereby my voice
may sing the praise of Thy goodness and
Thy Name.

My life is with Thee. Do what seems right to
Thee, and give me in accordance with it.

For me, who has come as a suppliant, Thou
alone art the protector. Thou art an ocean-
of-mercy.

Through the power of Thy Name the ocean
becomes a path for the feet. Through it,
distressing results of my *karma*, are burnt
to nothing.

Thy constant thought is the excellent fruit to
taste which prevents the experience of rebirth.

If we use those names of Ram, Krishna,
Narayan, there will be no longer the bond-age
to this worldly existance.

What is this worldly existence but mere straw.
The fire (of Thy Name) can devour it in a moment.

In a moment's time it can burn up the heap of
sins. It can raise the despicable to such a
status that he becomes the object of worship
even to the holiest.

Thyself make true Thy reputation of Saviour-
of-the-Sinner, Protector-of-the-helpless.

O Protector of the helpless, O Lord of the
Gopis, fulfil the longings of my heart.

Says Tukaram, "Whatever longings of the heart
Thy servant holds, be thou the satisfier."
 (Tukaram)

Listen, O Pandurang, to a word of mine. I
have become Thy servant, Thy slave.

Save me in the way that seems wise to Thee.
My own thoughts for the future have come to
their limit.

Hypocrisy and pride are seeking to destroy
that which I have achieved.

I am one intellectually weak, and of a low caste.
Still conceit seeks to dwell in my heart.

Says Tukaram, "These will harm me, without
a moment's delay, therefore, save me, O God."
 (Tukaram)

199. Musicians. *(Stone frieze, Halebid 13th century.)*

Appendices

Notes

Visions of the Dark Lord

1 Majumdar, R.C., *The Classical Accounts of India*, Calcutta, 1960, p. 22.

2 Kennedy, J., 'The Child Krishna, Christianity and the Gujars', in *Journal of the Royal Asiatic Society*, 1907, p. 961; quoted in White, C.S., s. note 3.

3 White, C.S., 'Krishna as Divine Child', in *History of Religions*, Vol. 10, N. 1, August 1970/71, pp. 158-159.

4 White, C.S., op. cit., p. 160.

5 Dimock, E., Jr., and Levertov, D., *In Praise of Krishna, Songs from the Bengali*, New York, 1967, p. 15.

6 id.

7 id.

8 *The Bhagavadgita*, Ed. Radhakrishnan, S., London, 1963, p. 273.

9 Bryant, K.E., *Poems to the Child God*, Berkeley, 1978, pp. 160-161.

10 Bhattacharya, D., and Archer, W., *Love Songs of Vidyapati*, London, 1963, p. 93.

11 *Prem Sagar*, London, 1897; quoted in Spink, W.M., *Krishnamandala*, Ann Arbor, 1971, p. 104.

12 *The Bhagavad Gita*, Trsl. Edgerton, F.; quoted in Kinsley, D.R., *The Divine Player*, Delhi, 1979, p. 1.

13 Bryant, K.E., op. cit., p. 186.

14 Kinsley, D.R., op. cit., p. 2.

15 *Matsya Purana*, 167. 31, Pt. II, p. 131; quoted in Kinsley, D.R., op. cit., p. 3, note 2.

16 Kinsley, D.R., op. cit., p. 63.

17 Zimmer, H., *Myths and Symbols*; quoted in Spink, W.M., op. cit., p. 106.

18 id.

19 *Mahabharata*, Anushasana Parva XVII (X, 107); quoted in Kinsley, D.R., op. cit., p. 6.

20 *Prem Sagar*, quoted in Spink, W.M., op. cit., p.99.

21 Bryant, K.E., op. cit., pp. 203-204.

22 *The Bhagavadgita*, Ed. Radhakrishnan, S., op. cit., p. 50.

23 id., p. 252.

24 id., p. 62.

25 Bryant, K.E., op. cit., pp. 159-160.

26 id.

27 id.

The Narrative

This account of the life of Krishna is based on the *Vishnu Purana*, on the *Bhagavata Purana* and on the *Mahabharata*.

The Elaboration of the Myth

1 *The Vishnu Purana*, book IV, chapter 24, Trsl. Wilson, H.H., 3rd ed., Calcutta, 1961, p. 390.

2 Majumdar, B.B., *Krsna in History and Legend*, Calcutta, 1969, pp. 7-11.

3 *Rig Veda*, VIII, 96, 13-15; for further references to various Krishnas in Vedic literature, s. Banerjee, P., *The Life of Krishna in Indian Art*, New Delhi, 1978, p. 4.

4 id., p. 5.

5 Majumdar, B.B., op. cit., p. 59. s. *Mahabharata*, book II, chapter 30, 11; II,36, 2; III, 15, 10; XII, 48, 10.

6 Bhattacharji, S., *The Indian Theogony*, Cambridge (England), 1970, p. 305.

7 Basham, A.L., *The Wonder that was India*, New York, 1954, p. 305.

8 Raychaudhuri, H., *Materials for the Study of the Early History of the Vaishnava Sect*, 2nd ed., New Delhi, 1975, pp. 48 ff.

9 *Chandogya Upanishad*, III, 17, 6; Trsl. in Panikkar, R., *The Vedic Experience: Mantramanjari*, Berkeley, 1977, p. 411.

10 Majumdar, B.B., op. cit., pp. 4 ff.

11 Fausboll: *Jataka* No. 454.

12 Raychaudhuri, H., op. cit., p. 41; Majumdar, B.B., op. cit., pp. 57-58.

13 Panini's *Ashtadhyayi*, IV, 3, 98; s. Banerjee, P., op. cit., p. 7.

14 Basham, A.L., op. cit., p. 306.

15 Raychaudhuri, H., op. cit., p. 23.

16 McCrindle, J.W., *Ancient India as Described in Classical Literature*, Westminster, 1901, p. 64.

17 Bhandarkar, R.G., *Vaisnavism, Saivism, and Minor Religious Systems*, Strasbourg, 1913, p. 3.

18 Majumdar, R.C., *The Classical Accounts of India*, Calcutta, 1960, p. 119.

19 Annual Report, Archaeological Survey of India, pp. 82 ff; s. Banerjee, P., op. cit., pp. 7-8.

20 Banerjea, P., op. cit., pp. 9-10, and Figs. 1, 2.

21 Banerjee, P., op. cit., Fig. 4.

22 Banerjee, P., op. cit., p. 8.

23 Banerjee, J.N., *The Development of Hindu Iconography*, Calcutta, 1956, pp. 385 ff.

24 Bak Kunbae, *Bhasa's Two Plays: Avimaraka and Balacarita*, Delhi, 1968, p. 210.

25 Joshi, N.P., *Mathura Sculptures*, Mathura, 1966, Fig. 58.

26 Rosenfield, J., *The Dynastic Arts of the Kushans*, Berkeley, 1967, pp. 104 ff.

27 Raychaudhuri, H., op. cit., p. 22.

28 *Harivamsha*, ch. 1, vv. 5-9 passim, Trsl. Dutt, M.N., Calcutta, 1897.

29 *The Vishnu Purana*, IV, 13, cit. ed., p. 346.

30 *The Vishnu Purana*, IV, 15, cit. ed., p. 351.

31 *Harivamsha*, ch. 59, vv. 15-20, cit. ed., passim.

32 *The Vishnu Purana*, V, 3, cit. ed., p. 403.

33 *The Vishnu Purana*, V, 3, cit. ed., p. 411.

34 id.

35 *The Vishnu Purana*, V, 9, cit. ed., p. 415.

36 id.

37 *Harivamsha*, ch. 74, v. 25, cit. ed., pp. 20-21.

38 *The Vishnu Purana*, V, 12, cit. ed., p. 422.

39 *The Vishnu Purana*, V, 13, cit. ed., p. 423.

40 id.

41 *The Vishnu Purana*, V, 20, cit. ed., p. 445.

42 *The Vishnu Purana*, V, 22, cit. ed., p. 448.

43 *Mahabharata*: Ashvamedha Parva, Trsl. Narasimhan, C.V., *The Mahabharata*, New York, 1965, pp. 195-196.

44 *Harivamsha*, ch. 276, v. 140, cit. ed.

45 *The Vishnu Purana*, V, 37, cit. ed., p. 479.

46 O'Flaherty, D., *Hindu Myths*, Penguin Books, 1975, p. 207, n. 35.

47 *The Vishnu Purana*, V, 2, cit. ed., p. 402.

48 *The Srimad Bhagavatam*, X, 27, Trsl. Sanyal, J.M., 5 Vols., 2nd ed., Calcutta, n.d., p. 115.

49 Bhattacharji, S., op. cit., pp. 305-306.

50 Bak Kunbae, op. cit., pp. 276-278.

51 *The Srimad Bhagavata*, X, 23, cit. ed., p. 138.

52 *The Srimad Bhagavata*, X, 1, cit. ed., p. 3.

53 *Harivamsha*, ch. 75, v. 15, cit. ed.

54 id.

55 *Harivamsha*, ch. 75, vv. 25, 30, cit. ed.

56 *The Vishnu Purana*, V, 13, cit. ed., p. 423.

57 *The Vishnu Purana*, V, 13, cit. ed., p. 424.

58 id.

59 *The Vishnu Purana*, V, 13, cit. ed., p. 425.

60 *The Srimad Bhagavata*, X, 33, cit. ed., p. 135.

61 *The Vishnu Purana*, V, 13, cit. ed., p. 426.

62 id.

63 id.

64 *The Srimad Bhagavata*, X, 33, cit. ed., p. 139.

65 *The Srimad Bhagavata*, X, 13, cit. ed., pp. 53-58.

66 *The Srimad Bhagavata*, X, 29, cit. ed, pp. 119-120.

67 *The Srimad Bhagavata*, X, 29, cit. ed., p. 120.

68 *The Srimad Bhagavata*, X, 33, cit. ed., p. 138.

69 Hopkins, T.J., 'The Social Teaching of the Bhagavata Purana', in Singer, M., *Myths, Rites and Attitudes*, Honolulu, 1966, pp. 6-7.

70 *The Srimad Bhagavata*, X, 32, cit. ed., p. 134.

71 Swami Prabhavananda, and Isherwood, C., *The Song of God: Bhagavad Gita*, New York, 1954, p. 96.

72 *The Srimad Bhagavata*, XI, 14, vv. 23-24, Trsl. Hopkins, T.J., cit. ed., p. 9.

73 *The Srimad Bhagavata*, X, 33, cit. ed., p. 136.

74 *The Buddhacarita*, Trsl. Johnston, E.H., Calcutta, 1936, pp. 48 ff.

75 id., pp. 52 ff.

76 *The Srimad Bhagavata*, X, 32, cit. ed., p. 134.

77 *The Srimad Bhagavata*, X, 29, cit. ed., p. 120.

78 id.

79 *The Srimad Bhagavata*, X, 22, cit. ed., p. 98.

80 Miller, B.S., *Love Song of the Dark Lord: Jayadeva's Gitagovinda*, New York, 1977, pp. 26-37; includes discussion of early references to Radha.

81 Spink, W.M., *Krishnamandala*, Ann Arbor, 1971, p. 88.

82 *The Brahma-vaivarta Puranam*, Krishna Janma Khanda, ch. 15, Trsl. Sen, R.N., Allahabad, 1920, p. 157.

83 *The Brahma-vaivarta Puranam*, Krishna Janma Khanda, ch. 67, cit. ed., p. 357.

84 *The Brahma-vaivarta Puranam*, Krishna Janma Khanda, ch. 5, cit. ed., p. 117.

85 *The Brahma-vaivarta Puranam*, Krishna Janma Khanda, ch. 77, cit. ed., p. 356.

86 *The Brahma-vaivarta Puranam*, Brahma Khanda, ch. 2, cit. ed., p. 4.

87 *The Brahma-vaivarta Puranam*, Krishna Janma Khanda, ch. 67, cit. ed., p. 357.

88 *The Brahma-vaivarta Puranam*, Prakriti Khanda, ch. 48, cit. ed., p. 218.

89 *The Brahma-vaivarta Puranam*, Brahma Khanda, ch. 5, cit. ed., p. 13.

90 *The Brahma-vaivarta Puranam*, Prakriti Khanda ch. 54, cit. ed., p. 230.

91 *The Brahma-vaivarta Puranam*, Krishna Janma Khanda, ch. 17, cit. ed., p. 174.

92 *The Brahma-vaivarta Puranam*, Krishna Janma Khanda, ch. 4, cit. ed., pp. 110-111.

93 *The Brahma-vaivarta Puranam*, Krishna Janma Khanda, ch. 4, cit. ed., p. 110.

94 *The Brahma-vaivarta Puranam*, Prakriti Khanda, ch. 54, cit. ed., p. 230.

95 id.

96 *The Brahma-vaivarta Puranam*, Krishna Janma Khanda, ch. 2, cit. ed., pp. 101-102.

97 *The Brahma-vaivarta Puranam*, Krishna Janma Khanda, ch. 2, cit. ed., p. 102.

98 id.

99 id.

100 *The Brahma-vaivarta Puranam*, Prakriti Khanda, ch. 49, cit. ed., p. 221.

101 id.

102 *The Brahma-vaivarta Puranam*, Krishna Janma Khanda, ch. 15, cit. ed., p. 154.

103 id.

104 *The Brahma-vaivarta Puranam*, Krishna Janma Khanda, ch. 15, cit. ed., p. 155.

105 *The Brahma-vaivarta Puranam*, Krishna Janma Khanda, ch. 15, cit. ed., p. 156.

106 *The Brahma-vaivarta Puranam*, Krishna Janma Khanda, ch. 15, cit. ed., p. 158.

107 *The Brahma-vaivarta Puranam*, Krishna Janma Khanda, ch. 15, cit. ed., p. 159.

108 id.

109 *The Brahma-vaivarta Puranam*, Krishna Janma Khanda, ch. 15, cit. ed., p. 160.

110 *The Brahma-vaivarta Puranam*, Krishna Janma Khanda, ch. 17, cit. ed., p. 174.

111 *The Brahma-vaivarta Puranam*, Krishna Janma Khanda, ch. 27, cit. ed., p. 228.

112 Kinsley, D.R., *The Sword and the Flute*, Berkeley, 1975, p. 73.

113 *The Brahma-vaivarta Puranam*, Krishna Janma Khanda, ch. 28, cit. ed., p. 229.

114 *The Brahma-vaivarta Puranam*, Krishna Janma Khanda, ch. 28, cit. ed., p. 231.

115 id.

116 *The Brahma-vaivarta Puranam*, Krishna Janma Khanda, ch. 28, cit. ed., p. 233.

117 id.

118 *The Brahma-vaivarta Puranam*, Krishna Janma Khanda, ch. 28, cit. ed., pp. 233-234.

119 *The Brahma-vaivarta Puranam*, Krishna Janma Khanda, ch. 28, cit. ed., p. 234.

120 *The Brahma-vaivarta Puranam*, Krishna Janma Khanda, ch. 28, cit. ed., pp. 234-235.

121 Kinsley, D.R., op. cit., p. 63.

122 *The Brahma-vaivarta Puranam*, Krishna Janma Khanda, ch. 28, cit. ed., p. 235.

The Cult

1 This list of the main *upacharas* is based on the description given by Walker, B., *Hindu World*, London, 1968, s. *worship*.

2 Stutley, J. and M., *A Dictionary of Hinduism*, London, 1977, s. *guru*.

3 Skelton, R.W., *Rajasthani Temple Hangings of the Krishna Cult*, New York, 1973, p. 23.

4 id., passim.

5 Tod, J., *Annals and Antiquities of Rajasthan*, Vol. II, Ed. Crooke, W., London, 1920, p. 609.

6 Yule, H., and Burnell, A.C., *Hobson-Jobson*, London, 1969, s. *Juggurnaut*.

7 Dubois, J.A., Abbé, *Hindu Manners, Customs and Ceremonies*, Ed. Beauchamp, Oxford, 1906, pp. 603-604.

8 Oral communication from Dr. Kulke, H..

9 Kulke, H., 'Rathas and Rajas: The Car Festival at Puri', in *Art and Archaeology Research Papers* 16, December 1979, pp. 19-26.

10 Mitra, R.L., *The Antiquities of Orissa*, Vol. II, Calcutta, repr. 1963.

11 Bhattatiri's *Narayaniyam*, opening stanza; quoted in Vaidyanathan, K.R., *Sri Krishna the Lord of Guruvayur*, Bombay, 1974, p. 3.

12 id., pp. 18-20.

13 id., p. 28.

14 *Malabar Gazetteer 1951*, Ed. Innes and Evans; quoted in Vaidyanathan, K.R., op. cit., pp. 40-42.

15 S. Krishna in the Performing Arts, pp. 181, 182.

16 Sharma, B.N., *Festivals of India*, New Delhi, 1978, passim.

17 S. Elaboration of the Myth.

18 S. Elaboration of the Myth.

19 Nabhaji's *Bhakta Mala*; quoted in Growse, F.S., *Mathura, A District Memoir*, New Delhi, repr. 1979, p. 200.

20 Goswamy, B.N., and Dallapiccola, A.L., 'Anmerkungen über eine Serie von indischen Miniaturen aus dem XVIII Jahrhundert', in Zeitschrift für Religions- und Geistesgeschichte, Bd. XXXIII, Heft 1, 1981, pp. 10-11.

Krishna in Painting

1 Khandalavala, K., and Chandra, M., *An Illustrated Aranyaka Parvan in the Asiatic Society of Bombay*, Bombay, 1974.

Krishna in the Performing Arts

1 Boner, A., in *Journal of the Indian Society of Oriental Art*, Vol. II, No 1, Calcutta, June 1935, p. 10.

Krishna in Poetry

1 S. Visions of the Dark Lord, p. 22.

2 Jesudasan, C. and H., *A History of Tamil Literature*, Calcutta, 1961, p. 111.

3 Bilvamangala, *The Bilvamangalastava*, Ed. and Trsl. Wilson, F., Leiden, 1973, p. 1.

4 Walker, B., *Hindu World*, London, 1968, s. 'Hindi'.

5 Nanddas, in *The Round Dance of Krishna and Uddhav's Message*, Ed. and Trsl. McGregor, R.S., London, 1973, p. 35.

6 id., p. 54.

7 Bilvamangala, *The Bilvamangalastava*, loc. cit., poems no.: 75, p. 71; 26, p. 49; 73, p. 71.

8 Bryant, K.E., *Poems to the Child-God*, Berkeley, 1978, poems no.: 10, p. 156; 18, p. 160; 5, p. 170; 17, 160; 7, p. 171; 5, p. 185.

9 Bilvamangala, *The Bilvamangalastava*, loc. cit., poems no.: 50, p. 61; 10, p. 43; 32, p. 53; 80, p. 75; 6, p. 41; 12, p. 43; 99, p. 83.

10 Jayadeva's *Gita Govinda*, Trsl. Stoler Miller, B., Delhi, 1978, cantos: I, vv. 38-47; V, vv. 1-6; VIII, vv. 1-10; IX, vv. 1-10.

11 Anonymous, Trsl. Goswamy, B.N.

12 Govindadasa, in Dimock, E., Jr., and Levertov, D., *In Praise of Krishna*, New York, 1976, p. 23.

13 Vidyapati, id., p. 27.

14 Govindadasa, id., p. 58.

15 Vidyapati, in *Love Songs of Vidyapati*, Trsl. Bhattacharya, D., London, 1963, poems no. 23, 71, 24.

16 Vidyapati, in Dimock, E., Jr., and Levertov, D., op. cit., pp. 17, 62.

17 Vidyapati, in *Love Songs of Vidyapati*, Trsl. Bhattacharya, D., London, 1963, poems no. 3,4.

18 Chandidas, in *Love Songs of Chandidas*, Trsl. Bhattacharya, D., London, 1967, poems no. 2, 8, 73, 62, 72, 42.

19 Govindadasa, in Dimock, E., Jr., and Levertov, D., op. cit., p. 11.

20 Chandidas, id., p. 29.

21 Govindadasa, id., p. 42.

22 Bryant, K.E., op. cit., poems no.: 1, p. 195; 2, p. 195; 9, p. 199; 10, p. 200.

23 Nanddas, in *The Round Dance of Krishna and Uddhav's Message*, op. cit., pp. 86 ff.

24 Mira Bai, Trsl. Goswamy, B.N.

25 Keshava Dasa, in *The Rasikpriya of Keshava Dasa*, Trsl. Bahadur, K.P., Delhi, 1972, pp. 5, 40, 81, 82, 100.

26 Keshava Dasa, in Randhawa, M.S., *Kangra Paintings on Love*, New Delhi, 1962, p. 186.

27 Bihari Lal, in *The Veiled Moon*, Trsl. Jha, A.N., and Mathur, G.K., New Delhi, 1973, pp. 35, 36, 40, 55, 47.

28 Bryant, K.E., op. cit., poems no.: 12, p. 188; 3, p. 184; 2, p. 206.

29 Namadeva, in Abbott, J.E., (Trsl.), *Stotramala: A Garland of Hindu Prayers*, Poona, 1929, p. 15.

30 Tukaram, anonymous Trsl.

31 Andal's *Tiruppavai*, quoted in: Hooper, J.S.M., (Ed. and Trsl.), *Hymns of the Alvars*, Calcutta, 1929, pp. 50-58.

32 Bilvamangala, *The Bilvamangalastava*, loc. cit., poems no.: 41, p. 57; 62, p. 67; 74, p. 71; 97, p. 81.

33 Vidyapati, in Dimock, E., Jr., and Levertov, D., op. cit., p. 69.

34 Bryant, K.E., op. cit., poem no. 1, p. 205.

35 Namadeva, anonymous Trsl.

36 Eknath, in Abbott, J.E., op. cit. p. 27.

37 Tukaram, id., pp. 36, 37, 38, 39.

Glossary

'Abd al-Samad ('Abd as-Samad)
Persian painter (fl. mid 16th century). He joined Humayun (s.) at Kabul (1549) and came to India with him (1554). With Mir Sayyid Ali (s.) he is the founder of the renowned Mughal school of painting.

Abhanga (Abhanga)
(= the unbreakable one)
Closely related to the *pada*, popular in Hindi and Bengali; the a. is an old form of song, generally based on some saying, which is enlarged upon or repeated with variations. The a. is used for short devotional lyrics in Maharashtra.

Abhinaya (Abhinaya)
The art of dramatic expression, through facial mimic and gestures.

Abhira(s) (Ābhīra; also: Āhīr[s])
Name of an immigrant tribe probably of non-Aryan origin. There are abundant but extremely confused records concerning these people's history. They are frequently mentioned in the *Mahabharata*. They live in the region delimited by the estuary of the rivers Sindhu and Sarasvati.

Abhisheka (Abhiṣeka)
Consecration by sprinkling of water. Religious bathing of an image with water poured ceremonially from a conch.

Abu'l Fazl Allami (Abū 'l Faẓl 'Allāmi)
(1551-1602)
Friend, Secretary of State and chronicler of Akbar (s.); he wrote, in Persian, the *Ain-i-Akbari*, or 'Institutes of Akbar' which is a statistical survey of the Empire combined with a detailed account of the court and administrative system. The leading authority for the narrative of the events in Akbar's time is the *Akbar Nama*, written by Abu'l Fazl and revised partly by Akbar himself.

Achamana (Ācamana)
The sipping of water from the palm of the hand before religious ceremonies, before meals, for purification.

Acharya (Ācārya)
(= knowing or teaching the *achara* or rules; spiritual guide or teacher) The title *acharya* affixed to names of learned men is rather like our "dr".

Achyuta s. Vishnu

Adiguru (Ādiguru)
(= the first guru)
In sectarian belief a deity is considered to be the founder of a particular order, and he is thus the 'original', the 'first' *guru*. The living *guru* is believed to be the embodiment of the founder deity and is thus the last in a line of succession starting from the god.

Aditi (Aditi)
(= not limited, infinity)
The *Vedic* goddess of space; the mother of the Adityas. A pair of earrings was produced at the Churning of the Ocean (s. Mandara), which Indra gave to A. and which were stolen by Naraka. (s. Narrative)

Aditya(s) (Āditya)
Sons of Aditi, who personify particular aspects of nature. They represent the whole range of phenomenal manifestations.

Agama(s) (Āgama)
(= anything handed down and fixed by tradition)
Traditional doctrine or precept. Texts of the early Shaiva sects.

Agara (Agara, Aguru)
Aquilaria Agallocha.
The fragrant Aloe wood and tree.

Agha, Aghasura (Agha, Aghāsura)
(= bad, dangerous, sinful, impure)

Agni (Agni)
(= fire)
The god of fire, one of the earliest of the *Vedic* gods, and one of the most important. He is the guardian of the southeastern direction of space.

Agni Purana (Agni Purāṇa)
(c. A.D. 10th cent.)
This P. was originally communicated by Agni to the *rishi* Vasishtha. It is an encyclopaedic compilation containing, besides some original material, many extracts from other works. (s. *Purana*)

Ahamkara (Ahaṃkāra)
Conception of one's own individuality; self consciousness. Egotism.

Ahir(s) s. Abhira

Ai Khanoum
Hellenistic town on the Amu Darya, near Termez.

Airavata (Airāvata)
(= born of the Milky Ocean)
The white, four-tusked elephant, which emerged from the Churning of the Ocean. Indra's vehicle.

Akbar (Akbar)
(1543-1605)
Mughal emperor. A. was the effective founder of the empire which dominated a large part of India until its gradual dismemberment in the 18th and 19th centuries. He was a great patron of the arts, especially of painting (s. Hamza Nama) and of architecture.

Akrura (Akrūra)
(= not cruel, gentle)
A noble Yadava, uncle of Krishna. He is chiefly noted as being the holder of the *syamantaka* gem. (s. Narrative)

Akshauhini (Akṣauhiṇī)
A large division of an army. It is described in the verses 19 to 26 in the second chapter of the *Adi Parvan* of the Malayalam *Mahabharata* as containing 21870 chariots, an equal number of elephants, 65160 horses and 109350 soldiers.

Alani
Eastern division of the Sarmatians, a wandering people resembling Mongols. First met with north of the Caspian, then (c. A.D. 1st cent.) spreading into the steppes of Russia, the A. made incursions into both the Danubian and the Caucasian provinces of the Roman Empire.

Alvar(s) (Āḷvār)
(= absorbed in meditation, lost in the Supreme)
A group of Tamil Vaishnava saints (A.D. 7th-9th cent.). Twelve Alvars are especially famous, one of them is a woman, Andal. They were concerned with the personal experience of the deity, rather than with philosophical speculation. The A. sang praise of Rama, of Narayana, of Krishna. Their deeply devotional songs, collected in the 10th century, constitute the prayer hymn-books of the southern Vaishnavas.

Amba (Ambā, Amba)
(= mother)
An aspect of Parvati or Durga as mother goddess. (s. Ambika)

Ambadevi Rasa (Ambādevī Rāsa)
Name of a dance from Gujarat performed during the Navaratri festivities in the months of October/November, in honour of the goddess Amba.

Ambika (Ambikā)
(= mother)
A nature-goddess around whom many earlier myths gathered. An aspect of Parvati or Durga.

Amshavatara (Aṃśāvatāra)
s. Avatara

Ananda (Ānanda)
(= joy, happiness, bliss)
A term used also to denote the ultimate bliss of the Supreme Being, and one of his three principal attributes.

Anandatirtha s. Madhvacharya

Ananta (Ananta)
(= endless)
A name of the serpent Shesha (s.).

Anchal (Āṅcal)
The head-piece of the *sari* which is worn over the shoulder, into which women tie money, keys and other valuables.

Angarkha (Angarkhā)
(= body protector)
A long tunic or coat worn by men. Muslims have it made to open on the left and Hindus to open on the right.

Aniruddha (Aniruddha)
(= unobstructed, self-willed, ungovernable)
Grandson of Krishna around whom a minor cult grew up. (s. Narrative) In the Pancharatra system Sankarshana (Balarama), Pradyumna and Aniruddha are gods in their own right, as they were with the early Bhagavatas. (s. Vyuhas)

Anshumati (Aṃśumatī)
Name of a river, not to be identified with certainty.

Antialkidas
An Indo-Greek king of Taxila, who reigned during about 150-100 B.C.

Anudha Nayika (Anūḍhā Nāyikā)
(= unmarried heroine)

Appan (Appan)
(= father, lord)
This Malayalam word is also used as an honorific title.

Apsara(s) (Apsara)
(= essence of the waters; moving in the waters or between the waters). Celestial nymphs, who dwell in Indra's paradise. They are the mistresses of the Gandharvas.

Aranyaka Parvan (Āraṇyaka Parvan)
(= forest section)
Book of the *Mahabharata*, generally known as *Vana Parvan*, which includes amongst others the story of Nala and Damayanti.
An illustrated manuscript of this book, dated 1516 is discussed in the chapter on Krishna in the Visual Arts.

Arati (Āratī)
(= waving)
One of the *upacharas*. Ceremony performed in adoration of a god by moving circularly around the head of the idol a platter containing a five-wicked burning lamp, flowers and incense.

Archa (Arcā)
(= worship, adoration)
An image or an idol destined to be worshipped.

Arjuna (Arjuna)
(= white)
The third of the Pandava princes, son of Indra and of Kunti. His exploits are presented in the *Mahbharata*. The *Bhagavadgita* was recited to him by Krishna. (s. Narrative)
Some other names: Bharata (Bharata) = descendant of Bharata; Dhananjaya (Dhanañjaya) = conqueror of booty; Jishnu (Jiṣṇu) = victorious, triumphant; Partha (Pārtha) = son of Pritha (i.e. Kunti)

Arjuna tree
Terminalia Arjuna. A large and shady tree.

Arrian (Flavius Arrianus)
(c. A.D. 96-180)
Greek historian and philosopher. The Roman emperor Hadrian appointed him Governor of Cappadocia (A.D. 131-137); he distinguished himself in a military expedition against the Alani (s.). His most important work is the *Anabasis of Alexander*.

Asharh (Asāṛh, Āṣāḍha)
Name of a month (June/July). Beginning of the year in some parts of Rajasthan and Gujarat. (s. Calendar)

Ashoka tree (Aśoka)
(= not sorrow)
Saraca indica. Gives forth orange or scarlet blossoms.

Ashram (Aśram)
Hermitage, abode of ascetics.

Ashtachhap (Aṣṭachāp)
(= eight seals)
Corporate name given to eight Hindi poets, who wrote in the Braj bhasha language. Four of them, including Sur Das, were associates of Vallabhacharya, and the others of his son Vitthalnatha.

Ashtadhyayi (Aṣṭādhyāyī)
(= eight chapters)
The title of Panini's (s.) great Sanskrit grammar. This is the earliest standard work extant on this topic.

Ashtaka (Aṣṭaka)
(= eight couplets)
The only written work by Chaitanya. (s. The Cult)

Ashvaghosha (Aśvaghoṣa)
(c. A.D. 1st cent.)
Writer and philosopher. One of the forerunners of the Mahayana school of Buddhism. His most famous works are the poems *Saundarananda* and *Buddhacharita* (History of the life of Buddha).

Ashvamedha Parvan (Aśvamedha Parvan)
(= horse-sacrifice section)
Book of the *Mahabharata*, in which the rite of the horse-sacrifice is described.

Ashvatthama (Aśvatthāmā)
(= horse-voiced)

Ashvin (Aśvin)
Name of a month (September/October). (s. Calendar)

Asura/s (Asura)
(= spiritual, divine)
Evil spirits in perpetual hostility to the gods.

Atharva Veda (Atharva Veda)
The 'Veda of the Atharvan', or 'knowledge of the magic formulas'. The fourth of the *Vedas*, depicting the world of popular animistic beliefs, magical rites, spells, incantations, *mantras* and exorcisms.

Atpati (Aṭpaṭi)
Flat turban, typical of the Akbari period.

Aurangzeb (Aurangzīb)
(1618-1707)
The sixth of the Mughal Emperors. A bigoted Muslim. In his fanatical attempts to suppress Hindu image worship he destroyed many Hindu temples. It was during his time that the image of Shri Nathji (s. Krishna) was transferred from Mathura to the State of Mewar.

Avatara (Avatāra)
(= descent)
Especially the descent (incarnation) of a god from heaven to earth. It can be 'complete', i.e. *purna avatara* or 'partial', i.e. *amshavatara*. (s. Dashavatara)

Ayodhya (Ayodhyā)
One of the seven sacred cities of the Hindus situated on the banks of the Gogra river, about four miles from the modern Fyzabad. (s. Map)

Babur (Bābur)
(1483-1530)
Mughal emperor. He was a descendant of Tamerlane and of Chingiz Khan, and founded in 1526 the Mughal Empire in India. Apart from being a man of action and very responsive to the arts, he was a remarkable poet as can be seen from his memoirs, the *Babur Nama*.

Badarikashrama (Badarikāśrama)
A famed pilgrimage resort in the Himalayas, the modern Badrinath, near one of the sources of the Ganges, the Badarika.

Badu Chandidasa (Baḍu Caṇḍidāsa)
(c. 14th cent.)
Poet, author of the *Shri Krishna Kirtana*. His identity is a matter of great controversy.

Baka, Bakasura (Baka, Bakāsura)
(= heron, crane)

Bala s. Balarama

Balabhadra s. Balarama

Balacharita (Bālacarita)
(= account of the [life of the divine] child)
Drama by Bhasa.

Baladeva s. Balarama

Balagopala s. Krishna

Balaji s. Krishna

Balarama (Balarāma)
(= Rama the strong)
Brother of Krishna, son of Rohini. (s. Narrative) Some other names: Bala (Bala) = Strength; Balabhadra (Balabhadra) = Bala, the auspicious; Baladeva (Baladeva) = the one who delights in power; Sankarshana (Samkarsana) = he who draws or ploughs.
(s. Vyuha)

Balasaraswati
Famous *Bharata Natyam* dancer.

Bali (Bali)
(= offering)
King of the Asuras, father of Bana. He bestowed upon Vamana (s.) three steps of land to build his hut. As a consequence of the Vamana episode he became the ruler of Patala, the Netherworld, and thenceforward the Asuras became the inhabitants of the Netherworld.

Bana (Bāṇa) (= arrow)

Banjara/s (Bañjārā)
Name of a sub-caste of the Vaishyas, the third of the Hindu castes, consisting of merchants, traders, grocers and money-lenders. They are settled in western and central India.

Banke Bihari s. Krishna

Bansuri (Bāṅsurī)
End-blown flute. A cylindrical bamboo tube with one end stopped and eight finger holes.

Banyan
Ficus indica, ficus bengalensis.
Skr.: *Nyagrodha* = down-growing
Remarkable for its great spread of rooting branches. This tree is sacred to Vishnu.

Barahmasa (Bārahmāsā)
(= twelve months)
Poetical genre consisting of the description of the twelve months of the year. It has a long history, rooted in folk songs and in oral tradition. In the course of time it became very popular in courtly poetry and painting.

Basanta Ragini s. Vasanta Ragini

Besnagar (Besnagar)
The modern name of the ancient Vidisha, famous for a monolithic pillar erected by Heliodorus.

Bhadon s. Bhadrapada

Bhadrapada (Bhādrapadā)
Name of a month (rainy month, August/September). (s. Calendar) Some other names: *Bhadra* (Bhādra); *Bhadramas* (Bhādramās); *Bhadon* (Bhādoṅ).

Bhagavadgita (Bhāgavadgītā)
(= song of the Divine One)
A celebrated episode of the *Mahabharata*, in which Krishna, the chief speaker, expounds his philosophical and ethical doctrines to Arjuna.

Bhagavata (Bhāgavata)
Related or coming from Bhagavat, i.e. Vishnu or Krishna. The name of a theistic cult which stressed the importance of worship rather than sacrifice. The devotees of Krishna became known as Bhagavatas, who later merged with the Pancharatras, a Vaishnava sect.

Bhagavata Mela (Bhāgavata Mela)
A form of *Kuchipudi*. (s.)

Bhagavata Purana (Bhāgavata Purāṇa)
(c. A.D. 8th-10th cent.)
This P. is named Bhagavata from its being dedicated to the glorification of Bhagavat, i.e. Vishnu or Krishna. The most popular part of the Bh.P. is the tenth book, which narrates in detail the story of Krishna. In the same book there is a section of five chapters, called the *Rasa Panchadhyayi*, devoted to the description of the *rasa* play, interpreted as a symbol of the gradual arousal and development of religious feelings. This section inspired the most learned and deep philosophical commentaries. (s. *Purana*)

Bhagavati (Bhāgavatī)
(= the lady)
Name of a gracious aspect of Parvati.

Bhagavatism
Related to the Bhagavata cult.

Bhagya Chandra Rajarishi (Bhagya Candra Rajarṣi)
(1763-1798 reg.)
King of Manipur, great patron of arts and letters, he was a writer himself. It was to him that the creation of the traditional Rasa Lila dance of Manipur is owed.

Bhajan/s (Bhajan)
(= reverence, worship, adoration)
A song of devotional love, accompanied by drums and string instruments, based on traditional religious themes, usually associated with the worship of Krishna. In Bengal it is called a *kirtan*.

Bhakta Mala (Bhakta Mālā)
(= garland of devotees)
Title of a work written in the 17th century by Nabhaji. It is a collection of verses giving valuable information on many Vaishnava *bhaktas* (saints) up to the early 17th century.

Bhangi (Bhaṅgi, Bhaṅgī)
(= a roundabout mode of acting or speaking, irony, wit, repartee)

Bhanudatta (Bhānudatta)
(14th cent.)
Author of the Sanskrit poem, the *Rasamanjari*, 'A Posy of Delights', dealing with the classification of 'heroes' and 'heroines'. An important set of paintings depicting this work is discussed in the chapter on Krishna in the Visual Arts.

Bharata (Bharata)
One of the most important rulers of the early *Vedic* times.

Bharata (Bhārata)
1. Descendant(s) of Bharata.
2. One of the names of Arjuna. (s.)

Bharata Muni (Bharata Muni)
(c. A.D. 2nd cent.)
Author of the famous *Natyashastra*, 'Treatise on Dramaturgy'. He is regarded as the father of Indian drama and dance theory, as well as of aesthetic criticism.

Bharata Natya(m) (Bharatanāṭya)
Classical solo feminine dance from southern India (Tamil Nadu) born in the temple, devotional in spirit. The Bharata Natyam is evenly divided between pure dance (*nritta*), and expressional compositions (*nritya*). (s.)

Bhasa (Bhāsa)
(A.D. 3rd or early 4th cent.)
Dramatist and author of several notable plays and short dramas based on epic stories. Among his most famous works is the *Balacharita*. (s.)

Bhaskara (Bhāskara)
(1114-1160)
Mathematician and astronomer. Author, among other works, of the treatise *Lilavati* on algebra.

Bhattatiri s. Narayana Bhattatiri of Meppattur

Bhima (Bhīma)
(= fearful, terrible, tremendous)
The second of the five Pandava princes. He was the son of Kunti and of the wind god Vayu. His truculent adventures are narrated in the *Mahabharata*.

Bhishma (Bhīṣma)
(= the terrible)
The eighth and the last of the sons of the Ganga, the goddess of the river Ganges. One of the prominent and wisest characters in the *Mahabharata*.

Bhoja/s (Bhoja)
Name of a tribe residing near the Vindhya mountains.

Bhramaragita (Bhramaragītā)
(= song of the bee)
Poem by Nandadas.

Bhurishravas (Bhūriśravas)
A relation of the Kauravas.

Bilhana (Bilhaṇa)
(1040 ?-1130)
Author of the Sanskrit poem called the *Chaurapan-chashika*, the 'Fifty Stanzas of the (love) Thief'.
An important set of paintings illustrating this work is one of the most notable examples of Indian painting in the 16th century. (s. Kulahdar Group)

Bilva (Bilva)
Aegle marmelos; wood-apple tree.
Its fruit when unripe is used medicinally; its leaves are employed in the ceremonial worship of Shiva.

Bimba (Bimba)
Momordica coccinia. A climber with bright red fruit.

Bindu (Bindu)
(= dot)
Mark on the forehead.

Birsingh Deo (Bīr Siṅha Deva)
(+ 1627)
Bundela Rajput, King of Orchha (Bundelkhand). He was a great patron of the arts, especially of poetry. It was at his court that Keshavadasa lived and composed, among other works, the *Rasikpriya*, the 'Lover's Breviary' (1592).

Bodhisattva (Bodhisattva)
(= the Buddha-to-be)

Brahma (Brahmā)
The supreme spirit manifested as the active creator of the universe.

Brahma Sutra s. *Vedanta Sutra*

Brahma Vaivarta Purana (Brahmavaivartapurāṇa)
(c. 16th cent.)
(= metamorphoses of Brahma) who is identified with Krishna. The character of the work is decidedly sectarian, and the sect to which it belongs, that of the worshippers of Krishna and the cowherdess Radha, explains its comparatively recent date.

Brahman (nt.) (Brahman)
(= all-pervading, self-existent power)
The supreme soul of the universe, self-existent, absolute and eternal, from which all things emanate and to which all return.

Brahman (m.) also Brahmin (Brahman)
A person belonging to the first of the four castes; the sacerdotal class, the members of which may be, but are not necessarily, priests. A Brahan is the chief of all created beings; his person is inviolate; he is entitled to all honour and enjoys many rights and privileges.
The chief duty of a Brahan is the study and teaching of the *Vedas*, and the performance of the sacrifices and other religious ceremonies; but in modern times many Brahmans engage in most of the occupations of secular life.

Brahmana (Brāhmaṇa)
(= belonging to the Brahmins)
(possibly composed between 800 and 600 B.C)
Works written by and for the Brahmins. That part of the *Veda* which was intended for the use and guidance of Brahmins in the use of the hymns and in the performance of the rites.

Brahmo Samaj (Brāhmo Samāj)
(= Society of God)
It was founded by Rammohan Roy (1772-1833) in 1828. Through it he hoped to transform radically the face of Hindu life and of Hindu religion. No sacrifices or oblations of any kind were permitted; no images, statues or paintings were allowed in the halls of worship, only monotheistic services, prayers and hymns were allowed. He introduced congregational worship.

Braja, Braj s. *Vraja*

Braja Rasa, Braj Ras (Brāja Rāsa) s. *Kathak*

Brajnathji s. *Krishna*

Brihashpati, Brihaspati (Bṛhaspati)
(= prayer lord)
The preceptor of the gods, also called Guru.

Buddha (Buddha)
(= the enlightened one)
1. s. Siddharta Gautama.
2. The ninth incarnation of Vishnu (s. Dashavatara). Vishnu is said to have appeared as Buddha to encourage demons and wicked men to despise the *Vedas*, reject caste and deny the existence of the gods, and thus to effect their own destruction.

Buddhacharita (Buddhacarita)
Poem written by the famous philosopher Ashvaghosha (s.); it is the first great work of the court epic and deals with the life of the Buddha.

Chaitra (Caitra)
Name of a month (March/April), beginning of the year in northern India. (s. Calendar)

Chakdar (Cākdār)
Jama (s.), coat, which had four pointed prolongations, two on each side of the hem of the skirt. Typical of the Rajputs.

Chakora (Cakora)
Alectoris graeca, a Himalayan partridge said to feed on the moonbeams and to be the lover of the moon.

Chakra (Cakra)
(= wheel, discus)
This term generally designates the discus held by Vishnu. (s. Sudarshana.)

Champaka, Champa (Campaka, Campa)
Michelia champaka; a large tree with fragrant light yellow flowers.

Chandala (Caṇḍāla)
(= wild)
The lowest in the whole heirarchy of the castes were the Chandalas. In Sanskrit writings they stood for everything that was unclean, unrighteous, irreligious and damned in humanity. Generally they were employed as executioners or as attendants on the cremation grounds.

Chande (Caṇḍe)
A cylindrical drum hollowed out of a single piece of wood with parchment head. It is struck by two sticks.

Chandra Kirti (Candra Kīrti)
(1832-1886)
King of Manipur. He is also credited with having created a *Ras* dance, known as *Nartana Ras* as well as sixty-four other dances based on the Manipuri drum technique.

Charanas (Cāraṇas)
A class of supernatural beings. Heavenly minstrels.

Carchari (Carcārī)
A kind of song, musical symphony, festive cries and merriment, festive sport.

Charyapada (Caryāpada)
The earliest extant specimens in Bengali are the *charyas*, short lyrical songs, composed between the 8th and the 12th centuries and embodying the tenets of the Buddhist Sahajiya sect. The word *charya* means: deportment, usage, behaviour, due observance of all rites and customs.

Chataka (Cātaka)
Cuculus melanoleucas; a type of swallow said to drink only raindrops as they fall from the clouds.

Chaturbhuja Das (Caturbhuja Dās)
(16th cent.)
Disciple of Vitthalnath. One of the *ashtachhap* (s.) poets.

Chedi(s) (Cedi)
Name of a kingdom and of its people. This kingdom was situated in northern India and was counted as one of the most prominent of ancient Bharata (India). One of the Chedi rulers was Shishupala.

Chera (Cera)
Ancient name of Kerala. The Chera kingdom covered a territory along the coast as far north as Konkan, embracing Malabar, Cochin and Travancore. The leading Chera dynasty were the Perumal Kings (A.D. 400-826).

Chhandogya Upanishad (Chāndogya Upaniṣad)
The *upanishad* (s.) of the 'singer of hymns'. One of the oldest of the *upanishads*, this work is particularly distinguished by its rich store of legends regarding the gradual development of Brahmanical theology.

Chhitasvami (Chitasvāmī)
(16th cent.)
Disciple of Vitthalnath. One of the *ashtachhap* (s.) poets.

Chiraharana (Cirāharaṇa)
(= stealing of clothes) s. Narrative.

Chitralekha (Citralekhā)
(= skilled in painting)

Chola (Coḷa)
Name of an ancient Tamil kingdom on the lower east coast of India along the banks of the river Kaveri. It is mentioned in the Epics, in the *Jatakas* and the *Puranas*, but its early history is obscure. The kingdom rose to prominence in the 9th century, and was the paramount power in southern India till the 13th century. Famous for its art patronage; especially noteworthy is the art of metal sculpture, which achieved an uncommonly high standard.

Choti (Coṭī)
Piece of black cloth hanging from the turban.

Company School
Paintings done by Indian artists for British patrons during the 18th and 19th centuries. The paintings try to imitate the style and the taste of contemporary European works.

Crore (Karoṛ)
Ten million.

Curtius Rufus Quintus
(A.D. 1st cent.)
Author of a history of Alexander the Great: *De rebus gestis Alexandri Magni*.

Daitya(s) (Daitya)
1. (= descendant(s) of Diti), giants or titans.
They figure only in post-*Vedic* literature, where they are represented as demons generally opposed to the gods.
2. A special group of priests attached to the temple of Jagannath at Puri (s.).

Calendar

Months of the year in the traditional Hindu calendar and their English equivalents:

Chaitra	March/April	Spring	Vasanta
Vaishakh	April/May		
Jyeshtha	May/June	Summer	Grishma
Asharh	June/July		
Shravana	July/August	Rainy Season	Varsha
Bhadon	August/September		
Ashvina	September/October	Autumn	Sharada
Kartika	October/November		
Aghana	November/December	Winter	Hemanta
Pausha	December/January		
Magha	January/February	Cool Season	Shishira
Phalgun	February/March		

Each month is divided into two fortnights or 'wings' called *paksha*. These are referred to as: *badi*, or *krishna paksha* (dark fortnight, i.e. waning moon) and *sudi*, or *shukla paksha* (light or bright fortnight, i.e. waxing moon). Each month starts on the day after the full moon. This is according to the traditional northern Indian calendar.

Dakshina (Dakṣiṇa)
Gift given by the institutor of a sacrifice to the officiants. (s. Gurudakshina)

Damaghosha (Damaghoṣa)
Father of Shishupala, king of the Chedi.

Damodara s. Krishna

Danava(s) (Dānava)
(= descendants of Danu), i.e. of one of the daughters of Diti. They figure mostly in post-*Vedic* texts. Enemies of the gods, they are represented generally as native tribes opposed to political and religious Indo-Aryan expansion.

Dapha (Daf)
Rim-type drum. A wooden or metal frame on which parchment is either laced or pasted. It can be played by striking it with different parts of the hands or with drum-sticks.

Darbar (Darbār)
A court, an audience or a levee: also the executive government of a state.

Das (Dās)
(= slave, servant)
It appears frequently as part of names. e.g. Govindadas = servant of Govinda.

Dasharha s. Krishna

Dashavatara (Dāśāvatāra)
(= ten avataras)
The ten incarnations (lit. descents) of Vishnu: 1. Matsya (Fish); 2. Kurma (Tortoise); 3. Varaha (Boar); 4. Narasinha (Man-lion); 5. Vamana (Dwarf); 6. Parashurama (Rama-with-the-axe); 7. Ramachandra (Rama); 8. Krishna/Balarama; 9. Buddha; 10. Kalki (the White Horse). (s. individual entries)

Deva (Deva)
A celestial power; the deification or personification of natural forces and phenomena, each distinguished by a name and by particular attributes.

Devakinandana s. Krishna

Devi (Devī)
The general term for a goddess; the feminine form of *deva*, god or celestial power.

Dhananjaya s. Arjuna

Dharma (Dharma)
1. Moral and religious duty, law, custom; that which forms a foundation and upholds or constitutes law and custom. D. implies movement, change, dynamic qualities, the chief characteristics of natural law.
2. King = Yudhishthira.

Dhiraj Pal (Dhiraj Pāl)
(1695-1725 reg.)
Raja of Basohli, son of Kirpal Pal, scholar and patron of the arts.

Dhoti (Dhoṭī)
A cloth worn around the waist and passing between the legs.

Diti (Diti) (= limited, bounded)
In contradistinction to Aditi. She is the goddess of earthly phenomena.

Doha (Dohā)
Rhymed couplet in which each line contains 24 metrical units.

Draupadi (Draupadī)
Daughter of Drupada, king of Panchala. She is the wife of one of the five Pandavas and one of the principal figures of the *Mahabharata*. Also called Krishna (Kṛṣṇā) and Panchali (Pāñcālī). (s. Narrative)

Drona, Dronacharya (Droṇa, Droṇācārya)
The military preceptor of the Kauravas and of the Pandava princes. He was the father of Ashvatthama. (s. Narrative)

Dubois, J(ean) A(ntoine) (Abbé Dubois)
(1765-1848)
Christian missionary, who was in India for about thirty-one years. He is the author of a remarkable work entitled *Description of the Character, Manners and Customs of the People of India and of their Institutions, Religious and Civil*, which gives a clear and trustworthy picture of the state of India from 1792 to 1823.

Duhshasana, Dushasana (Duhśāsana, Duśśāsana)
(= hard to rule)

Durga (Durgā)
(= inaccessible)
A composite goddess embodying a number of local divinities and demonesses associated with mountains, vegetation and fire. She is portrayed in the *Puranas* and Epics as a female warrior, the bloodthirsty destroyer of giants and *Asuras*.

Duryodhana (Duryodhana)
(= hard to conquer)
The eldest son of the king Dhritarashtra, who became leader of the Kauravas in the war against the Pandavas. One of the most prominent figures in the *Mahabharata*. (s. Narrative)

Dvadashi (Dvādaśī rātri or tithi)
(= twelfth) day of a fortnight.

Dvapara Yuga (Dvāpara Yuga)
The second of the four *yugas*.

Dvaravati (Dvāravatī, Dvārāvatī)
Another name of Dvarka.

Dvarka, Dvaraka (Dvarka, Dvārkā)
(= many-gated)
City on the shore of the Arabian Sea, capital of Krishna's kingdom. (s. Map) (s. Narrative)

Dvarkadish s. Krishna

Ekadashi (Ekādaśī rātri or tithi)
(= eleventh) day of a fortnight.
The E. of every lunar fortnight is held as particularly auspicious and many rites, ceremonial fasts, etc. take place on this day.

Ektara (Ektara)
(= one string)
One-stringed instrument, consisting of a bowl-shaped gourd resonator pasted over with parchment, with a hole through which a long bamboo stick is passed. A steel string tied on the underside to the projecting body is passed across a bridge to the tuning peg on the upper end. Held vertically in the hand it is plucked by the finger.

Elorembavay (Ēlōrembāvāy, Ēlōrempāvāy)
The meaning of this phrase is very doubtful. It can be interpreted as a supplication to a god.

Fattu (Fattu)
(18th/19th cent.)
Painter. One of the most renowned artists of Sansar Chand's atelier.

Gandharva(s) (Gandharva)
Semi-gods. Divine musicians dwelling in the atmosphere.

Gandiva (Gāṇḍiva)
Name of the magical bow of Arjuna, which possessed the power of a thousand bows and had two inexhaustible quivers. It was presented to Arjuna by Agni, but after the departure of Krishna to heaven lost its power.

Ganesha (Gaṇeśa)
(= lord of the *ganas*, i.e. goblins)
The god of wisdom, the protector of scholars, artists and of all those starting any new activity. He is particularly fond of sweets and easily recognisable because of his elephant head. He is the son of Parvati.

Garib Nivas (Garib Nivas)
(= protector of the poor)
(16th cent.)
King of Manipur. He came under the influence of the Vaishnavas, and as a result of this a great change in the religious and cultural history of Manipur took place.

Garuda (Garuḍa)
(= the devourer)
A mythical being, half-man half-bird, on which Vishnu rides. It is the subject of numerous stories in the Epics and in the *Puranas*.

Gayasukumara Rasa (Gayasukumāra Rāsa)
Old Gujarati work, possibly composed in 1250, by Delhana. Gayasukumara was, according to the Jains, the younger brother of Krishna-Vasudeva. As an ascetic he remained unswerved in his meditation in the face of extreme physical torture and consequently attained omniscience.

Ghamandi (Ghamandī)
(16th cent.)
Alleged initiator of the Ras Lila.

Ghanashyama s. Krishna

Ghat (Ghāṭ)
Any approach, step or path to a pond, a stream, a river, used for bathing, fetching water and washing clothes.

Ghata Jataka (Ghāṭa Jātaka)
One of the Jatakas (s.).

Ghi (Ghī)
Clarified butter.

Ghora Angirasa (Ghora Aṅgirasa)
A son of the sage Angiras, reputed to be Krishna's teacher.

Ghosundi (Ghosūṇḍī)
Archaeological site near Nagari in the Chitorgarh district of Rajasthan.

Giri (Giri)
(= Mountain)

Giridhar Gopal(a) s. Krishna

Gita Govinda (Gītā Govinda)
(= song of the cowherd)
Poem by Jayadeva written in the 12th century in Sanskrit. This poem describes the amorous adventures of the young Krishna with the lovely Radha.

Godhu (Gaudhu)
(18th cent.)
Painter. Son of the famous painter Nainsukh. He was apparently attached to the court of Sansar Chand of Kangra.

Gokul(a) (Gokul, Gokula)
(= cow-house or station)
A pastoral district on the Yamuna near Mathura, where Krishna passed his boyhood with the cowherds. (s. Map) (s. Narrative)

Gokulachandrama s. Krishna

Goloka (Goloka)
(= Cows' world, place of the cows)
Krishna's paradise situated on Mount Meru.

Gopa(s) (Gopa, Gopā)
(= cowherd)

Gopala s. Krishna

Gopi(s) (Gopī)
(= female cowherd)

Gopivallabha s. Krishna

Gosvami (Gosvāmī)
(= master of the senses)
Honorific title of the families whose hereditary right it is to tend the great temples of Vrindavana and surrounding Vraja. This title is reserved for the priestly lineages that became established in Vraja by transplant from elsewhere in India in the sixteenth century.

Govardhan Chand (Govardhan Cand)
(1713-1773 reg.)
Ruler of Guler. Devoted to Krishna, he built some temples. At his court worked the most distinguished artists of the time: Manak, Kushala and Fattu, Gaudu and others.

Govardhana (Govardhana)
(= increaser of cattle)
Name of a mountain in Vrindavana. (s. Map) (s. Narrative)

Govardhanadhari s. Krishna

Govinda s. Krishna

Govindabhishekam (Govindābhiṣekam)
The lustration of Krishna performed by Indra, after the Govardhana-episode. (s. Narrative)

Govindasvami (Govindasvāmī)
(16th cent)
Disciple of Vitthalnath. One of the *ashtachhap* (s.) poet.

Guha s. Kartikeya

Guna (Guṇa)
(= quality)
This term is extensively employed in many branches of Hindu learning. It is used to indicate the attribute or property of a thing. The *gunas* exist in all individuals in varying degrees.

Gupta (Gupta)
(A.D. 320-510)
Name of a dynasty of northern India. The Gupta epoch marks an unprecedented flourishing of literature and the arts.

Guru (Guru)
1. (= teacher)
2. Other name of Brihashpati (s.)

Gurudakshina (Gurudakṣiṇa)
The honorarium or gift given by the institutor of the sacrifice to its priestly officiant. It is not a fee nor a required gift, though one is expected.

Hamza Nama (Hamza Nāmā)
The *Dastan-i Amir Hamza* ('Story of Hamza') illustrates the adventures of Amir Hamza, an uncle of the Prophet. The story was very popular in the pre-Mughal Sultanates and in 1567 Akbar commissioned a copy in twelve volumes, 1,400 paintings in all. According to contemporary accounts the compositions were drawn by Mir Sayyid Ali (s.) and Abd as Samad (s.), but painted by fifty or more recruits. Thus the Hamza Nama was the training ground of Akbari painting.

Hara s. Shiva

Hari s. Vishnu

Haridas(a) (Haridāsa, Haridās)
(16th cent.)
Alleged initiator of the Ras Lila.

Harivansha (Harivaṇśa)
(= genealogy of Hari)
Work written in pauranic style which forms an appendix to the *Mahabharata*. It consists of three books, the second of which narrates the story of Krishna.

Hastinapura (Hastināpura)
Capital city of the Pandavas, about 57 miles north of Delhi. It was founded by Hastin, the first Bharata king. Most of the city has been washed away by the Ganges.

Heliodorus
Greek ambassador of the Indo-Greek king Antialkidas of Taxila, who erected a pillar in Besnagar in honour of the god Vasudeva (Vishnu) in 90 B.C.

Hemachandra (Hemacandra)
(1088-1172)
Jain scholar, wrote numerous major Sanskrit works on subjects both in the scientific and literary fields. His *Kavyanushasana*, 'Instructions in Poetry', contains an important section on dramaturgy.

Hiranyakashipu (Hiranyakaśipu)
(= having golden garments)
A mythical *daitya*, killed by Vishnu in his Man-lion incarnation. (s. Narasinha - *avatara*)

Hiranyaksha (Hiranyākṣa)
(= golden-eyed)
A *daitya* who dragged the Earth to the depth of the Ocean. He was killed by Vishnu in his Boar incarnation. (s. Varaha-*avatara*)

Hoyshala (Hoyśāḷa)
(1006-1343)
A dynasty of Mysore which arose from the ruins of the Chalukyan empire. Its traditional founder was Shala, (1006), who established his capital at Dorasamudra, today's Halebid (i.e. Old Capital), and developed two religious centres at Belur and Somnathpur. The Hoyshalas are notable for having raised some unique temples in their florid style. The best examples of Hoyshala architecture are the temples built in the 12th and 13th centuries at Belur, Halebid and Somnathpur.

Humayun (Humāyūn)
(1507-1556)
Son of Babur, the first of the Mughals, unable to consolidate his father's conquests, Humayun was driven out of India by Sher Shah. Irresolute but sensitive, Humayun spent many years at the Persian court of Shah

Tahmasp. He was to come back to India in 1555, accompanied by two of the leading courtly painters, Abd as Samad and Mir Sayyid Ali.

Indra (Indra)
Son of Aditi. Initially regarded as the chief of the gods, bestower of rain, of cattle and of other material benefits. Another name: Shakra (Sakra) = strong, powerful.

Indra Brahmachari (Indra Brahmacāri)
Author of the *Shrikrishnalila-rahasya*, 1938. A four-volume collection which provides a substantial and representative sampling of the literature on which the playwrights of the Krishna Lila depend.

Indradyumna (Indradyumna)
A pious king who, directed by Vishnu, requested the divine artist Vishvakarma to mould an image from the holy relics of Krishna.

Indraprastha (Indraprastha)
(= Indra's place)
The ancient capital of the Pandavas, believed to be situated near old Delhi.

Jaganmohan(a) s. Krishna

Jagannath(a) s. Krishna

Jai Singh I (Jai Singh)
(1625-1667)
Raja of Amber (Jaipur). One of the greatest generals and diplomats of the 17th century, he held a key position in the Deccan policy of Aurangzeb. Great patron of the arts.

Jainism
Religious movement of extreme antiquity, whose last reformer, Mahavira (5th cent. B.C.), is regarded as its historical founder. Jain speculation is marked by dogmatism, a precise dialectical method and a passionate predilection for numbers. Jainism developed its own art forms, especially in painting.

Jama (Jāma)
Type of coat with full sleeves and pleated skirts, the length of which varies.

Jambusvami Charita (Jambusvāmi Carita)
Old Gujarati poem by Dharma (1210). Jambusvami was the fourth Jaina pontiff of the Jaina pontificate which started with Mahavira.

Janardana s. Krishna

Jataka(s) (Jātaka)
(= birth)
Title of a collection of tales composed in Pali narrating the previous lives of the Buddha, of his successive rebirths in the animal kingdom until his reincarnation among human beings. The tales form part of the early Buddhist literature.

-ji (-jī)
Suffix denoting respect.

Jina(s) (Jina)
(= victorious)
Name given to the Jaina prophets.

Jishnu s. Arjuna

Jiva (Jīva)
(= existing, living)
State of consciousness. It is temporary and individual, subject to the vicissitudes of the empirical world.

Jiva Gosvami (Jīva Gosvāmi)
(16th cent.)
Great scholar, nephew of Rupa and Santana whom he assisted in defining the theology of Chaitanya.

Jnana (Jñāna)
(= knowing, the acquisition of knowledge)
The way of knowledge (*jnana yoga*): one of the three ways to acquire control over one's own psychic powers.

Jnanadeva (Jñānadeva)
(1275-1296)
Marathi saint-poet. Author of the *Jnaneshvari* (1290), a free rendering of the *Bhagavadgita* in Marathi. He also wrote devotional Vaishnavite hymns, often substituting Vitthal and Rukmini for Krishna and Radha.

Jnanappana (Jñānāppana)
Malayalam poem, 'Song of Wisdom', in praise of Krishna. Its author was Puntanam Nambudiri.

Jobares
The Greek name of the river Yamuna.

Jyeshtha (Jyeṣṭha)
Name of a month (May/June). (s. Calendar)

Kadamba tree (Kadamba)
Ipomoea aquatica.
A tree sacred to Krishna.

Kala s. Krishna

Kalanemi (Kālanemi)
(= rim of the wheel of time)

Kalayavana (Kālayavana)
(= black Yavana)

Kali Yuga (Kali Yuga)
(= the dark age)
The present age, fourth and last of the four *yugas*. (s.)

Kalindi (Kālindī)
Another name of the Yamuna river.

Kaliya (Kāliya)
(= black)
A son of Kadru. The chief of the Nagas, dwelling in the Yamuna river. He is represented as a five-hooded snake. (s. Narrative)

Kalki (Kalki)
(= white horse, sinful, impure)
The future incarnation of Vishnu, variously described as a hero mounted on a white horse, a giant with a white horse's head, or simply as a white horse. His mission will be to restore the law of right and justice. (s. Dashavatara)

Kalyan Rai s. Krishna

Kama (Kāma)
(= desire)
The god of love, son of Lakshmi.

Kamashastra (Kāmaśāstra)
(= treatise on the art of love)

Kanhaiya s. Krishna

Kanka (Kaṁka)
Younger brother of Kansa.

Kansa (Kaṇsa)
(= brass)

Kansavadha (Kaṇsavadha)
(= the killing of Kansa)

Kanu s. Krishna

Karma (Karma)
(= action, deed)
According to Hindu beliefs, the full effect of actions performed in this life or in a former one is the factor that determines one's present and future character and form.

Karna (Karṇa)
Natural son of Kunti and of the Sun god. One of the principal characters in the *Mahabharata* war, the chief rival of the Pandava prince Arjuna.

Karnikara tree (Karṇikāra)
Pterospermum acerifolium.
A large tree with broad leaves.

Kartik (Kārtika)
Name of a month (October/November). Beginning of the year in some parts of Gujarat and of southern India. (s. Calendar)

Kartikeya (Kārtikeya)
(= son of the Krittikas, i.e. of the Pleiads)
Name of the son of Shiva.
Another name: Guha = the secret one.

Kashiputra Bhagabhadra (Kaśiputra Bhāgabhadra)
(1st cent. B.C.)
A Shunga king, contemporary of Heliodorus.

Kathak (Kathak)
Type of dance. A major solo style of dance of northern India. It can be performed by both men and women. The dance we know today is a synthesis of two streams: the sacred and the secular. Its source is the devotional,

mimetic recitation of the storytellers attached to the temples of the Vraja (Braj) region, hence the name of Braj Ras. With the advent of the Mughals, the Kathak style moved to the courts of kings and nobles and acquired much of its present polish and grace.

Kathakali (Kāthakali)
(= story-play)
Dance-drama of Kerala.
(s. Krishna in the Performing Arts.)

Kaunteya (Kaunteya)
(= descendant of Kunti)

Kaurava(s), Kuru(s) (Kaurava, Kuru)
The descendants of Kuru. The cousins and rivals of the Pandavas, with whom they fought the great battle for the conquest of the kingdom whose capital was Hastinapura. (s. Mahabharata)

Kauravya (Kauravya)
(= descendant of Kuru)

Kaustubha (Kaustubha)
A magical jewel which emerged from the Churning of the Milky Ocean (s. Mandara). Vishnu/Krishna wears it on his chest.

Kavya (Kāvya)
(= poem)
In Sanskrit literature this is an extended poetical composition distinguished for its artifice, mannerism and erudition.

Kesara (Kesara)
Mimusops elengi. Tree with medicinal properties.

Keshava s. Krishna

Keshi (Keśī)
(= long haired)

Kinnara(s) (Kinnara)
(= what [kind of] men?)
Mythical beings with the form of a man and the head of a horse. They are celestial choristers and musicians dwelling in Kubera's paradise on Mount Kailasa.

Kinpaka (Kinpāka)
Trichosantes palmata, or *Strychnos nux vomica.*
A cucurbitaceous plant of a very bad taste.

Kirpal Pal (Kirpāl Pāl)
(1650-1693)
Raja of Basohli, very religious and great scholar. He was a patron of the arts and learning.

Kirtan (Kīrtan)
Devotional singing consisting of repetitive chanting of the names of God, specifically of Vishnu/Krishna.

Kirti Simha (Kīrti Siṇha)
(1370-1380 reg.)
King of Mithila father of Shiva Simha and patron of Vidyapati. It is in his honour that Vidyapati wrote his eulogy *Kirtilata,* i.e. 'The Creeper of Glory'.

Kishen s. Krishna

Kishora (Kiśora)
(= Adolescent)

Kleisobora
Greek name of Krishnapura. Possibly this name would refer to Vrindavana, or some other locality associated with the Krishna cult.

Kokila (Kokila)
Eudynamis scolopaceus.
A dark bird commonly found in mango gardens, during the flowering and fruiting periods.

Kotavi (Koṭavī, Koṭṭavī)
(= naked woman)
A powerful demoness identified later with Durga. She was the mother of Bana.

Koti (Koṭi)
A large number. Usually ten million.

Kripa (Kṛpa)
A master in archery, who trained the Kauravas and the Pandavas in this art.

Krishna (Kṛṣṇa)
Names and epithets.
Krishna being an incarnation of Vishnu shares with him his one thousand names. There are, however, names and epithets referring exclusively to Krishna, deriving

from his appearance, his adventures and his exploits. Here is a list of the names and epithets of Krishna mentioned in the present work.

Balagopala (Bālagopāla) = child-cowherd.
Balaji (Bālajī) = the dear child. Especially worshipped at Surat and in Saurashtra. The image shows the infant crawling along with a ball of stolen butter in his right hand. Balaji is one of the principal images of the Vallabhacharis.
Banke Bihari (Bānke Bihārī) = the most handsome of those that wander in the fragrant groves.
Brajnathji s. Shri Brajnathji
Damodara (Dāmodara) = with a rope around his belly
Dasharha (Daśārha) = descendant of Dasharha, a Yadava king.
Devakinandana (Devakīnandana) = son of Devaki
Dvarkadish, Dvarkanathji (Dvārkadiś, Dvārkānāthjī, Dvārkanāthjī) = Lord of Dvarka. Four-armed image of Vishnu, apparently carved from a black stone, carrying the usual attributes: in the upper hands, discus and mace, and in the lower hands, conch and lotus flower. This image, one of the principal images of the Vallabhacharis, is enshrined in a large *haveli* at Kankroli, north of Nathdwara.
Ghanashyama (Ghanaśyāma) = dark as a cloud.
Giridhar Gopal(a) (Giridhar Gopāl, Giridhār Gopāl) = the cowherd lifting the mountain.
Gokulachandrama (Gokulacandramā) = moon of Gokul. This image shows Krishna as a dark-coloured youth playing the flute. It is enshrined at Kamvan, near Mathura, and is one of the principal images of the Vallabhacharis.
Gopala (Gopāla) = protector of the cows.
Gopivallabha (Gopīvallabha) = beloved of the *gopis.*
Govardhanadhari (Govardhanadhari, Govardhanadhāri) = the uplifter of the Mount Govardhana.
Govinda (Govinda) = cowherd.
Jaganmohan(a) (Jaganmohana) = the enchanter of the world.
Jagannath(a) (Jagannātha) = Lord of the world. The aspect of Krishna worshipped at Puri.
Janardana (Janārdana) = agitating men.
Kala (Kāla) = the dark one.
Kalyan Rai (Kalyāṇ Rāi) = auspicious, excellent, prosperous lord. This aspect of Krishna is especially revered at Kishangarh.
Kanhaiya (Kanhaiyā) = handsome youth.
Kanu (Kānu) = handsome youth.
Keshava (Keśava) = with long, handsome hair.
Kishen = Name found in the Greek accounts of the 1st cent. B.C.
Krishna (Kṛṣṇa) = the dark one.
Kunjavihari (Kuñjavihārī) = one who wanders in the fragrant groves.
Lalji (Lāljī) = the dear one.
Lila Purushottama (Līlā Puruṣottama) = the sublime player.
Madana Gopala (Madana Gopāla) = the lovely cowherd.
Madana Mohana (Madana Mohana) = alluring as the god of love. This image shows Krishna playing the flute, with four arms, the upper right holding a ball of butter. The image is gold in colour and is attended by a female figure on either side. It is enshrined at Kamvan near Mathura. One of the principal images of the Vallabhachari.
Madhava (Mādhava) = honey-sweet, vernal.
Madhava (Mādhava) = son or descendant of the Yadava Madhu.
Madhusudana (Madhusūdana) = slayer of the demon Madhu.
Makhanchor (Mākhancor) = butter-thief.
Mohana (Mohana) = bewildering, perplexing, infatuating, fascinating.
Muralimanohar (Muralīmanohar) = the handsome one with the flute.
Murari (Murāri) = the enemy of Mura.
Nandagopan (Nandogopān) = cowherd Nanda.
Nandalal (Nandalāl) = Nanda's darling son.
Nandanandana (Nandānandana) = son of Nanda.
Narayana (Nārāyaṇa) = moving on the waters, son of the waters.
Natavara (Nāṭavāra) = the foremost of the dancers.
Navanitapriya (Navanītapriyā) = lover of fresh butter. Especially revered at Nathdwara, it is the household deity of the head priest of the Shri Nathji *haveli.* This image, one of the principal of the Vallabhacharis, is said to

have been found by Vallabhacharya himself in the Yamuna.
Parthasarati (Pārthasārati) = the charioteer of Partha (i.e. Arjuna).
Ranchhorji (Raṇchodjī) = he who fled from the battlefield (allusion to the episode of Kalayavana). Especially worshipped at Dvarka.
Rasashiromani, Rasakashiromani (Rāsaśiromani) = musician-dancer supreme.
Sanvara (Sānvarā) = dark one.
Shauri (Śauri) = descendant of Shauri, i.e. Vasudeva.
Shri Brajnathji (Śrī Brājnāthjī) = lord of Braja. Krishna in this aspect is especially worshipped at Kota.
Shri Nathji (Śrī Nāthjī, Śrī Nātha) = the lord of Shri, (i.e. Lakshmi). Aspect of Krishna especially worshipped at Nathdwara. He appears in this image in the form of the Lord of Mount Govardhana. He stands with his left hand raised to hold up the mountain.
Shri Thakurji (Śrī Thākurjī) = the honourable lord.
Shyama (Śyāma) = the dark one.
Vallabha (Vallabha) = the beloved one.
Vanamali (Vānamāli) = wearer of a garland of forest flowers.
Vasudeva (Vāsudeva) = descendant of Vasudeva.
Venu Gopala (Veṇu Gopāla) = the cowherd with the flute.
Vihari (Vihārī) = the one who wanders about at pleasure.
Vrajakishor (Vrājakiśor) = the handsome boy from Vraja.
Yadavendra (Yādavendra) = lord of the Yadavas.
Yadupati (Yadupāti) = lord of the Yadus.

Krishna Das(a) (Kṛṣṇa Dās)
(16th cent.)
Disciple of Vallabhacharya. One of the *astachhap* (s.) poets.

Krishna Dvaipayana Vyasa (Kṛṣṇa Dvaipāyana Vyāsa)
(= dark-skinned, island-born arranger [of the *Vedas*])
Also called Veda-Vyasa. The arranger, editor or compiler of the *Vedas* (s.). A mythical *rishi* reputed to be the traditional compiler of the *Mahabharata* (s.).

Krishnattam (Kṛṣṇāttam)
Dance-drama developed in Kerala by Manavedan (s.), Zamorin of Calicut. This dance drama, intimately connected with the Guruvayur temple was based on the model of a folk dance. For the sake of staging the *Krishnattam,* Manavedan composed the *Krishnagiti* in Sanskrit. It consists of eight dramas, depicting the most crucial events of Krishna's life. They are staged at night in the temple precincts.

Kshatriya (Kṣatriya)
A person belonging to the class of the warriors, the second of the four castes. This class included also the royal house, the various branches of the royal family, and possibly also the nobles and their families.

Kubera (Kubera)
A *yaksha,* the lord of riches. One of the eight guardians of the world (*lokapala*). He is the lord of the Northern Regions.

Kubja (Kubjā)
(= hunch-back) (s. Narrative)

Kuchipudi (Kuchipudi)
One of the major styles of classical dance. It took its name from the village of Kuchipudi, Andhra Pradesh, where it originated as a form of dance-drama based on religious themes. It is only in recent times that it has begun to be performed as a solo dance and by women. Similar in many ways to the *Bharata Natyam* (s.), it has its own distinctive music and a more plastic, fluid line.

Kulahdar group of paintings (Kulāhdār)
(= having a crest)
Name of a school of painting which flourished in northern India in the 16th cent., so called because of the typical shape of the turbans worn by the male figures. This school is also called *Chaurapanchashika* school of painting because the only extant illustrations to this poem are in this style.

Kulashekhara (Kulaśekhara)
(A.D. 9th cent.)
Name of a Chera king, who wrote a work in praise of Vishnu, the *Mukundamala.*

Kumbha (Kumbha)
Name of a month (February/March). (s. Calendar)

Kumbha Rana (Kumbha Rana)
(1433-1468 reg.)
One of the greatest rulers of medieval India. He spent two thirds of his ruler's life on the battlefield but could still find time to devote to the cultivation of the arts and literature. Buildings such as the Kirtistambha (Tower of Fame) at Chitor, or his musical treatises bear testimony to his wide range of interests and patronage.

Kumbhan Das (Kumbhan Dās, Kumbhandās)
(16th cent.)
Disciple of Vallabhacharya. One of the *ashtachhap* poets. (s.)

Kumkum (Kumkum)
Powdered saffron.

Kunda (Kunda)
Jasminum pubescens.
A kind of jasmine.

Kundinapura (Kuṇḍinapura)
The capital of ancient Vidarbha, modern Berar, seat of King Bhishmaka. (s. Narrative)

Kunja (Kuñja)
Thicket, grove, a secret place in the forest.

Kunjavihari s. Krishna

Kunti (Kuntī)
Sister of Vasudeva. Her son Karna was born from her connection with Surya, the Sun god. Subsquently she married the king Pandu and bore three sons: Yudhishthira, Bhima and Arjuna. She is also called Pritha.

Kurma (Kūrma)
(= tortoise)
The second incarnation of Vishnu. (s. Dashavatara) The tortoise was used to support Mount Mandara, which served as churning stick when the gods and the *asuras* churned the ocean (*samudramanthana*). (s. Mandara)

Kurma Purana (Kūrma Purāṇa)
(c. A.D. 900)
One of the *Puranas* (s.). Vishnu as tortoise explains the purpose of life. It glorifies the worship of Shiva and Durga.

Kuru(s) s. Kaurava(s)

Kurukshetra (Kurukṣetra)
(= land of the Kauravas)
An extensive plain near Delhi where the great battle between the Kauravas and the Pandavas was fought. Also an important pilgrimage place. (s. The Cult) (s. Map)

Kushala, Kushan Lal (Kuṣan Lāl)
(18th cent.)
Painter. He was the favoured painter of Sansar Chand of Kangra.

Kushana(s) (Kuṣāṇa)
(c. A.D. 78-200)
Name of a famous dynasty who ruled over northern India. The Kushana epoch marks the second great era of Indian political, social and religious development.

Laddu (Laḍḍū)
Round-shaped sweets. The favourite dish of the elephant-headed god Ganesha.

Lakh (Lakh)
(= one hundred thousand)

Lakshmana Bhatta (Lakṣmaṇa Bhaṭṭa)
Vallabha's father.

Lakshmanasena, Lakshmana Sena (Lakṣmaṇasena)
(12th cent.)
King of Bengal. It was at his court that Jayadeva flourished.

Lakshmi (Lakṣmī)
(= good fortune)
The goddess of prosperity, wealth and fortune, consort of Vishnu and mother of Kama.
Some other names: Shri (Śrī) = splendour, radiance; Tamil name: Nappinnai (Nappiṇṇai)

Lalji s. Krishna

Lallu Kavi s. *Prema Sagara*

Lanka (Laṅkā)
The name is frequently used in the *Ramayana* to denote the island of Ceylon, the modern Shri Lanka.

Lasya (Lāsya)
Dance characterised by graceful and languorous movements. Meant for female roles.

Lila (Līlā)
(= play or display)
1. *Lila* is often translated as 'sport' or 'whim' and applied to the spontaneous, unpremeditated act of creation or destruction.
2. Playets on the life of Krishna.

Lila Purushottama s. Krishna

Lodi Sultans (Lodī Sulṭāns)
(1451-1526)
Afghan dynasty settled in northern India with its capital in Delhi, defeated by Babur at Panipat in 1526.

Madana Gopal(a) s. Krishna

Mandana Mohan(a) s. Krishna

Maddale (Maddale)
A barrel-shaped drum played on both ends with the hands.

Madhava s. Krishna and also Madhu

Madhavi (Mādhavī)
Hiptage madhablota.
Climber, herald of spring.

Madhu (Madhu)
1. *Asura*. One of the *asuras* born from the ear-wax of Vishnu.
2. King. A son born to Yadu of his Naga wife Dhumravarna. The renowned Yadava dynasty was established by Yadu and his son Madhu or Madhava. The Yadavas are also called Madhus, i.e. descendants of Madhu.

Madhusudana s. Krishna

Madhvacharya, Madhva (Madhvācārya, Madhva)
(1197-1280)
Philosopher, also known under the name of Anandatirtha, founder of the Brahma *sampradaya*. In his doctrine, referred to as *dvaita*, or dualism, Brahma or God is supreme and the cause of the world; yet essentially different from the *jiva*, or the human soul. God and the soul have a real and eternally distinct essence.

Magadha (Magadha)
The country of southern Bihar.

Mahabharata (Mahābhārata)
(= the great [war of the] Bharatas)
The great epic poem of the Hindus, probably the longest in the world. It is divided in eighteen *parvans*, or books, and contains about 220,000 verses. It is a vast miscellany, partly narrative, partly didactic of myths, folk tales, legends, which gradually accumulated round an epic poem describing the struggle between the Pandavas and the Kauravas for the possession of Upper India. Its nucleus is traditionally ascribed to Krishna Dvaipayana Vyasa, called Vyasa, 'the arranger' (s.). Though the date of its composition like the name of its author, is uncertain, it appears that it cannot be dated earlier than the fourth cent. B.C. and not later than the fourth cent. A.D. (s. also: *Aranyaka Parvan, Ashvamedha Parvan, Bhagavadgita, Nala and Damayanti, Narayaniya*)

Mahabhashya (Mahābhāṣya)
(= great commentary)
The title of Patanjali's commentary on Panini's *Ashtadhyayi*.

Mahadeva s. Shiva

Mahatmya (Mahātmya)
(= magnanimity, high-mindedness, the peculiar efficacy or virtue of any divinity or sacred shrine)
A work giving an account of the merits of any holy place or object.

Mahavira (Mahāvīra)
(= great hero)
(died c. 480 B.C.)
The name of the twenty-fourth and last of the Jain prophets, founder or reformer of Jainism.

Maheshvara s. Shiva

Maitreya (Maitreya)
A sage of great brilliance to whom another sage, Parashara, related the *Vishnu Purana*, the text of which takes the form of a dialogue between the two sages.

Makara (Makara)
Crocodile-like mythical beast.

Makhanchor s. Krishna

Maladhar Vasu (Mālādhar Vasu)
(15th cent.)
Poet. The first translator of the *Bhagavata Purana* in Bengali. M.V. was, among other things, the author of a poem in praise of Krishna, the *Krishnavijaya*.

Mallika (Mallika)
Jasminum Zambac.
A kind of jasmine.

Manak (Manak)
(early 18th cent.)
Painter. Eldest son of the Pahari painter Seu, originally from Guler.

Manas (Manas)
(= mind, intelligence)

Manavedan (Mānavedan)
(1595-1658)
Keralese prince, Zamorin of Calicut. Creator of the dance-drama *Krishnattam* (s.). He was the author of eight Sanskrit dramas, collectively known under the name of *Krishnagiti*. These are: *Avatara* (the ten incarnations), *Kaliyamardana* (the quelling of the snake Kaliya), *Rasakrida* (the play of Rasa), *Kansavadha* (the killing of Kansa), *Svayamvara* (one's own choice, i.e. a girl choosing her husband), *Banayuddha* (the fight with Bana), *Vividavadha* (the killing of Vividha) and *Svargarohana* (the ascent to heaven).

Mandara (Mandara)
A mythical mountain supported by Vishnu in his tortoise incarnation, (s. *kurma*), and used as a churning stick by the *devas* and the *asuras* for churning the ocean to gain the essential objects necessary for the survival of gods and mankind. The ocean represents the unmanifested cosmos which contains 'in potentia' everything necessary to form a new world.

Mandara (Mandāra)
Erythrina indica.
Small tree with red flowers.

Manigriva (Maṇigrīva)
(= bejewelled neck)

Manipuri (Manipuri)
Style of dance from the northeastern part of India (Manipur Valley). The dances of Manipur are mainly devotional. Lyrical grace, lightness of tread and delicacy of hand-gestures, set Manipuri apart from the geometric structure of Bharata Natyam and the linear quality of Kathak. The characteristic Manipuri dances are the *Rasa* dances performed by women. These dances are based on the Krishna legend and on the pre-Vaishnava Manipuri cultural tradition.

Manjira (Mañjīra)
Metal clapper, struck mainly on the edges and held by the loop.

Mantra (Mantra)
A sound or group of sounds (which may or may not have a conventional meaning) recited during Hindu worship and meditation, often almost endlessly, to evoke an aspect of the deity.

Markali (Mārkaḷi)
Tamil name of a month. (December/January).

Markandeya (Mārkaṇḍeya)
Name of a famous sage, who on seeing the whole earth engulfed by water, begged Vishnu to save him. Vishnu appeared to him in the form of a child in whose body the whole universe was contained.

Marut(s) (Marut)
(= flashing)
Storm gods. The friends and allies of Indra. They are closely associated with the fire god Agni and the wind god Vayu.

Maryada Purushottama s. Rama

Mathura (Mathurā)
City on the banks of the river Yamuna. Birth place of Krishna. One of the seven sacred cities of India. (s. Narrative) (s. Map)

Matiram (Matiram Tripathi)
(fl. 1650-1682)
Poet. His *Ras Raj* is a treatise on lovers containing a *Nayika Bheda* (s.) and was quite popular with Pahari painters. His verses appear on several of their miniatures.

Matsya (Matsya)
(= fish)
First incarnation of Vishnu, whose function was to save the best of mankind and other precious things from the flood. (s. Dashavatara)

Matsya Purana (Matsya Purāṇa)
(c. A.D. 250-500)
A heterogeneous mixture, borrowing much from the *Vishnu Purana* and from the *Mahabharata*. It was related to Manu by Vishnu in the form of a fish. (s. Purana)

Maulashri (Maulaśri)
Mimusops elengi.
An evergreen tree with sweet-scented, star-shaped flowers.

Medini Pal (Medinī Pāl)
(1714-1736)
Raja of Basohli, son of Dhiraj Pal.

Megasthenes
(4th-3rd cent. B.C.)
Ambassador appointed by Seleukos Nicator to the court of Chandragupta Maurya. Megasthenes spent eight years (306-298 B.C.) at Pataliputra (Patna), where he wrote an account of the country, the *Indika* i.e. 'Things Indian'.

Megha Malhara (Mallara) Raga (Megha Malhāra Rāga)
Name of a *Raga* to be played during the rainy season.

Meithei(s) (Meithei)
The earliest inhabitants of the Manipur Valley.

Meithei Purana (Meithei Purāṇa)
A conglomeration of Meithei legends and Hindu pauranic and mythical lore, giving origin to what could be called a *Manipura Purana*.

Menaka (Menakā)
An *apsara*.

Meppattur Narayana Bhattatiri s. Narayana Bhattatiri of Meppattur

Meru s. Sumeru

Methora
The Greek name of Mathura.

Milan (Milan)
(= reconciliation, union, adjustment)

Mir Sayyid Ali (Mīr Sayyid 'Alī)
(16th cent.)
Persian painter who joined Humayun at Kabul in 1549. With Abd as Samad (s.) he was the founder of Mughal painting. His unusual naturalistic manner and keen observation are characteristic of his style. He is said to have planned the lay-out of the *Hamza Nama* (s.).

Mohana s. Krishna

Mohsin Fani (Muhsim Fānī)
(17th cent.)
The *Dabistan al Madhahib*, 'The school of religions', a work in Persian describing the different religions in particular the religious situation in Hindustan in the 17th cent. was thought for a long time to have been written by him. It was finished between 1654-1657. Little is known of the life of the poet.

Moksha (Mokśa)
(= release, deliverance)
Release from the empty pleasures and pains of everyday life so that one might fully realize and merge with the Absolute and escape endless deaths and rebirths. This is one of the four basic aims of Hindu life, the ultimate goal and purpose of existence.

Moorcroft, W(illiam)
(19th cent.)
Traveller, who wrote: *Travels in the Himalayan Provinces of Hindustan and the Punjab...., from 1819 to 1825*. Published in London, 1841. This work contains the most valuable information on the political and cultural situation of the Punjab Hill States and of the other adjacent smaller states.

Mridanga (Mṛdaṅgam)
A barrel-shaped drum played on both ends with the hands.

Muchalinda (Mucalinda)
Name of a king of the Nagas, who sheltered the Buddha from a violent storm by coiling himself around him.

Mudra (Mudra)
(= seal)
Ritual hand gestures used in Hindu worship and meditation, through which is established a firmer bond between the devotee and the god.

Mukti (Mukti)
(= deliverance)

Muni (Muni)
An inspired person, a sage or an ascetic, especially one who has taken a vow of silence.

Mura (Mura)
A great *daitya*. He was an ally of the demon Naraka, and assisted him in the defence of Pragjyotishpur against Krishna.

Muralimanohar s. Krishna

Murari s. Krishna

Naga(s) (Nāga)
(= snake)
Mythical semi-divine beings, having a human face, the tail of a serpent, and the hood of a cobra.

Nagapasha (Nāgapaśa)
(= serpent-noose)

Nakkara (Nakara)
Bowl-shaped drum. It is popular over a wide area of northern India. It is mainly used in processions, temple ceremonies and in ensembles as a second drum. It is generally played with sticks.

Nala and Damayanti (Naladamayantī)
An episode drawn from the *Vana* or *Aranyaka Parvan* (The Book of the Forest) of the *Mahabharata*. It narrates the nuptials of prince Nala with lady Damayanti, the loss of Nala's kingdom through gambling, and its eventual restoration. This episode was a favourite with poets and painters.

Nanaghat (Nānāghāṭ)
Archaeological site with important inscriptions in the Thana District (Maharashtra).

Nanda (Nanda)
(= joy)

Nandagopan s. Krishna

Nandalal s. Krishna

Nandana (Nandana)
The mythical grove of Indra, in which the divine *parijata* tree grows. (s. Narrative)

Nandanandana s. Krishna

Nandikeshvara (Nandikeśvara)
(c. 1280)
Authority on *raga* music and author of the *Abhinayadarpana* i.e. 'The Mirror of Gesture', which describes in detail the various movements of the head, face, eyes and other parts of the body, as well as their significance.

Nandisha (Nandīśa)
Name of an attendant of Shiva.

Nappinnai s. Lakshmi

Nara (Nara)
Eminent *rishi* noted for his extreme asceticism and holiness.

Nara Hari Tirtha (Nara Hari Tīrtha)
(14th cent.)
Kanarese saint-poet, abbott of Udupi Monastery.

Narada, Narad (Nārada)
(= bringing to Man[?])
Musical seer who functions in Vaishnavite literature as the emissary of the gods in the human realm, preeminently an arranger of events.

Naraka, Narakasura (Naraka, Narakāsura)
(= hell, place of torment)

Narasinha (Narasiṇha)
(= man-lion)
The fourth incarnation of Vishnu, which took place in order to save Prahlada, who was a staunch Vishnu devotee, from the persecution of his father, the *asura* Hiranyakashipu. (s. Dashavatara)

Narayana (Nārāyaṇa)
(= moving on the waters, son of the waters)
1. Personification of the solar or cosmic energy and of creative power, identified with Vishnu.
2. Name of a *rishi*, brother of Nara; both of them are thought to be emanations of Vishnu.
3. One of the names of Krishna.

Narayana Bhatta (Nārāyaṇa Bhaṭṭa)
(16th cent.)
Alleged initiator of the Ras Lila.

Narayana Bhattatiri of Meppattur (Nārāyaṇa Bhaṭṭatiri of Meppattūr)
(1560-1646)
Author of many works, the most important of which is the Sanskrit poem in praise of the Lord of Guruvayur, the *Narayaniyam*.

Narayaniya (Nārāyaṇiya)
Section of the *Shanti Parvan* or the 'book of peace' of the *Mahabharata*, which is one of the sources of Vaishnava tradition.

Narayaniyam (Nārāyaṇiyam) s. Narayana Bhattatiri of Meppattur

Narmada (Narmadā)
The name of one of the great rivers of India, considered by many Hindus to rank second only to the Ganges.

Nartana (Nartana)
(= dancing, acting, dancer)

Nataka (Nāṭaka)
Drama in its highest form, in five to ten acts. It is the heroic play; the subject is not invented by the poet, but drawn from mythology or history. Its language is lofty.

Nataraja s. Shiva

Natavara s. Krishna

Nath (Nāth)
(= refuge, help, protector, patron, lord)
Often in composite forms. It appears in names of gods and men. e.g. Jagannath = Lord of the World.

Nathdwara (Nāthdwāra, Nāthadvāra)
Principal seat of the Vallabhacharyas near Udaipur (Rajasthan). (s. Map)

Nathji s. Shri Nathji

Natyashastra (Nāṭyaśāstra)
(= treatise on dance)
Treatise on dramaturgy, written by Bharata Muni. (s.)

Navanitapriya s. Krishna

Nayaka (Nāyaka)
(= hero)

Nayaka-Nayika-Bheda (Nāyaka-Nāyikā-Bheda)
(= Classification of the heroes and the heroines)
A description of the various types of 'heroes' and 'heroines' in a love situation.

Nayika (Nāyikā)
(= heroine)

Neminatha (Neminātha)
Jaina prophet. (s. Krishna in the Performing Arts)

Nihalchand (Nihalcand)
(born 1708/15?)
Kishangarh painter. The most famous of the artists at the court of Savant Singh of Kishangarh. He created a new female type, which became characteristic of all Kishangarh painting.

Nilakantha (Nīlakaṇtha)
(17th cent.)
The most popular commentator of the *Mahabharata* and of the *Harivansha* in India.

Nim (Nīm)
Margosa tree.
Its bitter and astringent twigs are used for brushing the teeth.

Nimbarka (Nimbārka)
(?1130?1200)
Philosopher, founder of the Nimandi doctrine. His philosophy held that Brahma or God has an independent reality. The individual soul and the inanimate world are both created, finite and sustained by, but not identical with God. They are dependent realities, distinct from God. This doctrine is called 'dualistic nondualism', i.e. *dvaitadvaita*.

Nritya (Nṛtya)
Dance with combined facial expression and body movements, which conveys thereby the thoughts and emotions of a character. It is usually accompanied by music.

Odorico da Pordenone (Friar)
(14th cent.)
Missionary, author of a work entitled *Itinerarius Orientalis*.

Orissi (Oḍissi)
Form of classical dance from Orissa. Its repertoire consists of literary compositions on the Krishna theme, the favoured being the *Gita Govinda*. While *Bharata Natyam* is devotional in spirit, Orissi is lyrical and sensuous.

Pada (Pada)
A verse form characterized by few fixed poetic conventions, allowing various schemes of end rhyme; typically consisting of six or eight lines, sometimes with refrain, but occasionally much longer.

Pada (Pāda)
(= foot)

Padma Purana (Padma Purāṇa)
(about 1100)
An extensive work divided into six books, which tells of the time when the world was a golden lotus, *padma*, and goes on to describe the creation, and the spheres of the earth, heaven and underworld. (s. *Purana*)

Pakhvaja (Pakhāvaja)
A drum similar to the *mridanga* (s.).

Pandava(s) (Pāṇḍava)
Sons of Pandu, the brother of Dhritarashtra. They were five brothers: Yudhishthira, Bhima, Arjuna, by his wife Kunti; and the twins Nakula and Sahadeva, by his wife Madri. The story of the great battle between the Pandavas and their cousins, the Kauravas, is described in the *Mahabharata*.

Pandharpur (Paṇḍharpūr)
The sacred town of Maharashtra. There Vishnu is worshipped under the name of Vitthalnath or Vithoba by a sect of *bhaktas* known as Varkaris. (s. Map)

Pandit (Paṇḍita)
(= learned, wise, shrewd, clever)
A scholar, learned man, teacher, philosopher.

Pandurang s. Vishnu

Panini (Pāṇini)
(dates uncertain, between the 7th and the 4th cent. B.C.)
The author of the *Astadhyayi*, the earliest standard Sanskrit grammar which is regarded as one of the most remarkable works in world literature.

Para (Para)
The Supreme, the Absolute Being. The Universal Soul.

Parakiya (Parakīyā)
(= belonging to another)
Illicit love relationship with a married woman.

Paramanand Das (Paramānand Dās)
(16th cent.)
Disciple of Vallabhacharya, one of the *ashtachhap* (s.) poets.

Parashurama (Paraśurāma)
(= Rama with the battle-axe [*parashu*]).
Sixth incarnation of Vishnu. (s. Dashavatara)

Parijata (Pārijāta)
Erythrina indica. The Indian coral tree, said to be one of the five trees produced at the Churning of the Milky Ocean. (s. Mandara) It grew in Indra's paradise and its scent perfumed the world. (s. Narrative)

Parikshit (Pārikṣit)
A son of Abhimanyu and Uttara. Yudhishthira abdicated the throne of Hastinapura in favour of Parikshit.

Parks F(anny)
(1794-1875)
Wife of Charles Parks, collector of customs at Allahabad, in the East India Company service. She lived twenty-four years in India and kept a diary: *Wanderings of a Pilgrim in Search of the Picturesque*.

Parshvanatha (Pārśvanātha)
The next to last Jaina prophet.

Partha s. Arjuna

Parthasarati s. Krishna

Parvati (Pārvatī)
(= the daughter of the mountain)
She is the consort of Shiva. Some other names: Bhagavati (Bhagavati), Uma (Uma).

Pashupata(s) (Pāśupata)
Followers of Pashupati, i.e. Shiva. They are considered to be the earliest shaiva sect.

Pashupati Shiva

Patanjali (Patañjali)
(2nd cent. B.C.)
Name of a grammarian and author of the *Yoga-Sutras* (books I-III), the earliest systematic treatise on Yoga. He was also the author of the *Mahabhashya* (s.).

Pauganda (Pauganḍa)
(= related to a boy, boyish)
Boyhood between the age of six and sixteen.

Periyalvar (Periyāḷvār)
(A.D. 9th cent.)
One of the poet-saints, the Alvars. He was a Brahmin born at Shrivilliputtur (Tamil Nadu), author of a poem on the life of Krishna, the *Tirumoli*, and adoptive father of the poetess Andal.

Phagu (Phāgu)
Traditional literary form from Gujarat and Rajasthan. The term derives from the custom of throwing red powder or red water on each other during the festival of Holi. It is a folk entertainment in which mime, dance, and singing intermingle, similar to the *jatra* (also *yatra*) of Bengal.

Phalgun (Phālgun)
Name of a month (February/March). (s. Calendar)

Pichhavai (Pichavāī)
(= that which hangs behind)
Painted cloth hangings, showing motives and scenes pertaining to the life of Krishna and to the Krishna cult.

Porus
King of the Pauravas (Panjab), vanquished by Alexander the Great in 326 B.C.

Prabhasa (Prabhāsa)
A place of pilgrimage on the coast of Gujarat. Today's Somnath. (s. Map)

Pradyumna (Pradyumna)
(= the preeminently mighty one)
Son of Krishna, by his chief wife, Rukmini. He is said to be an incarnation of Kama, the god of love. He appears to have been an historical figure deified in the course of time, and he was regarded as a *vyuha*, an emanation, of the highest god, Para Vasudeva, in the Pancharatra cult.

Pragjyotishpur (Prāgjyotiṣpur)
The capital of the *asura* Naraka. Situated in the east, in Kamarupa, on the borders of Assam. Another name of the city is Pragjyotisha.

Prahlada (Prahlāda)
(= joyful excitement)
A *daitya*, son of Hiranyakashipu and father of Bali. For him Vishnu took the form of Narasinha.

Prakriti (Prakṛti)
(= primal material nature)
Prakriti is personified as the active female principle.

Prema Sagara (Prema Sagāra)
(= the Ocean of Love)
Title of a Hindi translation of the tenth book of the *Bhagavata Purana* by Pandit Lalluji Lal (19th cent.) also called Lallu Kavi.

Pritha (Pṛthā) s. Kunti

Puntanam Nambudiri (Puntanam Nambūdiri)
(c. 1545-1640)
Author of the Malayalam poem *Jnanappana* (s.).

Purana(s) (Purāṇa)
(= Old)
Hence: ancient legend or tale of olden times. It should expound five subjects: 1. Creation of the Universe; 2. Its destruction and recreation; 3. The genealogy of the gods and of the patriarchs; 4. The reigns and the periods of the Manus; 5. The history of the Solar and Lunar Dynasties.
s. *Agni P.*; *Bhagavata P.*; *Brahma Vaivarta P.*; *Kurma P.*; *Matsya P.*; *Padma P.*; *Vishnu P.*

Puri (Pūrī)
(= town)
The 'town' *par excellence*. One of the holy cities of India, on the coast of Orissa. It is famous for the Jagannath temple. (s. Map)

Purna Avatara (Purna Avatāra) s. Avatara

Purusha (Puruṣa)
(= man, male)
It is depicted as a cosmogonic figure, a creative source, the primeval male, who envelops the whole earth and who represents totality. There is nothing higher or beyond the P. It represents the material form from which the world was made, as well as its creator.

Putana (Pūtanā)
(= the stinking one)

Putanavadha (Pūtanāvadha)
(= the killing of Putana)

Radha (Rādhā)
A beautiful *gopi*, wife of Rayan. As a young man Krishna is reputed to have been on intimate terms with the cowherds' wives and daughters, especially with her. She is immortalized by the 12th cent. poet Jayadeva in his *Gita Govinda*, to which much of the popularity of the romantic legend of Krishna and Radha is owed.

Radhakrishnan, S(arvepalli)
(1888-1975)
Statesman and philosopher, author of numerous works. President of India.

Raga (Rāga)
(= that which colours)
The basic unit of organization of classical Indian music, combining mode and melodic pattern.

Ragamala (Rāgamālā)
(= garland of Ragas)
Set of 36, 42 or 84 paintings or even more, depicting the moods conveyed by the various musical melodies.

Raghunath(a) Bhatt(a) (Raghunātha Bhaṭṭa)
(16th cent.)
One of the six principal *Gosvamis*, followers of Chaitanya.

Ragini (Rāgiṇī)
Musical mode, the 'wife' of a Raga.

Raidas (Raidās)
(fl. 1430)
A leather worker by profession who became a disciple of Ramananda. Raidas acquired fame as one of the greater saints of the Vaishnava revival in northern India and in the Maratha country.

Raj Singh (Rana Rāj Singh)
(1652-1680 reg.)
Ruler of Mewar. He conducted the image of Krishna from Vraja to Mewar because of Aurangzeb's religious policy. This image was then enshrined at Nathdwara.

Rajput(s) (Rājput)
(= king's son)
The name given to a large miscellaneous category of fighting races of northern India, who suddenly appeared in India in the early Middle Ages and were active and powerful for over a thousand years.

Rakshasa (Rakṣasa)
Demon. A *rakshasi* is a demoness.

Rama (Rāma)
Seventh incarnation of Vishnu (s. Dashavatara), also called Ramachandra; He represents the ideal of an educated and cultured man. His career is told in the epic poem, the *Ramayana*, i.e. the 'Career of Rama'. An epithet of Rama is: *maryada purushottama* (maryada purusottama), the 'sublimely balanced'.

Ramacharitamanas (Rāmacaritamānas)
(= The lake of Rama's deeds)
Hindi version of the *Ramayana* composed by Tulsi Das, in which emphasis is laid on duty to one's neighbour, and on the doctrine of universal brotherhood.

Ramanuja (Rāmānuja)
(?1017-?1137)
Philosopher founder of the Shri *Sampradaya* (s. The Cult). His doctrine called *vishishtadvaita*, i.e. qualified non-dualism, maintains that both the Supreme Being as well as the individual soul possess reality. The individual soul is a fragment, but not identical with the Supreme.

Ramayana (Rāmāyaṇa)
(c. 350 B.C.-A.D. 250)
(= The career of Rama)
One of the two great epics of India, said to have been composed by the sage Valmiki. Of the seven books constituting the *Ramayana* the last book and part of the first one are interpolated. In these two books, Rama is spoken of as divine, although in the genuine books (II-VI) he is represented as a mortal hero. The work numbers 96,000 verses.

Rambha (Rambhā)
An *apsara*.

Ranchhorji s. Krishna

Ranganath(a) s. Vishnu

Rangba (Raṅgba)
(16th cent.)
The first Vaishnava king of Manipur.

Ranjit Singh (Ranjit Singh)
(1780-1839)
Sikh ruler of great political genius, who welded the disparate elements of the Punjab into a powerful state.

Rasa (Rasa)
(= liquid, taste, flavour)
Hence: mood, an aesthetic or devotional sentiment.

Rasa (Rāsa)
1. Krishna's round dance with the *gopis*, whose enactment is included as a permanent part of every *ras lila*.
2. Type of composition in rhymed verses treating an heroic or romantic subject.

Ras(a) Lila (Rāsa Līlā, Rāslīlā)
(= the play of passion)
1. The circular dance of Krishna and the *gopis*, during which he multiplied himself. (s. Narrative)
2. Theatrical form. (s. Krishna in the Performing Arts)

Rasaka (Rāsaka)
1. A kind of dramatic entertainment. A type of dance.
2. An obscure form of medieval dramatic literature cultivated by the Jains and others.

Rasashiromani, Rasakashiromani s. Krishna

Rasdhari (Rāsdharī)
A member of a professional troupe, particularly the leader of a *Ras Lila* troupe.

Rasika (Rasika)
(= person well versed in *rasa*)
Connoisseur (one who appreciates *rasa*). Krishna is the ideal type of rasika.

Ratha (Ratha)
(= car)
Ceremonial or processional car.

Rati (Rati)
(= desire, passion, love)
The wife of Kama. Her other name is Mayavati.

Ravana (Rāvaṇa)
The king of the Rakshasas, dwelling in Lanka.

Rhubab (Rabāb)
String instrument similar to the European lute.

Rig Veda (Ṛgveda)
The first of the *Vedas*, a repository of sacred lore consisting of a collection of hymns.

Rishi (Ṛṣi)
(= seer)

Roli (Roli)
Mixture of rice, turmeric and alum with acid, used by the Hindus to paint the sectarian mark on the forehead.

Rudra s. Shiva

Rudras (Rudras)
(= the howling or red-ones)
In the *Vedas* they are identified with the Maruts, the sons of Rudra. But later they correspond to the eleven life energies of the individual, ten of them representing the physical and sensory energies, the last one, the self.

Rukminiharana (Rukmiṇīharaṇa)
(= the abduction of Rukmini)

Rupa (Rūpa)
(16th cent.)
One of the six principal *Gosvamis*, followers of Chaitanya, he was the brother of Santana, and was chosen by Chaitanya himself to define his doctrine. A man of great literary capacity, acute theologian and passionate poet.

Rut
The fluid or juice that exudes from the rutting elephant's temples.

Sadas (Sadas)
(= assembly, a shed erected in the sacrificial enclosure)

Sadhya(s) (Sādhyas)
A class of semi-divine celestial beings.

Sahaja (Sahaja)
(= original, natural)
The state of ultimate and blissful unity.

Sahibdin (Sahibdin)
(First half of the 17th cent.)
Famous painter who illustrated various important manuscripts. He worked in Udaipur and exercised a powerful influence on the development of painting in Mewar.

Sakhi (Sakhī)
Confidante, female companion of the 'heroine'.

Sama Veda (Sāma Veda)
(= *Veda* of the Sama, i.e. melody)
Collection of melodies used by the priest who acted as a cantor at the sacrifice.

Sampradaya (Sampradāya)
(= transmission of tradition)
Represents a body or group of persons who believe in a traditionary doctrine originated by a teacher and handed down from generation to generation. e.g. Shri Sampradaya, originated by Ramanuja; Brahma Sampradaya, originated by Madhvacharya; Sanaka Sampradaya, originated by Nimbarkacharya and Rudra Sampradaya, originated by Vishnusvamin. These four are the principal *sampradayas* to be found in Vaishnava philosophy.

Sanchi (Sāñcī)
Famous historical and archaeological site near Bhopal in Madhya Pradesh.

Sangita (Saṃgīta)
(= music)

Sangita Ratnakara (Saṃgītaratnākara)
(= *Thesaurum musicae*)
Work by Sharangadeva.

Sankarshana s. Balarama

Sannyasi (Sannyāsi, Sanyāsi)
A begging wanderer at the fourth and final stage of an ideal Hindu life who, abandoning all worldly ties, wanders homeless in search of the ultimate truth.

Sansar Chand (Sansār Cand)
(1775-1809 reg.)
Raja of Kangra. Masterful and ambitious ruler with an exceptional interest in painting. He had an immense collection of pictures and drawings. He made the Kangra state not only the greatest, but also the richest state in the Punjab Hills. An ardent Krishna devotee.

Sansara (Sansāra)
(= the bondage of life, death and rebirth)

Santana, Sanatana (Sanātana)
(16th cent.)
One of the six principal Gosvamis, followers of Chaitanya. He was the brother of Rupa, and was chosen by Chaitanya himself to define his doctrine.

Sanvara s. Krishna

Saptakshetri Rasa (Saptakṣetri Rāsa)
Anonymous work in Old Gujarati, dated A.D. 1271. It gives, in 119 stanzas, a detailed description of the seven prescribed channels of religious charity.

Sarangi (Sāraṅgī)
String instrument, a kind of violin with four main strings and a variable number of sympathetic strings (between 9 and 25).

Sari (Sāṛī)
A long piece of cloth (c. 6 yds.) used as a female garment.

Saurashtra (Saurāṣṭra)
A region in the west of India, on the Arabian Sea.

Sauvira (Sauvīra)
Ancient country near the river Sindhu. Its inhabitants are the Sauviras.

Savant Singh (Savant Singh)
(born c. 1700-1764)
Ruler of Kishangarh. Ardent devotee of Krishna, he was a poet who wrote several verses under the pen-name of Nagari Das.

Sesodia(s) (Śiśodiya)
Name of a Rajput clan. The Sesodias were settled in Mewar.

Seu (Seu)
(18th cent.)
Painter, probably from Kashmir, and the ancestor of a family of artists. He worked in one of the capital cities of northern India and appears to have migrated to the Hill State of Jasrota about 1740.

Shachi (Śaci)
(= powerful help)

Shah Jahan (Shāh Jahān)
(1592-1666; reg. 1628-1658)
Mughal Emperor, son of Jahangir. He spent his early years at the court of his grandfather Akbar. He was responsible for most of the military successes during the reign of his father. He had a peaceful and prosperous reign, till a serious illness in 1657. During the war of succession between his two sons he was imprisoned by Aurangzeb and died in captivity in 1666. His reign saw a splendid development of the arts, especially architecture (e.g. Taj Mahal).

Shailabhadra (Śālibhadra)
(12th cent.)
Author of one of the earliest specimens of Old Gujarati *rasa*, the *Bharateshvara Bahubali Rasa*, dated 1185. It narrates the war between the kings Bharata and Bahubali, sons of the first Jaina prophet, Rishabha.

Shaivites
Followers of Shiva.

Shakra s. Indra

Shakti (Śakti)
(= energy)
This is the term applied to the wife of a god, and signifies the power of a deity manifested in and through his consort. It is also defined as the female principle.

Shakuni (Śakuni)
Uncle of the Kauravas. He was an expert at dice and advised Duryodhana during his game with Yudhishthira, when the latter lost the whole of his possessions.

Shalagrama (Śālagrāma, Śaligrāma, Śalgrām)
(= from the 'village with the *shala* trees')
Black ammonite stone, one of the symbols of Vishnu, found in a village situated on the river Gandaki in Nepal.

Shamba, Samba (Śāmba, Sāmba)
The son born to Krishna by his wife Jambavati.
(s. Narrative)

Shambhu s. Shiva

Shandilya (Śāṇḍilya)
(c. A.D. 100)
The first to systematically promulgate the Pancharatra doctrine; he composed several *bhakti sutras*, i.e. devotional aphorisms, about the deity. The *samhitas* (collections) of Shandilya and his followers, known as the *Pancharatra Agamas*, embody the chief doctrines of the Vaishnavas.

Shankara s. Shiva

Shankaracarya (Śaṅkarācārya)
(A.D. 788-820)
Saint-philosopher. Founder of the monistic, i.e. *advaita*, philosophy. The goal of his doctrine is to be one with God, to rise above the illusive separateness of the self and become part of the great ocean of being.

Shankaradeva (Śaṅkara Deva, Śaṅkar Dev)
(1449-1568?)
Assamese author (his name in Assamese is Honkar). He wrote several dramas inspired by the life of Krishna, as also an Assamese version of the *Bhagavata Purana* in verse. Some of his works are: *Amritmanthana* (Amṛtamanthana) = The 'Nectar-Churning'; *Gajendraupakhyana* (Gajendraupakhyāna) = The story of the King of the Elephants; *Kaliyadamana* (Kāliyadamana) = The Quelling of the Snake Kaliya; *Parijataharana* (Pārijātāharana) = The Stealing of the Parijata tree; *Patni Prasad* (Patnī Prasād) = The Appeasement of the Consort; *Rukminiharana* (Rukmiṇīharana) = The Abduction of Rukmini.

Sharadatanya (Śāradātanaya)
(12th or 13th cent.)
Author of the *Bhavaprakasha*, i.e. 'Illustration of Bhava'. The work is divided into ten chapters and treats extensively of the *rasa* theory, of dramaturgy etc. It is compiled of different sources, most of which are no longer available, hence the special importance of this work.

Sharagadeva (Śārṅgadeva)
(1210-1247)
Author of the *Sangitaratnakara*, an important text on musical theory.

Shastra (Śāstra)
(= rule, treatise, law-book)
The *shastra* is the formal exposition of a particular subject.

Shauri s. Krishna

Shenhai, Shanhai (Śāhnāī)
Wind instrument. A kind of oboe.

Shesha (Śeṣa)
(= remainder, rest)
The one who remains after the periodic evolution and devolution of the universe, the cosmic serpent. Another of his names is Ananta.

Shikandar Shah Lodi (Sikandar Shāh Lodī)
(died A.D. 1517)
A vigorous ruler who annexed several territories. His realm comprised: Punjab, the Northwest Provinces, Bihar and a portion of Rajasthan. (s. Lodi Sultans)

Shilappadikaram (Silappadikāram)
(= The Lay of the Anklet)
Tamil work attributed to Prince Ilango Adigal.

Shiva (Śiva)
(= the auspicious one)
It is Shiva who destroys the universe at the end of each age-cycle. Some other names: *Hara* (Hara) = the destroyer, the seizer; *Mahadeva* (Mahādeva) = the great God; *Maheshvara* (Maheśvara) = the great Lord; *Nataraja* (Nāṭarāja) = the king of dancers; *Pashupati* (Paśupati) = lord of animals; *Rudra* (Rudra) = roarer (originally this was the name of the *Vedic* god of the tempest, who at a later time ceased to be a separate entity and became completely identified with Shiva); *Shambhu* (Śambhu) = causing or granting happiness; *Shankara* (Śaṅkara) = the auspicious.

Shiva Simha (Śiva Siṃha)
(14th cent.)
King of Mithila, patron of the poet Vidyapati.

Shivaji (Śivājī)
(1627-1680)
Shivaji Bhonsle was a Maratha ruler. Both chivalrous and religious, he fought for the revival of Hinduism and against foreign Moslem occupation. He used the songs of the saints of Maharashtra to galvanize the rough mountain men, who formed the bulk of his troops.

Shravana (Śrāvana)
Name of a month (July/August). Beginning of the year at Nathdwara. (s. Calendar)

Shri (Śrī)
1. s. Lakshmi
2. Honorific title. e.g.: Shri Nathji.

Shri Nathji s. Krishna

Shri Thakurji s. Krishna

Shri Vithoba s. Vishnu (Vithoba)

Shri Vitthal s. Vishnu

Shribhashya (Śrībhāṣya)
Ramanuja's commentary on the *Vedanta Sutra*. The classic text for today's Vaishnavas.

Shrimad Bhagavata (Śrīmad Bhāgavata) s. *Bhagavata Purana*

Shrivaishnava (Śrīvaiṣṇava)
Vaishnava doctrine of Tamil Nadu, in which all the *avataras* of Vishnu are worshipped.

Shrivatsa (Śrīvatsa)
(= favourite of Shri)
Particular mark denoting a great man or signifying divine quality or status. Depicted by a triangle, a flower or simply by a whirl of hair on the chest.

Shudra (Śūdra)
The fourth of the castes, the servile caste.

Shunga (Śuṅga)
(185-72 B.C.)
A dynasty of northern India.

Shyama s. Krishna and Vishnu

Siddha(s) (Siddha)
A class of supernatural beings.

Siddharta Gautama (Siddhārta Gautama)
(566?-486? B.C.)
The Buddha. The founder of Buddhism.

Sikh(s) (Sikh)
Followers of a reformist Hindu sect founded by *guru* Nanak in the late 15th and early 16th centuries.

Simul tree (Śālmali)
Bombax heptaphyllum or *malabaricum*. Cotton tree. It flowers in March, when bare of leaves.

Sirah (Siṅhaṛ)
The former name of Nathdwara.

Sita (Sītā)
(= furrow)
The wife of Rama.

Sitar (Sitār)
A guitar, form of lute with a single calabash as resonance-box.

Soma (Soma)
The name of the *Amanita muscaria* (fly agaric mushroom) and of its juice; after being ritually filtered, it was sometimes mixed with other ingredients such as: water, milk, butter or barley. This juice was the essential libation of all the early *Vedic* sacrifices.

Somadatta (Somadatta)
A king of the Kuru dynasty.

Sophari (Saphari)
Cyprinus saphore. Name of a small, bright fish living in ponds and rivers.

Sourasenai
Greek name of an Indian tribe living in the Mathura region.

Stupa (Stūpa)
Name of an edifice which serves as a receptacle for a relic or as a monument. It is hemispherical or bell-shaped.

Stuti (Stuti)
(= invocation, hymn of praise)

Sudarshana (Sudarśana)
(= beautiful to look at)
1. The name of Vishnu's *chakra* (discus), symbolising the limitless power of his mind and the speed of his thought. 2. Name of Gandharva. (s. Narrative)

Sumeru (Sumeru)
The 'golden Meru'. Mythical mount, the *axis mundi*.

Sura(s) (Sura)
In the *Vedas*, a class of beings connected with Surya, the Sun. Also a name denoting a divinity in general.

Sutra (Sūtra)
(= thread)
The term was applied to compositions written in an aphoristic style. The *sutra* style was adopted in all Indian quasi-philosophical systems, but necessitated commentaries, such as those on Panini's grammatical treatise.

Svami (Svāmī)
A spiritual preceptor and holy man. Now a cult title applied to initiates of certain religious orders, who have taken the vow of the *sannyasin*.

Svarga (Svarga)
(= heaven, paradise)

Svargarohana (Svargārohaṇa)
(= the ascent to heaven)

Svarupa (Svarūpa)
(= own form or shape)
1. An icon.
2. A child actor who impersonates the deity and is regarded as a temporary 'residence' of the god.

Svayamvara (Svayaṃvara)
(= one's own choice)
This was the right exercised in ancient times by girls of noble birth to choose a husband. (s. Narrative)

Syamantaka (Syamantaka)
A magical jewel presented by the Sun to Satrajit. It was an inexhaustible source of good to the virtuous wearer, deadly to the wicked one. (s. Narrative)

Tamal tree (Tamāla)
Garcinia xanthochymus, or *Cinnamomum tamala*. A tree symbol of Krishna.

Tambul (Tāmbūl)
Betel-nut

Tandava (Tāṇḍava)
A kind of wild dance; originally a Dravidian word, cfr. Tamil: *tantavam* (tantavam) = leaping, jumping. It is emblematic of Shiva's cosmic function of creation and destruction.

Tanpura (Tambura)
Multi-stringed instrument essentially tonal in character, played by plucking.

Tapas (Tapas)
(= heat)
Austerity, self-mortification, self-restraint.

Tavernier, J(ean) B(aptiste)
(1605-1690?)
French traveller, author of *Les Six Voyages de Jean Baptiste Tavernier*. Original French edition 1676.

Thug (Thag)
A member of a secret fraternity of assassins, whose origin and rites have been the subject of much fanciful speculation. They were worshippers of Bhavani, a form of the goddess Kali, and they offered human sacrifices to her by strangling victims in her honour.

Tod, J(ames) (Col.)
(1782-1835)
Political agent to the Western Rajput States. Author among others of *The Annals and Antiquities of Rajastan* as well as of *Travels in Western India*.

Tulsi, Tulasi (Tulsī, Tulasī)
Ocymum sanctum. The basil plant, sacred to Vishnu, which symbolises Mahalakshmi, the consort of Vishnu, who is said to have taken the form of the basil.

Tulsi Das, Tulsidas (Tulsī Dās, Tulsīdās)
(?1527-1623?)
(= the servant of Tulsi)
Hindi poet. He wrote more than a dozen works, but is chiefly renowned for his version of the *Ramayana*, composed in Eastern Hindi and titled: *Ramacharitamanas* (s.)

Turmeric (Haridrā)
Radix curcumae.
The rhyzome of a plant. It gives a powder of a deep yellow colour and it is used as a spice as well as for cosmetic purposes.

Ugrasena (Ugrasena)
(= powerful, terrible, mighty army)

Uma s. Parvati

Umapati (Umāpati)
(fl. 1320)
Famous Maithili poet, who was the minister of Harasinha, the last king of Mithila.

Upanayana (Upanayana)
(= brought before [i.e. before the *guru*])
The ceremony in which the *guru* initiates a boy into one of the three 'twice born' (*dvija*) castes. These are: Brahmins, Kshatriyas and Vaishyas. In this ceremony the boy receives the sacred thread, the *yajnopavita.*

Upanishad(s) (Upaniṣad)
(c. 700-300 B.C.)
(From: *upa* = supplementary, additional and *ni-shad* = to sit down) i.e. to sit at the feet of a teacher from whom a pupil received esoteric knowledge. Most of the two hundred or more so-called *Upanishads*, however, contain neither esoteric doctrine, nor teaching imparted in secret. Only thirteen or fourteen actually contain esoteric tenets or teachings. The dating of the fourteen classical *Upanishads* is conjectural, but internal evidence suggests that they were composed between 700 and 300 B.C.

Uparupaka (Uparūpakā)
Minor form of drama. It is based on *nritya* (s.) and provides opportunities for dance, music and mime. The dramatic element predominates however.

Urvashi (Urvaśī)
An *apsara.*

Uttaradhyayana Sutra (Uttarādhyayana Sūtra)
(1st cent. B.C.)
A Jain canonical work. Its intention is to instruct the young monk in his principal duties, to commend an ascetic life by precepts and examples, to warn him against the dangers in his spiritual career, and to give some theoretical information. This work was probably collected over the course of time, possibly in the first centuries before our era, and its first edition was made in the fifth cent. A.D.

Vaijayanti (*mala*) (Vaijayantī mālā)
(= the glorious [garland])
The garland worn by Krishna and Vishnu.

Vaikuntha (Vaikuṇṭha)
(= related to what is not blunt)
The dwelling place of Vishnu, whose location is said to be either in the depths of the Ocean or on the northern or eastern peak of Mount Sumeru.

Vaishampayana (Vaiśampāyana)
Ancient sage. The narrator of the *Mahābharata.*

Vaishnavas (Vaiṣnavas)
The followers of Vishnu. The Vaishnava cult is one of the three great divisions of modern Hinduism, the other two being the Shaiva and Shakta.

Vaishya(s) (Vaiśya)
A member of the third of the four castes. His occupation can be cattle-raising, land cultivation and trading of every kind, and also keeping accounts.

Vajra (Vajra)
(= thunderbolt)
Son of Aniruddha.

Vaka (Vaka)
The bark of a tree which is ground to powder and used as a soap. It has highly antiseptic properties.

Vallabha (Vallabha)
1. s. Krishna
2. = Vallabhacharya

Vamana (Vāmana)
(= dwarf)
The fifth incarnation of Vishnu (s. Dashavatara). He appeared before Bali, and begged of him as much land

as he could step over in three steps. The generous monarch complied with the request: Vishnu took two strides over heaven and earth; but respecting the virtues of Bali, he then stopped, leaving the dominion of Patala, or infernal regions, to Bali.

Vanamali s. Krishna

Vanjula, Banjula (Vañjula)
Creeper: *Calamus rotang*, or *Hibiscus mutabilis.*

Varaha (Vārāha)
(= boar)
The third among the incarnations of Vishnu (s. Dashavatara). The demon Hiranyaksha had dragged the earth to the bottom of the sea. To recover it, Vishnu assumed the form of a boar.

Varshneya (Vārṣṇeya)
(= descendant of the Vrishnis)

Varuna (Varuṇa)
(= all-enveloping)
One of the earliest *Vedic* gods. He is one of the Adityas, the guardian of the West and the god of seas and rivers.

Vasanta Ragini (Vāsanta Rāgiṇi)
(= spring R.)
Name of a *ragini* sung during the spring.

Vasava (Vāsava)
Name of Indra = chief of the Vasus.

Vasudeva (Vasudeva)
(= lord of wealth)
The father of Krishna. (s. Narrative)

Vasudeva-Krishna (Vāsudeva-Kṛṣṇa)
Name of a very early god, widely worshipped especially in western India. At a later point in time, Vasudeva was identified with the *Vedic* Vishnu.

Vasus (Vasus)
A group of eight gods, whose chief was originally Indra, then Vishnu.

Vatsa, Vatsasura (Vātsa, Vātsāsura)
(= calf, calf-demon)

Vayu (Vāyu)
The wind god.

Vayu Purana (Vāyu Purāṇa)
(c. A.D. 500)
The oldest of the *Puranas*, it is devoted to Shiva.
(s. Purana)

Veda (Veda)
(= knowledge)
A term specifically applied to the 'supreme, sacred knowledge' contained in the four collections called *Vedas*. (s.: *Atharva Veda, Rig Veda, Sama Veda* and *Yajur Veda*)

Vedanta (Vedānta)
(= end of the *Veda*)
The complete knowledge of the *Veda*. Orthodox school of philosophy.

Vedanta Sutra (Vedānta Sūtra)
(c. A.D. 200-450)
Also called *Brahma Sutra*. It comprises the collected *sutras* of Badrayana and is specifically an exposition of earlier philosophical themes.

Venu Gopala s. Krishna

Vidhi (Vidhi)
(= rule, injunction, direction)
Manner or way of life. Conduct or behaviour. e.g. *Satvata vidhi* = precepts or rites of the Satvatas.

Vidisha (Vidiśa)
City near Sanchi, in Madhya Pradesh.

Vidura (Vidura)
A son of Vyasa by a slave girl. He was reputed to be the wisest among the wise and gave good advice to both the Kauravas and the Pandavas. In the great war, however, he sided with the later. (s. Narrative)

Vihari s. Krishna

Vikarna (Vikarṇa)
One of the hundred sons of Dhritarashtra.

Vina (Vīṇā)
Lute, staff-zither. Name of a popular musical instrument usually having seven strings. Vina has become the general name for all stringed instruments.

Viraja (Virajā)
A cowherdess who, for fear of being cursed by the incensed Radha melted away and became a river which flows around Vishnu's heaven, the Goloka.

Vishnu (Viṣṇu)
(= pervader)
One of the major deities of the Hindu pantheon, the preserver of the universe and the embodiment of goodness and mercy. He came to earth in various forms to save mankind from suffering and wickedness. (s. Dashavatara).
Some other names and epithets: *Acyuta* (Acyuta = unfallen, imperishable, permanent; *Hari* (Hari) = greenish-yellow; *Narayana* (Nārāyaṇa) = moving in the waters; *Pandurang* (Paṇḍurāṅg) = white-limbed. This aspect of the god is especially worshipped at Pandharpur (s.). The image is represented as golden in colour with the two hands resting on the hips, and is shown attended by his wife Rukmini. *Ranganatha* (Raṅganātha) = Lord of the assembly hall. This image is especially worshipped at Shrirangam. It shows Vishnu resting on Ananta. The same aspect of the god as Ranganatha is worshipped at Kanchi (Śri Varadarājasvāmi) and at Tirupati (Śri Venkateśvara); *Shyama* (Śyāma) = the dark one; *Vithoba* (Viṭhobā), or *Shri Vitthal* (Śri Viṭṭhal), forms of Vishnu especially revered in Maharashtra.

Vishnu Purana (Viṣṇu Purāṇa)
(c. A.D. 5th cent.)
The text takes the form of a dialogue between Parashara and Maitreya. (s.) Its basic teaching is that Vishnu is the creator, sustainer and controller of the world. This *Purana* is the most perfect and best known of all the works of this class. (s. *Purana*)

Vishnusvamin (Viṣṇusvāmin)
(end of the 14th cent.)
Founder of the Rudra *sampradaya.*

Vishnuvardhana (Viṣṇuvardhana)
(c. 1050)
A Hoyshala king.

Vishva (Viśva)
(= to pervade; whole, entire, universal)
It appears often in composite words and names. e.g. Vishvakarman = accomplishing or creating everything.

Vishva(s) (Viśva)
A class of supernatural beings.

Vishvakarma(n) (Viśvakarma)
(= all creator)
The architect of the gods.

Vishvarupa (Viśvarūpa)
(= containing all forms)

Vishvedeva(s) (Viśvedeva)
(= all divine)
A class of minor gods.

Vithoba s. Vishnu

Vitthalnath (Viṭṭhalnāth)
(1516-1576)
Son of Vallabhacharya. Organiser of the Vallabhacharya *sampradaya*. His main impulse appears to have been towards devotional literature and ritual, in which he displayed his gifts as a poet and as a musician.

Vitthal s. Vishnu

Vraja (Vraja)
District of the Mathura region not far from Vrindavana (s.) where Krishna spent his boyhood.

Vrajakishor s. Krishna

Vrindavan(a), Brindaban(a) (Vṛndāvan[a], Bṛndabān[a])
(= forest of the chorus of women)
Name of an area in the Mathura District, where Krishna spent his youth. (s. Map)

Vrindavandas (Vṛndāvāndās)
(= the slave or servant of Vrindavana)
(16th cent.)
The last disciple of Nityananda. Bengali writer, author of the *Chaitanya Bhagavata*, (c. 1550) an account of the life of Chaitanya.

Vrishchika (Vṛścika)
(= scorpion)
Name of a month (November/December). (s. Calendar)

Vrishni(s) (Vṛṣni)
(= manly)
The descendants of Vrishni, son of Madhu, whose ancestor was the eldest of the sons of Yadu.
Another name of the Yadavas.

Vyasa s. Krishna Dvaipayana Vyasa

Vyuha (Vyūha)
(= emanation)
Name of the four appearances or manifestations of Vishnu. The four Vyuhas are: Vasudeva (Krishna), Sankarshana (Balarama), Pradyumna and Aniruddha. All these are endowed with special sanctity in the developed Bhagavata-Pancharatra cult.

Yadava(s) (Yādava)
(= related to or descendants of Yadu)
The celebrated tribe where Krishna was born. Other names: Vrishnis, Yadus (s.).

Yadavendra s. Krishna

Yadu (Yadu)
The name of the founder of the Yadava tribe. (s.)

Yadupati s. Krishna

Yajur Veda (Yajur Veda, Yajurveda)
The *Veda* of the Yajus, a manual for the guidance of the priest in the performance of the sacrifice. It consists of two closely connected but separate collections, known as the White and the Black *Yajur Veda*.

Yaksha(s) (Yakṣa)
Collective name of godlings or spirits which frequent field, forest and jungle, and whose activities are theme of much Indian folklore. They may be either beneficient or malignant.

Yakshagana (Yakṣagaṇa)
Dance-drama of southern Karnataka. (s. Krishna in the Performing Arts)

Yama (Yama)
(= twin, curb or bridle)
The ruler and judge of the dead, he is the guardian of the South.

Yamuna (Yamunā)
Name of the river Jumna, one of the tributaries of the Ganges, which it joins at Allahabad. (s. Map)

Yantra (Yantra)
(= tool, implement)
An abstract geometrical figure that captures an aspect of a deity and diagrams his basic energies. Used for meditations upon and worship of the god.

Yavana(s) (Yavana)
(= Greek)
This name was first applied in northwestern India to the Greeks from Asia Minor, especially the Ionians (hence the term Yavana), who from the 6th cent. B.C. spread to the North and to the East, and established settlements in Bactria.

Yoga (Yoga)
(= yoke) The act of yoking the mind and body to achieve perfect unity.

Yogamaya, Yoganidra (Yogamāyā, Yoganidra)
(= meditation, sleep)
Personified as a goddess, a manifestation of Vishnu's magic power of delusion. She is a form of Durga.

Yojana (Yojana)
A distance traversed in one harnessing without unyoking. It corresponds roughly to four or five English miles.

Yudhishthira (Yudhiṣṭhira)
The eldest son of King Pandu and of his wife Kunti. He was the leader of the Pandavas. (s. Narrative)

Yuga (Yuga)
The four periods or ages of the world's existence. Their duration becomes progressively shorter, hinting thus at the similar reduction of the physical and moral standards of each age. The four *yugas* are: 1. Krita (Kṛta); 2. Treta (Tretā); 3. Dvapara (Dvāpara) and 4. Kali (Kali) the present period, the 'dark one'.

Zamorin (Zamorin)
The Ruler of Calicut. A title for many centuries of the Hindu sovereign of Calicut and of the country around. It means 'Sea-King'.

Index

The Index consists of:
— *Names of persons*
— *Names of historical or mythical places*
— *Names of geographical sites*
— *Sanskrit and Vernacular terms*
— *Titles of anonymous works*
We shall, however, enter the name of the authors, even in those cases in which the work is mentioned without its author.
E.g.: Gita Govinda, shall always appear under the name of its author, Jayadeva.

Index of Sanskrit and Regional (Vernacular) Terms

213

Index of names

Bibliography

Works of general interest

Basham, A.L. *The Wonder that was India*, New York 1954

Coomaraswamy, A.K. 'Lila', in: *Journal of the American Oriental Society*, Vol. 61 (1941), pp. 98-101

Crooke, W. *The Tribes and Castes of the North-Western India*, Delhi repr. 1974

Dowson, J. *A Classical Dictionary of Hindu Mythology* and Religion, Geography, History and Literature, London 10th ed., 1961

Dubois, J.A. (Abbé) *Hindu Manners, Customs and Ceremonies*, Ed. H.K. Beauchamp, 3rd. ed., Oxford 1906

Growse, F.S. *Mathura: A District Memoir*, Indian Repr., New Delhi 1979

History and Culture of the Indian People, Ed. R.C. Majumdar
 Vol. II, *The Age of Imperial Unity*, 4th ed., Bombay 1968
 Vol. V, *The Struggle for Empire*, 2nd ed., Bombay 1966
 Vol. VI, *The Delhi Sultanate*, 2nd ed., Bombay 1966
 Vol. VII, *The Mughul Empire*, Bombay 1974

History of Mediaeval Deccan, Ed. H.K. Sherwani and P.M. Joshi, Hyderabad 1973-74

MacCrindle, J.W. *Ancient India as Described in Classical Literature*, Westminster 1901

Majumdar, R.C. *The Classical Accounts of India*, Calcutta 1960

Mani, Vettam *Puranic Encyclopaedia*. A comprehensive Dictionary with special Reference to the Epic and Puranic Literature, Delhi-Patna-Varanasi 1979

Mitra, R.L. *The Antiquities of Orissa*, Repr. Calcutta 1961-1963

Orissa. Kunst und Kultur in Nordost-Indien, Ed. v. E. Fischer, S. Mahapatra, D. Pathy, Zürich 1980

Renou, L. and *L'Inde Classique*, Paris 1947-1953
Filliozat, J.

Russell, R.V. *Tribes and Castes of the Central Provinces of India*, Indian repr.,
and Hira Lal Delhi 1975

Schwartzberg, *A Historical Atlas of South Asia*, Chicago 1978
J.E.

Singer, M., Ed. *Traditional India: Structure and Change*, Philadelphia 1959

Sörensen, S. *An Index to the Names in the Mahabharata*, London 1904, Repr. 1963

Stutley, M. and J., *A Dictionary of Hinduism*, London 1977

Thurston, E. *Castes and Tribes of Southern India*, Repr. Delhi 1975
and
Rangachari, K.

Tod, J. *Annals and Antiquities of Rajasthan* or the Central and Western Rajput States of India, Ed. W. Crooke, London 1920

Walker, B. *Hindu World*. An encyclopedic survey of Hinduism, London 1968

Yule, H. and *Hobson-Jobson, A Glossary of Colloquial Anglo-Indian Words*
Burnell, A.C. *and Phrases*, London 1969

Works on the Krishna cult and related subjects

Archer, W.G. *The Loves of Krishna in Indian Painting and Poetry*, London 1957

Bhandarkar, R.G. *Vaishnavism, Shaivism and Minor Religious Systems*, Strassburg 1913, Repr. 1965

Bhattacharji, S. *The Indian Theogony*, London 1970

Dasgupta, S.B. *Obscure Religious Cults* as a Background to Bengali Literature, Calcutta 1946, Repr. 1976

Dasgupta, S.N. *A History of Indian Philosophy*, London 1932-1955

De, S.K. *Early History of the Vaishnava Faith and Movement in Bengal from Sanskrit and Bengali Sources*, Calcutta 1961

Dimock, E.C. Jr. 'Doctrine and Practice among the Vaisnavas of Bengal', in: *History of Religions*, Vol. 3, No. 1 (1963) pp. 106-127

Dimock, E.C. Jr. *The Place of the Hidden Moon*. Erotic Mysticism in the Vaishnava-Sahajiya Cult of Bengal, Chicago 1966

Eschmann A; Kulke, H; *The Cult of Jagannath and the Regional Tradition of Orissa*,
Tripati, G.C. New Delhi 1978
Eds.

Joshi, R.V. *Le Rituel de la Dévotion Krishnaïte*, Pondichéry 1959

Kennedy, J. 'The Child Krishna, Christianity and the Gujars', in: *Journal of the Royal Asiatic Society*, 1907, pp. 951-991

Kinsley, D.R. *The Divine Player: A Study of Krishna Lila*, Delhi 1979

id. *The Sword and the Flute*. Kali and Krishna, Dark Visions of the Terrible and the Sublime in Hindu Mythology, Berkeley 1977

Kosambi, D.D. 'The Historical Krishna' in: *Times of India Annual*, 1965, pp. 27-36

Kulke, H. 'Rathas and Rajas. The Car Festival at Puri' in: *Art and Archaeology Research Papers*, 16, Dec. 1979, pp. 19-26

Masson. J.L. 'The Childhood of Krishna' in: *Journal of the American Oriental Society*, Vol. 94 (1974), pp. 454-459

Mishra, K.C. *The Cult of Jagannath*, Calcutta 1971

Panikkar, R. *The Vedic Experience: Mantramanjari*, Berkeley 1977

Classical Sources

Ashvaghosha *Buddhacarita, or the acts of the Buddha*, Trsl. E.H. Johnston, Calcutta 1936; Delhi 2nd ed., 1972

Bhagavadgita *The Song of God: Bhagavad Gita*, Trsl. Swami Prabhavananda and Ch. Isherwood, New York 1954

id. Radhakrishnan, S. (Ed. and trsl.), London 1963

Bharata Muni *The Natyasastra; A Treatise on Hindu Dramaturgy and Histrionics*. Trsl. M. Ghosh, rev. 2nd. ed., Calcutta 1967

Bhasa *Two Plays: Avimaraka and Balacarita*, Ed. and trsl. Bak Kunbae, Delhi 1968

Brahma Vaivarta Puranam, Trsl. R.N. Sen, Allahabad 1920

Harivamsha Trsl. M.N. Dutt, Calcutta 1897

Jatakas Ed. Fausböll, London 1875-97

Mahabharata An English Version Based on Selected Verses (by) Chakravarthi V. Narasimhan, New York 1965

id. Ed. and trsl. J.A.B. van Buitenen, Chicago 1973

Nandikeshvara (Abhinaya Darpana) *The Mirror of Gesture, being the Abhinaya Darpana of Nandikeshvara*, Trsl. A.K. Coomaraswamy and G.K. Duggirala, New Delhi 1970

Srimadbhagavatam Trsl. J.M. Sanyal, 2nd. ed., Calcutta (1950-52)

id. Trsl. V.G. Tagare, Delhi 1978

Vishnu Purana *A System of Hindu Mythology and Tradition*, Trsl. and illust. and notes by H.H. Wilson, 3rd. ed., Calcutta 1961

Anthologies

O'Flaherty, W.D. *Hindu Myths. A Sourcebook translated from the Sanskrit,* London 1975

Puranas *Classical Hindu Mythology; A Reader in the Sanskrit Puranas*, Ed. and trsl. C. Dimmitt and J.A.B. van Buitenen, Philadelphia 1978

Raychaudhuri, H. *Materials for the Study of the Early History of the Vaishnava Sect*, New Delhi, 2nd ed., 1975

Sharma, B.N. *Festivals of India*, Delhi 1978

Singer, M., Ed. *Krishna: Myths, Rites and Attitudes*, London, 2nd impression 1971

Sitapati, P. *Sri Venkatesvara. The Lord of the Seven Hills, Tirupati*, Bombay 1968

Spink, W.M. *Krishnamandala*. A Devotional Theme in Indian Art, Ann Arbor 1971

Thomas, P. *Festivals and Holidays of India*, Bombay 1971

Tucci, G. *Storia della filosofia indiana*, Bari 1957

Vaidyanathan, K.R. *Sri Krishna. The Lord of Guruvayur*, Bombay 1974

White, Ch., S.J. 'Krishna as Divine Child' in: *History of Religions*, Vol. 10, No. 1, 2 (Aug. Nov. 1970)

Poetry: Selected Translations

Abbot, J.E. trsl. *Stotramala. A Garland of Hindu Prayers*, Poona 1929

Adigal, Ilango *Shilappadikaram* (The Ankle Bracelet), Trsl. A. Daniélou, New York 1965

Antal *Un Texte de Dévotion Vishnouite: le Tiruppavai d'Antal*, by J. Filliozat, Pondichéry 1972

Bhattacharya, D., Ed. and trsl. *The Mirror of the Sky*. Songs of the Bauls from Bengal, London 1969

Bihari Lal *The Veiled Moon*. Translations of Bihari Satsai, by A.N. Jha, Ed. G.K. Mathur, New Delhi 1973

Bilvamangala *Bilvamangalastava*, Ed. and trsl. F. Wilson, Leiden 1973

Chandidas *Love Songs of Chandidas*, Trsl. D. Bhattacharya, London 1967

Dimock, E.C. Jr. and Levertov, D. *In Praise of Krishna. Songs from the Bengali*, Trsl. E.C.D. and D.L., New York, 1967

Hooper, J.S.M. Ed. and trsl. *Hymns of the Alvars*, Calcutta 1929

Jayadeva *Love Songs of the Dark Lord: Jayadeva's Gitagovinda*, Trsl. B. Stoler Miller, Delhi 1978

Keshavadasa *The Rasikapriya of Keshavadasa*, Ed. and trsl. K.P. Bahadur, Delhi 1972

Lallu Lal Kavi *The Prema-Sagara or Ocean of Love* being a literal translation of the Hindi text of Lallu Lal Kavi, by F. Pincott, London 1897

Macnicol, N. trsl. *Psalms of the Maratha Saints*, Calcutta n.d. [1919]

Mirabai *Poems of Mirabai*, Pandey, S.M. and N. Zide (Trsls.) Chicago 1964

Nanddas *The Round Dance of Krishna and Uddhav's Message*, Ed. and trsl. R.S. McGregor, London 1973

Sur Das *Pastorales par Sour-Das*, Ed. and trsl. Ch. Vaudeville, Paris 1971

Vidyapati *Love Songs of Vidyapati*, Trsl. D. Bhattacharya, Ed. W.G. Archer, London 1963

Works on Indian Literature

Belsare, K.V. *Tukaram*, New Delhi 1967

Bryant, K.E. *Poems to the Child-God*, Structures and Strategies in the poetry of Surdas, Berkeley 1978

Dimock, E.C. Jr. and others *The Literatures of India. An Introduction*, Chicago 1974

Glasenapp (von), H. *Die Literaturen Indiens, von ihren Anfängen bis zur Gegenwart*, Stuttgart 1961

Goetz, H. *Mira Bai, her life and times*, Bombay 1966

Jesudasan, C. and H. *A History of Tamil Literature*, Calcutta 1961

Kulkarni, S. *Saint Eknath*, New Delhi 1968

Mukherjee, R. *The Lord of the Autumn Moons*, Delhi 1967

Nair, P.K. Parameswaran *History of Malayalam Literature,* Trsl. E.M.J. Venniyoor, New Delhi 1967

Siegel, L. *Sacred and Profane Dimensions of Love in Indian Traditions as Exemplified in the Gitagovinda of Jayadeva*, Delhi 1978

Winternitz, M. *A History of Indian Literature*, trsl. from the German, Calcutta and Delhi 1927-1967, repr. 1977

Zvelebil, K.V. *Tamil Literature*, Wiesbaden 1974

Fine Arts

Appasamy J. *Tanjavur Painting of the Maratha Period*, New Delhi 1980

Archer, W.G. *Indian Paintings from the Punjab Hills*, London 1973

Banerjea, J.N. *The Development of Hindu Iconography*, 3rd ed., New Delhi 1974

Banerjee, P. *The Life of Krishna in Indian Art*, New Delhi 1978

Chitra, V.R. and Srinivasan, T.N. *Cochin Murals,* Madras 1940

Coomaraswamy, A.K. *Rajput Painting,* repr. New York 1975

Desai, K. *Iconography of Vishnu in Northern India*, New Delhi 1973

Dey, M. *Birbhum Terracottas*, New Delhi 1959

Dickinson, E. and Khandalavala, K.J. *Kishangarh Painting*, New Delhi 1959

Goswamy, B.N. 'Pahari Painting: The Family as the basis of style' in: *Marg*, Vol. XXI, No. 4 (Sept. 1968)

Goswamy, B.N. *Painters at the Sikh Court*, Wiesbaden 1975

Joshi, N.P. *Mathura Sculptures*, Mathura 1966

Khandalavala, K.J. 'A Gita Govinda Series in the Prince of Wales Museum', in: *Prince of Wales Museum Bulletin*, 1953-54, No. 4, pp. 1-18

id. *Pahari Miniature Painting*, Bombay 1958

Khandalavala, K.J. and Chandra, M. *An Illustrated Aranyaka Parvan in the Asiatic Society of Bombay*, Bombay 1974

id. *New Documents of Indian Painting — a reappraisal*, Bombay 1969

Kramrisch, S.; Cousens, J.H. and Poduval, V. *The Arts and Crafts of Kerala*, Cochin 1970

Lee, S. *Rajput Painting*, New York 1960

Pal, P. *Krishna: The Cowherd King*, Los Angeles 1972

Randhawa, M.S. *Basohli Painting*, Calcutta 1959

id. *Kangra Paintings of the Bhagavata Purana*, New Delhi 1960

id. *Kangra Paintings of the Bihari Sat Sai*, New Delhi 1966

id. *Kangra Paintings of the Gita Govinda*, New Delhi 1963

id. *Kangra Paintings on Love*, New Delhi 1962

Rao, S.R. and Sastry, B.V.K. *Traditional Paintings of Karnataka*, Bangalore 1980

Rao, T.A.G. *Elements of Hindu Iconography*, Madras 1914-1916, repr. 1957-1964

Rosenfield, J. *The Dynastic Arts of the Kushans*, Berkeley 1967

Sarswati, S.K. *Early Sculpture of Bengal*, Calcutta 1962

Sinha, R.P.N. *Geeta Govind in Basohli School of Indian Painting*, Calcutta n.d.

Sivaramamurti, C. *Indian Sculpture*, Delhi 1961

Skelton, R.W. *Rajasthani Temple Hangings of the Krishna Cult*, New York 1973

Welch S. C. and Beach, M.C. *Gods, Thrones and Peacocks*, New York 1965

Zimmer, H. *Myths and Symbols in Indian Art and Civilisation*, Ed. J. Campbell, New York 1962

Performing Arts

Ashton, M.B. and Christie, B. *Yakshagana. A Dance Drama of India*, New Delhi 1977

Classical and Folk Dances of India, Marg Publications, Bombay 1963

Hawley J.S. and Shrivatasa Goswamy *At play with Krishna. Pilgrimage dramas from Brindavan*, Princeton 1981

Hein, N. *The Miracle Plays of Mathura*, Delhi, New Haven 1972

Iyer, K. Bharatha *Kathakali, the sacred dance-drama of Malabar*, London 1955

Karanth, K. Sh. *Yakshagana*, Mysore 1975

Kothari, K.S. *Indian folk musical instruments*, New Delhi 1968

Lévi, S. *Le Théâtre indien*, Paris 1890

Menon, K.P.S. *A Dictionary of Kathakali*, New Delhi 1979

Mukhopadhyay, D. *Lesser known forms of performing arts in India*, Delhi 1976

Pandeya, G.A. *The Art of Kathakali*, Allahabad 1961

Sachs, C. *Die Musikinstrumente Indiens und Indonesiens*, Berlin und Leipzig 1923

Vatsyayan, K. *Classical Indian Dance in Literature and the Arts*, New Delhi 1968

id. *Indian Classical Dance*, New Delhi-Calcutta 1974

This book, published by Edita S.A. Lausanne,
was created under the direction of Ami Guichard,
Enrico Isacco, Anna Dallapiccola and Constance Devanthéry-Lewis.
Layout by Max Thommen.

Photolithography by Cromoarte, Barcelona
Printed by G.E.A., Milan
Bound by Maurice Busenhart, Lausanne

Printed in Italy